Man and God in Art and Ritual

MAN *AND* GOD IN ART AND RITUAL

A Study of Iconography,
Architecture and Ritual Action
as Primary Evidence of
Religious Belief and Practice

S. G. F. BRANDON, M.A., D.D.

Professor of Comparative Religion in the University of Manchester

CHARLES SCRIBNER'S SONS / NEW YORK

Copyright © 1975 I. A. Brandon

Library of Congress Cataloging in Publication Data

Brandon, Samuel George Frederick.
 Man and God in art and ritual.

 Bibliography: p.
 1. Art and religion. 2. Ritual. I. Title.
N72.R4B72 246 73-1358
ISBN 0-684-13657-0

1 3 5 79 11 13 15 17 19 Q/C 20 18 16 14 12 10 8 6 4 2

PRINTED IN THE UNITED STATES OF AMERICA

DESIGN BY RONALD FARBER

Contents

PART THREE
Man and God in Art and Ritual:
The Evidence Interpreted 337–399

Preface

This is a pioneering essay in a field of study that has for too long been neglected by scholars. For most historians of religions have shared with theologians a preoccupation with the intellectual expression of religion. They have tended to concentrate their attention on the written records of the world's religions, as though such records provided the truest evidence of what men and women have felt about their gods and their own place in the scheme of things. The importance of such literary evidence is not to be minimised; but the almost exclusive attention given to it has resulted in a serious neglect of the witness of art and ritual. Too often it has been forgotten that man expressed his religious ideas in art and ritual long before he learned to write. And even in those religions that are distinguished for their sacred literature, most ordinary folk think of their gods in terms of a traditional iconography and serve them according to traditional rites. Thus, for example, the Buddhist makes his offerings and meditates before an image of the Buddha, and even evangelical Christians carry in their minds an impression of Jesus acquired unconsciously from pictures seen in childhood.

In this book an attempt is made to show how rich in insight, and fascinating in its imagery, is the evidence of religious art and ritual. Through iconography a more immediate and effective impact can be made with the ideas and emotions of men and women, in other ages and cultural traditions, than can ever be had from their written records. This rich treasury of information should no longer be neglected; but, in saying so, it must also be recognised that another factor has probably operated, beside that of an academic predeliction for written sources, to account for its neglect. It is that the interpretation of an image or a ritual scene is a more indefinite and uncertain exercise than the interpretation of texts. Help can be obtained from historians of art on styles, techniques and art traditions; but the

historian of religions is left to his own devices in evaluating the religious significance of a cult image or a tomb-fresco. However, a beginning has to be made to the task of establishing a methodology of this subject. To this end, the author hopes that his book will contribute in setting up some signposts for further research, as well as by stirring interest in a theme of undeniable importance for the history and comparative study of religions.

The author wishes to record his thanks to Mr. Charles Scribner for his ready acceptance of the idea of publishing a book on this subject, and for making it possible to illustrate it so profusely. He is greatly indebted also to Mr. G. A. Webb and Mr. W. McCullock for the efficient service provided by the Photographic Department of the Arts Library of Manchester University, and to the Director of the John Rylands Library, Manchester, for his kind cooperation in making manuscripts available for reproduction, and to the Director of the Manchester Museum for the photographing of Egyptological objects. He also acknowledges gratefully the permission kindly given by many other persons and institutions for the reproduction of illustrations. The acquisition of illustrations was done by Florett Robinson. Finally, the author desires to express his deep gratitude to Miss Susan Wood for her patient interpretation of his manuscripts.

Professor Brandon died tragically in October, 1971, shortly after the manuscript of this book had been delivered to the publishers. The manuscript was complete and accurate, and the illustrations were all chosen. A certain amount of necessary checking has however been done by Dr. Eric J. Sharpe of the University of Lancaster.

The Department of Comparative Religion,
Manchester University.

Arrangement of the Pictures

This book contains 511 pictures important for the study of the history of religion. It has been planned in such a way that the pictures illustrate the text as closely as possible. At times this involved reproducing certain pictures more than once.

Each picture, numbered in boldface type, is accompanied by a caption explaining it. Numbers in the margin of the text—both boldface and lightface—refer to pictures that illustrate the subject under discussion. Boldface numbers indicate the key picture or pictures that illustrate each section; these pictures appear on a page opposite or adjacent to the text. Lightface numbers indicate other pictures that should be referred to for comparison; wherever possible, these pictures are reproduced in the margin on the same page. If they do not appear in the margin, they can be found elsewhere in the book in numerical order.

Credits for all pictures appear in a section beginning on page 493.

Abbreviations

Ae.R.T.B. *Die ägyptische Religion in Texten und Bildern,* by G. Roeder, 4 vols., Zürich/Stuttgart, 1959–61.

A.N.E.T. *Ancient Near Eastern Texts Relating to the Old Testament,* ed. J. B. Pritchard, Princeton University Press, 2nd ed., 1955.

A.S.A.E. *Annales du Service des Antiquités de l'Egypte, Cairo.*

Bilderatlas. *Bilderatlas zur Religionsgeschichte,* ed. H. Haas, Leipzig/Erlangen, 1924–30.

B.J.R.L. *Bulletin of the John Rylands Library,* Manchester.

C.A.H. *Cambridge Ancient History,* 12 vols., 1924–39, Vols. of Plates I–V, 1928–34. 2nd ed. Vol. I, Part I: *Prolegomena and Prehistory,* 1970.

D.C.C. *The Oxford Dictionary of the Christian Church,* ed. F. L. Cross, London, 1958.

D.C.R. *A Dictionary of Comparative Religion,* ed. S. G. F. Brandon, New York/London, 1970.

E.J.R. *Encyclopedia of the Jewish Religion,* ed. R. J. Zwi Werblowsky and D. Wigoder, New York/London, 1965.

E.P.R.O. *Etudes préliminaires aux religions orientales dans l'empire romain,* ed. M. J. Vermaseren, Leiden.

E.T. English translation.

E.R.E. *Encyclopaedia of Religion and Ethics,* ed. J. Hastings, 12 vols. and Index, Edinburgh, 1908–26.

G.B. *The Golden Bough,* by J. G. Frazer, 12 vols., London, 1936.

H.D.B. *Dictionary of the Bible,* ed. J. Hastings, 2nd ed., 1963.

H.G.R. *Histoire générale des religions,* ed. M. Gorce and R. Mortier, 5 vols., Paris, 1947–52.

H.R. *History of Religions,* University of Chicago Press.

I.L.N. *Illustrated London News.*

Jb.f.A.C. *Jahrbuch für Antike und Christentum,* Münster, 10 vols., 1958–.

J.N.E.S. Journal of Near Eastern Studies, University of Chicago Press.

J.R.A.S. Journal of the Royal Asiatic Society of Great Britain.

Kleine Pauly. Der Kleine Pauly Lexikon der Antike, Stuttgart, 1962–.

N.T.S. New Testament Studies, Cambridge University Press.

Numen. Numen (International Review of the History of Religions), Leiden, 1954–.

O.C.D. The Oxford Classical Dictionary, Oxford, 1949.

P.B.A. Proceedings of the British Academy.

R.A.C. Reallexikon für Antike und Christentum, ed., T. Klauser, 6 vols., Stuttgart, 1950–.

R.G.G. Die Religion in Geschichte und Gegenwart, 3rd edition, Vols. I–VI, ed. K. Galling, Tübingen, 1957–62.

R.H.R. Revue de l'histoire des religions, Paris.

R.S. La Regalità Sacra/The Sacred Kingship (Contributions to the Central Theme of the VIIIth International Congress for the History of Religions, Rome, April, 1955). Leiden, 1959.

S.O. Sources orientales. A series comprising volumes variously entitled and by various contributors, Paris, 1959–.

Turchi, Fontes. N. Turchi, *Fontes Historicae Mysteriorum Aevi Hellenistici,* Roma, 1923.

W.P. Wonders of the Past, ed. J. A. Hammerton, 3 vols., London, 1923–4.

PART ONE

The Priority of Art and Ritual

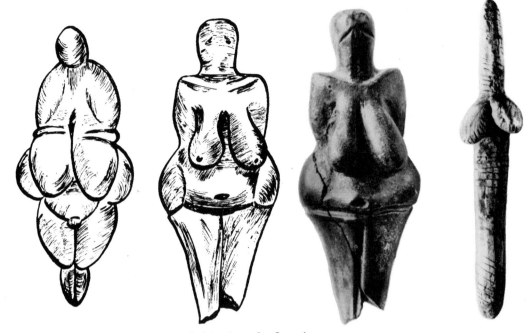

1a,b,c. Selection of Palaeolithic female figurines.

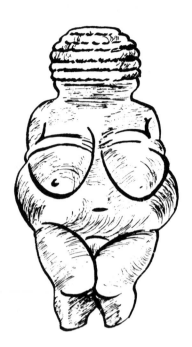

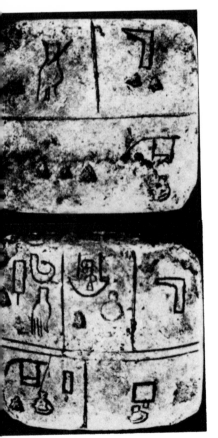

2. Earliest known pictograph tablet from Kish (*c.* 3500 B.C.).

3a,b. Palette of Narmer, both sides.

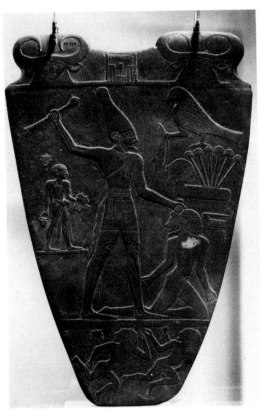

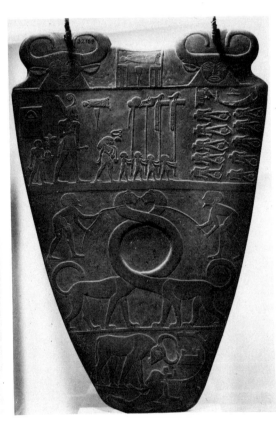

When seeking to understand and explain the religions of mankind, scholars turn, almost instinctively, to the sacred texts and other written records of these religions. That they should do so is understandable, because the religions with which they are most familiar are "book religions." Christianity has its New Testament, which depends in turn upon the Hebrew Bible of Judaism; and Islam is inextricably rooted in the *Qur'ān*. Accordingly, it is natural that when they approach other religions, scholars at once seek out what they deem to be the relevant documents; thus, they begin the study of Hinduism by reading the earliest writings of India, and they look for information about Buddhism in the recorded discourses of the Buddha. And likewise with the so-called "dead religions" of Egypt, Mesopotamia, Greece, Iran and China: it is to whatever texts are available that attention is chiefly directed.[1] There seems to be a tacit but widespread assumption that the primary source of evidence for any religion is its literature, or other forms of writing such as inscriptions that may not merit the title of literature.

10

1a, b, c, 10

But man drew pictures long before he could write books, or carve inscriptions. Indeed, his innate ability to express his ideas pictorially is attested both by the earliest evidence of human culture and by the readiness of young children to make pictorial representations of imagined scenes or happenings. The time gap that separates man's earliest known depictions and the first evidence of his ability to write is immense. Already in the Upper Palaeolithic era (*c.* 25,000–10,000 B.C.) he was carving female figurines and painting animal forms on the walls of caves;[2] but it was not until the end of the fourth millennium B.C. that he began to express his ideas in a crude pictographic script. These earliest scripts, moreover, as the designation "pictographic" indicates, were derived from drawings of the objects which they were meant to signify.[3] And, later, when pictographs were used as ideographs, the latter denoted ideas associated with the things portrayed.[4] Ancient Egypt provides some notable evidence of the transitional state between pure pictorial expression and writing proper in the celebrated Palette of Narmer (*c.* 3000 B.C.). In this record of his victories, the pharaoh is represented, at one and the same time, realistically, symbolically and by his name written in hieroglyphs.[5] Evidence of similar import has been found in the earliest forms of Chinese

2

3a, b

[3]

writing on the so-called "Oracle Bones" unearthed at Anyang: a pictogram of a man with a large head has lived on in written Chinese as a radical denoting "soul," while "ancestor" (*tsu*) was denoted by a symbolic phallus.[6]

In this context, it is significant also that many primitive peoples survived into the twentieth century without a written language, though able to express their religious conceptions in a complex iconography. And the fact that their spoken language has often been fluent still further underlines the non-essentiality of written material as evidence of a rich cultural life. The origin and antiquity of speech is a fascinating but unsolved problem. We can only surmise that the Palaeolithic peoples, who could so ably express themselves in art, were equally able to communicate their ideas and emotions by spoken word and gestures.[7]

In these introductory considerations of art as a primary form of religious expression, the mental stimulus afforded by drawing and modelling must also be noticed. The evident delight experienced by a child when it learns that by drawing it can create the forms of people, animals and things surely reflects something of the wonder felt by our remote ancestors when they first discovered this peculiarly human aptitude. For, to the dawning mind, it doubtless seemed a marvellous thing that on the blank surface of a rock the figure of an animal could be made to appear, or that a piece of stone could be shaped as a woman.[8] In a later age, when the potter's craft had been invented, men were to conceive of gods who moulded mankind from clay.[9] And so deeply disposed was early man to believe that the figures which his art had created were endowed with some mysterious potency that a people as gifted as the Egyptians sometimes felt it necessary to mutilate certain hieroglyphic signs in a tomb inscription, to render them innocuous.[10]

That art was one of the earliest forms in which man expressed himself, and that it long antedated writing, is incontestable. But our special concern here is with the manner in which art reflects ideas and emotions that may be described as religious. From that tradition of religious art with which most people would be reasonably familiar, namely, Christian art, it might well be concluded that two motives have apparently been operative in religious art generally. What would

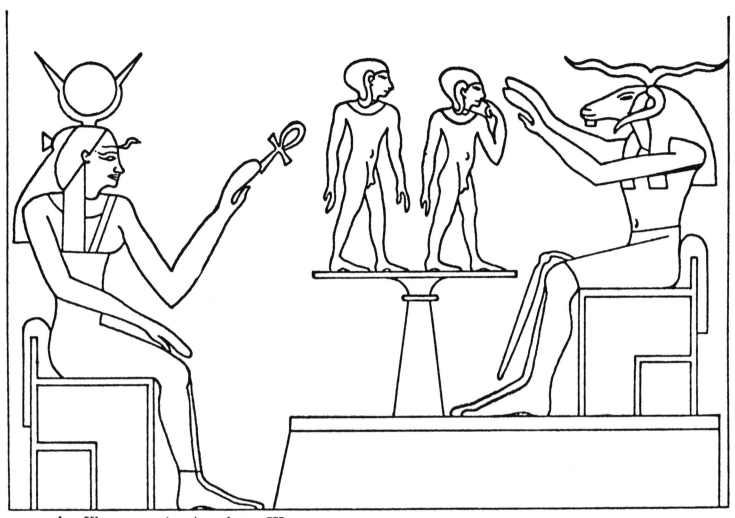

4. Khnum creating Amenhotep III.

5. Egyptian hieroglyphic signs mutilated.

45, 61, 63,
363-67, 369

152-53, 155-56,
158-64

364

369

6, 268, 271,
279a, cf. 445a

doubtless be regarded as the more significant of these motives is the didactic. Many will recall that the mediaeval parish church was itself the "poor man's Bible"—that through its images and pictures and stained glass it sought to teach the illiterate the truths of their religion.[11] The other motive was that of the consecration to God of the richest products of human skill, so that He might be worshipped in the beauty of holiness.[12] These are certainly valid and well-authenticated motives so far as Catholic Christianity is concerned; but it is clearly evident that they did not inspire Palaeolithic art or that of the early historic religions. An indication of the more mysterious nature of the motives operative in Palaeolithic art is given by the fact that most of its products are situated in the innermost recesses of caves, most difficult of access and enshrouded in complete darkness.[13] Quite obviously paintings so positioned were not intended for instruction or decoration. It is generally agreed by prehistorians that the purpose of these paintings was magical; but in what manner will be a subject for our later consideration. Similarly significant is the fact that much of ancient Egyptian art was intended for the tomb, and was for ever enclosed with the dead after the completion of the funerary rites.[14]

The mention of just these factors indicates that art has had a variety of functions in religion; it will now assist our purpose at this stage to mention another factor of a somewhat different kind. An iconographic tradition, once it is firmly established, becomes a powerful influence in a religion—indeed, in many instances, one of the most powerful. The reason for this lies in the constitution of the human mind. The vast majority of persons think primarily in terms of visual images. The "eye-gate," as educationalists have called it, is the most effective and most used of our senses, and the impressions received through it most profoundly influence our ideas and emotions.[15] Consequently, the depictions of deities constitute a factor of immense importance for the study of religion. Most people who have been brought up in the Christian tradition would undoubtedly admit, if questioned, how profoundly their conception of Jesus Christ has been influenced by the conventional portrayals of him—indeed, it is significant how often the image of a beardless Christ will now offend, even though it is the more ancient presentation.[16]

From this cursory survey it is thus evident that art has had a

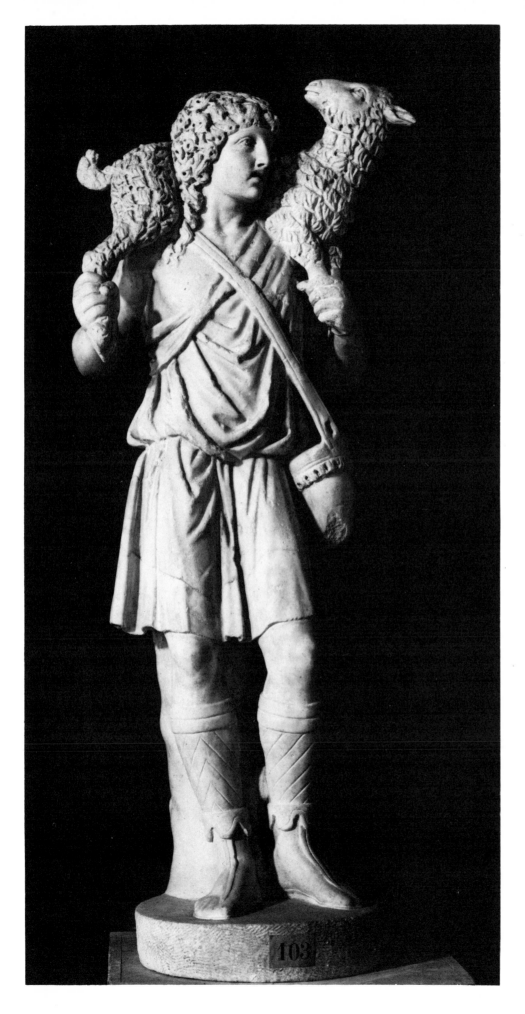

158b

152

271

6. Statue of Christ as the Good Shepherd, marble, 3rd-4th centuries.

threefold role in religion. It has been a primary means of religious expession in a variety of ways yet to be described; it has provided a medium of operation charged with magical potency; and it has constituted a most powerful factor in shaping popular conceptions of the gods.

Religious iconography incontestably predates religious literature; but it can also flourish in company with it and greatly assist the presentation and diffusion of the ideas and doctrines contained in such literature. It should perhaps be noted here that, although art has never been inimical to the claims of a sacred scripture, history records some notable instances when a sacred scripture has proscribed, or been invoked to proscribe, iconography: namely, in Judaism,[17] and Islam,[18] and during the Iconoclastic controversy in Byzantine Christianity (726–843)[19] and the Protestant Reformation in Europe.[20] But, however that may be, so far as a general impression has worth in this context, it would seem that iconography has effectively influenced the popular conception of deity even in those religions that are dominated by a holy book.[21]

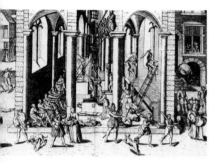

444

But before he could draw, man doubtless expressed his emotions and ideas in ritual action. Such action appears to be almost instinctive in human beings, when intensely desirous that something should happen which they cannot achieve by their own practical effort. A simple instance, which will be familiar to many, is often experienced when watching a drama or an athletic contest which causes a sense of deep emotional involvement. An urge, which is fundamentally irrational, may be felt to assist the desired event by miming some action that might achieve it. Such an impulse to imitative action, which a sophisticated mind will at once repress, meets a ready response with the unsophisticated, and this response is often consciously elaborated. Hence, among primitive peoples carefully controlled imitative action, based upon the principle of what is known as "sympathetic magic," has developed into established rituals. Thus water may be solemnly sprinkled on the ground to induce needed rain to fall, or peasants leap high to encourage the growth of corn, or light fires in mid-winter to strengthen the weakening sun at the critical moment of the solstice. Often rituals will comprise an elaborate miming drama designed to

7, 8, 12, 14, 16,
47, 97

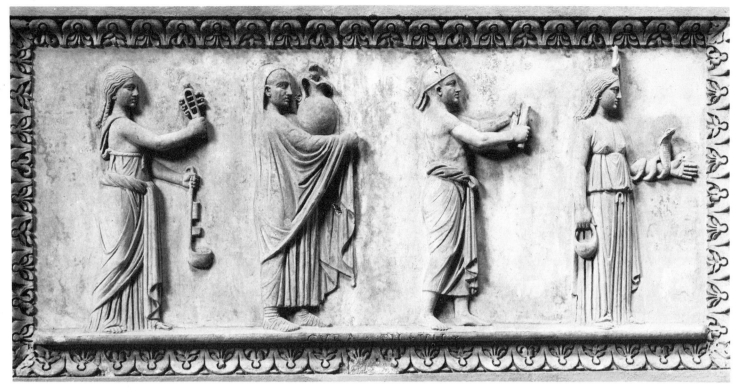

7. Procession of ministrants in a festival of Isis.

8. Anointing of Queen Elizabeth II at her coronation in Westminster Abbey.

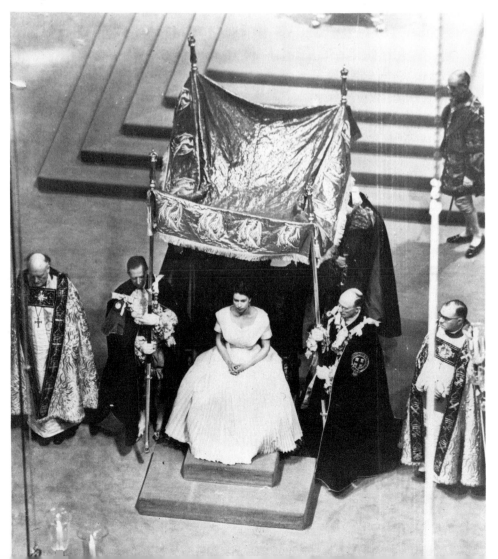

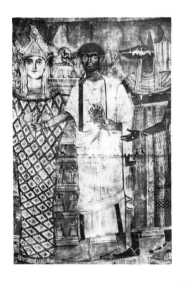

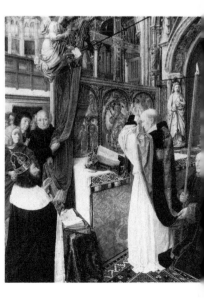

re-create or represent some signal event of the legendary past, such as the creation of the world or the triumph of some hero over death. Sometimes the ritual action may be accompanied by the recitation of explanatory formulae or invocations of supernatural powers.[22]

Ritual action, therefore, in its original and essential nature, is not just a decorous or traditional way of doing things on solemn occasions, although it may become so, as for example, in the anointing of the monarch in the British coronation service.[23] It is essentially a *drōme-non*, a "thing done," as the ancient Greeks called the rites performed in the Eleusinian Mysteries, which is believed to achieve some desired end, usually of a spiritual nature.[24] Such a concept may, indeed, be ranked as primitive and closely associated with the practice of magic. But its significance and influence in human culture should not, in consequence, be underestimated. In Catholic Christianity ritual action is still regarded as an essential factor in worship and the ministration of the sacraments. This view finds expression in the principle of *ex opere operato*, according to which divine grace is mediated to the faithful, for example, by the proper performance of the Mass, irrespective of the personal merit of the priest who performs it.[25] In other words, the ritual transaction is held to generate a spiritual potency by the very fact of its being performed or "done" (*drōmenon*).

The relation between art and ritual, which was established long ages before religion became literate, constitutes, therefore, an important topic for our investigation. For the moment, however, it will be enough to note that our earliest evidence of ritual action, with one exception,[26] is provided by Palaeolithic art. Thus, the association of art and ritual goes back to the very beginning of the archaeological record of human culture, although there is reason on *a priori* grounds, as we have noticed, for thinking that ritual probably preceded art as a medium of religious expression.

The many references made so far to the data of Palaeolithic archaeology bear witness to the fact that any investigation of the religious significance of art and ritual must logically start with a consideration of this material.

This evidence of human culture—of which the record begins at the start of Upper Palaeolithic era (*c.* 40,000 to 30,000 B.C.) with

8

122-23

16, 102

24, 25, 27

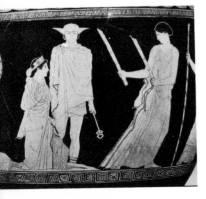

122

the first skeletal remains of *Homo sapiens*—is necessarily meagre and fragmentary.[27] Consequently, its interpretation is inevitably speculative, and the investigator can only hope that by careful reasoning he might achieve a sound evaluation of its testimony. But problematic as they are, the cultural relics of the earliest known ancestors of our race truly have an evidential value, as indeed every human artefact has; and their significance, moreover, is unique by the very fact that they are the earliest so far known. Hence, despite the scepticism professed by some scholars about the possibility of obtaining any useful information concerning religion from data so fragmentary and enigmatical, the effort is justified; for, otherwise, we might resign ourselves to a frustrating and profitless agnosticism towards a subject that is both intrinsically fascinating and profoundly important to the study of man.

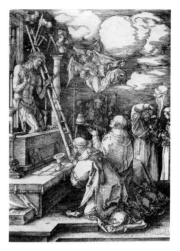

102

The data provided by Palaeolithic archaeology divide into four obvious categories, three of which are of basic significance for the history of religions. These categories comprise, respectively, artefacts such as implements of stone or bone, and ornaments; burials of the dead; carved figurines and bas-reliefs; and paintings and engravings in caves. It is the three last of these categories that, naturally, command our attention here, and they provide the basic pattern according to which our study will be arranged and developed in the concluding section of this book. For each relates to a topic of basic human concern, which has continued since that remote time to find significant expression in the religions of all subsequent peoples.

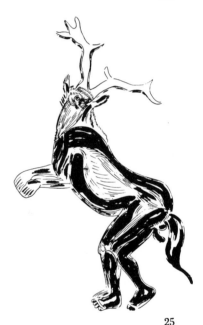

25

The burial of the dead is most notable as a practice that distinguishes mankind from all other species. It is a practice, too, in which *Homo sapiens* was actually anticipated by his immediate hominid precursor, the so-called Neanderthal or Mousterian Man, though naturally in a cruder way.[28] This careful disposal of the dead is of crucial significance for the history of religions, because of its implications. In its earliest forms it was clearly not motivated by sanitary considerations, since the dead were invariably buried with an equipment of food, implements and ornaments that imply belief in some kind of afterlife. In other words, at the very dawn of human culture, as it is revealed by archaeology, death is shown to have been a matter about which man felt impelled to take special action, involving economic cost to himself— for the surrender of food and other equipment must have constituted a

9, 410

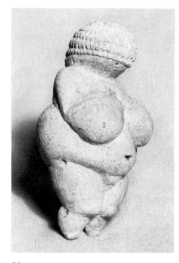

30

1a, b, c, 30, 46

considerable sacrifice to people living at bare subsistence level as were these Old Stone Age hunters.[29]

The very fact, then, that the Palaeolithic peoples thus took care of their dead attests that already death was a matter about which they consciously thought and acted. For such funerary equipment implies the currency of specific ideas concerning death and the condition of the dead. But that is not all, although the implication itself certainly has profound significance. As we shall see, there is evidence of a variety of ritual practice in the burial of the dead that, in turn, indicates a variety of belief concerning the end of man and what lies beyond. And so, with the first appearance of our species in the archaeological record there emerges evidence of a preoccupation with death that was to become a major theme of religion. Confronted with the phenomenon of mortality, man had already resorted to ritual action as a primary means of dealing with its consequences, such as he imagined them to be.

Accordingly, we are given a theme of basic import for our study: namely, that for tens of thousands of years before the invention of writing, mortuary rituals were established and practised which provide evidence of man's primaeval reaction to the most disturbing fact within the world of his experience. Man's subsequent ability to express his ideas in writing is not likely to have changed radically this primaeval pattern of reaction or to have reduced its significance. It will be our task, then, duly to trace out and endeavour to interpret the various rites in which this reaction has found its chief forms of expression.

The evidence of Palaeolithic culture also shows how early man reacted to two other major issues of his existence, namely, birth and the food supply. His concern about the former found expression in artistic creation. The female figurines and bas-reliefs of women which he carved reveal a preoccupation with the idea of the mother as the source of life. These images will require our special consideration later. They are mentioned now because they introduce another basic theme of religious concern which finds expression in iconographic and ritual forms of ever increasing complexity in later ages. The theme is that of new life, and it has served to counterbalance man's concern about the grim prospect of death. The phenomenon of birth has encouraged hope, in an infinite variety of ways, that life is stronger than death, and can be perpetually renewed.

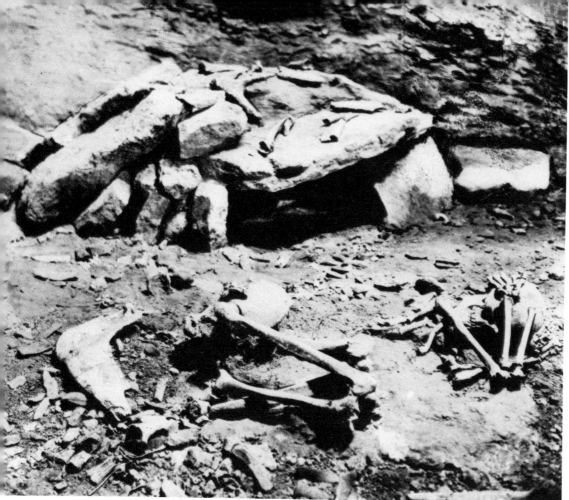

410

9. Palaeolithic burial of Magdalenian cultural era.

10. Paintings of animals on left wall of the so-called Rotunda, or "Hall of Bulls," of the Lascaux caves (Montignac, Dordogne, France).

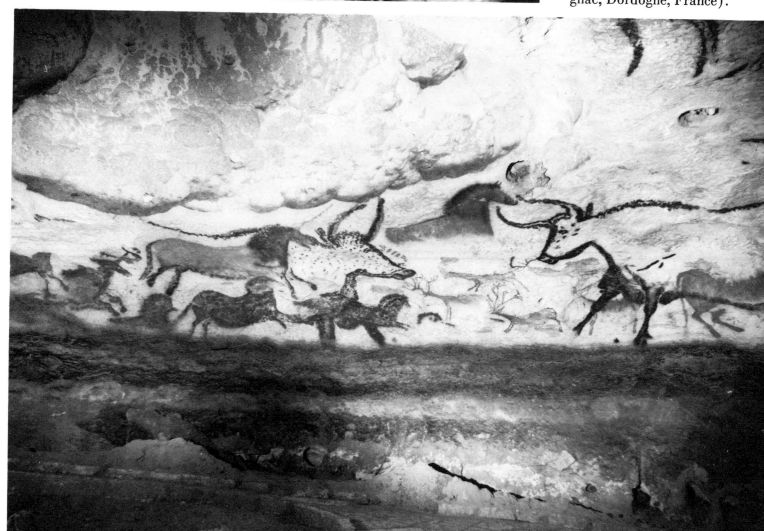

The third subject of concern which is attested by the evidence of Palaeolithic culture is that for the supply of food. But such concern will doubtless be thought so obvious and mundane that it may seem perverse to single it out as having a religious significance. The efforts of Palaeolithic man to obtain food, however, were not wholly of a practical nature. He was a hunter, and evidently expert and bold enough to prey upon such mighty beasts as mammoths, bison and bears.[30] But to his hunting skills and prowess he sought to add supernatural forces, and his cave paintings bear record of the means which he used to this end.

10

19, 25

This aspect of Palaeolithic culture, accordingly, represents early man's reaction to his basic need of food; but it also involves belief in the possibility of invoking or utilising power beyond that which he naturally possessed. In other words, Palaeolithic cave art, as we shall see, reveals the beginnings of man's awareness, admittedly crude and unformed, of the existence of supernatural power or forces which he sought to manipulate to his own advantage. It was from such primitive intuition that there was to stem, in process of time, the conception of deities that controlled the natural world, and upon whose providence the well-being of mankind depended.[31]

19

The remains of Palaeolithic culture, meagre and enigmatic though they are, thus reveal that our earliest known ancestors, confronted with the basic problems of death, birth and subsistence, expressed their concern in ritual and art. In so doing, they initiated three traditions of conceptual thought and action that form the foundational pattern of all religions. We shall trace out and seek to interpret, in Part Three of this study, the witness of each of these traditions in art and ritual from their first beginnings in the Upper Palaeolithic era. In this way we may hope to gain some insight into man's agelong quest to understand himself and his destiny, as it is revealed in his primal forms of expression.

PART TWO

Ritual and Art as Primary Evidence of Religion: The Scope, Nature and Problems of Their Witness

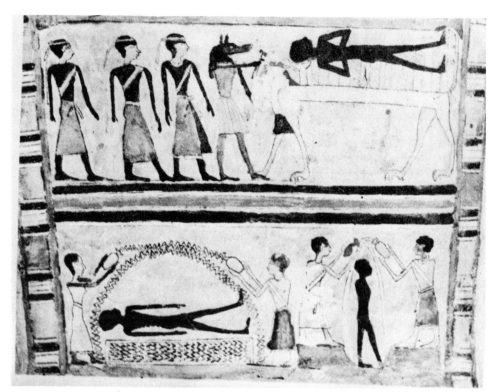

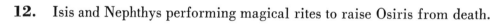

11. Ritual washing of a corpse in Egyptian mortuary rites.

12. Isis and Nephthys performing magical rites to raise Osiris from death.

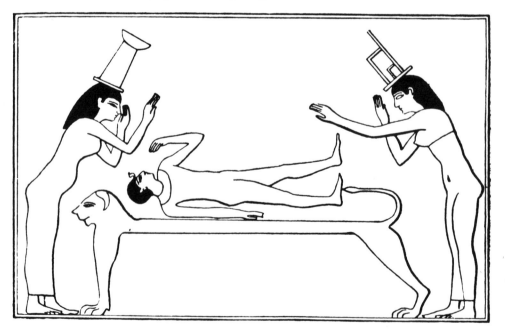

I. RITUAL: ITS RELATION TO MYTH AND DOCTRINE; ITS EFFICACY *EX OPERE OPERATO*

Ritual action appears to have been in origin instinctive, rather than rationally conceived; but it is evident that ritual practice in even the most primitive communities conforms to a tradition that has to be learned by the young, and instruction in it is usually an important part of initiation ceremonies.[1] Indeed, in most religions ritual action is usually complex, and its meaning is rarely obvious to the uninstructed. Often such action is accompanied by the recitation of a kind of libretto, which may be explanatory of the action. Two examples may be noticed here which are taken from religions widely separated in time and cultural setting.

In the ancient Egyptian mortuary ritual recorded in the *Pyramid Texts* (*c.* 2400 B.C.), the following utterance appears to have accompanied the ritual lavation of the corpse of the dead king: "Isis brings a libation for you, Nephthys cleanses you; your two great sisters restore your flesh, they reunite your members, they cause your two eyes to appear in your face."[2] This example has much that is significant for our study. It reveals that the preparation of the body of a dead Egyptian king for burial combined practical and ritual action. The corpse was washed, but the washing was charged with a supernatural significance. The water both cleansed and revivified the dead. That the washing had this supernatural efficacy was due, according to Egyptian belief, to the fact that it re-enacted ritually what had once been done by the goddesses Isis and Nephthys in raising the divine hero Osiris from the dead.[3]

11, 12, 13

The utterance, which accompanied the ritual action, was apparently designed to identify the purpose of what was being done by the officiants at this point in the ritual of embalmment. It takes the form of an assurance addressed to the dead king; but it appears also to have something of the nature of an incantation. It is possible, therefore, that such a solemn declaration of the meaning of the rite was deemed necessary, in order to endow it with the same magical potency as that of the original action that had revivified the dead Osiris. The declaration, moreover, presupposes that the dead king is ritually assimilated to

13. *Pyramid Texts* in Sarcophagus Chamber of the Pyramid of Unas, West Wall.

Osiris, so that those who perform the ritual lavation on his behalf are similarly to be identified with the goddesses Isis and Nephthys.[4]

14, 95

We know of this ritual libretto because the priests of Heliopolis chose to record it in writing on the interior walls of the pyramids of certain pharaohs of the fifth and sixth dynasties.[5] Their reason for so recording it is not exactly known; but it is unlikely that it was didactic. For once the burial ceremonies were completed, all entrance to the pyramid concerned was carefully closed, so that the inscribed texts were left in the darkness that enclosed the dead monarch. That they were thus recorded suggests that it was deemed advisable to perpetuate the efficacy of what had been uttered and done in the mortuary ritual by carving the texts concerned into the very fabric of the tomb, which was the "eternal house" of the deceased pharaoh where he hoped to dwell for "millions of years."[6]

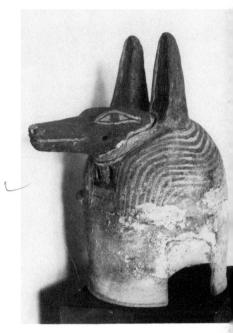

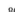

95

The *Pyramid Texts*, accordingly, reveal that the Egyptians, about the middle of the third millennium B.C., performed an elaborate funerary ritual for their dead kings which was accompanied by a kind of spoken commentary. This commentary was primarily designed to relate the various ritual actions to a series of authenticating archetypal actions associated with Osiris. No formal explanation is given in the *Texts* for this unique significance of Osiris; but it is evident that knowledge of a distinctive myth or legend concerning his death and resurrection was presumed.[7] We are, therefore, acquainted with a situation of considerable import for our subject. We see that, already, at this early stage in the history of religions, ritual action was significantly related to a complex of ideas concerning the possibility of salvation from death and its consequences. These ideas were embodied in a personalised narrative or myth concerning the destiny of a divine hero called Osiris. This myth-and-ritual complex, moreover, was not formally recorded in writing, but knowledge of it was transmitted orally and by constant ritual representation over a truly immense period of time.[8] In other words, this single ritual action upon which we have chosen to concentrate attention out of the complex ritual system documented by the *Pyramid Texts* involves an elaborate belief of a very distinctive kind, about the possibility of resurrection from death.

40, 80

80

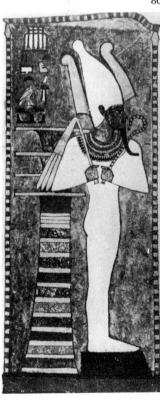

How such a belief came to be held in Egypt is beyond our knowing. What is certain is that, doubtless long before the *Pyramid Texts* were

inscribed, a complex royal mortuary ritual had been worked out in connection with the myth of Osiris. In the *Pyramid Texts*, the myth forms the rationale of the ritual, and the linkage finds oral expression in the libretto that accompanies the ritual action. This connection is very clearly stated in another *Text*, in which the god Atum is invoked to raise the dead pharaoh Unas from death as he had once raised up Osiris: "Recite: O Atum, it is thy son—this one here, Osiris, whom thou hast caused to live (and) remain in life. He liveth (and) this Unas (also) liveth; he (i.e., Osiris) dieth not (and) this Unas (also) dieth not."[9] As this *Text* indicates, the mortuary rites were based upon the ritual assimilation of the dead king with Osiris. The primitive principle of sympathetic magic involved here had obviously been the basis upon which the ritual technique for ensuring the resurrection of a dead king had originated, possibly in the Predynastic period of Egyptian history.[10] Since the mortuary ritual, evidenced by the *Pyramid Texts*, included the practical action of embalming, an interesting, though insoluble, question arises—did the myth of Osiris originate from primitive efforts at embalming, designed to preserve the body of a dead king from physical disintegration and restore him to some form of life, or was the ritual technique of embalmment inspired by some ancient legend of a resurrected king?[11] The extant evidence does not justify further speculation about these interesting possibilities. But what is important for the purpose of our study is that such an elaborate complex of ritual action and authorising myth, concerning death and resurrection, was established and practised for long centuries without written formulation and directives. Moreover, the fact that we know of this early form of the Osirian mortuary ritual through the *Pyramid Texts* is, paradoxically, not proof of the essentiality of written evidence, but rather the reverse. For these *Texts* would be largely unintelligible to us, were it not for the later iconographic illustration that survives of the Osirian myth and mortuary ritual, as we shall see in our subsequent study.

For comparison and supplementation of evidence, alongside of this ancient Egyptian example we may set the following ritual act from the celebration of the Catholic Mass. After reciting the words of consecration over the sacramental bread or Host, the celebrant solemnly raises with both hands that which has now become, according to Catholic

14

15

14. The ritual assimilation of the dead to Osiris.

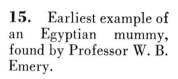

15. Earliest example of an Egyptian mummy, found by Professor W. B. Emery.

16. *The Mass of St. Giles*, by the Master of St. Giles (late 15th century).

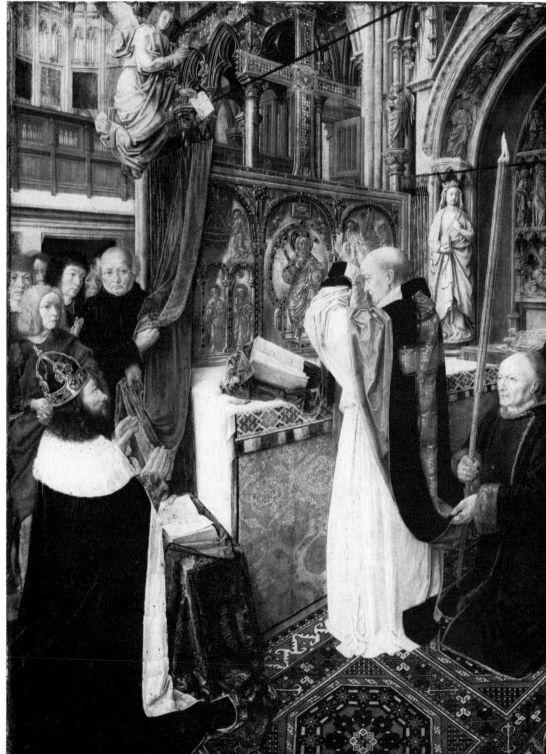

belief, the Body of Christ. Similarly, after consecrating the wine, he lifts up the chalice in which the sacramental Blood of Christ is contained.[12] These two ritual actions constitute what is known as the Elevation; they symbolise the offering of Christ's vicarious sacrifice, for the sins of mankind, to God the Father. In popular devotion, the Elevation is regarded as the climax of the Mass, and its crucial nature is signified by the ringing of bells and by censing the sacred elements as the celebrant holds them aloft. This ritual act is made independently of the text of the Mass, which contains no reference at this point to the offering of Christ's sacrifice to the Father. The Elevation, however, is the unique ritual expression of the doctrine of the Sacrifice of the Mass, which constitutes one of the cardinal doctrines of Catholic Christianity.[13]

16, 102

In this Christian example we have a peculiarly instructive instance of a ritual act, charged with great theological and devotional significance, which seems to have become an established practice, though not specifically enjoined or endorsed by the text of the liturgy. In its liturgical context, the gesture of elevation may fairly be seen as a natural instinctive action of offering sacrifice to a deity located in heaven, and it could be paralleled by similar sacrificial action in many other religions.[14] However, in the Catholic Mass this ritual act of Elevation implicates a theology of peculiar distinction and complexity, although in itself the act reveals nothing of this. We are, accordingly, acquainted with another factor for consideration when seeking to evaluate a ritual act that may have the appearance of a natural self-evident gesture—the apparent lack of sophistication in such an act may cloak a significance of great theological profundity.

50

The two examples just analysed serve also to show that ritual action may express beliefs about human destiny and divine providence of very varying kinds. The ritual purification of the corpse in the Osirian mortuary cultus was integral to a complex of religious faith and practice, centred on the myth of Osiris, which was believed to assure a dead person immunity from the corruption of death and an eternal state of well-being. The significance of the Elevation in the Mass derives from an interpretation of the Mass which identifies the rite as a divinely covenanted re-presentation to God the Father of the sacrificial death of Christ for the salvation of mankind; as such it relates to the Chris-

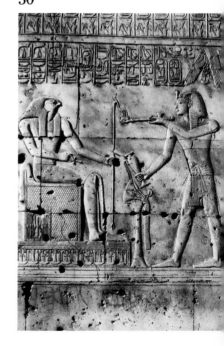

tian doctrine of the Atonement, which in turn involves belief in the divinity of Jesus of Nazareth as the incarnate Son of God.[15]

Our examination of these examples of ritual action will help also to keep us mindful of two important aspects of ritual during our further study. The first is that, however instinctive it may be in origin, ritual, in both its historical and current exemplifications, implicates complex systems of theological belief which are not self-evident—indeed, like the proverbial iceberg, a ritual act may be the only visible expression of basic doctrine. This factor leads on to the second point for consideration. Information about ritual action itself is often of an indirect or secondary kind. For whereas ritual can be actually observed in the practice of living religions, the rituals of many other religions, sometimes including the past practice of living religions, can be known only through iconography or archaeological data such as burials or the ruins of temples and churches.[16] This fact inevitably complicates our task in seeking to use the evidence of ritual as one of the primary forms of religious expression. However, the recognition of this difficulty enhances the importance of iconography.

There remains another aspect of ritual that must be borne in mind as we seek to assess its witness to man's quest for significance. As we noted earlier, ritual action in primitive society is not regarded merely as symbolic but as efficacious in itself. For the very doing of a ritual action was held to achieve the desired end for which it was performed. The idea found apt expression in the term *drōmena,* "things done," which denoted the ritual acts of the famous Eleusinian Mysteries; and in both ancient India and America the cyclic rhythm of the universe was essentially related to the ritual cycle of sacrifice.[17] The element of imitative magic involved in such praxis naturally raises the question whether such a view of the efficacy of ritual has, in effect, been current also in sophisticated religions such as Catholic Christianity. Any suggestion of magic, in a pejorative sense, in this context would certainly be invidious as well as misleading. However, it must be recognised that unqualified emphasis has been laid in Catholicism upon the necessity of the exact performance of ritual acts, especially in connection with the administration of the sacraments: for example, the making of the sign of the cross on the candidate has been regarded as an essential constituent of a valid baptism, and the "manual" acts are carefully

prescribed for at the Consecration in the canon of the Mass.[18] Indeed, the Catholic doctrine that the grace of a sacrament is guaranteed to the faithful *ex opere operato* puts a plenary importance on properly performed ritual action, irrespective of the personal faith or character of the minister of that sacrament.[19] Assessment, therefore, of the nature or degree of supernatural potency attributed, by the devotees of a specific faith, to some ritual action is intrinsically difficult to make. And it must be recognised that the belief is possible, even in a sophisticated religion, that the performance of a ritual act changes significantly the situation of a person in relation to the deity—baptism is a most notable Christian example of this.[20]

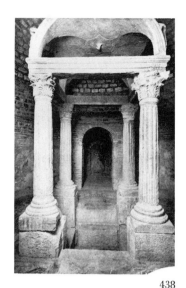

438

438-39

II. THE DAWN OF ART AND ARCHITECTURE

In a very true sense, both art and architecture were created by man to meet his religious needs. The cave paintings of the Palaeolithic peoples, and their carvings, represent the earliest known products of man's art, and, although they may have given some aesthetic pleasure, they were clearly designed for religio-magical purposes.[1] For the paintings were doubtless seen only on ritual occasions, when they would have been but faintly illumined by torches or primitive lamps, since they are located, for the most part, in the more inaccessible recesses of the caves, far from the reach of daylight.[2] Moreover, the fact that figures of animals have often been imposed on earlier depictions indicates a preoccupation with the magical significance of each figure irrespective of its aesthetic qualities.[3] The purpose of the many female figurines which have been found is not so clearly evident; they have invariably been discovered on sites of domestic habitation—one has been unearthed in a grave.[4] Of the cultic purpose of the celebrated bas-relief of the "Venus of Laussel" there can be little doubt; for it was clearly the focal object of what seemed, on discovery, to have been a rock sanctuary.[5]

The adumbrations of religious significance thus implicit in Palaeolithic art have been amazingly fulfilled by the excavation of the Neolithic settlement at Çatal Hüyük, in Anatolia, which dates back to the seventh millennium B.C. There evidence has been found of specially

30

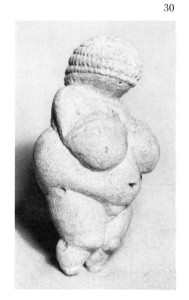

1, 30

46, 411

411

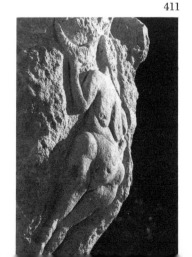

17a, b, 18,
413-15

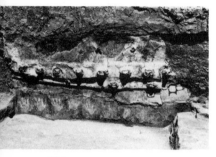

413

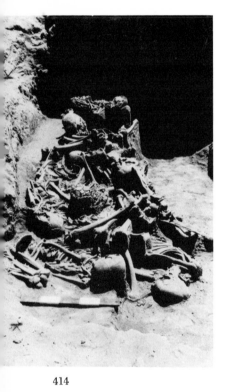

414

designed shrines for the cult of a fertility goddess, who was represented iconographically in what appear to have been various but related roles: in childbirth, as mother, and possibly as mistress of the animals and the dead.[6] Images of bulls and arrangements of bulls' horns in these sanctuaries witness also to concern with the male principle in fecundity.[7] Frescoes—found in one of these sanctuaries—depicting horrific vultures that menace headless corpses raise problems for our studies that will be discussed elsewhere.[8]

The Çatal Hüyük discoveries thus provide most striking evidence that by *circa* 6000 B.C. the resources of art and architecture were already being exploited to express the ideas, and implement the requirements, of a complex religious cultus concerned with both life and death. The evidence confirms the intimations of Palaeolithic art, and it points forward to the great achievements of religious art and architecture in the first literate cultures of the ancient Near East, namely, in Sumer and Egypt.[9]

III. THE CULT-IMAGE

Man's resort to linear and plastic art as a means of expressing his religious or magical ideas and purposes, from the very dawn of culture, is thus truly a fact of the greatest interest and significance; but it involves problems of a peculiarly elusive kind. To assist our further study we must consider some of these problems now, even though their solution may elude us.

19

First, we must reflect on the fact that to make an image of something is, in effect, to establish a relationship with it. It is, moreover, a relationship in which the maker has taken the initiative and achieved some circumscription of the object which he has drawn or fashioned, thus seemingly gaining a measure of control over it. For example, the Palaeolithic artist was wont to depict an animal transfixed with lance or darts on the wall of a cave, where magical ceremonies to ensure a successful hunt were held. By representing the animal in that state, the artist doubtless expressed what he and his fellow hunters hoped would happen to it, and which they believed the representation thereof would assist in causing to happen in reality.[1] A similar conception of an effec-

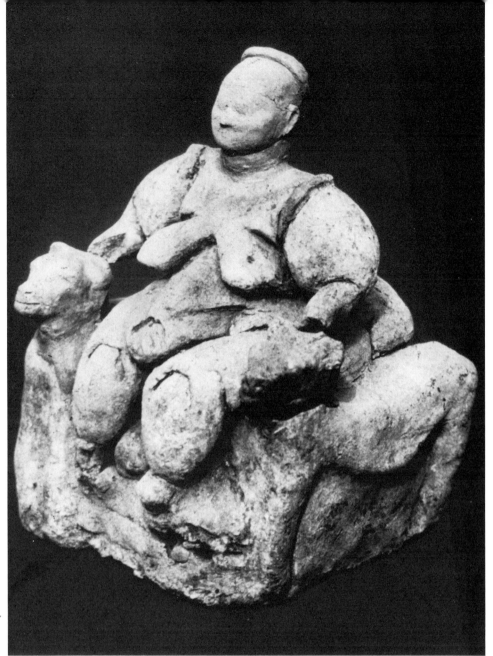

415b

17a. The "Great Goddess" at Çatal Hüyük as mistress of the animals.

17b. The "Great Goddess" in childbirth.

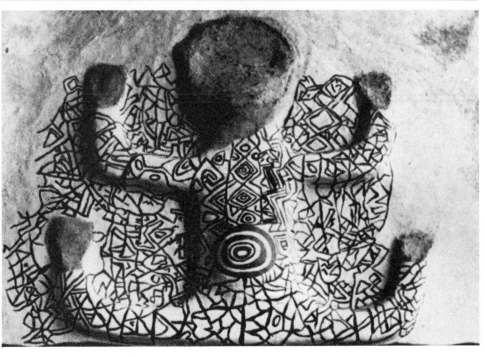

18. Reconstruction of sanctuary at Çatal Hüyük, showing bulls' horns.

19. Palaeolithic cave-painting showing animals wounded by darts.

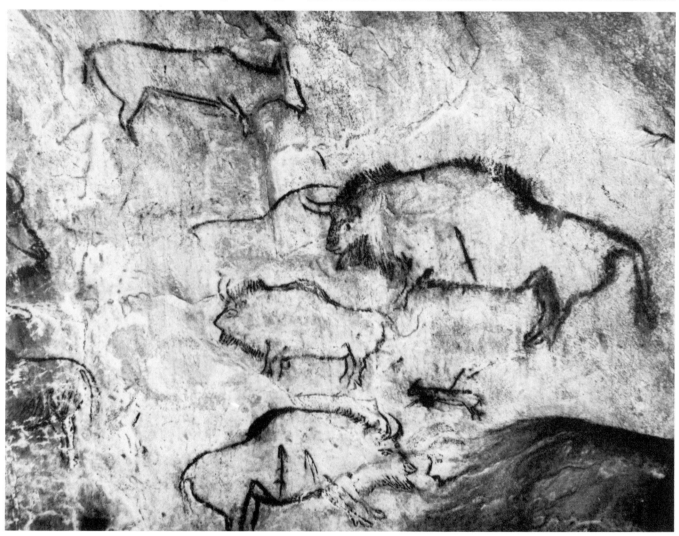

tive relationship existing between the maker of an image and a person whom the image represents has found notorious expression in so-called "black magic." On the principle that like begets like, it has been believed that a victim could be injured and even killed by afflicting an image of him.[2] It is possible that Palaeolithic artists may sometimes have used their skill in this baleful way.[3]

 20

 21

Another motive operative in representational art is that of conservation. The making of an image of any object provides a kind of double or substitute of it, and so in a manner extends its chance of survival. The ancient Egyptians were well aware of this potential in making their so-called *ka* and portrait-statues, which were exact replicas of the deceased and provided substitute bodies for them.[4] But portrayal could also fix or perpetuate an action or an event that was inherently transitory. This factor seems to have been utilised by Palaeolithic artists in a peculiarly notable way, namely, by the depiction of cultic events involving ritual action. Two examples can be cited. An engraving on a bone pendant, found in the Raymonde cave near Chancelade (France), appears to represent a cultic act connected with a dead bison.[5] That such a scene should be depicted seems strange on reflection, especially in view of the magical character of Palaeolithic art. For it is difficult to see what purpose would be served by so recording a ritual act, unless in some way it was deemed necessary thereby to preserve the efficacy of the act. A clue to the purpose behind such a representation may perhaps be found in another painting known as the "Sorcerer," in the cave of the Trois Frères in Ariège (France).[6] This strange depiction shows an anthropoid figure, covered with a hairy pelt, and having an animal's tail and the antlers of a stag. Its posture suggests the movement of dancing. Prehistorians have generally interpreted it as a representation of a man, disguised as an animal, performing a mimetic dance. Invoking analogous practices among primitive peoples of the modern world, they have argued that the mysterious figure portrays a Palaeolithic shaman or sorcerer performing a magical dance, to gain power over animals whose characteristic movements he imitates and whose skin and other attributes he wears.[7] If this interpretation be right, an interesting question arises: why was it thought necessary to depict a shaman performing such a dance on the wall of a cave sanctuary? There seems to be only one satisfactory answer: the picture served as a

 22, 23

 24

 25

 26, 27

20. Puppets used in witchcraft for injuring a victim by black magic.

21. Death of bird-headed man depicted in Lascaux caves.

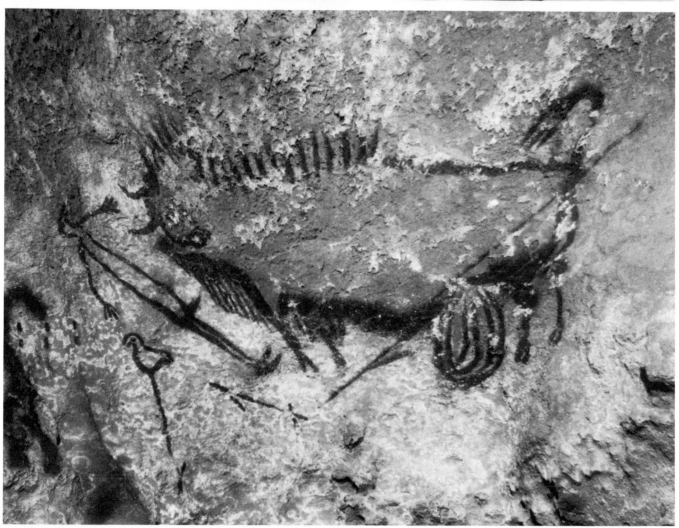

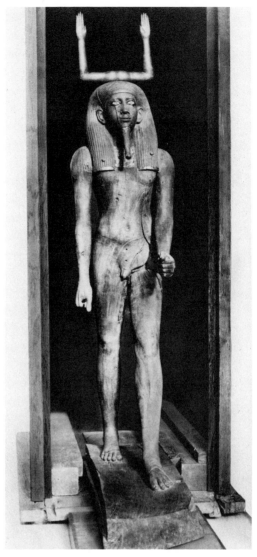
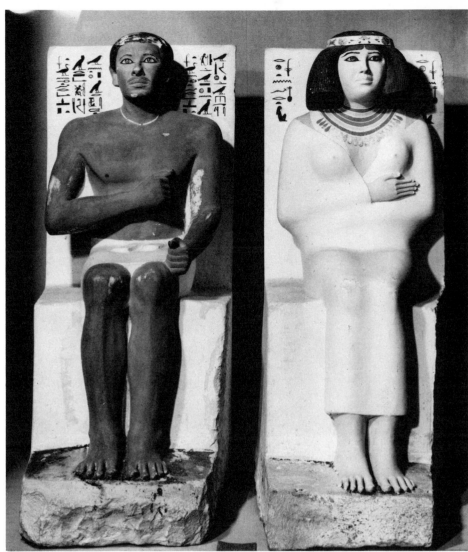

22. Egyptian *ka*-statue of King Hor. **23.** Portrait-statues of Rahotep and Nofret.

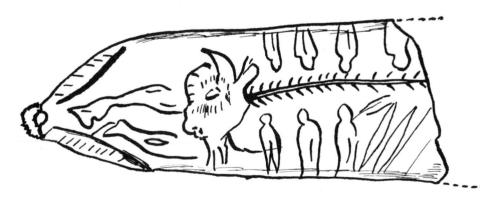

24. Palaeolithic bone pendant from Raymonde cave (Chancelade), depicting cultic scene.

25. The "Dancing Sorcerer" of Les Trois Frères cave (Ariège).

26. Siberian shaman.

27. Drawing of a Palaeolithic shaman disguised as an animal, seeking to attract animals by playing an instrument.

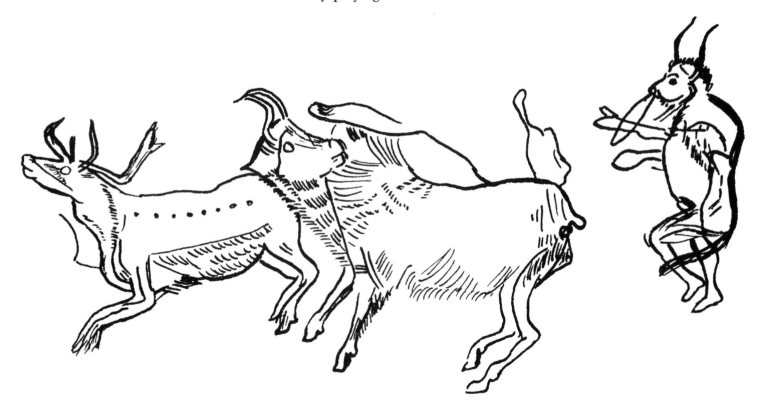

substitute for the real sorcerer when he could no longer dance. In other words, the picture solved a time problem which concerned these early people: how to maintain or preserve the magical efficacy of ritual dance when it was not actually being performed. The enigma of the transitoriness of action seems thus to have been sensed even in the Palaeolithic era, and a solution attempted by pictorial representation.[8] This primitive solution, as we shall see, found expression in the iconography of later religions, from representations of the pharaoh perpetually offering sacrifice to the gods in Egyptian temples to the statue of Pope Pius VI which for ever shows the pontiff in prayer at the *Confessio* above the tomb of St. Peter, in the great basilica dedicated to the saint in Rome.[9]

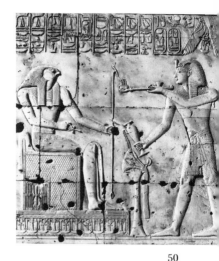

50

28, 29, 50

The type of magical or religious iconography which we have so far considered has been predominantly imitative in origin and character. Palaeolithic man drew the forms of the animals he knew and hunted. His female figurines, whatever their religious significance, reproduced the features, doubtless often in exaggerated form, of the women of his company.[10] However, sometimes his depictions give evidence of imaginative creation. Thus even his representations of the female body, which impress by their gross realism, mostly depart from the purely imitative by their lack of facial features.[11] This curious trait cannot be due to inability to depict the human face, in view of the skill shown in rendering the other features of the body. The omission must have been deliberate, and it implies a disciplined restraint on the part of the artist in thus leaving his work incomplete. What was the reason for this restraint is unknown; all that we can legitimately infer is that the purpose for which these images were made was served by emphasising the sexual features and omitting the facial.[12]

1a, b, c, **30,** 46

These female images thus conformed to some imaginative conception that departed from strict reality. There is other evidence that, in terms of the religio-magical purpose he served, the Palaeolithic artist could use his imagination to conjure up non-existent animal forms. The most notable instance occurs in the famous cavern of Lascaux. Among other easily identifiable animals there is depicted a fantastic creature that has been inaptly called the "Licorn" or "Unicorn." It has two long straight horns projecting forward from its forehead, massive hindquarters, a curious sagging belly, and a square muzzle. What it is supposed to be or to signify is wholly a mystery. It appears to be

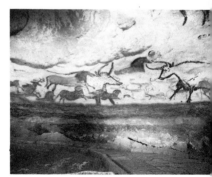

10

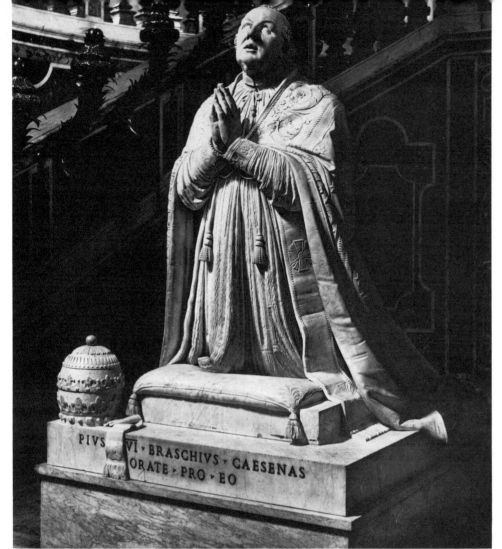

28. Statue of Pope Pius VI at the *Confessio* in St. Peter's, Rome.

29. *The Madonna and Child with the Chancellor Rolin,* by Jan Van Eyck.

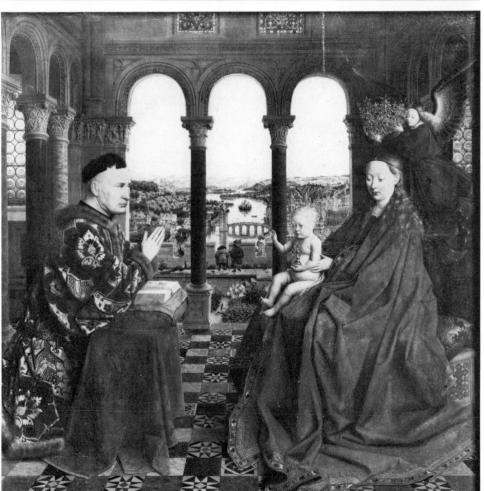

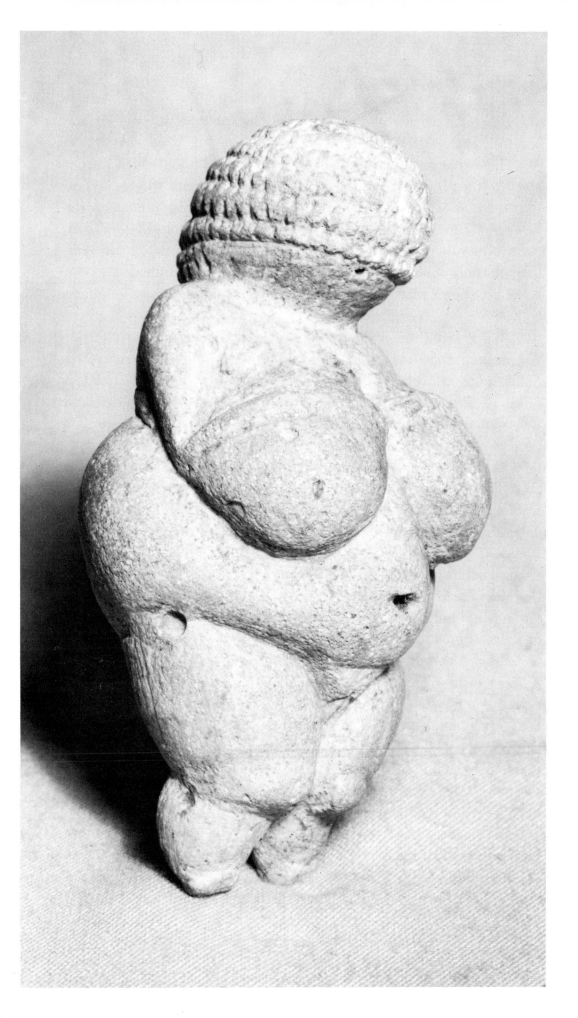

30. The *Venus of Willendorf.*

moving, together with other animals, towards the interior of the cavern.[13]

There are also many problematic anthropoid figures which further attest to the ability of the Palaeolithic artist to create strange hybrid forms. Some of these figures could be reasonably interpreted, as the "Dancing Sorcerer" has been, as representing men disguised as animals.[14] But others, generally of a very schematic kind, defy interpretation; for they are headless, yet are clearly depicted in animated action. Some are shown with animals' or birds' heads upon otherwise human bodies.[15]

21, 31

This Palaeolithic evidence, enigmatic though it is, clearly attests that, from the dawn of culture, man used his art to depict the creations of his fantasy as well as objects of his physical environment.[16] The fact raises a further point for our consideration, as we seek to understand the original springs of religious iconography. For since early man was thus able to represent in linear or plastic form figures created by his imagination, we must reckon with the possibility that such figures thereby came to be endowed with a concrete reality for him. In other words, although he had never actually seen beings with such forms, once he had drawn their image they acquired a definite visible existence.[17]

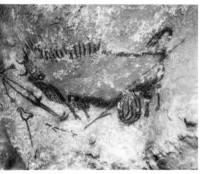

21

It must be remembered, in this context, that artistic creation is also essentially a personal process, no matter how important may be environmental influences in shaping the ideas of an artist. The creations of Palaeolithic art were, accordingly, the products of the imagination of individuals; but since these products were evidently of immense concern to the communities to which the artists belonged, their acceptance and use implies that they were regarded as valid conceptions by the communities. The fact has important consequences for our study. It means that conceptions stemming from the imagination of an individual capable of depicting them in linear or plastic form, were recognised by others as images of significant beings whom they had never seen but in whose existence they believed.[18]

32, 33

The alchemy of such initial recognition is beyond our analysis; but it is a process that must have operated from the genesis of every iconographic tradition. Supernatural beings, vaguely conceived by a community, were given a distinctive visible image by individuals capable

31. Palaeolithic drawings of headless and hybrid beings.

32. Pottery bowl from Bakun, Iran (*c.* 3500 B.C.), showing demonic figure with monstrous hands.

33. Demonic form carved in rock at El Ratón near Hoz de Guadiana, Spain (*c.* 2500-2000 B.C.).

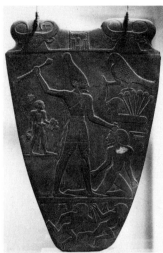

3a

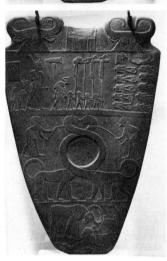

3b

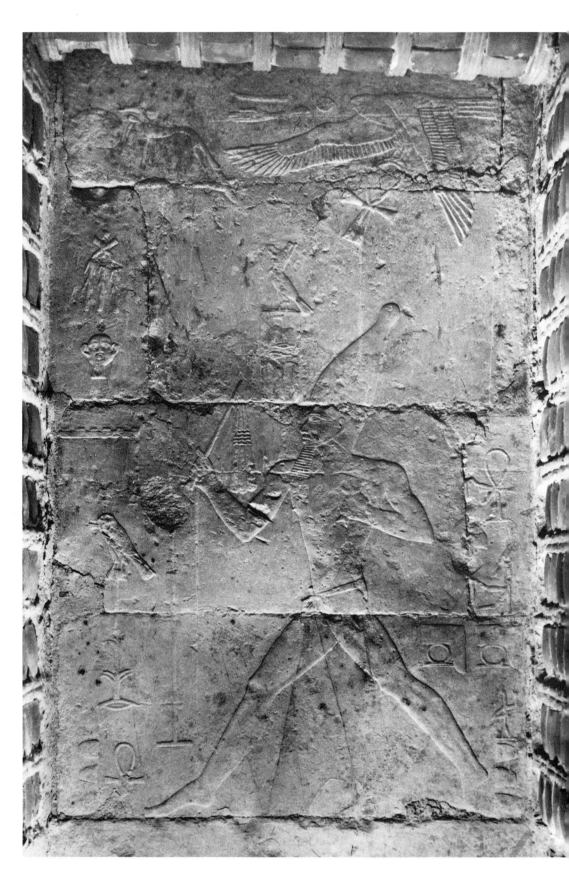

34. Relief from southern mortuary chapel of the Step Pyramid, depicting King Zoser under the protection of the divine Horus.

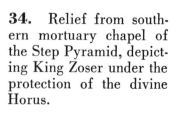

of artistic creation. The acceptance of the image as a valid representation of an indistinct common notion would have been a primordial act, of which the occurrence is existentially certain though it cannot be dated, in the development of any culture. Once the image was accepted, it quickly acquired authority and decisively influenced subsequent conceptual thought and expression. A most notable example of the process is afforded by the evolution of the ancient Egyptian depiction of deity. The earliest known depiction is on the Palette of Narmer, which has already been discussed. The god Horus is represented as a falcon, with a human hand and arm, helping to subdue the king's enemies. Another depiction of this deity, dating about two centuries later, occurs in a building adjacent to the famous Step Pyramid of King Djoser.[19] It shows the divine hawk flying protectively over Djoser, and holding the *ankh*, the symbol of life. The deity is again depicted there, on a much smaller scale and wearing the double crown of Upper and Lower Egypt, over the hieroglyphs of the Horus name of Djoser. This presentation of Horus as a falcon, which some artist must originally have initiated and the community accepted, continued for over two thousand years; although often the image is partly anthropomorphised by depicting the deity as having a falcon's head on a man's body.[20]

3a, b

34

35

As a comparative parallel, we may briefly note that the characteristic Hindu depiction of multi-armed, and sometimes multi-headed deities, although it was not the most primitive form of presentation, quickly established itself. It seems to have been introduced during the early Gandhara period (second & third century A.D.) by some unknown artist who sought thus to represent divine omnipotence.[21] That it speedily became a tradition of Hindu iconography must surely mean that it was popularly accepted as valid and agreeable, despite the monstrous aspect which it gave to deities so depicted. However, it did not become an exclusive tradition, and a more naturally human depiction of deity continued alongside of it.[22] A similar attempt in Christian mediaeval art to represent the triune nature of the Trinity by three heads growing from a single body failed to commend itself, and resort was made to a more elegant form of symbolism.[23]

36, 37a, b

38, 39

It is in the portrayal of deity that the distinctive ethos of a religion and its associated culture finds its most eloquent expression. Nuances that could never be sensed from the relevant texts are immediately

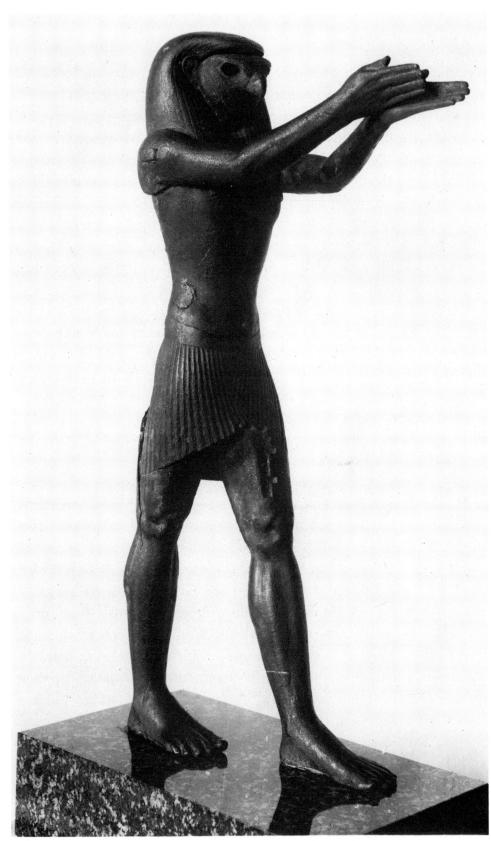

35. Horus, represented as a man with a hawk's head.

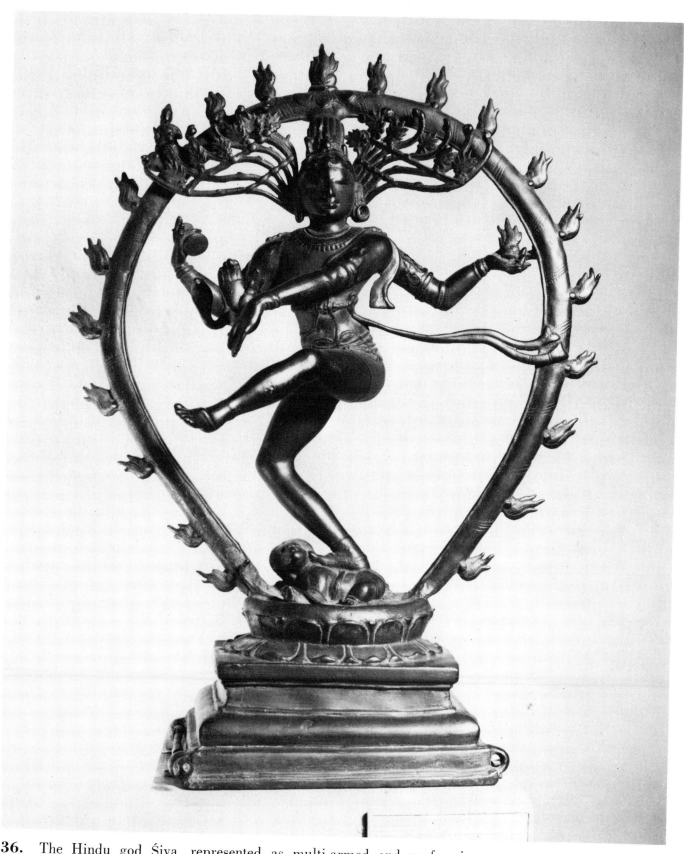

36. The Hindu god Śiva, represented as multi-armed and performing the cosmic dance.

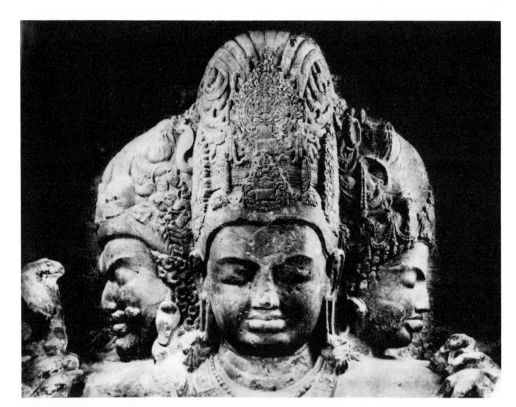

37a. Sculptured image of Śiva Mahādeva (the Hindu Trimurti) at Elephanta, India.

37b. Bronze Mesopotamian figure of a four-faced god, from Ishchali.

38. Opposite: A mediaeval attempt to represent the Christian Trinity from an English psalter (*c.* 1260).

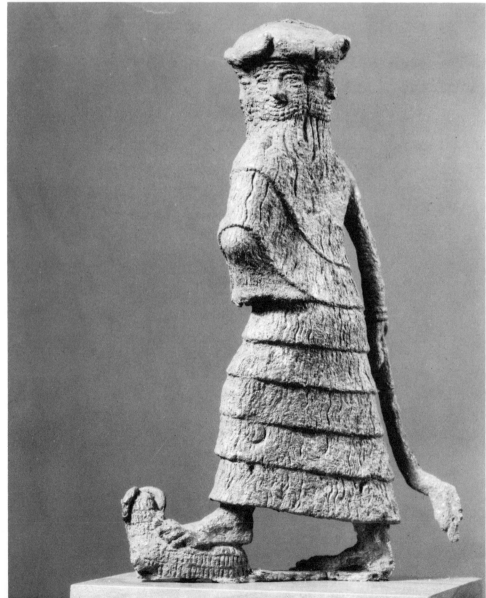

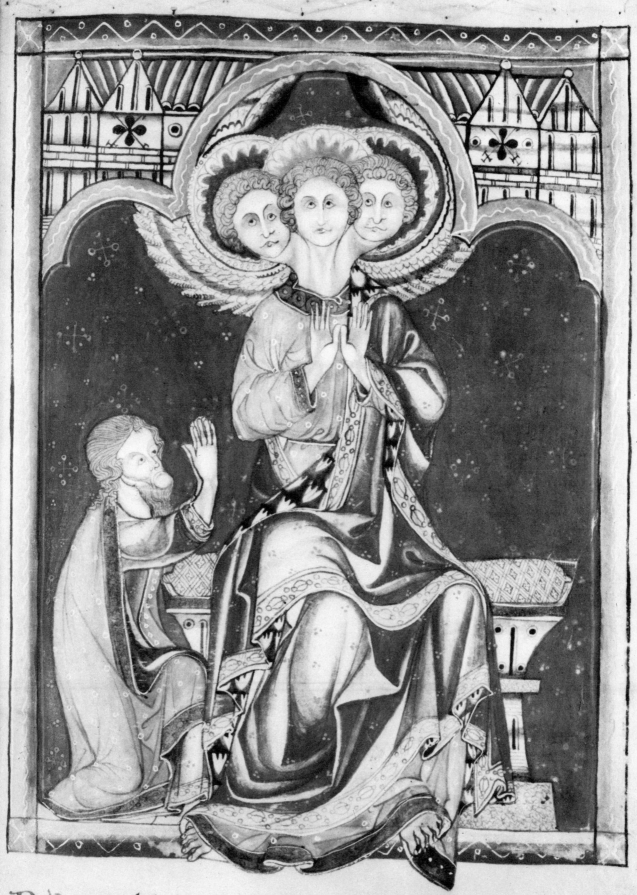

De dño apparente abrahe in figura trinitatis Ge. xviii.

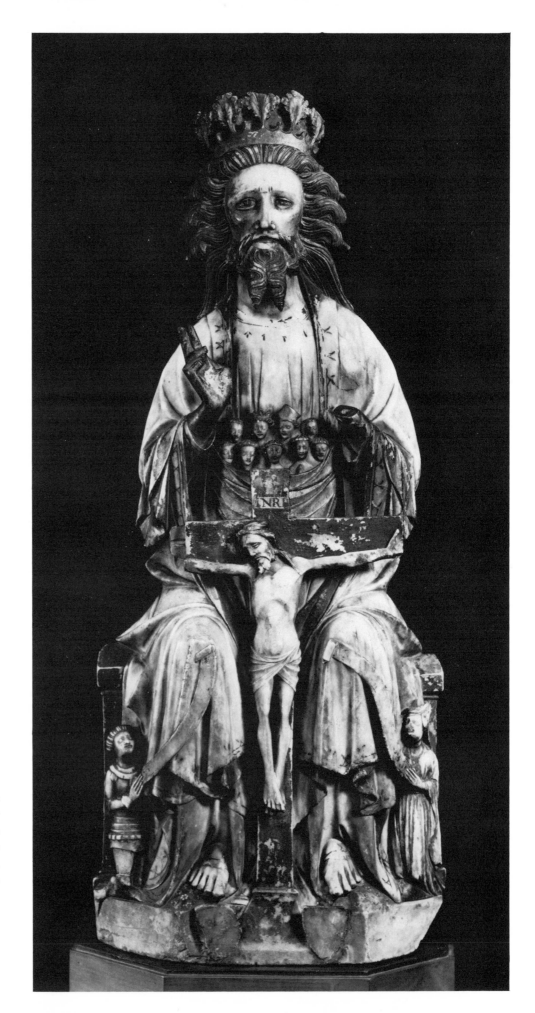

39. Mediaeval representation of the Trinity (English, *c.* 1410). Courtesy, Museum of Fine Arts, Boston. Purchased from the Decorative Arts Special Fund.

apparent in iconography. Thus, to cite some illustrative examples: the image of the god Osiris expresses the peculiar ethos of ancient Egyptian culture as an image of Vishnu or Shiva does that of India; the spirit of classical Greece is manifest in a statue of Apollo as that of ancient Mexico is sensed through a depiction of Quetzalcoatl; and even the un-initiated must be aware of the different evaluations of human nature and destiny implicit in the figure of the Buddha and that of the cruci-fied Christ.[24]

40, 80
41
42
43

44, 45

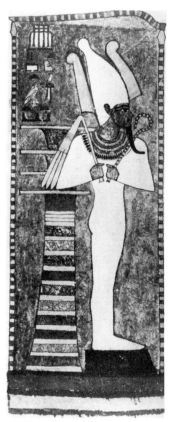

80

The motives that have inspired the iconographic representation of deity would seem to be various and complex, and generally we can only speculate about them. Such speculation has, in fact, a long his-tory that witnesses to the interest and perplexity of earlier ages about the matter. For example, in the second century B.C., the Hellenistic Jew who wrote the *Wisdom of Solomon* attacked the cult of images at length, attributing the practice to the innate wickedness of man. He expatiated on the obvious folly of those who worship what they have carved from wood or fashioned from clay.[25] However, in his diatribe he strangely traces the origin of image worship to two causes: "For a father worn with untimely grief, making an image of a child quickly taken away, now honoured him as a god which was then a dead man, and delivered to those that were under him mysteries and solemn rites."[26] And he explains that images of kings were also made to be venerated during their absence, and that this custom often led to an artist's making so impressive an image that "the multitude, allured by reason of the grace of his handywork, now accounted as an object of devotion him that a little before was honoured as a man."[27]

This piece of naïve rationalisation is significant since it reveals that, at a period when the veneration of images was widespread, those who condemned it felt obliged to explain the origin of a practice which they held to be nonsensical. That they did so may possibly indicate that they were uneasily aware that they were in contact with some deeper sense which they cared not to recognise. For the very fact that the nonsensical aspect of such a practice was so obvious warned them that its existence and persistence among people, who were otherwise shrewd and intelligent, required a considered explanation.[28] Although we cannot claim to do what the ancient critics of "idolatry" failed to do, we are today in a better position, due to our greater knowledge, to

40–45. A comparative presentation of iconographic conceptions of six deities: Osiris, Vishnu, Apollo, Quetzalcoatl, the Buddha, and Christ. See details below.

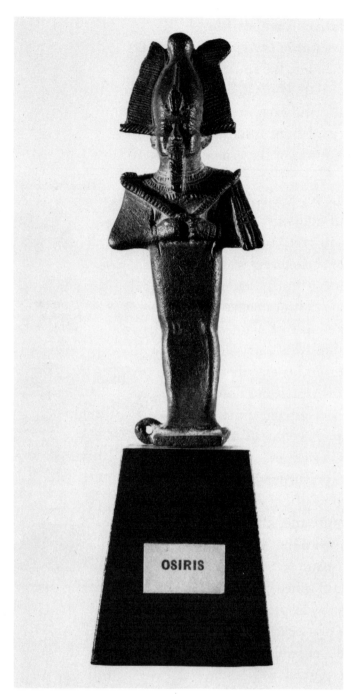

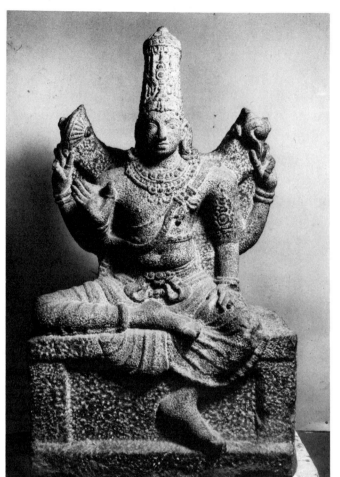

40. Osiris, bronze figurine.

41. Hindu god Vishnu. Eighth-century sculpture.

42. Statue of Apollo, from west gable of Temple of Zeus at Olympia.

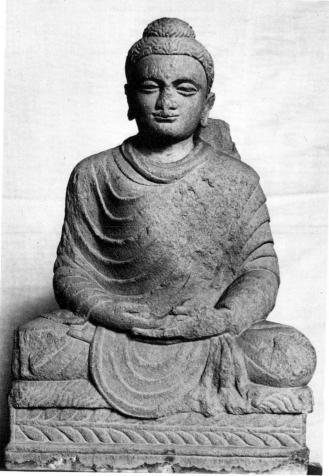

43. Quetzalcoatl, from the Codex Fejervary Mayer.

44. The Buddha. Indo-Greek statue.

45. Crucified Christ. Fourteenth-century crucifix in Collegiate Church, Kempten, Bavaria.

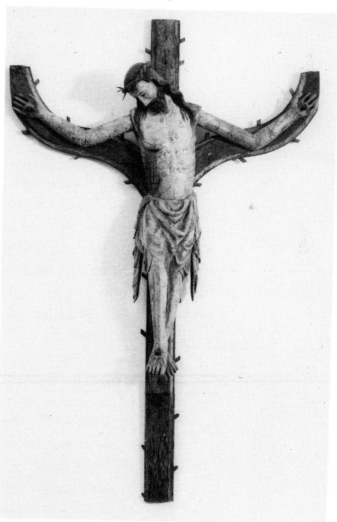

appraise both the complexity and the significance of the problem constituted by the iconography of deity.

46, 411 It is the so-called "Venus of Laussel" that first confronts us with the enigma of an image that was evidently not meant to be the portrait of a particular person. Its lack of facial features and its original location indicate that it was a cult object of peculiar significance.[29] But that conclusion does not elucidate the purpose that inspired the Palaeolithic artist to carve the figure for the community of which he was a member. The "Venus" has been reasonably interpreted as representing our earliest evidence of the deification of the female principle as the source of new life, being thus a kind of Palaeolithic prototype of the Great Goddess of later religions.[30] However, if this interpretation be accepted, the prior question for us has still to be answered: what moved that ancient artist to represent, in a stone carving, the idea which he and his fellows had of a kind of supernatural Woman who was the source of life?[31] And, a logically sequential question, how did they relate the carved image to their idea?

In answer to the second of these questions, it would seem to our modern analytical minds that the early peoples concerned must surely have differentiated the stone image from the supernatural being of whom they conceived. And yet the evidence of the cultic use of the image proves that it was the focus of their devotion, thus implying an effective measure of identification between concept and icon. This inference, which it would seem legitimate to draw, in turn suggests a further question: did those who venerated the "Venus of Laussel" perform some ritual designed to "animate" or make the image the locus of the "Goddess"?

Palaeolithic archaeology does not supply an answer to this question; but we certainly know that the ancient Egyptians felt it necessary to animate their cult statues. After a statue had been made, an elabo-

47 rate ceremony known as the "Opening of the Mouth" was performed on it in the "Goldhouse" or atelier of the sculptor.[32] The basic motive of the ritual was to endow the image with the ability to consume the offerings made to it; but other faculties, such as sight, hearing and locomotion, were also provided for. A similar ceremony was also used

217 to revivify an embalmed body before burial, so that it might live in the tomb and receive nourishment.[33] There is evidence that in ancient

217

46. The "Venus of Laussel."

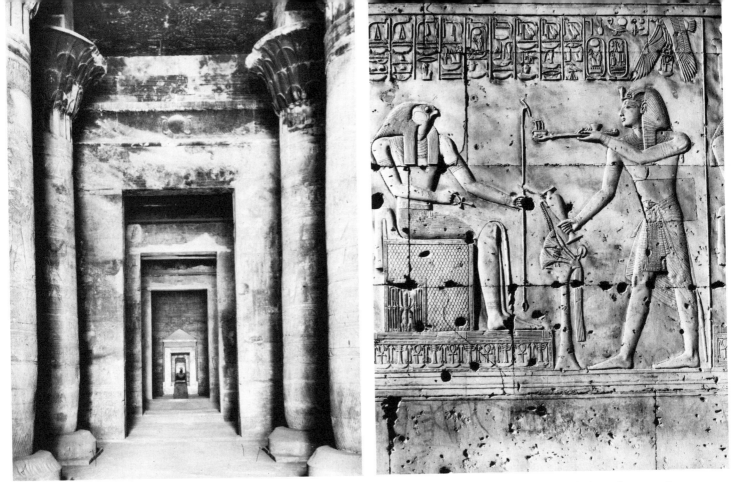

49. Temple of Horus, Edfu. The "holy of holies," containing the granite naos or chapel, which housed the cult image.

50. King Seti I offering sacrifice to Ptah Soker.

51. The daily toilet ritual of an Egyptian cult image. Seti I presenting stoles and ornamental collar to an image of Ptah.

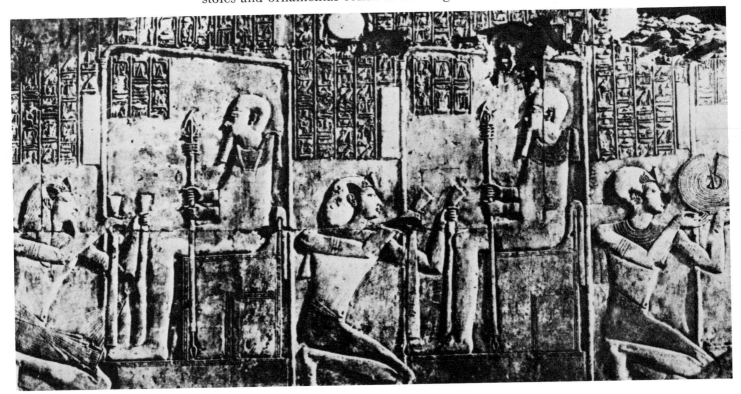

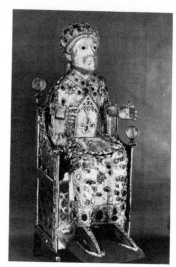

206

48, 206

Mesopotamia, also, images were ritually brought to life.[34] In India, elaborate rites of consecration are deemed to be necessary before an image is fit to be worshipped.[35] Tibetan Buddhists have taken more practical action, even inserting internal organs made of dough or clay into statues, while other primitive peoples have employed sorcerers to introduce spirits into idols.[36] A specific act of consecration seems to have been regarded by the ancient Greeks as endowing a statue with a new status;[37] and in Catholic Christianity images and icons are similarly invested with a sacred aura, which makes them objects of a veneration that is ritually expressed by censing, the burning of candles and offering of flowers, and sometimes of jewels.[38]

This identification or intimate association of a statue or icon with a deity has found a great variety of practical expression in the history of religions, though carefully formulated definitions of relationship have been rare.[39] The psychological attraction of an image as a focal point for devotion and petition is obvious, and it is understandable that it should be insensibly identified with the presence of the deity concerned. In this connection, it is significant that the fiercely aniconic religion of ancient Israel venerated the Ark of Yahweh as the locus of the deity's presence, and it was regarded as being so holy that contact with it was fatal to any lay person.[40]

In some religions a distinction was evidently drawn between the cult image of a god and other linear and plastic representations of it. Thus in an ancient Egyptian temple the cult image, which was comparatively small, was housed in a shrine situated in the dark inner sanctum, to which the priests alone had access.[41] In other parts of the temple, however, the same deity would be depicted in bas-relief, on a larger scale, on walls and columns.[42] Such representations of the deity were ritually important, since they figured in scenes of the pious service of the pharaoh, as we have seen; but they obviously were not regarded as enshrining the presence of the god as did the cult image. The cult image, moreover, was treated as though it were the god himself in a daily toilet ritual, and offerings were made to it.[43] At certain festivals it was carried out from the temple, set in a ceremonial boat, borne on the shoulders of priests, and often it was taken to the temple of some related deity.[44] On such occasions it was deemed that the deity itself, enshrined in its statue, made the ceremonial visit. Thus,

49

50

51

52, 53, 54

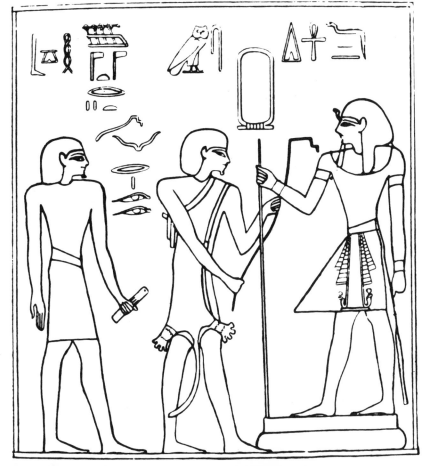

47. "Opening of the Mouth" of a statue of Seti I.

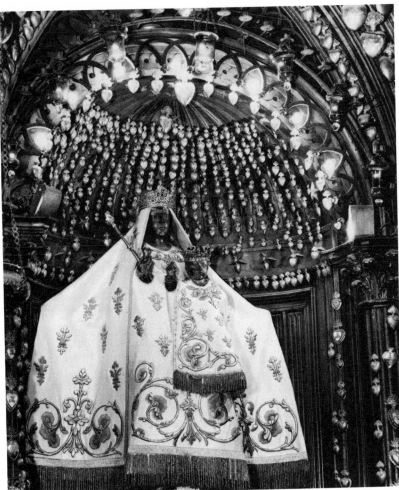

48. Statue of Notre Dame du Pilier, Chartres Cathedral.

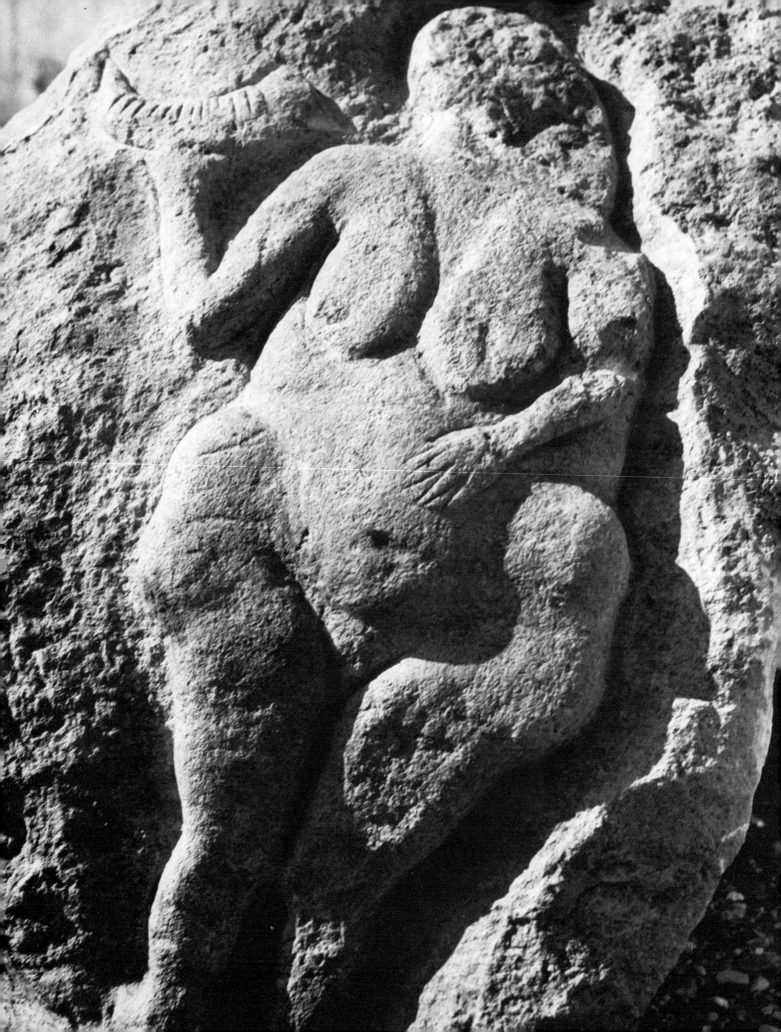

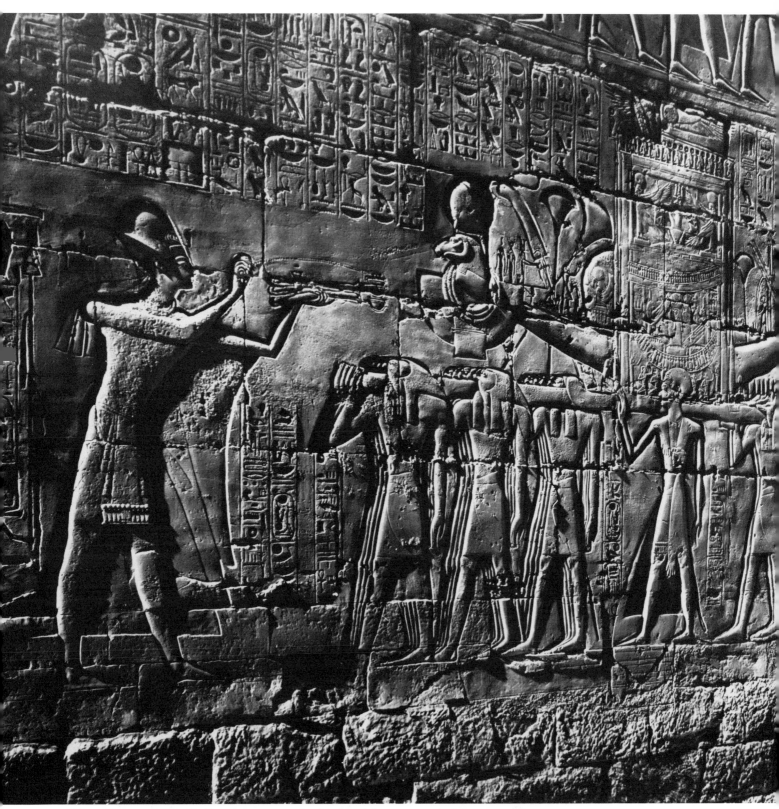

52. Ramses III offering incense to the bark of Amun carried in procession.

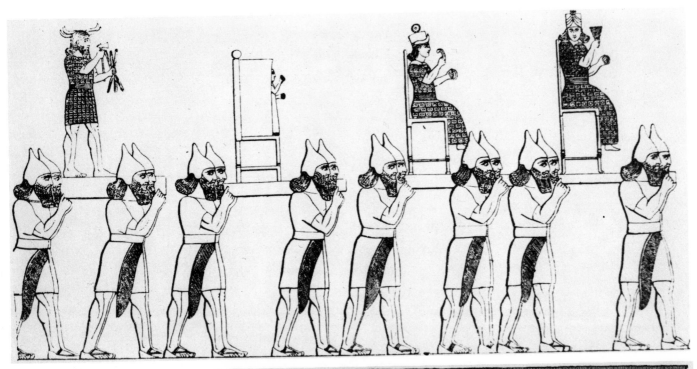

53. Assyrian gods carried in procession.

54. Statue of the Virgin carried in procession.

in Ptolemaic times, the goddess Hathor (in her cult image) went in a solemn procession, on the Nile, from her temple at Denderah to visit Horus in his temple at Edfu. During the fourteen days of festival at Edfu, the statues of the two deities were significantly housed each night in the Mammisi or Birth Chamber.[45] These festivals were, in effect, the periodic epiphany the god concerned made to ordinary people; for they then joyously beheld in the cult image the "beauty of their lord."[46]

The dressing and feeding of the cult image is an obvious devout service that unsophisticated worshippers have naturally been moved to offer to their gods. The ancient Egyptian practice, just described, can be paralleled, to varying degrees, in other religions, pre-eminently in Hinduism. But the identification of the image with the deity it represents has been reflected also in such crude practices as the fettering of images in ancient Greece and India to keep the particular god with its devotees,[47] by insulting gods through their images and taking them prisoner.[48] And it is significant, in this context, that the early Christians, despite the monotheistic character of their faith, could not regard the statues of pagan gods as merely pieces of carved wood or stone. Instead, they believed as a second-century Christian explained:

the impure spirits, or demons . . . conceal themselves in statues and consecrated images (*imaginibus consecratis*), and by the afflatus that issues from them acquire authority as of an existent deity (*praesentis numinis*), by inspiring prophets, haunting temples, animating the entrails of sacrificed victims (*extorum fibras*), guiding the flight of birds, determining lots, and uttering oracles, invested in lies.[49]

The attitude of Catholic Christianity towards images of God, of Christ, and of the saints was officially defined at the Second Council of Nicaea in 787. By that time the use of images was well established, and the Church Fathers were obviously intent on encouraging it, though feeling obliged to instruct the faithful about the kind of devotion that they should direct towards the images. They declared that by seeing images, men are reminded of their "prototypes" (*pros tēn prototypōn mnēmēn*). That they should reverence (*aspasmon*) the images and offer them honourable veneration (*timetikēn proskunēsin*) but not true worship (*alēthinēn latreian*), which is reserved for God alone. Incense and lights were to be used in honouring holy images;

55

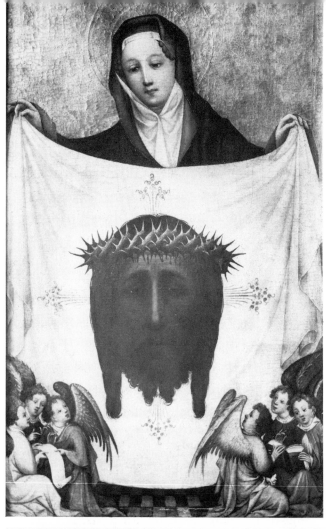

55. Assyrian soldiers breaking up an image of a god (detail at bottom).

56. St. Veronica with the sudarium bearing the impression of the face of Christ.

57. Holy Shroud of Turin.

58. The *Volto Santo* in Lucca Cathedral.

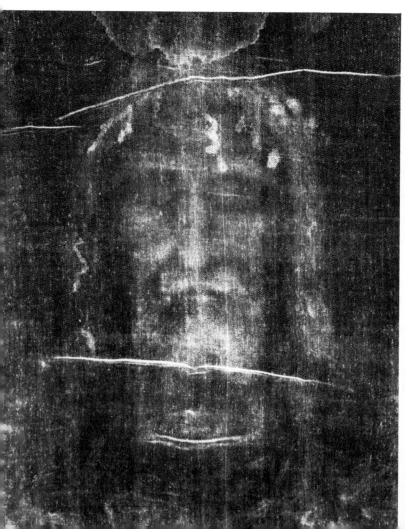

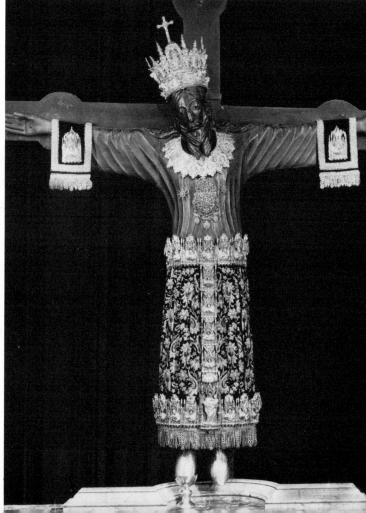

"for the honour paid to the image passes to the prototype (*hē gar tēs eikonos timē epi to prototypon diabainei*)."[50] But such subtle distinctions of devotional attitude were not calculated to be understood and followed by the mass of the faithful, and the records of mediaeval Christianity abound with evidence of what may technically be described as "idolatry."[51] However, it is equally evident that images could promote deep spiritual feeling and make the deity very real and close to the devout—we may recall the famous instance of St. Francis of Assisi's belief that the ancient crucifix of San Damiano had spoken to him bidding him to restore God's falling church.[52] Moreover, the great theologian of the Western Church, St. Thomas Aquinas, ruled that "the veneration (*reverentia*) exhibited to an image of Christ and the veneration (*reverentia*) exhibited to Christ himself is one and the same. Since, therefore, Christ is adored by the adoration of *latria* (*adoratione latriae*), it follows that his image may be adored with the adoration of *latria* (*adoratione latriae*)."[53] To this may be added that it had been declared by the Second Nicene Council in 787 that *latreia* (absolute adoration or worship) was *not* to be offered to images, but to God alone. Images might be offered only reverence (*proskynesis* or *douleia*). Clearly, however, the image of Christ himself was an exception to this rule.

Buddhism has evolved a cult image of peculiarly subtle didactic significance. For whereas the iconography of Christ has sought to portray his various roles of Saviour, Cosmocrator and Judge by appropriate ancillary symbolism,[54] the roles of the Buddha are indicated by the *mudrās* or positions of the hands.[55] And Buddhist mysticism has achieved also the most complex and sophisticated conception of deity in the whole history of religious iconography. The conception is enshrined in the temple of Barabudur in Java. The whole architectural plan and sculptural programme of this great edifice constitutes, in effect, a mandala or schematised presentation of the celestial universe and the mystical Buddhas that preside over its various regions.[56] For the multitude of images of the Dhyāni Buddha that cover the structure were obviously not intended for worship: seventy-two of them are actually enclosed in latticework stupas, which render them virtually invisible.[57] Instead of serving as objects of worship, the images are arranged to manifest the pattern of a mandala, so that each

56, 57, 58, 59

60

61, 62, 63

64, 65, 66

67

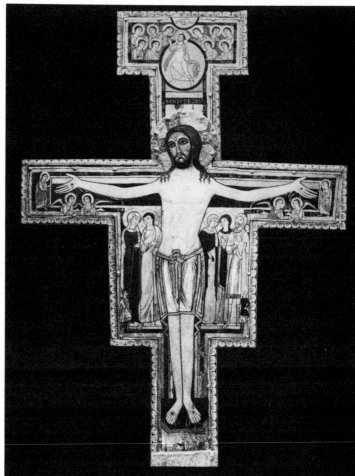

59. Icon known as Our Lady of Vladimir (*c.* 1130).

60. Crucifix of San Damiano, now in the Basilica of Santa Chiara, Assisi.

61. Amelsbüren Altarpiece (central panel), by Johann Koerbecke (*fl.* 1446-91).

62. Opposite: Christ represented as Cosmocrator. Apse mosaic of S. Vitale, Ravenna.

63. Opposite: Christ represented as Judge. Central panels of *Last Judgment* altarpiece by Rogier van der Weyden (1443-46).

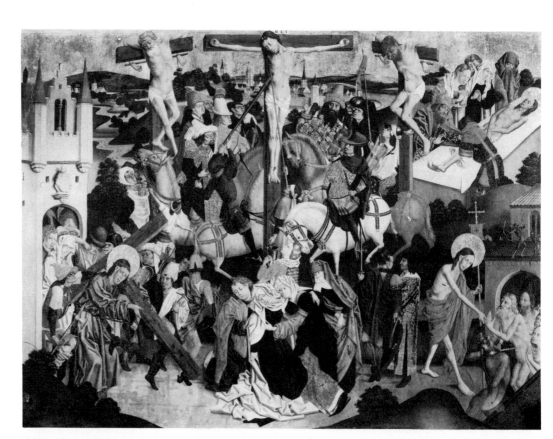

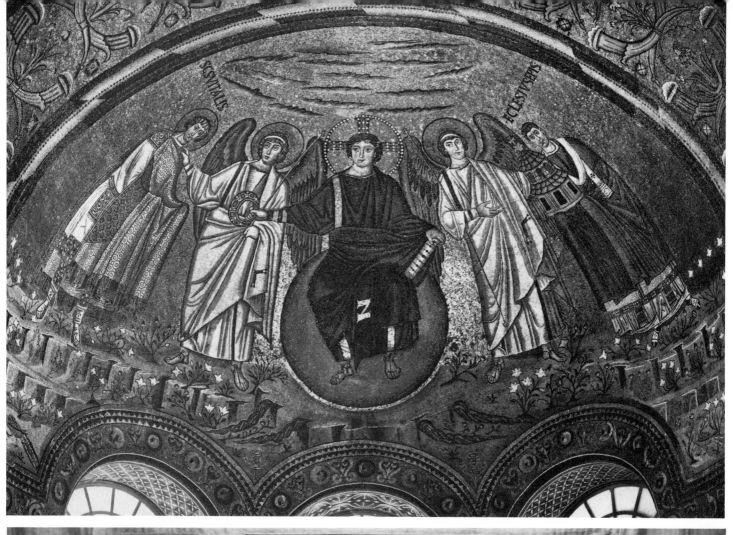

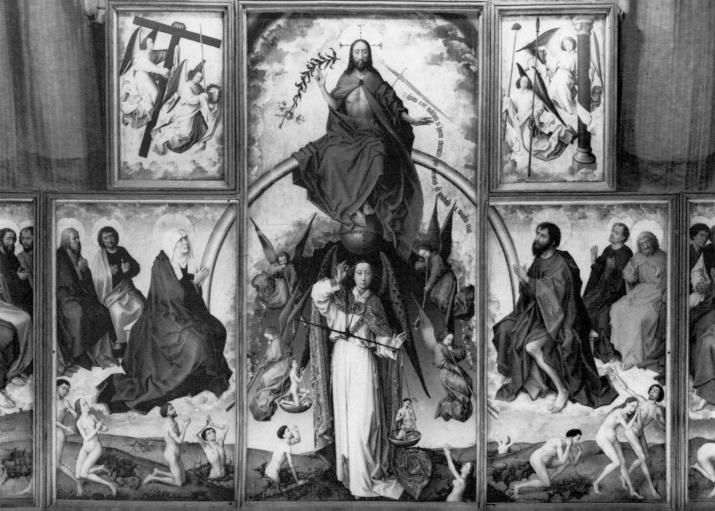

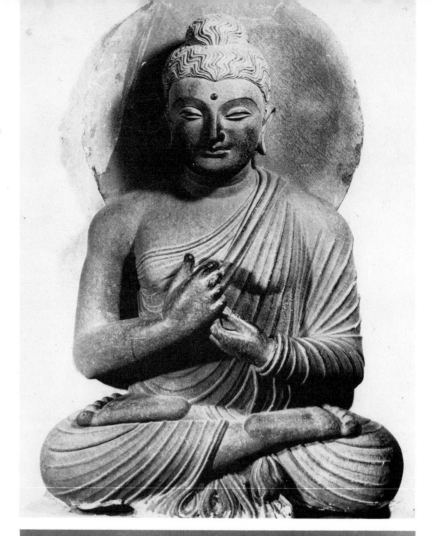

64. The Buddha as Teacher. Statue from Loriyan Tangai, West Pakistan.

65. The Buddha depicted with right hand in *abhaya-mudrā* position (protection), and left hand in *varada-mudrā* position (granting a wish).

66. The Amitābha Buddha, represented in a posture of meditation.

67. Barabudur, Java. Three uppermost terraces with central and other stupas.

68. Barabudur from the air.

69a. Chinese guardian figure. Lacquer, T'ang period. Courtesy, Museum of Fine Arts, Boston. Bequest of Charles B. Hoyt.

69b. Shou-lao, Chinese god of longevity.

individual image, while having its own intrinsic significance, subserves the scheme as a whole. Barabudur does, in fact, represent the furthest point to which religious iconography developed, in esoteric mysticism, from the primitive urge to have a visible image of deity.[58]

 68

In religious faith and practice, the image has thus had, primarily, a cultic role; but it has often been set also to play an apotropaic part. Indeed, the placing of images of gods or daemonic beings to guard both the temples of the gods and the homes of men is widely attested. China has probably provided the most amazing examples of such iconic guardians, many of which were also deemed to give good fortune as well as supernatural protection.[59] Something of the range and curious variety of such apotropaic iconography may be had by mentioning the sculptured representations of the Gorgon's head found on buildings and tombs of ancient Greece and Italy, of the human head among the ancient Celts,[60] and the fantastic monsters and dragons that guard the Romanesque churches of Britain and the stave churches of Norway.[61] Such a use of iconography witnesses significantly to the primitive conception of the image as an object having its own distinctive form of being, and endowed with magical potency.

 69a, b

 70

 71

 72

 73, 74

IV. SYMBOLISM

It is rare that the image or picture has been left, in religious art, to manifest its significance or convey its message without the aid of symbolism. Examples of symbolless images that do exist in primitive cultures, such as the wooden figure of the ape-god Mbotumbo now in the Rijksmuseum voor Volkenkunde, Leiden, though giving no visible indication that they represent supernatural beings, were doubtless well known as cult images to their devotees through instruction and ritual praxis.[1] The nobler products of religious art, such as Michelangelo's *"Pietà"* in the Cathedral at Florence, which impart deep spiritual insight or emotion through the genius of their creators, likewise depend upon the ability of the viewer to interpret their religious context.[2] Consequently, the *"Pieta"* of Michelangelo to a viewer who knew nothing of Christianity would be inexplicable. He would see it as a profoundly moving portrayal of the dead body of a nude man being

 75

 76

70. Guardian statues of Tut-Ankh-Amun found in his tomb.

71. Gorgon, clay relief, found in Sicily.

72. Celtic apotropaic heads.

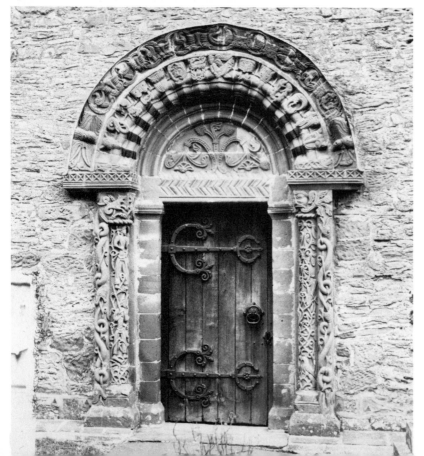

73. Doorway of Kilpeck Church, England.

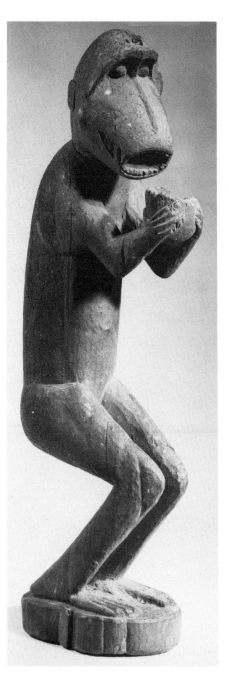

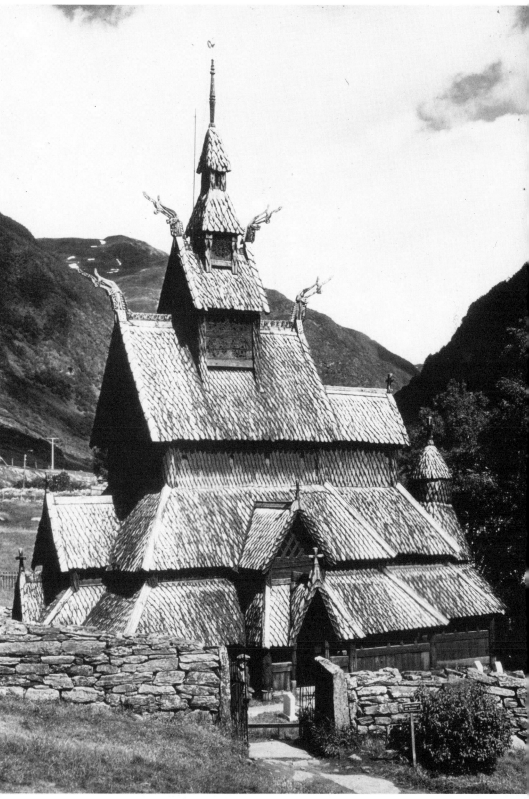

74. Norwegian stave church at Borgund.

75. The ape-god Mbotumbo, Ivory Coast.

[65]

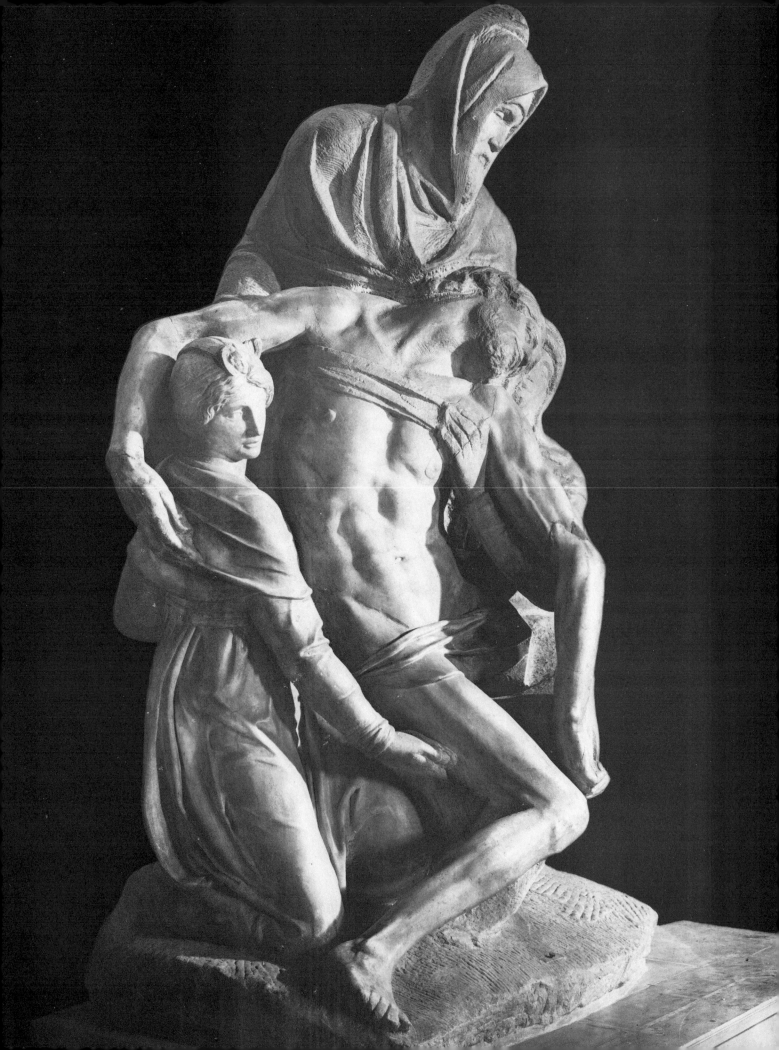

gently lowered to the ground by three deeply sorrowing persons. But the meaning of the group would elude him, since the sculptor has given no sign nor symbol that indicates the religious significance of the figures. Greek art also provides some curious problems in this connection. For example, the nobly restrained relief of the *Mourning Athena*, now in the Acropolis Museum, Athens, shows a woman, wearing a warrior's helmet, looking in an attitude of sorrow at a funerary stela.[3] The Athenians, undoubtedly, recognised at once in the figure the great goddess of their city, and saw her depicted there as the divine representative of their sorrow. But the absence of religious symbols raises a more difficult question in the case of Praxiteles' famous statue of Hermes and the infant Dionysos or some images of Aphrodite; for in such figures it would appear that the artists were concerned only to portray idealised examples of the human form.[4]

77

78, 79

These instances of symbolless iconography serve to emphasise the importance of symbols in religious art. The word "symbol" has come to acquire a variety of meanings in modern parlance, and often it is used to denote a kind of surrogate for the real thing, so that the presence of the symbol implies the absence of what it symbolises.[5] But symbols in religious art have an essential interrelated function: they represent certain essential attributes of a deity which also serve to identify the image of that deity to its devotees. Three widely differing examples may be cited by way of illustration. The Egyptian god Osiris is invariably depicted tightly swathed in linen bandages as a mummy, except for the face, which is that of a living man, and the hands, which hold symbols of royalty. This mummiform and the kingly insignia relate to the deity's role in the mortuary cultus and his position as lord of the *duat* or underworld.[6] The symbolism in turn distinguishes him from the other Egyptian deities, and identified him to his devotees as the god who had died and rose to life again. Zeus, the head of the Greek pantheon, was identified by the thunderbolt which, as the sky-god, he holds or hurls. Poseidon, the sea-god, had a trident.[7] The importance of such an identifying symbol is to be seen most notably in the case of the superb bronze statue of a deity found in the sea off Cape Artemision, and now in the National Museum, Athens. The bearded figure is represented in the act of casting some object from his right hand. But since this object was not found with the statue, the

40, 80

81

76. Michelangelo's *Pietà* in the Cathedral of Florence.

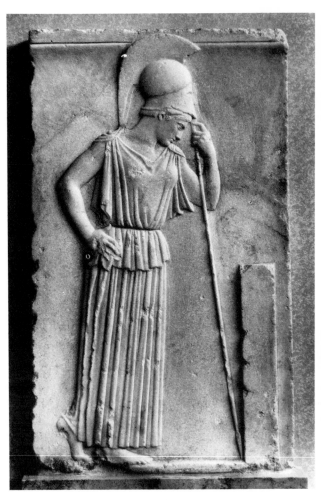

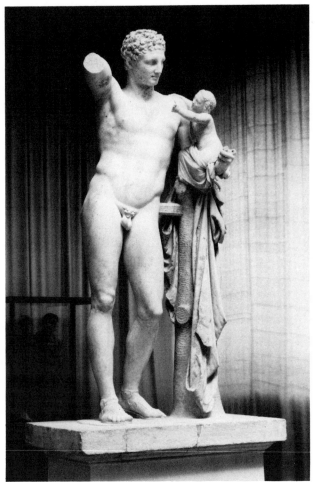

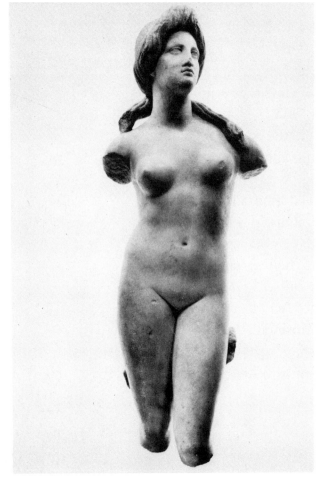

77. The *Mourning Athena*, votive relief in Acropolis Museum.

78. Hermes and the infant Dionysos: statue by Praxiteles.

79. Statue of Aphrodite in the Cyprus Museum.

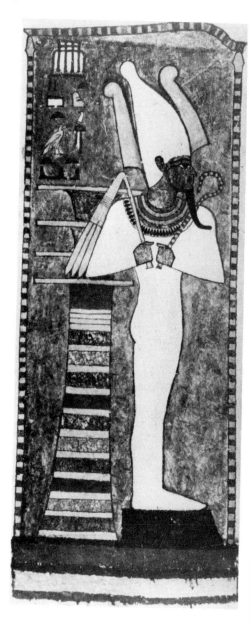

80. Osiris.

81. Bronze figure of deity (Poseidon or Zeus) found in the sea off Cape Artemision.

82a,b. Statue of the Aztec god Xipe Totec.

83. Altar of Brak "Eye-Goddess," reconstruction by Gaynor Chapman.

identity of the god concerned remains a mystery: for if the object had been a thunderbolt, the image would be that of Zeus; if it were a trident, the image would represent Poseidon.[8] In a very different art tradition, a statue of the Aztec god Xipe Totec reveals its identity, and the deity's significance, by a row of large stitches on the chest and a pattern of tied thongs at the back. These curious markings reminded the worshipper of the savage but vital rite that characterised the cult of Xipe Totec, the god of spring—the skin of a human victim, offered in sacrifice to the god, was worn by the officiating priest.[9]

82a, b

In the iconography of deity the symbol may sometimes take on, as it were, a life of its own and become partially or wholly personified. Egyptian art provides much evidence of this tendency, of which the two following are notable examples. The Aten, or sun's disk, which the pharaoh Akhenaten exalted as the supreme manifestation of deity in his attempt to reform his country's religion, was often depicted with radiating rays that end as human hands, and bless the royal family or hold the *ankh*, the sign of divine life, to their nostrils.[10] Even more instructive, perhaps, of the hypostatisation of symbols is a bas-relief commemorating the Sed festival of King Senusret III (1878–1840 B.C.). The enthroned king is depicted twice in his joint roles of king of Upper and Lower Egypt. Before him, as king of Lower Egypt, the standard-symbol of the capital of this province is represented as standing and offering him a notched palm stalk symbolising innumerable years of life. This standard-symbol has human arms and hands, as has also the standard-symbol of the capital of Upper Egypt, which is depicted making a similar offering to Senu-sret as its king.[11] A clue to this strange transformation of imagery is doubtless to be found in the fact that the two standards incorporate the figures of a hawk and an okapi, which were, respectively, forms of the gods Horus and Set.[12] It would, accordingly, seem that the ancient artist identified the standards so closely with the deities, whom he thought of primarily in human form, that he depicted them as having human arms in making their donation of longevity to the king.[13]

83, 84, 97, 308

85

86

Indian art also provides evidence of how a deity might be merged, in iconographic conception, with its symbol.[14] The god Śiva personified the ceaseless vigour of the principle of cosmic creation; but this creative power could also be symbolised by the *lingam* or phallus.

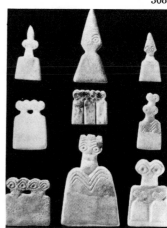

308

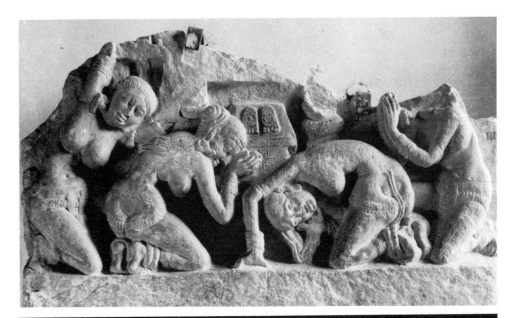

84. Aniconic representation of the Buddha. Scene in relief on a medallion from stupa at Amaravati. Scene shows Ruhula saluting the Buddha, who is symbolised by the empty throne and footprints.

85. The Aten, represented as the sun's disk sublending rays ending in human hands. In the tomb of Eje at Amarna.

86. Representation of the Sed-festival of King Senusret III.

Thus, the god, as generative energy, would be represented equally as a dancing human figure, whose many arms hold symbols of his cosmic activity, and as a giant *lingam*.[15] But the essential nexus between the god and his symbol found significant iconographic expression in the *lingobhāvamūrti* form, whereby Śiva was revealed incorporated in the *lingam*.[16] In this context, reference might also be made to the *hermae* of ancient Greece. These were originally stone or bronze pillars surmounted by a bust of the god Hermes, with an erect phallus. The *hermae* were used as sign-posts, boundary marks, and on graves; they probably had a good luck or apotropaic significance.[17]

 The transmutation of deity and symbol occurs even in Christian iconography, where the Gospel portrayal of the historical Jesus might be deemed so strong as to have established an exclusive tradition of realistic depiction. Thus, the idea of Christ as the victim sacrificed for the salvation of mankind, finding its authenticating prototype in the lamb sacrificed at the Jewish Passover, produced the image of the *Agnus Dei*, the "Lamb of God."[18] Accordingly, a lamb became an accepted symbol of Christ the Saviour, and sometimes replaced the figure of Christ as an object of devotion and veneration in a church.[19] The famous Van Eyck altarpiece of the *Adoration of the Lamb,* in the Cathedral of St. Bavon, Ghent, is the supreme example of this Christian transmutation of symbol into divine icon.[20] Of more obscure origin and of equal antiquity is the use of the fish as a symbol of Christ. The symbol can be plausibly explained as deriving from the fact that the initial letters of the Greek words *Iesous Christos Theou Uios Soter* ("Jesus Christ, Son of God, Saviour") form the Greek word for "fish" (*ichthus*); but there is evidence of the pre-Christian use of the fish as a religious symbol.[21] Whatever the true origin of the usage of the symbol for Christ, in early Christian art the symbol was so well known that it could be used, without explanation, for both Christ and the Eucharist, which epitomised his soteriological role.[22] However, after being a traditional symbol of deep significance for Christians for some five or six centuries, the fish curiously disappeared as a Christ symbol from Christian art. The reason for its disappearance is not clear. It is possible that since its symbolism was not self-explanatory, nor sanctioned by Holy Scripture, as was that of the lamb, its meaning was gradually forgotten, and it possessed no intrinsic aesthetic appeal to ensure its retention.[23]

36, **87**

88

89

90, 159

91

92

159

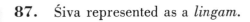

87. Śiva represented as a *lingam*.

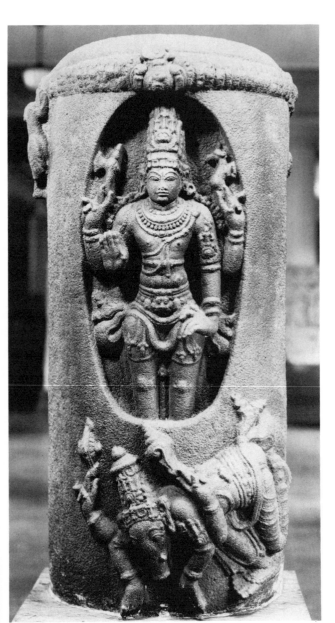

88. Śiva represented in the *lingobhāvamūrti* form.

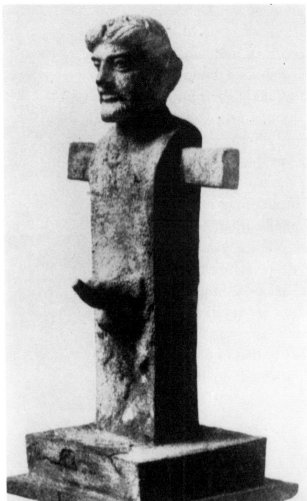

89. Greek *herm*.

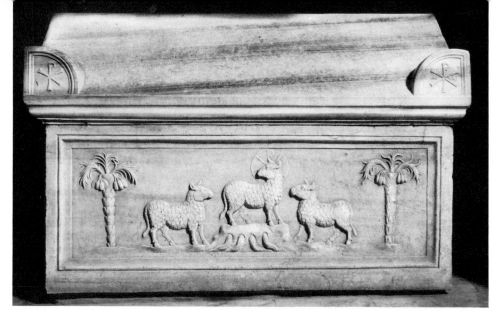

90. Christ represented as Agnus Dei, between two sheep. Relief carving on the Constantius Sarcophagus, in the Mausoleum of Galla Placidia, Ravenna.

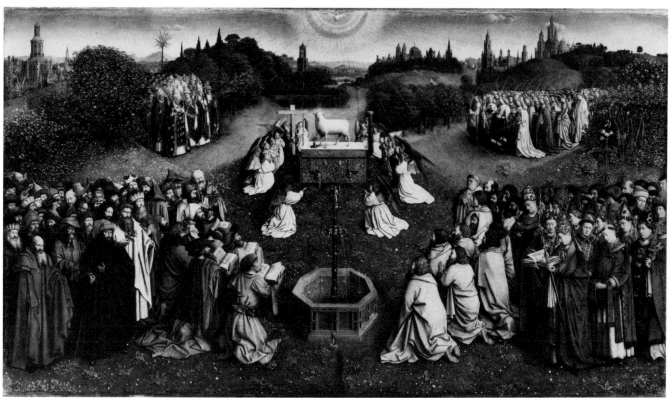

91. *The Adoration of the Lamb* by the brothers Van Eyck.

92. Christ represented under the symbol of a fish in the Catacomb of San Callisto.

Our brief survey of the function of symbolism in iconography may fittingly end with an example of how complex and erudite religious symbolism could become. The north porch of the great Cathedral of Chartres is adorned with twelve pillar statues of Old Testament patriarchs and New Testament saints. The series begins with Melchizedek, who holds a chalice, and ends with St. Peter, who bears some symbol that either foretells the coming of Christ or represents him. The group **93, 94** as a whole symbolises accordingly the sacred *Heilsgeschichte* or Salvation-History upon which Christian soteriology was based: Melchizedek prefigured Christ as the divine high priest who pleads his own vicarious sacrifice for the redemption of mankind; and St. Peter, clad in dalmatic and wearing the papal tiara, represented the Church which Christ founded to re-present unceasingly his sacrifice in the ritual drama of the Mass.[24]

V. RITUAL DRAMA

We have now to consider a form of religious expression that interrelates with both ritual and iconography, and which has undoubtedly affected both by its own achievements as an intermediary between them. The activity concerned is drama, the practice of which can be traced back to the middle of the third millennium B.C. in Egypt. The ritual origin of drama has long been recognised, and the earliest examples of it are really extended series of ritual acts, loosely connected by some mythic theme. The text of such a ritual drama has been preserved on the so-called "Shabaka Stone," now in the British Museum.[1] This gives the libretto and rubrics of a kind of "mystery play" that was performed at Memphis about 2500 B.C., to commemorate the union of Upper and Lower Egypt under pharaonic rule. These provinces had formerly been separate kingdoms, and their rivalry was mythically presented in terms of the struggle between Horus and Set, being respectively the gods of Lower and Upper Egypt.[2] The play was undoubtedly composed by the priests of Ptah, the patron god of Memphis, which had become the capital of the new united kingdom of Egypt. The theme of each act was stated by a presenter, and then enacted by actors representing the *dramatis personae*. The transactions

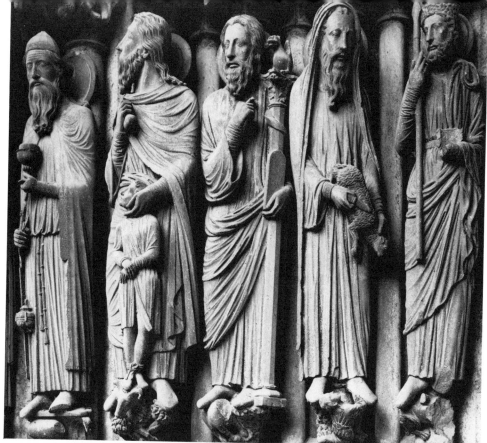

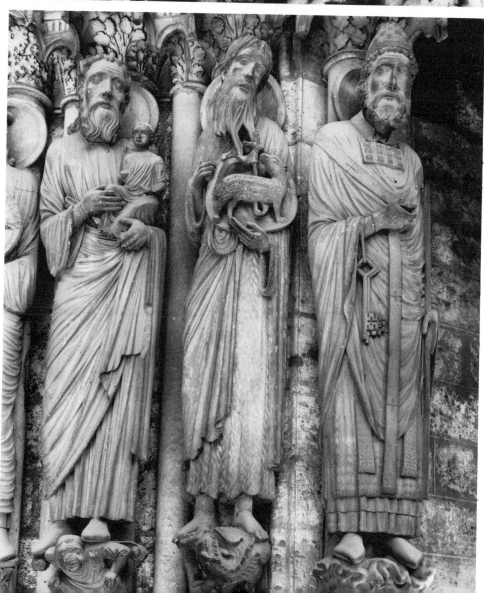

93,94. Statues of Old and New Testament saints in two groups, on the north porch of Chartres Cathedral.

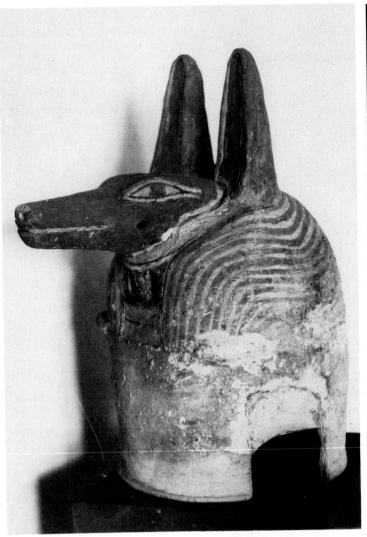

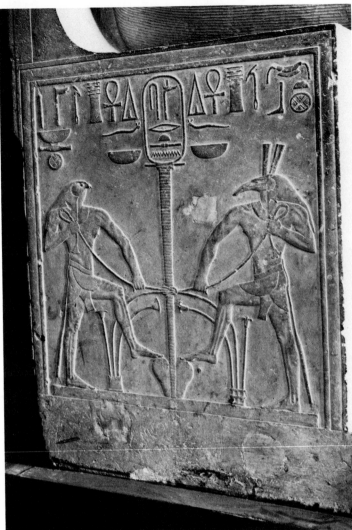

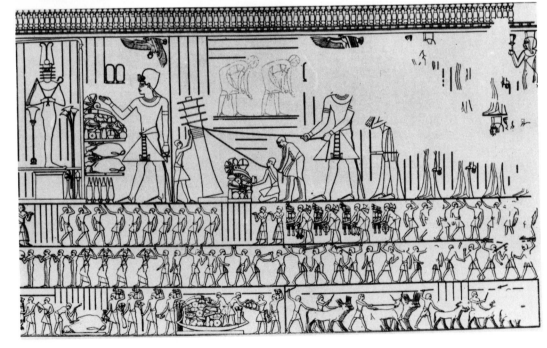

95. Ritual mask used by priest impersonating the Egyptian god Anubis.

96. The union of Upper Egypt and Lower Egypt ritually represented by Horus and Set intertwining symbolic "reed and papyrus." Sides of throne of Senu-sret I.

97. Ritual raising of Djed-column by Amenhotep III (Tomb of Kheru-ef, Gournek).

were, without doubt, regarded as something more than a kind of
pageant play, and, in view of their ritual character, we should be
justified in supposing that they were believed to achieve or maintain
the well-being of the Egyptian state.[3]

The effect which such a play had both on the spectators and upon
iconographic conception must have been very great. Those who
watched the spectacle saw veritable replicas of their gods in action of
momentous import. The play was, in fact, a ritual perpetuation of
events of the "age of the gods," which made the efficacy of those
events a present reality.[4] The gods appeared as they were represented
in the traditional iconography; but the costume worn by the actors
who impersonated them raises an interesting question for our consider-
ation. In Egypt, and in other countries where like practices prevailed,
did such ritual drama precede the depiction of deities in linear and
plastic art? In other words, was the iconography of deity inspired by
the costume worn in ritual dances and drama, or was this costume
modelled on the images created by art? The evidence at our disposal
generally suggests that the representation of deities in painting and 95
sculpture preceded their depiction in ritual drama.[5] However that may
be, the mystery play performed at Memphis reveals how closely
iconography was connected with ritual drama. Thus, reference is made
to the setting up of "reed and papyrus" at "the portal of the Temple
of Ptah," to signify that Horus and Set were reconciled and Egypt
united.[6] This union was probably portrayed ritually by the intertwin-
ing of the respective plants by two priests wearing masks representing
Horus and Set, for such a scene is depicted on the throne of King
Senu-sret I (1970–1936 B.C.).[7] The origin of divine iconography is, 96
incidentally but significantly, commemorated in a hymn of praise to
Ptah, as the Supreme Creator, towards the end of the play:

... he (Ptah) set the gods in their cult-places . . . he founded their shrines,
he made their forms (*twt*) to satisfy their hearts. So the gods entered into
their bodies (*d.*t), (made) of (*m*) all kinds of wood, all kinds of mineral,
all kinds of clay . . . in which they manifest themselves.[8]

Ancient Egypt provides much other evidence of the relation of
iconography and ritual drama;[9] most of this evidence concerns state 97
festivals, but there is some indication that the Judgment of the Dead

may have been represented in a kind of ritual drama. The subject was frequently illustrated in copies of the so-called *Book of the Dead,* with the depiction representing the deceased owner of each particular copy as being justified when his heart is weighed against the symbol of *maat* (truth or justice).[10] The purpose of these depictions is not clear: they may have been intended to instruct the dead about what they would have to undergo in the next world; but they might also have been designed to assist in securing a favourable outcome of the dread ordeal of judgment by anticipating the fervently hoped-for declaration that the deceased were *maa kheru* ("true of voice," i.e., justified). The possibility that the scenes of the weighing of the heart in the *Book of the Dead* might have had the latter intent is complicated by a large-scale depiction of the Judgment of the Dead in bas-relief on the wall of a small temple, dedicated to Hathor and Maat, at Deir el Medineh, near the ancient city of Thebes.[11] The temple, which was begun by Ptolemy IV (221–204 B.C.), was concerned with the afterlife, and it has been suggested that in the hall, which has the Judgment scene, the fateful drama was ritually enacted.[12] If this suggestion could be substantiated, which it cannot be on the evidence at present available, a most valuable insight would be afforded into both the Egyptians' attitude to the *post-mortem* judgment and their use of iconography and ritual drama. For in view of the elaborate re-presentation of the death and resurrection of Osiris in the mortuary ritual which has been previously noticed,[13] it would certainly be intelligible that the drama of the weighing of the heart before Osiris might also have been acted out on behalf of a deceased person, in order to promote a favourable verdict at the dread tribunal.

But there is another aspect to the question which the depiction of the Judgment scene in the Deir el Medineh temple raises. In presentation, the depiction follows the portrayals of the Judgment in the *Book of the Dead*; but these re-presentations were for private use, and the papyrus scrolls on which they were drawn were buried with their owners in the tomb. The unusual *locus* of the Deir el Medineh representation of the Judgment suggests, therefore, that it had a public, rather than a personal, function or purpose. It would seem, accordingly, that the depiction could be interpreted, with equal reason, in two ways: either as an iconographic perpetuation of a ritual enact-

98a,b. *The Judgment of the Dead,* depicted on the wall of a Ptolemaic temple at Deir el Medineh.

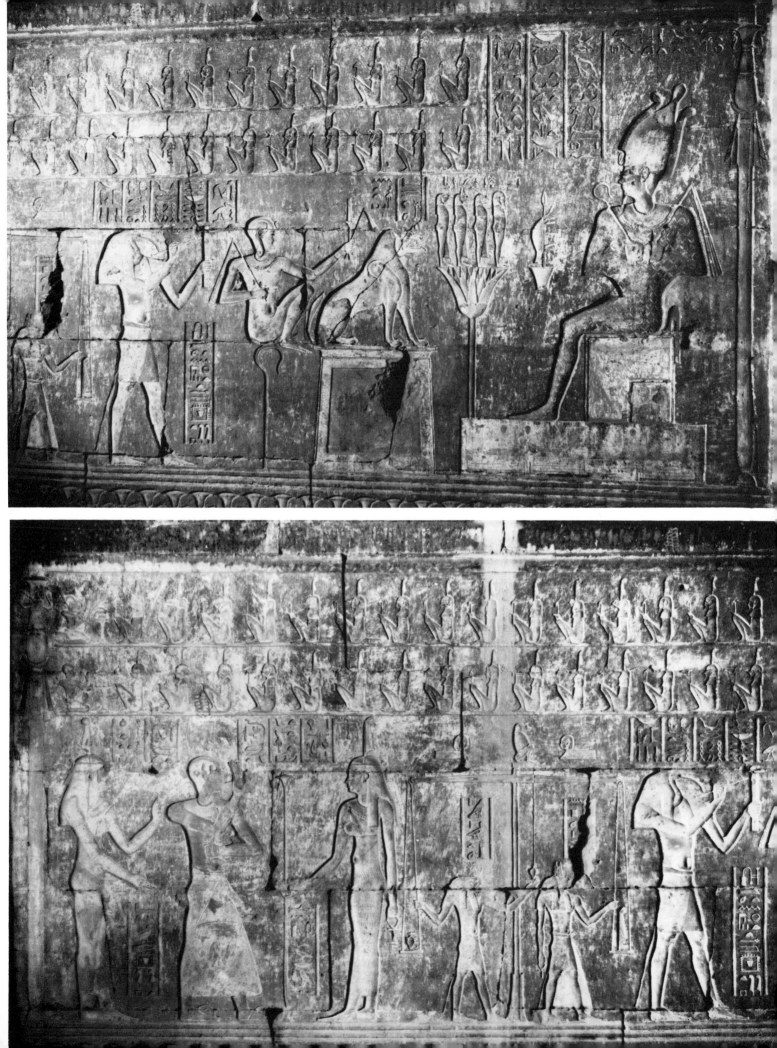

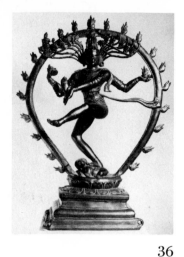

36

99, 100

405

101

ment of the Judgment performed in the temple, or as a minatory *aide-mémoire* to those who came there.[14]

Some of the problems concerning the relation of iconography and ritual drama which first appear, chronologically, in the religion of ancient Egypt occur in other religions in connection with sacred dances.[15] We may briefly notice the problem in Hinduism as a particularly notable example. The great god Śiva was known as *Natarāja*, the "king of dancers," and early bronzes show him performing the cosmic dance, symbolising the ceaseless energy, creative and destructive, in the universe.[16] Krishna, also, from the second century A.D., appears in iconography in dancing posture.[17] There is evidence of ritual dancing in Indus Valley civilisation, and in some of the earliest forms of Indian sculpture the *yakshīs* or Dravidian fertility spirits are shown as dancing.[18] Indeed, the Indian classical dance developed movements and hand gestures (*mudrā*), through which the life and thought of divine beings could be portrayed.[19] The representation of deities in such ritual dances raises a like question to that which we encountered in the ritual context of Egyptian culture, namely, did the iconography of the Indian gods precede their portrayal in the dance or vice versa? The extant evidence permits no certain answer here either; but iconographic material found in the Indus Valley suggests that deities were already portrayed there in other than dancing postures,[20] and the earliest examples of Indian sculpture otherwise depict deities standing or reclining.[21]

Whatever may be the true answer to the question of how far the ritual dance decisively influenced the conception of deity in Hinduism, and perhaps some other religions, there can be no doubt that iconography, the ritual dance, and the ritual drama all combined to present the gods realistically to their devotees.[22] And the influence of such forms of representation was definitive, in that all persons would think of the deities, whom they worshipped or supplicated, in the forms in which they saw them portrayed.

It is mediaeval Christianity that provides the richest treasury of iconographic tradition and ritual drama; but since both forms of expression do not date from the beginnings of the Christian movement, the evidence of their interrelation differs somewhat in significance from that which we have been considering. Thus, Christianity pos-

405

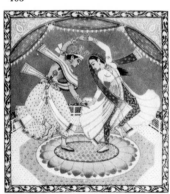

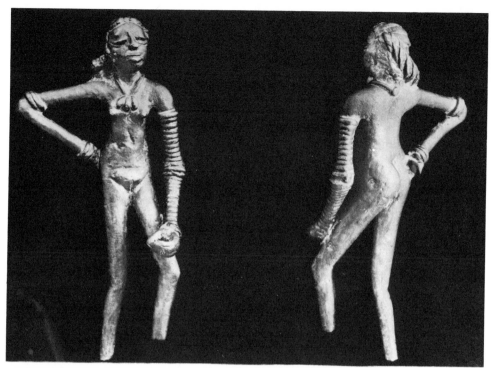

99. Indus Valley statue suggesting a dancing posture. Found at Harappa.

100. Railing pillars depicting yakshīs, from Bhutesar.

101. Indus Valley god, horned and in yogic posture. Sealstone found at Mohenjo-daro.

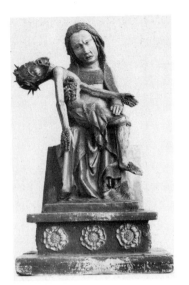

327

sessed as its central act of worship a rite, namely, the Eucharist or Mass, which was firmly rooted in a historical event, the Last Supper of Jesus, but which acquired a pivotal significance later in the theology of salvation.[23] Its dramatic character was early appreciated; for, according to a sixth-century Syriac homily, "The priest who celebrates bears in himself the image of our Lord in that hour. All the priests in the sanctuary bear the image of the Apostles who met together at the sepulchre. The altar is a symbol of our Lord's tomb, and the bread and wine are the Body of the Lord which was embalmed and buried."[24] However, even with the increasing emphasis upon the Sacrifice of the Mass, the celebrant and other ministers never ritually impersonated Christ and his Apostles. Instead, the belief that Christ was himself truly present at each celebration of the rite found popular expression in the legend of the Mass of St. Gregory, and it was graphically illus-

102

trated by Albrecht Dürer in 1511 in a notable woodcut. At the Consecration of the sacrament, St. Gregory sees the altar and its cross transformed into the sepulchre, from which Christ emerges, crowned with thorns and showing in his hands the imprint of the nails of Crucifixion.[25]

Although the Mass was truly a liturgical drama, of great emotive power, the faithful did not see Christ realistically represented therein as, for example, Egyptian deities were represented by masked priests in the ritual drama previously noted. The conception which they had of Christ as priest and victim in the Mass was formed by iconography

103, 61
326, 327, 367

—in particular, by the crucifix on reredos and rood screens, and the illustrations contained in missals and books of devotion.[26]

The mediaeval Christian was, however, given powerful aid in visualising the doctrines of his religion by ritual drama, as well as by iconography. As far back as the fourth century, as the travel memoirs of the Lady Etheria record, elaborate liturgical ceremonies commemorating the events of Christ's Passion were enacted by clergy and people at the sacred sites of Jerusalem.[27] By the ninth century in the Western Church, Christ's entry into Jerusalem on Palm Sunday was being represented by a dramatic ritual, the Saviour himself being symbolically portrayed by a cross, Gospel book, or consecrated Host, and

104

later by a carved effigy seated on an ass, which was mounted on wheels.[28] The Holy Week ceremonies, which were introduced by the

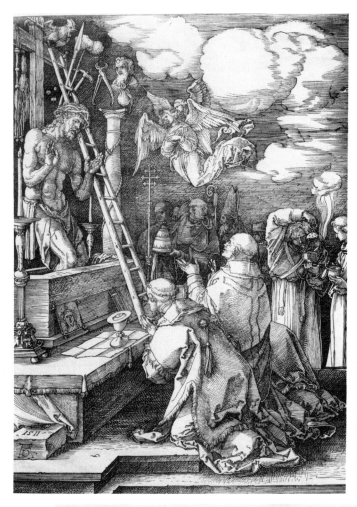

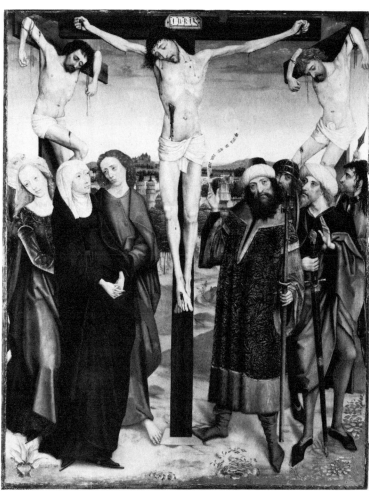

102. *The Mass of St. Gregory,* by Albrecht Dürer (1511).

103. *The Crucifixion,* by the Meister des Marienlebens.

104. Palm Sunday effigy of Christ riding on an ass.

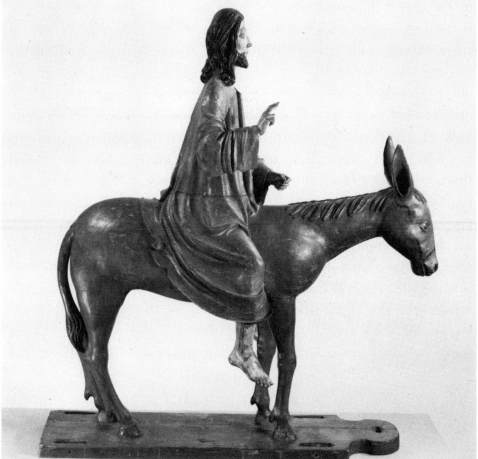

drama of Palm Sunday, were designed to build up the sense of the impending tragedy of Good Friday. The rites were both of a symbolical and representational character. Thus on Maunday Thursday, a consecrated Host was reserved from the Mass and solemnly deposited in a *monumentum* or Easter Sepulchre, thus re-presenting the death and burial of Christ with a sense of sacramental reality, for Christ was present in the Host.[29] The rites of that day concluded with the *Mandatum*, in which Christ's washing of the feet of his disciples at the Last Supper was re-enacted by a bishop or abbot.[30] The most emotive of the rites that commemorated the Crucifixion of Christ on Good Friday was the Adoration of the Cross. Clergy and people, in turn, prostrated themselves before the cross and kissed it, while antiphons and versicles were solemnly chanted, describing Christ's sufferings for sinful mankind.[31]

From this liturgical drama the transition to the Passion and mystery play seems to have been effected through a representational dialogue or trope, known as the *Quem quaeritis*.[32] The dialogue was derived from that recorded in the *Gospel of Mark* (xvi:6) between the holy women who came to Christ's sepulchre on the first Easter morning and the angel who greeted them there. Directions are given in tenth-century liturgical texts for a ministrant, after matins on Easter Morning, to sit, vested in an alb, by the "sepulchre," in which the cross used for the Adoration on Good Friday was deposited. Three other ministrants, representing the holy women, then approach, and are greeted by the "angel" with the question *Quem quaeritis* ("Whom seek ye?"). To their reply: "Jesus of Nazareth," he answers: "He is not here. He is risen as he foretold you." The "angel" then invites them to see the place where the body of Jesus had lain, and he shows the veil that had covered the cross, which had been previously removed.[33]

In this simple piece of representational drama, the only actor who seems to have been dressed specially for the part was he who impersonated the angel. But his dress, an alb, came from the ecclesiastical wardrobe and was not specially designed for the part. The elaborate Easter and other religious plays, which the *Quem quaeritis* heralded, were, however, ornately dressed and required special properties and

staging.[34] Such plays presented the teachings of Christianity vividly to the people, and powerfully influenced their visual conception of biblical events and strange eschatological ideas like the Harrowing of Hell.[35] There is some evidence that these plays, in turn, influenced the iconographic portrayal of certain themes. A notable instance is provided by the depiction of Hell in the Guild Chapel at Stratford-on-Avon, which is compartmented like stage scenery, with a devil fanning, with a pair of bellows, the fire beneath a very domestic-looking cauldron of Hell.[36]

107

Whatever influence religious drama may have had on later mediaeval iconography, there can be no question about the anteriority of iconography as the visual form in which Christian belief found expression. But what is of greater importance in this context is that Catholic Christianity, during the period of its greatest achievement, was characterized by a superb iconography and a rich tradition of ritual and representational drama, which mutually assisted each other's witness. Thus, the faithful were enabled to visualise clearly the three Persons of the mysterious Trinity, the glorious company of the saints, and the events of the divinely guided *Heilsgeschichte* or Salvation-History, both past and future.[37]

108, 369

In concluding this section, it may be observed that ritual drama, as distinct from ritual action, generally depends on an accompanying libretto to explain its theme and make sense of its actions. The importance of the libretto increases with the sophistication of the drama. Thus, the mediaeval Christian mystery plays depended essentially on the spoken dialogue of the actors to achieve their purpose, whereas in ancient Egyptian ritual drama the action generated its own specific efficacy.[38] But, whatever the degree of dependence upon the libretto, it is important for our purpose to note that religious drama represents in visual form both divine beings and sacred events. It must, accordingly, be associated with iconography as a primary source of evidence concerning the manner in which man has conceived of his gods, and reacted to his conceptions.

105. Easter Sepulchre, in Waston Church, Nottinghamshire, England.

106. Good Friday ceremonies in Seville, Spain.

107. Mural depiction of Hell in the Guild Chapel at Stratford-on-Avon, after a drawing by T. Sharp, "Dissertation on the . . . mysteries . . . performed at Coventry" (1875).

108. The Martyrdom of St. Apollonia, presented as a scene from a mystery play.

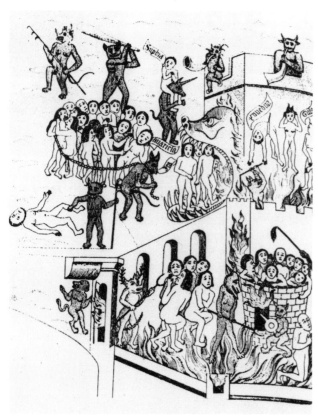

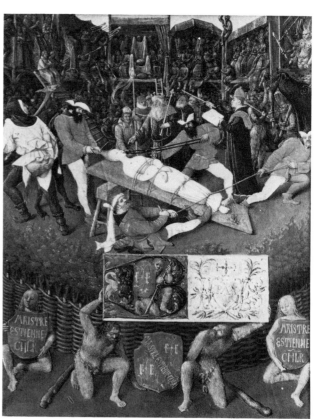

411

VI. THE SANCTUARY

In localising the presence of his gods in image or in symbol, man has been concerned also to provide a fitting environment for these holy objects. The evidence of Palaeolithic archaeology suggests that particular parts of caves were used as sanctuaries: for example, the figure of the Sorcerer is engraved on the wall of one of the inner recesses of the Trois Frères cave system, and the Venus of Laussel was the central object in a kind of *cella* at the end of a rock shelter.[1] Because of their dark and mysterious nature, seeming to be entrances to the underworld, caves form natural sanctuaries, and they have been used as such in all parts of the world since Palaeolithic times.[2] Their numinous character has often been enhanced by art: in the rock temple at Abu Simbel, the effigies of four deities sat in darkness until illuminated momentarily by a ray of the rising sun;[3] a gigantic three-faced head of the Saivite Trinity (*Maheśvara-mūrti*) seems to emerge from a mysterious unknown in the cave-temple of Elephanta;[4] and the "Caves of the Thousand Buddhas," near Tun-huang, attest to the fascination of caves as sanctuaries in Central Asian Buddhism.[5]

411

109a, b

37a

110a

Although caves, natural or artificial, have thus been used from earliest times as sanctuaries, the fact that man soon learned to build habitations for himself caused him to construct habitations also for his gods. Indeed, the ancient Mesopotamians believed that the gods had created mankind to build temples for them and offer sacrifice for their sustenance.[6] Excavations at Jericho and Çatal Hüyük have revealed that, in the earliest known towns, sanctuaries were already being built in the seventh millennium B.C.[7] The sanctuary dedicated to the cult of the Mother Goddess at Çatal Hüyük shows that it was equipped with symbols (bulls' horns and models of female breasts), and linear and plastic depictions of the goddess and painted scenes that defy our interpretation.[8] In other words, the goddess was provided with a special place where she could be worshipped and supplicated, and it was doubtless believed that her presence was uniquely located there.

17b

17a, b, 18, 413-15

It can be said with much justification, therefore, that architecture was created to serve religion; for, although the sanctuaries at Jericho and Çatal Hüyük were integrated with secular buildings, in the ancient

109a. Rock temple at Abu Simbel (before removal).

109b. Images of four deities in innermost sanctuary of the temple of Abu Simbel, Egypt.

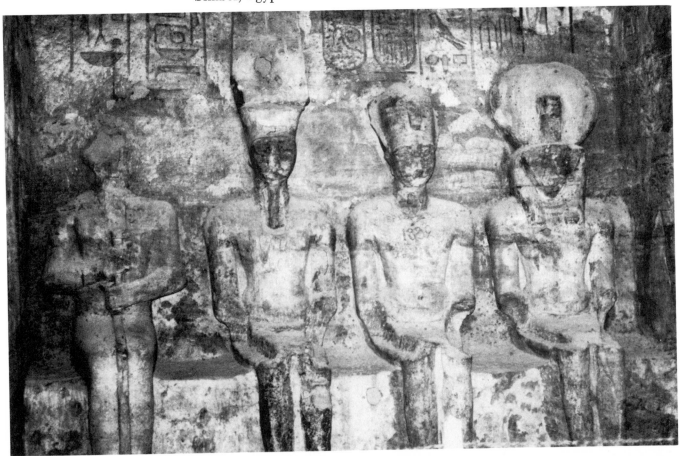

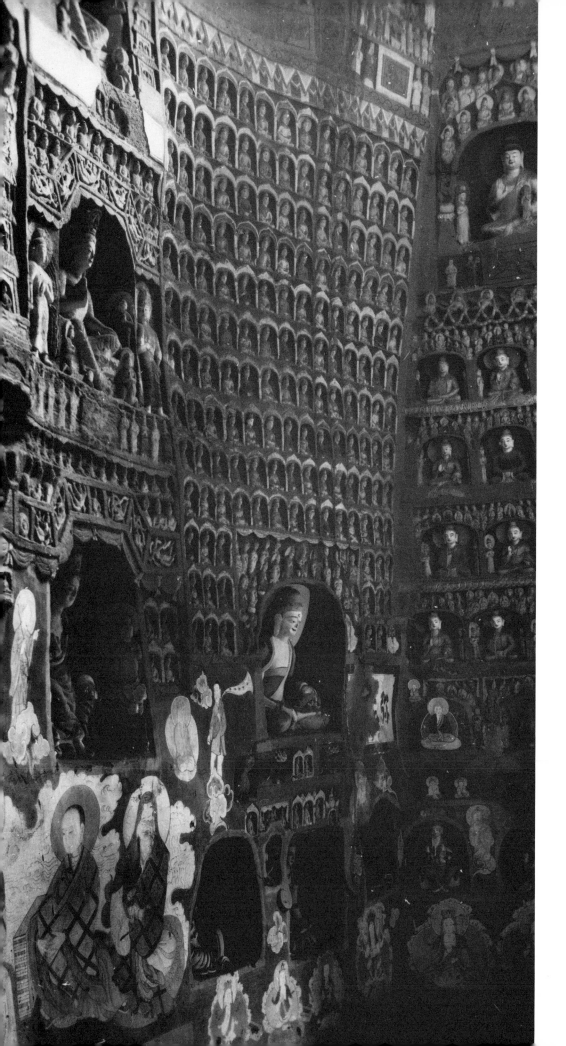

110a. Statues of the Buddha in the "Caves of the Thousand Buddhas," near Tun-huang.

civilisations of Egypt and Mesopotamia the greatest and most durable buildings were the temples of the gods. In both states, the temple was regarded as the palace of the god, where his presence dwelt in his cult statue.[9] As we have noted, this statue was the object of a daily toilet and feeding ritual which was the practical expression of the belief that the god was thus served through this devout care lavished on his image.[10] The temple, accordingly, assured the people of the presence of the god among them, and its layout and adornment were designed to promote this feeling in a highly concrete manner. Both in Egypt and Mesopotamia the founding of an important temple was associated with the creation of the world. According to the oldest Egyptian cosmogony, the temple of Atum-Rē at Heliopolis was built on the primaeval hill which arose out of the watery abyss of Nun, and on which Atum-Rē stood when he began the work of creation.[11] In **110b** Sumer, the ancient temple of the god Enki at Eridu was reputed to be founded upon the *abzu* or primordial deep of the sweet waters.[12] And the *Enuma elish*, the Babylonian Creation Epic, tells how the gods built Marduk's great temple of Esagila as a thank-offering for his victory over Ti'âmat, the monster of primordial chaos, and for his creation of the universe out of its body.[13]

The plans of temples expressed, in their manipulation of space by walls and other structures, conceptions of the divine beings who resided in them. A selection of examples will serve to illustrate something of the variety of manner in which art and architecture were, accordingly, used to express religious beliefs or promote mystic experience.

A. Egyptian Temples

In Egypt, two different types of temple were built, which notably reflect the nature of the deities concerned. Temples of the sun-god at **111** Heliopolis and elsewhere consisted of an open court, surrounded by a walled enclosure. The court was dominated by a great truncated obelisk, erected on a tall podium, before which was set a large altar for sacrifice. The obelisk appears to have served, instead of a cult statue, as the locus of the divine presence. The significance of the obelisk is unknown; but it would seem to have represented the *ben-*

110b. Reconstruction of the Sumerian temple of Ur.

111. Reconstruction of Egyptian sun temple.

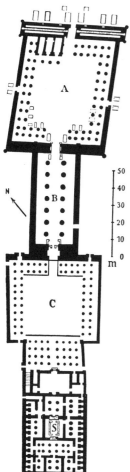

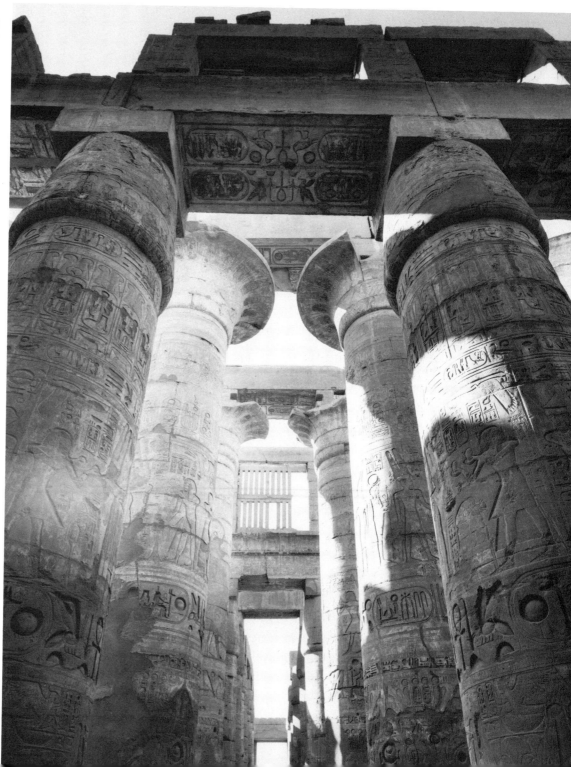

112. Plan of an Egyptian temple. Temple of Amun at Thebes (Luxor).

113. Lotus capitals (in background), Temple of Amun at Karnak. (In the foreground are papyrus capitals.)

49

ben stone at Heliopolis, which marked the place of the "primaeval hill" where the sun-god first appeared and started the work of creation. Outside the precinct wall a large boat, built of bricks, symbolised the solar barque in which Rē, the sun-god, was believed to cross the sky each day.[14]

112

49

The sun-temple was evidently designed for the worship of the sun-god under the canopy of heaven. Its openness contrasted with the other type of temple, which was built from the New Kingdom period (1580–1098 B.C.) onwards. Temples of this kind comprised an open peristyled court that led to a series of halls, roofed and colonnaded, at the far end of which was situated the "holy of holies," where a naos, carved out of a block of stone, enshrined the cult image. This chamber was unlighted by windows, so that progress towards it was a transition from the bright light of the secular world outside into mysterious darkness in which the divine presence dwelt.[15]

113

The temple, as a whole, was designed to represent the universe: its ceiling depicted the sky and the celestial phenomena, while the pillars that supported it were shaped as gigantic lotus flowers or papyrus reeds, symbolic of the Nile Valley.[16] Entrance into the temple was guarded by two massive pylons, which were mystically identified with the goddesses Isis and Nephthys, who had watched over the dead Osiris and secured his resurrection to life.[17] Before the pylons stood two stone

114, 182a

obelisks and giant images of the pharaoh who had built the temple, and from tall masts coloured streamers floated in the wind. For some distance the approach to the temple was guarded by double rows of couchant sphinxes.[18] Scenes of the pharaoh's victories and ritual

182b

scenes adorned the outer and inner walls of the structure; within the edifice were also statues of other deities related to the divine lord of the temple. The temple was, in effect, not a place for congregational worship or private meditation, as is a Christian church or Muslim mosque, but a kind of religio-magical powerhouse in which the deity dwelt to protect and maintain the well-being of the land and its people.[19]

The Egyptian temple of this type undoubtedly constituted the most elaborate form of the divine sanctuary erected in the ancient world. However, to appreciate fully the importance of the sanctuary in concept and function, reference must be made to other examples existent among other peoples and cultures.

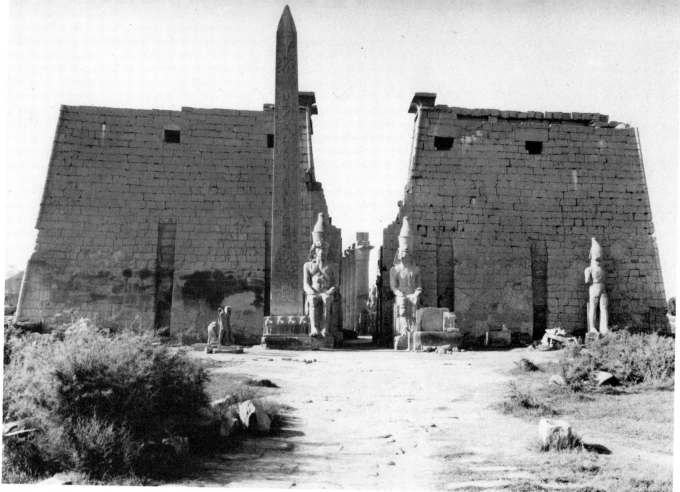

114. Pylons of an Egyptian temple. Temple of Amun at Luxor.

115. Kandariya Mahadeo temple, Khajurāho.

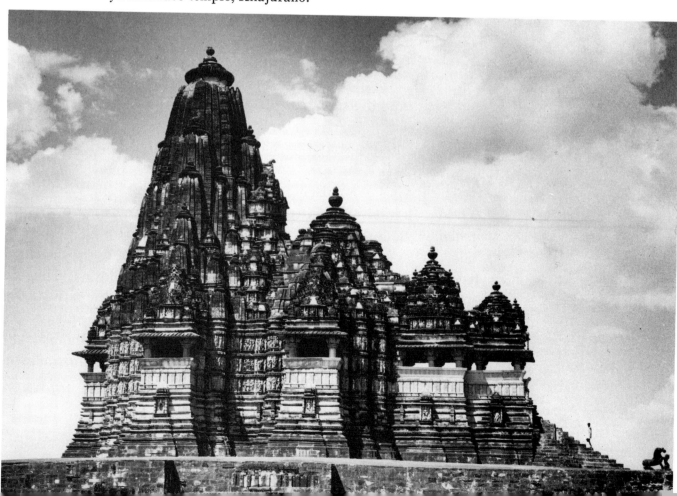

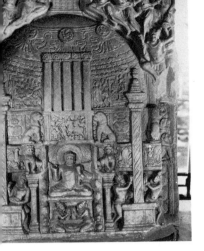

196

340

115

116

117

118

119, 68

67, 196, 339,
340, cf. 197

B. Hindu and Buddhist Temples

The Hindu temple is not only an ornate structure designed to house the image of the deity to whom it is dedicated; for its devotees it is endowed with a divine existence of its own, which is mystically described under various similes. Thus its fabric is thought of as constituting a form or body in which the deity manifests itself; since its shape resembles a mountain and its *sikhara* or spire means "mountain peak," it is likened to Mount Meru, the sacred world-mountain; or it is equated with the body of Purusha, the Universal Man.[20] Elaborate geomantic rites control its plan, which is that of a square or mandala, subdivided into smaller squares dedicated to the divine company that surrounds Brahma.[21]

The profusion of images that adorns the Hindu temple conforms to a specific iconographic scheme. Thus, the friezes of *mithunas* on the temples of Khajurāho, which depict men and women in erotic embrace, symbolise the ecstasy of that union of the soul with Brahman, the principle of divine reality, which is the ultimate goal of Hindu endeavour.[22] The temple of Sūrya, the sun-god, at Konāraka (Orissā), is conceived as the solar chariot: around its basement twelve huge wheels are intricately carved in stone, and colossal statues of horses before its main portal suggest that the whole edifice might ascend to the sky.[23] The architects and craftsmen who designed and built such temples claimed to be descendants of the craftsman-god Viśvakarman, and were carefully initiated into the mystic lore that governed their construction.[24]

The earliest form of the Buddhist shrine, from which the pagoda developed, was the stupa. It was in origin a tumulus or burial mound in which relics of the Buddha were deposited. Being mystically conceived as a kind of architectural body that replaced the body abandoned by the Buddha on entering Nirvāna, the stupa itself became an object of veneration.[25] In its more elaborate forms, as seen at Sanchi or Barabudur, the stupa was planned to embody a complex cosmological imagery based on the alternation of square and circle. From the top of the mound rises a series of circular "umbrellas" which symbolise the *devalokas* or heavens of the gods, culminating in that of Brahma. The mound is encircled by a processional way, the stone balustrades of

116. *Mithunas* sculpture on Hindu temple at Khajurāho, India.

117. Carved wheels of the solar chariot in the sun temple at Konāraka.

118. Adoration of the stupa. Relief from Pasenadi Post of Southern Gate of the Stupa of Bharhut.

119. Stupa at Sanchi.

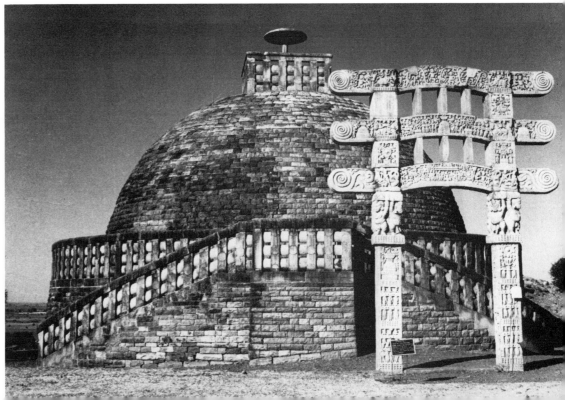

120. Culminating scene of the Parthenon frieze, depicting the presentation of a robe to Athena.

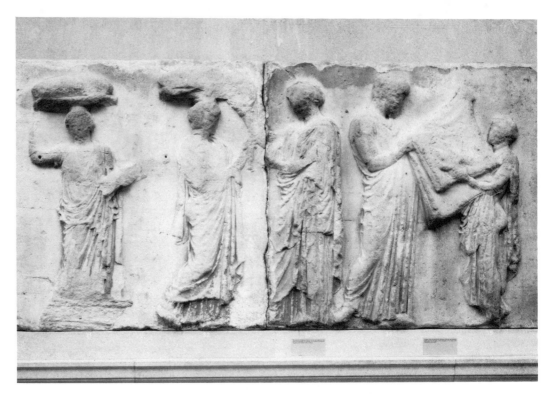

121a. Parthenon, Athens.

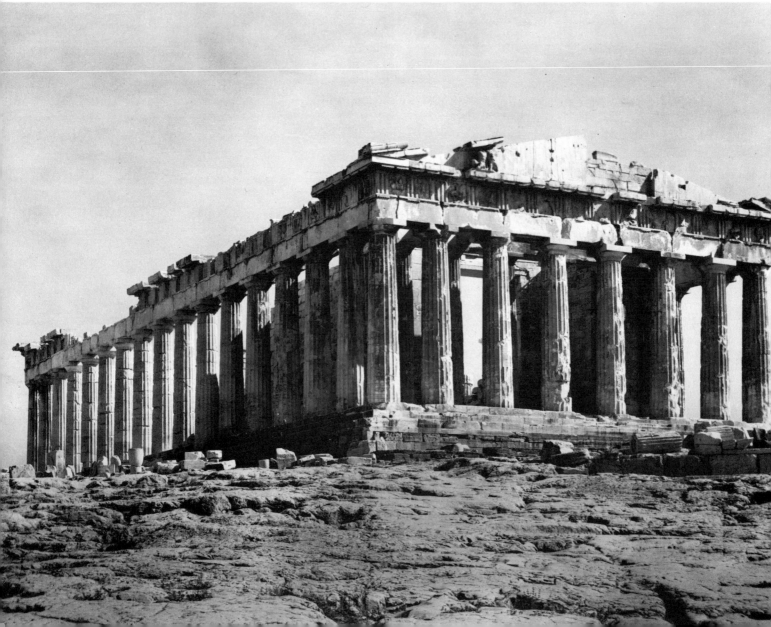

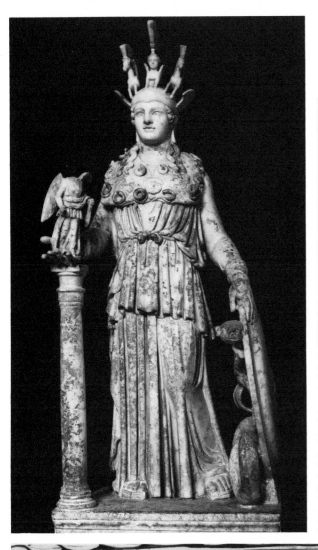

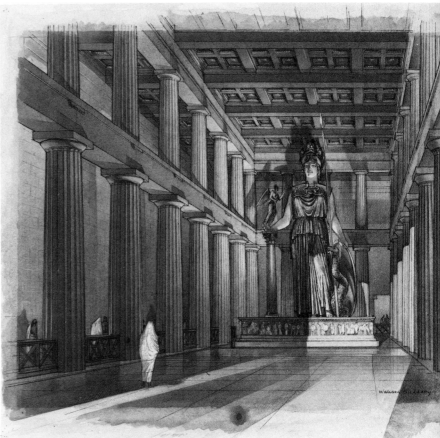

121b. Reconstruction of the cult image of Athena in the Parthenon.

121c. Cult image in position.

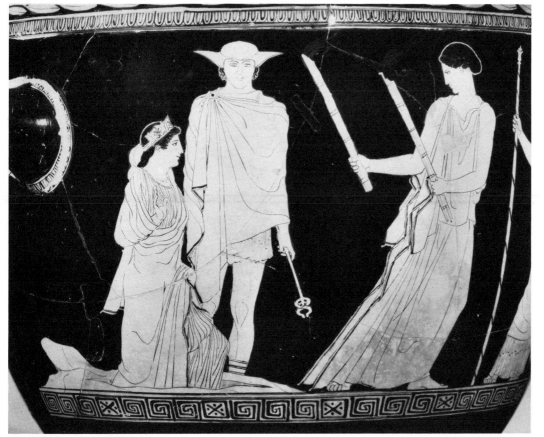

122. Representation on a calyx krater of Persephone returning from the Underworld.

123. Sculptured group representing Demeter, on the "Mirthless Stone," approached by votaries.

124. The Telesterion at Eleusis.

which are carved with scenes from the life of the Buddha or stages in the career of a Bodhisattva.[26]

C. Greek and Roman Temples

The world of Greece and Rome possessed sanctuaries of varying kinds that embodied differing conceptions of deity and ritual needs. The classical Greek temple has been aptly described as a "casket containing the image," for it was planned primarily to exhibit the cult image, and was consequently well-lighted compared with Egyptian and Hindu temples.[27] As the supreme example of the Parthenon shows, the sculptures that adorned the pediments and walls of the structure were designed to portray events of the mythos of the tutelary deity, and other related divine beings and heros.[28] The cult images of Athena in the Parthenon and of Zeus at Olympia seem to have been conceived to impress worshippers with a sense of the majesty of perfection of the deities, through their size and superb artistry.[29]

120, 121a

121b, c

In contrast to such temples, which provided a setting appropriate to the civic nature of the cults they served, was the complex of sacred buildings connected with the famous mystery rites celebrated at Eleusis. Several places within the precincts commemorated the foundation myth of the abduction of the Corn Maiden, Persephone, by Pluton.[30] The *Plutonion* contained a cavern from which the priestess who impersonated Persephone emerged during the performance of the mysteries, thus portraying Persephone's emergence from the underworld realm of Pluton.[31] The "Mirthless Stone" (*Agelastos Petra*) marked the spot where the sorrowing Demeter, the Corn-Goddess, sat during her search for her lost daughter Persephone, and the nearby *Kallichoron* or "Well of the Maidens" recalled her meeting with the daughters of Keleos, king of Eleusis.[32] The chief edifice of the sacred precinct was the temple of Demeter, known as the Telesterion. Its interior arrangement was unique. Square in plan, each of its four sides had eight tiers of seats, which accommodated the initiates of the mysteries. Within the central area was the *anaktoron*, or "holy of holies," in which were kept the mysterious *hiera* or holy objects, which were used during the rites.[33] The exact nature of these rites are unknown to us; we know only that they were elaborate and impressive, and that they were

122

123

124

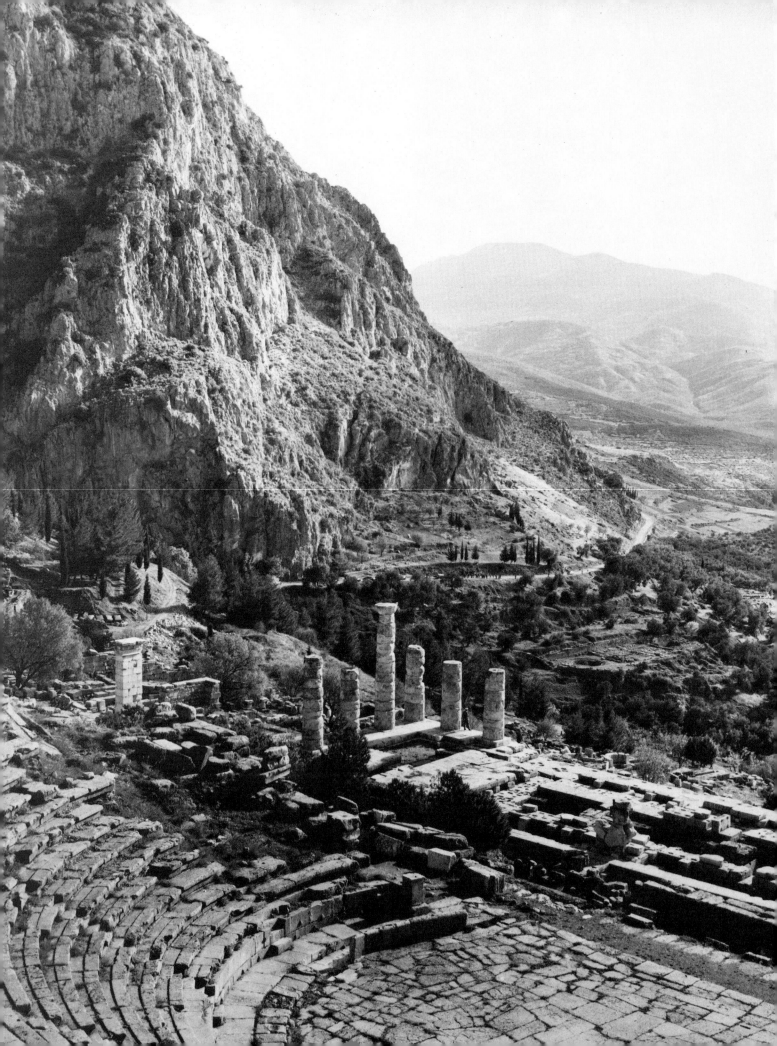

believed to impart to the initiates the assurance of a happy lot after death.[34] Although its shattered ruins give little help in reconstructing its former state, the Telesterion was evidently designed for the presentation of ritual dramas that were calculated to convey to the initiates the sense of supernatural experience by what was "done" (*drōmena*), what was "shown" (*deiknumena*), and what was "said" (*legomena*).[35] That the rites conducted within this unique sanctuary must have achieved their purpose is surely attested by their great popularity and long history—in fact, they ended only with the forcible suppression of pagan cults, by imperial decree, in favour of Christianity, in the fourth century A.D.[36]

316

Two other sanctuaries in ancient Greece must have had unusual features which related to their peculiar religious functions: the temple of Apollo at Delphi which contained the chamber where the Pythia mediated the famous Oracle;[37] and the temple of Asklepios at Epidauros, which was the centre of a complex of buildings concerned with the cult of divine healing that was practised there.[38] Unfortunately, both sites have been too ruined to permit of the reconstruction of their original arrangement. Something of the mysterious locus of the Delphi Oracle is probably to be sensed from the awe-inspiring grotto of the Sibyl of Cumae, where the excavated remains provide a convincing setting for the dramatic visit of Aeneas to consult the Cumaean Oracle, which Virgil describes in the *Aeneid* (III, 443).[39]

125

316

126

The temples of the classical world were generally rectilinear in plan; but some circular temples were built which embody specific conceptions. Thus, in Rome, the original temple of Vesta took that shape from its being the sacred hearth of the city, where the perpetual fire was tended by the Vestal Virgins. The annual opening of the shrine's mysterious *penus* and cleaning of the building were days of ill-omen, possibly because the well-being of the city was deemed to be essentially dependent on the maintenance of the holy fire on its ritual hearth.[40] The famous Pantheon of Rome, which was dedicated to the seven planetary deities, was also built on a circular plan, being thus symbolic of the all-embracing universe.[41] In the Roman Empire, the temples of Mithras were also of unusual design. Where possible, a natural cave was used for the mysterious rites of this Iranian deity, whose cult was so popular with the Roman army; artificial caves were constructed

127

128

129

125. Temple of Apollo at Delphi.

126. Grotto of the Sibyl at Cumae.

127. Roman relief probably depicting the Temple of Vesta in the Forum of Rome.

128. Interior of the Pantheon, Rome. Painting by Giovanni Paolo Pannini.

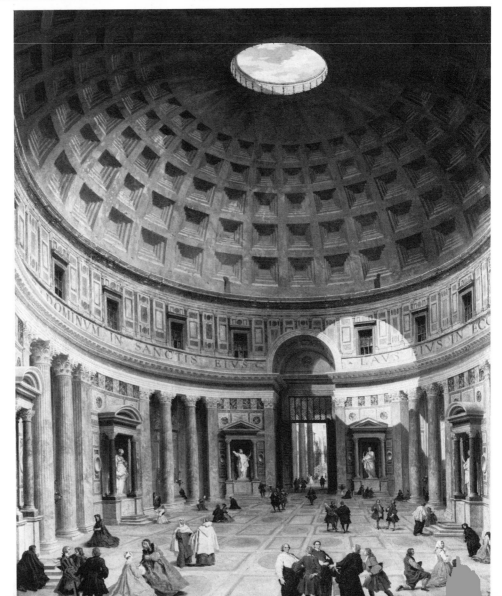

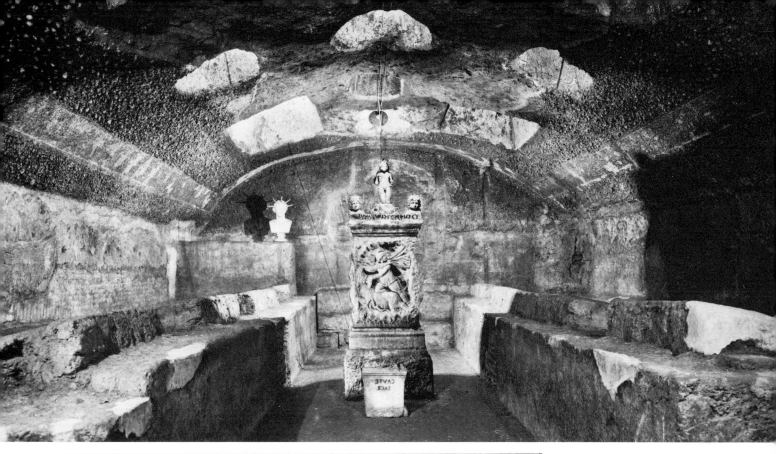

129. The Mithraeum beneath the Church of San Clemente, Rome.

130. Time-god Zurvan-Aion.

434b

where natural ones were not available.[42] The origin of this use of caves as *mithraea* is not known; but an explanation given by the Greek writer Euboulos is significant and probably represents the current belief in the Graeco-Roman world: "The cave provides an image of the cosmos (*eikona tou kosmou*), of which Mithra was the *demiourgos,* and the things at measured distances within the cave bear symbols of the cosmic elements (*tōn kosmikōn stoicheiōn*) and climates."[43] The images of the sun-god Helios and the time-god Zurvan-Aion, which have often been found in the *mithraea,* would also have served to endow these sanctuaries with a cosmic significance which related to the theology of Mithraism.[44] The focal point of the Mithraic sanctuary was the sculptured representation of Mithra slaying the Cosmic Bull.[45]

130

434b

D. The Jerusalem Temple

The great Temple of Yahweh at Jerusalem was a most notable example of the provision of a dwelling place for a deity, which was carefully equipped with all that was required for his cultus and worship. According to Hebrew tradition, the first temple was built there by Solomon to house the Ark of Yahweh.[46] The Ark had been the locus of Yahweh's presence during the nomadic period of Israel's history, and Hebrew literature records the detailed instructions that Yahweh was believed to have given Moses for its construction, furnishing and housing.[47] On capturing the Jebusite fortress of Jerusalem, *circa* 996 B.C., David had deposited the Ark there, doubtless with the intention of making the place the political and religious capital of his kingdom.[48] The selection of the site, and Solomon's erection of the temple there, was represented in subsequent Hebrew literature as an ordinance of Yahweh's.[49]

131

132a

This first temple seems to have set the plan on which the second Temple of Zerubbabel was built in 516 B.C., and which was followed by Herod the Great in his magnificent rebuilding of the shrine which began in 20 B.C.[50] Basically it comprised an open court and a two-chambered building, which was oriented eastwards.[51] The anterior and larger chamber was significantly known as "the house" (*bayith*), and it led to the inner chamber, the "holy of holies." It was in this sanctum that the Ark of Yahweh was placed, and it was guarded by the two

132b

large images of cherubim, whose wings overshadowed it, presumably in a gesture of protection.[52] Into the "holy of holies," only the high priest was permitted to enter on ritual occasions.[53] The "house" contained an altar of incense, the "table of showbread" on which bread was daily provided for Yahweh, and lampstands—in the Herodian temple the famous Menorah or seven-branched lampstand stood here.[54] Somewhere in this vicinity, in the first temple, was a mysterious cult image in the form of a brazen serpent.[55] Two large bronze pillars stood, one each side, before the porch of Solomon's temple. They had each a special name—Jachin and Boaz; they are described in some detail in *I Kings* vii:15 ff., but their significance has not yet been explained.[56] Equally mysterious is the "brazen sea," which was a huge circular basin that rested on the backs of twelve bronze oxen, arranged in groups of four facing the cardinal points. It possibly symbolised the primaeval abyss of *Genesis* i:2, or "the waters which were above the firmament" (*Genesis* i:7).[57] Before the "house" stood the "altar of burnt offering," on which the bodies of animals sacrificed to Yahweh were burned.[58]

133

In the *Book of Kings*, Solomon is represented as declaring to Yahweh: "I have surely built thee a house of habitation, a place for thee to dwell in for ever."[59] Although Hebrew literature clearly recognised that Yahweh dwelt in the highest heaven and could not be contained in a building,[60] yet it is abundantly evident that the Jerusalem temple was truly regarded as his dwelling place on earth—for example, Josephus reports that, in A.D. 70, priests had heard at night a mighty voice saying: "Let us depart hence," thus signifying Yahweh's departure from the doomed shrine before its desecration and destruction by the Romans.[61]

Although nothing survives of the great Temple of Yahweh, it is clearly evident from the descriptions given in the Bible, by Josephus and in rabbinical literature, that the ancient Jews believed that Yahweh had chosen this place in which to let his presence dwell.[62] Consequently, they employed the best of their resources to provide him with a fitting habitation, and to serve him there by offerings of food and incense, and the life-blood of sacrificial victims. In other words, the religion of Israel, which is pre-eminently associated with a sacred literature, was distinguished by the elaborate cultus which was maintained

131. The *Ark of Yahweh* depicted in a synagogue mural at Dura-Europos.

132a. Jerusalem, from the Mount of Olives.

132b. Plan of Herod's temple.

133. The Menorah, depicted on the Arch of Titus.

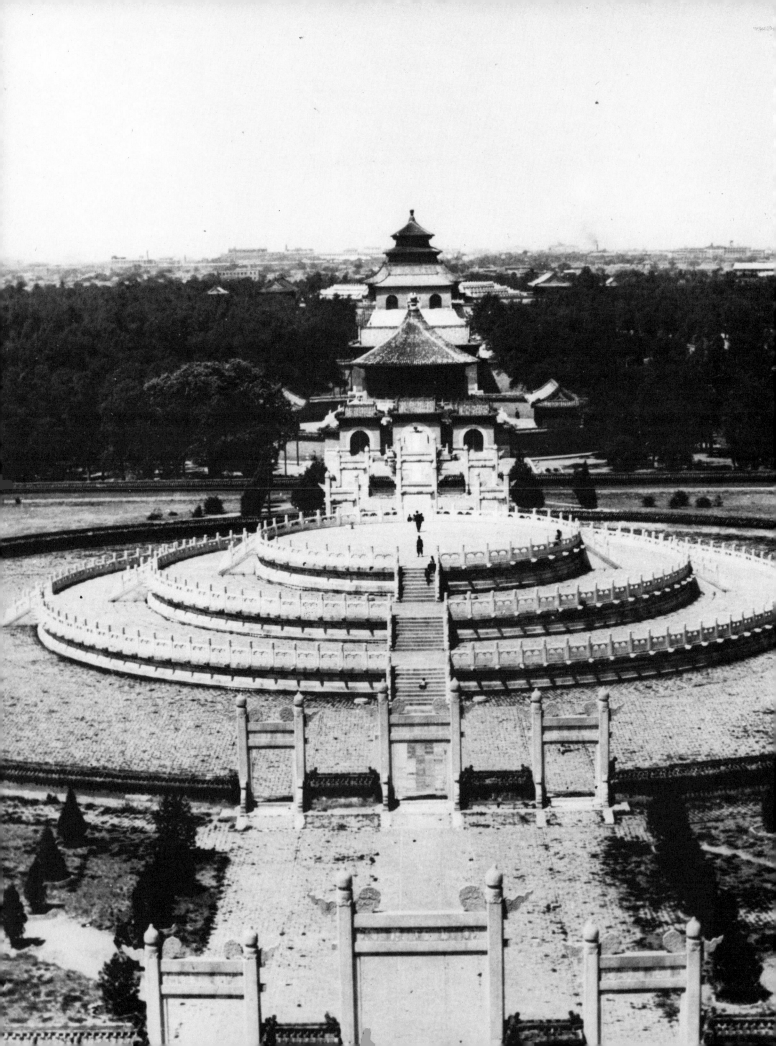

in Jerusalem by a daily ritual service to Yahweh and by periodic festivals.[63] This cultus was performed in a unique sanctuary, which was superbly equipped from the resources of contemporary art and architecture, including a symbolic iconography and divinely prescribed vestments for the high priest.[64]

E. Chinese Temples

The ritual practice of Chinese religion required elaborate planning in which architecture was made to subserve a mystic ideology. The selection of sites for both temples and tombs was decided by *feng shui*, a geomantic system based on an ancient Chinese Nature cult which involved the idea of an active cosmic life-force (*ch'i*), the interaction of the alternating cosmic principles of *yin* and *yang*, and the conception of five primary elements.[65] Within the temple precinct, the altar was of primary importance. Images of deities, unknown before the entry of Buddhism into China, were housed in buildings distinguished by their ornate carvings, painted and gilded, and their beautifully tiled roofs, which were gracefully curved upwards at the eaves.[66] The most notable of all Chinese sanctuaries was the complex of sacred buildings at Peking, which were used for the state cult of China in Imperial times. The focal point was the Altar of Heaven, at which the emperor offered the great annual sacrifice to Shang Ti, the Supreme Deity, at the winter solstice.[67] An impressive structure of white marble, the altar stands under the open sky at the centre of three concentric terraces, and is approached by four flights of steps from each of the cardinal points. Nearby are the Temple of the Prosperous Year, the Hall of Abstinence, and other buildings which served the national cult. The whole architectural complex thus provided both an august setting for the Imperial rites, upon which the well-being of the state depended, and an auspicious site of cosmic significance.[68]

134

F. The Mosque of Islam

The Islamic mosque affords an interesting contrast to the sanctuaries described, which have been regarded primarily as houses or courts of the deities concerned. It also differs from the Peking temple com-

134. The Temple of Heaven, Peking.

135. A *mithrāb* in a Muslim mosque.

136. The Ka'ba, Mecca.

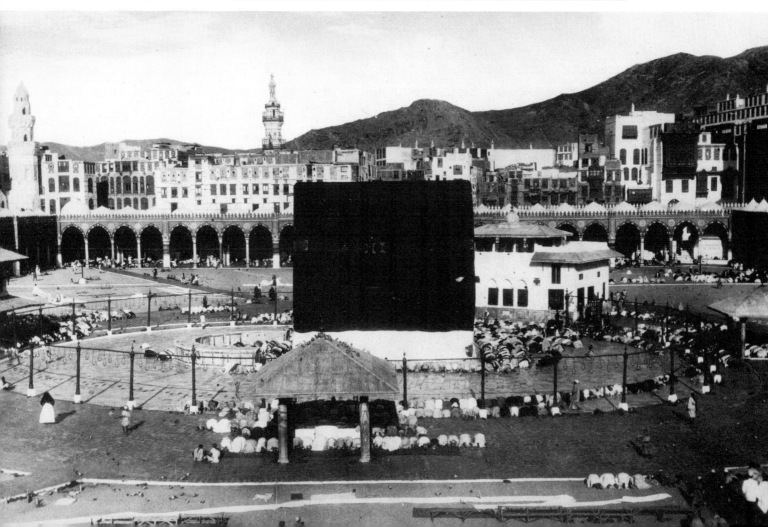

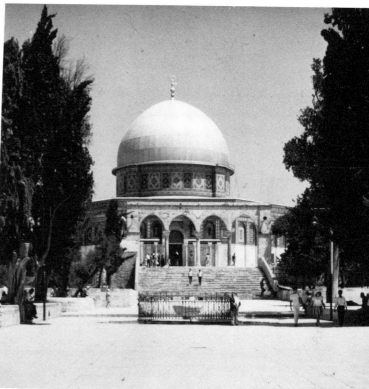

137. Minaret, Istanbul.

138. The Dome of the Rock, Jerusalem.

139. The Sacred Rock (Sakhra) in the Dome of the Rock.

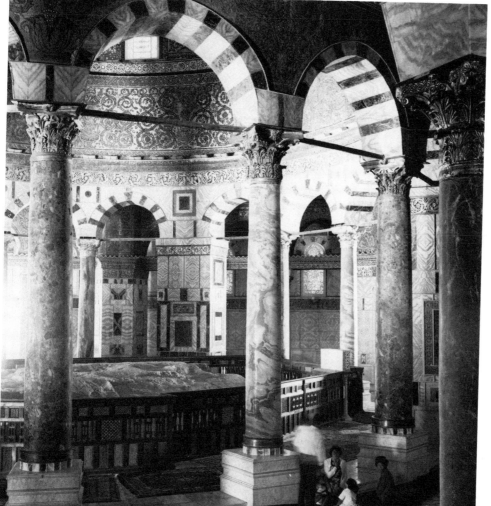

plex, which seems to provide, by virtue of its distinctive orientation, a focal point for the service of a celestial deity rather than a dwelling place for it on earth. Although primarily a place of prostration (*masjid*), the mosque is designed to fulfill a ritual requirement, namely, to provide the proper direction (*qibla*) in which the worshippers must face in making their prostrations and saying their prayers.[69] This *qibla*

135

is indicated by a niche (*mithrāb*) in the wall of the mosque, and points in the direction that the Ka'ba at Mecca is calculated to lie.[70] The

136, 385

Ka'ba, which is thus the focus of Muslim devotion throughout the world, is a shrine, traditionally built by Adam and rebuilt by Abraham and Ishmael, which contains the sacred Black Stone.[71] This stone, probably an aerolite, was venerated from the pre-Islamic times, and the kissing or touching of it forms an essential part of the ritual performed by the Muslim pilgrim to Mecca.[72] Apart from this mystic orientation, the layout of the mosque is functional. A pulpit (*minbar*) is provided for the Friday sermon, and a water tank in the courtyard serves for the requisite ablutions before prayer. The minaret, which

137

characterises the external appearance of the mosque, is also functional, providing a place of vantage from which the muezzin can call the faithful to prayer.[73] The required removal of shoes before entering a mosque is a ritual act of uncertain significance. The divine injunction to Moses, in *Exodus* iii:5, to remove his shoes because of the holiness of the place in which Yahweh manifested his presence, may have suggested the custom; but the sacred character of the mosque is not imparted by belief that Allāh localises his presence therein.

138

Mention must also be made of the famous Dome of the Rock (*Kubbet as-Sakhra*) at Jerusalem; for although this is not strictly a mosque (*masjid*) but a shrine (*mashhad*), it is one of the most notable monuments of Islam. It was built in A.D. 691, on the orders of the Umayyad Caliph Abu al-Malik, as a place of pilgrimage for Syrian Muslims, who were prevented by political troubles from travelling to Mecca. The site at Jerusalem was a holy one, for the great outcrop of rock in the temple

139, 386

area was the traditional spot from which Muhammad was believed to have made his miraculous ascent to heaven. The Dome of the Rock was designed to cover the sacred Sakhra (rock), and enable pilgrims to circumambulate it as the Mecca pilgrims circumambulated the Ka'ba.[74]

385

386

G. The Minoan Sanctuary

To complete our survey, before considering the Christian church which, in the form of the mediaeval Gothic cathedral, must surely represent the supreme expression of the synthesis of iconography and architecture in the service of religion, we must notice some instances of the location of deity in open-air sanctuaries. The most graphic evidence is provided by ancient Cretan art (*post* 1400 B.C.) in the scenes painted on a terra-cotta coffin or sarcophagus found at Hagia Triada, and now in the museum at Heraklion.[75] On each of the longer sides a series of ritual acts is depicted as being enacted in the open air. That these ceremonies are performed at an established sanctuary is indicated by large double axes, erected on plinths. The double axe was a religious symbol of high significance in Minoan religion, although what it signified is not known to us.[76] The birds, which are shown perched upon the axes, doubtless indicate that the sanctuary was devoted to the cult of the Great Goddess of ancient Crete.[77] The figure of a trussed bull, on one of the sides, suggests that a sacrifice was about to be made, and a female officiant prepares the altar, near which stands an ornate structure surmounted by the typical Minoan symbol of bull's horns.[78] If the scene on the other side of the sarcophagus is part of the same ritual occasion, which seems likely, a female ministrant pours a libation into a large amphora, placed between two double axes. The act appears to be supervised by a priestess, to the accompaniment of music played on a cithara.

Since no temple remains have been found in Crete, it would seem that worship or ritual service usually took place in open-air sanctuaries such as that depicted on the Hagia Triada sarcophagus.[79] If the sanctuary shown there was indeed typical, the absence of a cult image is to be specially noted. The absence of such an image does, in fact, add further to the problem that besets our understanding of Minoan religion. Representations of what appear to be the Cretan "Great Goddess" are found engraved on gold signet rings, thus indicating that an iconographic tradition did exist.[80] But female figurines, of various cultural periods, which seem to be of a cultic nature, could be equally well interpreted as representations of either a goddess or a priestess. In other words, we have another instance of the problem constituted by the

140, 141

cf. 224

142

143

140, 141. Minoan sanctuary depicted on Hagia Triada sarcophagus.

142. The Aegean "Great Goddess" depicted on a gold signet ring found at Mycenae.

143. Minoan earth goddess or priestess, holding snakes. Faience figure found at Knossos, Crete.

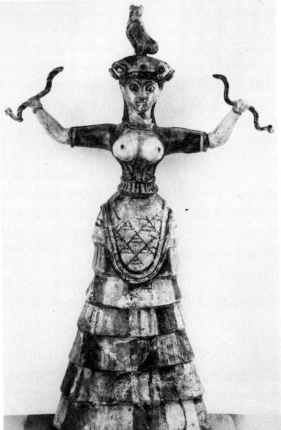

symbolless image; for these Cretan figurines have no distinctive attributes of divinity.[81]

H. Megalithic Sanctuaries

What is known as Megalithic Culture is characterised by the use of open-air sanctuaries made up of patterns of large standing stones, usually roughly shaped.[82] The well-known story of Jacob's dream of the Heavenly Ladder in *Genesis* xxviii graphically records a numinous experience in such a sanctuary. Jacob, on awaking from his dream, exclaims: "How dreadful is this place! This is none other but the house of God, and this the gate of heaven." It is then related how he anointed the stone upon which he had slept, and set it up "for a pillar," and called the place Bethel.[83] The story is probably a Hebrew foundation legend, ascribing the origin of a notable Canaanite sanctuary to a Hebrew patriarch.[84] But, whatever its origin and purpose, the story does witness to a belief that the presence of God might be localised in a particular place, which was marked by standing monoliths. A surviving Canaanite example of such a sanctuary is the so-called "Obelisk Temple" at Byblos, in the Lebanon.[85]

The most impressive of megalithic sanctuaries is Stonehenge on Salisbury Plain. Composed of concentric circles of monoliths of graduated sizes, the sanctuary reached its present form in three stages, from *circa* 1900 to 1400 B.C.[86] The fact that a number of blue stones, which form one of the circles, were brought there from the Prescelly Mountains in Wales, a distance of some 135 miles, suggests that a special sanctity was attached to them by the builders of Stonehenge.[87] Of the deity or deities worshipped at Stonehenge, and of the rites performed there, nothing is known. There are some indications that the sanctuary may have been connected with a sun cult, and also possibly with a mortuary ritual.[88] Some archaeologists have suggested that there may have been a ritual connection between Stonehenge and the older megalithic sanctuary at Avebury and the huge artificial hill of Silbury, both of which are in the near neighbourhood.[89] But whatever may have been the nature of the religion practised at Stonehenge, the location of the great sanctuary at this place must surely have been inspired by a deep and urgent sense of its numinous nature. And the possibility that the

144

145

146

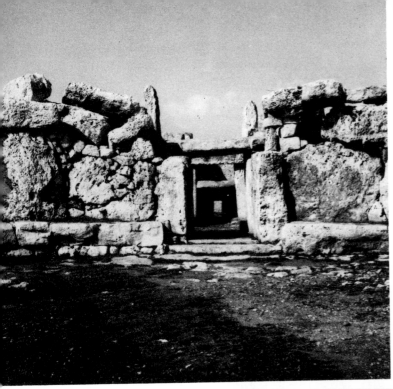

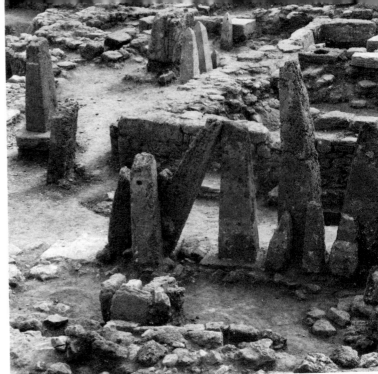

144. Megalithic temple in Malta.

145. "Obelisk Temple," at Byblos.

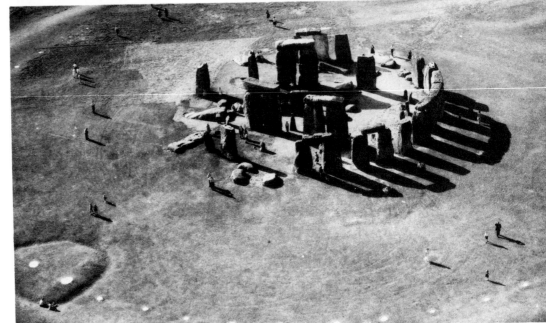

146. Stonehenge, England.

147. Ancient Maya Temple of Kukulcan, Chichen Itza.

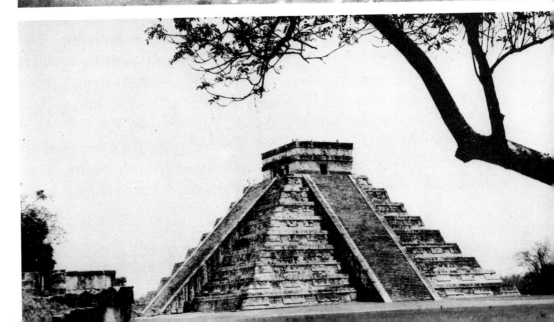

Romans, later, attempted to destroy Stonehenge points to its continuance as a place of unique significance for the ancient Britons for over a thousand years after its completion.[90]

I. The Ancient American Temple

Among open-air sanctuaries may be reckoned the pyramidal temples of pre-Columban America. The staged pyramid, which developed from a round earth mound, was essentially an elevated platform for the altar on which the vital sacrifices were made to the cult deity. A small building, behind the altar at the top of the pyramid, contained the cult image, where blood and hearts torn from the sacrificial victims were offered to the god. A plaza, below the pyramid, accommodated the assembled worshippers.[91] The pyramid, and its associated structures, were decorated with symbolic carvings, including sometimes representations of decapitated heads or skulls.[92] Although the Aztec word for temple, *teocalli*, meant literally "house of god,"[93] these ancient American temples appear to have been not so much dwelling places of the gods as contact points at which men could pass their offerings to the deities. In other words, they were essentially functional structures, designed to accommodate and facilitate the ritual sacrifices on which it was believed the proper relationship between mankind and the gods depended.

147

J. The Christian Church

The Christian church was, in origin, functional. It provided accommodation for the faithful, where they could meet to celebrate the Eucharist, baptise converts, pray together, and receive instruction and exhortation. Such meeting places, during the first three centuries, were invariably in houses or domestic buildings adapted for the purpose. The earliest known example of such a house-church was found at Dura-Europos, a Roman garrison town on the Euphrates, and dates from the middle of the third century. It contained several rooms, one being a rectangular hall with a raised platform at the eastern end where the altar, on which the Eucharist was celebrated, probably stood. There was also a baptistry, its font being covered by a baldachino. The walls

148

438

149a, b

150

151, 438

62

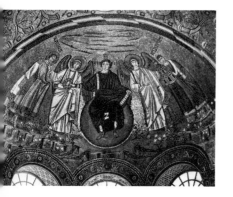

152, cf. 62

of the "church-room" were decorated with painted scenes, drawn from the Bible.[94]

When Christianity was finally accorded legal status by the Roman government in the fourth century and it became possible to build churches for public worship, the new structures were also designed in terms of their functional purpose. Contemporary architectural styles were followed, and the basilica plan was adopted, with an apsidal end, undoubtedly because it best suited the needs of Christian worship.[95] The altar was placed at the chord of the apse, and provided the focus of attention, which was fitting since the Church's chief act of devotion, the Eucharist, was celebrated upon it.[96] The floor of the apse was generally raised above the level of the nave of the church and was reached by steps. The apse contained the *confessio*, where the relics of a saint were deposited beneath floor or altar. This *confessio* continued an earlier custom of celebrating the Eucharist at the tomb of a martyr, and it endowed the church with a special sanctity, apart from that with which it was invested through the celebration of the Eucharist.[97] The apse also served to express an hierarchical distinction; for it was the part of the church reserved for the clergy, and was known as the *presbyterium*. Behind the altar stood the *cathedra* or throne of the bishop, and the priests and other ministers not occupied in the performance of the rites sat in a semi-circle on either side of it. Outside the apse was the *ambo* or *pulpitum* for the liturgical reading of the Holy Scriptures.[98] The baptistery, which contained a font large enough to permit of the total immersion of an adult in its waters, was invariably a separate structure. It was arranged to accommodate the ministers and candidates at the impressive baptismal ceremonies which were held on the eve of certain great festivals of the Church's liturgical year.[99]

The Christian church was thus, from the fourth century, in course of transition from being a wholly functional structure, in which the faithful assembled for the ministry of the sacraments and for instruction, to being a veritable sanctuary invested with a numinous aura.[100] Symbolic of this new status was the custom, which began to develop from the end of the fourth century, of utilising the hemispherical dome of the apse to represent a celestial scene that extended, as it were, the dimensions of the church beyond this world. Thus, for example, in Santa Pudenziana, Rome, Christ is represented enthroned, with attendant

saints, against a skyline of the Holy Places of Jerusalem, which are dominated by a great jewelled cross; in the sky behind the cross the Four Living Creatures of the Apocalypse, which Christians identified with the four Evangelists, hover in their mystic service to the enthroned Christ. The link between this supernal vision and the church is clearly proclaimed in the words written on the open book which Christ bears: *Dominus Conservator Ecclesiae Pudentianae* ("The Lord is the Preserver of Puden's Church").[101]

In the apse mosaic of San Vitale, Ravenna, which was consecrated in 547, Christ is depicted as the Cosmocrator, enthroned on the heavenly sphere, and attended by two archangels, and St. Vitalis and Bishop Ecclesius. The church itself is linked with this heavenly scene through St. Vitalis, whose *martyrion* it was and on whom Christ bestows a victor's crown, and Ecclesius, its founder, who offers a model of San Vitale to Christ.[102] In this context, too, must be set the famous mosaic portraits of the emperor Justinian and his consort Theodora, who, with their retinues, are depicted bearing offerings to Christ—a memorial of their piety that perpetually associated them with Christ in pious service and imperial splendour.[103]

In the basilica of Sant' Apollinare Nuovo, also in Ravenna, two lines of figures, in mosaic, seem to move in solemn procession along the nave walls, just below the clerestory. On one side it is a company of male saints who proceed towards an enthroned Christ, who is attended by four angels. The saints carry jewelled crowns, and they pass through a celestial meadow, studded with flowers, in which palm trees grow.[104] In a like position on the other side of the nave, richly apparelled virgin saints appear to join the Three Magi in offering gifts to the infant Christ, who is seated on the Madonna's lap and attended by four angels.[105] The impression created by these two superb series of Virgins and Martyrs, proportionally large and beautifully coloured, is that within the church itself acts of celestial worship are taking place, which the visitor witnesses from a lower mundane plane. Today these heavenly figures dominate the basilica. How they were related to the iconography of the apse is unfortunately not known, since the original apse has been destroyed. It is interesting to note, however, that high above the Virgins and Martyrs, and on a diminutive scale, is a series of mosaic scenes of incidents from the earthly life of Christ.[106] Situated thus so

153, cf. 62

154a, b

155

156

157

148. Christian house-church at Dura-Europos. The baptistery and murals.

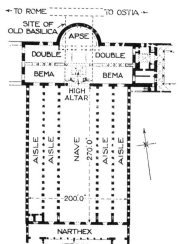

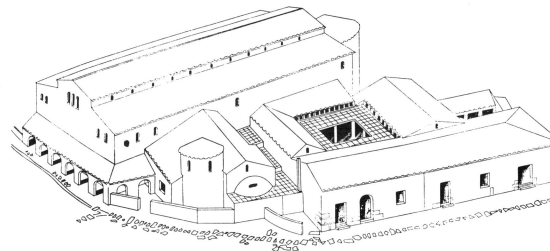

149a,b. Plan of basilical church.

150. San Clemente, Rome, showing the presbyterium area, with altar and ambo.

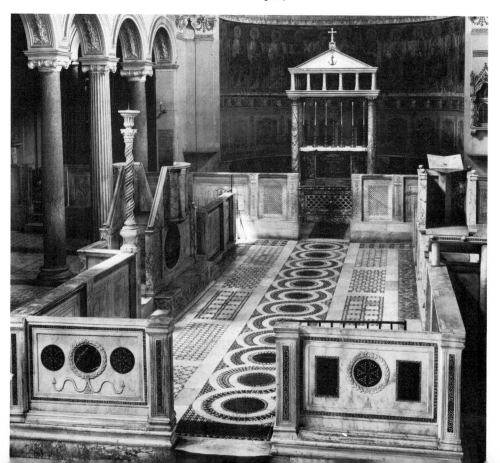

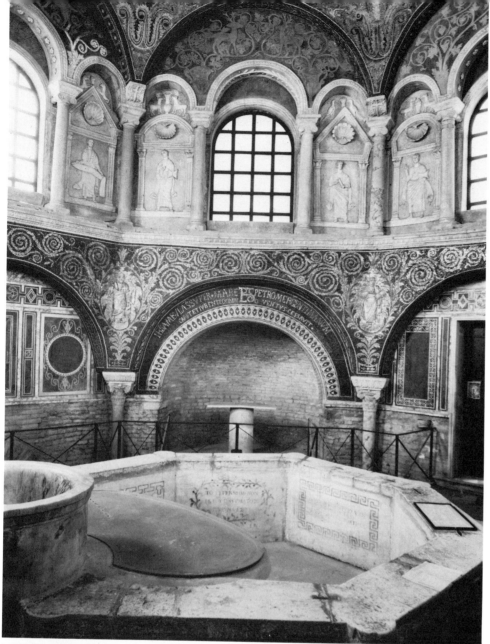

151. The Baptistery of the Orthodox (interior), Ravenna.

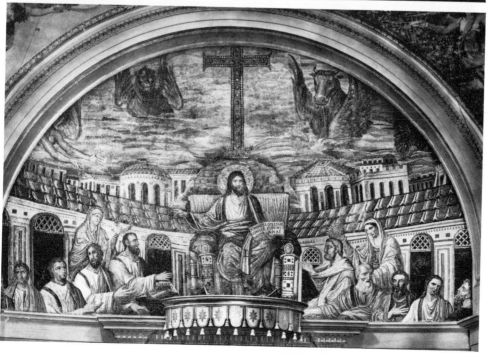

152. Apse mosaic of S. Pudenziana, Rome.

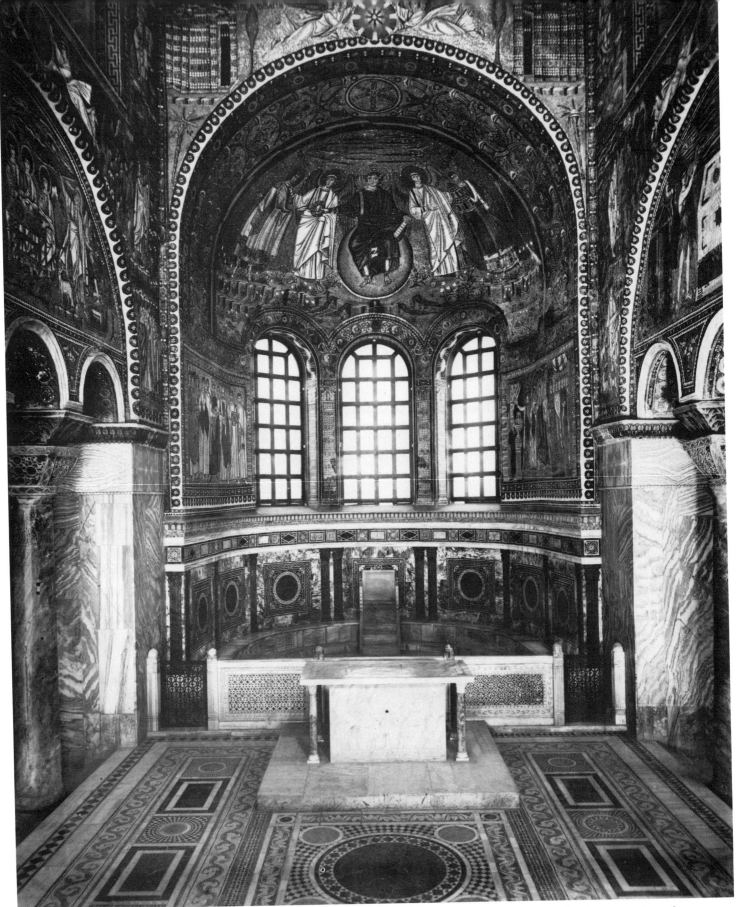

153. The presbyterium of S. Vitale, Ravenna. General view showing the position of various mosaics and the altar.

154a,b. Mosaic pictures of Emperor Justinian and Empress Theodora, with retinues, in S. Vitale, Ravenna.

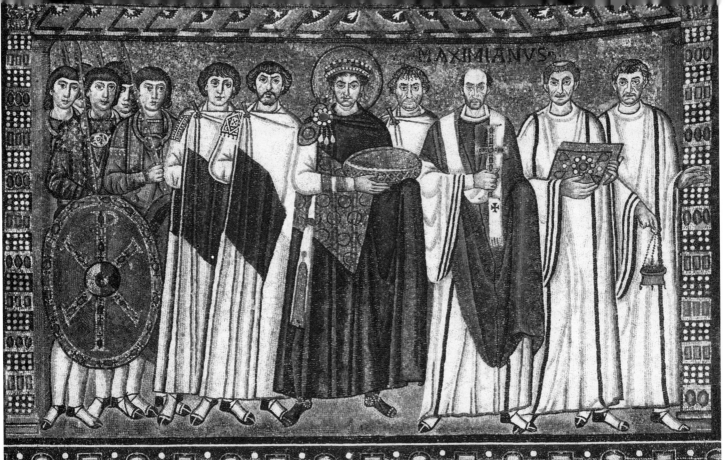

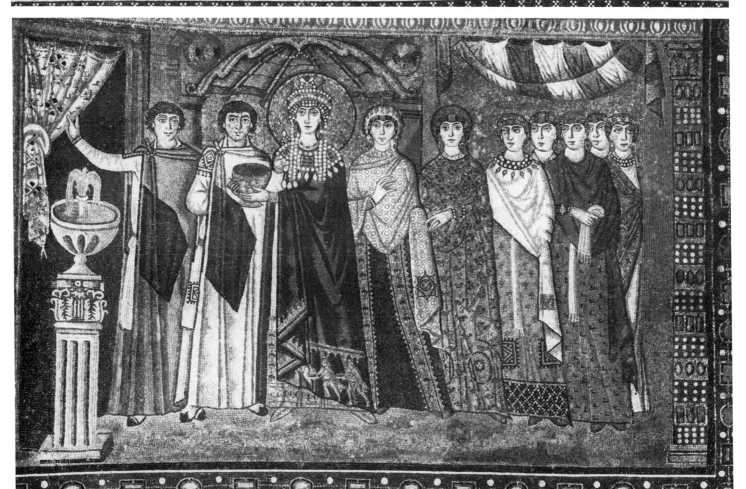

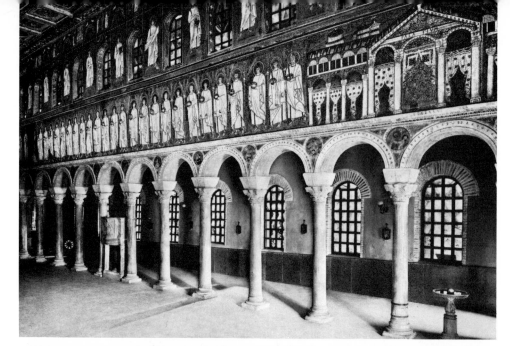

155. Procession of Saints in S. Apollinare Nuovo, Ravenna.

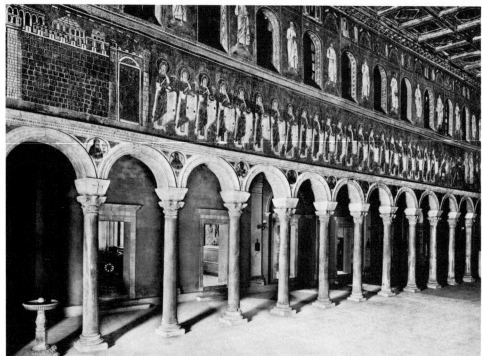

156. Procession of Virgins in S. Apollinare Nuovo.

157. Christ on the way to Golgotha. Clerestory mosaic scene in S. Apollinare Nuovo, Ravenna.

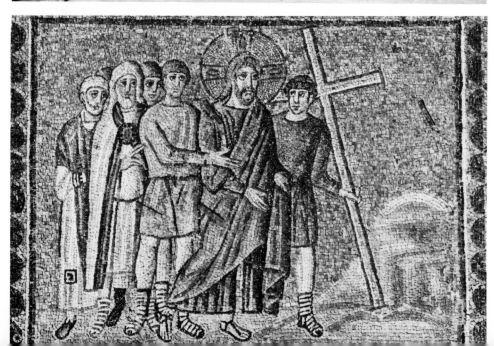

high above the floor of the basilica and shadowed by the roof, these depictions could scarcely have been intended for the instruction of the faithful. Since they were also clearly not decorative, it would seem that their purpose must lie in their representation of the events they portray; in other words, that it was deemed beneficial to the church, and to those who worshipped there, to have events of the life of Christ thus depicted, even if they could not be properly seen. The notion implicit here is one that we have met in some other religions. It doubtless derives from an instinctive disposition to think that a picture has some intrinsic virtue relative to what it portrays or re-presents.[107]

Early Christianity also took over from contemporary Roman architectural styles the rotunda or dome. The most notable pagan example, as we have seen, was the famous Pantheon in Rome.[108] This temple was designed to provide a vast domed space within its structure, such as would befit its dedication to astral deities; its exterior was austere and unadorned by sculpture. The cosmic significance of the dome accorded with the developing Christian conception of its churches as places of contact with Heaven, since within them Christ was sacramentally present, on the altar, at the Eucharist. The supreme Christian example of the use of the dome is the great cathedral church of Hagia Sophia (Holy Wisdom) at Constantinople, which the emperor Justinian ordered to be built in 532.[109] Its celestial effect is primarily conceived by the skilful arrangement of the numerous windows, at varying levels, in the dome, so that an ever-changing pattern of sharply focused sunlight pours into the interior throughout the day. Of the rich and variegated mosaics that once adorned the inside of the dome only the mighty figures of four seraphim survive, recalling Isaiah's vision of Yahweh's presence in the temple, where "above him stood the seraphim" (vi:1ff.).[110] Something of the original glory of the mosaics that once covered the inside of the dome can be gathered from those that adorn the dome of the contemporary (sixth-century) cathedral of San Vitale, Ravenna, and which lead the eye upwards, past the figures of four supporting angels, to the Lamb of God poised against a deep starry sky.[111]

A custom gradually developed in the Byzantine churches of Eastern Christendom which involved a notably different conception of the sanctuary, as a setting for the Eucharist, from that current in the West, which we have next to consider. The Eastern view was signified, from

128

158a, b

159

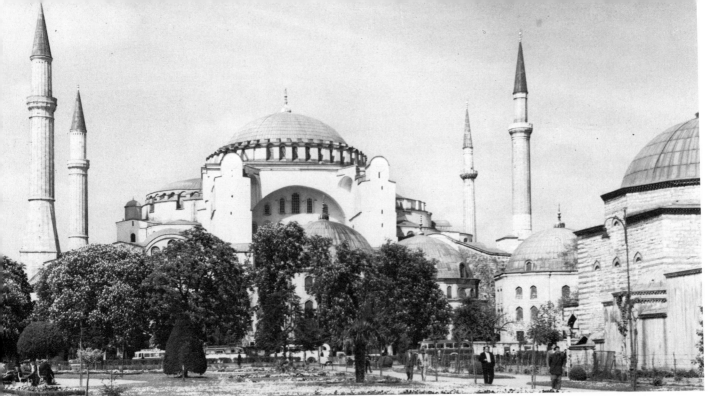

158a. Hagia Sophia, Istanbul.

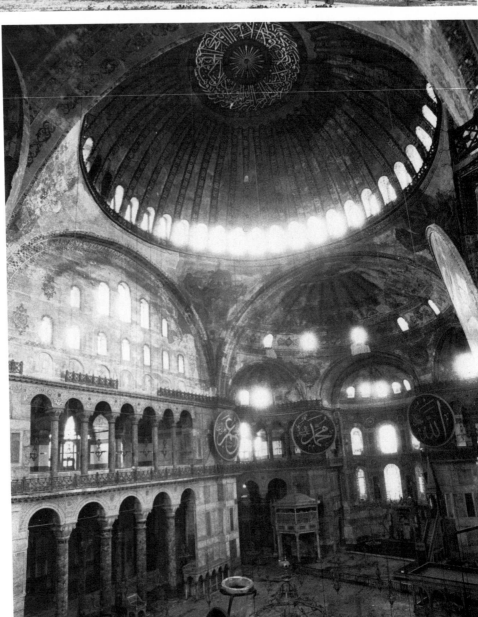

158b. Interior of Hagia Sophia.

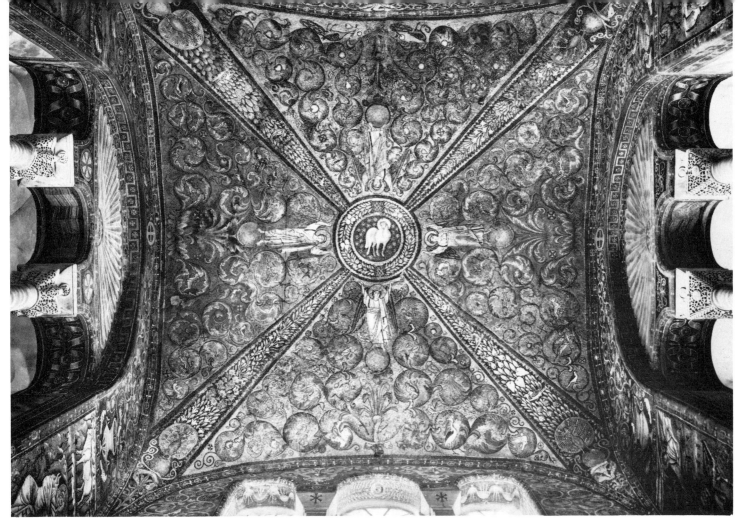

159. Mosaic decoration of the dome of S. Vitale, Ravenna, showing four angels supporting "Lamb of God."

160. The *iconostasis* in a Greek Orthodox church.

160

102

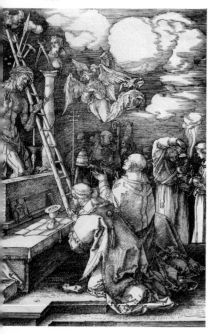

161, 102

162a, b

163

the twelfth century, by the erection within a church of a screen known as the *iconostasis,* which separates the presbyterium or sanctuary, containing the altar, from the main body of the building. The *iconostasis* has three doors which are kept closed during the most sacred parts of the Eucharist, thus excluding the laity from witnessing the consecration and offering of the sacramental Body and Blood of Christ.[112] This conception of a "holy of holies," into which only the priests can enter, is reminiscent of the arrangement of the ancient Hebrew sanctuary, as commanded by Holy Scripture, and which found concrete expression in the great Temple of Yahweh at Jerusalem.[113] The *iconostasis,* which is adorned by sacred icons, is mystically regarded as demarcating the "Heavenly Jerusalem" (the sanctuary) from the "Earthly Jerusalem" (the nave or body of the church).[114]

Very different from this Byzantine view became the conception of the church in Western Christendom. The altar was not set in an inner sanctum, so designed to conceal the mysteries of the Eucharist from the gaze of lay-folk, thus leaving them to participate only from afar and through the mediating ministry of the clergy. Instead, the mediaeval cathedral and parish church were planned to provide an august setting for the high altar, which could usually be seen even from the far, that is, the western, end of the building.[115] Thus the high altar was made the focus of attention for the faithful, at which they could watch, solemnly enacted by a richly vested clergy, the great ritual drama of the Mass, which re-presented Christ's sacrifice for man's salvation. The culminating act of the drama—the Elevation of the sacred Host by the celebrant—was devoutly witnessed by the assembled worshippers, clerical and lay, and its solemnity was proclaimed to them by the ringing of the sacring bell and the rising cloud of incense—seen often through rays of coloured light as the sun shone through the stained-glass windows of the sanctuary.[116]

But the mediaeval cathedral (and, in a lesser key, the parish church) was not designed only to provide a superb setting for the drama of the Mass. It was indeed a sanctuary, a "holy of holies"; but it was also designed as both an idealised epitome of the universe and as the Celestial City or the Heavenly Jerusalem.[117] In mediaeval iconography, God as the Creator is sometimes represented as an architect with measuring calipers, and Heaven was often depicted as the interior

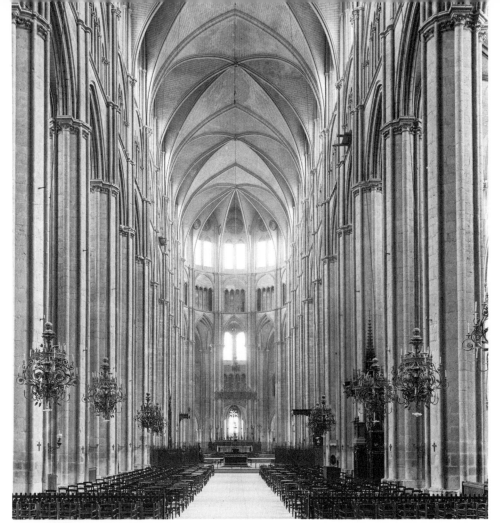

161. Interior of Bourges Cathedral, looking east.

162a. Western façade of Bourges Cathedral, France.

162b. Western façade of Wells Cathedral, England.

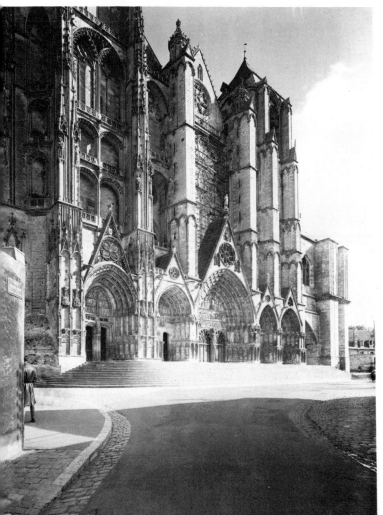

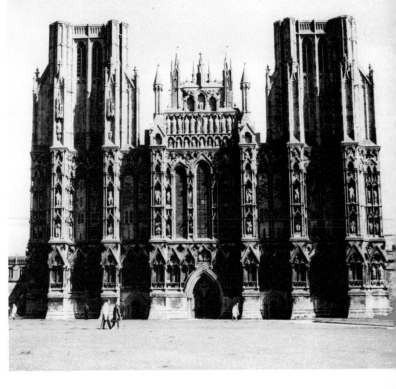

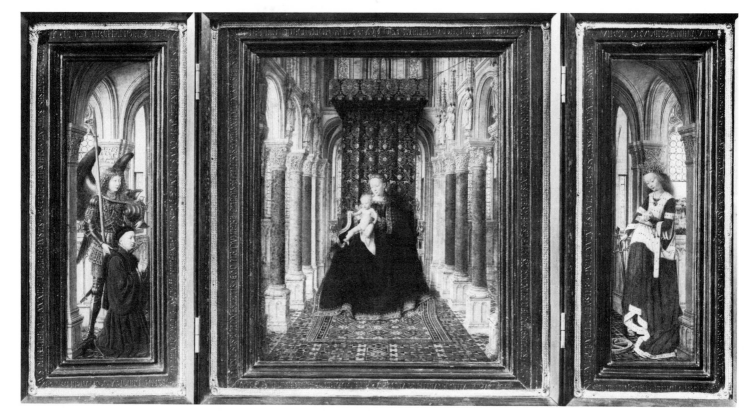

163. Travelling altarpiece of Charles V, by Jan Van Eyck.

164. Spire of Salisbury Cathedral.

165. The Host reserved in a hanging pyx.

of a Gothic cathedral.[118] And so to the building of their great cathedrals and churches the mediaeval Christians devoted the best of their resources and their skills. In these structures they sought to erect a Heaven on earth, to house a God who became sacramentally present on the altar at the celebration of each Holy Mass. Hence the mediaeval architect, inspired by the example of the divine Architect of the universe, endeavoured to erect a building of such harmony of line and beauty of adornment that, both within and without, it would be a veritable *Domus Dei,* a House of God set among, but transcending, the abodes of men.[119]

164

The increasing concentration of popular devotion on the Host or sacramental Body of Christ, to which the institution of the Feast of Corpus Christi by Pope Urban IV in 1264 gave official encouragement, still further enhanced the sanctity of churches;[120] for the consecrated Host was kept reserved in churches, where it was solemnly exposed, on ritual occasions, to the faithful. Consequently, in the popular mind, Christ was deemed to be veritably present in that place, in the church, where the Host reposed in its specially designed pyx or tabernacle, and many curious legends attest to the reality of the belief as well as to the superstitions it encouraged.[121]

165

That the church was not, in Catholic Christianity, just a functional building, as indeed it became in Protestant forms of Christianity, is significantly attested by the rites of its consecration to the service of God. The elaborate ritual of consecration, which was performed by a bishop, was basically a form of initiation and generally followed the pattern of the initiation rites of baptism and confirmation. Thus, the altar and the church were, in turn, purified by ritual ablution and consecrated by anointing with holy oils.[122] Among the ceremonies two are of peculiar interest. Immediately after entering the unconsecrated church, the bishop proceeded to trace on its floor, with his pastoral staff, the letters of the alphabet in two diagonal lines that intersected to form a "St. Andrew's Cross."[123] The meaning of this curious custom is not known. The fact that the Greek alphabet, as well as the Latin, was used recalls the proclamation of Christ in the Johannine Apocalypse: "I am the Alpha and the Omega, the beginning and the end, the first and the last."[124] The inscribing, therefore, of the whole alphabet in the form of a cross, on the floor of an unconsecrated church,

could constitute a cryptogram signifying the cosmic totality of Christ, to whose service the edifice was thus formally devoted. The other ceremony involved the solemn anointing by the bishop of twenty-four crosses, which were either carved or painted on the walls of the church. These consecration crosses were distributed equally throughout the building: three being affixed to the north, south, east and west walls respectively, on the external and internal sides. It would seem that these twenty-four crosses constituted, as it were, seals testifying to the building's solemn consecration. The bishop's words of consecration sanction this view: "May this temple be sanctified by this unction and our benediction, in the name of the Father, and of the Son, and of the Holy Spirit."[125]

166

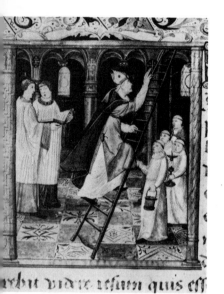

166. Bishop anointing consecration crosses.

The ceremony of consecration was completed by the solemn deposition of holy relics, generally of the saint or saints to whose memory the church was dedicated.[126] After the bishop had enclosed the relics in the altar, the first Mass was celebrated in the new church. The church was thus invested with a charismatic character, and ecclesiastical law strictly forbad its secular use. It was, significantly, deemed to have lost something of this character if a heinous crime, such as murder or suicide, occurred within it, and its reconsecration was carefully prescribed.[127]

And so, from being a room set aside in a house for the celebration of the Eucharist, the church developed in Catholic Christianity into a sanctuary, made numinous both by the drama of the Mass and the abiding presence of Christ in the reserved Host. It epitomised, in its design and ornament, the altar-throne of the Lamb of God within the Heavenly Jerusalem, which the prophet John had described in the awesome imagery of his *Apocalypse*.[128] And therein it was that the faithful could witness, day after day, the ritual re-presentation of the drama of their salvation, and join in the offering of Christ's sacrifice to God the Father for the forgiveness of their sins.[129]

91

VII. THE TOMB AND ITS SIGNIFICANCE

The disposal of the dead, from the dawn of human culture in the Upper Palaeolithic era, has rarely been only a utilitarian action,

prompted by sanitary considerations. For seldom have the dead been regarded as really and truly defunct. From the earliest times, and in all parts of the world, burial customs have witnessed to a belief that the dead continue, in some form, to exist and to be connected with their bodies. Consequently, the places in which their bodies have been deposited have generally been adapted, in varying ways, as places of repose or dwelling places. Thus, at the beginning of the archaeological record, Palaeolithic graves reveal that the dead were carefully laid in a contracted position, with food, ornaments, tools and weapons set by them for their supposed use.[1]

9

This Palaeolithic funerary practice marks the beginning of a care for the dead which, in the course of ages, has produced such immense structures as the Egyptian pyramids and the Taj Mahal, as well as the conventional modern grave and its memorial stone. In this vast effort of tomb construction are embodied the many and varying conceptions of the state of the dead that have been held by mankind during its long quest for the significance of human destiny. Though rarely described or explained in the literature of the religions concerned, this mortuary architecture and its related iconography constitute evidence of primary importance, which should not be neglected in any historical or comparative study. The history of the tomb, when considered as a document of man's reflection on his fate, presents an immense field for research. A brief attempt only can be made here to outline something of its potentiality and significance, in the context of art and ritual, as a primary source of religious faith and practice.

A. The Tomb as the Abode of the Dead

The idea of the grave or tomb as the dwelling place of the dead is a primitive concept that was obviously prompted by the fact of the deposit of the corpse within it. Sometimes this idea was held together with another that logically contradicted it. For often the dead were imagined as departing to another world, where they dwell in the vast company of all who have died, ruled by some divine lord or mistress of the dead; in intelligible context with this belief, the grave has sometimes been conceived as a kind of ante-room or portal to a subterranean realm of the dead.[2] But the grave or tomb could also be treated as the

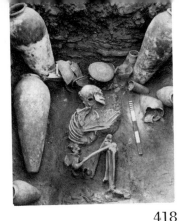

418

abode of the dead when it was believed that the dead ascended to a celestial dwelling place. This ambiguity of conception can be seen most notably in the ancient Egyptian tomb.

Starting from a primitive custom of inhumation, with a simple provision of grave goods for the physical needs of the dead, the Egyptian tomb was gradually developed as a secure dwelling place, built of stone or excavated from rock, which was significantly designated the "beautiful house of eternity."[3] In it the dead owner hoped to dwell for ever, and it was arranged and furnished to this end. Primarily, it was planned to guarantee the maximum possible security to the embalmed corpse which, enclosed in wooden coffins and a stone sarcophagus, was placed in a special sepulchral chamber, concealed and most difficult of access.

167

Other chambers were stored, according to the resources of the owner, with all the material needs of life such as he had used during his lifetime in this world.[4] So complete and realistic was this equipment that sometimes even lavatories were built in tombs.[5] On the walls

214-16, 406a, b

of the Old Kingdom tombs scenes of domestic life were painted, including both hunting and feasting, which were doubtless intended, by their magical efficacy, to reproduce within the tomb the life which the dead had known and desired to perpetuate.[6] Images of the deceased

22, 23

preserved his likeness, acting as substitute bodies should the embalmed body be destroyed.[7] At the entrance to the tomb complex was

168

the so-called "false door" or *Scheintür*, which served to enable the deceased to come out from his tomb, in order to receive the food offerings made by his relatives or the priests commissioned for the purpose.[8]

The significance of the ideas which the Egyptian tomb embodied and served will be the subject of our later study. Here it must be noted that, together with this amazing concentration on equipping the tomb for the eternal residence of the dead, there went an elaborate mortuary

219, 371, 374,
375, 419

ritual that was performed to enable the deceased either to join the sun-god Rē in his perpetual circuit of the sky or to journey to the *duat* or underworld, over which Osiris ruled.[9] So obvious a conflict of eschatological topography resulted from the fusion of three distinctive mortuary traditions. The most primitive was doubtless that which envisaged the grave as the dwelling place of the dead.[10] The Osirian hereafter was probably more ancient than the solar conception, which

374

167. Mortuary equipment stored in the tomb of Tut-Ankh-Amun.

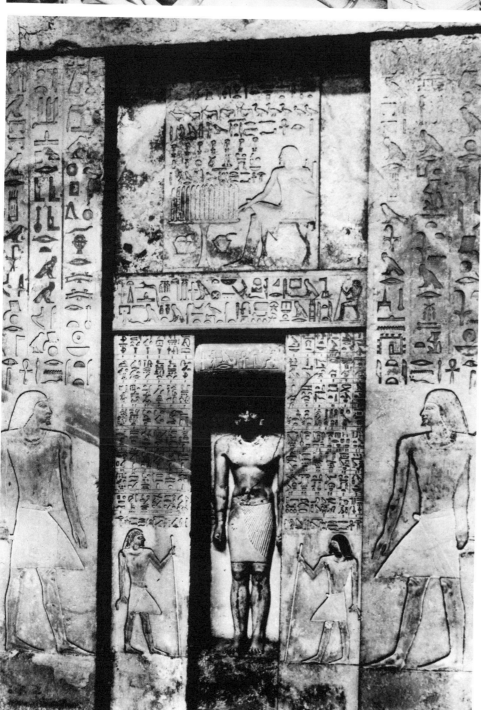

406b

168. "False door" of the Egyptian tomb of Ateti.

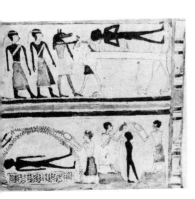

11

169, 11, 14

170

171

seems to have been propagated by the priesthood of Heliopolis, the cult centre of Atum-Rē, the sun-god.[11] Although in process of time the Osirian and the solar eschatologies were synthesised, the tomb still continued to be regarded as the abode of the dead. The persistence of this belief, despite the increasing dominance of the Osirian mortuary cultus, significantly attests to the strength of the primitive instinct to identify the deceased with their corpses. The continuance of the practice of mummification until the suppression of the native religion of Egypt, in the fourth century A.D., reveals how essential the preservation of the body was deemed to be for an effective *post-mortem* existence.[12]

Because of the immense preoccupation of the ancient Egyptians with the task of securing a happy lot after death, the Egyptian tomb provides the most notable evidence of the tomb as the dwelling place of the dead. Similar beliefs, though not so carefully catered for, have left archaeological evidence of their currency in many other widely scattered places. The early "royal tombs" of the ancient Sumerian city of Ur, when found by Sir Leonard Woolley, afforded much gruesome evidence of a belief, once current there, that royal personages could expect to enjoy the services of their attendants and retainers after death. The tomb of "Queen Shub-ad," in particular, revealed the variety of service that was expected: the skeletons of twelve female servants included a harpist; five armed soldiers had been sacrificed to act as guards; and a chariot, drawn by two asses, was deposited to provide transport.[13] Whether this sumptuous equipment was buried for use in the grave itself, or in a realm of the dead, cannot be decided from the material deposited; but since the actual things, including the chariot and asses, had been placed there, it would seem that an existence in the tomb or some subterranean world, to which it gave access, was envisaged—it must, however, be noted that no attempt was apparently made to preserve the bodies as was the practice in Egypt.[14] Of like import is the evidence unearthed of Shang Dynasty (twelfth or eleventh century B.C.) and Chou Dynasty (eighth to seventh century B.C.) tombs in China. Here, also, servants and chariots, with horses and drivers, were buried for the *post-mortem* service of their lords.[15]

Such mortuary arrangements suggest that the dead could be endowed once and for all with what they needed for their *post-mortem*

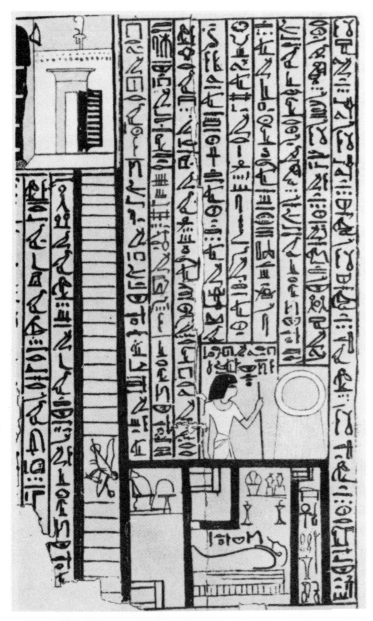

169. The *ba* of Ani, shown as a bird, revisiting Ani's body, which lies in the sepulchral chamber.

170. Ground plan of the royal tombs at Ur.

171. Burial of chariot horses and a charioteer at Ta Ssŭ K'ung near Anyang, China.

existence, and then be left to fend for themselves. This conclusion would be consistent with a belief that the grave itself was not the actual dwelling place of the dead, but perhaps a place of temporary sojourn en route to the underworld, to which the deceased would pass with his funerary equipment and retinue. By way of comparison, striking evidence of belief that the dead were actually living in their tombs has been found at various ancient Phoenician, Cretan and Cypriot sites. It takes the form of clay pipes or conduits, leading down into the tomb from outside, through which liquids were poured for the refreshment of the dead below—the provision graphically illustrating a widespread belief, in the ancient world, that the dead suffered greatly from thirst.[16]

The custom of making offerings of food at the grave, which has been widespread throughout the world, also attests to an instinctive tendency to regard the grave as the abode of the dead, who are believed to remain in some way sentient within it.[17] The custom could prevail even when death was regarded as the irreparable shattering of the psycho-physical organism that constituted a proper human being. Thus, mortuary offerings were made at the tombs of the dead in ancient Mesopotamia, Israel and Greece, although it was believed that what survived of the living person after death was only a shadowy wraith that descended into a dark underworld—indeed, the curious episode appended to the famous *Epic of Gilgamesh,* which is concerned to show the hopelessness of man's quest for immortality, appears to be designed to emphasise to relatives the need of making the regular offerings of food to their dead.[18]

In Islam a most remarkable belief has existed in connection with the idea of the tomb as the abode of the dead. After the funeral party has retired and the dead man is left alone, it is believed that the "Chastisement in the Tomb" is then enacted. Two angels, Munkar and Nakir, enter the tomb and question the deceased about his faith. If he answers rightly, the angels open a door on the right side of the tomb, which gives access to Paradise. But should his answers reveal his impiety, he is terribly tormented in the tomb until the end of the world and the Final Judgment. In consequence of this belief, the tomb is vaulted and given sufficient height to enable the deceased to sit up and answer his grim inquisitors.[19]

172, 173

174

175. Muslim tomb, arranged for visit of Munkar and Nakir.

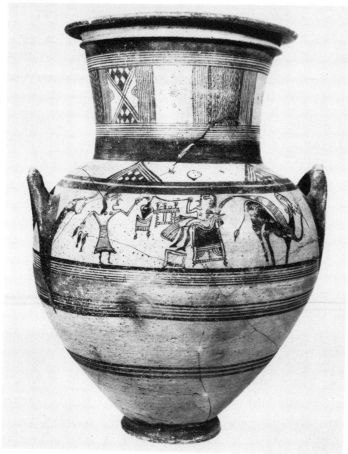

172. Pottery conduit for drink offerings for the dead, found at a Ras Shamra grave.

173. Scene on Cypriot vase of the dead receiving drink offering.

174. Egyptian "Letter to the Dead," inscribed on a bowl that might have contained offerings to the dead.

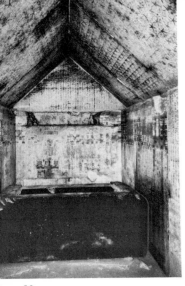

13

B. The Tomb as a Shrine

1. IN EGYPT:

The tomb, as the dwelling place of the dead, became also a shrine when the deceased, enclosed within it, was a charismatic figure to his people or coreligionists. If a tomb acquired such distinction, it was usually adapted specially to its cultic use. The most notable examples of the tomb-shrine are the long-famed pyramids of the Old Kingdom pharaohs of Egypt. Their pyramidal form was developed from the so-called *mastaba* tomb, which probably represented the royal residence.[20] The pyramids, whether in the intermediate form of the Step Pyramid of Djoser (*c.* 2680 B.C.), or fully evolved as the famous Great Pyramid of Khufu (Cheops: *c.* 2575 B.C.), were always essentially tombs. Their internal arrangement, within the constituent mass of masonry, was designed to facilitate the bringing in of the heavy stone sarcophagus enclosing the body of the king, and its deposit in the sepulchral chamber.[21] The pyramidal shape did not result from a fortuitous evolution, but was carefully planned. Its adoption was doubtless related to the contemporary dominance of the cult of the sun-god Atum-Rē, centred at the nearby city of Heliopolis—the influence of this cult is very evident in the *Pyramid Texts*, which are inscribed within the pyramids of certain kings of the Fifth and Sixth Dynasties.[22] The pyramidal shape has been variously explained, in terms of this solar theology, either as representing, in stone, the rays of the sun descending upon the earth,[23] or as constituting a ladder by which the pharaoh ascended to join the sun-god in the sky.[24] That some such solar symbolism was intended is further supported by the finding of boat-pits and the remains of a cedar boat in close proximity to the Great Pyramid; for these relics doubtless witness to the belief, abundantly attested in text and picture, that Rē, the sun-god, traversed the heavens each day in a magical boat, in which the deceased king hoped to find a place.[25]

Since the pyramid, as a structure, was wholly devoted to ensuring the security of the king's body and probably facilitating his union with the sun-god, a separate mortuary temple was built for the mortuary service and cult of the deceased monarch, who was regarded as a god.

176

177

178, 13

179, 219

For though he had ascended to join his divine father Rē in the sky, his body reposed in his pyramid—indeed, the idea finds expression in popular song: "The gods, who lived formerly, rest in their pyramids."[26] Hence, around the pyramid there was set a complex of buildings concerned with the royal ritual, such as survive in ruin about the Step Pyramid of Djoser.[27] After the Middle Kingdom period (*c.* 1580 B.C.), the Egyptian kings ceased to be buried in pyramids which were intended to command public attention.[28] For greater security against plunderers, their bodies were buried during the New Kingdom in deep rock-hewn tombs in the remote "Valley of the Kings" that runs among the rugged hills west of Thebes, in Upper Egypt.[29] Since the concealment of the actual tomb was now of primary concern, the mortuary temple for the cult of the dead pharaoh was no longer built in the tomb's vicinity but at some distance from it, on the flat land bordering the western bank of the Nile. These mortuary temples, however, which the pharaohs described as their "houses of millions of years," were actually dedicated to the great Theban god Amun.[30] The image of the king who built the temple was placed within it, so that it might share, and he through it, in the offerings made to the god. The change is significant. Learning doubtless from the ruin of the pyramid-shrines of their ancient predecessors, the New Kingdom rulers sought to ensure their own eternal futures by concealing their tombs and associating their mortuary service with that of the state-god Amun.[31]

180

181

182a, b

Egypt provides two other notable examples of the tomb-shrine. At Abydos, in Upper Egypt, the tomb of Osiris, the dying-rising god of the mortuary cultus, was the holy place *par excellence,* to which pilgrimage was made and where an elaborate ritual drama was annually performed.[32] That a god should have a grave is certainly strange; but the idea occurred also in ancient Crete where the tomb of Zeus was shown, and it must be remembered that the tomb of Christ also became a shrine of great cultic significance for Christians.[33] The development of the cult of the tomb-shrine of Osiris significantly illustrates man's desire to locate sacred events in the careers of his gods at specific places, which he can identify and venerate by concrete monuments commemorative of those signal happenings. It is uncertain how Osiris came originally to be connected with Abydos. The connection

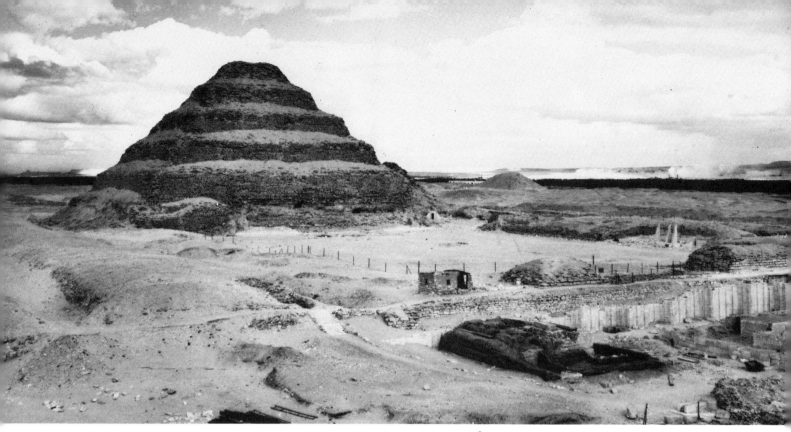

176. Step Pyramid of Djoser.

177. Internal arrangement of the Great Pyramid.

178. Atum-Rē in solar boat.

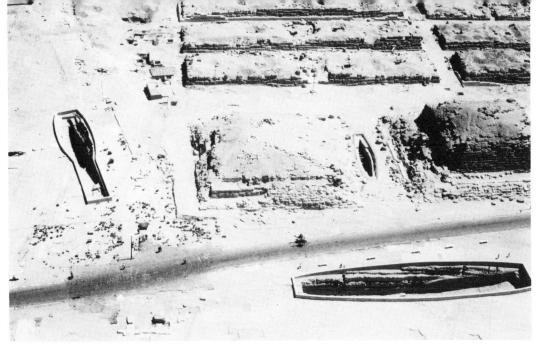

179. View from top of the Great Pyramid showing boat pits.

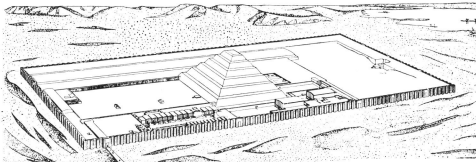

180. Reconstruction or plan of mortuary buildings around the Step Pyramid.

181. Royal tombs in the Valley of the Kings.

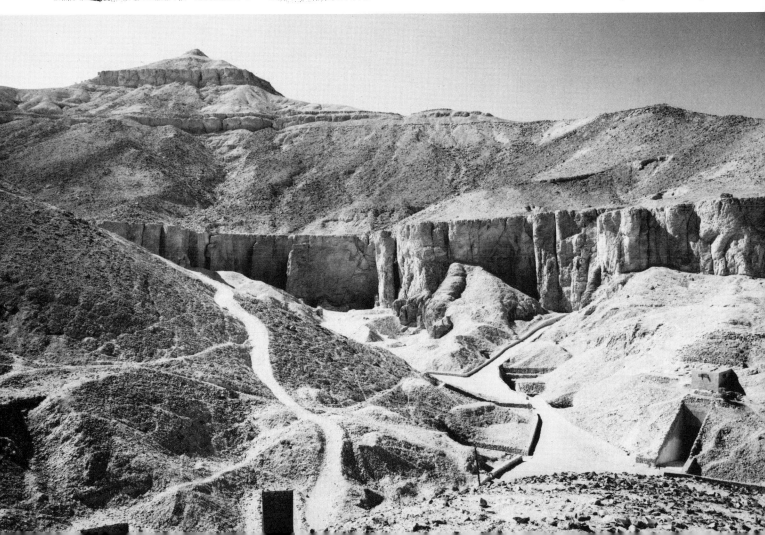

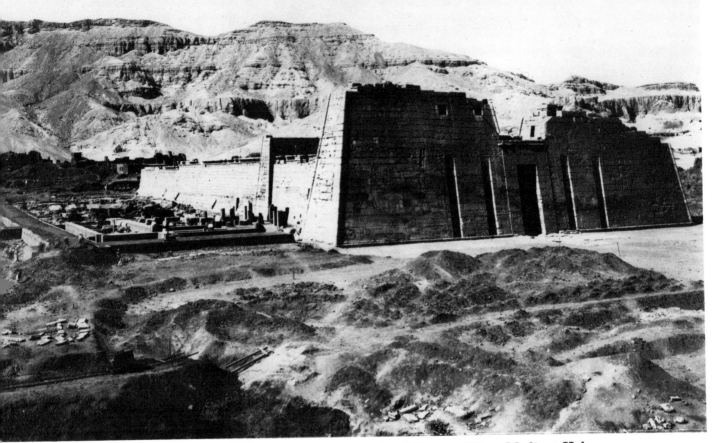

182a. Mortuary temple of Ramses III at Medinet Habu.

182b. Inner sanctuary of temple of Ramses.

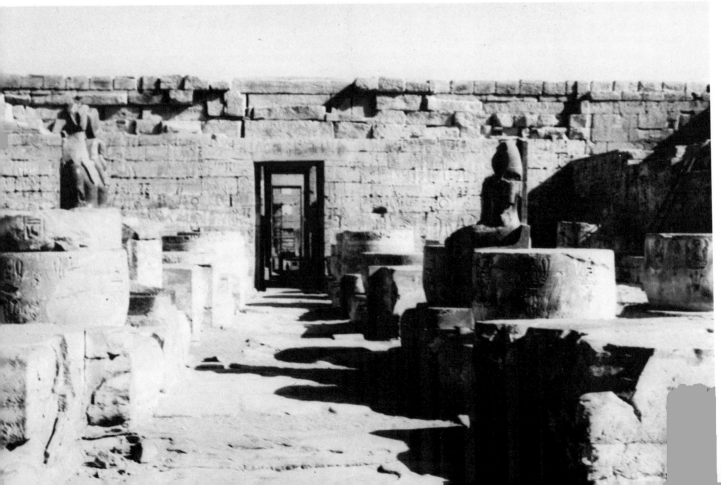

probably stemmed from the fact that the most ancient kings had been buried there, under the patronage of Chonti-Amentiu, "he who heads the Westerners [i.e., the dead]," a primitive jackal-god of the necropolis of Abydos. Osiris was identified with this god, and absorbed or superseded him at Abydos.[34] A curious symbol, resembling a beehive on a pole, surmounted by two feathers, which represented Osiris there, has been interpreted as a reliquary in which the head of Osiris was preserved; for one version of his legend told how his body had been dismembered and scattered throughout the land of Egypt.[35] The location of the grave of Osiris in the nearby necropolis of Umm el Gaab is first definitely mentioned by an official named Ikhernofret, who was sent by the pharaoh Senu-sret III (1887–1850 B.C.) to represent him in the mysteries of Osiris, which were celebrated at Abydos.[36] In the course of the elaborate ritual drama, which was then enacted, it would appear that an image of Osiris was interred in a grave, and later resurrected and reinstated in the temple there.[37]

183

Abydos, by this period, had become a centre of pilgrimage, and people sought to be buried there or erect memorials of themselves, doubtless in order to benefit from close proximity to the grave of Osiris. Kings also built cenotaphs for themselves there, though preferring to be buried in the royal necropolis of Thebes.[38] The most notable and best preserved of these cenotaphs is that of Seti I (1304–1290 B.C.). The monument adjoins the elaborate mortuary temple which he caused to be built there; it is often mistakenly but understandably called the Osireion. Its plan is both unique and significant. It was designed to symbolise the "primaeval hill," surrounded by the waters of Nun—water was conducted about it by canals.[39] Upon the "primaeval hill" a substitute sarcophagus of the pharaoh, who was assimilated to Osiris in death, was doubtless placed. There is much reason for thinking that this "Osireion" of King Seti reproduced the form of the tomb of Osiris at Abydos;[40] for about the end of the Eighteenth Dynasty (1580–1320 B.C.), it would appear that the tomb of the First Dynasty king Zer, in the neighbouring necropolis at Umm el Gaab, had been identified as the tomb of Osiris. The large granite sculpture representing Osiris lying on a bier (now in the Egyptian Museum at Cairo) which was found in the tomb of Zer probably formed part of the real Osireion, as it was arranged in the Twenty-Sixth Dynasty (663–525 B.C.).[41]

184

185

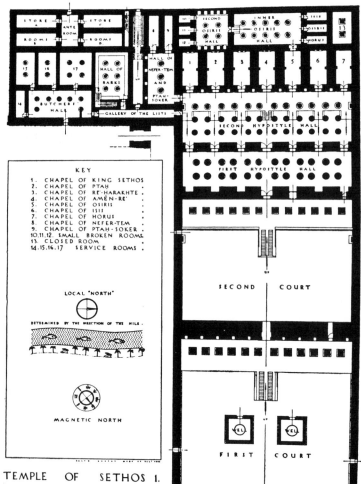

183. Relief from Osiris chapel in temple of Seti I at Abydos, showing reliquary shrine of Osiris.

184. Plan of the Osireion at Abydos.

185. Recumbent figure from Abydos of Osiris, lying on couch, with Isis in form of sparrow hawk.

The other notable example of the shrine-tomb, with an attendant cult, in ancient Egypt is connected with the curious transformation of Imhotep, the architect of the Step Pyramid, into a god of healing. As the grand vizier of King Djoser (*c*. 2680 B.C.), as well as the designer of his pyramid, which represented a most remarkable advance in Egyptian technology, Imhotep acquired the reputation of the sage *par excellence*.[42] By the Persian period (*c*. 525 B.C.), he was being regarded as the son of Ptah, the great creator-god of Memphis; and during the Ptolemaic period he was identified by Graeco-Egyptians with Asklepios, the Greek god of healing.[43] At least three temples were dedicated to him as the divine healer: that at Memphis became a most famous centre for healing, and was known to Greeks as the Asklepieion. Many votive inscriptions commemorate the cures which were ascribed to the benign influence of the divine sage. It would appear that the cult of Imhotep was originally connected with his tomb, which was located in the desert somewhere in the vicinity of the Step Pyramid, and that it continued to be the chief focus of his cult.[45] The tomb has not yet been discovered; but evidence has been collecting from the recent excavations of Professor W. B. Emery at Saqqara which indicates that it was associated with the great cultic complex that existed in the area of the Serapeum in Graeco-Roman times.[46] The Serapeum at Memphis may also be ranked as a tomb-shrine; for it housed the cult of the dead Apis-bull, which was identified with Osiris under the name of Oserapis.[47] In the catacombs beneath the Serapeum the embalmed bodies of former Apis-bulls were buried in great sarcophagi.[48] From the cult of Oserapis there was derived, during the Ptolemaic period, the curious concept of the god Sarapis, who also became associated with Imhotep-Asklepios as a god of healing.[49]

2. IN MAYA CULTURE:

The transformation of the tomb into a shrine, which found such remarkable forms of expression in ancient Egypt, is a process that has operated in many other lands. An interesting parallel to the Egyptian pyramid-shrine has been discovered at the ancient Maya site of Palenque, in Mexico. The so-called Temple of Inscriptions there, which surmounts a 65-foot stepped pyramid dating from the seventh to eighth centuries A.D., was found to have at its base a large tomb-chamber, in

186. Statuette of Imhotep, seated with a scroll opened on his knees.

187

which a great carved stone slab covered a monolithic sarcophagus. The funerary equipment of the person buried there indicated one of high social or religious status. Near the sepulchral chamber were discovered the remains of six young adults, who had probably been sacrificed to accompany the great one to the next world.[50] This mortuary arrangement suggests that the pyramid-temple served the cult of an erstwhile ruler of the Maya settlement at Palenque.[51]

3. IN GREEK CULTURE:

The cultic significance of the tomb is to be seen also in ancient Greece, where it found expression in the hero cult. This cult, which seems to have rivalled the cult of the Olympian gods and contradicted its eschatology, was based on the belief that the hero dwelt in his tomb.[52] The identity of these "heroes" constitutes a problem about which there has been much debate among classical scholars. The ancient Greeks were wont to refer to the heroes as "reverend *chthonioi* who dwell in the tombs."[53] The term *chthonioi* meant "subterranean ones," being derived from *chthōn* ("earth"). Consequently, the term could denote supernatural beings, probably connected with fertility, who were imagined to dwell beneath the ground, instead of heroic figures such as ancient kings or warriors, whose memory might understandably be reverenced. Dr. L. R. Farnell, who specialised in the study of the Greek hero cult, commented thus upon the problem involved:

> . . . unfortunately there was always great resemblance between the ritual at a buried hero's tomb and that at the underground shrine of the earth-deity or daimon; therefore in certain cases it might be hard to determine whether the personage belonged to one class or the other class; and in the shifting popular tradition the one could easily be transformed into the other.[54]

The ritual employed at a hero's tomb was indeed significant, and it recalls the arrangements made in ancient Phoenician and Cretan tombs which were mentioned above.[55] The altar used for the offerings made to a hero was called an *eschara* ("hearth"), while the sacrifices were performed over a pit or trench (*bothos*), so that the blood might descend to the hero, resident in his grave beneath the ground.[56]

The hero was regarded as existing in his tomb in the form of a

188

large serpent, or as manifesting himself in this form. This strange
belief, which finds graphic expression in tomb sculpture and vase
paintings, possibly originated from the phenomenon of snakes emerg-
ing from or disappearing into holes in rocks.[57] The belief was, how-
ever, explained in a more macabre manner: when the marrow in the
spine of a corpse dried, it became a snake.[58] This strange notion would
seem to indicate that the heroes, whatever their true origin, were
thought of as having originally lived on earth in human bodies, though
after death appearing in serpent form. Belief in their essential human-
ity is also confirmed by cults of their relics. Thus the Athenians were
advised, after the Persian Wars, to bring back the bones of their hero
Theseus from the island of Skyros; and Spartans were similarly coun-
selled to get possession of the bones of Orestes.[59] The cult shrine had
the form of a tomb. The reputed grave itself was a mound of earth,
set within a *temenos* or sacred enclosure. Over the mound was raised
the *hērōon* or cult chapel, and the precinct was planted with trees. The
presence of the hero, in his tomb, was believed both to bless and pro-
tect the land, and many stories were told of the supernatural aid
given by ancient heroes in times of great danger.[60]

The hero tomb was often the centre of a healing cult, the cures
being ascribed to the hero and commemorated by the hanging there of
votive models of the limbs affected.[61] Some tombs were regarded as the
seat of an oracle, the belief probably stemming from a widespread idea
that the dead were possessed of supernatural knowledge and so were
aware of what the future held. Pausanias has left a detailed account of
the ritual procedure, which had carefully to be followed, in consulting
the oracle of Trophonios at Lebadeia. The inquirer, after a period of
preparation, had to descend at night into the cave tomb of Trophonios,
in which the hero's image stood.[62] The rites prescribed for consulting
an oracle must often have rendered the undertaking a truly alarming
experience, both physically and mentally. The hero cult thus signif-
icantly attests to what was the reality of ancient Greek faith and
practice.[63]

4. IN ISRAEL:

In Israel, also, there is much evidence that, despite the official
Yahwist policy, it was popularly believed that certain heroic figures

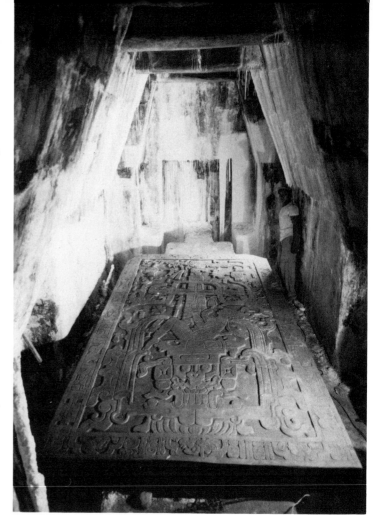

187. Drawing from a funerary stele of late Ptolemaic period, in the British Museum, showing Imhotep as son of Ptah, with Osiris and Sarapis and other gods of Memphis.

188. Funerary Crypt in the Temple of Inscriptions, Palenque, Mexico.

189. Hero represented as snake within grave mound. Drawing from a black-figured lekythos in the Naples Museum.

190. Drawing from a Greek vase, of Boeotian origin, in the National Museum, Athens, showing a hero feeding the snake and votive offerings at his tomb.

of the past dwelt in their tombs, conscious of contemporary happenings and often endowed with supernatural power.[64] Thus, the author of the Matthean Gospel at the end of his account of the murder of the Innocents in Bethlehem and its environs, on the orders of Herod, sees in the event the fulfillment of a prophecy of Jeremiah: "A voice was heard in Ramah, wailing and loud lamentation, Rachel weeping for her children" (ii:17–18; *Jeremiah* xxxi:15). The significance of both Jeremiah's original utterance and Matthew's citing of it is that the tomb of Rachel was located near Bethlehem, and the revered ancestress is thought of as being conscious of the sufferings of her descendants.[65] A similar piece of contemporary Jewish folk belief is also preserved by Matthew when, describing the effects of the earthquake that marked the death of Jesus, he asserts that "the tombs also were opened, and many bodies of the saints who had fallen asleep were raised, and coming out of the tombs after his resurrection they went into the holy city and appeared to many" (xxvii:52–3).[66] Of belief in the magical power of the bodies of holy men after death the *Second Book of Kings*, xiii:20–1, provides remarkable proof. A dead man, being hastily buried in the tomb of the prophet Elisha, is reported to have been immediately revivified when his corpse touched the holy remains.[67] The curious episode of the sacrifice of Jephthah's virgin daughter, recorded in *Judges* xi:34–40, doubtless alludes to an annual pilgrimage made by Israelite women to her tomb (xi:39–40).[68] Significant also as evidence of a first-century tomb cult is the reproof attributed to Jesus in *Matthew* xxiii:29: "Woe to you, scribes and Pharisees, hypocrites! For you build the tombs of the prophets and adorn the monuments of the righteous. . . ."[69] The witness of these biblical passages is confirmed by much rabbinic evidence.[70]

Tombs of famous biblical figures were preserved and venerated in various parts of Palestine.[71] Josephus describes the fine workmanship and excellent marble of which the tombs of Abraham and his sons were constructed at Hebron, and how, close to the town, a huge terebinth tree was shown (*deiknutai*), which was reputed to be as old as the Creation and was identified with the oaks (or terebinths) of Mamre, where Abraham built an altar to Yahweh (*Genesis* xiii:18).[72] How these tomb-shrines were arranged may possibly be inferred from two tombs of the Hellenistic period, built on the lower slopes of the

191

Mount of Olives, on the eastern side of Jerusalem. They are generally identified as four separate tombs, which are traditionally known as the tombs of James and Zechariah and Absalom and Jehoshaphat.[73] But it would appear that they constitute two sepulchral complexes; for the tombs of James and Zechariah intercommunicate, as do those of Absalom and Jehoshaphat.[74] A clue to the relationship of each pair is given in the Hebrew inscription above the porch of the Tomb of James, which states that it is "the tomb (*kbr*) and *nephesh*" of the persons whose names are then listed. The word *nephesh*, which generally means "life" or "soul" must here denote a sepulchral monument as distinct from the actual tomb.[75] The so-called Tomb of James is clearly a burial place, since it comprises a series of rock-hewn chambers, containing apertures (*kokkim* and *arcosolia*) for the bodies. The adjacent "Tomb of Zechariah" would therefore be the *nephesh*, which is intelligible since it is a monolithic cube, surmounted by a pyramid, without entrance to its interior. The Tomb of Absalom would similarly seem to be the *nephesh* to the Tomb of Jehoshaphat.[76]

The purpose of the *nephesh* is not known; but it is possible that some indication of it is to be found in the account given by Josephus of the plundering of the tomb of King David by Herod the Great. What Josephus tells of this notable tomb, to which reference is also made in the *Acts of the Apostles*, is particularly significant in the present context. The tomb was apparently a multi-chambered edifice, with the sepulchral chamber carefully concealed. The other chambers housed a rich funerary equipment, which was obviously intended for the mortuary use of the dead monarchs.[77] According to Josephus, Herod's attempt to find the bodies of David and Solomon was thwarted by a supernatural flame (*phlogos*), which killed two of his bodyguard. To atone for his sacrilege, Josephus alleges that Herod built at the entrance of the tomb a "propitiatory memorial" (*hilastērion mnēma*), of white marble.[78] Josephus acknowledges that Nicolaus of Damascus, a historian at the court of Herod, had recorded the erection of this memorial, without telling of Herod's violation of the tomb.[79] Whatever the truth of Josephus' tale about the marvellous flame, the fact that Herod did erect a *hilastērion mnēma* before the tomb of David may thus be accepted as certain. Such a monument, of which all trace has been lost, would correspond very well to the sepulchral *nephesh* as

192, 193a, b

191. The Tomb of Rachel, near Bethlehem.

192. Tombs of James and Zechariah in the Kedron Valley.

193a. The Tomb of Absalom in the Kedron Valley, Jerusalem.

193b. Plan of the Tombs of Absalom and Jehoshaphat.

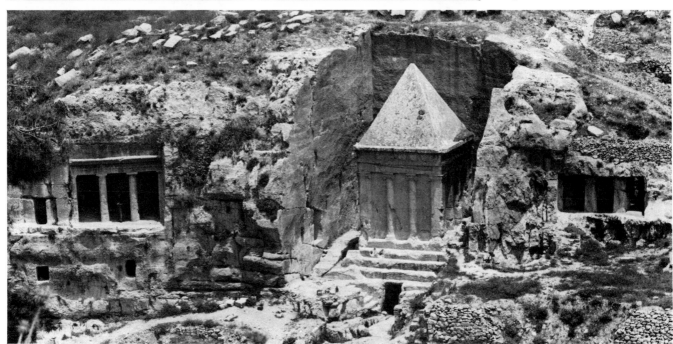

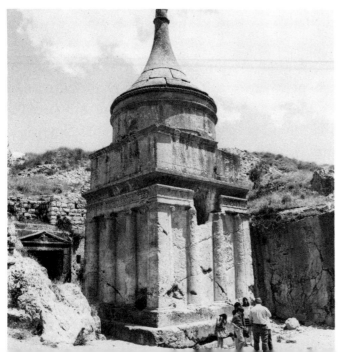

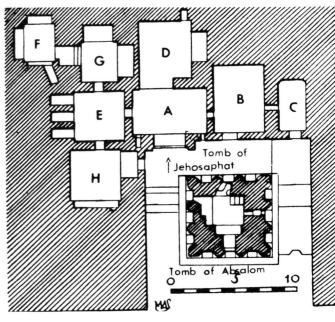

exemplified in the so-called tombs of Zechariah and Absalom on the Mount of Olives. The qualifying adjective *hilastērion* suggests a shrine that not only perpetuated the memory of the dead kings, but also propitiated them by the offerings made at it. Herod's action might well represent a new phase in a traditional cultus of the dead, for which the building and adornment of the tombs of saints and prophets, recorded in *Matthew* xxiii:29, provides other witness.[80] It is perhaps also to this cultus that Rabbi Hanina (*c.* A.D. 250) alludes in his recorded saying: "Wherefore does one go to the burial place? In order to beseech the dead to be compassionate towards us."[81]

5. IN ISLAM:

The tomb-shrine plays an important role in Islam. The holiest of such shrines is naturally that of Muhammad in Medina. A visit to it, though not a prescribed part of the Meccan pilgrimage, is regarded as obligatory by the faithful Muslim; for Muhammad is recorded by a tradition (*hadīth*) to have said: "Whoso performs the Pilgrimage and fails to visit me [i.e., in his tomb at Medina], deals undutifully by me."[82] The prophet's tomb is in the Masjid-al Nebi (the "Prophet's Mosque"), which is reputed to have originated from Muhammad's home in Medina. The tomb-chamber, surmounted by a green dome, is called the Hujrah, and is supposed to have been originally the apartment of 'A'ishah, the Prophet's favourite wife. The chamber contains the tombs of Muhammad, and his two successors Abū Bakr and 'Umar. A place is left vacant beside them for the tomb of Isā ben Maryam, that is, Jesus, Son of Mary, who is reckoned the greatest prophet next after Muhammad.[83] According to another *hadīth*, Muhammad had declared that those who visit his tomb merit his intercession with Allah.[84]

For the great mass of Muslims throughout the world, a visit to Medina is, inevitably, a privilege rare though highly prized. But in most lands they can obtain, so they believe, spiritual and material blessings by visiting the tombs of holy men. These tombs, known as *walīs*, abound in Muslim countries.[85] They have a distinctive form: a domed building (*kubbah*) shelters the tomb, and is kept carefully whitewashed by its guardians. The *kubbah* is generally set on a plot of ground, surrounded by a wall.[86] The saint who is buried there is be-

194

195

lieved to possess miraculous powers, and the faithful seek his aid for all manner of things, but especially for healing and fertility. Propitiatory offerings are required of those seeking the saint's aid, usually the sacrifice of an animal, whose blood is applied to the door-posts and lintel of the tomb. Shreds of garments are left tied to the gratings of the *kubbah* or neighbouring trees, thus to constitute a link between the petitioner and the saint.[87] The *walī*-cultus obviously rests upon an implicit conviction that the saint abides, conscious and powerful, in his tomb. The cult provides a local focus for Muslim devotion, in terms of an intimate personal source of supernatural help, which is wanting in the wider classic form of the faith. Its appeal is both individual and communal; for the individual can take his or her problem for solution to the powerful being resident in the local tomb-shrine, while the annual *ziyārah* brings the whole community together in festive mood, at the shrine.[88] Of such contacts, and the satisfaction derived from them, is a popular religion surely made.

6. IN BUDDHISM:

Although the Buddhist view of human nature should have precluded any veneration of tombs, the stupa quickly became the focus of popular Buddhist worship. The Sanskrit word *stūpa* (in Pali *thūpa*) meant a "mound" or tumulus," and there is much reason for thinking that in India, before the rise of Buddhism, mounds covering the burial places of notable persons were already objects of popular veneration. The Buddhist stupa was supposed to have originated from the mounds built over relics of the Buddha, after the cremation of his body.[89] In later Buddhist tradition, the Buddha is represented as actually having instructed his followers to build stupas over his remains.[90] The great period of stupa construction was during the third century B.C., when King Ashoka, the celebrated patron of early Buddhism, is reported to have erected 84,000 in three years.[91] So popular became these tomb-shrines that the Buddhist authorities evidently felt that the stupa cult should be justified by endowing it with a spiritual significance. They carefully defined those who were "*stūpa*-worthy" (*stūpārha*), besides the Buddha; for stupas may also commemorate Buddhist saints. The ritual worship of a stupa, which includes the use of garlands, incense and paint, was alleged to promote "*cittapasāda*," which is a blissful

196, 119

119

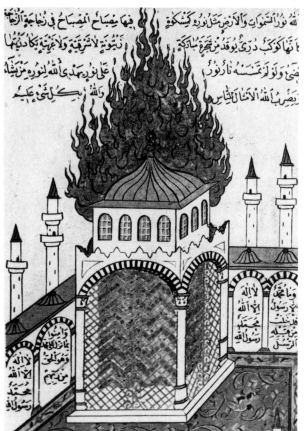

194. The Prophet Muhammad's Tomb in the Masjid-al Nebi (the "Prophet's Mosque"), Medina.

195. Visit to the tomb of a marabout. Sketch of a North African scene.

196. Relief illustrating a stupa, enshrining the Buddha.

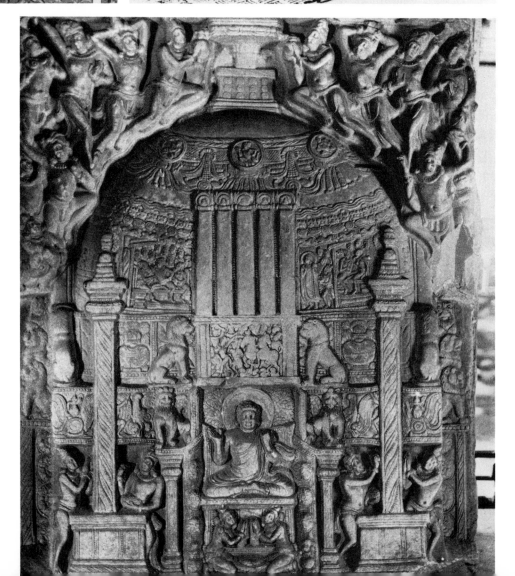

state of mental tranquility, induced by meditating on the virtues of the
holy person whom the particular stupa commemorates.[92] In popular
Buddhism, however, the stupa itself became an object of worship,
being endowed with the aura of the divine presence. Accordingly, it
was treated as though it were a Buddha image: it was circumambu-
lated, obeisance was made to it, and it was honoured with offerings of
flowers, incense and costly fabrics.[93] Although not every stupa con-
tained a relic of the Buddha or a Buddhist saint, each stupa was essen-
tially a tomb-shrine. It was regarded as embodying the presence of the
Buddha, and where a stupa or pagoda was reputed to enshrine some
notable relic, its prestige has been immense. Thus the Shway Dagon
Pagoda at Rangoon, through its possession of eight hairs of the
Buddha, became and has continued the focus of the devotion of Bur-
mese Buddhism.[94] Of even greater renown, perhaps, has been the
Dalada Maligawa or Temple of the Tooth at Kandy, in Ceylon, where
a tooth of the Buddha has been venerated since the fourth century
A.D.[95]

118

197

7. THE ANCESTRAL SHRINE IN CHINA:

The native religion of China provides an interesting variation to
the tomb-shrine as found in many other religions. Ancestor worship
or veneration has characterised Chinese culture, with the ancestral
shrine or temple forming an essential possession of every family, and
its size and prestige naturally reflecting the social status of the family
concerned.[96] But the locus of the ancestral cult was not the tomb, nor
was the ancestral shrine or temple situated at the tomb or in its near
vicinity. Instead of the tomb, a tablet inscribed with the name and
rank of the deceased served as the focus of his presence in the ances-
tral shrine. This "spirit-tablet" had a unique significance both for the
departed one and for his family. A period of three years of mourning
had to elapse before the permanent "spirit-tablet" was placed in the
ancestral shrine, and its coming there meant that the oldest existent
tablet was removed and placed with earlier ones in a special chest.[97]
This curious practice was related to an established convention that the
number of ancestors venerated by a family was governed by that
family's social standing. While his "spirit-tablet" was in the ancestral
shrine, a deceased member of a family was deemed to retain an indi-

118

197. The Shway Dagon
Pagoda, Rangoon.

198. The Tomb of Con-
fucius at Chufou, China.

vidual form of being, and offerings and other forms of service were made to him through his tablet surrogate. When it became the turn of his "spirit-tablet" to be consigned to the ancestral chest, his individual existence was merged with the indistinct mass of the family's remote ancestors.[98]

There is in China one famous tomb-shrine, that of Confucius at Chufou. There the body of the sage lies buried under a great mound of earth, upon which trees grow. In front of the mound is set a large inscribed stone tablet, before which stands a stone altar for sacrifice and a stone lantern. This tomb-shrine is the focus of a long-continuing cult of Confucius, who is hailed in the inscription as "Ancient, Most Holy Teacher."[99]

8. CHRISTIAN TOMB-SHRINES:

Christianity's most revered sanctuary is a tomb-shrine, namely, the Holy Sepulchre of Christ in Jerusalem. Consistent with its foundational belief in the Resurrection of Christ, the tomb it reveres is empty, as was apparently the tomb of Osiris at Abydos.[100] The authenticity of the Holy Sepulchre is one of the most fascinating problems of early Christian archaeology.[101] The first church, which was built to enclose it, was erected on the instructions of the emperor Constantine, who first gave Christianity legal recognition and munificently patronised the faith. It is likely that a site was already identified by Christians as marking the location, or vicinity, of the Sepulchre; for pilgrimages to the "Holy Places," mentioned in the Gospels, were already an established custom in the third century.[102] Eusebius, bishop of Caesarea, in a laudatory account of the emperor Constantine, describes the excavation of the tomb, which, he asserts, had been purposely buried, some two centuries before, by the heathen beneath a great mound of earth, upon which they had impiously erected a temple to Venus.[103] After freeing the sacred cave from this pollution, Constantine instructed Macarius, bishop of Jerusalem, to arrange for the construction of a magnificent church, in order "to render the blessed locality of our Saviour's resurrection an object of attraction and veneration to all."[104] Drawing upon imperial resources, a sumptuous and complex edifice was raised, of which the plan was fundamentally that of the existing Church of the Holy Sepulchre. It comprised two main components: a

198

199

200

199. Church of the Holy Sepulchre, Jerusalem (entrance).

1. Western Road
2. Ancient Hypogeum
3. Exedra
4. Propylæa and Eastern Road
5. Outbuildings
6. Calvary
7. Baptistry
8. Ancient Arch of the Forum of Ælia

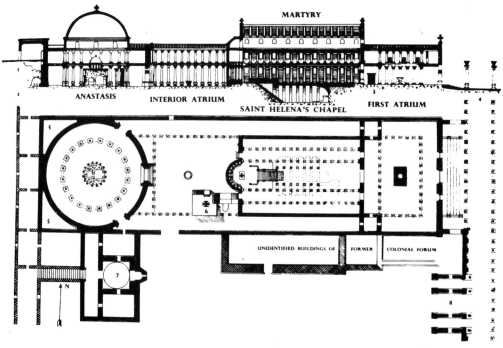

MARTYRY

ANASTASIS INTERIOR ATRIUM SAINT HELENA'S CHAPEL FIRST ATRIUM

UNIDENTIFIED BUILDINGS OF FORMER COLONIAL FORUM

200. Plan and section of the Constantinian Church of the Holy Sepulchre, Jerusalem.

circular domed building, called the Anastasis (Resurrection), which sheltered the holy tomb; then, joined to this by an atrium, a large basilica-church known as the Martyrion.[105] Within this complex was included the traditional site of Golgotha, where Christ had been crucified.[106]

This unique tomb-shrine, regarded as the "divine monument of immortality," quickly became, and has ever since remained, a supreme focus of Christian devotion. Its inherent sanctity was further enhanced by the relics of Christ's Passion which were treasured there, pre-eminent among them being the very Cross of his Crucifixion, which St. Helena, the mother of Constantine, was believed to have found by divine guidance.[107] The Lady Etheria, a Spanish abbess who visited the Holy Land about the end of the fourth century, describes the unceasing round of devotion that took place each day in the Anastasis. The services commenced at cockcrow, when the shrine was opened to the waiting crowds of the faithful, and they did not end until darkness set in.[108] She leaves a vivid picture of the scene during Vespers: "there hang everywhere a vast number of great glass lanterns, and numerous also are the *cereofala* (candles mounted on tall candlesticks), before the Anastasis, and in front of and behind the Cross."[109]

This devotion grew as Christianity spread throughout the known world, and pilgrims of all nations made the long and arduous journey to Jerusalem. The strength of that devotion inspired the Crusades, when Jerusalem passed under the control of the Seljuk Turks in 1071 and access to its Holy Places became increasingly dangerous and often impossible.[110] It was to defend the Holy Sepulchre, and the pilgrims who sought to visit it, that the famous order of military monks, the Knights Templar, was formed, and the round churches which they built in many parts of Europe still commemorate the rotunda of the Anastasis.[111]

The awe which was felt for the tomb of Christ found strange but significant expression in the ritual kindling of the Holy Fire within it on Easter Even. A graphic account of the scene in the Church of the Holy Sepulchre has been left by the early nineteenth-century traveller Alexander William Kinglake. He tells how the pilgrims were

driven to the verge of madness by the miracle displayed before them on Easter Saturday. Then it is that the heaven-sent fire issues from the Holy

Sepulchre. The pilgrims assemble in the great church, and already, long before the wonder is worked, they are wrought by anticipation of God's sign, as well as by their struggle for room and breathing space, to a most frightful state of excitement. At length the Chief Priest of the Greeks, accompanied (of all people in the world) by the Turkish Governor, enters the tomb. After this there is a long pause, but at last and suddenly, from out of the small apertures on either side of the Sepulchre, there issue long shining flames. The pilgrims now rush forward, madly struggling to light their tapers at the holy fire. This is the dangerous moment, and many lives are often lost.[112]

The Holy Sepulchre, by virtue of its association with the burial and Resurrection of Christ, has had a unique significance for Christians which no other shrine can challenge. Although it is an empty **201a** tomb, it has been, and indeed still is, invested with a supernatural aura that evokes a whole range of emotions from reverent respect to the fanaticism reported by Kinglake. Its abiding appeal is the more significant, in terms of the psychology of religion, since the development of the doctrine of the Real Presence of Christ in the Eucharist provided the faithful with a localised focus for their devotion, as we **201b** have already noted.[113] It would seem that to contemplate and touch the very tomb in which, it was believed, the Body of Christ had actually lain, and from which it had miraculously arisen, offered an efficacious sense of communion with the saving event of Christ's Resurrection, such as the Eucharistic experience could not parallel or offset.

But for most Christians the Holy Sepulchre was in a far country and remained beyond their reach. To make the pilgrimage there was a hope that all cherished; but most had to remain content with the tales of those who accomplished the holy journey and returned with some amulet made sacred by contact with the wondrous shrine. The multitudes of little crosses, scratched by generations of pilgrims on the walls of the Holy Places, abide as pathetic witnesses of the desire to remain forever linked with those sacred shrines.[114] But if the tomb of Christ was for the majority of Christians only the goal of pious aspiration, in most parts of Christendom there were the tomb-shrines of **202** saints, often far renowned for miracles, that could be reached and merit thereby acquired.[115]

The Christian cult of the tomb-shrine began very early in the history of the faith. Although the beginnings of the veneration of

201a,b. The Chapel of the Holy Sepulchre, within the Church of the Holy Sepulchre, Jerusalem.

202. Figures of two pilgrims among the saved, represented in the *Last Judgment* on the west portal of Autun Cathedral, France.

Christ's tomb cannot be traced, it was evidently well established before Constantine ordered the building of the Anastasis.[116] The veneration of martyrs' tombs can definitely be dated to the early second century; for it is recorded by the Christians of Smyrna that, after the martyrdom of Bishop Polycarp in 155: "we took up his bones, which are more precious than the costliest jewels and finer than refined gold, and laid them in a suitable place (*hopou kai akolouthon ēn*). There the Lord will permit us to assemble, as we are able, with joy and gladness, to celebrate the 'birthday' (*hēmeran genethlion*) of his martyrdom."[117] The custom of celebrating the Eucharist at the tomb of a martyr led to the establishment of the *confessio*, which marked the spot where the saintly relics were deposited, as a regular feature of the early basilica-churches, as we have already noted.[118] The prestige of these tomb-shrines naturally corresponded to the reputation of the saint concerned. The three following examples will serve to show how important has been the holy tomb and its cultus in the life of the Western Church.[119]

The excavations carried out beneath the great cathedral church of St. Peter in Rome, during the fourth decade of this century, have enabled the evolution of the tomb-shrine of that pre-eminent Apostle to be reconstructed. It would appear that about the year 200 a memorial shrine to St. Peter, called a "trophy" (*tropaion*), existed on the Vatican Hill, and was an object of veneration to the Christians of Rome. This "trophy" has been identified by archaeologists with the remains of what is termed the "Aedicula," a small niched shrine, adorned by colonnettes.[120] It cannot be established with certainty whether this shrine covered the grave of St. Peter or marked the spot where he was martyred. However, the balance of probability inclines in favour of its being a memorial set over his grave, and it is evident that from the mid-second century the Roman Christians believed that their great Apostle lay buried there. Continuity of veneration is impressively attested by the numerous *graffiti* scratched on the adjacent wall, in which visiting Christians recorded brief prayers for the spiritual welfare of loved ones, either living or dead.[121]

The shrine appears to have remained in its original situation, in a pagan cemetery on the slopes of the Vatican Hill, until the emperor Constantine I undertook the immense task of enclosing it in the great

203

basilica that became the old St. Peter's. The primitive shrine, encased in rare marble, formed the focal point of the church and its liturgical centre. St. Jerome,[122] writing in 406, refers to the bishop of Rome as offering sacrifice to God on the tombs of St. Peter and St. Paul which "rank as altars of Christ (*Christi arbitratur altaria.*")[123] And a significant glimpse into the popular cultus at the tomb is given by Gregory of Tours, who records how, about 590, it was customary to seek a token that St. Peter would grant a specific request made to him at the tomb —the petitioner would pass a piece of cloth into the shrine for weighing: if the weight increased, it was taken as a sign of the Apostle's assent.[124] The possession of the tomb of St. Peter naturally conferred a unique distinction upon the great church in which it was housed, and it constituted a powerful factor in establishing the claim of the bishops of Rome to a unique pre-eminence in the Church as the successors of St. Peter, the foremost Apostle of Christ.[125]

The cult of the tomb-shrine was so powerful a factor in mediaeval Christendom that it could even cause the presence of a saint's remains to be located in an inherently impossible place. Thus, in 813 Bishop Theodomir of Iria Flavia, in northern Spain, announced that he had discovered, through the guidance of supernatural lights, the tomb of St. James the Great (in Spanish, "Santiago"). The presence of the body of this Apostle in Spain, at that particular spot, was explained as due to a miracle: the stone coffin, in which the deceased saint had been placed by his disciples in Judaea, had miraculously made its way to Iria Flavia, where many years before he had preached the Gospel. The story found willing believers, and its truth was signally confirmed when St. James appeared and gave the Christian army victory over the Moors at Clavijo in 844. His cult was speedily established, and the Apostle became the heavenly champion of the Christian effort to expel Islam from Spain. In the eleventh century, Pope Urban II changed the name of Iria Flavia to Santiago de Compostela (possibly from the Latin *campus stellae*, "field of the star," with reference to the miraculous light that had revealed the tomb to St. Theodomir).[126] A cathedral church, erected over the tomb, was consecrated in 1211, to accommodate the crowds of pilgrims that now flocked to venerate the marvellous tomb and benefit from its curative powers.[127] From France four pilgrimage routes led to Santiago, and a special *Guide du Pèlerin* was

204

205

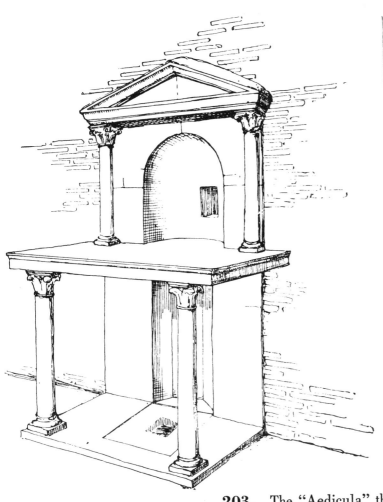

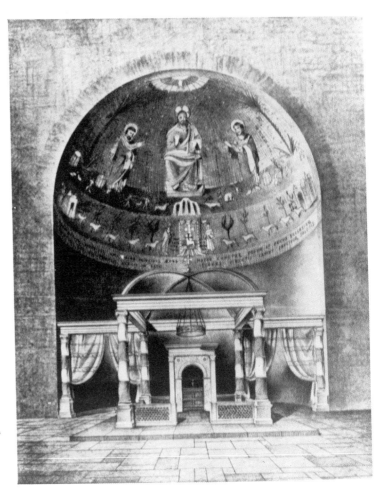

203. The "Aedicula" that probably marked the tomb of St. Peter on the Vatican Hill.

204. Reconstruction of the Shrine of St. Peter as it appeared in the Basilica built by Constantine.

205. Tomb of St. James the Great in the Cathedral of Compostela.

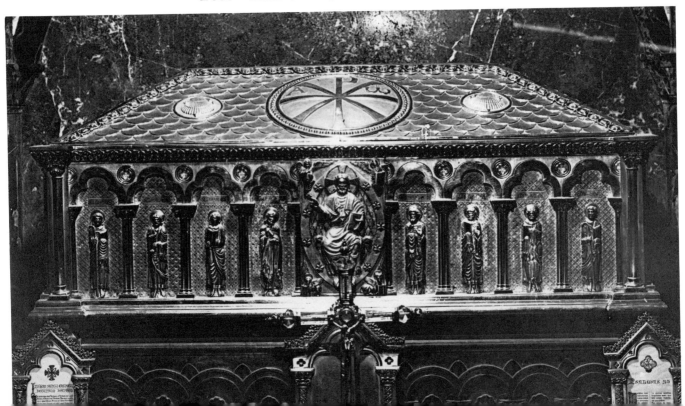

written in the twelfth century listing the many other tomb-shrines which the pilgrim could visit en route for Compostela. Thus, for example, at Toulouse he could venerate the body of St. Sernin, at Conques wonder at the golden image-reliquary of Saint Foy, and at Térigueux make his devotions at the beautiful tomb of St. Front, which was circular in shape like the Holy Sepulchre in Jerusalem.[128]

206

That a tomb-shrine, of which the origins were so dubious as those of Santiago at Compostela, could become so powerful a magnet for Christian devotion, helps to explain the immense popularity which the tomb of Thomas Becket at Canterbury so quickly acquired. His dramatic murder in his own cathedral, on December 29, 1170, gave the Church a martyr-saint, who had died defending her rights against royal pretension.[129] Canonised by Pope Alexander III in 1173, his tomb quickly attracted pilgrims: miracles were reported to happen there, and his relics were eagerly sought and treasured thoughout Europe.[130] A magnificent shrine was built in the Trinity Chapel, which forms the apsidal eastern end of Canterbury Cathedral. This shrine, and the saint's remains, were utterly destroyed at the Reformation, for King Henry VIII was especially intent on eradicating the cult of the martyred Becket.[131] From his researches, Dean Stanley, who had been a canon of Canterbury Cathedral, has provided a valuable account of the appearance of the shrine in the heyday of the cult:

The lower part of the Shrine was of stone, supported on arches; and between these arches the sick and lame pilgrims were allowed to ensconce themselves, rubbing their rheumatic backs or diseased legs and arms against the marble which brought them into the nearest contact with the wonder-working body within. The Shrine, properly so called, rested on these arches, and was at first invisible. It was concealed by a wooden canopy, probably painted outside with sacred pictures, suspended from the roof; at a given signal this canopy was drawn up by ropes, and the Shrine then appeared blazing with gold and jewels. . . . As soon as this magnificent sight was disclosed, everyone dropped on his knees, and probably the tinkling of the silver bells attached to the canopy would indicate the moment to call the hundreds of pilgrims in whatever part of the Cathedral they might be. The body of the Saint in the inner iron chest was not to be seen except by mounting a ladder, which would be but rarely allowed.[132]

207a

207b

There is some evidence that the martyr's head, or the portion of the skull struck off by the sword of one his slayers, was exposed separately for the devotion of the pilgrims, possibly in the round chapel at the

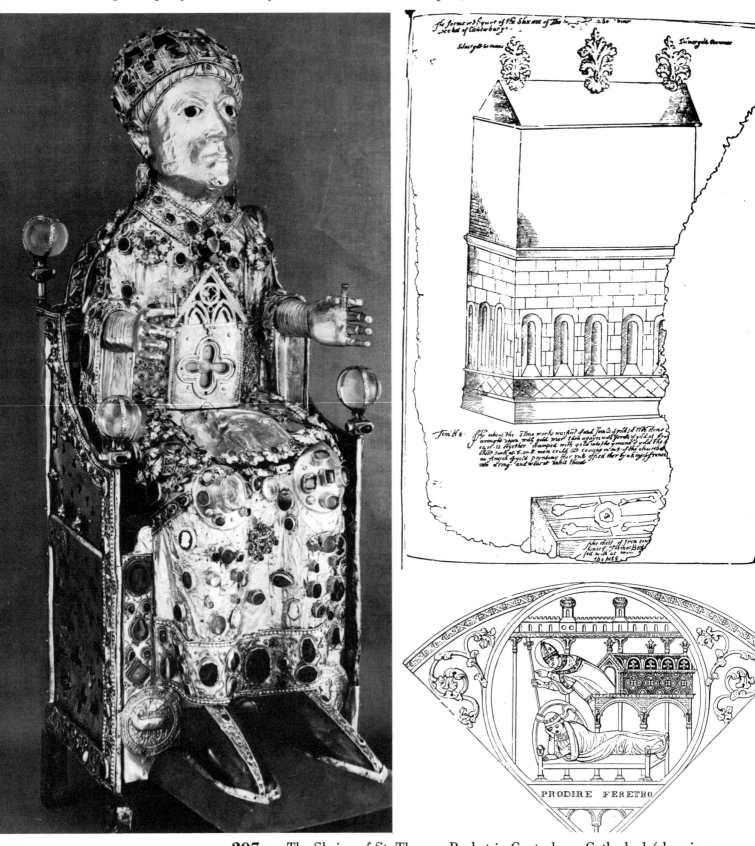

206. Image-reliquary of Saint Foy in the Cathedral of Conques, France.

207a. The Shrine of St. Thomas Becket in Canterbury Cathedral (drawing from an early ms.).

207b. Drawing of a glass painting in Canterbury Cathedral of St. Thomas Becket issuing from his shrine.

extreme eastern end of the cathedral, known as the Corona or Becket's Crown.[133] Of the compound of gaiety and devotion that animated the mediaeval pilgrims Chaucer has left an imperishable record, as

> . . . to Canterbury they wend
> The holy blissful martyr for to seek,
> That them hath holpen when that they were sick.[134]

The appeal of the tomb-shrine, which has found expression in so many religions, must surely stem from some deeply rooted human instinct to venerate, and even adore, the mortal remains of those held pre-eminent for their charismatic character. From those who once sought the tomb of Osiris at Abydos to the crowds that file, in solemn silence, pass the embalmed body of Lenin in Moscow's Red Square there stretches a continuity of cultic tradition, impressive alike for the reality and persistence of its fervour.[135] Despite the wide varieties of belief involved concerning human nature and destiny, this long and ubiquitous tradition attests to a universal disposition to attribute to the mortal remains some enduring connection with the person who once indwelt them. It is a cultus which, though leaving little literary evidence, has expressed itself in an impressive series of tomb-shrines that starts with the Step Pyramid of the pharaoh Djoser and ends with the Mausoleum of Lenin, the apostle of world communism. And each tomb-shrine, in that long series, has involved a ritual service, expressive of human needs and aspirations set forth in the idiom of its contemporary culture.

208

C. The Iconography of the Tomb

Tombs, as the abodes of the dead, have been equipped or adorned with sculptures and paintings by many peoples, past and present. This funerary art affords a rich treasury of insight into man's reaction to the menace of death, which is paradoxically the issue of greatest concern with which his experience of life confronts him.[136] This reaction has expressed itself in three distinctive ways, each of which reflects the dominant theme in the evaluation of human destiny current in a specific religion or culture.

Whether the iconography of any particular tomb should be de-

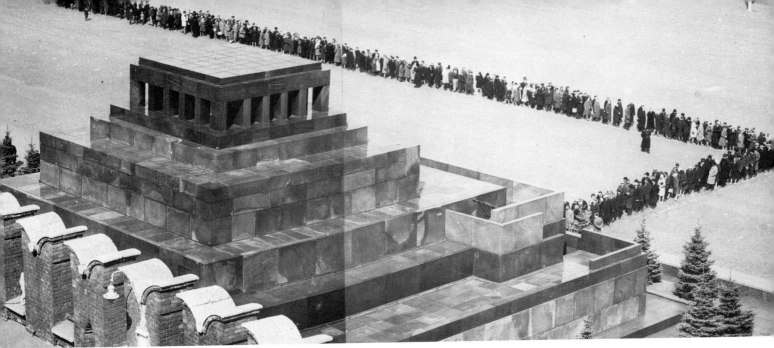

208. The Mausoleum of Lenin in Red Square, Moscow.

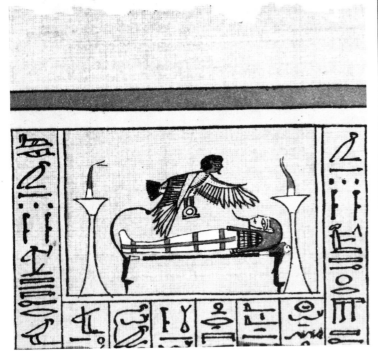

209. The *ba* revisiting the mummy of the deceased (*Papyrus of Ani*).

210. Three portrait statues of King Senu-sret I, from Lisht.

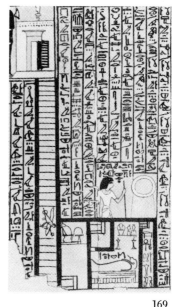

169

scribed as equipment or adornment is determined by the purpose which it is conceived to serve, as will be seen in the following illustrative examples. The three main aspects of funerary art, which will concern us here, may be conveniently defined as the magical, the commemorative, and the minatory. These categories are not mutually exclusive; but one of them invariably characterises the funerary art of a particular religion or culture.

1. EGYPT:

Once more, in this survey, ancient Egypt provides the earliest, the most abundant and the most graphic evidence. Egyptian iconography was essentially of a magical kind, and it is therefore to be regarded as equipment. Reference has already been made to the so-called *ka* and portrait-statues of deceased that were placed in the tomb.[137] These statues were obviously designed to portray very exactly the facial features; less attention was given to the rest of the body, although certain of its features were often skilfully rendered.[138] A variety of postures were used: the deceased could be shown as standing, walking, seated in a chair, or sitting cross-legged in the manner of scribes.[139] A few statues have the *ka* symbol mounted on the head, thus suggesting that they were specially associated with the *ka*, the mysterious double of the individual person, which will be the subject of our later study.[140] The portrait-statue seems to have provided a substitute body for the deceased, thereby guaranteeing a locus for his *ba*, should his embalmed body be destroyed. The *ba*, represented as a human-headed bird, was an essential constituent of the personality, and it is often depicted as perched on the sarcophagus containing the mummy of the deceased.[141] Tombs were sometimes equipped with more than one portrait-image; for example, no less than ten identical statues of King Senu-sret I (1970 – 1936 B.C.) were found in his tomb at Lisht.[142]

A subtle symbolism was exployed in the presentation of the portrait-image. Amulets and the position of the hands signify that the deceased has been resurrected to a new life, and sits, alert and vital, to receive the offerings due to the glorified dead.[143] Sometimes a more esoteric symbolism was used: the deceased was portrayed enveloped in a cloak such as the pharaoh wore when he was ritually revivified at the Sed festival,[144] or he was depicted in a curious "block" form, as if he

22, 23

22, 337c

209, 169

210

211

cf. 86

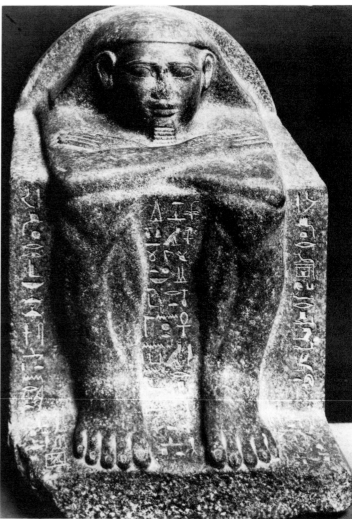

211. Old Kingdom funerary stele of Neferu from the region of Denderah.

212. Block statue of Hetep (Twelfth Dynasty).

213. Wooden coffin of the early Twelfth Dynasty showing the *uzat* eye. From Deir el Medineh.

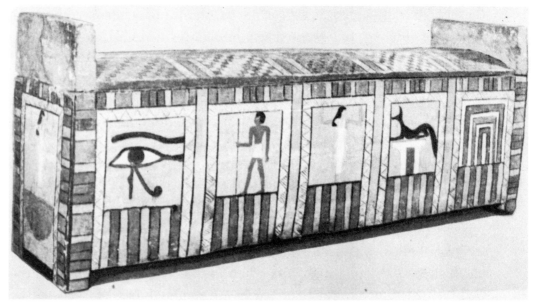

were merged with a stone seat—the reference here being doubtless to the hieroglyphic sign of a throne that denoted the goddess Isis, who raised Osiris from death and with whom the dead man was ritually assimilated.[145]

212

The portrait or *ka* statue was for the eternal darkness of the tomb, where it served the needs of the deceased who was buried within. At the entrance to the tomb, as we have already noted, was the so-called "false door" through which the dead owner could look out on the world and receive his mortuary offerings.[146] In the Old Kingdom period, the deceased was sometimes represented at the "false door" by a statue; later by two magical *uzat*-eyes.[147] In the area about the "false door," other images of the dead man were often carved, including one showing him seated before a table loaded with funerary offerings of various kinds. Accompanying hieroglyphic texts recorded the name and title of the deceased, and listed the offerings made to him.[148] In process of time, such texts included appeals to those "living on earth," who passed by the tomb, to recite the magical formulae inscribed there, so as to conjure up for the dead one immense quantities of food and drink; there were also warnings of the dire vengeance that would befall any who violated the tomb.[149] Such inscriptions tacitly acknowledged the futility of reliance on the piety of descendants or on covenants with priesthoods for the perpetual supply of one's mortuary needs.[150] Even more significant in this context are the funerary stelae found built into the walls of temples, on which the deceased is depicted supplicating a deity, usually Osiris, for the provision of his *post-mortem* needs.[151] Such stelae witness to a belief that the image of a dead man, with an appropriate inscription, would ensure his participation in the offerings made daily to the deities worshipped in the temple concerned.

168

213

211

Iconography was enlisted to serve the Egyptian dead in other ways also. Thus there were carved or painted, on the walls of tombs, a variety of scenes which were believed to help the dead to continue in their enjoyment of the life they knew in the land of the Nile, or to ensure their acceptance into the company of the gods, or their passage safely through the perils that beset the way to the next world.

In seeking magically to reproduce, within the tomb, the circumstances of everyday life, all kinds of secular events were depicted by the Egyptian artist: the daily routine of the house and estate, hunting

168

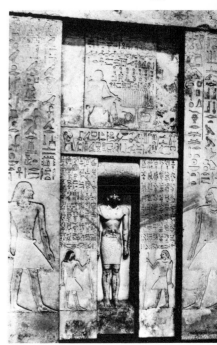

214, 406a among the papyrus thickets of the Nile or sailing on its waters, feasting and merrymaking.[152] To the portrayal of such topics the mural iconography of the Old Kingdom tombs was exclusively limited, thus witnessing to the contemporary ideal of being an *"akh, effectively equipped with all that is necessary,"* as the texts describe a *post-mortem* existence of eternal beatitude, complete in all that an Egyptian of that time held to be essential to the good life.[153] In the iconography of later tombs, religious themes find increasing expression; but the depiction of secular life continued into the New Kingdom era, and it has left on the

215 walls of Theban tombs the delightful scenes of conviviality that are so often, and rightly, featured in books on ancient Egyptian life and art.[154] There is, however, a notable difference between these secular scenes of the two periods. In the earlier compositions, the figure of the deceased invariably dominates the scene or series of scenes, though seemingly aloof and detached from the action. Such detachment is often absent from the New Kingdom depictions, most notably in the tomb of Ramose

216 which show the departed one mingling with his relations and guests in ordinary social intercourse.[155]

 The reliefs and mural paintings of the New Kingdom tombs attest to a changing emphasis in eschatological concern. Although the primitive conception of the tomb as the "eternal house" of the dead was still strongly held, as the mortuary equipment and the scenes of secular activities graphically show, the importance of the funerary ritual and relationship with the gods began to absorb greater interest. Accordingly, it was deemed advantageous to have the performance of such important

217 funerary rites as the "Opening of the Mouth" depicted upon the walls of one's tomb;[156] for there its representation doubtless served both to record the fact that these essential rites had been properly performed on behalf of the deceased, and, by the magical potency of the pictorial record, to perpetuate the efficacy of the ritual action, which might otherwise weaken with the passing of time.[157] Depictions of the de-

218 ceased at prayer, accompanied by the text of his prayer, or worshipping the gods, were also calculated to serve as abiding and efficacious surrogates of his pious conduct.[158] Sometimes, as in the tomb of Amenhotep II and on the golden shrines of Tut-Ankh-Amun, scenes from the Book of *Amduat,* showing the sun-god's life-giving journey nightly

219 through the underworld, were represented for the benefit of the dead.[159]

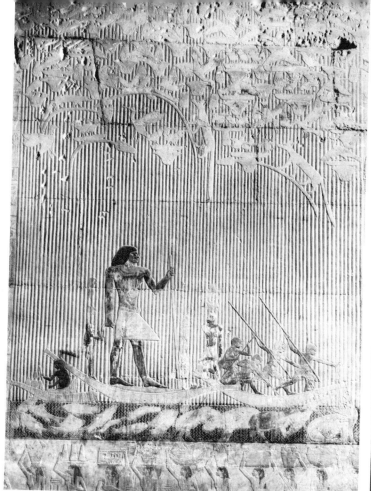

214. Relief from tomb of Ti, at Saqqara, showing the deceased hunting hippopotami.

215. Festival scenes from the tomb of Nakht, priest of Amun, at Thebes.

216. Guests sitting with Ramose at funerary meal, from the tomb of Ramose at Thebes.

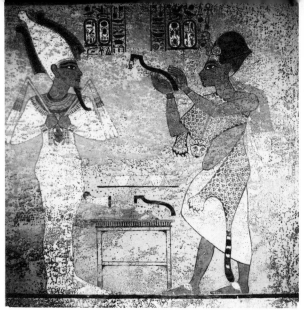

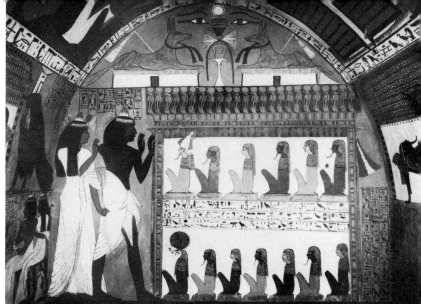

217. Cultic scenes (the "Opening of the Mouth") from the Tomb of Tut-Ankh-Amun.

218. The deceased worshipping gods. Painting from the tomb of Sennedjem at Deir el Medineh, Thebes.

219. Journey of the sun-god through the underworld, from tomb of Amenhotep II near Thebes.

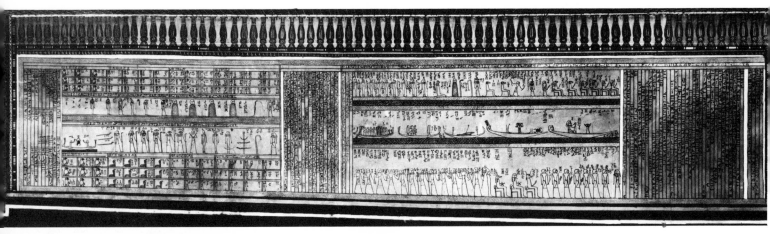

220a. Tomb models of women spinning flax, from the tomb of Meketre.

220b. Wooden tomb model of servants preparing bread.

To the magical potency of the scenes depicted on the walls of tombs other forms of iconographic resource were added. For example, to supplement or reinforce the linear repesentation of economic and domestic activities necessary to the continuation of the good life after death, models were carefully made of servants, occupied in these activities, and placed in the tomb. In the *post-mortem* world these miniature substitutes would be endowed with a magical reality, and so serve the needs of their dead owner, who likewise had been magically revivified.[160] Another means of supernatural aid was provided for the deceased in the shape of small mummiform images known as *ushabtis*.[161] These figures were depicted holding the hoe or mattock of the Egyptian labourer, and with a string bag hung across the back. Inscribed on the mummiform body was the hieroglyphic text of Chapter VI of the *Book of the Dead,* in which the deceased owner of the *ushabti* commanded it to answer for him, if he were called upon to labour in certain specified ways in the next world. The word *ushabti* seems to have been understood as meaning "answerer," although its original significance is uncertain. These *ushabti* figures varied in size, and in the material from which they were made (those found in the tomb of Tut-Ankh-Amun were of solid gold). Often they were deposited in great numbers in tombs, as though the dead owners sought thus to ensure that they would be adequately provided with substitutes for the chores of the next world.[162]

Besides this equipment which the Egyptian craftsmen carved or moulded for the use of the dead, the resources of iconography were enlisted to invest the anthropoid coffins and the sarcophagi, in which the mummified body was encased, with apotropaic power. For it was deemed necessary to use every means to protect the body from the many supernatural perils which beset it. The cover of the coffin was, accordingly, moulded to represent the features of the deceased, and on the body area were painted prophylactic symbols and figures of the gods, with appropriate texts. Inside the bottom of the coffin on which the body rested, or inside its cover, the figure of the sky-goddess Nut or some other potent deity was depicted, so that the dead lay enfolded about by divine protection and vitalising care.[163] In the later Graeco-Roman period, instead of the traditional moulded head mask, a realistic portrait of the deceased was inserted in the anthropoid cartonage

220a, b, c

220c. *Ushabti* (Egyptian).

221a

221b

222

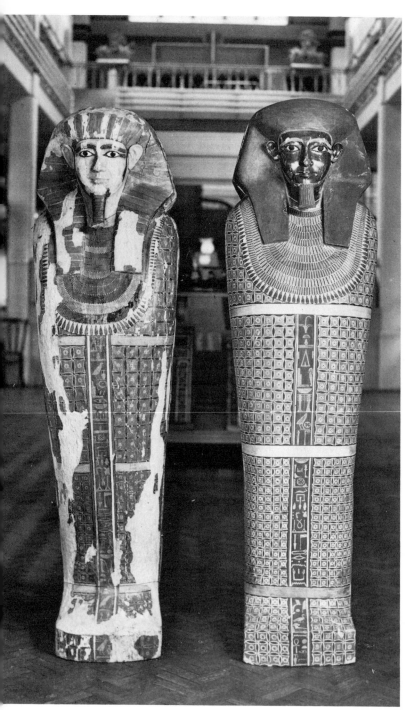

221a. Mummy cases of Khnumu-Nekht and Nekht-Ankh (*c.* 2000 B.C.).

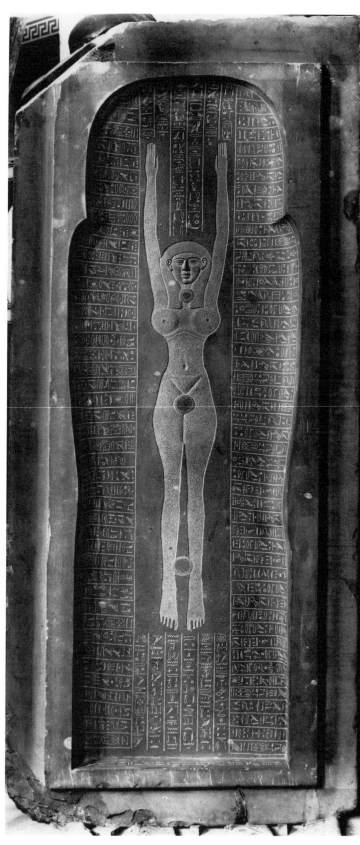

221b. The sky-goddess Nut, represented on the inside of the sarcophagus of Queen Ankhnes-neferab-Ra.

case.[164] The magic potency of iconography was utilised also in the making of the four so-called "Canopic jars," in which the embalmed viscera of the deceased were preserved: the lid of each jar was carved to represent one of the sons of Horus, to whose protective care these vital organs were committed.[165]

223

And so, to render the revivified dead for ever safe and secure in their "house of eternity," the ancient Egyptians were lavish in their use of iconographic representation. They drew upon the resources of plastic and linear art for the magical equipment of the tomb, not for its decoration. For when the last rites were accomplished and the masons sealed the entrance to the tomb, all this glowing imagery was left in impenetrable darkness with the embalmed body of the deceased, whose security and well-being it was designed eternally to maintain.

2. AEGEAN CULTURE:

The magical aspect of Egyptian tomb iconography is without parallel, both for its graphic presentation and for the immense period of time through which it remained an effective factor in cultic faith and practice.[166] In the funerary art of other peoples it is more difficult to discern or evaluate the magical factor, or indeed to be certain whether such a factor was operative in the making and use of a particular image or picture. But as the following examples will show, statues and figurines were often deposited in tombs for purposes obviously other than that of commemorating the dead or providing them with mementoes of their life in this world.

One of the most puzzling specimens of tomb iconography, as revealed by archaeological research, is a clay model of a sanctuary found in the Early Bronze Age cemetery at Vounous, near Bellapais, in Cyprus.[167] Within the circular enclosure a number of crudely shaped human figures appear to be engaged in some cultic act, directed towards three human figures wearing bull's masks and holding snakes: around the walls are models of bulls in pens. Fertility cults, probably having some eschatological significance, in which bulls and snakes figure prominently, characterised the religion of the Aegean peoples in pre-Hellenic times.[168] Some such cult is doubtless represented in this clay model; but why it should have been thus portrayed for deposit in a tomb is obscure. The representation of cultic acts, as we have already

224

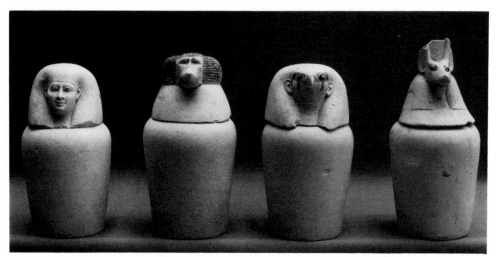

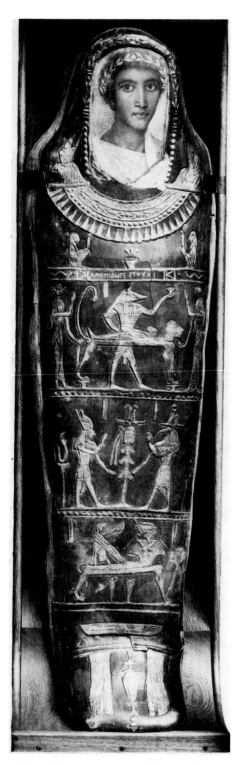

222. Mummy case of Artemidorus (*c.* A.D. 200).

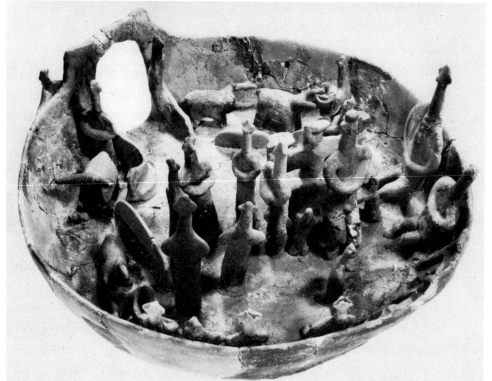

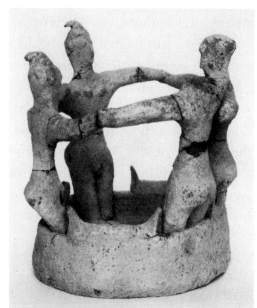

223. "Canopic" jars.

224. Clay model of a sanctuary found at Vounous, near Bellapais, Cyprus.

225. Group of dancers, within a circular wall containing "horns of consecration," found in tomb of Kamilari, near Phaistos, Crete.

noted, was probably inspired, in most cases, by the desire to perpetuate the efficacy of rites after their performance had ended. It is possible, therefore, that the rite depicted in this Cypriot model was believed to benefit the dead, and that the clay representation of it would ensure the continuance in the grave of the virtue of the rite. That such a use of funerary art was not peculiar to Cyprus, a pottery model of four nude dancers within an enclosure surmounted by symbolic "horns of consecration" would seem to attest; for it was found in the tomb of Kamilari (*c.* 1500 B.C.), near Phaistos in Crete.[169] These two representations of cultic acts, it is important to note, differ from the examples found in Egyptian tombs in that they portray rites that do not appear to be of a mortuary character.

3. BEISCHLÄFERIN:

Another puzzling type of iconographic equipment, found in early graves and tombs throughout the ancient Middle East and the Aegean area, is the female figurine. Examples vary in the degree of realism shown in the rendering of the body, which is invariably nude, and in the absence or crudity of the facial features. The sexual attributes, however, are usually delineated clearly.[170] Some specimens represent a woman holding an infant.[171] It has become customary for scholars to identify such figurines as images of the "Mother Goddess."[172] Many may well be such, especially since cults of fertility goddesses, having many features in common, flourished in the areas where these figurines occur: namely, in Mesopotamia, Iran, the Indus Valley, Anatolia, Syria, Egypt, Crete, Cyprus, and the Aegean area. That images of a "Mother Goddess" should be buried with the dead can also be plausibly explained, since there is evidence that certain of these goddesses had a dual role: they personified the earth as the source of life and the womb to which the dead returned.[173] There is, however, reason for doubting whether this interpretation is so widely applicable as it was once thought to be.[174]

Egyptian archaeology may provide a clue to the purpose which some of these figurines were intended to serve in other lands than Egypt. For it is clear from Egyptian examples of the dynastic period that such images justify the designation given to them by German Egyptologists of *Beischläferin* ("sleeping companions"). Such evi-

225

226

227a

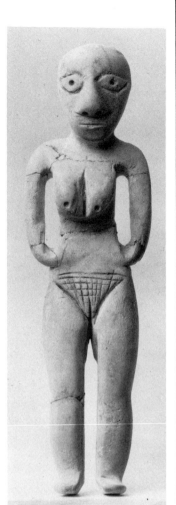
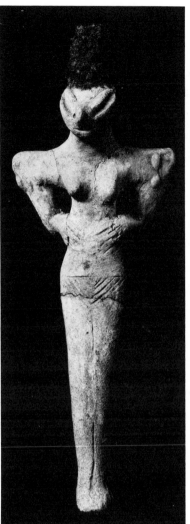
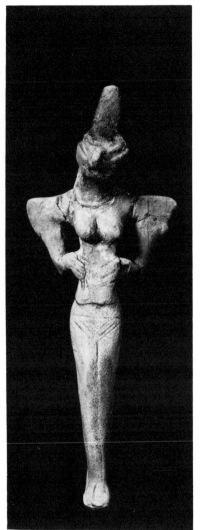
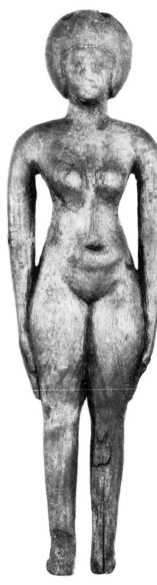

226. Types of female figurines.

227a. Right: Ancient Egyptian *Beischläferin*.

227b. Grave figures of female musicians of the T'ang period (7th century A.D.).

dence as seems relevant suggests that the images were probably designed to provide, magically, for the erotic needs of the dead. In some instances, however, their purpose may have been to give a man who had died childless the opportunity of begetting children in the afterlife—the mythic example of Osiris would have authorised such a hope, for after death he had fathered Horus on his wife Isis.[175] That such belief motivated the placing of female figurines in graves in other lands must, admittedly, remain hypothetical, though plausible. But whatever the purpose or purposes these figurines may have served, they significantly witness to man's ready resort to iconography to meet his mortuary needs, such as they have been conceived in various times and places.

4. CHINA AND JAPAN:

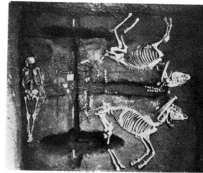

171

In ancient China and Japan, the iconography of the tomb derived from the grim practice of human sacrifice. As excavation of royal tombs at Anyang of the later Shang Dynasty (*c.* 1300–1100 B.C.) revealed, members of the court and other retainers were executed and buried with their deceased master, doubtless with the idea that they would thus continue to serve him in the next world.[176] This savage custom ended with the fall of the Shang rulers; after that time the sacrifice of human servants seems to have been substituted by the burying of wooden effigies in graves.[177] Later, in the Han Dynasty (206 B.C.–A.D. 220), the custom developed of placing figures made of clay in tombs. A considerable variety of *post-mortem* activities were provided for in this manner, including realistic representations of the game *liu po* and wrestling.[178] But not only were human beings thus substituted by pottery figures in this *ming ch'i* ("burial furniture"); the needs of habitation were also met by the provision of ceramic houses and pavilions.[179] Such funerary equipment recalls that of ancient Egypt, and implies a like conception of the afterlife; for it was evidently believed also by the ancient Chinese that such models could be magically transformed into the real things they represented, thus reproducing in the next world the conditions of this.

227b

228

For our understanding of this funerary equipment we are wholly dependent on the evidence of the objects themselves, since relevant written sources are lacking. Comparison with Egyptian practice is cer-

228. Mortuary model of a watchtower. Han period (*c.* A.D. 200).

229. Tomb figure of court-lady holding mirror. Coloured glazes on fired terra-cotta.

230. Limestone figure of a guardian warrior of the tomb of Emperor Yung-Lo at Nan-k'ou.

231. Japanese *haniwa* (clay) figure of warrior, from Kuai, Nitta County. Late Tomb period.

tainly illuminating. But it suggests that the Chinese were never so completely preoccupied with providing for their *post-mortem* needs as were the Egyptians, and neither did they elaborate so complete and so complex an eschatology as that which prevailed for so long in Egypt. Further, the delightful terra-cotta figures of elegant ladies and splendid horses found in tombs of the T'ang period (A.D. 618–906) often give the impression that they were made to delight the living by their beauty, and that their mortuary function was perhaps somewhat secondary—they seem to lack that sense of concentration on their other-worldly tasks that so obviously characterises the Egyptian figures.[180] A similar impression, that aesthetic interest was a dominant factor, is given also by the large sculptured figures of warriors and fierce animals which stand as sentinels to certain imperial tombs, most notably those that line the avenue to the tomb of Emperor Yung-Lo of the Ming Dynasty (c. 1403–1424).[181]

229

230

Japanese tradition tells how the emperor Suinin (c. third century A.D.), horrified by the spectacle of human sacrifice at the funeral of his uncle, arranged for the replacement of the custom by depositing substitute clay figures of men and animals on the slopes of tombs.[182] The tradition is doubted by some scholars, who think that the figures evolved from clay cylinders, of uncertain purpose, which were planted about tombs in more ancient times.[183] The *haniwa* images, as they are known, appear to represent the various ministrants concerned in the mortuary ritual: bearers of offerings, musicians, dancers and other entertainers. There were also figures of armoured warriors, who stood guard over the tomb.[184] Whether these *haniwa* figures did truly originate as substitutes for human victims as the Chinese tomb figures certainly seem to have done, and as Japanese tradition taught, remains thus uncertain. There can, however, be no doubt that their function must originally have involved some element of magic. And so China and Japan testify also to a primitive association of funerary iconography with magic such as we have noted in Egypt and elsewhere in the ancient Middle East and the Mediterranean area.

231

5. "PERSEPHONE" FIGURES OF CYRENE:

It will be useful now to notice, in sequence, two exceedingly strange instances of what appears to be funerary iconography of a magical

kind. They represent very different traditions of mortuary faith and practice from those evidenced in the material reviewed so far, and for that reason they have an added interest for us; they are, moreover, widely separated from each other in time and space. The more ancient of these monuments comprise faceless half-length images of women, which were designed to stand on the covers of sarcophagi, so that they appear to be emerging from them. The statues concerned have been found in the cemetery of the ancient Greek city of Cyrene, in Libya. A particularly fine specimen, unearthed by the Manchester University Cyrenaican Expedition during its excavations in 1955–57, depicts the upper portion of a female torso, in classical costume, holding an alabastron or small oil vase. But where the neck and face should be, a **232** cylindrical column rises from the shoulders. This column is capped, at the appropriate level, with a sculptured representation of waved hair, upon which, as upon a woman's head, a *kalathos* is set.[185] This *kalathos* was doubtless intended to be a symbol of fertility, such as was worn by Sarapis, the Graeco-Egyptian god of the underworld, and by the goddesses Hecate and Cybele, who also had chthonian associations.[186] The significance of this statue, and others like it, is not indicated by inscriptions. But there is good reason for supposing that they were representations of Persephone, the goddess of the underworld, who was associated with the corn-goddess Demeter in the celebrated Eleusinian Mysteries. According to the myth preserved in the so-called *Homeric Hymn to*

122

Demeter, each spring Persephone made her ascent (*anodos*) from the realm of the dead, thus symbolising the resurrection of vegetation— the annual miracle in which men saw hope of their own rebirth from death.[187] The Cyrene statues were probably intended to represent the *anodos* of Persephone by seeming to emerge from the sarcophagi of the dead, on which they were placed. Thus they would have re-presented or symbolised the hoped-for resurrection to immortal life of those who were buried there. And it would have been a symbolism that, in terms of ancient thought, was intended to achieve what was symbolised.[188]

The strange facelessness of these Libyan statues constitutes an enigma without parallel in classical iconography, though remarkably reminiscent of the so-called "Venus" figures of Palaeolithic art which we have already noted. However, this curious aspect of the Libyan

statues clearly has a different explanation. A clue to it is, doubtless, provided by the cylindrical column that replaces the face and neck of the human figure. For the hair seems to be imposed upon the top of this stone column or pillar, and the body appears to be fashioned around it. Since there is evidence of a primitive Libyan cult of sacred stones, which marked the locus of a chthonic daimon or divinity, it is possible that the Greek immigrants who settled at Cyrene identified this Libyan divinity with their own goddess Persephone; for both were chthonian beings, concerned with the annual cycle of Nature's birth and death.[189] Accordingly, these strange images may perhaps embody the intimations of ancient Libyan and Greek eschatology in what may be termed an aniconic iconography.

6. EASTER ISLAND AND THE AHU STATUES:

Turning from ancient Libya to the remote Easter Island, in the southern Pacific Ocean, we find that it was also once the custom of the inhabitants there to erect statues on the burial places of their dead. The practice began about A.D. 1100, and it marked the overthrow of an earlier culture characterised by the worship of the sun, and by the introduction of the cult of a mysterious bird-man deity.[190] The statues, which were carved of stone and sometimes as much as 36 feet tall, were erected on raised platforms of stone, within which the dead were buried. Each platform or *ahu* belonged to a family. Since the number of statues standing on a *ahu* varied between one and sixteen, it seems more likely that they represented certain specially distinguished ancestors of the family than images of the individuals buried there.[191] The statues all show only the head and nude torso, as far as the hips, of males, and they were originally surmounted by cylindrical stone "hats." There is evidence that each statue was carefully completed at the quarry, whence it was hewn, except for the eyes, which were not carved until it was erected on the *ahu*. This curious fact recalls the ancient Egyptian ritual of the "Opening of the Mouth" of statues and mummies, in order to animate them.[192] If some such intention explains the Easter Island custom, it would mean that these "ancestral" images were regarded as being magically endowed with life, and so had more than a commemorative significance. Unfortunately, violent conflicts, probably of racial origin, brought this *ahu* cult

122

233, 234

232. Faceless statue of Persephone, found at Cyrene, Libya.

233. Below: Easter Island statues on platforms.

234. Far right: Easter Island statue, wearing cylindrical stone "hat."

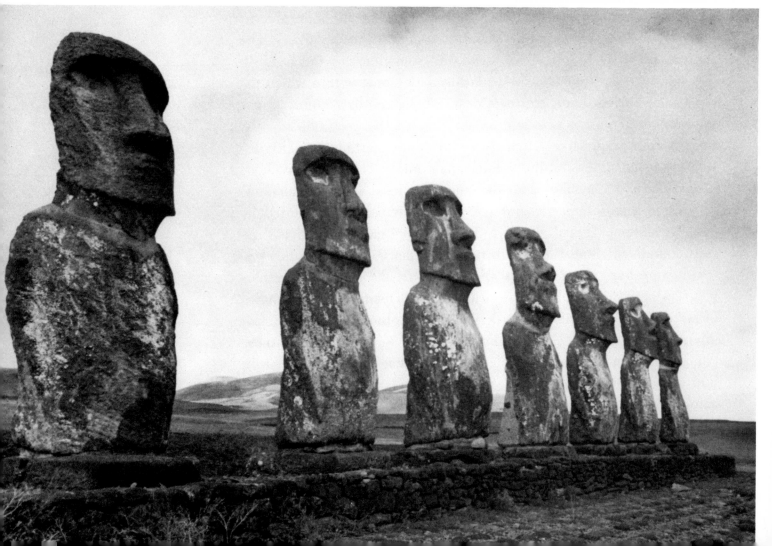

to an end, and there are no written records of the beliefs that had inspired it.[193] But whatever their purpose, the six hundred or more colossal figures found on Easter Island form an impressive, though mute, company of witnesses to the use of mortuary iconography in this far-off spot in the Pacific Ocean.

7. ETRUSCAN CULTURE:

The funerary art of the Etruscans, which now requires our attention, presents a series of problems that have the salutary effect of reminding us that mortuary beliefs and practices cannot always be neatly assigned to predetermined categories; and it also constitutes a major instance of an iconography that has to be interpreted without the guidance of contemporary texts.

The Etruscan tomb was modelled to represent a house, thus seemingly giving expression to a belief that the dead lived on in their tombs, as the Egyptians also believed.[194] So realistically conceived was this belief that in the "Tomb of the Reliefs" (third century B.C.), at Caere, domestic utensils and animals, as well as weapons and armour, were carefully depicted in stucco relief on the walls and pillars.[195] On the analogy of Egyptian funerary art, it is tempting to interpret such representations as magical substitutes for the real things. However, among the depictions of utilitarian objects there are also representations of such mythical beings as Scylla and Cerberus, the three-headed dog that guarded the entrance to Hades. It is difficult to believe that these figures were also magical substitutes that would acquire some *post-mortem* reality for the service of the dead.[196]

235

236

237

A similar problem is provided by the frescoes that have been found in many Etruscan tombs. In the earlier examples, which date from the fifth and sixth centuries B.C., scenes from everyday life are depicted—banquets, music and dancing, hunting and fishing, and athletic games.[197] Again, on the analogy of the Egyptian tomb-paintings, it seems reasonable to assume that such depictions were meant to perpetuate magically the pleasures of this life in the afterlife of the dead. However, certain features suggest that other motives inspired the Etruscan frescoes. Thus, in the banqueting scenes, despite their gaiety and evident delight in conviviality, a reminder is given of their sombre purpose by representing certain of the participants as holding an

238

235. Etruscan ash-urn in the form of a house. From Chuisi.

236. Etruscan "Tomb of the Reliefs," at Caere (Cerveteri), Italy, showing domestic implements.

237. "Tomb of the Reliefs," at Caere (Cerveteri), showing weapons and mythical beings, including Cerberus.

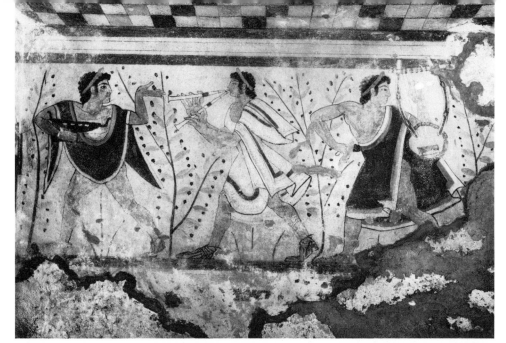

238. Festal scene, showing young men with wine bowl, musical pipes and lyre. From the "Tomb of the Leopards," Tarquinia, Italy.

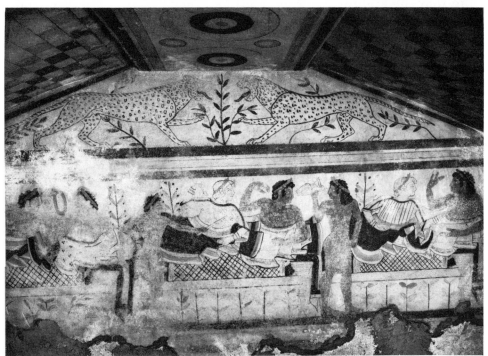

239a. Banqueting scene from the "Tomb of the Leopards," Tarquinia.

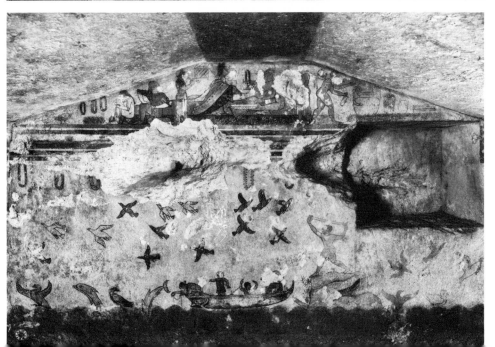

239b. Fishing scene from the "Tomb of the Hunt and Fishing," Tarquinia.

egg. This egg is clearly not intended to be an article of food consumed at the banquet, but a symbol of new life after death.[198] In other words,

239a these convivial scenes probably represent the funerary banquet, at which the deceased is imagined as being present in his *post-mortem* form of being.[199]

What might be the significance of the scenes of dancing, hunting

239b and fishing, and athletic contests in the Etruscan tombs presents an even more difficult problem. It has been suggested that such representations of joyous vitality and vigorous action were designed to assist in revitalising the dead.[200] This could well be; but it is necessary to note that the athletic contests doubtless relate to the funerary games which formed a distinctive feature of the Etruscan obsequies.[201] A funerary style, dating from *circa* 400 B.C. and now in the Museo Civico, Bologna, graphically attests to this connection. In the major register the deceased is shown in a chariot led by a daimon, en route for the underworld. Below this scene, and obviously associated with

240 its symbolism, funerary games are represented.[202] But Etruscan mortuary art has other puzzling features. For example, the mid-sixth-century "Tomb of the Bulls," at Tarquinia, has a large picture of an

241 incident from the Trojan War: Achilles is depicted waiting in ambush behind a fountain for the unsuspecting Troilus, who approaches on horseback.[203] Above this scene is a frieze of enigmatic import: on one side two nude beings shelter behind the inadequate protection of a single plant from a charging man-faced bull.[204] Whether such scenes should be regarded as having some esoteric meaning, or merely as decoration of a whimsical kind, such as frequently appears in mediaeval Christian art, cannot be known.[205] But, whatever may have been their meaning and purpose, for us they witness to the variety of subject and complexity of motive manifest in the iconography of the Etruscan tomb.

Etruscan funerary art presents yet another problem of great importance for the history of Etruscan culture, and one that relates also to a curious issue of the comparative study of tomb iconography. From the fourth century B.C., baleful monsters from the Etruscan under-

242 world appear in the funerary scenes: Charun, whose body has the hue of decaying flesh and who holds the mallet with which he deals the blow of death;[206] the beak-nosed Tuchulcha, who menaces the dead

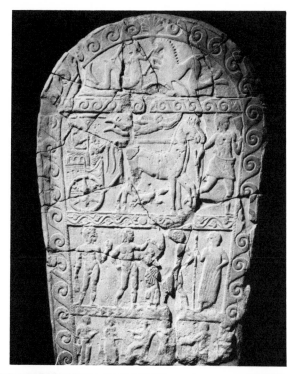

240. Etruscan tombstone from Bologna, showing funerary games and passage of the dead to the Underworld.

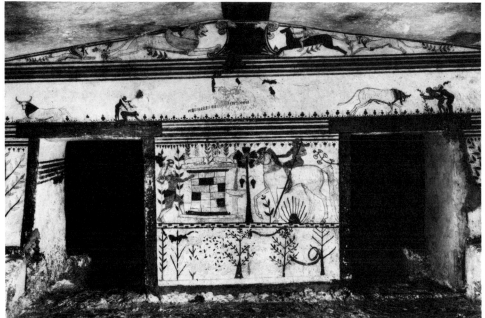

241. "Tomb of the Bulls," Tarquinia, showing Troilus and Achilles, beneath a bull frieze (*c.* 530 B.C.).

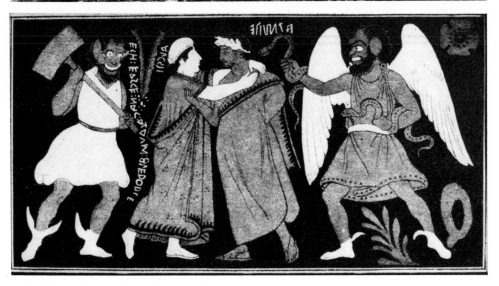

242. Parting of Alcestis. Etruscan vase painting showing Charun and Tuchulcha.

243

with horrible snakes;[207] and the wolf-capped Lord of the Underworld, whose grim countenance frowns from a wall of the "Tomb of Orcus."[208] On the sides of sarcophagi, scenes of slaughter and human sacrifice begin to be carved.[209] The cause of this change from the apparent serenity of the early sepulchral art has been much discussed. Some scholars have attributed it to the decline of Etruscan political power before the rising might of Rome.[210] But it might also reflect that increasing morbidity that characterises many cultures after they are past their apogee; and we shall presently consider a like phenomenon in Christian art of the late mediaeval period.

244a

244b

245

The iconography of the Etruscan tomb often included an image of the deceased, sometimes with his wife, set on the top of a sarcophagus or cinerary casket. These images varied considerably in size; but whether large, as in the case of the superb terra-cotta effigies of a man and wife found at Caere and now in the Museo di Villa Giulia, Rome, or diminutive as the figures of an aged couple on a small terracotta urn in the Museo Guarnacci, Volterra, these images are realistic portraits of the persons concerned.[211] But what their function was is not clear. Inevitably we are reminded of the portrait- or *ka*-statues of ancient Egypt: however, there is no evidence that the Etruscans attached the same importance to the preservation of the body, or to having a sculptured replica of it, as did the Egyptians. It is, consequently, uncertain whether these mortuary images were placed in the Etruscan tombs to provide a magical substitute for the body, disintegrated by death, or to preserve the memory of the visible appearance of the deceased. What is probably the most notable example of the complexity of Etruscan eschatology, which still eludes our analysis, is the funerary monument of Arnth Velimnes Aules in the "Tomb of the Volumni," near Perugia.[212] Fashioned out of stone in the second century B.C., the deceased is shown reclining serenely on a couch above the cinerary casket. In this casket a sealed door, similar to the "false door" of the early Egyptian tombs, is guarded on either side by the winged figures of *lasas*, daimonic beings of the Etruscan underworld.[213] The monument eloquently epitomises the ambivalent spirit that pervades Etruscan funerary art: the dead are portrayed as feasting or resting with quiet dignity, unconcerned by their sombre fate and the grisly beings that surround and menace them.

243. The wolf-capped Lord of the Underworld, depicted in the "Tomb of Orcus," Tarquinia.

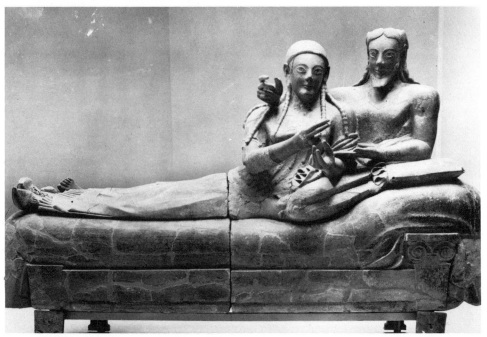

244a. Etruscan terracotta sarcophagus from Caere (Cerveteri) (*c.* 500 B.C.) showing reclining effigies of a husband and wife.

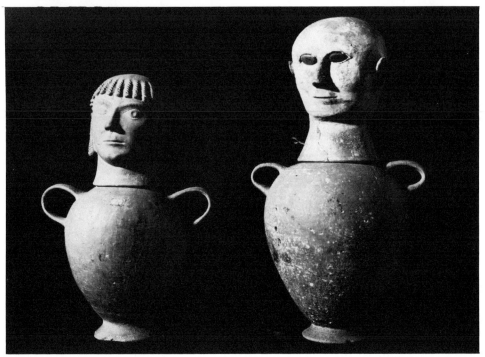

244b. "Canopic" burial urn from Chiusi, Solaia (late 7th century B.C.). Clay lid in the form of a head on a bronze urn.

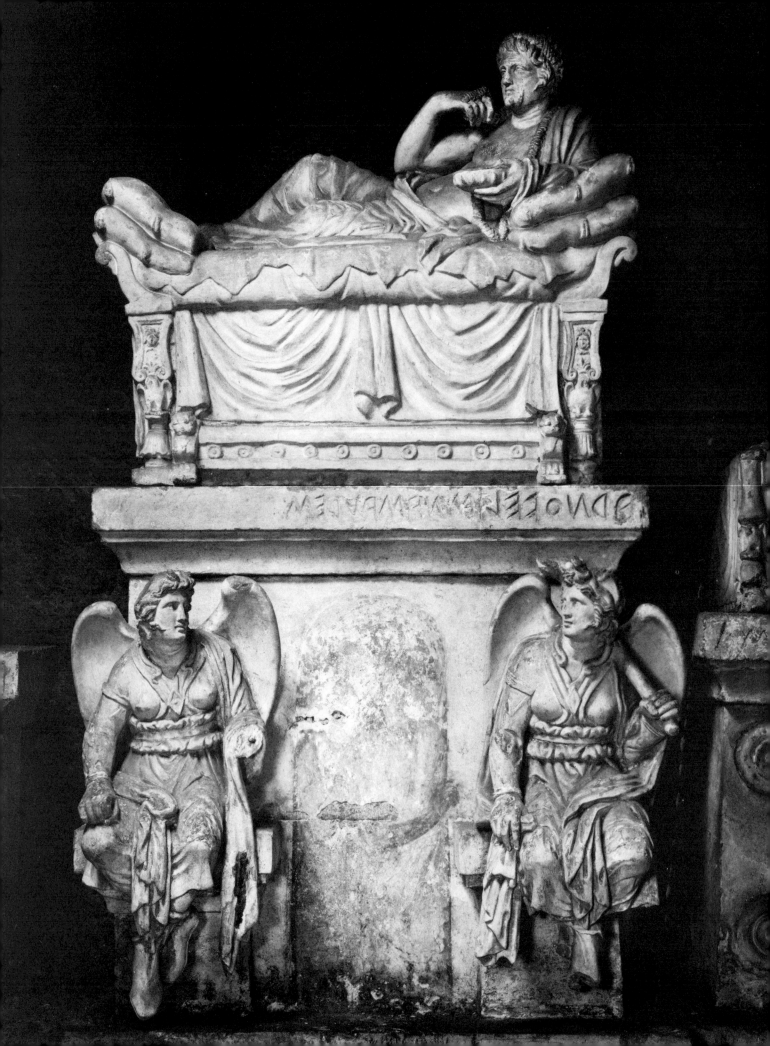

8. ARAMAEAN AND PALMYRAN FUNERARY ART:

The sepulchral images of Etruria, ambiguous in their significance, will serve to introduce us to a form of funerary iconography which seems to be primarily commemorative, but which may also have some magical intent. We may conveniently begin our survey with an ancient Aramaean funerary stela, which shows the image of the deceased, Sin-zir-ibni, carved in bas-relief.[214] An inscription, which identifies the deceased, has a considerable significance for our studies. It reads:

Concerning Sin-zir-ibni, priest of Sahar at Nerab [Neirab]. He is dead; this is his image and resting place. Whoever you might be who would damage this image and tomb or remove it from its place, Sahar and Shamash and Nikkal and Nusku will blot out your name, your place and your life, and they will cause you to die an evil death, and make your posterity perish. But, if you will preserve his image and this resting place, in recompense may you and yours be preserved.[215]

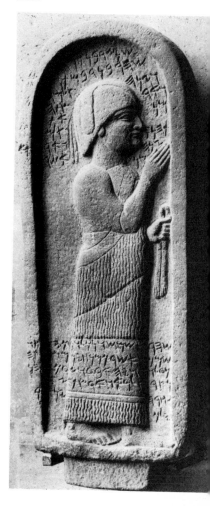

246. Funerary stele of Sin-zir-ibni, found at Neirab.

This threat of divine vengeance on any who might destroy the image, as well as the grave, clearly attests to the importance attributed to such funerary images in ancient Aramaean society. From the wording of the inscription, it would seem that the image was essentially commemorative of the deceased, and was in no way regarded as a substitute form for the soul to inhabit. Its commemorative function, however, was certainly connected in some way with the *post-mortem* well-being of the deceased. Some indication of what this may have been is perhaps given in another stela of a priest named Agbar, of the god Sahar, also at Neirab. The dead man is shown seated and partaking of offerings made to him by a smaller figure, which might represent his son. The image thus seems to have served two purposes: it gave the deceased the solace of knowing that his likeness would be preserved after the dissolution of his body, so helping to keep his memory green among men; and it provided a necessary psychological focus for those who ministered to his mortuary needs and reverenced his memory.

This twofold function of the mortuary image surely reflects an instinctive yearning for the continuance of personal significance beyond the oblivion of death. And it unites with the natural desire of relatives and friends to recall the features of those, beloved or re-

245. Tomb of Arnth Velimnes Aules, in the "Tomb of the Volumni," Perugia.

spected, whose mortal remains lie buried in the tomb. It is the sentiment to which the English poet Thomas Gray gave expression in words of haunting poignancy:

> For who, to dumb forgetfulness a prey,
> This pleasing anxious being e'er resign'd,
> Left the warm precincts of the cheerful day
> Nor cast one longing lingering look behind?
>
> On some fond breast the parting soul relies
> Some pious drops the closing eye requires;
> E'en from the tomb the voice of Nature cries
> E'en in our ashes live their wonted fires.[217]

In testimony to the ubiquity of this feeling, the iconography of the tomb in many cultures, past and present, provides abundant and impressive evidence. A selection only of examples can be given here; but they will suffice to show how readily man has turned to the durability of stone or metal to preserve the memory of his own impermanent form.

From the witness of Etruscan and Aramaean funerary art, which has brought us to the commemorative aspect of the iconography of the tomb, we may pass on to the rich treasury of Palmyran mortuary sculpture. The citizens of the famous caravan city of Palmyra were accustomed, during the first three centuries of the present era, to bury their dead in tower tombs and subterranean *hypogea*. The sarcophagi were placed in mural niches (*loculi*), which were closed by sculptured representations of the deceased. A particularly notable example of this sepulchral arrangement has been reconstructed in the Damascus Museum.[218] The focal point is a sarcophagus, upon which a sculptured group is represented at a funerary banquet. Surrounding this group, on the other walls, are busts of relatives, behind which their bodies were deposited. The mausoleum, as a whole, constitutes an assemblage in effigy of a family or clan, and a depository of their mortal remains. About the same time in the city of Edessa, in northern Mesopotamia, families of the dead also were commemorated, *en masse*, by portrayal in coloured mosaics. They appear standing, alive and alert, or partaking of the traditional funerary banquet.[219] It is to be noted that at Edessa the setting up of funerary images was sometimes stated, in inscriptions, to have been done in obedience to divine command.[220]

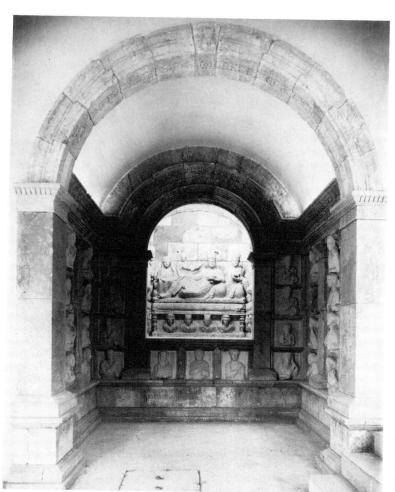

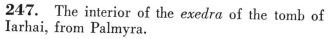

247. The interior of the *exedra* of the tomb of Iarhai, from Palmyra.

248. "Funerary Couch Mosaic," from Edessa (Urfa), dated A.D. 278, representing a funerary banquet.

249. Pre-Islamic Arabian funerary stele, showing stylised head.

250. Stele of 'Igli. Pre-Islamic Arabia.

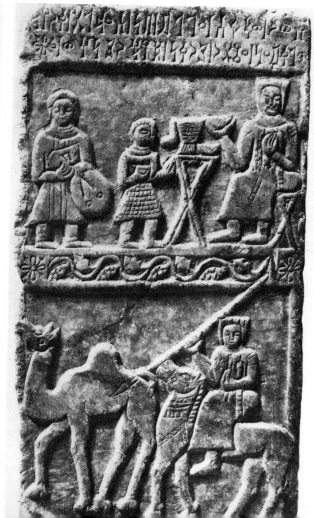

9. PRE-ISLAMIC ARABIA:

In contrast to this sophisticated funerary iconography of Palmyra and Edessa, but expressive also of the reaction of a Semite people to death, are the memorials raised to the dead in pre-Islamic Arabia. Crudely carved statuettes and stelae, and sometimes roughly delineated heads only, were erected over graves.[221] So crude are they that it is difficult to believe they could have been considered as adequate portraits of the deceased. Consequently, the fact that they were made and erected suggests that they served some purpose that required a semblance of the human form, if not exact portraiture—possibly they provided a locus for the *nafs* (souls) of the deceased, to which mortuary offerings could thus be directed.[222] A more elaborate example of such stelae may be noticed, because it shows the dead man feasting and riding, and it carries an inscription that significantly testifies to its religious importance: "Funeral image and stela 'Igli, son of Sa'dlati Qurain. And may 'Athtar of the East smite him who effaces it."[223]

10. GREECE AND ROME:

Turning westwards in our survey, we find that, whilst ancient Crete provides no evidence of tomb iconography, the famous royal graves at Mycenae (*c.* 1500 B.C.) have yielded unique material.[224] Certain men, evidently kings, had been buried there with gold masks covering their faces. These masks appear to have been designed as portraits of the deceased; for, although crudely moulded, they represent different types of faces.[225] No other evidence permits us to interpret the significance of these masks. We can only conclude that, in the case of the persons concerned, there had been some desire to preserve the memory of their facial features in the grave; but this must have been done for the sake of the dead, since the living had no access to the bodies after burial. Of seventeen stelae that marked the graves in Circle A, in which the masks were found at Mycenae, a few have sculptured scenes but with no apparent funerary significance.[226]

In contrast to this meagre use of iconography, Greek funerary practice in subsequent centuries has left to posterity some of the noblest funerary monuments of all time. Under the influence of what became the classical view of human nature and destiny, it is the theme

of commemoration that characterises these monuments. For believing that death was virtually extinction, the Greeks inevitably sought rather to perpetuate their memory among the living than to plan for their mortuary needs.[227] However, there do exist a few monuments that reflect belief in a more effective kind of afterlife, being thus representative of another evaluation of the nature and destiny of man.[228] One of the most notable of these monuments was, significantly, erected at Xanthos in Lycia (*c.* 550–500 B.C.), where Greek culture intermingled with other cultural traditions.[229] Known as the "Tomb of the Harpies," the central sections of two of its reliefs show the deceased **252** lord and lady, seated and receiving mortuary offerings. Flanking one of these reliefs are sculptured depictions of winged creatures, half-human and half-bird, flying off with small human figures. These **253** winged beings have been identified with the mythical harpies, snatching away human souls.[230] The identification is uncertain; but there can be little doubt that the reliefs were intended to represent death as a ravishing of the soul, imagined as a diminutive human being as Christian artists of the Middle Ages were also to conceive of it.[231] How this idea of the carrying off of the soul was related to the representation of the dead lord and lady as fully constituted human beings, alive and alert and able to receive and enjoy offerings of a material kind, is obscure. However that may be, the Tomb of the Harpies witnesses, iconographically, to a forward-looking faith: the dead are thought of as existent, not as defunct beings. These scenes may be **254** compared with that on a sixth-century B.C. tomb at Chrysapha. In this Spartan relief, the mortuary snake indicates that the enthroned couple are deceased.

It is the memory of those regarded as departed and defunct that the funerary monuments of classical Greece record, in a sculpture that is noble alike in its expression of pathos and its dignity of composition. In a variety of scenes, the deceased is portrayed as one who has left, for ever, the familiar world of everyday things and its warmth of human relationships. There are scenes of wistful farewell: a woman gazes sadly at her jewels; a little girl cherishes her doves; an old man **255a, b** quietly gives a cicada to his dog.[233] Each scene suggests, with an infinite sadness, that some little personal act, so often done, has now been done for the last time. In other ways, too, the pathos of death

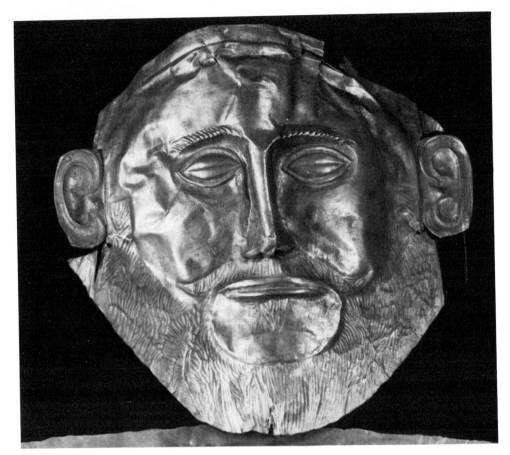

251. Gold funeral-mask of a Mycenaean prince (so-called "Mask of Agamemnon").

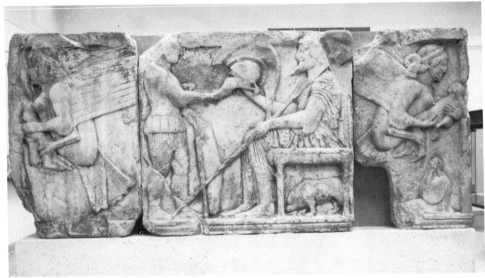

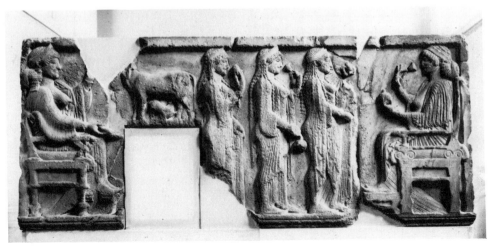

252, 253. Centre reliefs from "Tomb of the Harpies" at Xanthos (two sculptured panels).

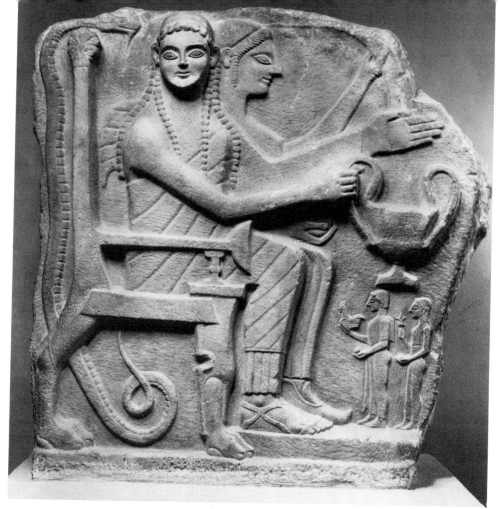

254. Relief from 6th-century tomb at Chrysapha, Sparta, showing deceased receiving mortuary gifts.

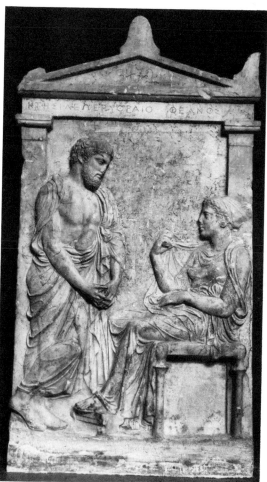

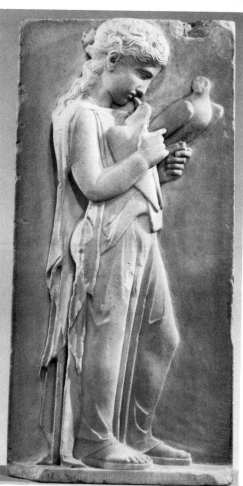

255a. Gravestone at Theano.

255b. Tomb-relief showing a young girl with doves (4th century B.C.), from Paros.

[205]

256

257

258

finds expression. An aged man sadly contemplates one who is young, perhaps his dead son, whose gaze seems fixed on an empty infinity, while at his side a small boy mourns.[234] Or, Demokleides, son of Demetrios, sits a solitary figure, mourning on the prow of the ship in which he met his doom.[235] Sometimes the dead were commemorated on *lekythoi*, small oil vessels which were deposited in the grave. One especially pathetic example shows a small child, holding a toy cart and waving good-bye to his mother, while Charon, the grim ferryman of the dead, waits to take him over the baleful river that divides the world of the living from the world of the dead.[236]

The inscriptions which accompany the sculptured scenes are laconic to a degree. Generally, they record only the name and the father of the deceased, with perhaps an added "Farewell."[237] Occasionally an epitaph was engraved, poignant in its austerity, as the following example: "Looking on the monument of a dead boy, Kleoetes, son of Menesaechmos, pity him who was so beautiful and died."[238]

We can only speculate on the motive that inspired the setting up of these memorials. They served no ritual purpose; yet they surely responded to a deeply felt need. It would seem that the very conviction of the impermanence of human life caused the Greeks to grasp at the opportunity, which the art of the sculptor offered, to perpetuate at least in stone effigy the features of relations and friends, thus striving to defeat the oblivion of death by the durability of carved stone.[239]

259

But Greek sepulchral art witnesses also to the development of a less austere view of man's fate. The mystery religions and mystical philosophies, such as Pythagoreanism, encouraged belief in the immortality of the soul and the possibility of some form of ethereal beatitude after physical death.[240] For the illustration of such metaphysical ideas, recourse was had to a recondite symbolism, which is often difficult to interpret. The supreme example of this type of funerary iconography was the famous Mausoleum at Halicarnassus, which was one of the "Seven Wonders" of the Ancient World. Erected about 350 B.C., by Artemisia, in memory of her husband Mausolus, prince of Caria, the monument was a kind of *hērōon* which proclaimed the apotheosis of Mausolus.[241] The theme of heroic victory was symbolised by the quadriga, which crowned the upper pyramidal structure. This massive sculptural group represented Mausolus, erect in a four-horsed chariot,

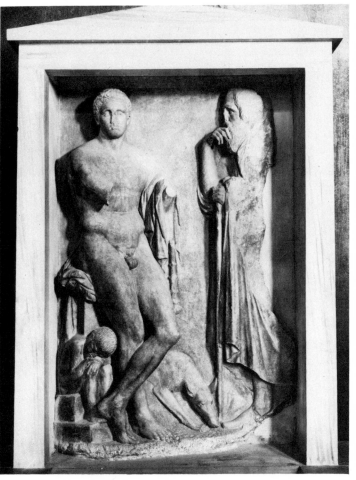

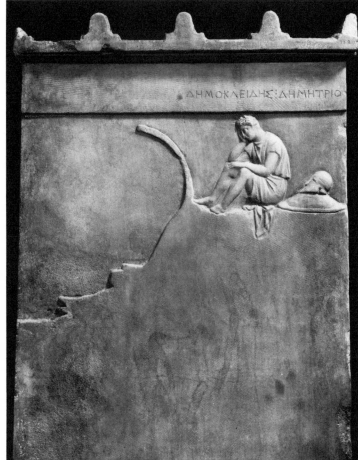

256. Funerary stele showing a deceased youth, contemplated by older cloaked figure, probably his father.

257. Stele of Demokleides, showing the deceased on the prow of a ship.

258. Attic lekythos (late 5th century), with the representation of a small boy, with toy cart, waving farewell to his mother, while Charun awaits him.

259. Reconstruction of the Mausoleum of Halicarnassus, by A. J. Stevenson.

260. Sculptured panel from the Mausoleum of Halicarnassus, showing the struggle between Greeks and Amazons.

symbolically in control of those potent but wayward forces that raised the soul above the world of time and space.[242] The theme of heroic contest was portrayed also in friezes depicting the mythological battles of Greeks and Amazons and Centaurs and Lapiths.[243]

<div style="text-align: right">**260**</div>

The transcendent destiny of the dead Mausolus, which the superb monument at Halicarnassus was designed to proclaim, was represented, on more modest scale for lesser folk, by elaborately carved sarcophagi which became fashionable in the Hellenistic period. Sometimes the apotheosis was symbolised by the portrayal of the deceased invested with the insignia of divinity. A notable instance of this form of mortuary presentation is the sarcophagus of a priestess, now in the Musée de Lavigerie, Carthage, on which the dead woman appears as a goddess, possibly Tanit or Isis.[244] But more typical were the sarcophagi with side panels bearing sculptured scenes drawn from the rich mythology of Greece. They became especially fashionable in Roman Italy, where they were doubtless much influenced by the Etruscan sarcophagi and ash caskets, already noticed. Two examples may be briefly described from the many specimens preserved in the museums of Rome and elsewhere.[245]

<div style="text-align: right">**261a, cf. 261b**</div>

The so-called "Prometheus Sarcophagus," now in the Museo Capitolino at Rome, was evidently intended to portray the hope of immortality which his parents cherished for their dead son, whose sleeping figure surmounts the lid of the sarcophagus.[246] On the side panel, a multiplicity of sculptured figures symbolise various aspects of the mythology of human destiny. The central scene is probably the most significant of the composition. It represents Prometheus creating human beings, into which the goddess Minerva inserts the souls in the form of a butterfly, which was itself a symbol of resurrection.[247]

<div style="text-align: right">**262**</div>

Some Roman sarcophagi seem to express, in their sculptures, beliefs inspired by the mysteries of Dionysos.[248] An instructive example, now in the Walters Art Gallery, Baltimore, portrays the finding of Ariadne by Dionysos on the island of Naxos.[249] That this scene, with its medley of Bacchanalian figures, was deemed an appropriate subject for a sarcophagus is surprising to our modern minds; but it had a deep significance for the initiate of the Dionysian mysteries. The myth of Ariadne, who was forsaken by Theseus at Naxos and found there by Dionysos and made his immortal bride, was seen as an allegory of the

<div style="text-align: right">**263**</div>

261a. Sarcophagus lid with carved effigy of a Punic priestess.

261b. Anthropoid sarcophagus found at Sidon (5th century B.C.).

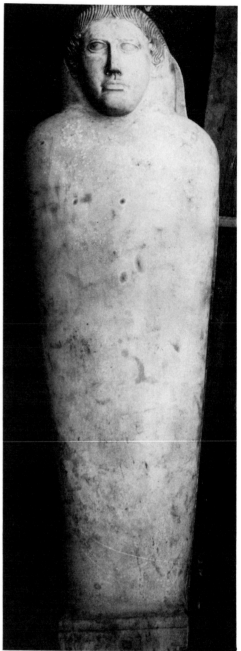

262. The "Prometheus Sarcophagus" (including lid).

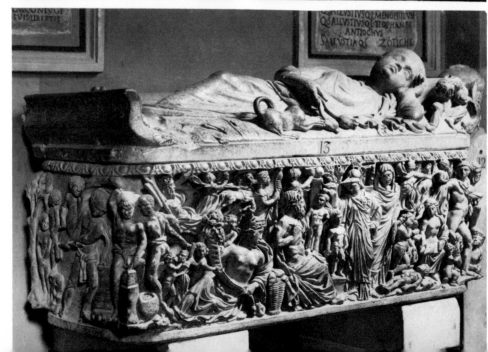

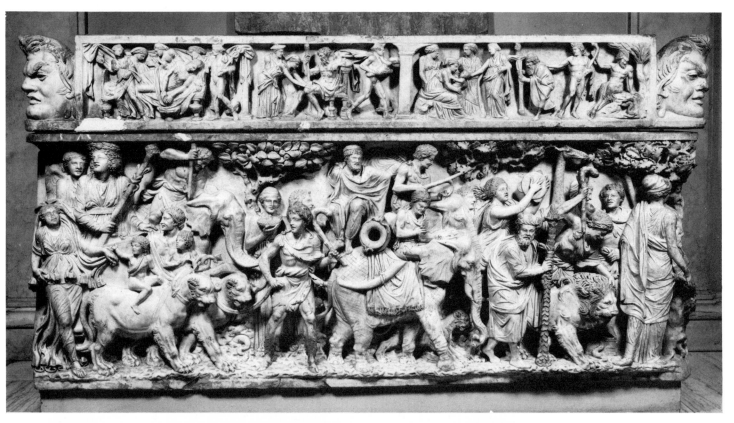

263. Dionysiac Sarcophagus (front).

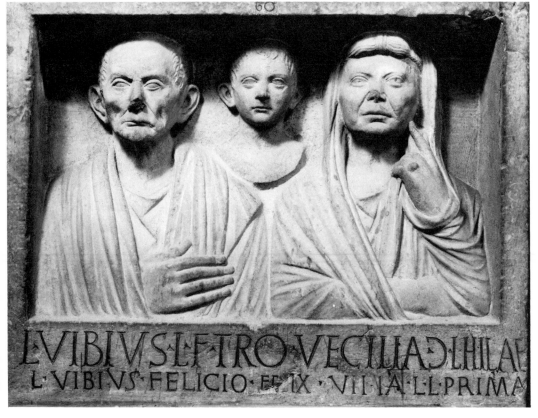

L·VIBIVS·L·F·TRO·VECILIA·Q·L·HILAE
L·VIBIVS·FELICIO·EE·IX·VILIA·LL·PRIMA

264. Tombstone of L. Vibius and family.

soul and its quest for salvation.[250] To link the dead woman, enclosed in the sarcophagus, with this sculptured parable, her portrait bust was placed over it and set amid *putti* engaged in Bacchic tasks.[251]

The use of these ornately sculptured sarcophagi was inevitably confined to wealthy families, who could afford thus to express their faith when they buried their dead. Elsewhere in contemporary Roman society, funerary art was generally of a commemorative kind. Among those of modest means, portrait busts, carved on tombstones, preserved the memory of their physical appearance when alive.[252] Sometimes more elaborate monuments recorded scenes from their lives: thus, the career of a successful general; or the bakery and its operations that had evidently brought wealth to M. Vergilius Eurysaces, whose curious tomb still stands near the Porta Maggiore in Rome.[253]

11. CHRISTIANITY:

In the vast and diverse legacy of mankind's sepulchral art, Christianity rivals the religion of ancient Egypt in the magnitude of its contribution, though it differs profoundly from it in its inspiration and purpose. Its earliest art form was pictorial; for, until Christianity gained legal recognition in the early fourth century, it was more possible to depict funerary themes on the walls of catacombs than to arrange for the dead to be buried in sarcophagi displaying carved representations of Christian themes. But before commenting on this catacomb art, mention must be made of some problematic evidence found in recent years in Palestine.

Ossuaries, dating probably from the first and second centuries and perhaps of Jewish-Christian origin, have been unearthed in various places, inscribed with the names of the deceased and crudely shaped cross-marks. Since there is reason for thinking that the cross-mark (*taw*) was an established Jewish symbol for eschatological salvation, and because Christians were "sealed" with the sign of the cross in baptism, the inscribing of a cross on these ossuaries is surely significant. The practice may thus represent the earliest essay in Christian mortuary symbolism.[254] Even more problematic, but fascinating for their witness of an obscure phase of primitive Christian belief, are the strange funerary stelae, of a somewhat later date, found at Hebron (Kherbet Kilkis) and elsewhere. They are mostly rectangular in form,

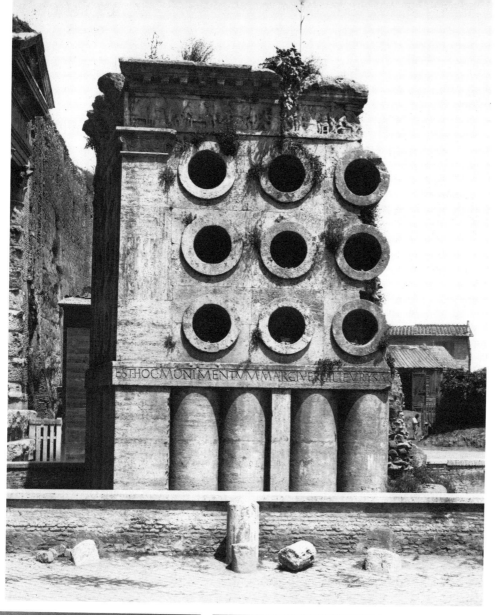

265. Tomb of M. Vergilius Eurysaces.

266. Ossuary No. 8, from Talpioth, showing a cross-mark.

267. Funerary stelae of Jewish-Christian sect found at Kherbet Kilkis (Hebron).

and surmounted with a crudely delinated head: some examples have legs and arms. Upon the flat body a variety of esoteric signs are inscribed: among them, notched crosses and palm branches figure frequently.[255] The symbolism has been interpreted as expressive of the beliefs of Jewish-Christian Gnostic sects.[256] Whether that identification be sound or not, the fact of their sepulchral character and anthropoid shape suggests that these stelae related in some way to the *post-mortem* destiny of the Christians whose graves they marked.[257]

Returning to the art of the catacomb, we shall do well to begin by noting how Christians, from an early period, regarded the disposal of their dead as a matter of communal concern. Belief in a physical resurrection caused them to reverence the bodies of the dead, and, as we have seen, the relics of martyrs, the elect heroes of the faith, soon became the most highly prized of cult objects.[258] The catacombs, which often contained the bodies of saints, were literally stacked with the bodies, each in its narrow *loculus*, of the ordinary Christian dead.[259] But they were not left there in darkness and oblivion. The anniversary of their death, especially if they were martyrs, was joyously kept as their birthday (*natalitia*) into eternal life. The Eucharist was celebrated, and a funerary feast (*agapē*) held at their tomb.[260] The early Christians called the burial places of their dead, significantly, *coemeteria* ("sleeping places"), in the belief that they would repose there in peace until the Resurrection at the Last Day.[261] The catacombs were decorated in a manner that was expressive of this faith.

The subjects chosen for portrayal in catacomb art seem, at first sight, singularly unconnected with death or other eschatological themes. Indeed, the only topic that definitely involves the depiction of a corpse is Christ's miracle of the Raising of Lazarus from the dead, which was often represented.[262] But the significance of this scene lay in Christ's power to confer new and immortal life. And it is this power which is the predominant theme of all other subjects depicted on the walls and ceilings of the catacombs. Chosen chiefly from the Old and New Testaments, these subjects typify the saving and revivifying power of God. Thus, Moses strikes the rock and the stream of life-giving water gushes forth; Daniel is safe in the lions' den; Jonah comes forth from the devouring sea monster; Christ heals the paralytic man and the woman with the issue of blood.[263] Other scenes have

268

269

270, 271

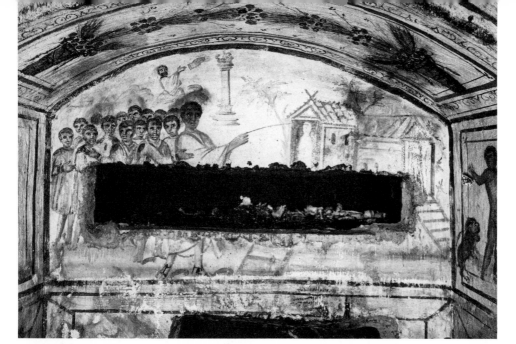

268. Early Christian catacomb painting of the Raising of Lazarus, showing *loculus*. Catacomb of the Via Latina, Rome (A.D. 350).

269. Representation of the *agapē* in the Catacomb of SS. Peter and Marcellinus, Rome (late 3rd century).

270. Jonah cast into the sea. Painting (*c.* A.D. 250) from the Catacomb of San Callisto, Rome.

271. Christ healing the woman with an issue of blood. Painting from the Catacomb of SS. Peter and Marcellinus, Rome.

272. Christ as the Good Shepherd, painting in the Catacomb of San Callisto (Crypt of Lucina), Rome (early 3rd century).

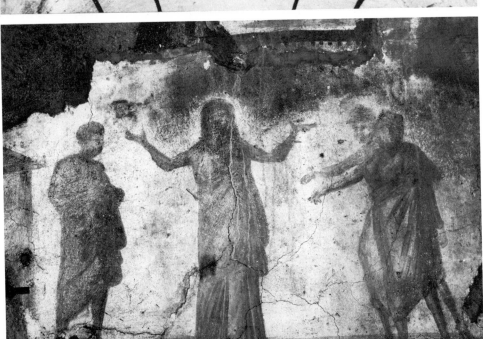

273. An "Orans" (*Donna velata*) depicted between two figures, in the Catacomb of Priscilla, Rome.

sacramental meaning. The regenerative virtue of baptism is portrayed, and so also the life-giving Eucharist, which is often symbolised by the fish that mystically represented Christ.[264] Other frequent and typical figures are the Good Shepherd and the "Orans" or praying figure signifying the pious soul.[265] This latter figure witnesses to an interesting development of Christian thought. In the earliest examples of catacomb art the ordinary deceased Christian is never portrayed, and the "Orans" was an allegorical representation, originally derived from pagan art, symbolising the pious worship of God. But about the middle of the third century, many "Orans" figures begin to show individual traits, thus suggesting they were portraits of deceased Christians, presented in the traditional posture of prayer.[266] The change, however, did not establish itself in catacomb art, and the "Orans" posture was later reserved for the representation of saints.[267]

It is time now to face the question of the meaning of this unique funerary art of the early Christians. There are a number of possibilities: that it was merely a form of pious decoration; that its purpose was didactic or designed to commemorate the dead buried in the catacombs; or that it was intended in some way to promote the eternal well-being of the dead.

That some element of aesthetic satisfaction was present in the painting of the walls and ceilings of the catacombs seems clearly evident in the foliate and geometric patterns and other ancillary motifs such as *amorini*, birds and flowers, which border the religious scenes —many of these artistic motifs were doubtless drawn from contemporary secular decoration, such as is found at Ostia and other sites.[268] However, such aesthetic motivation was obviously incidental, and the religious concern of the paintings is indisputably paramount. That the scenes would have served to instruct the living who entered the catacombs, and remind them of the saving truths of their faith, is certainly evident; but, since the depictions were only occasionally seen, it seems unlikely that their purpose was primarily didactic. The preservation of the memory of the dead could, also, scarcely have been the major motive; for, as we have noted, portraits of the deceased rarely appear,[269] and the inscriptions on the plaster that covered the openings of the *loculi* were essentially prayers or statements concerning the *post-mortem* state of the dead, and not commemorative records relat-

439

92, 269
272, 273

439

92

274a, b, c, d

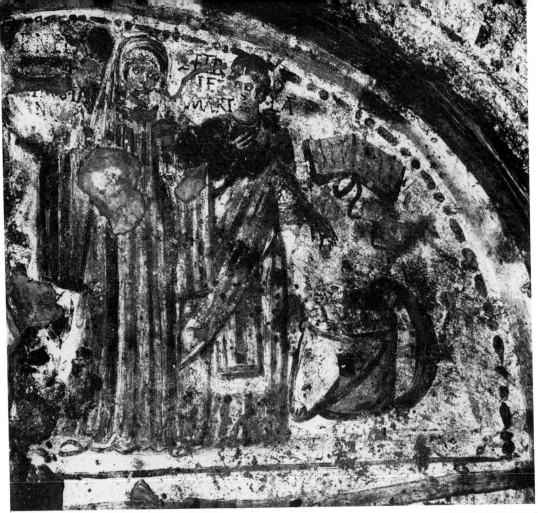

274a. One of the few depictions of the deceased: Veneranda led into Heaven by St. Petronilla. Catacomb of Domitilla, Rome (*c.* A.D. 350).

274b. Another unusual portrait of the deceased: Vibia carried off by Pluto. Catacomb of Praetextatus, Rome (tomb of Vicentius).

274c. Judgment of Vibia. Catacomb of Praetextatus.

274d. Vibia led into Paradise. Catacomb of Praetextatus.

275

276a, b

277

278

ing to their identity and status in this life. Indeed, the most typical inscriptions are those that give the name of the deceased, followed perhaps by some simple phrase such as *in pace* ("in peace").[270]

It would seem, therefore, that the catacomb paintings were intended to benefit the dead, and were not addressed primarily to the living. Hence, the scenes of divine deliverance or salvation, although they represent events recorded in the Old and New Testaments, were not painted to recall these events for the instruction or edification of such as might visit the catacombs. Rather, they were painted to present once again the saving efficacy of the events for the sake of the dead who were buried there. For Christ depicted raising up Lazarus, or freeing the paralytic from the constriction of his disease, would renew the revivifying power of that miracle of resurrection or provide release to a new life from the bonds of sinful mortality. Likewise, the re-presentation of baptism and the Eucharist perpetuated the grace of these sacraments for those who lay *in pace* within the tomb.[271]

Similar motives, doubtless, inspired the production of the sculptured sarcophagi which came into use after the emperor Constantine gave peace and his patronage to the Church. These sarcophagi followed the style of those already in fashion in pagan society, and of which we have already taken note. Sometimes certain pagan motifs were retained in their decoration, but the iconographic program as a whole was essentially Christian.[272] Indeed, many of the established concepts of catacomb iconography appear on the sculptured sides of these sarcophagi: for example, Jonah and the "whale," Daniel and the lions, the raising of Lazarus.[273]

Since the sides of a sarcophagus permitted the organisation of an interrelated ideology in a manner not apparently possible on the walls of catacombs, a distinctive theological theme is often presented in a series of sculptured scenes.[274] Such themes are invariably soteriological in character, and the fact that the meaning is not indicated by inscribed texts is especially significant, as we shall presently see. Thus, on the same sarcophagus, the following key events from the Christian "Salvation-History" (*Heilsgeschichte*) might be portrayed: the Temptation and Fall of Adam and Eve; Abraham's sacrifice of Isaac; the sufferings of Isaac; the sufferings of Job; Daniel in the lions' den; Christ enthroned above the heavens.[275] The sarcophagi, in contrast to

275. *Dionysias in Pace* (late 3rd century). Painting from the Catacomb of San Callisto (Cubiculum of the Cinque Santi), Rome.

276a. *Crowning with Thorns.* Painting from the Catacomb of Praetextatus, Rome (3rd century).

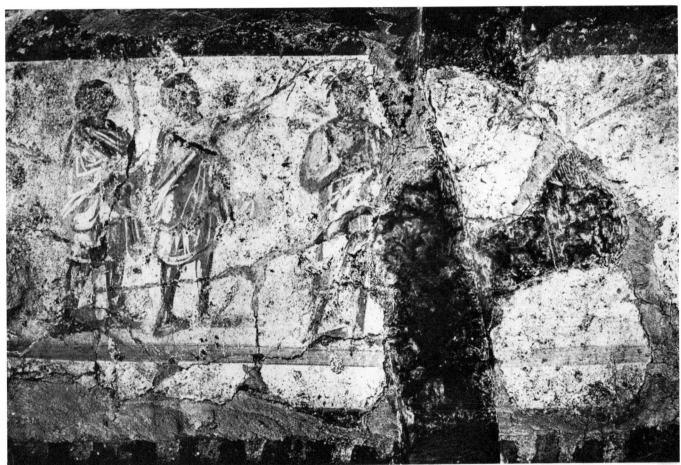

276b. Early Christian seal-stones, depicting "salvation-events" drawn from the Old Testament.

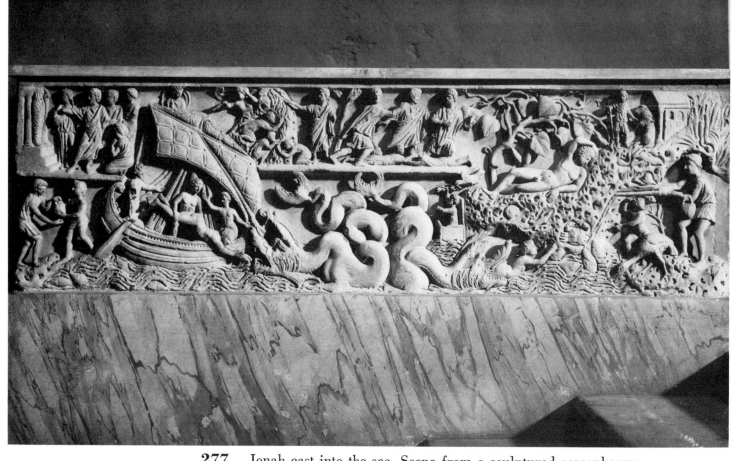

277. Jonah cast into the sea. Scene from a sculptured sarcophagus.

278. Sarcophagus (*c.* 4th century) with sculptured scenes of Creation of Man, Miracle of Cana, Raising of Lazarus, etc. From San Paolo fuori le mura.

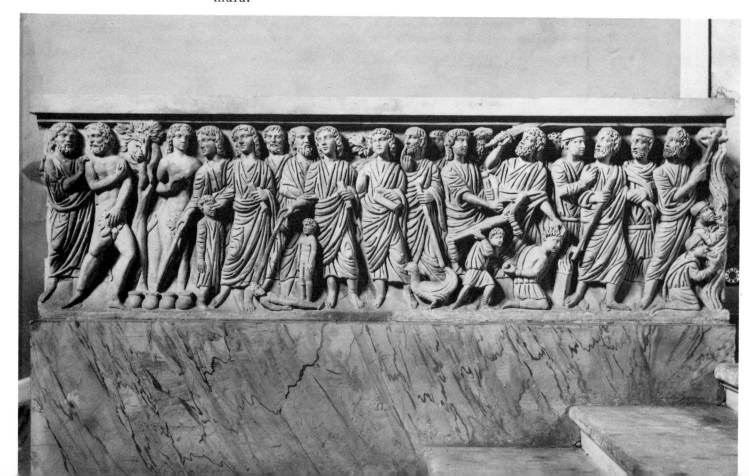

the catacomb paintings, depict many events of Christ's Passion; but the Crucifixion itself is never portrayed, and where the Cross does appear, it is wreathed with a victor's crown of laurel.[276]

279a, b

The dead, whose bodies were enclosed in the sarcophagi, are not represented on the lids, as was usual with the pagan sarcophagi. Instead, their busts are frequently portrayed within a sculptured medallion (*imago clipeata*), at the centre of the sculptured scenes.[277] How the dead, thus represented, were related to the iconographic program of their sarcophagi is perhaps indicated by the absence of explanatory texts, as was noted above.[278] For the elaborate carving of a variety of unidentified scenes, of which the significance is apparent only to specialists, precludes a didactic intention. In other words, it is scarcely likely that such recondite imagery was designed to instruct living Christians, who might view the sarcophagi, in the truths of their faith. Hence, it would seem that these sculptured representations of events of the sacred *Heilsgeschichte* were meant to promote the salvation of the dead and ensure their eternal beatitude, as were the catacomb paintings. Undoubtedly, in the minds of the early Christians the disposition existed, which we have encountered in many other religions, to try to perpetuate the efficacy of past events of divine succour by representing them in linear or plastic art. Thus, this funerary iconography did not look back only to commemorate the past; it commemorated the past in order to affect the future—in this case, the *post-mortem* future of those laid within the sarcophagi. It is perhaps significant also, in view of the later practice of Christian funerary art, that the portraits of the deceased on these sarcophagi show them as alive and vigorous, not recumbent in the sleep of death.

The sculptured sarcophagi, though of great significance for the history of Christian art, were used in a comparatively restricted area for a limited period—their production was rare after the collapse of the Roman Empire in the West.[279] More typical of what was to become the customary form of mortuary monument were the grave stelae used in Christian Egypt and North Africa. On them the deceased was depicted standing and alive, usually with a brief identifying inscription. A particularly interesting example of Coptic art is the tombstone of Rhodia, found at Kom Bulieh in Middle Egypt and dating from the sixth century.[280] It represents the deceased woman standing in the

280a

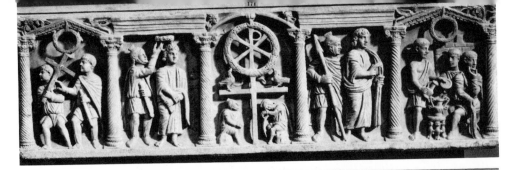

279a. Niched columnar sarcophagus, showing scenes symbolising the Triumph of the Cross.

279b. Sarcophagus of Junius Bassus. Vatican Grottoes, Rome.

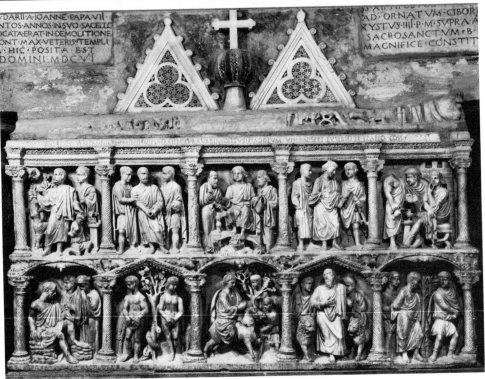

280a. Coptic tombstone of Rhodia, from the Faiyum.

280b. Mosaic tomb slab of Crescentia, from Thabraca, Tunisia.

"Orans" position in a pillared portico, on the lintel of which her name only is written. In the pediment above is carved the ancient Egyptian *ankh* sign, symbolising life but now transformed into the Christian cross, beneath the arms of which are the mystic letters Alpha and Omega.[281] The composition as a whole has an ambivalent aspect: it commemorates, if somewhat crudely, the physical appearance of the dead Rhodia as she was in life; yet it presents her in her *post-mortem* state, as a worshipping soul, reborn through the revivifying virtue of the Cross of Christ. Of like presentation, though with variant symbolism and décor, are some mosaic tomb slabs found in Tunisia. One shows a man, possibly a priest, standing in the "Orans" posture and encompassed by birds, beneath his epitaph: *Crescentia, innocens, in pace* ("Crescentia, blameless, in peace").[282] Whether this declaration of his virtue was protestatory or apotropaic is not certain; but it anticipates, surprisingly for this early period, the fulsome asseverations of virtues that characterised a much later tradition of Christian epitaphs, most notably of the eighteenth and nineteenth centuries.

280b

The great tradition of mortuary iconography that distinguished the Christian mediaeval culture of the West from the culture of Eastern Christendom began to find expression in the twelfth century.[283] Its monuments are almost exclusively in churches and cathedrals; for unlike most peoples of the Ancient World, who feared the dead and kept their tombs outside their cities, the Christians rejoiced to bury their dead within their sacred buildings, where they could lie close to the relics of holy martyrs and in the redeeming presence of the Holy Eucharist. In process of time, the ground within the churches grew inevitably surfeit with human remains, so that intra-mural burial could be granted only to persons of high ecclesiastical or social rank; ordinary folk had to rest content with burial in the ground around the church, which was specially consecrated for the purpose.[284] So important was burial in hallowed ground that in 1203 earth was actually brought from the Holy Land by the citizens of Pisa to make their famous Campo Santo.[285]

281

282

Among the vast and varied funerary monuments surviving from the Middle Ages in the cathedrals and churches of Europe, four distinctive categories of iconographic presentation can be discerned. It is

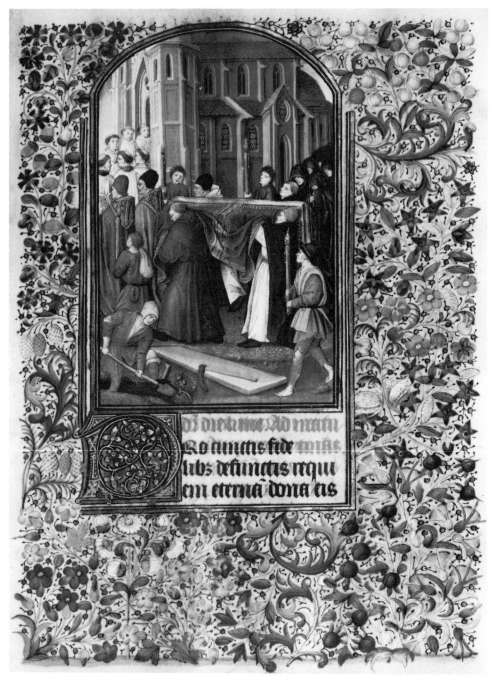

281. Miniature from a "Book of Hours," showing a funeral procession.

282. The Campo Santo, Pisa.

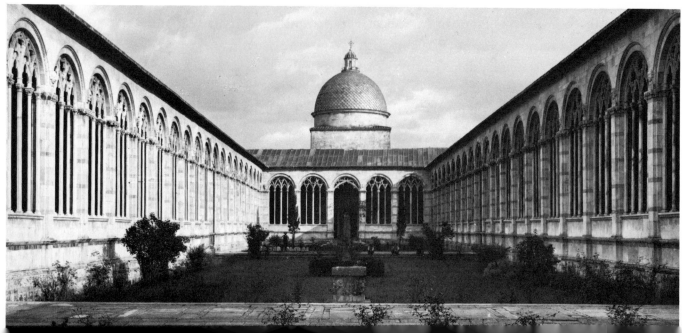

reasonable to suppose, from the fact of their location, that they represent varying attitudes towards death which were sanctioned by the teaching of the Church, and adopted according to the temperament of individuals.

The form of presentation that most obviously continues the Coptic and North African tradition of portrayal shows the deceased as though alive or in *representation au vif,* according to an ancient terminology. In this type of funerary image the deceased appears, with eyes open, in various postures—reclining, lying, standing, sitting, kneeling or even mounted on horseback.[286] These effigies *au vif* generally show the dead in the garments and insignia appropriate to them when alive on earth. Thus the bishop wears his cope and mitre, the knight his armour, and his lady the fashionable dress of her day. Inscriptions give their names, and record their length of life and rank. These images, accordingly, have all the appearance of being, as it were, commemorative documents, recalling for posterity the features and form of the deceased, their place in the ecclesiastical or social hierarchy, and often their achievements. They could even serve to perpetuate political claims and interests as, for example, several archbishops of Mainz caused themselves to be portrayed on their tombs crowning German kings, thus in death asserting this prized privilege of their archiepiscopal see.[287] Kings and warriors proclaimed their victories in sculptured scenes and inscriptions, with themselves arrayed for war or crowned in triumph; scholars told of their learning and academic distinctions, portrayed as they lectured to their students;[288] popes, in full pontificals, pronounce in effigy their papal blessing.[289] The inscriptions which accompany these mortuary images are brief and restrained on mediaeval tombs; their length and pretence increase from the Renaissance on into the nineteenth century. Often the most admirable virtues, personal and social, are then claimed for the deceased, and are curiously reminiscent of the "ideal biographies" inscribed on many ancient Egyptian tombs of the Old Kingdom period.[290] Frequently also, in these later epitaphs, confidence is expressed that the deceased has attained to heavenly bliss.

It is unlikely that these presentations of the dead *au vif,* in view of their great variety of postures and manifest differences of ethos, were generally inspired by any motive other than that of commemora-

283, 284, 285

286

287
288

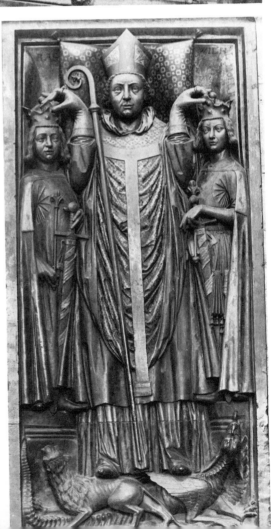

283. Tomb Effigy of Pope Clement II in Bamberg Cathedral.

284. Tomb of Don Martin Vazquez de Arce, in the Cathedral at Sigüenza, Spain (*c.* 1488).

285. Equestrian effigy of Paolo Savelli on his tomb in the Frari Church, Venice.

286. Tomb effigy of Archbishop Siegfried III of Eppstein (*c.* 1249), Cathedral, Mainz.

287. Tomb of Michele da Bertalia (1328).

288. Tomb of Pope Innocent VIII, by Antonio Pollaiuolo, St. Peter's, Rome.

tion. Some figures are, indeed, shown kneeling in prayer, thus recall-
ing those depictions of pious service in ancient Egyptian religious art
and their magical intent. But no such intent is likely to have motivated
289, 290 the presentation of deceased Christians at their devotions.[291] The pos-
ture would seem only to commemorate the piety of the dead for pos-
terity; for even at prayer their rank is advertised by their dress and
insignia. Perhaps the most amazing exhibition of funerary pomp and
circumstance, in a pietistic setting, is the spectacular tomb of the
291 emperor Maximilian I (1459–1519) in the Hofkirche at Innsbruck.
This Holy Roman Emperor appears as kneeling in prayer, invested
in cope and imperial crown, and surrounded by effigies of his ances-
tors, actual and legendary, including King Arthur of Britain.[292]

The representation of the deceased *au vif* continued doubtless
unknowingly, the custom of the early Christians of presenting their
dead alive and alert. But the early Christian depictions had a different
motive, as we have seen. They were not addressed to posterity as were
the mediaeval and later funerary images; their brief epitaphs were con-
cerned only with the *post-mortem* state of the deceased, and recorded
nothing of their state and achievements in this life. The mediaeval
and later images, which are essentially memorials of the living ap-
pearance and status of the deceased, stem from a sophisticated Chris-
tian civilisation rather than from the young religion of Christianity,
which the earlier iconography reflects. A more genuinely religious in-
spiration, however, seems to have informed the other three types of
mediaeval sepulchral art, though in curiously variant forms, as we
shall next see.

A fragment of a mosaic tomb slab, now in the Museum of St.-
Omer, inaugurates, so far as existing records go, a new manner of
depicting the dead in Christian art.[293] It shows William, count of
Flanders, who died in 1109, as dead, in that his eyes are closed and
he appears to be lying on a bed, with a coverlet partly over his body.
Such a presentation of the deceased, enfolded in the sleep of death,
led on to the recumbent effigy, set usually on the cover of the tomb,
which is technically known as a *gisant*. The effigy does not always
292 depict the lassitude of death. Often the hands are held in an attitude
of prayer, which could scarcely be maintained in a corpse; sometimes
293 knights are shown with their legs crossed and in the act of drawing

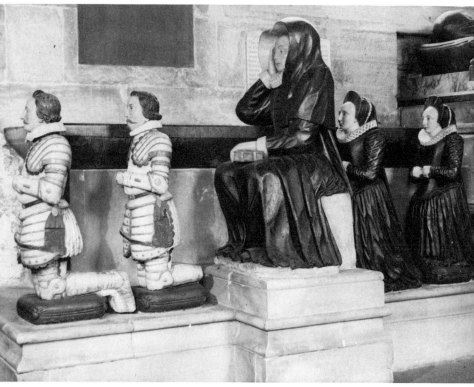

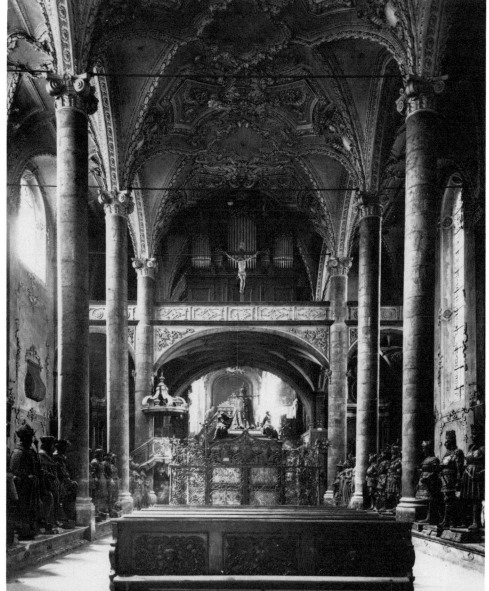

289. Effigy of Edward le Despenser, on the roof of the chantry chapel, Tewkesbury Abbey, Gloucestershire (*c.* 1370-75).

290. Seated funerary image of Dame Alice Fytton (1626), with her children. Gawsworth parish church, Cheshire.

291. Tomb of Emperor Maximilian I (left), with statues of ancestors (below). Hofkirche, Innsbruck.

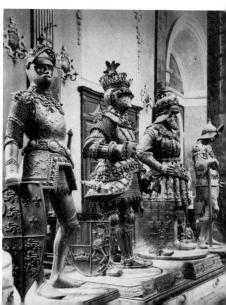

292. Tomb of the Black Prince, Canterbury Cathedral.

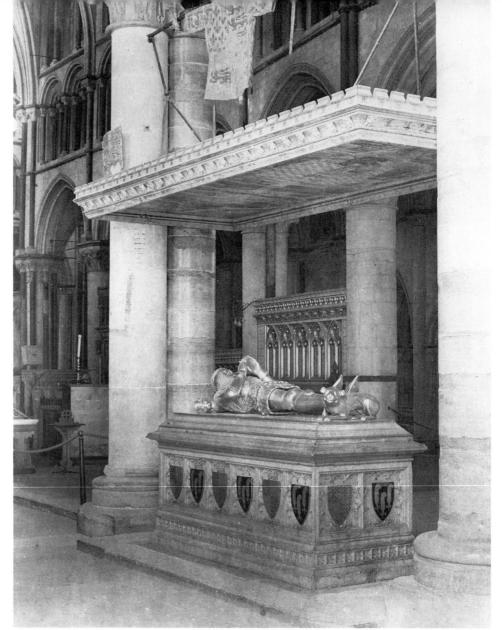

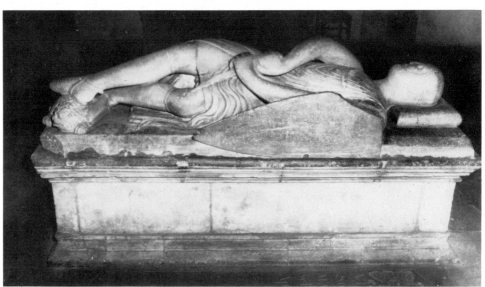

293. Tomb effigy of a knight in Dorchester Abbey Church, Oxfordshire.

their swords in death.[294] In this form of portraiture, the dead are also represented in the dress and insignia appropriate to their office or social status, as in the *au vif* effigies, and inscriptions record their titles and dignities. The *gisant* images thus seem also to be commemorative of the past life of the deceased. However, they incorporate one profound difference: they remind the living that these notable persons are dead—that whatever their erstwhile power and prestige, they lie now silent and unseeing, cold and unmoving, outside the warm precincts of life.

The minatory hint implicit in these *gisants* becomes a dominant theme of later mortuary art. It produced some of the most horrific monuments known to the history of art; and it graphically attests to the emergence in late mediaeval Christianity of a morbidity strangely reminiscent of that which, as we have seen, occurred in ancient Etruscan art. Monuments of this kind were designed to serve as a *memento mori,* by representing the corpse in an advanced state of physical corruption.[295] To emphasize their message, the monuments usually took a "double-decker" form. Thus, for example, the tomb, in Wells Cathedral, of Bishop Thomas Beckington, who died in 1451, has two levels or stages: on the upper, the bishop lies in his episcopal dignity, vested in cope and mitre, with crozier in hand; below he appears as an emaciated cadaver, almost naked as he had come into the world at birth.[296]

Many variations of this grisly theme are found in sculptured tombs, incised grave-stones and monumental brasses, on through the fifteenth and sixteenth centuries.[297] This minatory obsession with the consequences of mortality in sepulchral art was matched by other evidence of an increasing morbidity of temperament, which some scholars have sought to attribute to the communal trauma inflicted by the Black Death.[298] The cause is not certain; but the phenomenon is remarkable and of great significance for both the social historian and the historian of religions. The obsession found other forms of iconographic expression, most notably in the "Dance of Death." Deriving probably from an ancient parable of the "Three Living and the Three Dead," superbly painted by Francesco Traini at the Campo Santo, Pisa, in 1350,[299] the idea of paralleling living persons with their dead selves had already been portrayed in 1425 at the Cemetery of the Innocents, in Paris. The idea evidently reflected the prevailing mood, and depic-

294a, b

295a, cf. 295b, 296

297

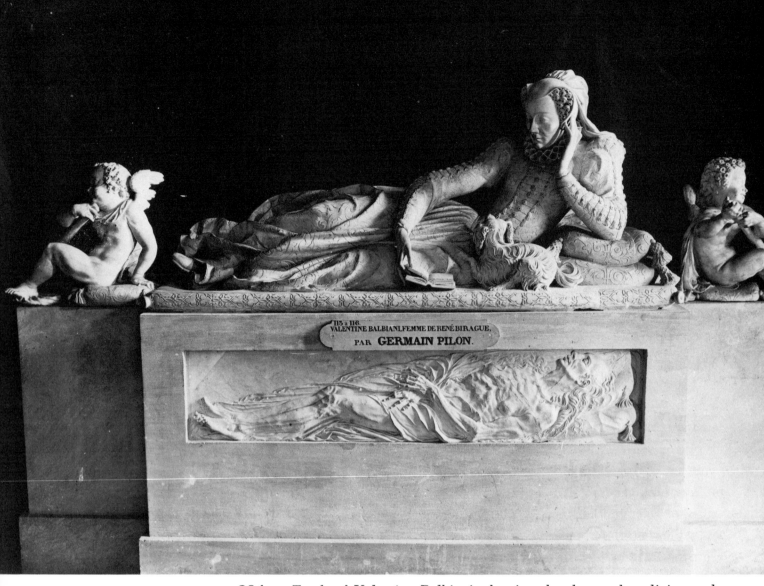

294a. Tomb of Valentine Balbiani, showing the deceased as living and *en Transi*, by Germain Pilon.

294b. *Memento mori* image of Canon Parkhouse in Exeter Cathedral, England.

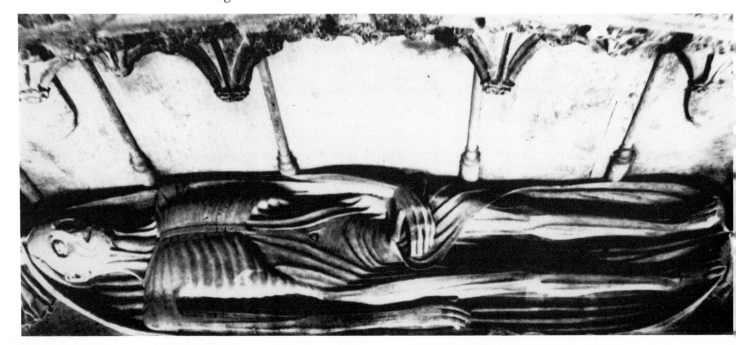

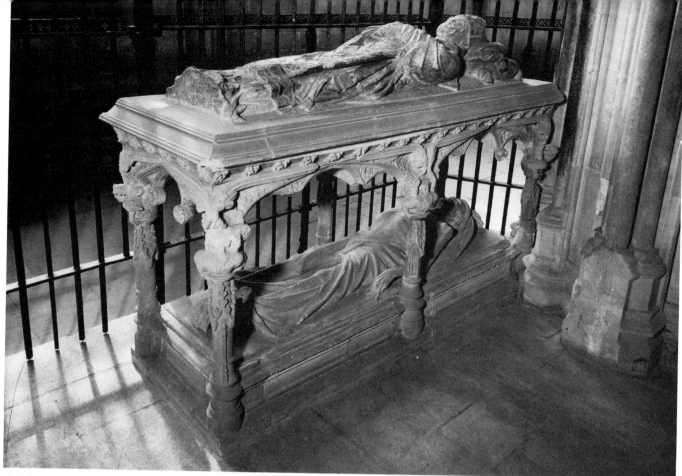

295a. Tomb of Bishop Beckington (d. 1465), Wells Cathedral, England.

295b. Tomb of Francis Fytton (1608). Gawsworth parish church, Cheshire.

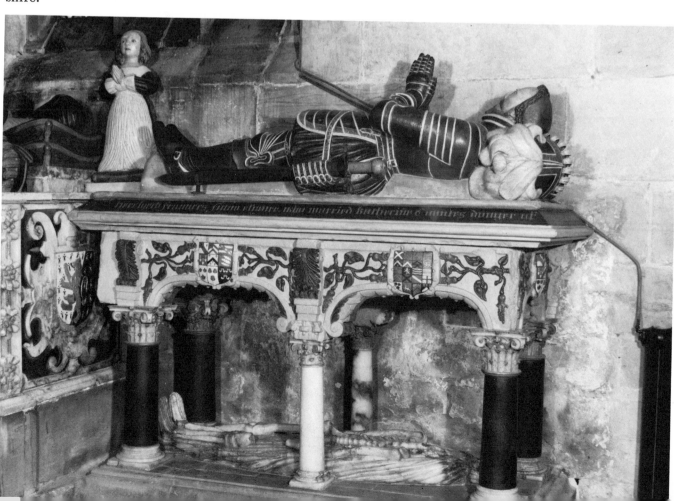

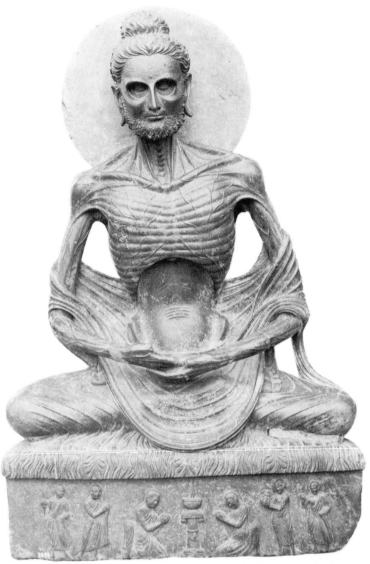

296. The Buddha, shown as an emaciated ascetic (Gandhara, 2nd-3rd centuries A.D.).

297. *The Triumph of Death*, fresco attributed to Francesco Traini, Campo Santo, Pisa (detail).

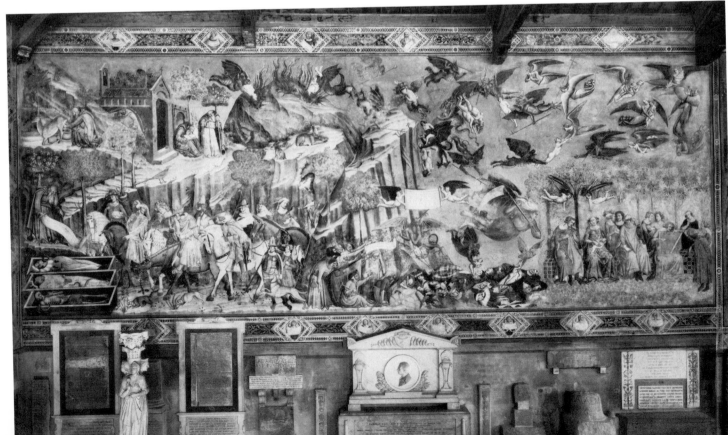

298. *The Dance of Death* (after Holbein).

299. Exorcising of Dā-kinis by magicians. Nine-teenth-century Tibetan painting on linen.

300. Bruegel, *The Triumph of Death* (c. 1562).

tions of the Danse Macabre, the Totentanz or Dance of Death were soon to be found in many other lands of mediaeval Europe. The theme gave scope for a morbid wit. All classes of society could be portrayed in terrified embrace with dancing skeletons, each wearing the appropriate trappings of rank or vocation: popes and princes, bishops and merchants, queens and nuns, soldiers and peasants, the young and the aged.[300]

Thus the *memento mori* tombs of the later Middle Ages reflect a morbidity of spirit that then permeated Western Christendom. In the art of Breughel and the Limbourg Masters of *Les Très Riches Heures du Duc de Berry* it found disturbing expression in the depiction of a fear that was first voiced in ancient Mesopotamia.[301] It was the dread consciousness that the dead infinitely outnumber the living, and that their mighty army might one day come forth from their tombs. Brueghel's grimly fascinating *Triumph of Death,* and a like scene in the *Très Riches Heures,* show the awful onslaught of the grisly host as it overwhelms those who survive them on earth.[302]

In contrast to the wholly minatory character of the *memento mori* tombs, which gives no hint of the possibility of deliverance beyond the doom of death, we may set the remaining type of Christian sepulchral art that we have yet to notice. A particularly illuminating example of it is provided by the tombstone of a priest named Bruno, who was buried in the cathedral church of Hildesheim in 1194.[303] Three scenes are carved on it: in the bottom register the body of Bruno is shown, attended by priests who are engaged in the funerary rites; the middle register depicts the soul of Bruno, represented as a minute nude figure, being carried to Heaven by two angels; in the top register the figure of Christ appears, as though waiting to receive the newly risen soul. A surrounding inscription significantly makes clear the somewhat complicated intention that inspired the monument: *Brunoni cuius speciem monstrat lapis iste/Qui sua pauperibus tribuit, da gaudia, Christe* ("To Bruno, whose features this stone portrays/ Who on the poor of his goods bestowed, grant O Christ, everlasting joy"). The carving seems thus to constitute a kind of identity card for addressing Christ on behalf of the deceased Bruno, whose charitable acts were deemed to merit eternal bliss. The representation of the ritual elevation of the corpse recalls similar ritual scenes in ancient

298, cf. 299

300

301

302

217

301. "The Horseman of Death" (*Apocalypse* vi:8), *Les Très Riches Heures du Duc de Berry*, 82 (fol. 90v).

302. Tomb slab of Bruno, a priest (d. 1194), in the Cathedral of Hildesheim, Germany.

303a. Tomb of Armengol VII (Spanish, 1299-1314), illustrating the hope that funerary ritual will ensure the ascent of the soul of the deceased to heaven.

303b. Funerary monument (*c.* 1200), showing the soul of a dead woman being carried by angels to heaven. Church of La Magdalena, Zamora Leon, Spain.

Egyptian mortuary art; but whether with a like intent cannot be known.[304]

The tombstone of Bruno thus reveals a concern for the achievement of *post-mortem* beatitude, which is not the dominant theme of mediaeval funerary art, as we have noted. As such it raises an interesting question about the relevance of this mediaeval sepulchral evidence. As we have seen so far, the bulk of the monuments that survive are of a commemorative kind, being addressed rather to posterity on earth than to God and the saints in Heaven. The *memento mori* phase, though testifying to a new emphasis on the horror of death, in contrast to the apparent complacency of the preceding tradition, is strangely silent about the Christian hope of future life. However, it must be remembered that with the mortuary art went the mortuary ritual. These funerary monuments stood within churches where elaborate mortuary rites were increasingly perfomed on behalf of the departed. Vespers and Absolution of the Dead prepared for their proper burial, and requiem masses were said for the repose of their souls. Sometimes, as in the cathedral church of Wells, the *memento mori* tomb was within a chantry chapel, specially consecrated to the constant mortuary service of the person buried there.[305]

<div style="text-align:right">303a</div>

The sculptured tombstone of Bruno at Hildesheim is not alone in its testimony, and other funerary sculptures exist elsewhere designed to anticipate the salvation of those whom they commemorate.[306] The method often adopted to achieve this end was the representation of the deceased in the presence of Christ and his Virgin Mother, to whom they are commended by their patron saints. A good example of such proleptic bliss is the funerary monument of Jean du Bois and Catherine Bernard, erected in the fifteenth century in the Cathedral of Tournai. It shows the dead pair kneeling before the infant Christ and his Mother, with John the Baptist and Catherine of Alexandria as their saintly sponsors.[307]

<div style="text-align:right">303b, cf. 304</div>

<div style="text-align:right">305</div>

Thus the iconography of the tomb is a rich source of information concerning the hopes and fears of men and women, when confronted with the mystery and menace of death. As our brief survey has shown, funerary art is a significant index to the attitude, optimistic or pessimistic, that people adopt towards the problem of human destiny after

304. Mosaic scene, found in a tomb at Lambiridi, Algeria, representing divine salvation. The Greek god of healing, Asklepios, is depicted raising a dead man to life. The scene symbolises the salvation hoped for by the dead lady, Cornelia Urbanilla, whose enshrouded corpse is shown at the top of the mosaic (late 3rd century A.D.).

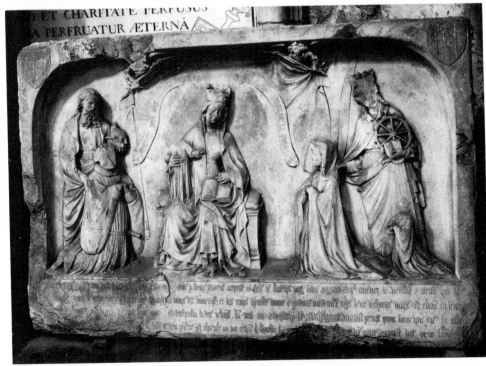

305. Sculptured panel representing Jean du Bois and Catherine Bernard in the presence of the Virgin Mary and Infant Christ. In Cathedral of Tournai, Belgium.

death. The two religions which in their long histories developed the most elaborate eschatological beliefs and practices, namely, the Osirian cult of ancient Egypt and Christianity, have also left the greatest legacies of mortuary art. Though widely different in their concepts of deity, each was based on a linear view of Time which made death the definitive end of a personal existence in a real world. Conversely, the religions of Hinduism and Buddhism, which have taught that those who mistake the present world for reality are subject to an unending series of births and deaths, have been signally unproductive of both funerary monuments and funerary art.[308]

VIII. VOTIVE ICONOGRAPHY

His ability to make replicas of objects, both animate and inanimate, has also been used by man to provide, in the form of statues, abiding surrogates of himself to serve before his gods or provide acceptable gifts to them. We have already touched upon some instances of this use of iconography in the representation of pharaohs ministering to the gods in the temples of Egypt; and possibly even the statue of Pope Pius VI at the *Confessio* in St. Peter's, Rome, originally had some such function. The following survey is intended to present a wider range of examples of this form of religious art.[1]

Valuable insight into the votive use of statues is first given in inscriptions of Gudea, ruler of the Sumerian city of Lagash (*c.* 2600 B.C.). For example, he says of a certain statue, installed in the temple, "It offers prayers"; and he also instructs a statue to communicate his request to the patron god of Lagash.[2] A similar view was expressed many centuries later by an Assyrian king, when he records: "I installed my royal statue . . . to appeal for life for myself before the gods in whom I have faith."[3] These inscriptions, although they concern royal usage in this connection, help to interpret certain strange collections of statues that have been found at various ancient sites. For example, in the ruins of the Abu Temple at Tell Asmar, in Mesopotamia, a group of twelve votive statues, dating *circa* 2500 B.C., was unearthed beneath the floor of the sanctuary. Two of the largest figures have been identified as the god Abu and a female consort. The others

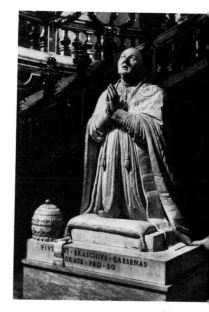

28

306

28, 50, 52

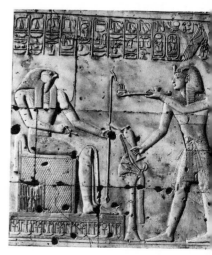

50

307

306. Bronze votive statue probably representing King Hammurabi of Babylon (*c.* 1792 B.C.) adoring the god Amurru. It was found at Larsa and was dedicated for the life of the king by a certain Awil-Nannar.

307. Group of votive statues found beneath the floor of the sanctuary of the Abu Temple at Tell Asmar, Mesopotamia.

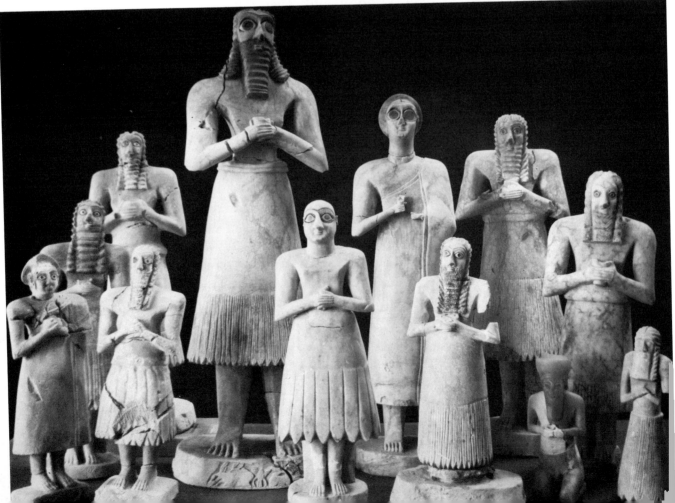

308. Alabaster eye-idols from the "Eye Temple," Brak.

309. Terra-cotta votive images found in the Ayia Irini sanctuary, Cyprus.

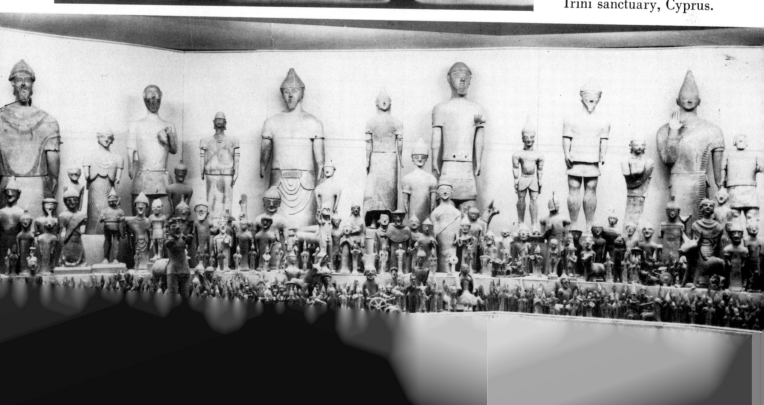

appear to be images of devotees which were placed in the sanctuary, probably around the cult statue of Abu, to act as surrogates of the devotees in thus providing a perpetual service to the deity.[4] An even stranger collection came to light when the so-called "Eye Temple" was excavated at Brak, in northern Mesopotamia. It consisted of thousands

308 of "eye-idols."[5] The mysterious deity worshipped there, whose symbol was a pair of eyes, has been identified with the Sumerian goddess Nin-hur-sag, who was connected with childbirth.[6] Since some of these biscuit-like "eye-idols" seem to depict two or more "eye" figures, it is possible that the "idols" were intended to be substitutes of devotees or families of devotees, dedicated to waiting silently on the "Eye-Goddess."

In one *salle* of the Cyprus Museum a truly amazing assembly of

309 statues confronts the visitor.[7] Made of terra-cotta, they come from a sanctuary at Ayia Irini, and date from about 625 to 500 B.C. Some two thousand were found by the Swedish Expedition that excavated the site in 1929. The figurines, of varying sizes, are mostly of men, standing erect. The larger models have lively facial expressions, and appear to represent individuals. In the collection are also figures of bulls, minotaurs, and war chariots. The human figurines, in view of their number, differences of size and presentation, must surely represent human worshippers, not deities. They were doubtless placed in the sanctuary by devotees who sought thus, in effigy, to be always before the god who dwelt there. No dedicatory inscriptions record the intention of those who deposited them there; but they remain to us impressive, though mute, witnesses of a man's ready resort to iconography to ensure that his likeness stood for ever before his god.

The so-called *kouroi* of early Greek art seem to have had some like

310 function. These statues of nude young men, which began to be made in the seventh century B.C., were placed in sanctuaries or on tombs.[8] Their sepulchral use did not mean, however, that they were intended to be portrait-statues of the particular young men buried in the tombs concerned. It used to be the custom among scholars to identify these *kouroi* as representations of Apollo; but the identification is no longer accepted, and it is also generally agreed that they were not cult images.

311 Their use, whatever its exact purpose, was undoubtedly of a votive nature, and it extended over a period of nearly two centuries, until

circa 500 B.C.[9] They are paralleled by a series of anonymous female statues, known as *korai* ("maidens"), many of which were dedicated to the goddess Athene during the sixth century B.C. Their sanctity was such that, after the Persians sacked the temple of Athena on the Acropolis in 480 B.C., they were carefully buried—possibly because they were regarded as polluted by their subjection to a barbarian invader; yet, since they had been dedicated to the goddess, they could not be broken up or put to a profane use.[10]

312a, b

An interesting little bronze statue of the early seventh century B.C., which was found in Boeotia, provides notable evidence of the Greek practice of dedicating statues to deities.[11] The inscription on it reads: "Mantiklos dedicated me as his tithe to the far-striking god with the silver bow. Do thou, O Phoebus, grant him his desired reward." The statuette probably represents the god Apollo (Phoebus). Since it is too small for cult purposes, it was evidently thought by its donor that the favour of Apollo could be won for some specific purpose by the gift of such a figurine of himself, set up in his sanctuary. Greek documents record other instances of vowing statues or receiving divine command to place statues in sanctuaries.[12] Another, and a particularly significant, form of votive iconography is constituted by sculptured scenes which commemorate the healing powers of certain gods and heroes. They depict the sick seeking the curative care of such a god as Asklepios, or in the process of being healed, as in a relief dedicated to Amphiaraos, now in the National Museum at Athens.[13] These Greek memorials to divine healing, it is interesting to note, had long been anticipated in ancient Egypt; for a stele exists (*c.* 1250 B.C.) showing a painter Neb-re kneeling before the god Amun, whom he praises for healing his sick son.[14] Mention must also be made here of a more realistic, if less aesthetic, use of iconography in ancient Greece. Models, carved in stone, of various parts of the human body have been found in certain sanctuaries, where they had doubtless been dedicated by grateful patients to commemorate acts of divine healing performed on the limbs or organs concerned.[15] The custom is well attested also at many Catholic healing shrines, where votive models of the same kind testify to cures achieved.[16]

313

314

315

316, 190

The use of votive iconography became well established in Catholic Christianity. Numerous were the statues dedicated to Christ and the

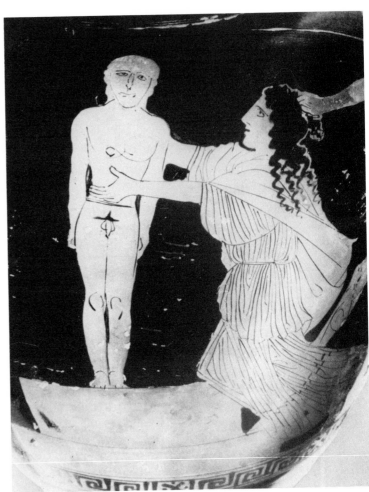

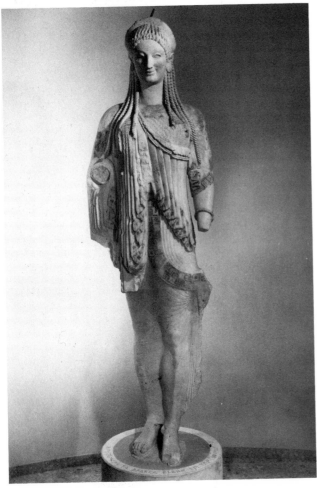

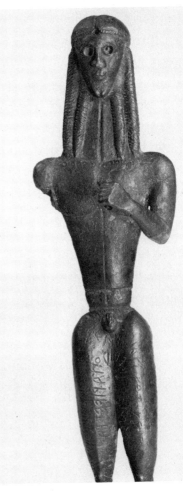

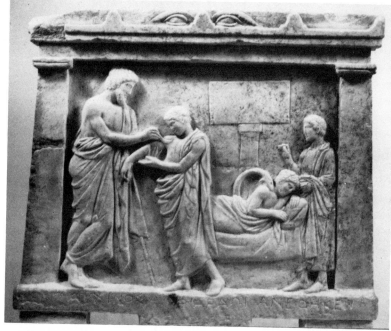

Opposite: top to bottom, left to right.

310. *Kouros* statue from Thera (*c.* 590-570 B.C.), probably a tomb statue.

311. Suppliant clinging to a statue of Apollo (as a *kouros*). From a red-figured vase in the British Museum.

312a,b. *Kore* statue found in Athens. Two views (*c.* 535 B.C.).

313. Bronze statuette of Apollo, dedicated by Mantiklos (early 7th century B.C.). Courtesy Museum of Fine Arts, Boston.

314. Left: Votive tablet dedicated for divine healing to Amphiaraos by a man named Archinos (*c.* 400 B.C.).

315. Below left: Votive stele dedicated to Amun by a painter, Neb-re, thanking the god for healing his sick son.

316. Below: A votive offering, dedicated for healing the limb and feet depicted.

saints in fulfillment of vows or in gratitude for favours received.[17] What is surely the most amazing piece of votary sculpture in a church

317 is the superb group of St. George and the Dragon, and the Princess whom he saved, in the Storkyrka, Stockholm: it was erected in 1489 in thanksgiving for a national victory.[18] Deserving of special notice also are the many votive monuments raised for the ending of plagues

318 in various places: one of the most spectacular is the Pestsäule in Vienna, vowed by the emperor Leopold I in 1679.[19] But, of all the many ways in which the resources of iconography might be employed in a votive context, perhaps the most significant is the altarpiece which depicts the donor in the company of the saints. Thus, to take a

319 typical example, in the triptych of the Master of Moulins (*c.* 1499–1502), in the cathedral at Moulins, Pierre II, duke of Bourbon, is represented as being introduced to the infant Christ and the Virgin Mary by St. Peter while St. Anne does a like service for Anne de Beaujeu.[20] Doubtless it was deemed soteriologically beneficial to be thus portrayed in the divine presence, and above the altar at which the Mass was constantly celebrated and the Holy Sacrifice pleaded.

IX. SCULPTURED CROSSES: EARLY ENGLISH AND CELTIC

Some mention should be made here of the sculptured crosses of early English and Celtic Christianity, although it is not certain how far they were of a votive nature. In the history of Christian art, these crosses are unique.[1]

It would seem that the Anglo-Saxon invaders of Britain, on their conversion to Christianity, erected tall stone crosses to mark places of worship and preaching before churches were built.[2] The oldest of

320 these sculptured crosses, which is at Ruthwell, Dumfries, dates from the late seventh century.[3] On its 15-foot shaft a series of scenes, each in a rectangular panel, present a rather curious selection of subjects. St. Paul and St. Anthony are depicted eating of bread miraculously brought by a raven. This scene possibly refers to the asceticism of monastic life which characterised early Anglo-Saxon Christianity, and the theme may also be implicit in the inclusion of John the Baptist in

317. St. George and the Dragon, in the Storkyrka, Stockholm. This monumental work was dedicated in 1489 by the Swedish Imperial Administrator, Sten Sture, to commemorate a national victory.

318. The Pestsäule, Vienna, erected in 1679 by the Emperor Leopold I, in thanksgiving for the ending of a plague.

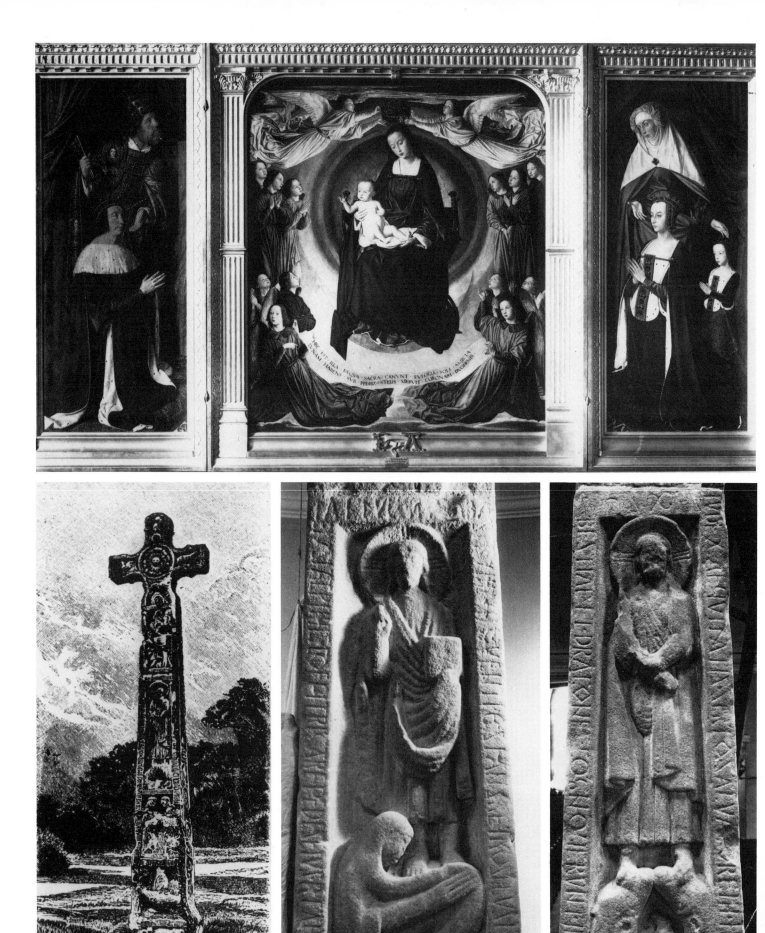

Opposite: top to bottom, left to right.

319. Triptych by the Master of Moulins (*c.* 1475-1500), in the Cathedral of Moulins. St. Peter and St. Anne are represented as commending Pierre II, Duke of Bourbon, and Anne de Beaujeu to the Virgin and the Infant Christ.

320. The Ruthwell Cross, Dumfries (late 7th century), before its removal to the church of Ruthwell.

321a. Ruthwell Cross: Mary Magdalene and Christ.

321b. Ruthwell Cross: Christ treading on beasts.

322. The Bewcastle Cross, Cumberland.

the sculptural program. The dominant figures, on both the front and back of the cross, are of Christ. In one scene, he stands before the kneeling figure of Mary Magdalene, who wipes his feet with her hair. In the other, he is depicted standing on two animals.[4] The significance of this scene is not difficult to interpret—the treading down of wild beasts was an established symbol for the subjection of evil forces. At the bottom of the rear side of the cross the Crucifixion of Christ is represented on a very diminutive scale. An accompanying runic inscription emphasises the heroism of Christ in facing such a death.[5]

321a
321b

The general impression created by the Ruthwell Cross is that of the mysterious majesty of Christ. A similar impression is given by the almost contemporary Bewcastle Cross, remotely situated beyond the Roman Wall in Cumberland.[6] A badly eroded inscription on this cross suggests that it was dedicated to the memory of the Saxon prince Alchfrith.[7] There is some evidence that such crosses were sometimes erected as memorials to notable persons; but not necessarily, it would seem, to mark their graves. If the Bewcastle Cross was a memorial to Alchfrith, it is remarkable that its sculptural program was wholly devoted to presenting religious themes. It would seem that the monument was designed rather for the instruction and admonition of a fierce people but recently converted to Christianity. But another idea may also have inspired the erection of this and other crosses. For they seem to stand, even today, as standards of a once triumphant faith, being themselves charged with a mystic meaning and power, as were once the military standards of pagan Rome.[8] It is surely not without significance that the Ruthwell Cross bears a runic inscription that recalls the famous Saxon poem *The Dream of the Rood*, in which the majesty of the Cross is proclaimed:

322

> It was not a felon's gallows,
> For holy ghosts beheld it there,
> And men on mould, and the whole Making shone for it
> —*Signum* of victory![9]

Some three centuries later in Cumberland the cross was still essentially the potent symbol of victory over paganism. The elegant cross that still stands in the churchyard at Gosforth presents, in its intricate carvings, the crucified Christ reigning serenely amid the old Nordic gods, who battle hopelessly at Ragnarök.[10]

323

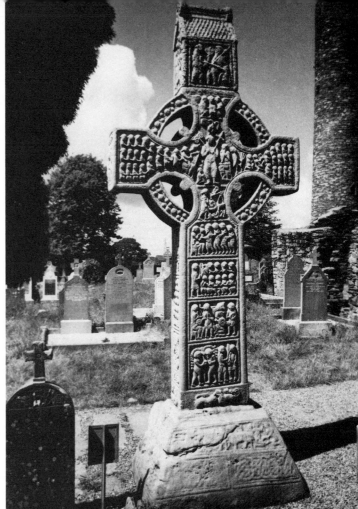

323. Sculptured cross (*c.* A.D. 1000) in the churchyard at Gosforth, Cumberland, showing the Crucifixion of Christ and scenes from pagan Scandinavian mythology.

324. Sculptured Cross of Muiredach, Monasterboice: east side, showing Last Judgment (9th century).

325. Sculptured Cross of Muiredach, Monasterboice (Louth): west side, showing Crucifixion.

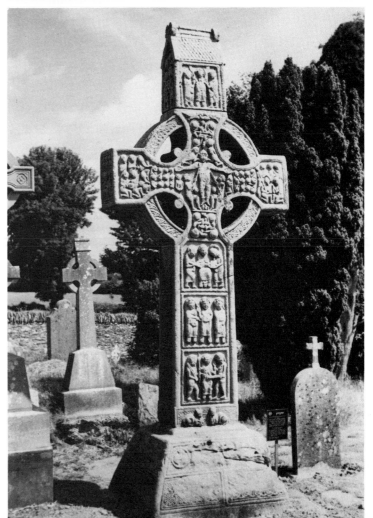

In Ireland, Celtic Christianity has left a unique legacy of sculptured crosses, dating from the ninth century. These crosses were erected in the precincts of monasteries, perhaps as potent symbols that both proclaimed the truth of Christianity and protected those who dwelt within its ambit from the powers of evil.[11] Inscriptions on some of the crosses suggest that they had also a votary character. Thus, for

324

example, on the famous Cross of Monasterboice a petition in Old Irish reads: "Pray for Muiredach who has caused this Cross to be erected."[12] The sculptured scenes on these crosses, which usually surround the figure of Christ crucified or in regal majesty, follow the soteriological scheme, drawn from the Old and the New Testaments, which first found expression in the art of the catacombs, and the sculptured sarcophagi.[13] The highly stylized form of these carvings makes identification of the scenes often so difficult that it would seem they were not designed for the visual instruction of ordinary folk. This is most no-

325

tably the case with the Crucifixion scenes, which in some instances appear almost as a kind of hieroglyph for this supreme act of divine salvation.[14] Consequently, it seems likely that these sculptured crosses were deemed potent instruments of supernatural virtue through their esoteric presentation of God's scheme for man's redemption.

In conclusion to this brief survey of votive iconography, and following on the soteriological pattern of the ancient Irish crosses, we may glance at the elaborate open-air Calvaries set up in Brittany in the sixteenth and early seventeenth centuries. At Guimiliau more than

326

200 realistically carved figures, and at Plougastel-Daoulas 180 figures, present the drama of Christ's Passion.[15]

X. RELIGION AND NARRATIVE ART

The image and the picture, with which we have so far been concerned as forms of religious expression, involve a time factor that might conveniently be described as "the eternal present." The divine image presents the deity in an eternal state of being, so that the worshipper contemplates his god or goddess as immediately existent. In other words, the image of a deity either presumes an eternity that transcends the dimension of Time, or it ignores the temporal cate-

326. The Calvary at Plougastel-Daoulas, Brittany (late 16th century).

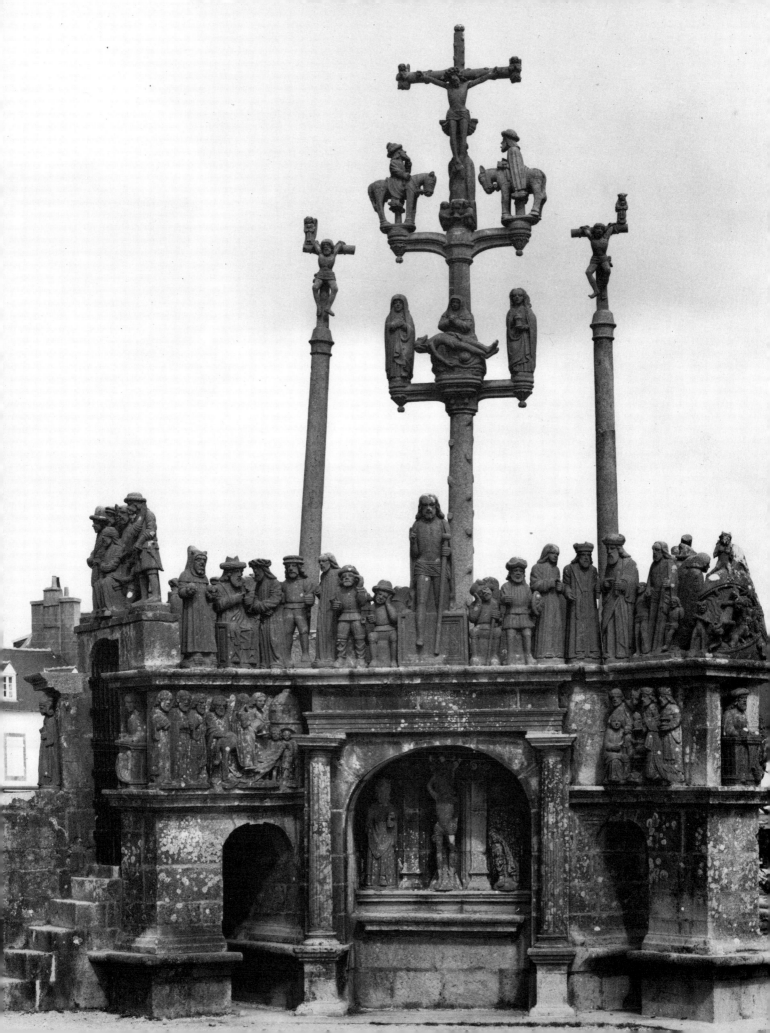

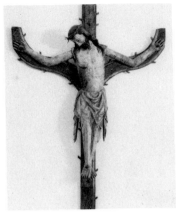

45

327

328

279a, b

279b

329

gories of "past" and "future" by its serene assumption of the absolute nature of the "presentness" of divine being. This element of timelessness is most notably manifest in Christian religious art in portrayals of the crucified Christ. The Crucifixion, which was a historical event, having a beginning and an ending in Time, is presented in the crucifix as an eternal happening—historical Time is, as it were, stopped, in a timeless moment, and Christ hangs for ever nailed and dying on the Cross. Likewise also with the *"Pietà"* or *"Vesperbild"*—the dead Christ, taken down from the Cross, lies for eternity in the lap of his sorrowing Mother.[1]

This assumption of "the eternal present" finds expression also in the other forms of religious iconography which we have surveyed. The representation of cultic acts in sanctuaries, and the depictions of the dead *au vif* in the iconography of the tomb, both contemplate a state of being that is oblivious of past and future. But there are forms of religious art in which attempt is made to express the sequential nature of human experience. In such forms, concern is shown for a process of action, instead of abstracting some one moment of that process and presenting it, insulated from its time context, as having quintessential and eternal significance.[2]

An interesting example of early Christian art, in this context, is provided by the sarcophagus known as the "Triumph of the Cross," to which reference has already been made.[3] Four sculptured scenes of the Passion of Christ are depicted, in a narrative sequence that appears to run from the Trial before Pilate, presented on the right, to the Crowning with Thorns and the Bearing of the Cross by Simon of Cyrene, shown on the left. These episodes are represented with some attention to the historical reality: namely, in the equipment of the Roman soldier and the situation of Pilate; but, by a subtle transformation of the Crown of Thorns into a laurel crown of victory, the triumph of Christ through his Passion is symbolised. This theme is significantly presented in the central panel of the sarcophagus. Here the Cross is surmounted by a laurel wreath of triumph, which encloses the *Chi Rho* monogram of Christ.[4] Below the Cross, two sleeping soldiers betoken the Empty Tomb and Christ's Resurrection. Thus, at this early period in the evolution of Christian art, and before it was considered safe or proper to portray the actual Crucifixion of Christ, by

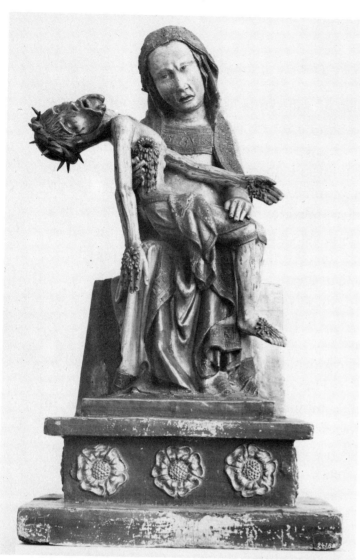

327. Painted wooden *Vesperbild,* by a Middle Rhenish master (*c.* 1300).

328. Virgin bearing Christ in her womb. Detail from an icon of the Annunciation.

329. Scurrilous representation of the Crucifixion (Roman, probably 2nd century).

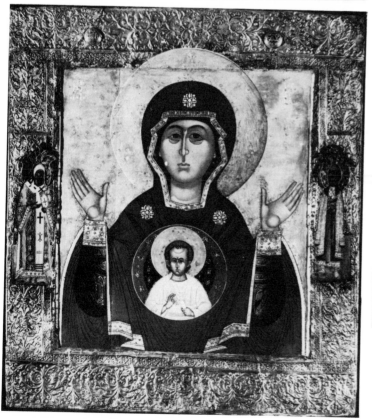

3a

3a, b

330a, b

3b

a medley of realistic depiction and symbolism the history of Christ's Passion and its theological significance was impressively represented.[5] Of the purpose of such a sculptured presentation on a sarcophagus we can only conjecture. Since these elaborately carved sarcophagi were likely to have been seen by more people than saw the products of catacomb art, it would seem probable that their sculptured scenes had sometimes a didactic purpose, in reminding the faithful of the salvation won by the death and Resurrection of Christ. But the possibility must also be considered that the depiction of such saving acts on a sarcophagus was thought to advantage the dead person who lay within it.[6]

Narrative art as a mode of expression for religious belief is very ancient: Egypt and Sumer provide examples dating from the end of the fourth millennium B.C. The celebrated Palette of Narmer, which we have already noticed, combines both realism and symbolism in commemorating the victories of that pharaoh, and the assistance of his gods.[7] Thus, while the rows of decapitated corpses record the actual fate of the foe, the image of the hawk-god Horus, in the act of subduing a symbolic representation of the king's enemies, invests the historical event with the aura of supernatural drama, with a god playing the decisive role.

Of similar import are the sculptured scenes on the stele set up by Eannatum, ruler of the Sumerian city of Lagash (*c.* 2500 B.C.), to commemorate his victory over the neighbouring city of Umma.[8] From the fragments that survive of the monument a twofold pictorial record of the event can be pieced together, representing the historical and the religious aspects of what had happened. On one side of the stele, Eannatum is depicted as both leading, on foot, a heavily armed phalanx of his troops and as preceding them mounted in his war chariot. Other smaller fragments show the consequences of the battle: vultures feed on the corpses of the enemy, while Eannatum presides over the burial of his dead. On this side of the stele, a vivid record was thus carved of the successful struggle with Umma, and of the grim realities of the encounter. The chief fragment of the other side portrays the giant figure of the god Ningirsu, to whom Eannatum ascribed his victory. The deity holds the men of Umma fast in a net with one hand, and destroys them with the war mace held in the other. Thus was this

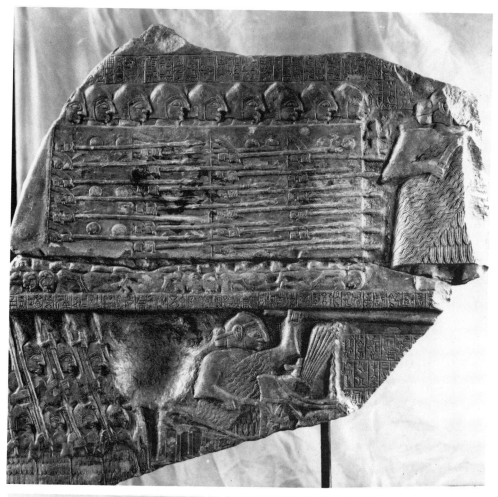

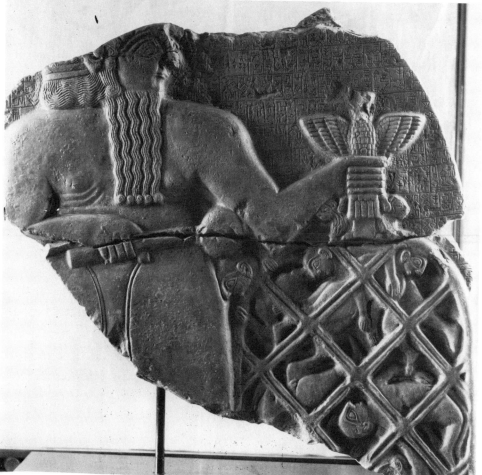

330a,b. Stele of Ean-natum of Lagash (both sides), also known as the "Stele of the Vultures."

ancient victory of Lagash over Umma recorded pictorially in a sequence of constitutive events, and at the same time presented as the providential action of the god Ningirsu on behalf of Lagash and its prince.[9]

In the history of narrative art, these two sculptured memorials from Egypt and Sumer introduce a long series of monuments, of diverse date and cultural origin, that attest to man's ready resort to iconography in his desire to record events in which he has discerned the operation of his gods, or, conversely, claimed that he has acted as the agent of the divine will. Notable among such monuments is the pictorial record of the Battle of Kadesh (1285 B.C.), which Ramses

331 II caused to be carved on temple pylons at Thebes, to commemorate Amun's divine aid and his own prowess in the ambiguous victory.[10]

332 Of like significance is the carved scene at Behistun, showing the Persian king Darius I (522–486 B.C.) triumphing over the rulers of vanquished peoples, while his god, Ahura Mazdah, hovers providentially over the scene;[11] or the bas-relief at Bishapur, which depicts the

333 Roman emperor Valerian kneeling before his conqueror Shapur I (A.D. 241–272), who is attended by representative contingents of his troops.[12]

Roman narrative art affords a particularly striking example of the depiction of divine intervention in the course of a military campaign. Among the succession of scenes from his wars against the northern barbarians, which decorate the famous Column of the emperor Marcus Aurelius in Rome, there is one commemorating the providential assistance given to the Roman army, when in a difficult situation, by the

334 Rain-God—doubtless a form of Jupiter Pluvius.[13] The strange figure of the deity appears hovering over a realistic presentation of the Roman troops. An instructive instance of Christian use of such iconographic commemoration is the scene which introduces the series of frescoes, by Matteo Perez d'Aleccio, of the epic Siege of Malta by the Turks in 1565. These frescoes, which adorn the palace of the Grand Masters of the Order of St. John, constitute a valuable pictorial record of successive episodes of the siege, which was interpreted as the defence of Christendom against the forces of Islam.[14] This interpretation is graphically presented in the first scene. Above a realistic depiction of the landing of the Turkish army at Marsaxlokk on May 20, 1565,

331. Ramses II charging at the battle of Kadesh. Relief (detail) on eastern tower of great pylon of the Temple of Amun at Luxor.

332. Relief at Behistun (Bīsitūn), showing Darius triumphing over enemies.

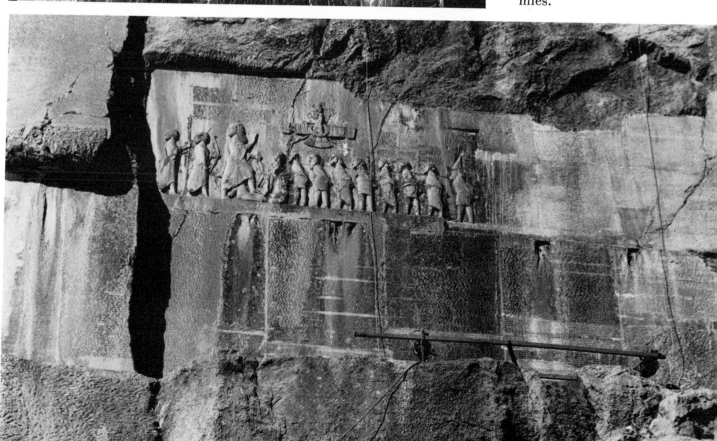

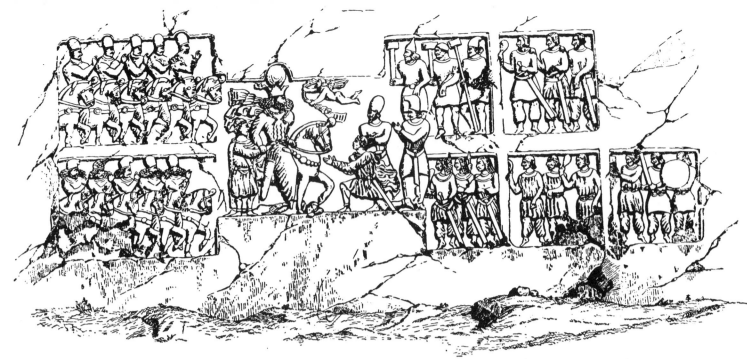

333. Relief at Bishapur, Iran, showing the triumph of Shapur I.

334. Scene from the spiral relief band on the Column of Marcus Aurelius in the Piazza Colonna, Rome, showing the Rain-God intervening to save the Roman army.

the Court of Heaven is represented with the patron saints of Malta and the Knights of St. John interceding with the Holy Family for the island and its defenders.[15]

335

The purpose of such narrative art is clear: it both commemorates notable events of a political kind, and interprets them as manifestations of divine favour on behalf of those who commissioned the monuments. Doubtless many such monuments have been made, at various times and places, to validate the claims of rulers to divine authority —the Palette of Narmer, the Stele of Eannatum, and the monument of Darius are all essentially proclamations that the god of the monarch concerned had signally confirmed his rule by victory. In ancient societies such proclamations were very necessary. For it was not enough that a successful war had given a leader the reality of power; it had to be shown visibly that the chief god concerned had endorsed the logic of events by his own cooperation in them.[16] A different motive, obviously, inspired the fresco that commemorates the successful defence of Malta in 1565. Here we would seem to have an iconographic memorial of a truly great and honourable achievement which the Knights of St. John rightly wished to record in pride and thanksgiving. They had dedicated themselves to the defence of Christendom against the infidel Turk, and so the successful issue of their epic struggle they piously attributed to the will of God, in whose service they had fought.

3a, b, 330a, b, 332

336

The kind of narrative art which has concerned us so far has been given priority attention because it provided, in Egypt and Sumer, the earliest examples known to us. But the medium could be used for more purely religious purposes than that of interpreting political events as manifestations of divine providence. Egypt again provides what is probably the earliest example of the depiction of an interrelated series of divine actions, designed to illustrate an important doctrine of its religion. The doctrine concerned was that of the divine procreation and birth of the pharaoh, by virtue of which he was regarded as the son and vicegerent of the supreme state-god.[17] Two Egyptian monarchs have left iconographic records of the events which were believed to have preceded their births: Hatshepsut (1486–1468 B.C.) in her mortuary temple at Deir el Bahari, and Amenhotep III (1398–1361 B.C.) in the temple of Amun at Luxor.[18] The record re-

337a, b, c, 4

LA SMONTATA DEL'ARMATA A MARSASCIROCCO, E CO
MERICONOSCE LE FORTEZZE DI BORGO, E ISOLA,
A DI 20 MAGG.ᵒ 1565.

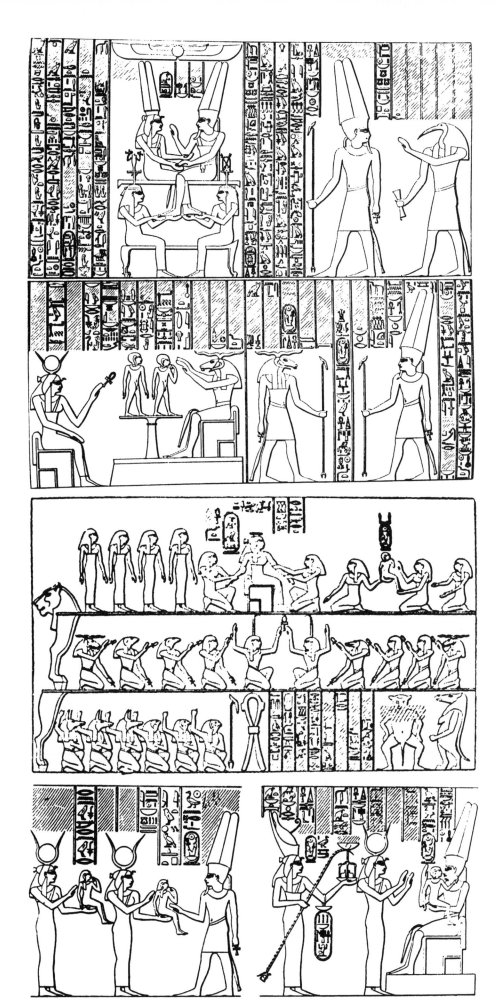

335. Opposite, top: Siege of Malta. Fresco by Matteo Perez d'Aleccio in the Grand Council chamber of the Knights of St. John, Malta, showing the Turks disembarking at Marsaxlokk, May 20, 1565, with Court of Heaven above.

336. Opposite, bottom: Relief at Naqsh-i Rustem of the investiture of Ardashir I by Ahura Mazdah.

337a,b,c. Reliefs illustrating the divine birth of Amenhotep III.

[267]

lating to Amenhotep traces, in a succession of scenes, six episodes of the process: the entry of the god Amun, directed by Thoth, the god of wisdom, into the chamber of the queen; the act of intercourse by Amun with the queen;[19] the conception of the royal infant and his *ka,* which is represented as the moulding of them by the god Khnum on his potter's wheel and their animation by Hathor; the birth of the infant and his *ka;*[20] their presentation to their divine father; and Amun's recognition of his son, to whom a long reign is decreed.

The purpose of these iconographic records is obscure. Since the depictions are on interior walls of the temples concerned, a small company of priests only would have seen them. Consequently, it would seem unlikely that their purpose was either didactic or that of asserting publicly the divine nature and authority of the pharaohs. Therefore, in view of the mainly magical character of ancient Egyptian art, it would appear more probable that such detailed representations of suppositious events were intended, by virtue of their magical efficacy, **338** to establish and maintain the filial relationship of the monarch with the state-god.[21]

These narrative depictions of the pharaoh's divine birth portray a series of events that were believed to have occurred partly in the royal palace at Thebes and partly in a divine locus inhabited by the gods.[22] The narrative arts of other religions generally locate the events depicted in this world.[23] Buddhist art, for example, was characterised from an early period by its portrayal of the traditional sequence of events that led to the Enlightenment of the Buddha. However, in some of the earliest examples, such as the carved scenes on the gates at **339** Sanchi, the Buddha himself was symbolised by his footprints amidst animated groups of realistically depicted human and animal figures.[24] But it was a passing phase of reticence, and in later sculptural programmes, pre-eminently at Barabudur, the episodes of the Buddhist *Heilsgeschichte* include the Buddha in human form, distinguished **340**, 390, 431b, from other human beings only by a halo, and, possibly, by a slightly **433** greater stature.[25] The purpose of such narrative sculpture seems to have been both didactic and aesthetic: the graphically presented scenes were calculated to stimulate the interest of the faithful and to instruct them, while at the same time the carvings richly adorned the sanctuaries in which they were installed.

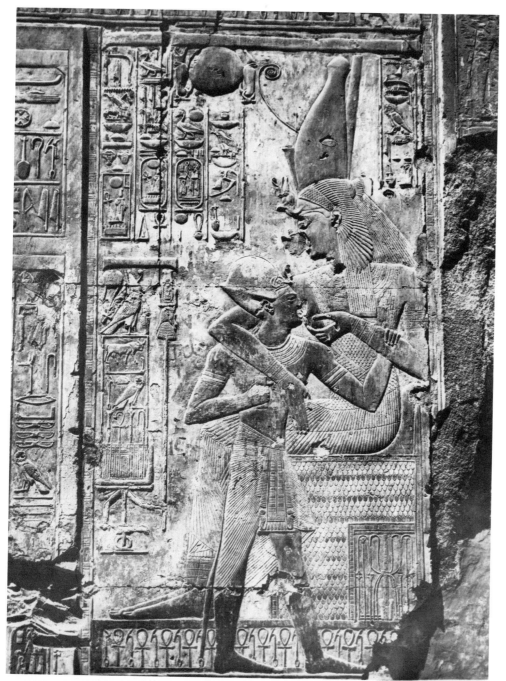

338. Relief showing Ramses II being suckled by the Goddess Anoukhet. Temple of Ramses at Bet el-Wali.

339. Buddhist relief of the "Great Departure," from the east gate at Sanchi.

340. The Buddha's life portrayed in narrative art at Barabudur.

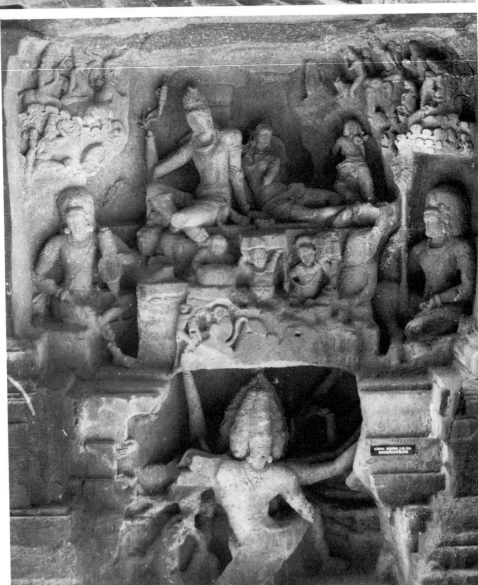

341. Ravana shaking Mount Kailāsa. Sculptured scene at Kailāsanāth temple, Ellūra.

Both Indian and Indonesian art have likewise used narrative iconography for the adornment of temples and the edification of the faithful, drawing upon Hindu mythology for its scenes. The *Rāmāyana* epic was a favourite source of inspiration, and complicated themes were chosen for portrayal. Thus, in the Kailāsanāth temple at Ellūra, the many-armed Rāvana is depicted shaking Mount Kailāsa, while Shiva sits unperturbed and at ease above.[26] The contrast between the demon's chaotic energy and the elegant serenity of the god is truly impressive, and was doubtless intended to inspire as well as instruct, as was also the amazing iconographic complex of the *Gangāvatārana* at Māmallapuram.[27] Mention also must be made of the elaborate reliefs of the great Khmer temple of Angkor Wat, in Cambodia, which have aptly been described as extending "like a continuous tapestry" around the whole circumference of the lower part of the building. Here, too, episodes from the *Rāmāyana* and the *Mahābhārata* and from the mythology of Vishnu and Shiva have been realistically portrayed.[28] However, the sculptural scheme of this great edifice was designed to promote the spiritual destiny of its royal creator, Suryavarman II (A.D. 1112–1152), whose sepulchre it was. Some of the sculptured scenes were intended to relate events of the king's career to like episodes of the sacred legends, while in the central tower of the temple complex was placed a statue of Suryavarman as Devarāja— one of the forms or *avatars* in which Vishnu was believed to manifest himself.[29]

Probably the most remarkable, and certainly the most intriguing, example of religious narrative art in the Graeco-Roman world is to be found in the superb frescoes of the Villa of the Mysteries, in ill-fated Pompeii.[30] They seem to date from the Augustan era (30 B.C.–A.D. 14), and they portray some form or aspect of the mystery cult associated with the Greek god Dionysos. The significance of the series of episodes depicted, their interrelationship, the identity of certain of the participants, and the meaning of the composition as a whole, are matters about which there has been much specialist discussion and conflict of opinion.[31] The Dionysian mysteries, which were closely linked with the mystical philosophy of Orphism, assured their initiates of salvation from death and rebirth to a blessed afterlife. Initiation seems to have involved an esoteric ritual and the revelation of

341

342

343a

343b

344, 345a, b

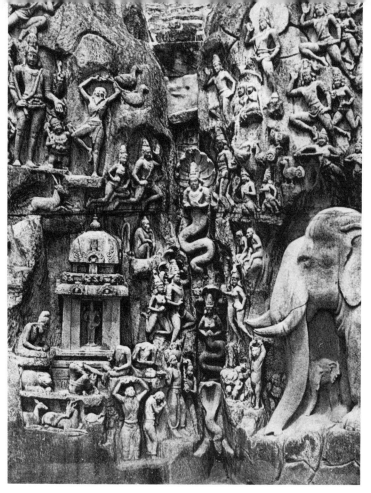

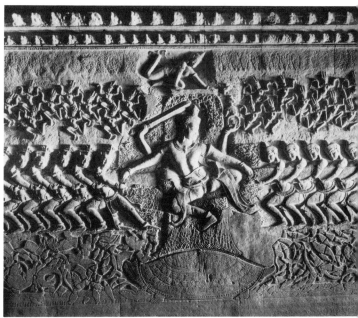

342. Rock-relief of the "Descent of the Ganges," at Māmallapuram, near Madras.

343a. Relief showing "The Churning of the Sea of Milk," Angkor Wat, Cambodia.

343b. Angkor Wat: view from the air.

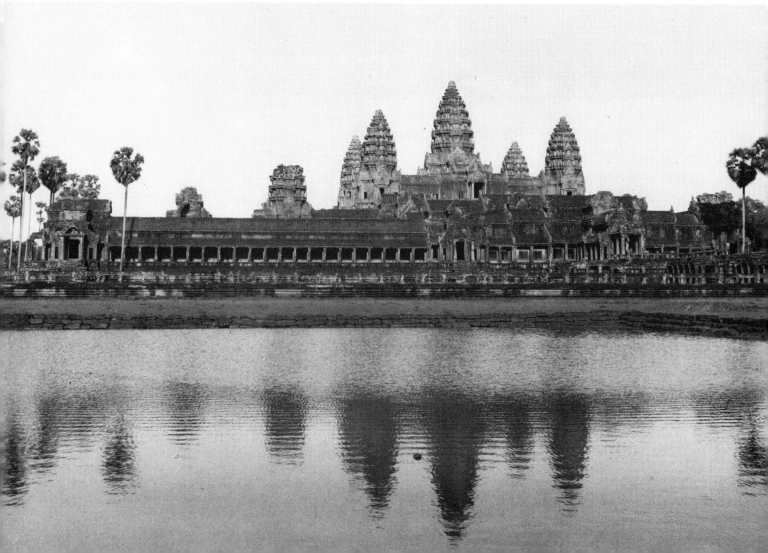

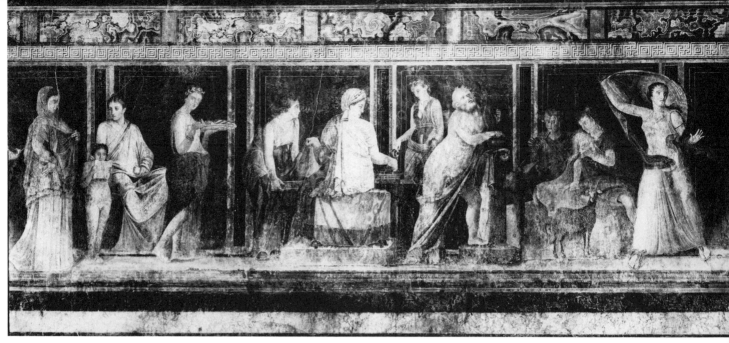

344. Dionysiac frescoes in the Villa of the Mysteries, Pompeii (section I).

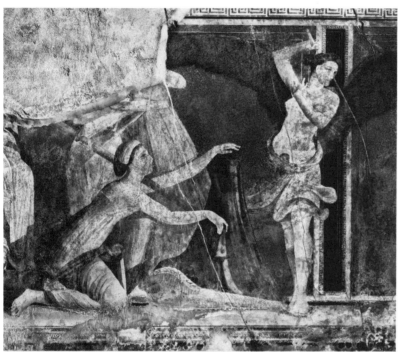

345a,b,c. Dionysiac frescoes in the Villa of the Mysteries, Pompeii (section II).

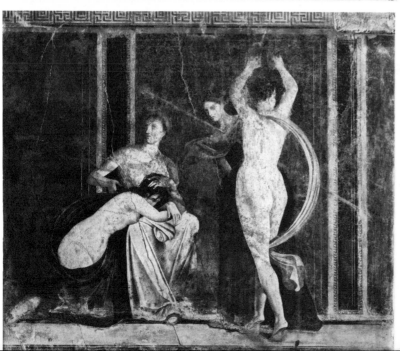

secret knowledge about human nature and destiny. The whole subject, unfortunately, is invested in obscurity for us, owing to the lack of reliable information. We have a mass of data attesting to the widespread influence of the Dionysian mysteries in Graeco-Roman society; but, on analysis, we can learn little of the basic soteriology and ritual practice.[32] This ignorance is most keenly felt in the presence of the frescoes in the Villa of the Mysteries. The fact that Dionysos appears there as the central figure of the series of scenes, together with other traditional Dionysian characters such as Silenus, ensures that the rites portrayed are of a Dionysian kind.[33] But the flagellation scene cannot be related to a Dionysian setting, and the winged female figure, which strikes the blow, seems to belong to some wholly alien context.[34]

However, we are concerned here with the frescoes as a most notable instance of the use of narrative art in the service of religion. Accordingly, it is important to observe that the series of scenes is so arranged, about the walls of the room, that the visitor, on entering, naturally turns to the left for the beginning of the series as he seeks to comprehend them.[35] His instinct is confirmed by a stately figure there—a heavily cloaked woman who is moving towards the right. This figure does not, however, initiate the series of scenes; for there are two preceding, but less obvious, groups of persons who compose the beginning of the ritual drama which is portrayed there. The main figure of the first group is a seated woman, who is attiring herself. The next figure is likewise seated—it represents a noble lady in pensive mood. The impression of immobility created by these figures

345c is broken by the cloaked figure, who seems to initiate a movement to the right, thus suggesting that the action of the ritual drama is to be followed through the scenes that follow in this direction. An impression is also given that the cloaked woman is the same person depicted in the preceding scenes, and that she is the subject of the drama that follows.[36]

The movement of the ritual action is maintained by the maiden, who bears a dish of viands for the liturgical meal that is next depicted.[37] The following group of figures emphasises the Dionysian context of the drama. Silenus plays a lyre, while Panisca suckles a kid—doubtless a symbolic reference to Dionysos in his form of Zagreus.[38]

The following scene is both dramatic and enigmatic. A woman, doubtless the initiate represented in the earlier scenes, is recoiling in alarm from what she sees reflected in a bowl held by a Silenus-figure. The reflection appears to be that of a horrific mask held by an acolyte behind Silenus; another acolyte peers intently into the bowl. There have been many attempts to interpret this scene but no agreed conclusion has been reached by scholars.[39] Clearly, we have depicted here a ritual act of great significance which has gone unrecorded in our written sources. From its place in the iconographic scheme, namely, that it ends the series of ritual acts that comes before the central scene of Dionysos and Ariadne, it probably represented some ordeal of revelation which precluded the redemptive agony that was to follow in the second stage of the ritual drama.[40]

This second stage opens with the kneeling neophyte unveiling the symbolic phallus of Dionysos, which figures also in other Dionysiac scenes.[41] The episode next depicted is perhaps even more problematic than that of the revelation from which the neophyte, in the first stage, recoiled: it is possible that the two scenes are essentially related in the drama of initiation. In this next episode, a tall female figure, winged and wearing high boots, and quite unknown in Dionysiac iconography, lashes the bare body of the neophyte, who buries her head in the lap of a matronly figure who seeks to comfort her. What this flagellation, administered by a supernatural being, signifies is unknown, though many ingenious explanations have been offered.[42] The fact of its depiction indicates that a whipping of the neophyte formed part of the ritual of initiation; but by whom it was actually performed is a mystery, for the dark wings of the otherwise human figure, shown in the act of striking, suggests a daemonic nature. The final scene seems to show the neophyte, new risen from the agony of her ordeal, dancing nude and in ecstatic joy—some scholars have interpreted the scene as a "resurrection" to a new life or state of being.[43]

These Pompeian frescoes are among the most impressive products of the religious art that have survived to us from the Ancient World. Even today, in their sadly damaged state, they are strangely disturbing, and the visitor feels that he is watching a mysterious drama that is unfolding in some other dimension of reality. Scholars have con-

centrated their attention mostly on interpreting the meaning of the individual rites and of the ritual transaction as a whole. Less consideration has been given to the question of the purpose of thus recording pictorially rites which, presumably, were often enacted in the Dionysiac *thiasos* or community of Pompeii. It has been argued that the composition was commemorative: that the lady who sits, in pensive mood, at the beginning of the series of scenes is the *Domina* of the house; that in the cloaked figure (the *"Entrante"*) she sees, in reverie, her past self moving through the Dionysiac rites, which her daughter is about to experience.[44] This graceful interpretation, involving the presence of three distinctive *personae* in the ritual drama, serves to show how replete are these frescoes with recondite suggestion. They irresistibly challenge all who see them to divine the meaning of the mysterious rites in which the participants are so intently absorbed, and through which one of them passes so strangely by suffering to exultation.

Of one thing, however, we can be certain in the context of our particular studies. These frescoes in the Villa of the Mysteries portray successive acts in a Dionysiac ritual drama. And it is reasonable to suppose that the rites were performed on specific occasions by Dionysiac initiates in the villa, doubtless in the room which contains the frescoes. But with that conclusion we encounter once more that question which inevitably confronts us in our study of the iconography of ritual acts—why should a pictorial record be preserved of rites that were periodically performed? In some other instances of ritual representation we have found reason to think that the motive was magical—to perpetuate the supernatural efficacy of a ritual action, as for example, in the depiction of the ritual "Opening of the Mouth" in an Egyptian tomb.[45] But this interpretation does not seem to be relevant to the frescoes of the Villa of the Mysteries. For these paintings depict a succession of scenes, of which the last only, the "Exultation," constitutes the desired experience or state of beatitude. Moreover, several of the scenes represent divine or supernatural beings, such as Dionysos and Silenus, who it is difficult to believe were impersonated by human ministrants of the rites.[46]

Accordingly, in view of the intermingling of human and supernatural beings in the series of scenes, it would seem that the frescoes represent an idealised form of the ritual drama, in which the god

Dionysos himself was present, and in which other members of his entourage assisted. If this interpretation should be deemed valid, an intelligible relationship may be discerned between the frescoes and the rites that were actually performed in the mystery chamber. The neophyte would thus have been portrayed, as it were on the plane of divine being, the enactment of the sacred rites in which she was now herself to participate on earth. Hence, the paintings were designed to authorise the rites, to instruct the neophyte, and to inspire the conviction that all would be done and endured *sub specie Dionysi.*

These frescoes in the Villa of the Mysteries supremely witness to the emotive power of a superbly presented iconography. Wholly independent of an explanatory text, for the guidance of which our literary-conditioned minds instinctively seek, they produce a sense of contact with the Dionysiac mysteries and their long-dead votaries that no written record can convey. The interpretation outlined above cannot be proved. It can only be offered as a possible solution of a unique memorial of the faith and practice of an ancient religion.

From the mystery that invests the transactions depicted in the Villa of the Mysteries we turn to the more easily recognisable subjects of the frescoes that once adorned the Jewish synagogue in Dura-Europos in the third century A.D. That the Jews should have used representational art at all, let alone in a synagogue, is certainly surprising in view of the condemnation of images in the Torah. However, there is an abundance of evidence to prove that the Jewish community of Dura-Europas was not uniquely heretical in this respect.[47] Moreover, it is recorded that Rabbi Jochanan bar Nappāhā, the revered head of the Jewish community in Palestine, had permitted the painting of synagogue walls.[48] Rabbi Jochanan died in 279, and the frescoes of the Dura synagogue were completed after its rebuilding in 245, thus possibly in accord with this sanction.[49] The frescoes, or what remains of them, owe their preservation to the burial of the synagogue by defence works, which were undertaken by the city against the threat of Sassanian invasion. Historically, they are the products of a type of art then fashionable in this Syrian city, which was situated on the Middle Euphrates, where the cultural traditions of the Hellenistic world, of Iran and of Palmyra intermingled.[50]

The most complete of the surviving frescoes once covered the

south-west wall of the synagogue, and surrounded the niche containing the traditional Ark of the Law. They comprised a series of separate scenes from the Old Testament, together with four panels representing

346a, b
349

single persons such as Moses. The scenes were presented in three tiers. The sole surviving scene of the top tier was of the Exodus and Passage through the Red Sea.[51] The subjects of the middle tier were, passing from left to right: the Wells of Elim, the High Priest at the

131

Sacrifice, with possibly the restored temple; and the Ark of Yahweh destroying the temple of Dagon.[52] In the bottom tier, Elijah was shown raising the Widow's Son to life; next the story of Esther was portrayed, followed by the Anointing of David; then came the Finding

347

of the Infant Moses in the Bulrushes.[53] There remain from the frescoes of the south-eastern wall representations of Elijah and the Widow's Cruse of Oil, and Elijah and the Prophets of Baal on Mount Carmel. From the north-western wall there has been preserved Ezekiel's Vision

348

of the Dry Bones, and some less easily identifiable episodes from the Ezekiel tradition.[54]

Most of these scenes are actually composed of two or more episodes, and are so designed as to present a pictorial narrative of the event concerned. Thus, in the portrayal of the Exodus, the Children of Israel are depicted marching out from a walled city (Egypt), led by the superhuman figure of Moses. Moses stands, with rod uplifted, on the bank of the Red Sea, which is already filled with the drowning Egyptians. He is portrayed again on the other bank, commanding the Red Sea to drown the pursuing Egyptians after Israel's safe passage through its waters. He appears the third time, preceded by the host of Israel.[55] The divine nature of this miraculous deliverance of the

349

Chosen People is indicated by the hands of God which emerge from the heavens.[56] Three successive episodes in the story of the deliverance of the Infant Moses are similarly portrayed. First, Pharaoh is shown (in Palmyran dress), issuing the decree of death for all Hebrew male children. Next, the mother of Moses hides her infant son among the bulrushes. The divinely guided saving of Israel's future leader is then

347

presented: unwittingly Pharaoh's daughter, bathing in the Nile, saves the child who is to bring the Ten Plagues upon Egypt.[57]

These Dura frescoes, since their discovery in 1932, have attracted the attention of many specialists in Graeco-Oriental art and Jewish

PLAN OF THE SYNAGOGUE DECORATIONS

WEST WALL

A	SOLOMON AND THE QUEEN OF SHEBA? ?	MOSES RECEIVING THE LAW?	MOSES? CENTRAL AREA	MOSES AND THE BURNING BUSH	EXODUS AND WILDERNESS WANDERING	A	
B	MIRIAM'S WELL	THE AARONIC PRIESTHOOD	?	?	SOLOMON'S TEMPLE	THE ARK IN THE LAND OF THE PHILISTINES	B
C	ELIJAH RAISES THE WIDOW'S SON	ESTHER AND MORDECAI	SACRIFICE OF ISAAC	SAMUEL ANOINTING DAVID	INFANCY OF MOSES	C	
	DADO			DADO			

SOUTH WALL

A			
B	THE ARK IS BROUGHT TO MOUNT ZION ?		
C	ELIJAH AND THE WIDOW'S CRUSE	SACRIFICE OF THE PROPHETS OF BAAL	ELIJAH'S SACRIFICE ON MOUNT CARMEL
	DADO		

NORTH WALL

A	JACOB'S DREAM
B	THE CAPTURE OF THE ARK BY THE PHILISTINES ? ?
C	EZEKIEL PANEL
	DADO

EAST WALL

A		
B		
C	DAVID SURPRISES SAUL ?	ELIJAH FED BY THE BIRDS ?
	DADO	DADO

346a. Plan of the synagogue frescoes, Dura-Europos.

346b. Dura-Europos Synagogue. Overall view of the frescoes on the western wall and of the Torah shrine.

347. Dura-Europos: fresco in the synagogue depicting the Finding of Moses in the Bulrushes.

348. Synagogue at Dura-Europos. Fresco depicting Ezekiel and the Valley of Dry Bones.

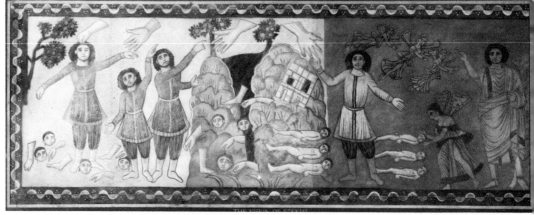

349. Dura-Europos: fresco in the synagogue representing Moses and the Children of Israel crossing the Red Sea.

culture, and various interpretations of their significance have been suggested. Some scholars have seen in them a veiled polemic against paganism, others have discerned the influence of the syncretism that characterised the culture of the people of Dura-Europos.[58] For us, in our quest for the significance of religious iconography, the frescoes have a special interest. They reveal how a people nurtured in a traditionally aniconic faith readily expressed their beliefs, when so permitted, in a graphic iconography. And it was the more graphic, because much of their sacred literature consisted of narratives of great dramatic appeal, which were easily visualized, in a concrete imagery. The frescoes give evidence of a lively consciousness of the continuity of action that constitutes a significant event. Thus, it was not enough to represent the Exodus as the miraculous passage of the Red Sea; the deliverance of Israel had to be shown as comprising three successive episodes: and the saving of the infant Moses was so presented that it would be seen as resulting from the pharaoh's cruel decree.

Of the purpose that inspired the Jewish congregration at Dura-Europos to cover the walls of its synagogue with pictures there has been a variety of opinion among scholars, as we have noted. However, for our concern with the comparative aspect of religious iconography, it is particularly notable that the surviving scenes appear to have one theme in common, namely, that of divine deliverance. Thus, for example, Israel is delivered from the bondage of Egypt, the Ark of Yahweh is delivered from the Philistines and deliverance from death is the theme of the Elijah, the Ezekiel and the Esther episodes. The presentation of this theme in the Dura synagogue naturally recalls its occurrence in early Christian art, both in the catacombs and the sculptured sarcophagi. But a significant distinction shows itself on closer examination. The subject of the acts of divine deliverance portrayed in the Dura frescoes is always, on the final analysis, Israel as the Holy People of God; in the Christian art, it is the salvation of the individual to which reference is made.[59]

The depiction of Yahweh's intervention, in times past, to save his people, would have served both to instruct and inspire the Jewish community, who lived at Dura amid a heathen Gentile people and subject to their constant menace. As they met in the synagogue to worship the God of their fathers and hear the reading of his sacred

270

270, 277

350

351

352

Law, their eyes could dwell upon encouraging reminders of his providence manifested to their race through the long centuries of their marvellous history.

Of Christian narrative art we have already noticed its most remarkable prototype in the sculptured sarcophagus known as the "Triumph of the Cross." Here three successive episodes in the Passion of Christ are represented realistically, while the Crucifixion and Resurrection are symbolically presented. The iconographic scheme of this sarcophagus marks a notable advance on what had previously been the practice of Christian art, both in the catacomb paintings and on the sculptured sarcophagi. For, except for a sequence of three episodes of the Story of Jonah, namely, his being cast into the sea, his delivery from the sea monster, and his resting beneath the gourd, only isolated events were depicted.[60]

Evidence of an increasing desire on the part of Christians for pictorial records of their faith, instead of the portrayal only of the traditional acts of divine salvation, finds notable expression in a *lipsanotheca*, or reliquary, now in the Civico Museo dell' Età Cristiana, Brescia. Dating from the late fourth century, its ivory sides and cover are carved with a great variety of scenes: the central panels portray incidents recorded in the New Testament, while, in the upper and lower borders, Old Testament events are depicted on a smaller scale.[61] Some of the scenes present a succession of incidents. Thus, on the cover, Christ is shown, first alone in the Garden of Gethsemane and then as being arrested there. Next, the sequence of events is represented by the denial of St. Peter. Then Christ is depicted in turn, at his trials by Caiaphas and by Pontius Pilate, the latter being represented in the act of washing his hands according to the record of the Matthean Gospel (xxvii:24-5).[62] Of particular interest, in view of its first appearance in Christian art, is the portrayal, on the casket, of the strange happening recorded in the *Acts of the Apostles* v:1–11: Sapphira stands before the seated St. Peter, with a money-bag at her feet, while a party of young men carry off her expiring husband. This telescoping of a series of events into what appears to be a simultaneous transaction obviously assumes, for its intelligibility, a knowledge of the account in *Acts*.[63]

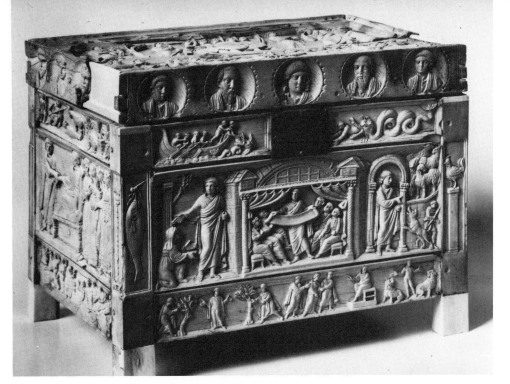

350. Early Christian reliquary casket (*lipsanotheca*).

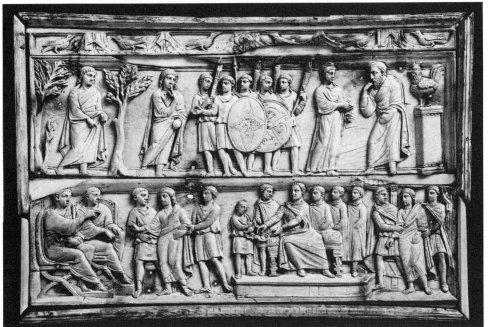

351. Cover of the Brescia lipsanotheca, showing the Arrest and Trial of Christ.

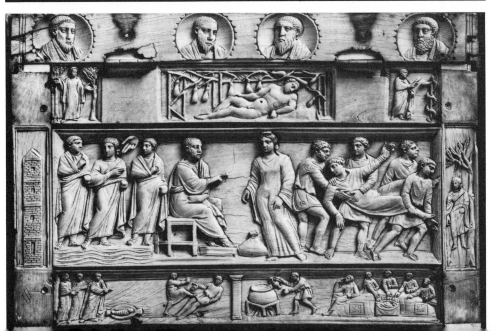

352. Back panel of the Brescia lipsanotheca, showing Sapphira before St. Peter, with Old Testament scenes in borders.

This Brescia *lipsanotheca* and its carvings raise once more a question that continuously confronts the student of religious art—pre-eminently in Christianity, but also in other religions: we have already encountered it, in varying degrees of pertinency, in the material which we have studied. For the portrayal of an event for public presentation, without an accompanying written explanation, seems to imply one of two assumptions. Either it is assumed that those who see the depiction are already well informed about the event depicted, so that they will readily recognise and appreciate its significance; or, the depiction is made on the assumption that its significance will be explained to the uninitiated by a competent teacher. It naturally follows, also, that the more complicated or esoteric the scene depicted, the more essential are these assumptions—unless we are willing to write off the great mass of religious art, especially of a narrative kind, as merely the casual decoration of sanctuaries or tombs, or sacred objects, or assume that the depiction of sacred events was regarded as intrinsically valuable in some mystic sense.[64]

353

In Christian narrative art we have the problem in what is probably its acutest form, especially as that art develops into its fullest flowering in the Middle Ages. Those well versed in the Christian scriptures can readily identify depictions of incidents or ideas recorded in them, although many mediaeval attempts to illustrate the strange imagery of the *Apocalypse of John* are exceedingly difficult to interpret.[65] But Christian artists came also to represent events recorded in apocryphal writings, such as the *Protevangelium* or the *Acts of St. John,* and in the legends of the saints. Consequently, to identify and interpret many products of mediaeval art demands of the scholar today a vast erudition, and the fact intensifies the problem of the intelligibility of that art in the service of mediaeval religion. Since few people could then read or have access to the Bible, let alone the more remote products of hagiography, it is necessary to assume that the majority of the faithful depended on verbal instruction for their understanding of the scenes they saw painted or carved in their churches. Such instruction was, doubtless, often given faithfully and assiduously by the clergy, and most people learned to recognise the chief figures and the significance of the holy scenes in which they were depicted.[66] But, on reflection, it would seem that we must also allow that many mediaeval

354

355, 356, 357, 358

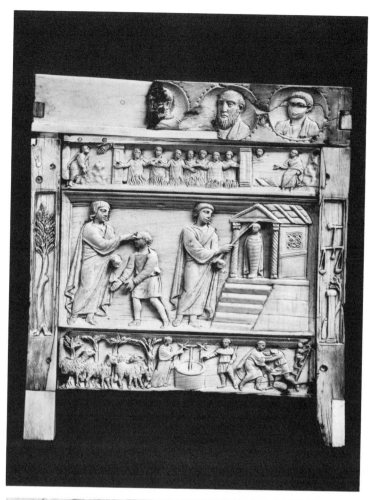

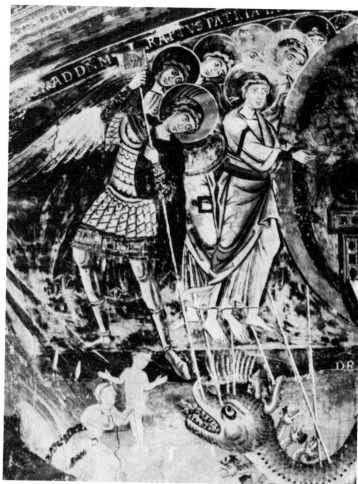

353. Right end of the Brescia *lipsanotheca*, showing Christ raising Lazarus and other scenes.

354. Scene from the Apocalypse of St. John, showing St. Michael slaying the Dragon. Wall painting in the Abbey Church of San Pietro al Monte, Civate (11th-12th centuries).

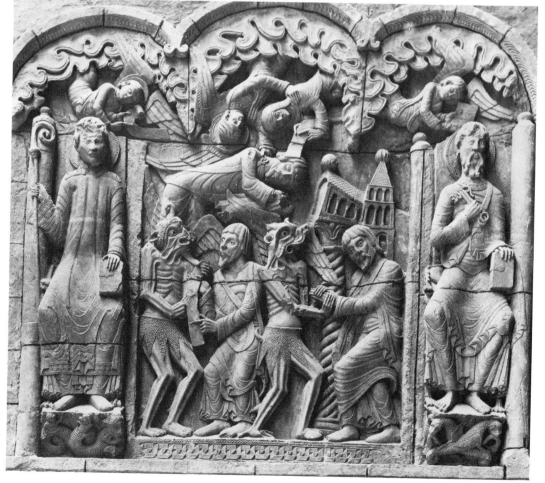

355. Legend of St. Theophilus: sculptured tympanum in the church of St. Marie, Souillac, France.

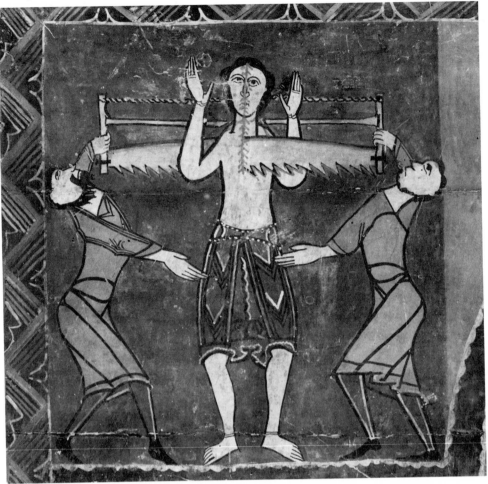

356. Unidentified scene of martyrdom on a painted altar frontal.

357. Unidentified scene on a 15th-century carved bench end in the parish church of Crowcombe, Somerset, England.

358. Foliate head (or "Green Man") on a bench end in the parish church of Crowcombe, Somerset, England (15th century).

Christians viewed the scenes, in awe and wonder, as revelations of mysterious happenings which they could not understand, but upon which they believed the salvation or damnation of their souls depended. Doubtless we have to reckon here with the fact that the strength of a religion may often lie in its mystery, not in its intelligibility. And perhaps we have to recognise that more truly religious is that art which creates a sense of awe and mystery, than that which seeks honestly to portray the historical reality behind the sacred tale.

After this necessary digression, we return to our brief survey of Christian narrative art by noting what is probably the earliest pictorial record of the Passion of Christ that includes a realistic portrayal of the Crucifixion. Its constitutive scenes are carved on the sides of an ivory pyxis, made in southern Gaul in the early fifth century.[67] With great skill, the artist has succeeded in depicting successive episodes from the Trial before Pilate to the Resurrection, within the confines of the four sides of the small casket. After the Trial, Christ carries his Cross to Calvary, while Peter denies him; next, as Christ hangs on the Cross, Judas Iscariot hangs from his tree of suicide; the Resurrection is then suggested by the open doors of the Sepulchre, and by the figures of the ministering women and the sleeping soldiers; finally, the Risen Christ with his Apostles, including the doubting Thomas, complete the drama of man's redemption by Christ.[68]

359-62

Of the rich treasury of mediaeval narrative art we may notice three representative examples. In the church of S. Ambrogio, Milan, the antependium of the altar is both a superb memorial of Carolingian metal work, dating from 835, and a pictorial record of the life of St. Ambrose, the patron saint of Milan, where he was the bishop from 374 to 397.[69] In twelve separate panels, twelve notable events of the saint's life are graphically depicted. To each scene a brief identifying inscription in Latin is attached; the brevity of the inscriptions is such that it would seem that the artist either assumed that the events were well known to all, or that with such minimal help the depictions could be left to tell their own story.

363

What is perhaps the most amazing attempt in the Middle Ages to provide a complete iconographic presentation of God's plan for mankind's salvation was undertaken by Giotto, between 1304 and 1313,

359–62. Scenes of the Passion of Christ carved on four sides of an ivory pyxis (early 5th century).

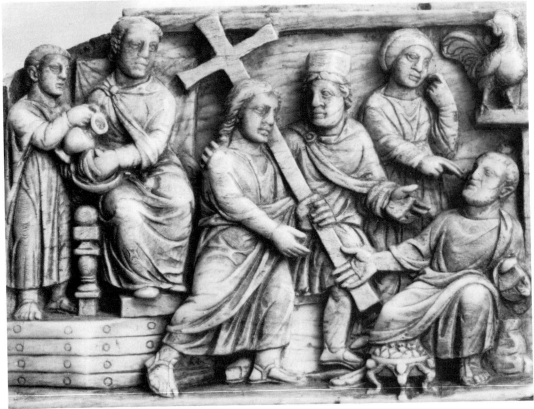

359. Christ bearing the cross.

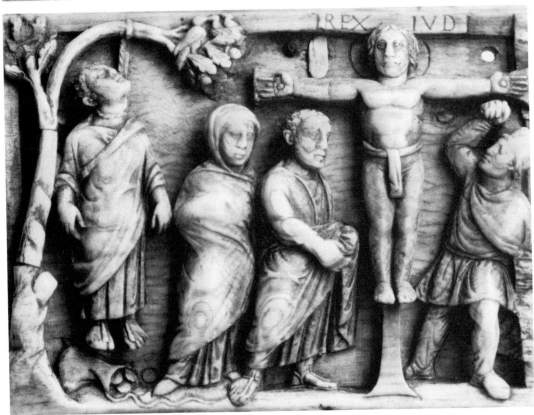

360. The Crucifixion.

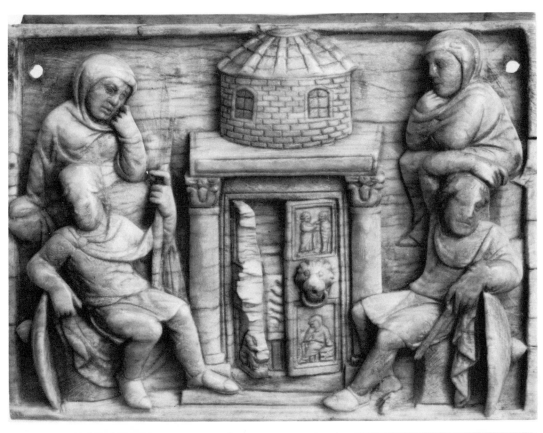

361. The Women at the tomb.

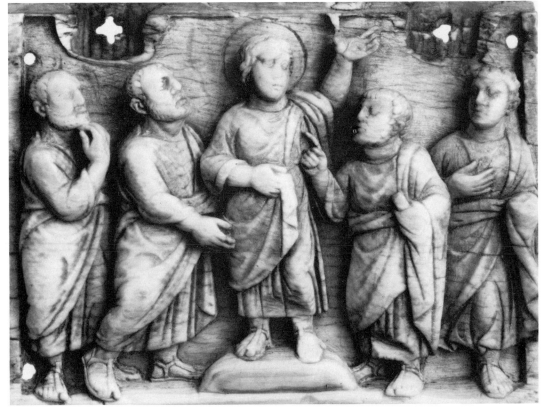

362. The Resurrected Christ.

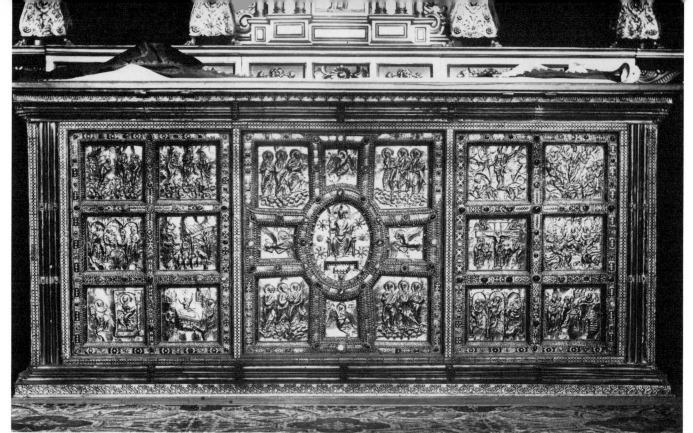

363. Altar antependium (9th century) in gold and silver gilt, representing the life of St. Ambrose. In the Church of S. Ambrogio, Milan.

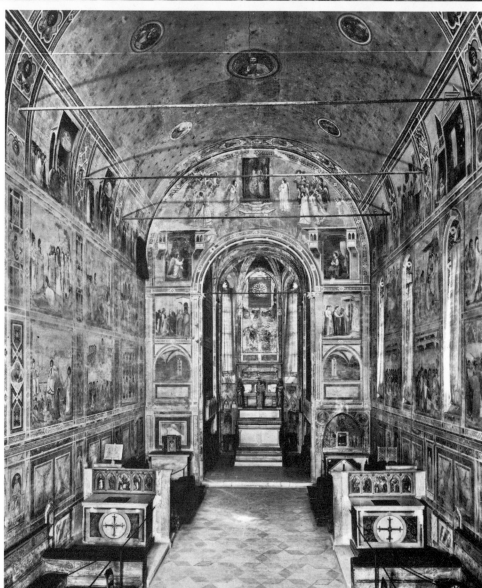

364. Interior of the Arena Chapel, Padua, looking east, with Giotto's frescoes.

in the Arena Chapel at Padua.[70] The walls of this building are covered with a series of painted scenes that form two interconnected cycles. The first cycle tells the life of the Virgin Mary, commencing with the rejection of Joachim, who was to be her father, from the Temple because he had no offspring.[71] To Giotto, as to most mediaeval Christians, the life of the Mother of Christ matched that of Christ himself in its soteriological significance.[72] The events portrayed, without explanatory inscriptions, attest to the popular knowledge of the legend of the Virgin. The life of Christ is presented in a series of equally vivid scenes, which bring out the drama and pathos of his Passion. The concluding depiction of the pictorial programme is an elaborate portrayal of the Last Judgment. It is significantly placed on the western wall of the chapel, so that it faces the altar and the scenes of God the Father announcing to the angels the decision to incarnate his Son and of the Annunciation made to Mary, which are painted on the chancel arch.[73]

The history of Christ's Passion was the frequent subject of the altarpieces that were placed behind and above the altar, on which the Mass was celebrated. Of the many such altarpieces which still exist in churches or have been transferred to museums, mention might be made of two that are particularly significant in the present context of our study. The earlier (1308–11) is by Duccio di Buoninsegna; it originally stood above the high altar of Siena Cathedral. Known as the "*Maestà*," this altarpiece consisted of twenty scenes of the Passion and Resurrection of Christ, thus forming a detailed pictorial history of the events which were believed to have achieved mankind's salvation.[74] This orderly presentation of the catena of episodes, set in their supposed historical milieu, contrasts interestingly with the Amelsbüren altarpiece, to which reference has already been made.[75] In the central panel of this composition, the artist Johann Koerbecke (*fl.* 1446–91) was concerned to show the soteriological consequences of Christ's death and resurrection. Accordingly, to the pattern of related episodes he added a scene of Christ's Descent into Hell, for the purpose of bringing up the pious souls who had died before his coming. Thus to a realistic depiction of the incidents of the Passion there was given a theological commentary, which was vividly presented in an iconographic setting. In one of the earliest, most impressive examples

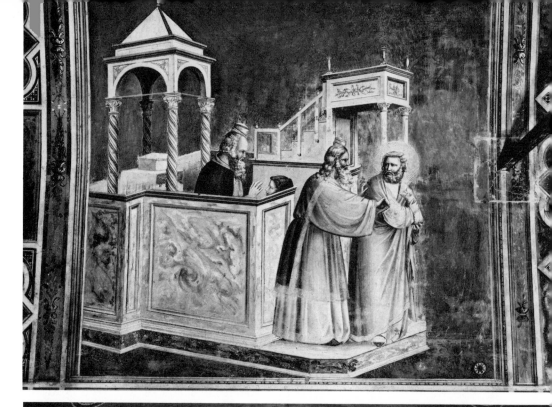

365. *Joachim Expelled from the Temple.* Fresco by Giotto in the Arena Chapel, Padua.

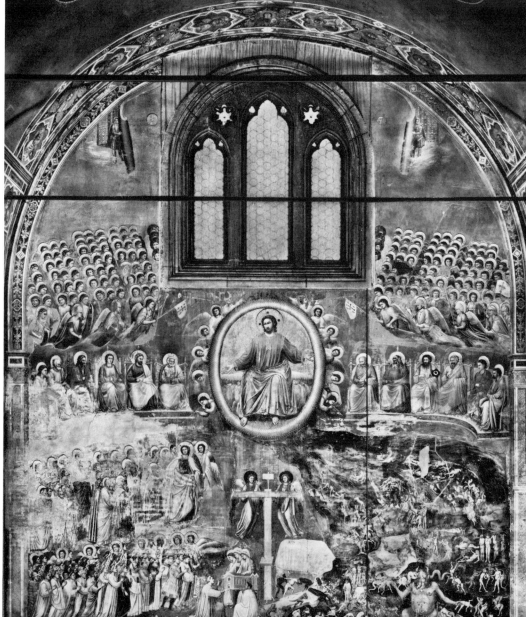

366. *The Last Judgment,* by Giotto, in the Arena Chapel, Padua.

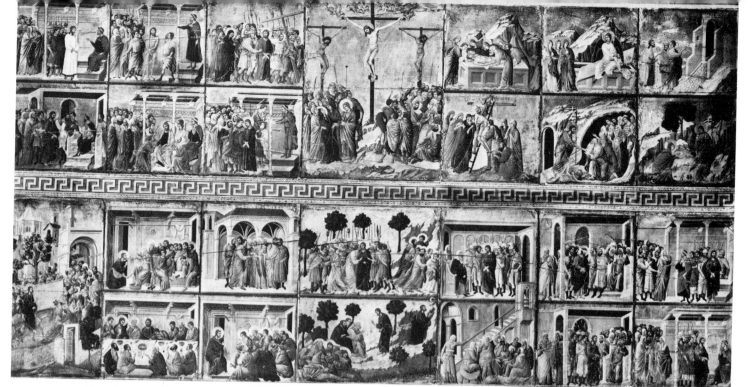

367. The *Maestà* altarpiece by Duccio.

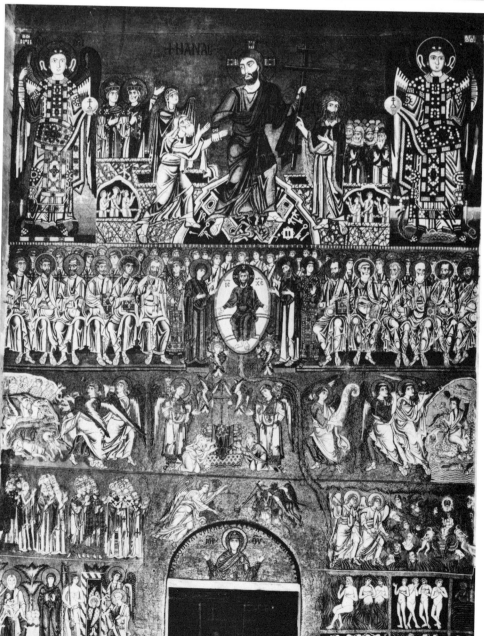

368. The *Judgment of the Dead* at Torcello.

of the mediaeval "Doom," that at Torcello, Christ's Descent into Hell is featured at the top of the series of registers portraying the Judgment.

That much of the iconographic art of the Christian Church has been of a narrative kind is surely due to the essentially historical character of its original tradition. For since the faith derived from historical persons and their contemporary situation in first-century Palestine, and the earliest records concerning them were written in narrative form, it was inevitable that their pictorial presentation should reflect this basic form. That the first essays of Christian art were not a narrative kind was due, as we have seen, to special conditions. But once the position of Christianity was assured, and churches could be built and decorated, a symbolic art did not continue to satisfy Christians. The very doctrine of the Incarnation of Christ, together with the narrative form of so much of the Holy Scriptures, made narrative art a natural form of expression.[77] And this form was adopted, also, for the presentation of what were essentially theological conceptions. Consequently, the iconography of the churches and cathedrals of Western Christendom was not limited to linear and plastic depictions of the life of Christ and the saints. Such doctrines as the Coronation of the Virgin and the Last Judgment were also portrayed prominently, in sculpture, painting and stained glass, with all the realism of events enacted within this world of time and space.[78]

369, 162a, b, 360, 368

XI. THE ILLUMINATED MANUSCRIPT AND BOOK

In our survey so far of narrative art as a form of religious expression, we have confined our attention to what might be termed its public role. In other words, we have studied its occurrence on monuments designed to present the religious aspect of political events, and in sanctuaries where the faithful were to be instructed or inspired by the sacred history of a god or divine hero. But the medium has been used also to serve the needs of individuals in the private practice of their religion. Its use in this way has found expression in the so-called "illuminated" manuscript and book. To complete our survey of narrative art, we must briefly notice some of the more pertinent forms of this genre.

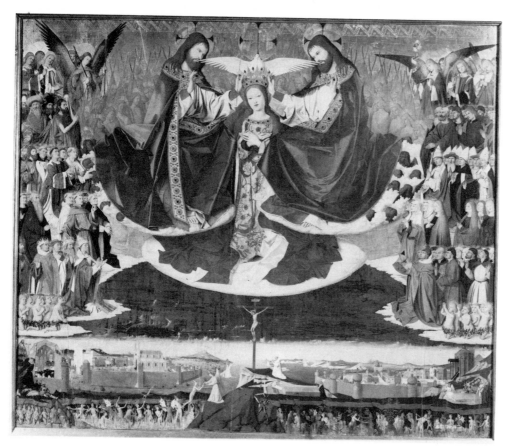

369. *The Coronation of the Virgin*, by Enguerrand Charonton.

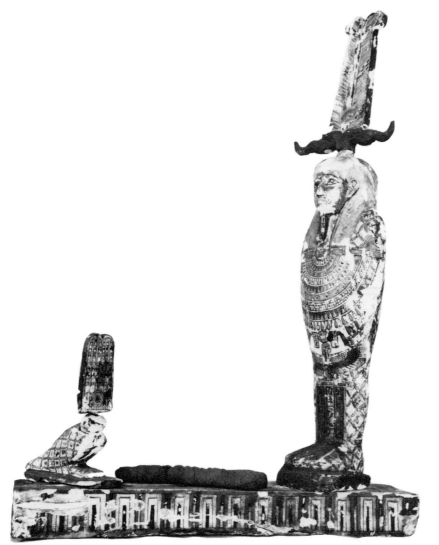

370. Figure of Ptah Soker on a box which may have contained a copy of the *Book of the Dead*.

Ancient Egypt once more supplies our earliest evidence in the so-called *Book of the Dead*. From about 1550 B.C. it became the custom

370 to deposit in the tombs of the dead, sometimes actually on the persons of the dead, papyrus scrolls on which were inscribed collections of texts, in the hieroglyphic or hieratic or demotic forms of the Egyptian language.[1] These texts were believed to be efficacious in helping the deceased to pass safely through the perils that beset his path to the next world, and to attain a happy lot when he arrived there. Many of the texts derive from the *Pyramid Texts* and so-called *Coffin Texts* of earlier times, which had a like purpose.[2] What distinguishes the *Book of the Dead,* and is of special interest to us, is that it was illustrated with vignettes which depict various aspects of the mortuary practices and beliefs of the Egyptians. Many of these depictions are of a symbolic kind; but others portray events which had taken place in

371 this world or would occur in the *duat* or realm of the dead.[3] Thus

372 various episodes of the mortuary rites and the funeral are depicted: servants carry equipment for the tomb, women bewail the dead, the embalmed body is drawn to its "eternal house" on a sepulchral sledge, the ritual "Opening of the Mouth" is performed.[4] Most notable among the scenes of what the deceased would experience in the next world is that of the dread Judgment before Osiris, where his heart would be

373 weighed against the feather symbol of *maat* (truth).[5]

These narrative scenes constitute a problem of particular interest for us. Why were the dead thus provided with pictorial records of their own funerals? Since the rites were completed when the door of the tomb was finally sealed, such a record could scarcely have been designed to assist the deceased after that, unless it were in one of two ways. Either the record was intended to serve as a form of certificate, in the next world, that the deceased had been buried according to the prescribed rites; or, the depiction of the rites was designed to perpetuate their efficacy after the manner of other forms of magical art which we have noticed.[6]

The vignettes which depicted situations that would be encountered in the next world evidently had another purpose. They provided guidance for the deceased at various critical junctures. For example, the vignette at the head of Chapter 93 of the *Book of the Dead* shows the

374, cf. 258 deceased standing on the bank of a river and addressing a daemonic

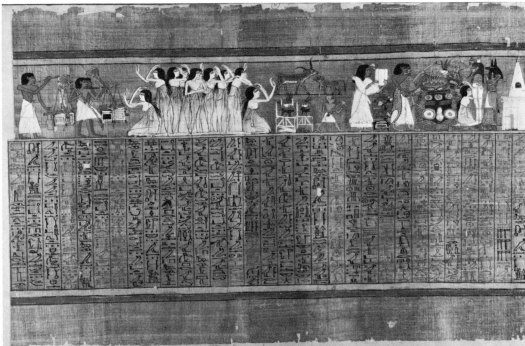

371. Plan of Two Routes to the Underworld, in *The Book of the Two Ways.*

372. Vignette from the *Papyrus of Ani,* showing a funeral procession and the ceremony of "Opening of the Mouth."

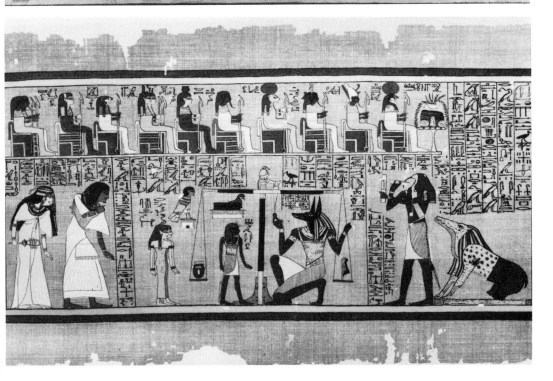

373. The "Weighing of the Heart," from the *Papyrus of Ani.*

ferryman, whose face looks backwards.⁷ The text that follows is a spell against sailing to the east in the underworld, which would apparently have fatal consequences. This chapter and its vignette were presumably designed to prepare the deceased for his encounter with this Egyptian Charon, and provide him with a magical formula to ensure that he was not malevolently transported in the wrong direction.⁸

The greatest ordeal which faced the Egyptian dead was clearly their Judgment before Osiris, the lord of the underworld. Two chapters, 30 and 125, of the *Book of the Dead* prepare them for the dread encounter. In most copies, an illustration of the scene accompanies Chapter 30, which takes the form of a prayer addressed by the deceased to his heart, imploring it not to act as a witness against him in the fateful trial.⁹ Chapter 125, which is not usually illustrated, is significantly entitled: "That which should be done when one enters the Hall of the Two Truths, in order to separate N. from all the sins which he has committed, so that he may behold the faces of the gods."¹⁰ There follow the texts of two "Declarations of Innocence," addressed severally to Osiris and forty-two daemonic beings who sit in the Judgment Hall.¹¹

The relation of these two chapters to the depiction of the Judgment is problematic; but the evidence of the finest extant version of the *Book of the Dead*, namely, the *Papyrus of Ani* (c. 1320 B.C.), suggests that the Egyptians imagined the Judgment as a two-phase process: first, the deceased made his "Declaration of Innocence"; then his heart was weighed against truth (*maat*), to assess his veracity.¹²

373

375

The portrayal of the Judgment and its sequel in the Papyrus of Ani is the most elaborate that has survived to us. It is presented in a sequence of three episodes: the weighing of the heart of the scribe Ani and the declaration of his innocence by the formula *maa kheru* ("true of voice"); his presentation by the god Horus to the enthroned Osiris; and his adoration of Osiris.¹³ The representations of the transactions in other copies, though more abbreviated in form, imply a similar sequence of episodes.¹⁴ Accordingly, they all constitute certificates, as it were, that the dead person concerned has passed this *post-mortem* examination and been declared *maa kheru*.

This aspect of the Judgment depictions in the *Book of the Dead* raises an interesting question for us. There is an abundance of evidence in Egyptian literature to show that, despite their ready resort to magic on all occasions, the ancient Egyptians viewed the Judgment after death as an awful ordeal, which could not be influenced or circumvented by magic. Consequently, it seems improbable that they believed that a representation of a dead person as being declared *maa kheru* at the Judgment before Osiris would, of itself, secure acquittal. But it is possible, in view of their belief in the magical potency of iconography, that they felt that it would at least be "propitious" to have themselves portrayed in the act of being vindicated at the tribunal of Osiris. A motive may have operated here similar to that operative in mediaeval Christian art where the deceased was portrayed in the company of the saints in Heaven.[15] There is, however, another possibility which should be mentioned. If, as we have seen,[16] the depiction of the Judgment on the walls of the Ptolemaic temple at Deir el Medineh may indicate that the Judgment was ritually enacted on behalf of the deceased before burial, the pictures of it in the *Book of the Dead* might represent idealised records of its ritual enactment. In other words, they may certify, like the depiction of the "Opening of the Mouth," that the deceased had been ritually identified with Osiris in the Judgment which, according to his legend, he had undergone, as well as in his burial and resurrection.[17]

The *Book of the Dead* was, accordingly, not just an illustrated guidebook for the dead; some of its illustrations may have been intended to assist *per se* in the achievement of a blessed afterlife. In this sense it appears to be unique, and is not to be likened to the *Bardo Thödol* or so-called *Tibetan Book of the Dead*.[18] For the Egyptian *Book of the Dead* was essentially related to a complex mortuary ritual, including the embalmment of the body, which was modelled on actions believed to have been done to restore Osiris to life.[19] It was not designed, as the *Bardo Thödol* appears to be, as an instruction in the art of dying; and it was based on a wholly different conception of human nature and destiny.[20] The illustrations of the Tibetan document, moreover, are of a wholly different order and purpose: they depict certain deities and their emanations.[21] Closer parallels to the narrative vignettes of the Egyptian *Book of the Dead* can be found elsewhere

305

98a, b

98a

376

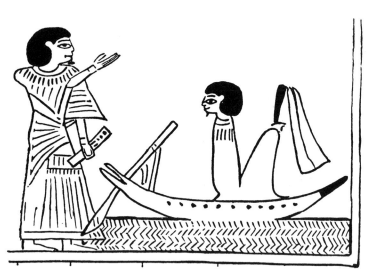

374. Vignette from *Papyrus of Nu* to Cap. 93 of *Book of the Dead*, showing the deceased addressing the daemonic ferryman.

375. *Papyrus of Ani*. The justified Ani is presented by Horus to Osiris.

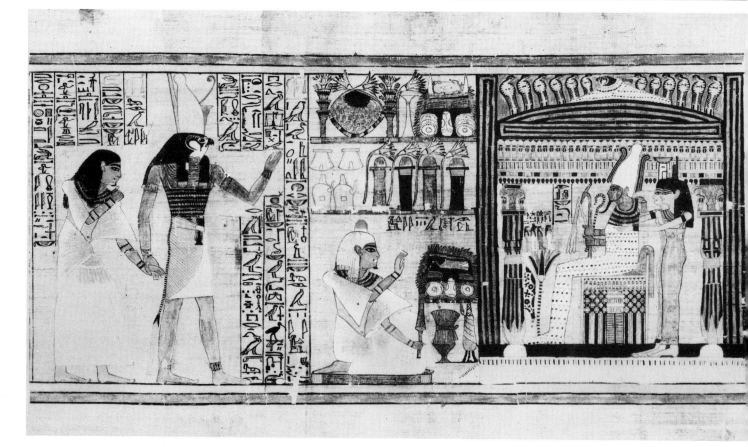

—most notably in Chinese Buddhist depictions of the Ten Hells through which the soul must pass after death; but the purpose of these was to warn the careless of the penalties which must be endured hereafter for the sins committed in this life.[22]

377a, b

The illustrated books provided for private perusal in other religions seem to have had no other purpose than to impart instruction and admonition, and inspire devotion. Christianity during the Middle Ages produced a wonderfully rich treasury of such works, which surely reflects a predeliction for realistic icongraphy that was stimulated by the narrative character of so much of its sacred literature.[23] All kinds of books were illustrated: bibles, missals, psalters, brevaries, and works of private devotion. The illustrations were usually related to the text, and they must surely have exercised an immense influence upon those who constantly used the books. For the artists, generally with great skill, presented both events and ideas, often but summarily mentioned in the texts, with a vivacity of depiction that commands attention and impresses the imagination.[24] Usually the scene was given a contemporary setting, so that it appeared not as something that had once happened long ago in a strange land, but rather as though it had taken place yesterday in the local countryside. Thus a representation of Jesus' raising of Lazarus from the dead, in a prayer book made about 1500 for a Flemish nun, shows the miracle as though it were happening just outside the walls of a Flemish town.[25] Or, to give another example, the miraculous finding of the true Cross by St. Helena seems to be happening in a contemporary Italian *palazzo*, according to an illustrated breviary of the late fifteenth century, once used in the Franciscan convent of S. Croce, Florence.[26]

378a

378b

379

The awful events, also, which Christians believed would mark the end of the world, when Christ returned to judge the living and the dead, were as frequently depicted in books of devotion as in the murals and sculptures of churches and cathedrals. The close and intimate study of these dread happenings, depicted in horrific detail in such books, must have endowed what were originally concepts of Jewish apocalyptic faith with a frightening reality for medieval Christians. We shall limit our examples of this aspect of Christian iconography to two, which will serve to illustrate both the more restrained and the more horrific depiction of the Last Things in miniature painting. A

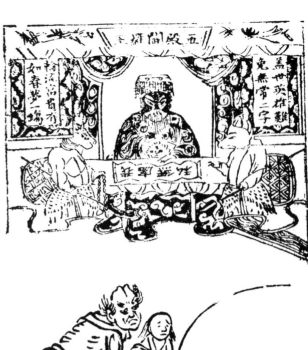

377a. Hindu version of the fate of the damned.

377b. Chinese popular print of the torments of Hell.

378a. *Christ before Pilate*. Miniature from the 6th-century Rossano Codex.

378b. *Raising of Lazarus.*

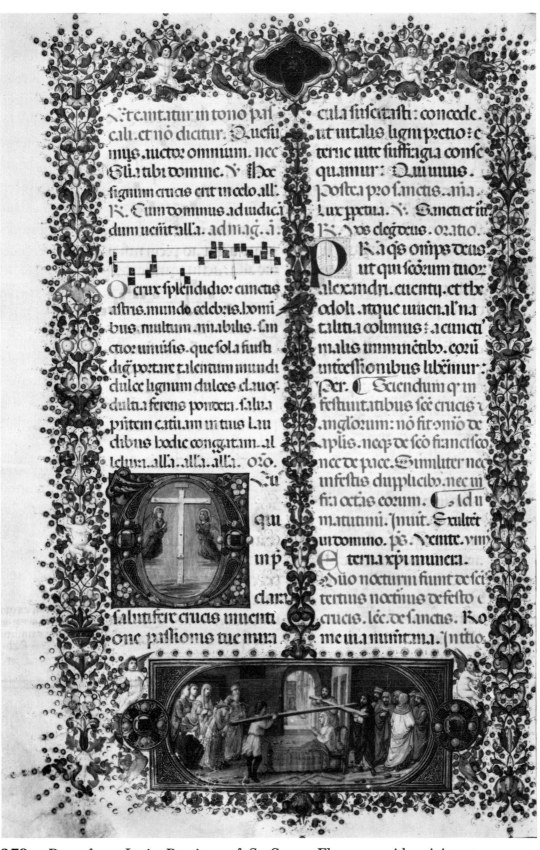

379. Page from Latin Breviary of S. Croce, Florence, with miniature showing the Finding of the True Cross.

380

fifteenth-century "Horae and Psalter," now in the John Rylands Library, Manchester, depicts the Resurrection of the Dead with a directness and simplicity that attest to the reality of the faith that inspired the portrayal.[27] The coming of Christ in Judgment is announced by two angels, at the sound of whose trumpets the dead begin to emerge from their graves. The Virgin Mary and St. John kneel to supplicate the avenging Christ to be merciful to frail humanity.[28] The other example is taken from the sumptuous *Book of Hours*, which the Duc de Berry caused to be made for his use in 1413–1416, and which ranks among the finest products of the mediaeval illuminated art.[29] It depicts

381

the torments of the damned in Hell, and is attached to the "Office of the Dead" section of the *Book*. What thoughts this horrible essay in demonic fantasy induced in the princely owner of the *Book* is a subject for curious speculation. But this depiction of the macabre is not alone

301

in the *Très Riches Heures* of the Duc de Berry, as we have already seen; neither is the portrayal in this work of such grim themes unique.[30] The mediaeval Christian in his private devotion was not spared that constant emphasis upon mortality and judgment that characterised the public expression of Christianity, in both its literature and art. And it is in keeping with this view of man's destiny that when printing was invented in the fifteenth century, an illustrated

382a, b

Ars moriendi (The Art of Dying) was one of the first works to be produced by the new process.[31]

The Christian illuminated book fulfilled in miniature, and for private contemplation, what paintings and sculptures in churches and cathedrals provided for publicly, namely, a demand for pictorial representation of the sacred history and doctrines of the faith. Even the iconoclasm of Protestantism, despite its initial vehemence, did not persist, and the visual conceptions which Protestant Christians have of Jesus, of God the Father, the Holy Spirit, and the Resurrection of the

383, 384

Dead and the Last Judgment, are as strongly moulded by a traditional iconography as are the like conceptions of Catholics.[32]

Islam, in this context, furnishes some significant evidence. By origin and genius a religion essentially aniconic, its mosques have remained generally devoid of iconographic representation, and for their decoration a rich tradition of non-representational design has been developed.[33] But a demand eventually arose, and was met, for a pictorial

301

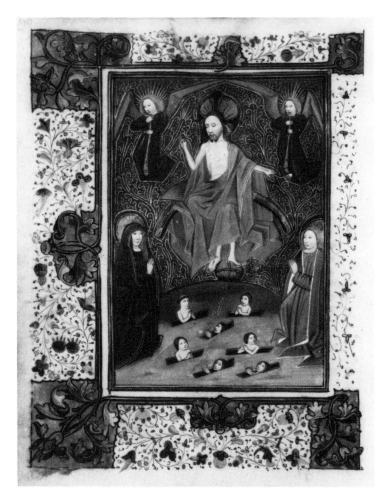

380. Miniature of the Resurrection and Last Judgment, from 15th-century Horae and Psalter. The miniature precedes the Seven Penitential Psalms.

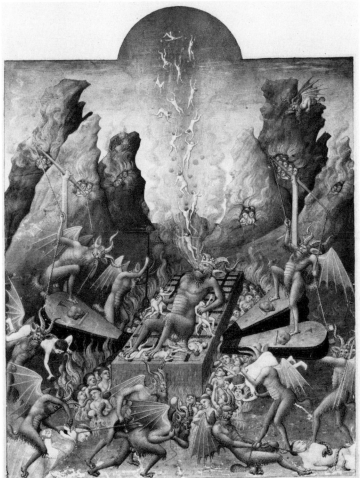

381. *Hell*, miniature in *Les Très Riches Heures du Duc de Berry*.

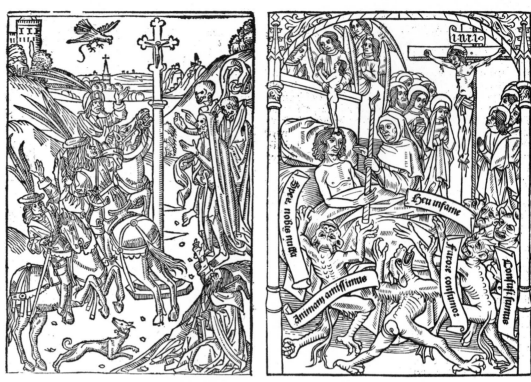

382a. Woodcut for the *Ars moriendi* showing cavaliers and skeletons.

382b. Woodcut for the *Ars moriendi*, showing demons reaching for a dying man.

383. *The Finding of the Saviour in the Temple*, by Holman Hunt.

384. St. Michael overcoming the Devil, by Epstein, Coventry Cathedral.

385. Muhammad replacing the Black Stone in the Ka'ba.

record of the life of Muhammad and the depiction of other sacred events and beliefs. A very informative series of such illustrations exists in certain manuscripts of Rashīd al-Dīn's *Jami'al-Tawarikh* or "Universal History," pre-eminently in that now in the University Library, Edinburgh, which dates from 1306.[34] Herein many incidents of Muhammad's career are realistically depicted, including the portrayal of supernatural beings such as the angel Gabriel and the mysterious Buraq, which transported the Prophet on his famous Night Journey to view Heaven and Hell.[35] The pictorial, but never the sculptured, representation of the life of the Prophet has continued down to modern times, and is now reproduced in popular prints.[36]

That the illustrated manuscript should have been found a congenial medium of expression in Hindu culture is intelligible in view of the strong iconographic tradition of Indian religion. Of outstanding quality in this art form are the miniatures, produced by Rājput painters, illustrating the great religious epics. Particularly notable for their realism are those in the Kāngrā style, dating about 1774 to 1823, in which the exploits of Krishna are depicted.[37] One of the most attractive of these pictures, known as the *Hour of Cowdust,* shows the divine hero in a typical scene of Indian rural life, thus making credible the avatar of deity by the authenticity of its setting.[38]

The hand-scroll, illustrated with narrative scenes from the legend of the Buddha, the *Jātakas,* and the lives of Buddhist saints, became a popular medium for instruction and meditation in eastern Asian lands, especially in China and Japan.[39] When printing from wooden blocks was introduced in China, its resources were quickly used by Buddhists, and the oldest known printed book, dating from the ninth century A.D., is of a Buddhist text, the *Diamond Cutter Sutra.*[40] A rich treasury of Buddhist iconographic art survives, in the form of painted scroll and printed book, of this more intimate witness to Buddhist faith and practice. It confirms the evidence of the iconography—in painting and sculpture found at stupas and in cave-temples and pagodas—that even this religion, which sought to release from the empirical world, instinctively expressed its beliefs in a linear and plastic art of a realistic kind. In this wise Buddhist art has not differed significantly from that of Christianity, which affirms the eternity of the incarnated form of Christ and believes in a physical resurrection of the dead.[41]

386. Muhammad's Night Journey: viewing the torments of the damned.

387. Modern Islamic print of Gabriel delivering the Qur'ān to Muhammad.

388. *The Hour of Cowdust*, miniature Rajput painting, Kāngrā school. Courtesy, Museum of Fine Arts, Boston. Ross Collection.

389a,b. Scenes from the life of Krishna.

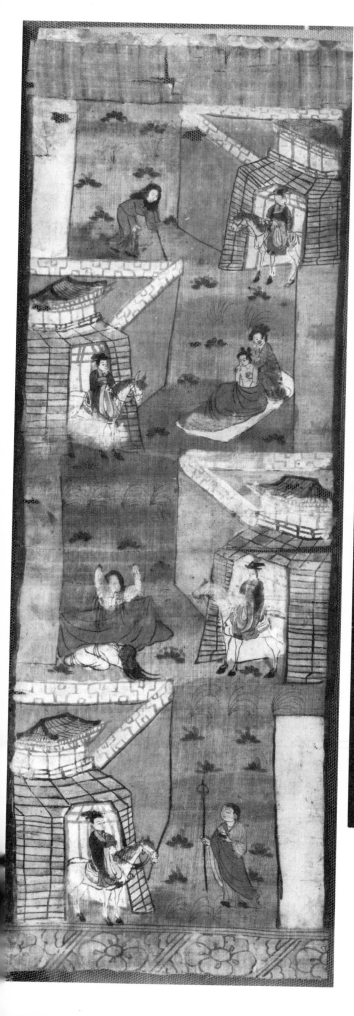

390. Chinese Buddhist painting from Tun-huang depicting four encounters of Buddha.

391. Votive plaque from Ur, showing a nude priest offering libations.

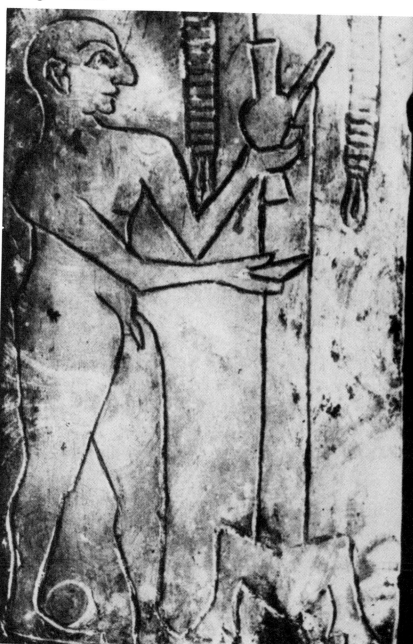

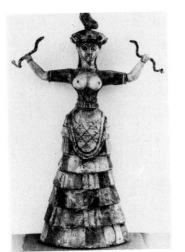

391

140, 143

11, 217

7

392

25

26, 27

XII. RITUAL VESTMENTS

In approaching his gods, man has often felt it to be proper or necessary to don special garments, frequently embroidered with symbols or devices of various kinds. The practice has not been universal in the history of religions. Indeed, there is even evidence that nudity has somtimes been regarded as the fitting state in which the gods were to be served. Thus, the ancient Sumerian priests ministered in their temples completely nude;[1] primitive Hebrew prophets prophesied naked;[2] and Cretan priestesses exposed their breasts, although in so doing they were probably following contemporary secular fashion.[3] The motives for such ritual nudity are various and complex; but in our present context their investigation is necessarily outside the range of our concern.[4]

Besides such comparatively rare instances of ritual nudity, it has also been the custom, and it is still current practice in some religions, to worship or perform ritual acts in ordinary secular clothing.[5] Thus in the religion of ancient Egypt, surprisingly in view of its strong hieratic tradition, priests ministered undistinguished by special vestments, except for a diagonal sash and the panther skin worn by the *sem*-priests.[6] Priestesses, similarly, wore only their secular attire, their sacerdotal office being denoted by the emblems or instruments they carried, notably the sistrum.[7] The service of the state-gods of Greece and Rome required the wearing of no specially designed sacerdotal garments by ministrants;[8] Roman priests wore the *toga praetexta* and various insignia, with the head veiled at sacrifices.[9] Hinduism, Jainism and Buddhism have evolved no sacerdotal attire; but Hindu sects are distinguished by facial markings, and Buddhist monks have their saffron-colour robes.[10]

Despite these notable exceptions, the use of special, and often ornamental, dress by officiants at religious rites is very ancient and widespread. The so-called "Sorcerer" of the Trois Frères cave, who has already had our attention, provides also our earliest known example of the donning of special vestments for the performance of a ritual dance.[11] Possibly, by the wearing of the skin of an animal or its horns, it was thought that the shaman-sorcerer became invested with the nature and being of the animal concerned.[12] Similarly, perhaps, the ritual masks

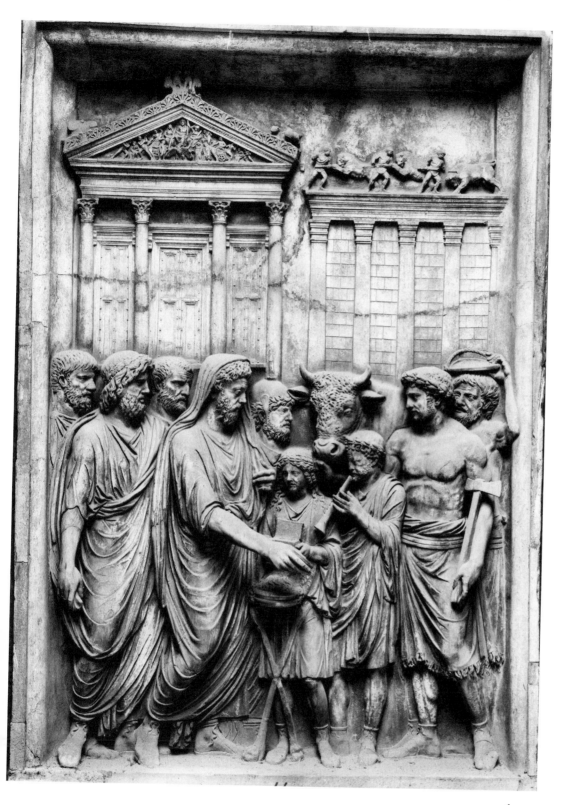

392. Relief showing Marcus Aurelius sacrificing. In the Palazzo dei Conservatori, Rome.

11

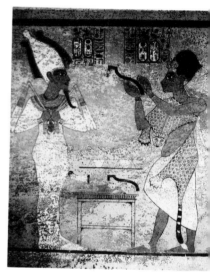

217

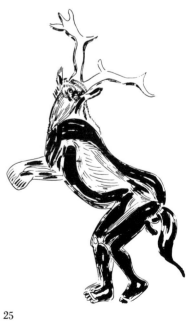

25

27

82a, b, 95
393a, b

worn by Egyptian and Aztec priests, and Mithraic ministrants, and the curious fish costume of the priests of Ea, were believed to render these ministrants, on specific occasions, embodiments of the gods whom they thus impersonated.[13] But for our most informative evidence of the use of religious vestments, for which divine prescription was also claimed, we must turn to ancient Israel.

Chapter xxxix of the *Book of Exodus* contains a long and detailed account of the instructions given by Yahweh to Moses for the making of the vestments of the high priest Aaron. The account is clearly an idealised "foundation legend," designed to explain the ritual dress of the Jewish high priest as representing the exact prescription of Yahweh, the god of Israel.[14] This claim to divine sanction is significantly asserted at the beginning of the account: "And of the blue and purple and scarlet stuff they made finely wrought garments, for ministering in the holy place; they made the holy garments for Aaron; as the Lord (Yahweh) had commanded Moses."[15] The garments, which are then minutely described, were obviously not designed to be only a fitting vesture (by virtue of their rich materials and fine embroideries) for ministering to Yahweh in the "holy of holies." For they served distinctive ritual purposes. Thus, into the tunic-like ephod, woven of gold, blue, purple and scarlet thread, there were inserted onyx stones engraved with the "names of the sons of Israel," which were "to be stones of remembrance for the sons of Israel."[16] Upon the ephod there was worn a "breastpiece" of similar composition, in which were set, in four rows, twelve different precious stones, each engraved with the name of an Israelite tribe.[17] Vested in this ephod and its breastpiece, it would seem that the high priest was designated thereby to be the personified embodiment of the People of Israel, in its worship of Yahweh. Of another, but related, purpose appear to have been the pomegranates and bells of pure gold that were attached to the robe worn beneath the ephod.[18] In *Exodus* xxviii:35 an explanation is given for the bells: "And it shall be upon Aaron when he ministers, and its sound shall be heard when he goes into the holy place before the Lord (Yahweh), and when he comes out, lest he die." This statement has a great significance, and it relates to other evidence in the Hebrew Bible concerning belief in the danger of unauthorised contact with, or intrusion into, the aura of holiness that invested the presence of Yahweh.[19]

82a 82b

In some aspect of the same belief doubtless lies the explanation of the next item of the holy vestments to be described. Instructions are given for the making of a mitre or turban for Aaron of fine linen, to which was attached a golden plate engraved with the words: "Holy to the Lord (Yahweh)." The explanation is then given: "It shall be upon Aaron's forehead, and Aaron shall take upon himself any guilt incurred in the holy offering which the people of Israel hallow as their holy gifts; it shall always be upon his forehead, that they may be accepted before the Lord."[20] The meaning of the passage is essentially obscure; for it seems to present Aaron or the high priest as a kind of scapegoat for Israel, by way of explaining his wearing of the gold frontlet and its curious inscription. However, there is probably a logic here that relates to the primitive concept of holiness. The high priest, by virtue of his contact with Yahweh and his status as surrogate for Israel, became an ambivalent figure. He went, as Israel's representative, into the awful presence of Yahweh, and thereby he acquired something of the dangerous holiness that invested Yahweh.[21] It is this dual aspect or character that appears to find expression in the vestments and ornaments prescribed for his ritual use. The significance of the pomegranates is even more puzzling. In Jewish folklore pomegranates generally symbolised fertility; but whether that was their meaning on the high priest's vestments, and, if so, in what particular context, remains a matter for speculation.[22]

The Jewish historian Josephus, writing in the first century A.D. on the beliefs and institutions of his people in a work addressed to Graeco-Roman readers, preferred to explain the vestments in another way.[23] Using a cosmic symbolism, which was probably congenial to his own way of thinking as well as calculated to interest his Gentile readers, he asserts that the various priestly garments signified the constituent parts of the universe. Nothing is said of the essentially Jewish significance of the twelve precious stones of the breastpiece; instead, they are interpreted to denote either the months of the years or the signs of the zodiac.[24] In a later passage, he attempts to explain the mysterious Urim and Thummim, which the statement in *Exodus* (xxviii:30) connects with the breastpiece, as a kind of supernatural talisman that by its flashing lights proclaimed the assurance of divine help for Israel at moments of crisis.[25]

95

393a. Assyrian priest of Ea, wearing a fish-mantle.

393b. Eunuch priest of Cybele (probably an archigallus), wearing female attire, and a pectoral ornament with effigy of Attis. In Palazzo dei Conservatori, Rome.

394. Mosaic showing Bishop Maximianus and two deacons in S. Vitale, Ravenna (6th century).

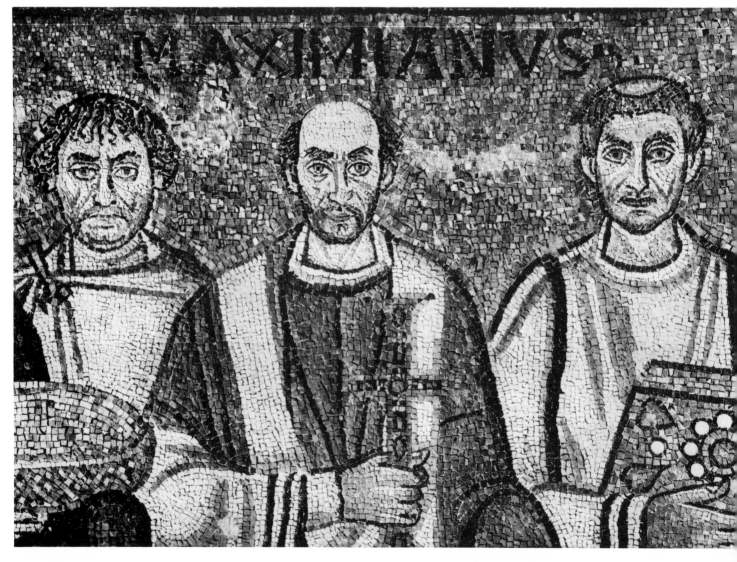

Josephus wrote of the priestly vestments as he had known them in his day; but when he wrote the great Temple of Yahweh at Jerusalem was in ruins and its cultus ended.[26] Something of the importance of these vestments is to be seen in the fact that during the period of Roman domination in Palestine, before the revolt in A.D. 66, their custody became an issue of considerable political significance. Their possession by either the Roman governor or one of the Herodian princes meant that the performance of those cultic acts, which involved the entering of the high priest into the "holy of holies," depended upon the consent of the secular power.[27]

The vestments of the Jewish high priest, and of the other clergy who maintained the elaborate cultus of the temple,[28] constitute the classic expression of the belief that divine worship could be conducted only by properly vested priests. The form and composition of these vestments, and the legend of their divine prescription, are also carefully documented so that our knowledge of them is matched only by that concerning Christian vestments, which we have next to consider. The use of special liturgical garments did not, however, end in Judaism with the destruction of the temple; for the wearing of the *tallit* or prayer shawl and the covering of the head at synagogue worship has continued an obligatory custom.[29]

The liturgical dress of the Christian clergy gradually evolved from the secular costume current in the early ages of the Church.[30] The iconography of the catacombs shows no distinction in the dress of the male figures portrayed, many of whom must have held ecclesiastical office. An intermediate stage in the development is to be seen in a mosaic representation of Bishop Maximianus and two deacons in S. Vitale, Ravenna, dating from the sixth century.[31] Maximianus wears the *paenula* or voluminous cloak of dark material, over a long white tunic, which was the usual outdoor dress of official persons in Rome. The only article of dress that denotes his ecclesiastical status is the *pallium* or stole, of white material embroidered with crosses, which he wears draped over his shoulders. The popes began to wear the *pallium* as a sign of their office from the early fifth century, and they subsequently conferred it on other bishops. Its origin is obscure; but it appears to have been adapted from the usage of secular magistrates who denoted their office by the wearing of a coloured stole or scarf.[32]

394

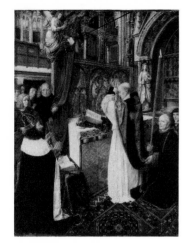

395a, b

16

102

281

286

396

102

It was from the *paenula* and the under-tunic that the two distinctive vestments of the Christian priesthood—the chasuble and the alb—severally derived.[33]

By the tenth century, the principal liturgical vestments of the Catholic Church in the West had achieved what has become their traditional form and use. An ivory antiphonary cover of this time, which was probably carved in Germany, provides interesting evidence of the vestments of a bishop and his clergy. It reveals how the now fully developed and firmly established hierarchy of the Church had evolved a form of attire designed to distinguish its members from the rest of contemporary society.[34] This ecclesiastical costume, moreover, came to comprise a variety of garments that related to the performance of specific rites. Thus, the celebrant at Mass wore the chasuble and alb; and to these were added lesser but significant articles such as the amice, stole, maniple and girdle.[35] For the deacon and subdeacon, who assisted the sacerdotal celebrant at High Mass (*Missa solemnis*), other special vestments (most notably the dalmatic and tunicle) were prescribed.[36] At other liturgical services, the officiant wore a cope over the alb.[37] Bishops became distinguished by special vestments and ornaments, the most characteristic being the mitre, crozier and ring.[38]

These vestments have been, and still are, regarded as sacred garments. They are specially consecrated for use, and the celebrant recites prescribed prayers as he puts on each of the Mass vestments.[39] Many of the vestments are decorated with sacred images and symbols, and their colours usually vary according to the liturgical season.[40] In process of time, mystical meanings have been attributed to certain of the vestments used at Mass.[41]

That these vestments are essential to the proper performance of the rites of the Church would certainly be denied by theologians; but in practice so great an importance seems to be attached to the principle that some sacred vestment should be worn, that even in the emergency administration of the sacraments priests are accustomed to wear a stole. Accordingly, although divine commandment has never been claimed by the Catholic Church, as it was in ancient Judaism, for the wearing of vestments, in practice its use of them has certainly been consistent with a conviction that the liturgical service of God requires the special attire of the officiants.

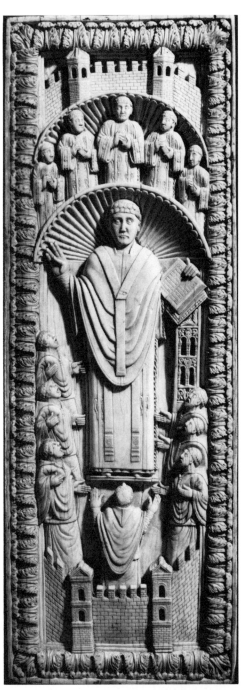

395a,b. Two panels of an ivory diptych probably made in Trier, showing, respectively, bishops saying Mass and giving a benediction (9th-10th centuries).

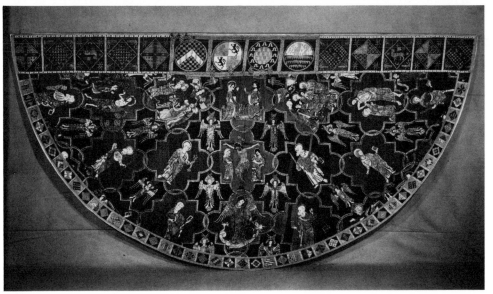

396. The Syon Cope.

The wearing of special dress and insignia has also characterised the office of kingship. Although with many monarchies some of this regalia has signified aspects of secular power and authority, in origin much of it has been associated with the divine character of kingship. Ancient Egypt, once more, affords the earliest and most notable example of such royal attire in the dress and insignia of the pharaohs. Thus, the Red and White Crowns of Lower and Upper Egypt were regarded as goddesses, and images of them were so placed on the crowns as to appear above the pharaoh's forehead as prophylactic amulets—a cobra represented the goddess Wadjet and a vulture the goddess Nekhbet.[42] When seated upon his throne, the Egyptian king held in either hand a crook and flail.[43] These curious insignia he inherited from his divine prototype, the god Osiris, who seems to have acquired them from a primitive nome-deity called Anzti.[44] The crook-sceptre (*'w.t*) was obviously derived from a shepherd's crook, and it doubtless signified originally the role of a divine shepherd or lord of the flocks. In pharaonic Egypt, however, this crook-sceptre became the hieroglyph symbol of the word *ḥḳz*, meaning "to rule."[45] The significance of the flail or whip is obscure. Like the crook, it could also be a shepherd's implement; certain deities, for example, the fertility-god Min, are often represented with such a flail.[46] Whatever the origin and exact nature of these emblems of Egyptian royalty, there is no doubt about their essentially religious significance. To the ancient Egyptians, the god Osiris was the divine prototype of the pharaoh, and he was invariably portrayed holding the crook and flail, and wearing the tall White Crown of Upper Egypt.[47]

Like the Egyptian priests, the pharaoh does not appear to have worn special vestments, except on particular occasions. Thus, at the Sed festival, when his vital powers were ritually renewed, he wore a curious cloak of shroud-like appearance, which was probably related in some way to the symbolism of rebirth.[48] When he functioned as the *sem*-priest at the ritual "Opening of the Mouth" of his deceased predecessor, as we see Ay doing in the tomb of Tut-Ankh-Amun, he wore the panther skin which characterised the officiant at this mortuary ceremony.[49]

The Roman emperor combined within his person the highest civil, military and religious offices of the state, and each had its appropriate

397, 34, 50, 210

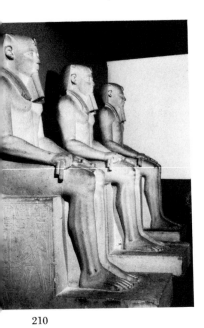

210

40, 80, 375

86

217

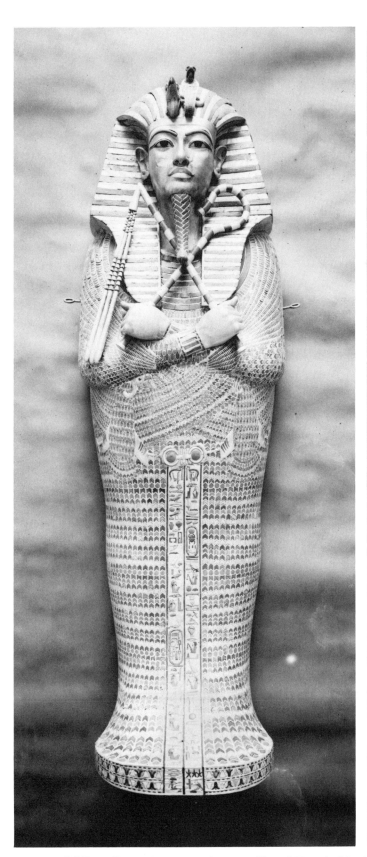

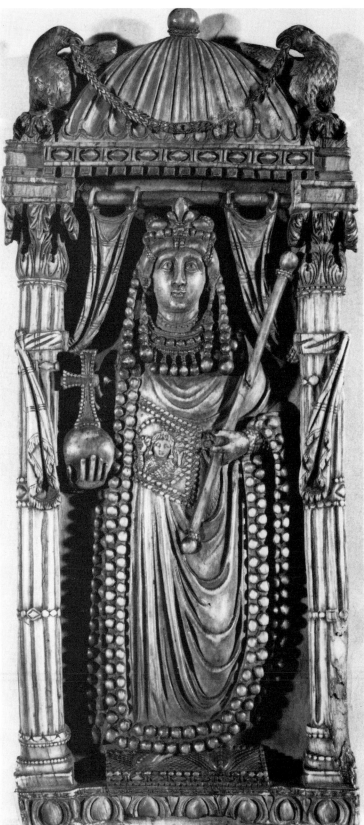

397. Second mummiform coffin of Tut-Ankh-Amun.

398. The Empress Ariadne (*c.* A.D. 500), represented on a leaf of an ivory diptych.

154a

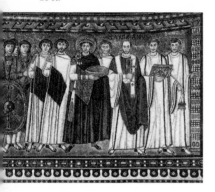

398, 154a

8

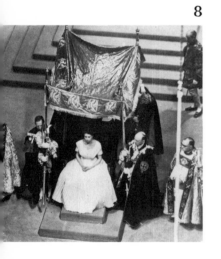

399

ritual and vesture.⁵⁰ With the acceptance of Christianity as the official religion of the Roman Empire in the fourth century, it was inevitable that both the imperial office and much of its ritual should be Christianised. With the removal of the capital from Rome, to Byzantium, where there was no ecclesiastic as powerful as the pope, the sacral character of the emperor became firmly established. From the year 602, the coronation of the new emperor took place in a church—from that of Constans II (641–668) the ceremony was performed on the *ambon* of the great Cathedral of Hagia Sophia.⁵¹ The emperor was vested in special vestments and crowned with a golden diadem. So clothed and crowned, and seated on a "throne of lordship," he was then venerated as the "*Autokrator* in God."⁵²

This Byzantine presentation of the Christian sacral king greatly influenced the conception of kingship and its ritual expression among the nations of Western Christendom during the Middle Ages.⁵³ The English coronation ceremony has alone survived to witness to this mediaeval conception, and to show how such a conception was embodied in special vestments and insignia. Thus, the solemn vesting of the monarch with the garments and insignia of royalty is a distinct episode in the coronation ritual. This investiture follows the rite of anointing, which confers a charismatic character on the monarch.⁵⁴ In turn, he is robed in a long white linen vestment (the *colobium sindonis*), over which is passed a *supertunica* of cloth of gold, in shape like a dalmatic. A stole called the *armilla* is next placed about the neck, and then the imperial robe or *pallium,* which is similar to a cope. The orb is next delivered into the monarch's hand; then the ring as "the ensign of kingly dignity and of defence of the Catholic faith." After that, he receives the royal sceptre, surmounted by a cross, and a rod bearing the image of a dove as the emblem of "equity and mercy." The culminating act is the placing of the crown of St. Edward upon the sovereign's head by the archbishop of Canterbury. Thus vested and adorned with the insignia of royalty, the crowned king then receives the fealty of the bishops and the homage of the nobles, and is acclaimed King by the people.⁵⁵

The English coronation service, thus, survives as a unique memorial of the ritual use of vestments in a context that combines religious and secular significance. It attests to a deeply rooted instinct that

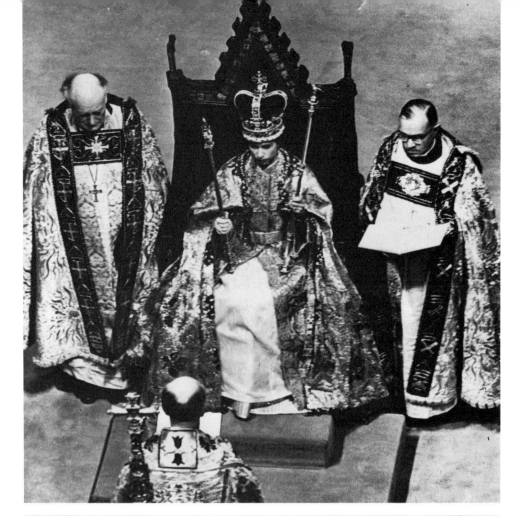

399. Queen Elizabeth II, sitting crowned and with sceptre and rod, at her coronation.

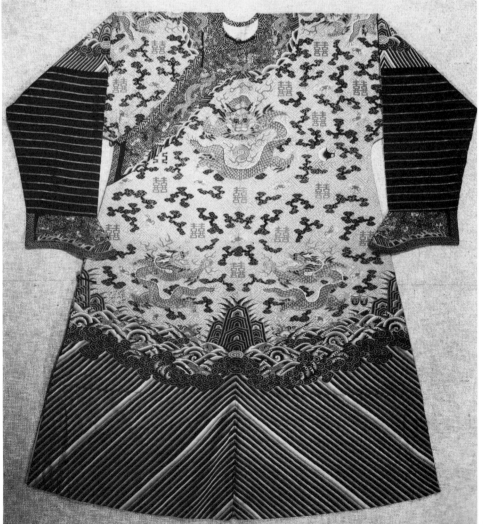

400. Chinese emperor's marriage robe, showing a five-clawed dragon and other symbols.

134

initiation into an office of singular distinction must find visible expression by the solemn vesting of the person concerned in special garments and insignia.

We may conclude this section of our study by briefly noticing another example of the sacred character of royal vestments, located on the other side of the world—in Imperial China.

The Chinese conception of mankind as being essentially an integral part of the universe, and the consequent necessity of integrating human affairs with what was believed to be the basic harmony of the cosmic process, found expression in an elaborate ritual.[56] The emperor, as the Son of Heaven, was the essential agent in the maintenance of this ritual, which was based upon the calendar. Each season of the year had its particular ritual requirements, among which was the wearing by the emperor of robes of the appropriate colour.[57] This requirement was but one consequence of the great importance that was attached to liturgical dress—an importance that is abundantly attested in art and literature. Thus, Chinese tradition preserved the authorising prescription of the legendary emperor Shun concerning the embroideries on the imperial robe:

I desire to see the symbols of the men of old—the sun, the moon, and the stars, the dragon and the flowery creature—depicted, or embroidered, on the robe; then the sacrificial vessel, the sacred grass, the flame, the rice-grains, the axe and the stripes finely embroidered on the skirt: so that the five decorations are displayed in the five colours in making the garments.[58]

400

Vested in such a robe, known particularly as the dragon robe, the Chinese priest-king, who was himself identified with the mythical *lung*, the dragon of life-giving power, offered those seasonable sacrifices upon which the life and prosperity of all depended.[59]

401, 134

The comparative study of the significance of ritual vestments is a subject to which little attention has so far been given by scholars. Our brief survey has at least served to show that mankind, in various times and places, has felt it necessary to wear a special vesture in approaching its gods in sacrifice and prayer.

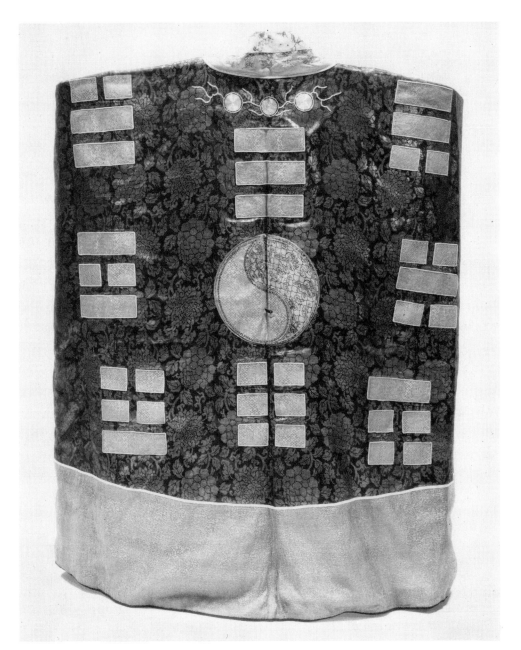

401. Taoist priest's robe, embroidered with the yin-yang symbol and the eight trigrams (18th-19th centuries).

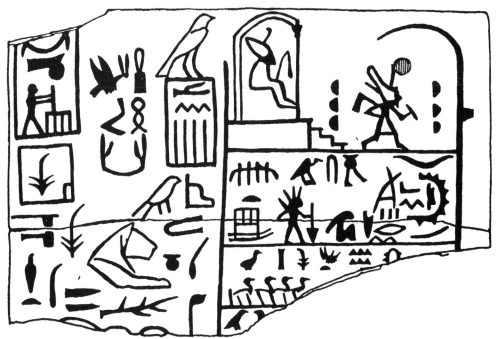

402. Scene from an ebony label, found at Abydos, showing king Udimu (First Dynasty) performing a ritual dance or race at his Sed-festival.

XIII. THE RITUAL DANCE

It is surely significant that of the two oldest "icons" that have survived to us, one represents a dancing figure. The so-called "Dancing Sorcerer" of the Trois Frères cave, contrasting in its animation with the static "Venus of Laussel," testifies to the remote antiquity of the dance as a form of religious, or rather religio-magical, expression.[1] From this Palaeolithic witness, evidence of the ritual dance can be traced down through the centuries and in almost every part of the world: already in our study we have encountered several instances of its practice.

25, 46

46

The ritual dance constitutes a subject so vast and so complex in its forms of manifestation that, in the present context of our study, we can but note something of its diverse significance. To this end, we cannot do better than cite an evaluation made by that great master of the history of the dance, Kurt Sachs.[2] After remarking that with the animals the action of dancing is only a reaction to an emotional state, he writes:

With man, on the contrary, the dance can be transformed into a means of participating in forces, outside the range of human ability, that shape destiny. The dance may be a sacrifice, a prayer, a magical transaction. It can invoke or combat the forces of nature, cure sickness, forge a link between the dead and their descendants; it can secure the harvest, ensure a successful hunt and provide victory; it creates, maintains, orders and protects. In the life of peoples and social classes still close to nature, the dance is the primary form of expression on all occasions: birth, circumcision, initiation of young girls, marriage, seedtime and harvest, the hunt, war, lunation.

Sachs has made an elaborate classification of types of dancing that were originally religious or socio-religious in inspiration and purpose. He first draws a generally applicable division between those dances that are non-imitative in their action and those that are imitative.[3] He then defines the following categories, which have both their imitative and non-imitative forms: dances of healing, fertility, initiation of adolescents, marriage, funerals, war, and those relating to celestial phenomena.[4] It is possible to add to this list. There are, for example, dances of rejuvenation or rebirth such as that performed by the Egyptian pharaoh at his Sed festival[5] or the Dionysiac initiate portrayed in the

402

Villa of the Mysteries at Pompeii.[6] Then, too, there are those dances that induce a form of religious ecstasy, such as those of the ancient Greek maenads,[7] the Muslim dervishes,[8] and the cult of Voodoo.[9] Many of the dances, in all the categories defined by Sachs, also require special dress or masks or such equipment as horns and weapons.[10]

Whether dancing is truly instinctive to man, as it seems to be to certain animals when mating, cannot be proved. But dancing has undoubtedly been a form of emotional expression to which man readily reverts on those occasions of crisis when he feels that something more than practical action is needed to achieve what he desires. Thus, as we have noted, the Palaeolithic hunter supplemented his own skill with the magical efficacy of a mimetic dance performed by a shaman in animal disguise.[11] Generally, it would seem that ritual dancing has been a communal activity. Even when such a dance is performed by one person only, it is invariably watched, with an intensity of participation, by others. So essential has been this corporate aspect of the sacred dance that Jane Harrison supposed that from the *dithyramb* or Spring Dance, danced by young men (*kouroi*) in archaic Greece emerged the concept of Dionysos, the divine *Kouros*.[12] Although it is improbable that a god was ever created in this way, there can be no doubt that communal dancing, prompted by a commonly shared purpose, can generate mass emotion of a very powerful kind. It can also have a contagious effect, as the mediaeval dancing manias so strangely showed.[13]

It is pre-eminently in India that the whole cosmic process, unceasingly creating and destroying life, has been conceived of as the action of a divine dancer. Many statues portray Śiva as *Natarāja*, "the great Dancer," for ever maintaining all existence as he moves with dynamic rhythm through the complex maze of cosmic reality.[14] This feeling for life as manifest in an unceasing rhythmic pattern of movement finds expression also in the myriads of dancing figures that adorn so many Hindu and Buddhist temples, and in the sacred mimetic dances performed by specially trained dancers.[15] It has, perhaps, been the exuberance of Nature's life, and its equally dramatic decay, in India that have caused the dance to be thus deified as the movement of a god.[16] But elsewhere, though in less exalted imagery, the dance has been regarded as an essential constituent of rites designed to ensure the proper functioning of Nature at certain critical junctures of its annual cycle.[17] An

345a, b, c

403, 404

36

405, 100

100

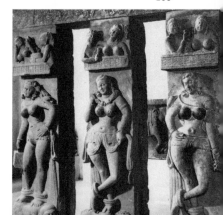

403. A maenad, drawing from a Greek kylix.

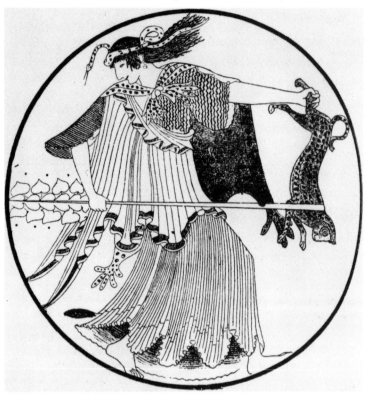

404. Dervishes in an ecstatic dance.

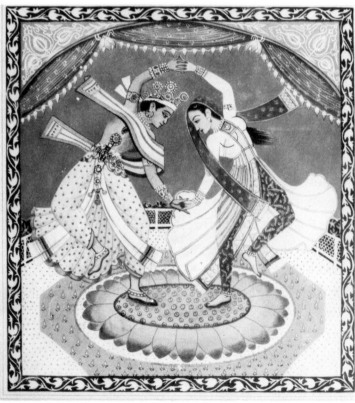

405. Modern Indian print of a sacred dance.

Egyptian text of the late period dealing with the ritual of the New Year, tells how, in consequence of the chief ritual act, "The heaven rejoices, the earth dances (*ibz*). The musicians of the temple play and dance."[18]

Egypt also provides, from the incomparable treasury of its art, precious iconographic evidence of the ritual dances which formed part of the complex ceremonies of the Sed festival. This festival, which was designed to renew the vitality of the pharaoh, was a ritual occasion of immense importance for the well-being of the land and people of Egypt.[19] In the New Kingdom period, the rites included the solemn raising by the king of the *djed* column. This mysterious object, which at Memphis represented Ptah-Sokar-Osiris, symbolised stability.[20] Its solemn raising from a supine position by the pharaoh, on this occasion, was doubtless connected with the idea of ensuring the stability of the kingdom of Egypt.[21] A courtier named Kheruf, who had assisted at the Sed festival of King Amenhotep III (1405–1370 B.C.), fortunately arranged for a pictorial account of the rites to be carved on the walls of his tomb in the Theban necropolis.[22] In the two middle registers of the scene, groups of dancers, male and female, are depicted, whose performance is accompanied by the music and hand-clapping of other persons. With the dancers there appear also men engaged in ritual combat.[23] How these dancers were deemed to assist the purpose of the ritual raising of the *djed* column is not clear; but it is evident that on this crucial occasion prescribed dances were regarded as necessary adjuncts to the proper accomplishment of the rites.

86, 402

97

Since dancing as a spectacle gives pleasure, it was natural that many peoples should have danced before their gods to please them. Ritual dancing in the service of the gods figured prominently in Egyptian religion, and several gods had specially designated dancers among their female ministrants.[24] The goddess Hathor included among her many titles that of "Mistress of the Dance," and dances characterised her cult.[25] The pharaoh danced before Hathor, as King David danced before Yahweh, the God of Israel.[26] David's dancing on the occasion of the bringing of the Ark of Yahweh into Jerusalem was evidently of an ecstatic kind—it earned the disapproval of Michal, the daughter of Saul, but not apparently of the people of Israel.[27] Hebrew literature also provides another interesting reference to the cultic use of dancing.

In the celebrated episode of the making of the Golden Calf by the Israelites during Moses' absence on Mount Sinai, dancing is mentioned as a natural concomitant of the worship.[28]

That the dance should be a mode of expression in which man has sought to honour or propitiate his gods is, on reflection, readily understandable. What is more problematic is that dancing should find a place in funerary rituals. Ritual lamentation could, of course, easily develop set rhythmic patterns of movement; but more difficult to understand is the type of dances depicted in some Egyptian tombs. These dances were performed by young girls, usually wearing some distinctive ornamentation.[29] Some of the dances take the form of high kicking or stepping in a manner that reminds us of modern ballet dancing; others seem to comprise acrobatic movements, and poses which German Egyptologists have designated *Lebender Bilder* ("Living Pictures").[30] In seeking to interpret the purpose of such dances, we are confronted with a twofold problem: what did they mean in the original context of the funerary ritual (supposing that they were actually performed at some stage of the obsequies), and why were they represented on the walls of the tomb?

The fact that the high-kicking dances were known as "Hathor dances" suggests a fertility motive, which is often strangely associated with the ritual of death, doubtless by way of asserting the renewal of life against its extinction.[31] But what might be the significance of the more distinctly acrobatic dances or poses can scarcely be explained in these terms. However, since one of the Beni Hasan "Living Pictures" clearly mimes a traditional representation of the pharaoh subduing his foes, possibly the enactment of such scenes of triumph was deemed to be magically efficacious in a mortuary context.[32] With regard to the depiction of these dances in the tombs, the practice is probably to be explained along the same lines as other scenes of Egyptian sepulchral iconography: to perpetuate the magical potency of the dances for the inmates of the tombs.[33]

Another facet of the Egyptian use of the dance in funerary ritual appears briefly in a remarkable story of the adventures of a courtier named Sinuhe, which dates from the Middle Kingdom period.[34] Involvement in a political plot had caused Sinuhe to flee Egypt, and live among the Bedouin of Syria, where he prospered. But as he grew older

406a, b

238

cf. **407, 238**

408. *Muu* dances depicted in an Eighteenth Dynasty tomb.

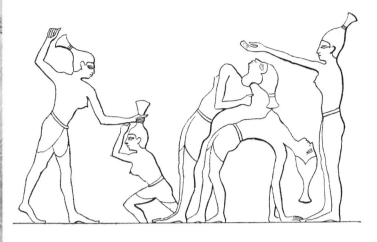

406a. Picture of girls performing acrobatic dances, from the tomb of Mehou at Saqqara.

406b. Girl dancers performing "Living Pictures," in a tomb at Beni Hasan.

407. Male and female dancers, Etruscan tomb painting. "Tomb of the Triclinium," Tarquinia.

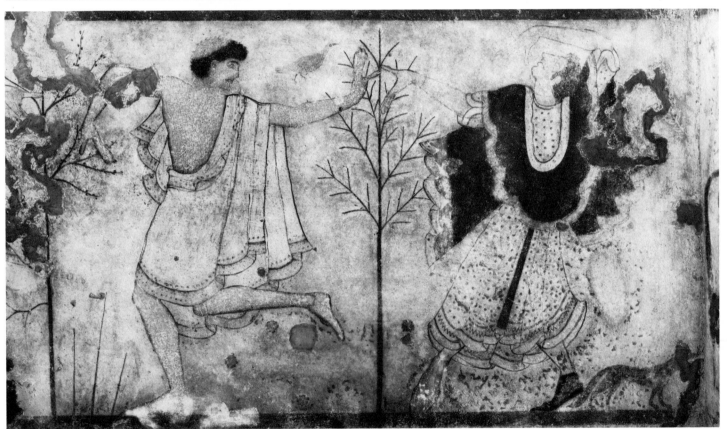

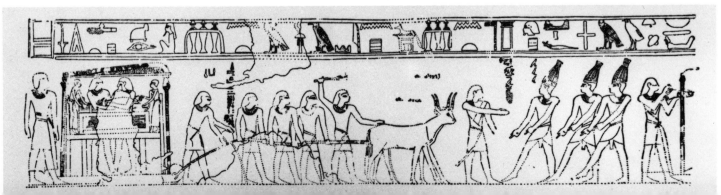

he became increasingly concerned about his prospects of a happy after-life, if he died in Syria without the advantage of the Egyptian funerary rites.[35] The pharaoh, learning of his plight, was compassionate, and offered him a safe return to Egypt and a proper funeral. In outlining the details of such a funeral, Sinuhe is assured by the king that his em-balmed body will be "placed upon a sledge, oxen dragging thee and singers in front of thee, when the dance of the *muu* is performed at the door of thy tomb."[36] These mysterious *muu* are depicted in funerary scenes in some tombs, and they are characterised by the wearing of curious tall hats rather like the White Crown of Upper Egypt.[37] There has been much specialist discussion concerning the identity of these *muu* dancers, and it seems now to be generally agreed that they repre-sented denizens of the other world who came, dancing, to welcome the deceased into the company of the blessed dead.[38]

408

These Egyptian examples have the merit, in the context of our studies, of providing some of our earliest iconographic evidence of the dance as a form of religious expression. They reflect the instinctive re-sort of this ancient people to the dance on the important ritual occa-sions of their lives, to which subsequent peoples have in like manner also turned. The secularisation of the dance in the modern Western world makes it difficult for us to appreciate its original religious role. In many other cultures, where the dance has retained its cultic or magi-cal significance, there is an increasing danger of its becoming merely a tourist attraction—such relics of the pagan past of England as the Helston "Furry Dance" and the Abbots Bromley Horn Dance have now very much the aspect of folklorist curiosities.[39] Yet, despite all the acids of modernity, there are religious sects in Western society that still find in the dance ecstatic experience, and doubtless many groups of young people would attest to the emotive power of their own forms of dancing.[40]

XIV. THE RITUAL USE OF INCENSE

Most ritual actions are, basically, practical expressions of human intention. Thus, prayer, said either standing or kneeling, naturally ex-presses man's desire to communicate with a divinity. And the offering

of sacrifice is an intelligible gesture of service whatever may be the purpose for which the offering is made.[1] But the burning of perfumed substances in the worship of deities or the cult of the dead is not self-explanatory, yet it is a practice both ancient and widespread—it was already an established custom in Egypt about 2400 B.C., and it is found in most religions, past and present, throughout the world.[2] So remarkable a practice demands, therefore, some notice here, brief though it must necessarily be.

Once more Egypt provides both our earliest evidence and best insight into the ideas that inspired the practice concerned. The ancient inhabitants of the Nile Valley associated perfume with the divine nature—Plutarch preserves the memory of this belief when he describes the wondrous fragrance given forth by the body of the goddess Isis.[3] At some unknown period the Egyptians had evidently obtained from the "land of Punt" resinous gums which exhaled fragrant smoke when burned, and they recognised in the phenomenon a wondrous emanation of the essence of divinity.[4] Consequently, this incense became a vital adjunct of their religious praxis; for by virtue of its derivation from the divine nature, it was obviously an appropriate offering to deity. As such, incense was used regularly in the daily service of the cult image, and in sacrifices and on all festal occasions. Depictions of the pharaoh offering incense to the gods adorned the walls of temples, thus symbolising his unceasing service and piety.[5] But such was the virtue of incense that it was deemed to have, also, an apotropaic and vitalising efficacy. Hence it was used in the service of the dead, especially in the essential rite of the "Opening of the Mouth"; and it was even placed within the embalmed body, to ensure its resuscitation and eternal well-being.[6]

The ritual use of incense was current practice also in the other religions of the Ancient World, although the method of using it differed.[7] In Greece and Rome it was customary to burn the incense on altars or in braziers, instead of in specially designed censers, as in Egypt and Israel, and in Christianity later.[8] Israel has the distinction of providing unique evidence of the ritual use of incense, in that its sacred literature records divine instruction for both the making of the substance and its use in worship.[9] The detailed directions, which Yahweh is represented as giving to Moses for the Atonement Day ritual, are especially signifi-

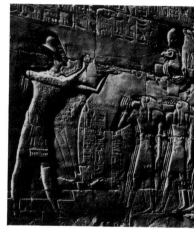

52

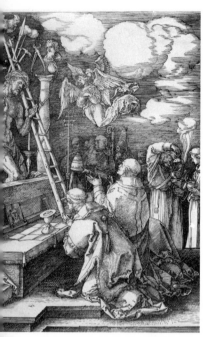

102

409

102

cant: "And he [Aaron, i.e., the high priest] shall take a censer full of coals of fire from the altar before the Lord, and two handfuls of sweet incense beaten small; and he shall bring it within the veil and put the incense on the fire before the Lord, that the cloud of the incense may cover the mercy seat which is upon the testimony, lest he die" (*Lev.* xvi:12–13). The function of the incense here appears to be purificatory and apotropaic, and is clearly associated with the concept of Yahweh's holiness. This "holiness" factor is evident also in the curious episode, recorded in *Leviticus* x:1–3, in which Yahweh kills the two sons of Aaron, who attempted to offer incense in the sanctuary when using "unholy fire."[10] According to *Numbers* xvi:46–50, a fatal plague was once stopped by Aaron's standing, with incense to "make atonement," between the living and the dead.

The use of incense in Christian worship, in both the Western and the Eastern Churches, has been long established and is carefully regulated. But the practice did not start until the latter part of the fourth century. The delay was probably due to the close association of incense with pagan worship, and especially since the offering of incense on a pagan altar was made an official test of the profession of Christianity during the period of persecution: Christians who apostatised were called *thurificati* ("incense burners").[11] However, Christians had scriptural authority for the use of incense, for the Magi were recorded to have offered frankincense to the infant Christ in the Matthean Gospel (ii:11).[12] And the *Revelation of John* also taught them that incense was offered to God, in Heaven, "mingled with the prayers of all the saints" (viii:3–4).[13]

Incense quickly became, after the fourth century, an essential adjunct of Catholic ritual not only in the Mass but in most other services, including the rites of the dead—in the Absolution of the Dead the coffin is solemnly censed.[14] During the Mass, the altar and its ornaments, sacramental bread and wine, the Gospel book, and the sacred ministers and people are all censed, doubtless with purificatory intent.[15] The censing of the consecrated Host at the Elevation, however, appears to be honorific. Incense is also used in two other curious but significant ways. Thus, during the dedication of a church, the bishop forms a cross made of grains of incense and recites a prayer of consecration while they are burning.[16] At the blessing of the Paschal candle, which is

409. Figure with censer, on altarpiece of the Virgin.

identified with Christ, on Easter Even, the celebrant affixes five grains of incense in the candle, to symbolise the Five Wounds of Christ.[17]

In the context of our study of the significance of ritual the use of incense certainly constitutes a curious, and in some ways a surd-like, factor. The complex of ideas that underlay the ancient Egyptian usage is certainly intelligible; but it is improbable that these ideas had any currency elsewhere. The widespread use of incense in religious praxis must, however, represent some common disposition of mind or reflect the expression of a common need or urge in worship. Since the materials employed as incense are various but have one attribute in common, it would seem that therein may lie the reason for the widespread ritual use of incense.[18] The one common attribute is an agreeable fragrance. Accordingly, we would seem to encounter here an olfactory phenomenon of religious significance—man has invariably identified the good with the sweet smelling, and the evil with the bad smelling.[19] Hence, to the service of his gods he has not only consecrated what is beautiful and precious in his eyes but has also used substances that give forth fragrant odour and delight his sense of smell, thinking thereby to please his gods in like manner.

We have now seen something of the vast and varied data that exist concerning man's expression of his spiritual needs and aspirations in art and ritual. We have noted the primacy of their witness to that of the written word, and also the immediacy of their impact on the senses, and the consequent profundity of their influence. There remains to us now the task of interpreting what this complex, but very fascinating, evidence tells of man's reaction to that mysterious unknown that surrounds, conditions, and menaces his life.

PART THREE

*Man and God in Art
and Ritual:
The Evidence Interpreted*

I. THE PROBLEM AND THREE BASIC THEMES IN MAN'S QUEST FOR SIGNIFICANCE

We observed at the outset of our quest that man had drawn and carved images of his gods long before he could write about them. And we noted also that this iconographic expression of his religious beliefs had been closely associated, from the beginning of the archaeological record, with ritual action. This ritual action, which appears to originate from instinctive mimetic movement in human beings when under the impetus of some urgent need or desire, probably antedates the ability to draw or carve. Whatever their respective antiquities, these two forms of action, the ritual and the iconographic, constitute, without question, the primary modes of religious expression. They embody, moreover, an immediacy of response that the written word can never have. And the invention of writing did not diminish their importance; for art and ritual have continued as the primary forms of religious expression in most literate societies. Accordingly, in the history of religions art and ritual have played a major role, if not always the dominant one, both in the expression of man's ideas about his own nature and destiny in the world of his experience, and in the implementation of those ideas in action. In turn, they have also created iconographic and ritual traditions that have effectively moulded the historic cultures of mankind, by imparting to subsequent generations the conceptual images and *mores* that condition their lives.

Factors of such basic importance, and the nature and extent of their influence, clearly constitute topics of fundamental concern for any serious study of the religious interpretation of human nature and destiny. But the evaluation of art and ritual in this context is not easy. Indeed, far to the contrary, it is beset by such immense difficulties that, by a kind of tacit agreement, scholars have invariably turned to written sources for understanding the nature of religion and its historical manifestations. Consequently, religious art and ritual have been interpreted, where possible, through what have seemed to be the relevant texts. And where written material has not been available, there has been a tendency to leave iconographic and ritual data aside as being outside the range of scientifically conducted investigation. For no self-

respecting historian of religions wishes to enter, without the assured guidance of his texts, into a field of study that has too often been the happy hunting ground of the esoterically imaginative and the seeker after primordial truth.

There are indeed dangers, and they are all the greater because of their insidious nature, in attempting to interrogate the witness of iconography and ritual without the guidance or controlling reference afforded by written documents. However, the material which we have surveyed, diverse as it is in age and provenance, often strange and repulsive in character, and being sometimes pathetic or hinting of dignity and resolution, is the product of human minds—of human minds moved by hope or fear in the presence of forces and events that were incomprehensible and from which there was no escape. And it reflects, moreover, not the minds of philosophers meditating in their studies or of theologians in academic debate. For the carved or painted images of gods and demons tell how men and women visualised the mysterious powers that encompassed them; and the rituals show how they sought to control or propitiate those powers. In other words, what has been described here is but a minute part of a rich treasury of evidence, direct and graphic in its witness, of what men and women, in many times and places, have thought, and how they have felt and acted, when confronted with the imponderable issues of life and death.

Our problem, therefore, having a lively sense of the danger and difficulties of the task, is whether this material, so obviously pregnant with meaning, can be usefully interpreted. Or, to put the issue in another way: can we deduce from the iconography and the ritual, without primary resort to texts, what they tell of man's quest for security and significance as his growing mind made him increasingly conscious of the perils and problems, and also the opportunities, of his environment?

One way does seem to offer itself which has both the merit of starting at the dawn of human culture, and the advantage of providing what are clearly three themes of basic concern for all human life. These themes became evident on our first contacts with the remains of Palaeolithic culture, and comment was duly made upon their significance in this context.[1] We noted how the art and ritual practices of the Old Stone Age peoples were concerned with the three fundamental issues

of death, birth and the food supply. This Palaeolithic resort to art and ritual magic, in dealing with the challenges which these issues constitute for all humankind, adumbrated a pattern of response that would gradually develop into the religions of history, both those of greater or lesser significance. Here, then, we have three themes for our investigation which are, by virtue of the basic nature of the issues involved, of abiding relevancy to human life in all ages and climates. We shall, accordingly, seek to interpret the evidence of man's concern with death, birth and the food supply as it has found expression in the art and ritual practice of his religions. These themes will be followed concurrently, so far as is possible, since they represent aspects of human life that are essentially interrelated in the common experience of both individuals and societies.

II. THE ADUMBRATIONS OF PALAEOLITHIC ART AND RITUAL

The evidence of Palaeolithic culture was seen to reveal that death, at this remote period in the archaeological record, was not only a phenomenon that already commanded a degree of concern from man such as is unknown among all other species, but it also evoked a variety of ritual action. This action is only intelligible on the supposition that death was not equated with the utter extinction of life in the dead. The depositing of food and other necessities of physical existence in the grave attests to a simple-minded belief that those who had died still needed such provision. Such belief is not intrinsically surprising; for it has evidently been harder, as the general burial practice of mankind shows, for the untrained mind to envisage personal annihilation than personal survival of death—indeed, it takes a fair measure of philosophical training to conceive of one's own complete extinction at death.[1]

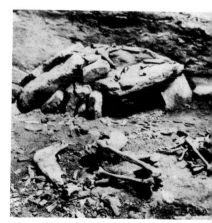

But the Palaeolithic peoples did not only bury their dead with equipment for a *post-mortem* existence, they evidently entertained some variety of belief concerning the nature of death and the activities of those who had died. This seems to be a reasonable inference from the frequent covering of the corpse with a red pigment, and its burial generally in a flexed posture.[2] The exact significance of these practices

9

is necessarily uncertain. Some prehistorians have interpreted the use of red pigment as evidence of magical action to revive the dead body by applying to it a substance having the colour of blood, the essential fluid of life.[3] If such a motive did inspire the practice, it would surely imply the holding of either a belief that the process of death could be reversed, or that survival after death depended upon such magical re-vivification.[4] Burial in a flexed or crouched position has been explained by some scholars as an attempt to simulate the ante-natal position of the infant, in the hope that thereby the deceased, laid in the womb of Mother Earth, would be born again.[5]

These explanations are reasonable inferences to make, in terms of our ways of thinking, from the evidence of Palaeolithic burial practice as it is known to us through archaeological research. But emphasis must be laid upon the qualification that such explanations are reasonable according to our ways of thinking; for we cannot know what constituted logic for the Palaeolithic mind. However, having made such necessary reservations, we are still left with the very significant fact that we have undeniable evidence of Palaeolithic man's ritual burial of his dead. And, although we cannot penetrate to the inner meaning of the rites he used, we may legitimately conclude that they attest to a general belief that the dead needed food and other equipment, and also to some variety of conception concerning either the nature of death or the state of the dead. To these conclusions another of considerable significance may be added. It is drawn from the fact that some Palaeolithic skeletons have been found so tightly flexed as to imply the close binding of the corpse before *rigor mortis* set in.[6] The exact meaning of such an unnatural practice we cannot expect to know; but since the pinioning of the dead before burial has been practised by some primitive peoples in modern times, we have an informative parallel. The custom among such peoples has been inspired by a fear that the dead might return from their graves to molest the living. Such a fear necessarily implies a belief that the dead, or some of them, remain potent beings and able to harm those who survive them. It would seem reasonable, therefore, to suppose that some such belief might account for the Palaeolithic custom.[7]

Our familiarity with the well-nigh universal custom of the careful disposal of the dead, usually accompanied by some form of religious service, should not keep us from appreciating the profound signifi-

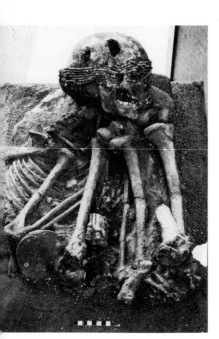

410. Crouched burial of Mesolithic period (10,000 B.C.) similar to Palaeolithic burials.

cance of the Palaeolithic funerary practice. For it means that from the very beginnings of human culture, as known to archaeology, this practice had been established. It had, moreover, been anticipated by *Homo sapiens's* immediate precursor, the so-called Neanderthal or Mousterian Man, though in a cruder form.[8] The point of interest for our concern, however, is that such ritual burial of the dead is uniquely distinctive of mankind; no other species has ever taken such care for its dead.

The significance of the Palaeolithic practice is, moreover, immense. For it implies a degree of human mental development at which death became a problem that demanded special action. And this action was not motivated by considerations of hygiene, but by ideas about death that ran counter to the evidence of the senses. For experience showed that a lifeless body could not be reanimated, and gradually disintegrated; yet it was carefully buried and given food, implements and articles of adornment that would doubtless have been useful to the survivors. That the service was given, at some cost to themselves, by those who survived the dead, probably means that they anticipated their own deaths and trusted that for their *post-mortem* needs similar provision would also be made.

The Palaeolithic funerary rituals thus implicate a primordial preoccupation with death which has continued to distinguish the human race. It would seem that already man was capable of abstracting himself from immersion in the here-now business of daily living and absorption in immediate experience, and of concerning himself with future states of his personal being, that is, with his "destiny." This ability to abstract himself mentally from the present, and to survey his life in a longer temporal context, stemmed from a consciousness of Time which is the most fundamentally decisive of all human attributes.[9] We shall have to reckon with other aspects of it in due course.

The funerary rituals of the Palaeolithic peoples necessarily imply, also, an effective degree of verbal communication. For the ideas and beliefs which they involved were evidently shared by the members of a community, and passed on to their children.[10] It would seem likely, moreover, that the ritual burying of the dead would not have been done in total silence, but rather to the accompaniment of recited formulae signifying something of the intention of the acts. All these beliefs and formulae would be preserved in the memories of the tribes-

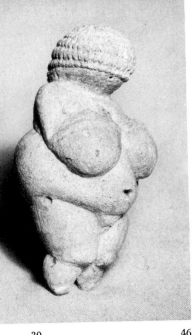

30 46

1a, b, c, 30, 46

men, and transmitted orally, since the art of writing would not be invented for many millennia yet to come. Thus, some 30,000 years ago man had already elaborated complex rituals which embodied and implemented his beliefs about death and an afterlife, together with a specialised vocabulary for verbal commentary.[11]

That death, whatever might lie beyond it, ended the career of his fellows and removed them from the life of the tribe, and so would end his own, must have been as evident to Palaeolithic man as it has been to his descendants. Yet the daunting mystery of death was balanced for him by another mystery that seemingly restored what death took away. The phenomenon of birth signified the renewal of life, and the new-born child replaced the deceased member of the community. Whether the Palaeolithic peoples understood the process of procreation remains uncertain; but there could be no ignorance of the process of birth. The emergence of the infant from the womb of its mother was veritable proof that the female was the immediate source of life, both in human kind and among the animals. Upon this mysterious fact Palaeolithic man clearly knew that his own well-being and the continuance of his community depended; for not only were the new-born needed to replace the dead, but it was essential also that the herds that were hunted for food should be constantly renewed.[12]

The realisation that life was created anew or renewed in the female so impressed the Palaeolithic peoples that their reaction found expression in the making of female figurines, and pre-eminently in the "Venus of Laussel," as we have seen.[13] The concentration of interest on the maternal attributes manifest in these images, and the neglect of the facial features, can surely mean one thing only: they were intended to symbolise maternity, and not to portray particular women. Of the original use of the figurines we have no certain knowledge. They are very small in size, and can be easily held in the hand; they have generally been found in caves, but not in positions indicative of their use.[14] Of the purpose of the "Venus of Laussel" there can be little doubt: when found, it occupied a focal position in what was evidently a rock sanctuary. But what exactly was its cultic use is less certain; and it is to be noted that it differs also from the figurines by holding in the right hand what appears to be a bison's horn.[15]

411

411. Opposite: "Venus of Laussel," photographed in the position in which it would originally have been seen.

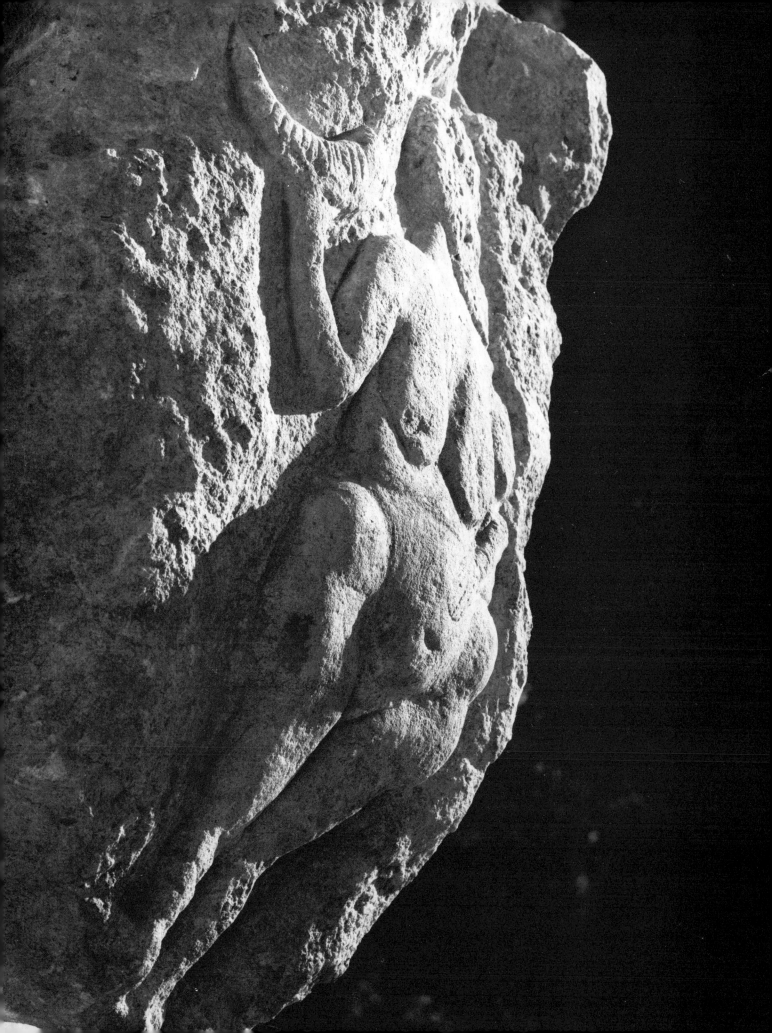

In the history of religions, the "Venus of Laussel" is unique, for it is certainly the oldest known "icon" found in a cultic setting. But whether it was actually worshipped we have no means of knowing. Some clue, however, might be had by comparing it with the figurines. As we have noticed, these are all minute, and they seem to have more the nature of amulets than of cult images. The fact that they could be held in the hand suggests some magical use, probably to promote fertility or assist in childbirth. The "Venus of Laussel," on the other hand, could not be manipulated, for it is not only too large but is also carved in a formation of rock. It was also associated with other carved figures of enigmatic character—one has been interpreted as a representation of the sexual act or of childbirth.[16] It would seem, therefore, that the "Venus" was designed to focus the attention of those who came to the sanctuary on a figure emphasising the attributes of maternity. But the bison's horn, if correctly identified, complicates this imagery. It could be interpreted to mean several things: the connection of the later Anatolian and Cretan "Great Goddesses" with bulls as symbols of virility affords a particularly obvious line of interpretation.[17] However, in the absence of any supporting Palaeolithic evidence of a bull cult, it is wiser to confess our ignorance of the significance of a bison's horn here.[18]

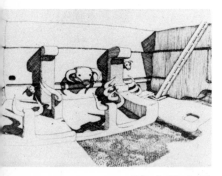

18, 140, 141

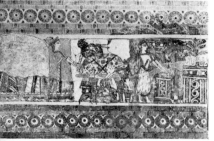

Despite these necessary reservations, the evidential importance of the "Venus of Laussel," in the context of our study, is of the highest order. For it reveals, as indeed do the figurines also, that man had already learned to translate his ideas into visual form. The subtle alchemy of mind and hand that created the very first image is beyond our discovery or analysis; but, at some time in the Upper Palaeolithic age, man had found that he could mold or carve suitable materials into the shapes of objects about him. The discovery of this ability must have provided a great mental stimulus; for it would have produced a sense of creativity of a marvellous kind—the artist could transform a piece of wood or stone into the form of a woman or an animal.[19] The fact that these simulacra were so much smaller than the actual objects they resembled is significant; for it seems that man easily accepted this necessary difference of size as not seriously impairing the validity of the image.

The discovery of his ability to reproduce likenesses of living things

did not, significantly, lead the Palaeolithic artist to increasing effort after exactitude of imitation. The evidence of both his plastic and linear art attests to his very considerable ability to reproduce characteristic features and traits of the animals that were the chief subjects of his art.[20] But, as the female figurines and pre-eminently the "Venus of Laussel" show, he could deliberately refrain from making a complete likeness of an object. Where this reticence occurs, and it does most notably in the comparatively rare portrayals of the human form, some special factor must have operated. Accordingly, we are justified in thinking that the female images, with which we are now concerned, fulfilled their purpose without the delineation of the facial features— indeed, that the portrayal of these features would have impaired this purpose. Thus, we reach the important conclusion that the intention of the Palaeolithic peoples in making these images was served by the careful, and probably over-emphasised, rendering of the maternal features of the body only.

This conclusion means that the imagination was already a potent factor in the conceptual thinking of the Palaeolithic peoples. And so it would seem that, when they sought to portray, in visible form, that power which made women the source of new life, they carved the image of a woman, emphasising those features that characterised the fecund mother; but they left the head faceless, for that feature was irrelevant in this context. Thus, their intention was, in effect, to portray the essence of maternity—the outward and visible image of that mysterious power that enabled women to produce new living beings.

Whatever may have been the use of the miniature figurines, in the "Venus of Laussel" we surely seem to have a cult image of the "Mother," of the mysterious force that creates new life enshrined in the female body. Of what manner of cult the image was the focus we have no means of knowing, but that it drew the veneration and service of those who used the sanctuary there can be little doubt. Whether the primitive devotees of the "Venus" should be regarded as treating it as the image of a deity, of a divine "Mother," the source or creatrix of all living things depends upon what we mean by a deity. A more reasonable and useful inference, and one of immense importance to our study, is that already man has made an "icon" of a concept of his imagination, namely, of maternity as the source of new life.

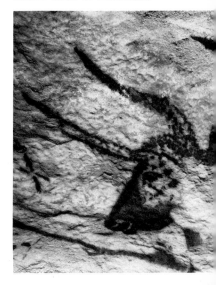

412. Head of a large black bull at Lascaux.

It is, admittedly, tempting to think of the "Venus of Laussel" as the prototype image of the Great Goddess or Mother Goddess, worshipped by many later peoples of the Ancient World. A reasonable case can be made out for the view; but for our present purpose it is more important to appreciate its iconographic significance. For it witnesses to man's primordial resort to iconography as a means of expressing his awareness of, and his reverence for, a power that profoundly concerned his own life and well-being. That he anthropomorphised his conception of this power is readily understandable, since it revealed its operations most obviously in the bodies of the women of his community. Yet his reluctance to give facial features to the images which he made of this power suggests that he consciously strove to represent the fecund nature of maternity, and not to portray a woman that embodied it.

There is one interesting and important question which repeatedly presents itself in the study of iconography, but which we have not yet considered. It presents itself now with a special pertinency, as we seek to interpret the earliest known examples of image making. It is the question of the nature of the relationship holding between the artist who creates the image and those who accept it as meaningful to themselves. Although the event is irrevocably buried in a past to which historical research can never penetrate, we must logically assume that at some time in the Upper Palaeolithic era someone carved the first female figurine. It embodied his conception of the mysterious power of fecundity, and other members of his community recognised its meaning. Whether they did so by their own intuition, or accepted its significance on the explanation or authority of its creator, are questions about which we can only speculate. Nonetheless, the very existence of an "icon" such as the "Venus of Laussel" necessarily predicates an artist who conceived the idea of it and translated his conception into a stone figure, and also those who found the figure so meaningful that they made their devotions to it.

Thus we encounter the primal occurrence of that strange nexus that unites the artist who conceives of and creates the holy image, and those who find his conception a valid expression of their own feelings and intuitions. However, if the primal image is thus valid, it is likely

soon to create an iconographic tradition. This situation seems already to have occurred at the remote period with which we have been concerned; for the figurines have been found over a wide area of Palaeolithic settlement.[21] Accordingly, unless we are prepared to assume that each figurine represents an original and independent conception created in the place where it was found, it would appear that they all derived from some prototype of seminal influence. By whom and what means the knowledge of this prototype became so widely diffused we can only, but not very usefully, surmise.

Profoundly impressed by the phenomenon of birth, Palaeolithic man thus resorted to iconography to express those intuitions of significance which he found revealed in the emergence of new life. Because he made his icons of durable materials, many have fortunately survived to us; but we must remember that these icons were undoubtedly linked with rituals, of which no trace now exists. Despite this loss, we can, however, confidently conclude that at the very dawn of human culture as it is known to archaeology, man had both meditated on the mystery of birth and sought to express his engagement in this mystery in art and ritual.

Birth and death inevitably constituted issues that could not be dealt with by practical human action; but the obtaining of food, which was generally within Palaeolithic man's competency, became also a matter for magical art and ritual. As we have seen, through their cave art and hunting rituals, the Palaeolithic peoples sought to reinforce their own abilities as hunters by non-practical or supernatural means.[22] There are many aspects of this cave art about which there is considerable diversity of opinion among prehistorians; but there is no disagreement about regarding it as essentially magical in inspiration and intent. Now, "magic" is admittedly a term of wide connotation, and it is often invoked as a convenient description for practices of many kinds that do not seem to be ordered according to a logical conception of cause and effect by our standards.[23] But difficult as it is to frame a satisfactory definition of magic, there can be no doubt that practices which are conveniently described as magical have one common characteristic. They presuppose the possibility of doing things that normal human action cannot achieve. Thus no one would pre-

sumably employ magical formulae or techniques merely to throw a stone; but he might do so, if he wished to hit a mark and had not sufficient confidence in his own skill. In other words, resort to magic implies the existence of forms of power, other and more potent than that natural to man, which can be utilised for obtaining what is beyond the ability of the individual or community to achieve.

There is little likelihood that Palaeolithic man ever worked out the metaphysics underlying his magic rituals. But we may well ask whether he consciously related himself to that power or powers whose help he sought for a successful hunt. If we are right in our interpretation of the female images, it would seem that he personalised the force that produced new infants in women; yet he did so with a curious restraint—he left the heads of his images without those features that are essential to human personality. If he thus sought to portray the creative power of maternity by embodying it in the form of a faceless woman, it is natural to seek in his cave art for some evidence of the manner in which he might have visualised the power he invoked for a successful hunt. We are, accordingly, brought to consider the problem constituted by the so-called "Sorcerer" of the Trois Frères cave in Ariège. As we have already noted, this strange figure occupies a significant position on the wall of one of the innermost recesses of the cave system.[24] So far as the features can be discerned from the faded original, the "Sorcerer" appears to be a human figure clad in a hairy pelt, and with attributes of various animals.[25] Since its posture can be reasonably identified with that of dancing, it is consequently sometimes described as the "Dancing Sorcerer." This appellation, as also that of the "Sorcerer," presumes the validity of an interpretation based on the assumption that the Palaeolithic peoples practised, as part of their hunting ritual, magical dances. These dances were performed by "shamans" who, disguised as animals, mimed the characteristic movements of animals. The chief evidence cited in support of this view is that certain primitive peoples of the modern world have practised such dances,[26] and that cave art also provides other indications of the wearing of animal disguise. This interpretation of the "Sorcerer" involves a peculiar problem which we must notice shortly. In the present context, however, we must first consider an alternative interpretation.

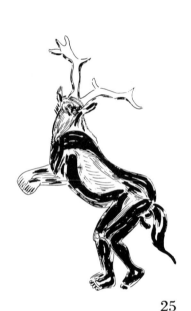

25

21, 27

Some prehistorians have discerned in the "Sorcerer" a kind of divine "Lord of the Beasts."[27] Such an identification would make it the earliest known image of a god, as the "Venus of Laussel" has been thought to be our earliest representation of a goddess. The recess in the Trois Frères cave where the "Sorcerer" is depicted has, accordingly, been called a sanctuary, and it is assumed that there the god was propitiated and worshipped as the creator and owner of the herds on which the tribe depended for its food.[28] There is, inevitably, no means by which the truth or error of this identification can be tested. Its acceptance or rejection by scholars seems largely to turn upon whether they believe that these Palaeolithic peoples were mentally capable of conceiving of the nature of deity—but a decision either way is necessarily a matter of personal intuition. A decision depends, also, much upon the definition of deity that happens to be held. For this can vary exceedingly in what is considered to constitute the essential attributes of divinity: to cite one obvious example, if eternity of being or immortality be deemed essential, many gods known to the history of religions would not qualify for divine status.[29] However that may be, if the "Sorcerer" is to be regarded as a cult figure, which it could well have been, it is more useful not to describe it by the ambiguous title of deity but to try to evaluate it in terms of its own intrinsic testimony.

Viewed without preconceptions, the "Sorcerer" witnesses to the fact that the Palaeolithic users of the Trois Frères cave depicted upon the wall of one of its most inaccessible recesses the figure of a hybrid being that cannot be identified with any particular animal. Such a figure must have been a consciously designed imaginary creature, similar to the enigmatic "Unicorn" of Lascaux, which we have noted.[30] According to the abbé Breuil's original drawing, it would appear that to a roughly anthropoid figure the artist added a hairy pelt, tail and genitals. He then crowned his creation with the antlers of a stag, gave it eyes like those of an owl,[31] and a long beard or tongue. Its posture, which is usually identified with that of dancing, might equally well be imitative of an animal walking on its hind legs.[32]

Such, then, being its appearance, can any meaning be deduced from it? If we trust to the general accuracy of the abbé Breuil's drawing of the "Sorcerer" in the early days of its discovery,[33] an impression of intention is given similar to that which we have discerned in the

10

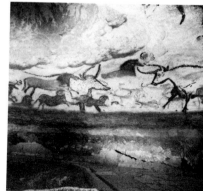

female figurines, namely, of portraying an idea. As the female figures emphasised the attributes of maternity, while carefully avoiding the portrayal of an actual woman, so does the "Sorcerer" in its own idiom avoid identification as man or beast. The animal characteristics are emphasised, yet the rear portion of the body unmistakably indicates a human form.[34] In other words, the "Sorcerer" appears as a being endowed with the external attributes of a beast, yet having basically the structure of the human body. If this conclusion be sound, and the figure was truly a cult object, then it would seem that it may be accepted as representing a Palaeolithic attempt to portray some idea of a supernatural being that combined various animal attributes with the form of a man. Such a conception, depicted in such a setting, might reasonably be regarded as approximating to the status of a divine "icon," in that it represents an idealised, and possibly a numinous, being as imagined by Palaeolithic man.

In view of the hypothetical nature of this interpretation of the "Sorcerer"—as representing what might guardedly be called an "embryonic" conception of deity—we must also consider the implications of the alternative theory. According to this theory, the "Sorcerer" depicts a man who is disguised as an animal, performing a mimetic dance. Now, as we have already noticed in our discussion of the "Image," if the "Sorcerer" is so explained, this depiction of a magical dance necessarily implies an attempt to perpetuate the efficacy of the dance after its performance had ended.[35] And the implication means, in turn, that these Palaeolithic peoples were concerned with the phenomenon of Time—in the sense of seeking to guard against the effacing effect of temporal change. For, according to the magical significance that iconography had for them, the image of their shaman or sorcerer, depicted in the very act of dancing, existed in a kind of eternal "now," so that the magical power of his dancing was for ever operative in their service.[36]

This implicit awareness of Time was necessarily of a practical kind, and it was unlikely to have been concerned with the metaphysical aspects of the subject which have subsequently engaged the attention of philosophers. Human beings become acquainted with Time through the changing pattern of the phenomena presented to their senses. The experience puzzles them and causes a sense of insecurity, which

is invariably connected at root with the prospect of death.[37] As we have already seen, Palaeolithic man was already profoundly concerned about the mystery of death, and in the death of his fellows he anticipated his own. Thus he was led to abstract himself from immersion in here-now experience, and to contemplate his life in a long-term context, which included his own demise. But if he learned to look forward in Time, he could also look back and ponder his own individual beginning in the act of birth. His preoccupation with this aspect of his destiny we have found graphically presented in his female figurines and the "Venus of Laussel." This preoccupation could, therefore, have conceivably led to some intuition about the cyclic course of life, of which birth and death were the alternating crises.[38]

There remains still for our consideration a product of Palaeolithic art that is probably even more enigmatic than those which we have already studied. It demands our attention, despite its problematic nature, because it raises certain issues of basic importance for our interpretation of Palaeolithic art and ritual. From its discovery at Lascaux in 1940, the picture concerned has been the subject of much conflict of opinion among prehistorians, and such is its nature that it will doubtless continue to provoke speculation about its origin and meaning.[39]

21

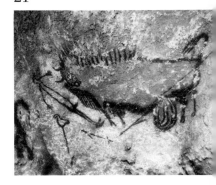

The picture, if that be the right term to describe it, presents an initial problem as to whether it contains one composite or two separate subjects. The scene that first catches the attention shows a strange, schematically drawn man with a bird's head, either lying prostrate or falling backwards, before a bison. This animal, which is more realistically portrayed, has its horns lowered as if it were striking down the bird-headed man; a lance transfixes its flank and its entrails appear to be hanging out. In the immediate foreground of the scene, a bird mounted on top of a stick is depicted, and close by what seems to be an implement for throwing spears. This scene exhibits a unity of composition that suggests that it represents a distinct incident; but this is not wholly certain. To the left of it is drawn the figure of a woolly rhinoceros, which appears to be moving away to the left. Differing opinions have been expressed by scholars about the relation of this rhinoceros to the group comprising the wounded bison and the

bird-headed man; it has been suggested that the rhinoceros had inflicted the terrible wound from which the bison suffers. Certainty cannot be established, but there are reasons for thinking that the figure of the rhinoceros is a separate composition—it is somewhat separated by the rock formation and it seems to be painted in a somewhat different style from that of the bison.

If the bird-headed man and the wounded bison are taken as constituting a distinctive scene, unrelated to the figure of the rhinoceros, we still have a perplexing, but very fascinating, problem of interpretation. Scholars have found a variety of meaning in the scene. Thus it has been suggested that it commemorates the death of a shaman, who wears a bird-mask, by a bison which he had wounded; or that it depicts the vision of a shaman lying in an ecstatic trance; or that it represents a duel between two rival shamans, one being disguised as a bird and the other as a bison.[40] There is, however, another explanation which has the merit of being consistent both with the curious location of the picture in the Lascaux cave complex and with the magical character of Palaeolithic art.

The location of the picture is especially notable. It is away from the chambers and galleries of the main cavern at Lascaux, where the wonderful friezes of animals are depicted. The artist who painted the scene chose instead a small chamber that could be reached only by descending a shaft some 7 metres deep.[41] A position so concealed and difficult of access suggests that the scene had a secretive nature or purpose, which was planned in terms of the logic of Palaeolithic art. Now, as we have seen, Palaeolithic art was essentially magical in character, which means that it was proleptic in intention. In other words, the Palaeolithic artists depicted on the walls of the caves what they wanted to happen in reality—an animal wounded with darts would cause this to happen in a future hunt, the drawing of animals helped to produce more animals. Accordingly, it would be reasonable to suppose that the incident involving the bison and the bird-headed man was intended to occur in the future. The malevolent intent, which would thus have been implicit in the depiction, would have been consistent with its secretive siting—unseen and unknown, it would work out its baleful purpose. According to this interpretation, therefore, the picture would be our earliest known essay in so-called "black

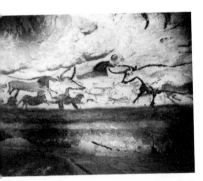

10, 19

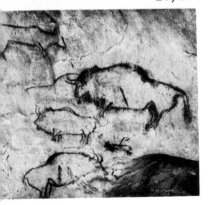

magic." The artist, or someone who had commissioned him, sought thus to bring about the destruction of a shaman who was hated, but who was too strong to be challenged directly. That his death was envisaged as happening in an encounter with a bison, which was wounded, doubtless stems from the artist's memory of a similar incident that had occurred in a past hunt—he sought to reproduce that baleful happening in the person of his enemy.[42]

If this interpretation of a very problematic scene should be justified, we have detected the possibility that a sinister factor might sometimes have operated in Palaeolithic magical art. In other words, we find that Palaeolithic man was ready on occasions to enlist supernatural means to destroy a fellow being as well as to promote the birth of new life or the renewal of life for the dead. It reveals also that the practice of ritual magic was in the hands of specialists, who doubtless exercised great, and sometimes a resented, influence over their fellow tribesmen. Probably a variety of physical traits, similar to those which characterise the shamans and sorcerers of primitive societies of the modern world, was the source of the distinction and spiritual authority of these Palaeolithic specialists.[43] Among them, possibly, there were also those expert in iconography, who both created the visual images of supernatural beings and transmitted the traditional forms of representation when established.[44]

These latter inferences are valid, whatever may be the soundness of the interpretation of the Lascaux "problem picture" outlined above, or the other interpretations that have been suggested for it. The picture, moreover, attests notably to the factor of creative imagination in this earliest art of mankind. Whatever the meaning of the depiction might be, its artist was clearly capable of conceiving of a complex magical transaction and of depicting it in a graphic linear form. His work also suggests another problem. For we can only wonder at the relationship that existed in his mind between the enigmatical situation which he envisaged and the visual image that he created of it.

These aspects of Palaeolithic ritual and art have been discussed at some length since they constitute our earliest evidence of man's reaction to the mysterious unknown that surrounds his life. That evidence reveals his preoccupation with three basic issues: birth, death and the

food supply. Although the challenges with which each of these issues confronted him were different, they prompted him to action that involved not only his own mental and physical powers, but recourse also to supernatural powers, more potent than his own. These powers he conceived as existing in a manner such as enabled him to make contact with them. And he visualised at least one of them in human form; but with a curious restraint, namely, in the faceless embodiment of maternity. Both his art and his burial customs also indicate an awareness of the menace of Time, which signifies that exclusively human ability for detachment from complete immersion in present experience and the consequent conception of destiny. Hence, birth and death became invested with hope and fear, and man began that agelong quest for personal significance which he still pursues.

And so the evidence of Palaeolithic art and ritual, fragmentary and enigmatic though it be, effectively witnesses to the existence, at the dawn of human culture, of the fundamental pattern of concerns and responses that underlies all the subsequent historical forms of religion. It also testifies to the status of art and ritual as the primary means by which man instinctively sought to deal with the basic issues of birth, death and the supply of food, and to express the ideas about them that formed in his mind.

There remains, finally, one piece of evidence to be mentioned, which though of a negative kind, has a special significance. In all the remains of Palaeolithic art so far discovered, no recognisable representation of the sun or moon or other celestial bodies has been found.[45] It would seem, therefore, that these earliest of our ancestors did not connect their destiny with the heavens; the field of their interest was limited to the environment of their immediate concerns.

III. THE AMBIVALENCE OF THE GREAT GODDESS

The three basic themes of Palaeolithic art and ritual, together with their implications of Time consciousness, provide the guidelines for our interpretation of all subsequent religious iconography and ritual practice. We can use them with confidence, because their relevance is so obviously basic and abiding for human life, in whatever age or climate.

The treatment of these themes in the more sophisticated cultures of subsequent ages naturally resulted in a great elaboration of concept and expression, and sometimes in exceedingly strange diversifications of the *raison d'être* of a particular theme. To give an example of the latter, the early Christian exaltation of virginity may be cited—here, the idea of maternity as the source of new life or the continuance of life was virtually repudiated in preference for the celibate state; yet maternity in the person of the Virgin Mary, as the Mother of God, was exalted as an essential factor in the divine scheme of mankind's salvation.[1]

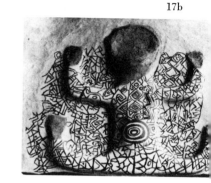

17b

17a, b, 18

It will be best to pursue our interpretation by following the elaboration of the themes in chronological sequence. Accordingly, we come first to consider the significance of the iconographic and ritual data of Neolithic culture. Here the rich treasury of Çatal Hüyük inevitably commands our chief attention, since it provides unparalleled iconographic evidence.

This evidence attests to a most impressive development of the Palaeolithic intimations concerning man's preoccupation with birth and death. A cult of a Mother Goddess has been established, in which two themes had apparently been fused in an ambivalent conception of deity. Thus, as we have already seen,[2] the goddess was not only presented iconographically as the divine personification of maternity, exemplified in childbirth and the nursing mother, but symbolically she was connected also with death. This fusion of roles found significant, though bizarre, expression in the plaster models of the female breast adorning her shrine, which contained the lower jaws of wild boars, and the skulls of vultures and other small predatory animals.[3] It was more grimly evidenced in the human skeletons and skulls that were buried beneath the floor of the sanctuary.[4]

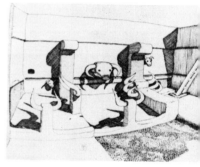

18

413

414

Thus it would appear that the inhabitants of the Neolithic settlement at Çatal Hüyük, which dates from the seventh millennium B.C., conceived of their goddess as the Mother of the living and the Mistress of the dead, and that their ritual practices were designed to serve her as manifested in these ambivalent roles. The iconographic evidence of a bull cult, which was also found in her shrines, suggests that the virility of the male was venerated also, though apparently as ancillary to the goddess as the source of life.[5]

18

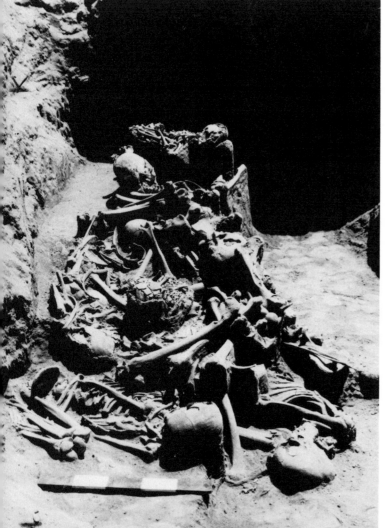

413. Çatal Hüyük: double row of plaster breasts.

414. Çatal Hüyük: group of contracted burials found beneath platforms of a shrine.

415. Çatal Hüyük: vultures attacking headless bodies.

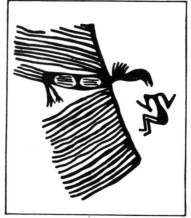

The Çatal Hüyük excavations have also provided puzzling, though clearly significant, evidence of a more macabre element in the religion of the Neolithic settlers there. It takes the form of paintings on the sanctuary walls, depicting huge vultures, of schematic form, menacing headless human bodies.[6] Since their discovery, it has become usual to interpret these paintings as representations of vultures picking at the human corpses. This grisly subject is not unknown in later ancient art: it appears on the celebrated Stele of Eannatum, which is often called the "Stele of the Vultures."[7] But this Sumerian version commemorates victory in battle, and its aftermath on the battlefield. The Çatal Hüyük paintings have no such martial context; instead, they appear on the walls of the sanctuary of a Mother Goddess. Further, it might well be questioned whether the vultures are represented as picking at corpses. It is true that the bodies are headless; but it is not certain that they are meant to be lying lifeless—indeed, they look quite lively and in movement. Moreover, headless figures occur elsewhere in Neolithic art, and they are usually identified as "daemonic."[8] The fact also that these pictures are painted on the walls of a shrine of the Mother Goddess suggests that they had some more esoteric meaning than that of the eating of corpses by birds of prey. But what this meaning might be is a matter for speculation only; however, it is likely to have been connected with the role of the Mother Goddess as the divine Mistress of the dead.[9]

415

330a, b

31, 33

The iconography of Çatal Hüyük thus attests to a stage in the evolution of religion when man sought, in the deification of the female principle, a concept of divine power that would account for the phenomena both of birth and death. Personified as the Mother *par excellence*, the goddess was served by rituals that involved an elaborate symbolism, including reference to the virility embodied in the figure of the bull. The cult probably involved also an eschatology that accounted for human destiny in terms of the providential care of the Great Goddess. But there was possibly a grimmer side to this eschatology, of which the mural depictions of vultures and headless bodies afford enigmatic witness. What place the theme of food, or the maintenance of physical well-being, had in the religion practised at Çatal Hüyük is not apparent in the iconography. Hunting scenes do appear; but agriculture evidently formed the economic basis of life there.[10] It

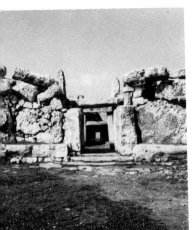

144

cf. 416, 417

is possible that the Mother Goddess was also associated with the fertility of the fields, as in later religions of this type.

Çatal Hüyük provides the most impressive evidence of the Neolithic cult of the Great Goddess. That the cult flourished among other peoples living on a Neolithic economy in other parts of the ancient Middle East and the Mediterranean world is sufficiently attested by archaeological remains, though not with so rich an abundance of iconographic material.[11] The megalithic temples of Malta, however, witness to the magnitude of effort devoted in that place to the service of the goddess.[12]

The increasing sophistication of life which marked the rise of the first great civilisations of the world is reflected as much in religious iconography as in technological achievement. The production of numerous and varied images of gods and goddesses, and also of monstrous daemonic beings, witnesses to much diversification of concept about the divine or supernatural forces that were believed to operate in the universe.[13] Nevertheless, the three fundamental issues of birth, death and food remained the paramount concerns. They effectively shaped the basic pattern of all the historic religions, and their influence is manifest in both art and ritual.

The immensity of the data that now becomes available necessitates selection, if we are to continue our attempt at interpretation. Accordingly, we shall pursue the three themes which we have adjudged basic to man's search for significance in the world of his experience, in those religions whose achievements in the history of human culture have been the most notable.

32, 33

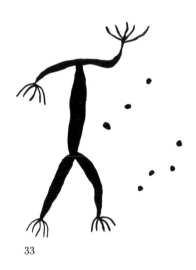

33

IV. EGYPT'S RITUAL TECHNIQUE OF SALVATION

As our preceding survey of the evidence of art and ritual so abundantly showed, it was in ancient Egypt that the most determined effort was made to deal with the menace of death. There, a ritual technique was established which was designed to hold off or reverse the physical decomposition consequent on death, and to revivify the deceased. This technique was based upon the principle of imitative magic; but it in-

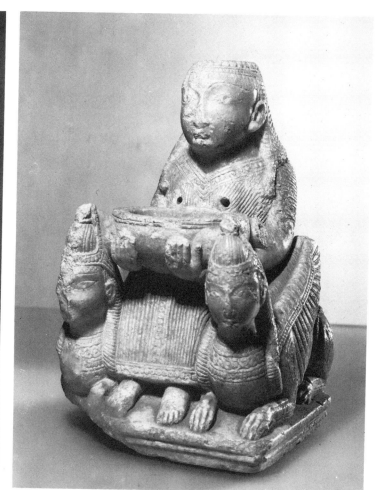

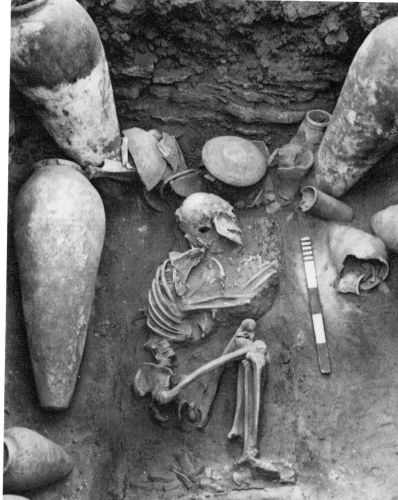

416. Megalithic goddess, Sardinia.

417. Astarte. Phoenician cult-statue (7th-6th centuries B.C.), found in Spain, at Tutugi (Galera).

418. Early First Dynasty Egyptian burial found at Saggara, showing grave equipment (c. 3000 B.C.).

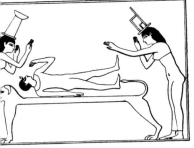

12

12, 14, 95

14

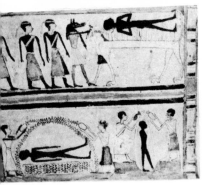

11

418

11, 15, 217

4, 22, 23,
337a, b, c

volved also belief in a very peculiar kind of god. For the whole process of the mortuary ritual was, in effect, a solemn re-enactment of what was believed to have been the acts that had once restored an ancient king, named Osiris, to life after he had been murdered. In this ritual re-presentation, the deceased person, on whose behalf the rites were being performed, was assimilated to, or identified with, Osiris.[1]

The Egyptian mortuary cultus incorporated a medley of ideas and practices concerning death and the afterlife, many of which were mutually contradictory. For this reason it is particularly instructive: indeed, it constitutes the classic example of the strength of the conservative factor in religion, and of how a people can hold and practise a faith that contains many obvious inconsistencies about matters of the greatest import. The eschatologies of most religions are found, on analysis, to exhibit similar inconsistencies in belief and practise. The Egyptian mortuary cultus, which was practised for some three thousand years, has the additional significance that it was not authoritatively prescribed and sanctioned in a sacred literature.[2] It found expression essentially in ritual and iconography; and each generation learned from these sources of it, aided doubtless by verbal instruction. Written documents such as the *Pyramid Texts,* the *Coffin Texts* and the *Book of the Dead* were ancillary to it, being primarily spells and incantations used as a kind of libretto to the ritual.

On analysis, the Egyptian mortuary cultus is found to contain three originally distinctive concepts of the afterlife and its location. They represent different lines of development from that instinctive belief which we have seen already operative in Palaeolithic times, that man in some way survived the experience of death. The oldest concept was that of the dead living on in their graves, where they needed the food and equipment used in this life.[3] This primitive idea was never abandoned by the Egyptians, and it led in time to that complex funerary provision of which we have seen abundant evidence. Believing that the body was essential to any proper form of personal existence, they carefully embalmed it and arranged, magically, for the restoration of its faculties.[4] At the same time, they also made provision for the other essential constituents, such as they conceived them, of the human person: the mysterious *ka* and *ba*.[5] Equipped with all his needs, and perpetually supplied with food, the deceased, now become

a glorified being (*akh*), was thought to dwell contentedly for ever in his tomb, coming forth each day to behold the divine sun.[6]

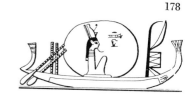

178, 179, 219

The priests of Heliopolis appear to have propagated, originally for the pharaoh, the idea of a solar afterlife. This conception found ritual and iconographic expression in the ascent of the deceased, or his *ba*, to heaven where he joined the sun-god Rē in his solar boat, making in his company the journey across the sky and through the nether world each night. This idea of *post-mortem* beatitude became fused, in process of time, with that connected with Osiris, with much resultant confusion of symbolism.[7]

The Osirian conception of the afterlife was based, as we have seen, on the ritual assimilation of the deceased with Osiris. But the dead person, who was thereby resurrected to a new life as Osiris had been, departed to the land of the dead over which Osiris reigned. Life in this realm was conceived in terms of life in Egypt, though in an idealised form, and in the company of supernatural beings of beneficent kind.[8]

218, **419**

Considered phenomenologically, these three Egyptian conceptions of *post-mortem* existence all witness implicitly to an instinctive desire to seek security from Time in some unchanging mode of existence— living in one's "house of eternity" and daily coming forth to behold the sun; unceasingly journeying with the sun-god across the sky; everlastingly enjoying a blissful life in the kingdom of Osiris. Time meant change, decay and death, with its inevitable consequence of corporeal corruption and disintegration.[9] As the figure of Ḥeḥ—on a chair found in Tut-Ankh-Amun's tomb—significantly shows, the Egyptians personified "millions of years" or eternity, and associated it with the *ankh*, the symbol of life.[10]

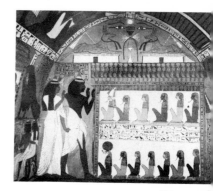

420 218

Ancient Egyptian eschatology has also the unique distinction of providing both the earliest and the most graphic evidence of belief in the judgment of the dead. In so doing, it acquaints us with another important factor in the evolution of man's conception of his nature and destiny. For it would appear that when the Egyptians became convinced that they had the means of ensuring a blissful *post-mortem* existence, they then began to fear that this happy situation might be spoilt by misdeeds done in this life.[11] The development of this idea of a moral judgment after death can be traced, in its earlier stages, only

168

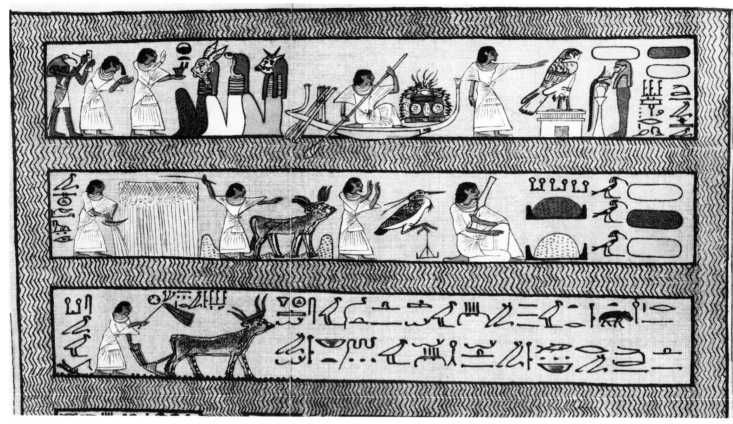

419. Scene from the *Papyrus of Ani,* showing the deceased in afterworld.

420. Ḥeḥ, Egyptian deity representing millions of years.

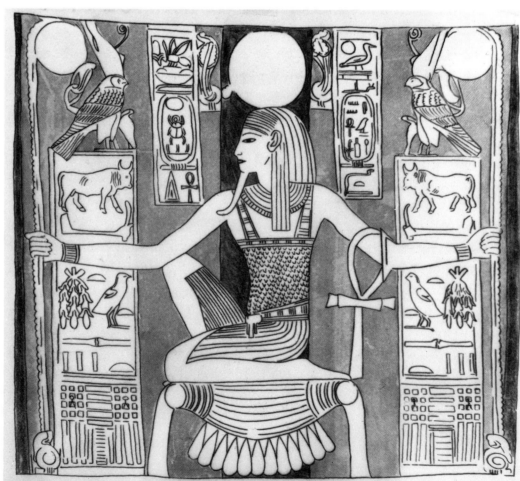

in the texts;[12] but about 1400 B.C. the idea was given graphic expression in iconography. As we have seen, it found dramatic presentation, in the *Book of the Dead,* in depictions of the weighing of the heart of the deceased against the symbol of *maat* (truth). The vignettes which portray the scene show how vividly the fateful transaction was visualised, and what efforts were made to stress its awful impartiality.[13]

373, 375

The idea of a *post-mortem* judgment involved a number of other interrelated ideas of great significance for the history of religions. Primarily, there was the basic concept of a cosmic law or balanced order of things, designated *maat* which the sun-god Rē, the chief state-deity of Egypt, embodied and maintained. This *maat* had its social side, being identified with the good order of the state: hence acts of injustice harmed *maat* and made the offender guilty before the "Great God" Rē.[14] There emerged, therefore, in Egyptian thought the idea that the person's destiny after death would be decided by his conduct towards a divinely established order of things which represented "truth" or "rightness" for all.

421a

185

The role of Osiris, so important in relation to human destiny, was complex; and it was made more complicated by the fact that he gradually assumed the judicial office of Rē.[15] In the earliest texts, Osiris is a divine hero who, after being foully done to death, is raised to life again by the magical assistance of other deities. In some forms of his cult, Osiris appears as a personification of the annual death and resurrection of vegetation—the idea was ritually represented in the funerary rites, as we have seen.[16] His legend, which formed the rationale of the mortuary ritual, had the effect of presenting death not as a natural event, but as the assault of an evil adversary—indeed, his murderer Set became virtually the Egyptian "Devil," the personification of evil.[17] Accordingly, by virtue of assimilation to Osiris in the mortuary ritual, the Egyptians believed that they would be "saved" from death, and raised to a new form of life. Belief in survival of death ceased, therefore, to be based upon that primitive instinct so evident in Palaeolithic times; it became dependent upon divine aid, thereby implying that death did not represent the divinely ordained end for man. However, belief in a *post-mortem* judgment complicated this view by envisaging forms of divine punishment for the wicked that were tantamount to a "second death."[18]

421b, 97, 185

422

423, 424

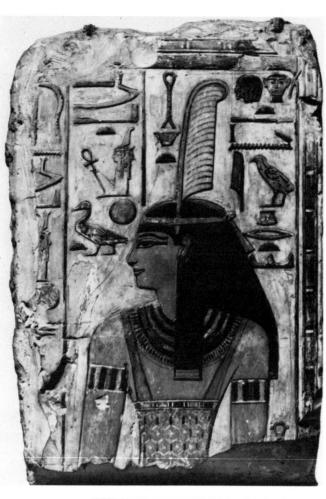

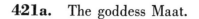

421a. The goddess Maat.

421b. Grain sprouting from the body of the dead Osiris, representing resurrection.

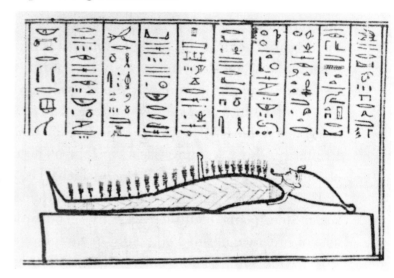

422. Egyptian god Set.

423. Egyptian symbolic representation of the punishment of the damned.

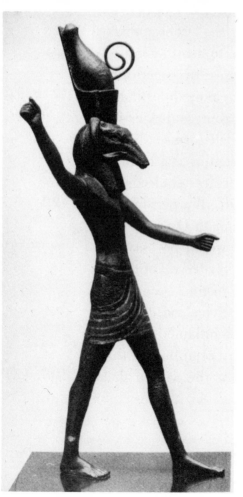

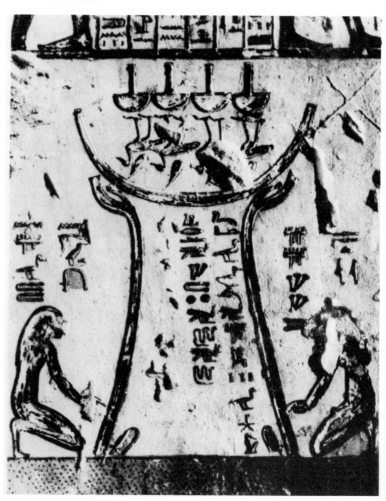

424. Egyptian fire-ovens for the damned.

425. Nut, represented as the celestial cow, with the sun-god travelling across her body.

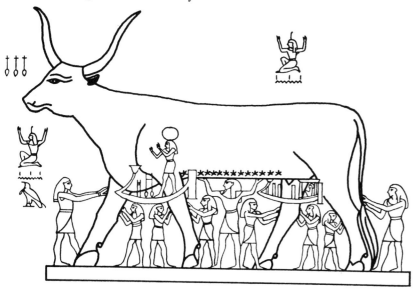

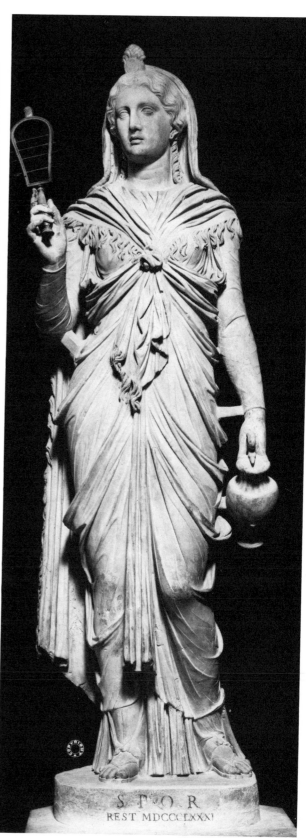

426. Isis as the Graeco-Roman Great Goddess.

221b

425

221b

185

426

The Egyptian view of human nature and destiny, as it finds expression in the mortuary cultus and its attendant iconography, was the most sophisticated in the ancient Near East, and it represented a very considerable advance in concept and praxis on the earlier traditions and those current elsewhere during the third and second millennia B.C. The theme of new life or rebirth, which in the Palaeolithic and Neolithic cultures had been so notably linked with the cult of a Mother Goddess, also assumed new forms in Egyptian thought. The idea of new birth or regeneration was a much-used concept. The sun-god, upon whom all life depended, was imagined as being born each morning from Nut, the sky-goddess, into whose womb he returned each evening.[19] And the figure of Nut was often painted or carved on the bottom or lid of sarcophagi, so that the dead lay under her protection.[20] The goddess Isis played the major role in the resuscitation of the dead Osiris, and consequently in the resuscitation of each dead person who was ritually identified with him. She had impregnated herself on the phallus of her dead husband, and thereby had born him a son, Horus, who was to avenge the death of his father Osiris on his murderer Set.[21] In the Graeco-Roman period, Isis was to become the Great Goddess *par excellence*, to whom men turned for deliverance from all kinds of ill.[22]

337a, b, c

86, 402

219, 373-75

To the providence of their gods the Egyptians looked, as did other peoples to theirs, for material well-being of all kinds. Implicit in their service of the gods was the recognition that they could not obtain good harvests, victory in war, or protection from malevolent daemons solely through their own abilities. But this belief was complicated in Egypt by the concept of the divine king. The pharaoh was regarded as the son of the sun-god Rē, and he ruled Egypt for his divine father. Theoretically, the pharaoh was the mediator between the gods and the people, and on his vitality depended the prosperity of the land—this belief found ritual expression most notably in the Sed festival, which we have already noticed.[23] The adverse forces, of which they were conscious in the valley of the Nile and the encompassing deserts, the Egyptians personified in various monstrous forms as their iconography graphically shows; their fears of what might be encountered in the underworld inspired the depiction of many fantastic daemons in the funerary literature and tomb painting.[24]

V. OTHER VARIATIONS OF THE BASIC THEMES IN THE ANCIENT NEAR EAST

In the history of religions, Egypt holds a unique position both by reason of the rich legacy of its religious antiquities and the elaborate development of faith and practice which they document. As we have noted, it was not until the rise of mediaeval Christianity that the conception of human nature and destiny found iconographic and ritual expression on a scale so graphic and detailed. However, the evidence that survives elsewhere of ritual practice and belief confirms that birth and death and the food supply continued to be the basic topics of religious concern. There is an almost universal custom of providing the dead with food and other equipment, as though they lived on in some form in their graves. These customs prevailed, curiously, even among peoples such as the ancient Mesopotamians, Hebrews and Greeks, whose writings witness to a belief that death irreparably shattered the psycho-physical organism that constituted human nature, and that only a shadowy wraith descended into the underworld.[1]

427

The iconographic and architectural remains of most peoples of the ancient Near East and the Mediterranean world, other than the Egyptians, indicate a predominating concern with the service of deities whom they regarded as their divine rulers, and to whom they looked for material well-being, victory in war, and protection from daemons. The sanctuaries which these peoples built for their gods attest, in terms of the labour and resources spent in constructing them, to the strength of their belief that their prosperity depended on the good will of their divine masters.[2]

These deities were invariably depicted in human form, and they represented personifications of cosmic phenomena of various kinds. Among them appear goddesses who have the attributes of the primitive Mother Goddess, but with the emphasis more on fertility than maternity. They were usually associated with a male divinity, who was regarded as both their son and lover.[3] This deity personified vegetation, particularly the corn which was the chief source of food. The annual life cycle of the corn inspired a pattern of myth and ritual, which presented the birth of the corn in spring, its cutting down in harvest, and

428

427. Hermes leading a dead woman to the boat of Charon. Attic lekythos (*c.* 450 B.C.).

428. Canaanite fertility goddess, between Min and Reshef on an Egyptian stele, found at Bethshan.

429a. Akkadian seal impression, showing Ishtar and a god emerging from a mountain.

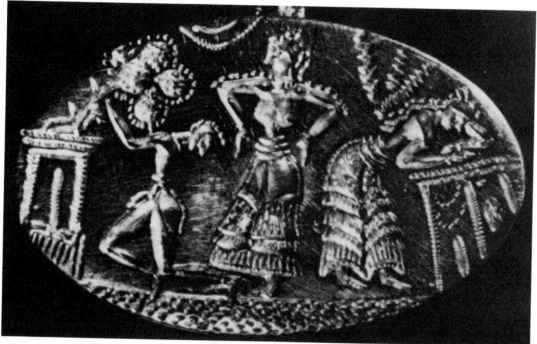

429b. Engraving on a Mycenaean gold signet ring, showing a ritual lamentation scene.

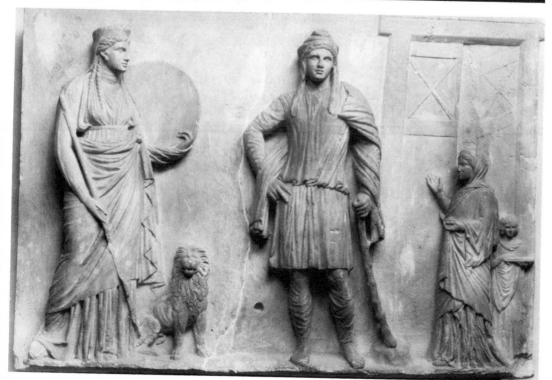

430. Cybele and Attis. (2nd century B.C.).

its rebirth in the new corn of the next year, as crises in the relations of the fertility goddess and the corn-spirit. The death of the corn-spirit or god of vegetation was mourned in a dramatic ritual, and its resurrection was carefully prepared for and celebrated with joy as a mystic assurance of the renewal of life.[4]

429a, b

In process of time, certain of these rituals associated with a fertility goddess and a "dying-rising" god of vegetation apparently prompted the hope that man might ritually participate in the death and resurrection of the vegetation deity. We cannot trace the stages of the development involved; but we find that the cults of Cybele and Attis and of Aphrodite-Astarte and Adonis became associated with mystery rites, into which devotees were initiated and promised some form of rebirth to immortality.[5] At Eleusis, in Greece, a similar transformation of a primitive agrarian ritual into a "mystery religion" seems to have taken place but here the ritual drama revolved around the return from the underworld of the "Corn Maiden" to her mother, the Corn-Goddess.[6] In these cults, initiation into the "mystery" represented, phenomenologically, that rebirth to new life for which primitive man seems to have sought in the cult of the Mother Goddess.

430

122-24

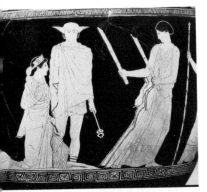

VI. HINDUISM AND BUDDHISM: THE PARADOXICAL WITNESS OF THEIR ART AND RITUAL

In the religions of the ancient Near East and the Mediterranean world, man's concern with the fundamental issues of birth, death and the supply of food was pursued, without rejection of life in this world as being in some manner undesirable or unreal. Indeed, there was a deeply rooted conviction that it was necessary to restore the physical body, with all its faculties, if a full and proper life was to be lived after death.[1] And the desire for eternal life mostly found expression in terms of the endless prolongation of existence in this world, with all its delights immeasurably enhanced. This instinctive acceptance of the desirability and the reality of existence in this world could scarcely have been challenged until man had learned to analyse the modes of his own thinking and establish some system of metaphysics. The ancient Egyptian attempt to visualise eternal life in more transcendental terms, as

eternal companionship with the sun-god Rē produced, understandably, a strange and uninviting imagery: but it did represent an initial effort to envisage a non-terrestial form of existence.[2]

219

In India, a view of human nature and destiny began to find expression during the seventh century B.C. which marked a profound change in man's thought about himself and the world of his experience.[3] Inevitably, we know of this change primarily through the philosophical literature of Hinduism; for it is fundamentally difficult to portray the subtleties of metaphysical thought iconographically. Indeed, even the ordinary modes of speech are insufficient, and special terminologies have to be invented and categories defined by those capable of thinking at such abstract levels. The diffusion of such ideas also presents a problem; for ordinary folk, inevitably, cannot grasp the rarefied doctrines of metaphysicians or mystics. However, they will listen with respect to such teachers, if their spiritual authority becomes established in other ways. This seems to have happened in ancient India, and we do have some iconographic clues as to how it came to pass.

101

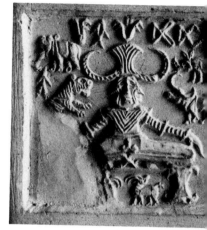

Since the discovery at Mohenjo-daro, in the Indus Valley, of sealstones, incised with a curious horned figure sitting in the yogic posture, it has been thought likely that asceticism was practised in India from about the latter part of the second millennium B.C.[4] Such asceticism would imply a radical change in man's evaluation of himself and his environment. For it would mean not only a conscious rejection of physical pleasures, but also a severe restraint in satisfying the basic necessities of physical life. Where such abnegation is practised, the individual concerned is invariably inspired by a view of life that causes him to despise and abstract himself, as far as possible, from involvement in the empirical world which ordinary folk accept without question. His example, however, has a curiously ambivalent effect upon his fellow men: his rejection of their values shocks them, but it will also induce a feeling of awe and veneration.[5]

101, 296

431a

The appearance of the ascetic in ancient Indian society is, accordingly, indicative of the emergence of a new attitude towards life. Instead of concern for the prolongation of life beyond the grave, in a form substantially the same as that lived in this world, to which the eschatologies of both the *Rig-Veda* and the Near Eastern religions witness, this world and its values were rejected.[6] A statue of the Buddha

431a. Colossal statue of Gommateśvara at Śravana Belgola.

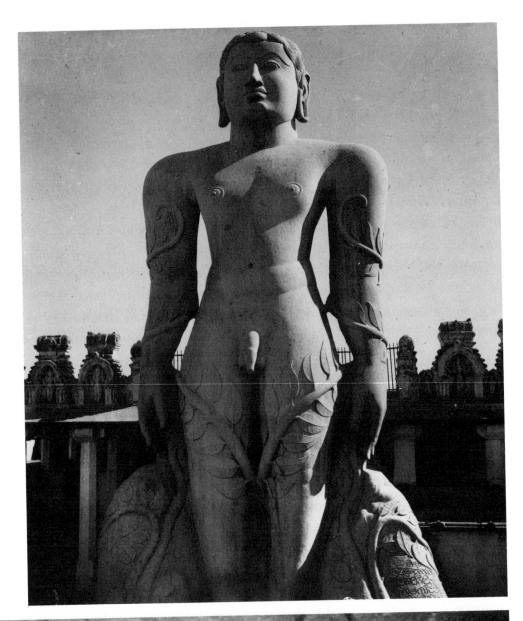

431b. Chinese Buddhist representation of metamorphosis.

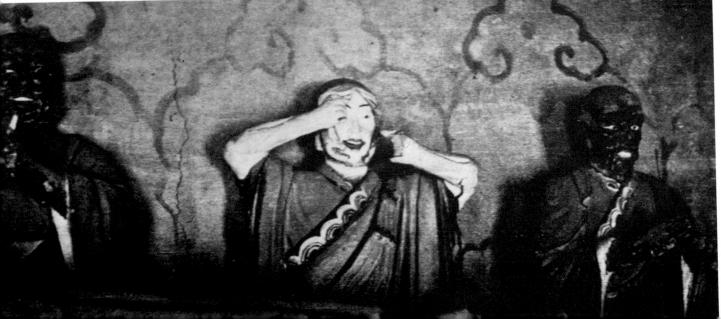

as an emaciated ascetic, dating from the Gandhara period, epitomises this world-denying attitude in a historical person.[7] The attitude, however, was not negative in its denial. For it was inspired by a conviction that all the pain and suffering of physical existence, including birth and death, stemmed from man's mistaking the empirical world for ultimate reality and clinging to existence in it. This error meant that each individual became involved in an unending cycle of births and deaths (*samsara*), with all their attendant pain. Deliverance from this ceaseless misery could be had by each person only by effectively repudiating the fateful error, and by eradicating all desire for continued existence in the empirical world.

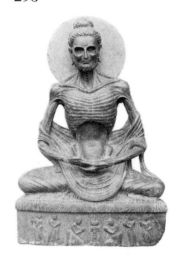

296

431b

Attainment to true reality, which is conceived in Hindu philosophy as union with Brahman, and in Buddhism as the state of Nirvāna, is a metaphysical concept so rarefied that it cannot be apprehended through the process of human logic or defined in human language. However, it is evidently conceived as a state of being outside Time and beyond birth and death. Accordingly, despite its abstraction, it represents that security from change and decay for which man has yearned from the dawn of culture.[8]

As presented in their sacred literatures, Hinduism and Buddhism set aside the world of common human experience as having only a provisional validity, because it is essentially the product of a primordial ignorance (*avidya, avijja*), which mistakes the true nature of reality. Apprehension of ultimate reality is achieved only through ascetical discipline and meditation, guided by the teaching of the Buddha or the revelations of Hindu *rishis*.[9] However, the art and ritual of both Hinduism and Buddhism witness, significantly, to the manner in which these religions have been practised as popular faiths.

As we have abundantly seen, Hinduism has found expression most obviously in the ritual service of deities, located in cult images. These deities are supplicated primarily for physical well-being and prosperity in this life. It is true that the doctrines of *samsara* and *karma* are generally accepted as constituting the basic pattern of existence; and rituals are practised relating to birth and death, and customs are observed, such as pilgrimages to holy places, to earn better forms of future incarnation.[10] But, in all this often strange and complex praxis, it is very evident that birth, death and the food supply are as much the basic issues of concern as in other religions.

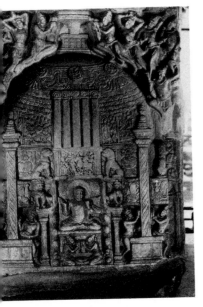

196

84, 118, 119,
196, 339

432, 433

431b

376, 377a

377a

Buddhism, which grew into a world religion accepted by the peoples of many diverse Asian lands, has remained focused on the Buddha. His image is the central object of every shrine, and to it offerings and prayers are made. The doctrine of the *Buddha-rūpa* has been used by Buddhist scholars to justify this image cult, which contradicts a basic principle of the Buddha's traditional teaching.[11] But, however their attempt at justification may be evaluated, Buddhist iconography significantly illustrates the need that was felt when a philosophy of life which originally denied the reality of this world became a popular religion. As early reliefs at Sanchi and Bharhut show, the Buddha himself was soon treated as a god, and people sought to worship objects connected with him. At first it was the stupa that enclosed his relics, or his footprints or begging-bowl.[12] Attempts were also made to venerate his teaching by representing it as the wheel of the Law, which the "Enlightened One" had set in motion; but these substitutes were quickly dispensed with once images of the Buddha himself began to be carved. And with the images came a narrative art which vividly portrayed events in the career of the Buddha, from the moment of his miraculous conception in his mother's womb to his final entry into Parinirvana.[13] The elaboration of this iconographic record eloquently witnesses to the satisfaction that Buddhists of many lands have felt in the visual presentation of the career of their saviour-god. It portrays an essentially human drama, set firmly in this world of time and space. For the great mass of the Buddhist faithful this is the reality that inspires and uplifts —not the subtle metaphysical doctrines, which are held with respect but hardly comprehended.[14]

A like situation is revealed by the eschatological iconography of Buddhism. As many popular depictions show, despite the basic doctrine of *anatta* (that there is no permanent self that continues after death), *post-mortem* existence has been conceived in very materialistic terms.[15] The dead are shown as passing through a series of nine hells, where their punishments are graphically portrayed, until they reach the tenth, from which they are reincarnated in the form deserved by their previous *karma*.[16] But strange as this departure may be from the basic doctrine of Buddhism, it is intelligible in terms of the comparative study of religious phenomenology. For it reveals a preoccupation with death as a definite event *per se*, and not as an infinitely repeated

432. The first bath and steps of the infant Buddha. Detail of a Chinese hanging scroll, from Tun-huang (T'ang Dynasty).

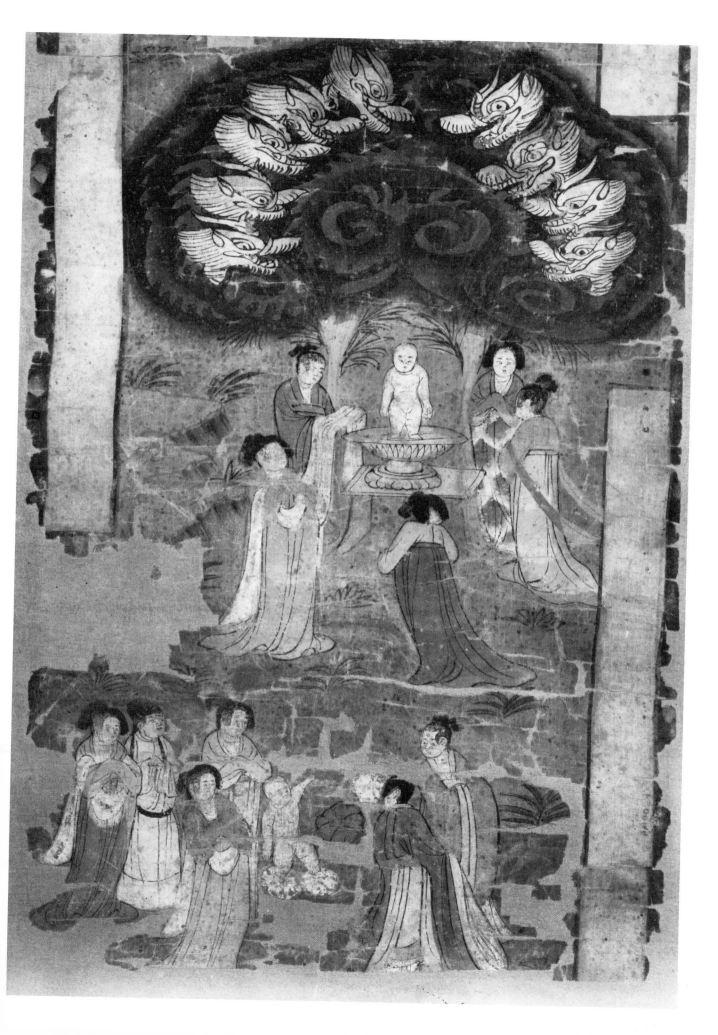

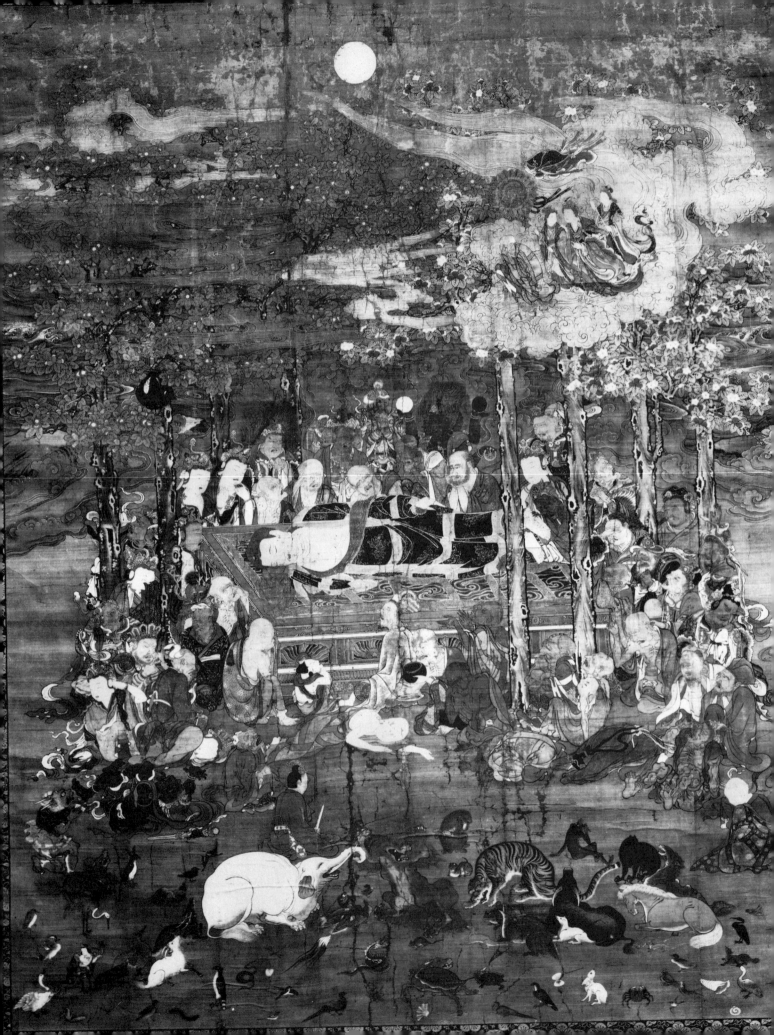

happening in an illusory world. In other words, even in a Buddhist context, the instinctive preoccupation with death and its immediate aftermath has remained effective. Furthermore, although *karma,* in terms of Buddhist metaphysics, is virtually a continuous process of judgment on past action, Buddhist eschatology has conceived of a judgment after every period of incarnation. And it has done so in imagery as materially realistic as was ever used in the religion of ancient Egypt or Christianity.[17]

VII. MYSTERY CULTS: SALVATION THROUGH INITIATION

Buddhist iconography reveals how one who was essentially a teacher of a new philosophy of life was transformed into a saviour-god and worshipped. Such a transformation testifies to man's instinctive craving for a personal saviour, of divine status, to deliver him from the menace of death and its dread aftermath. In the course of time, this need led, in other parts of the world, to a proliferation of esoteric cults that promised salvation from the common fate of humanity. In terms of both historical and phenomenological interest, the most significant of such cults flourished in the Graeco-Roman world.[1]

The idea of salvation, obtained through a divine being, had existed in Egypt since the third millennium B.C., as we have seen. But this salvation, which was mediated through ritual assimilation with Osiris, was essentially *post-mortem* in its reference. The ancient Egyptian could only hope and plan, during his lifetime, that when he died, other persons would faithfully arrange for the proper embalmment of his body and the careful performance of the necessary rites. The so-called "mystery cults" that arose in Graeco-Roman society, although they were also essentially concerned with death and the afterlife, offered the assurance of salvation in this life. Further, in contradistinction to the Osirian mortuary ritual, they all appear to have based their claims upon possession of secret knowledge about human nature and destiny and the means whereby divine salvation could be obtained from the common fate of mankind. This secret knowledge was imparted to those who sought initiation into the "mystery." Initiation seems generally to have

433. Buddha's entry into Perfect Nirvāna. Japanese hanging scroll.

345a

122-24

344, 345a, b, c

434a, b

435

436

437

involved ritual acts that re-presented certain crucial episodes in the sacred history (*hieros logos*) of the deity or divine hero on whom the cult was centered.[2]

Since both the rites and the doctrine were invested with secrecy, our information about the various mystery cults or religions of the Roman Empire is inevitably of a fortuitous character. It comprises mostly literary material of an indirect and problematic character, and archaeological data of various kinds. Some of this latter evidence we have already noticed: intimations of the Eleusinian Mysteries may be gleaned from the shattered ruins at Eleusis and from a few sculptured reliefs and vase paintings;[3] we have sensed something of the dramatic rites of Dionysos, once enacted in tragic Pompeii;[4] and in the frescoes of the tomb of Vicentius we have seen the hopes that inspired those initiated in the secrets of Sabazios.[5] Something of the stern rites of initiation undergone by devotees of Mithra is still evident in faded paintings found in the mithraea;[6] and buried Herculaneum has provided impressive evidence of the mysteries of Isis and Osiris, as they were performed in a Graeco-Roman setting.[7] Of the esoteric symbolism used by those who sought salvation through the mystical philosophies of Neo-Pythagoreanism, the strange subterranean basilica and its frescoes at Porta Maggiore, Rome, bear enigmatic witness, as do also the cryptic amulets once worn by members of Gnostic cults.[8]

This fragmentary evidence—variously iconographic, literary and architectural—which survives from the world of Graeco-Roman culture, documents a new phase of signal import in man's quest for significance. It reveals that in societies of comparative economic affluence, where men are not primarily occupied with the production of food, the problem of human destiny may become an issue of increasing concern. In other words, that the greater the sophistication of life, the stronger grows concern about its meaning and purpose. And so the primitive urge to provide for *post-mortem* needs becomes transformed into desire for the assurance of some transcendental form of eternal being. New theories about human nature are invented to prove that there is an inner essential self, which is independent of the body and rightly belongs to a higher ethereal plane of existence.[9] Divine aid is enlisted to achieve this transcendental destiny; but it is assumed that such aid can be obtained only through special initiation into mysterious truths

345b

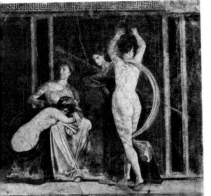

434a. Mithraic initiation by fire: from the Mithraeum at Capua.

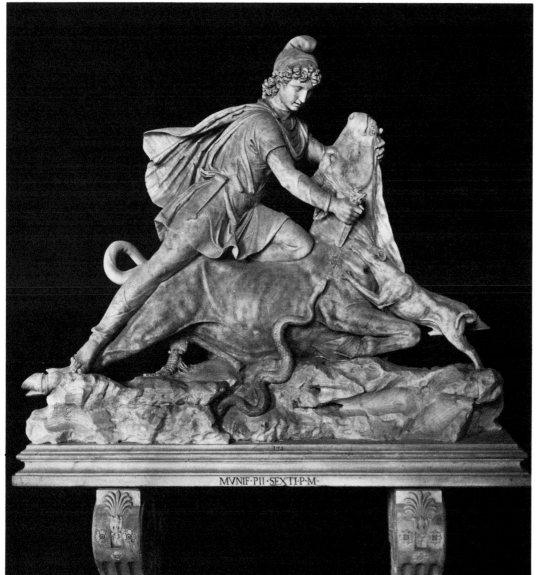

434b. Mithra slaying the Cosmic Bull, in the Vatican.

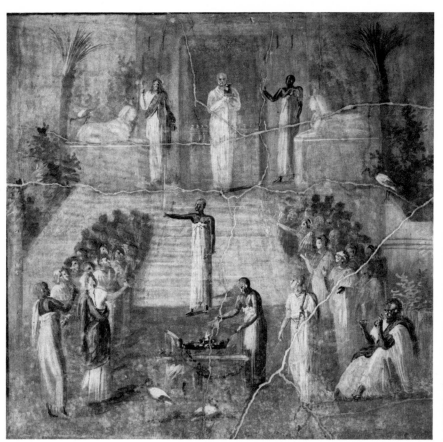

435. Wall painting, from Herculaneum, showing Isiac ceremony.

436. Underground basilica near Porta Maggiore, Rome.

437. Gnostic amulets.

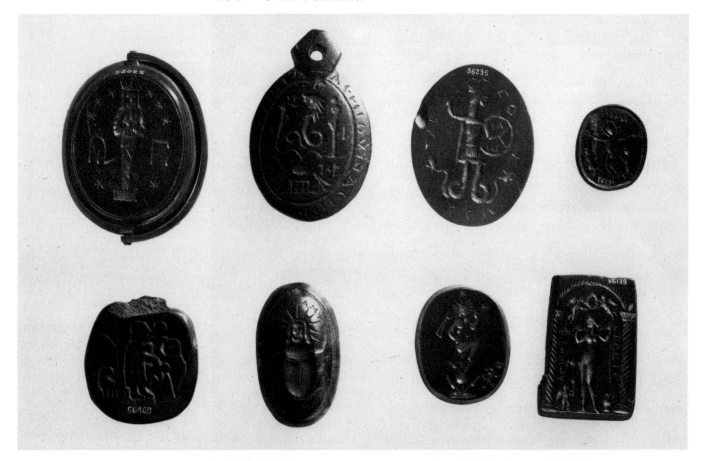

and practices which the divinities concerned had entrusted to the guardianship of special priesthoods. Such initiation, in turn, fostered a sense of spiritual election in the devotees of each specific cult, and promoted a feeling of brotherhood among them. Initiation, also, invariably involved the acceptance of a certain discipline of life, and recognition of the spiritual authority of a hierarchy of ministrants.

Historically considered, the rise and popularity of these mystery cults and esoteric philosophies in the Graeco-Roman world witness to a demand for the satisfaction of personal needs in religion, for which the civic or state cults did not cater.[10]

VIII. CHRISTIAN ART AND RITUAL: THE CHANGING EMPHASIS FROM NEW LIFE TO JUDGMENT AND DAMNATION

It is in the context of the spiritual quests of the Graeco-Roman world that the emergence of Christianity is to be understood. This faith, which originated as a Jewish Messianic movement in first-century Judaea, was transformed, through the genius of St. Paul and the obliteration of its primitive Jewish form in A.D. 70, into a universal savior-god religion. The process of transformation has been dealt with at length elsewhere; for its elucidation is basically a matter of literary and historical research.[1] Our concern here is with the interpretation of Christianity, as a religion of the Graeco-Roman world, in the light of its art and ritual practice.

The earliest surviving evidence of the actual faith and practice of Christianity is to be found in the ruins of the "house-church" at Dura-Europos, which dates from A.D. 232. It is, of course, by chance that the earliest evidence should be preserved in this fortress town on the eastern frontier of the Roman Empire. However, remote though Dura-Europos was from the main centres of the early Church, its witness can be confidently accepted as typical of Christian life elsewhere. The "house-church" was an arrangement used by Christians throughout the Roman Empire when their religion lacked legal status and public places of worship could not be safely erected.[2] The "house-church" at Dura-Europos, though badly ruined, has preserved significant evidence

148

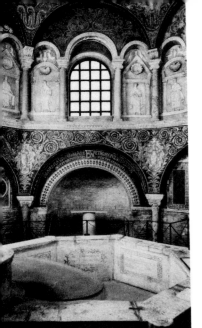

of Christian ritual practice at this early period. It takes the form of a specially built baptistery, thus witnessing to the importance attached to the rite of baptism by the Christian community there. This baptistery is the earliest example of a series of such structures which reveal that Christians set so high an importance on baptism that they made such special provision for its administration.[3]

151

This emphasis found impressive expression when the emperor Constantine gave legal recognition and his imperial patronage to Christianity, and the building of churches was zealously begun. The baptisteries were erected as separate structures, adjacent to the churches. They were usually octagonal in form, and their interior construction was specially planned to serve the elaborate ritual of baptism.[4] The central area contained the *fons* ("fountain"), in the form of a great basin, into which those who were to be baptised descended by stone

438

steps. Niches were provided in the walls of the baptistery for their clothes, for the neophytes were baptised in a state of complete nudity.[5] The ritual action, as a whole, was conceived as a ritual dying and rebirth of the neophyte, to a new life *in Christo*. St. Paul's prescription in the sixth chapter of his *Epistle to the Romans* provided scriptural authority for this conception. The neophyte was ritually assimilated to Christ in death, descending beneath the waters as Christ descended into the grave. Having thus died with his divine Lord, he came up from the waters to a new life, as Christ had risen from the dead.[6] Baptism was thus a dying to one's old self and a regeneration to a new self. This mystic transformation was further ritually represented when the newly baptised was received by the bishop into the membership of the Church, the mystical Body of Christ; for he was reclothed in a white baptismal robe, given a new name, and symbolically fed with paradisial milk and honey.[7]

151

The candidates for baptism at this period were adults, and their preparation for the sacrament was long and rigorous. The rite was thus invested for them with the utmost sanctity, which was enhanced by the solemnity of its setting in the uniquely fashioned baptistery, adorned with mosaic depictions of saintly figures and holy symbols.[8] For the early Christians, baptism had thus a truly awful significance such as we can scarcely comprehend today, when infant baptism has become a routine custom of little meaning to most who witness it.

The pristine sense of deliverance from the fatal darkness of pagan-
ism found significant expression, also, in the art of those catacombs
where the Christians buried their dead. As we have seen, selections of
scenes from the Old and New Testaments illustrated the theme of di-
vine salvation: Daniel is saved from the lions, and the three servants
of God from the fiery furnace; Christ releases the paralytic from his
infirmity and heals the woman with the issue of blood.[9] Baptism is
depicted and the Eucharist or Agape, so symbolising the Christians' re-
birth and continuing communion with their divine Saviour.[10] Refer-
ence to death appears only in the context of resurrection: Christ raises
Lazarus from the tomb.[11] The figure of the Good Shepherd with his
sheep commemorated Christ's watchful care over those whom he had
saved, and the "Orans" typified the pious soul uplifted in prayer.[12]
The message of this catacomb art is one of the new life, serene and
blessed, that was offered to man through the saving grace of God and
guaranteed by his continuing care. There in the *loculi,* hollowed in the
catacomb walls, the bodies of the Christian dead rested *in pace,* as many
inscriptions record. There is no note of gloom or sadness, nothing
macabre or menacing.[13]

271

269, 439

268, 272

273

275

The witness of this earliest Christian iconography is impressive. It
was a popular art, in the sense that it directly expressed in crudely
drawn figures what these first Christians felt when they buried their
dead. Those who painted the scenes, and those who accepted them as
valid expressions of their faith, were serenely confident, as Christians,
that they, both the living and the dead, had a joyous destiny through
the special providence of God manifest in Christ. It is remarkable,
therefore, that in the earliest paintings no attempt was made to portray
Christ as a divine being; except perhaps in a third-century depiction
of his baptism in the catacomb of SS. Pietro e Marcellino, where a
dove is shown in the act of pouring out the baptismal water—the dove
doubtless represents the Holy Spirit, according to *Luke* iii:22, but its
effusion of the water is an original feature.[14] It was not until the fourth
century that Christ's divinity was indicated by a nimbus of supernatu-
ral light.[15] Usually Christ appears in contemporary Roman dress, some-
times slightly larger in stature than other human figures. It is notable,
also, that winged angels do not figure in this primitive Christian art;
the demons that abound in the later iconography are likewise absent.[16]

439

440

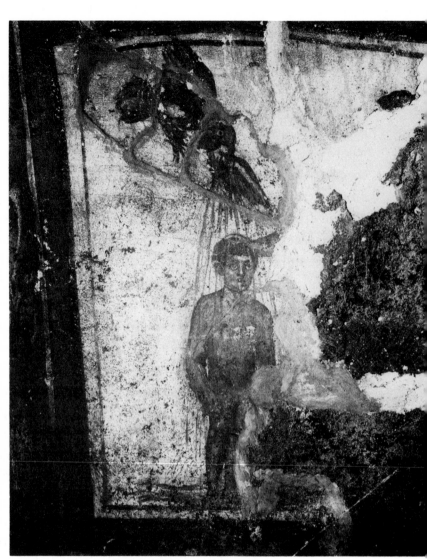

438. Baptismal font at Cuicul (modern Djemila), Algeria (5th century).

439. Baptism of Christ (late 3rd century). Painting in the Catacomb of SS. Peter and Marcellinus, Rome.

440. Portrait of Christ: wall painting in the Catacomb of Commodilla, Rome (mid-4th century).

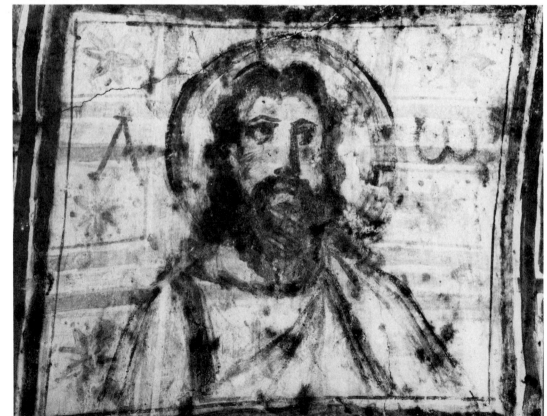

From the fourth century onwards, to the full flowering of early Christian art in the great basilicas of the sixth century and their superb mosaics, both the architecture and the iconography of the Church continued to mirror that assurance of spiritual security which the profession of Christianity seemed from the first to confer. The provision made for the administration of baptism and the celebration of the Eucharist show that these two sacraments, and their soteriological function, were still the dominant concerns of Christian liturgical life. However, the internal arrangement of the churches indicates the emergence of two other factors that were destined to exercise an increasing influence in both the private and communal life of Christians. The position of the bishop's *cathedra* or seat, in the centre of the apsidal end of the church, signified the establishment of a hierarchy that claimed to hold the authority and charismatic power that Christ had bestowed on his Apostles.[17] This hierarchy gradually evolved and administered a series of sacraments that shaped the pattern of Christian living, from its beginning in baptism to the holy unction given *in extremis* at death.[18] Then, the siting of a *memoria* or *confessio*, containing the relics of a saint, beneath the altar encouraged a cult of relics that was symptomatic of a changing evaluation of the status of the ordinary Christian.[19] For, from a natural veneration of those who had given their lives in testimony to their faith, there developed the idea of a glorious company of saints who had amassed a treasury of merit with God; and from this treasury the shortcomings of ordinary Christians might be made good.[20]

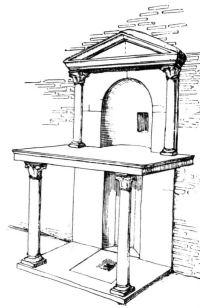

203, 204

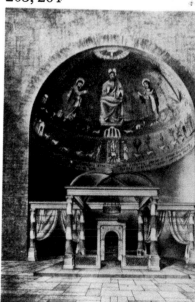

In the earliest phase of Christian iconography, no overt reference is made to the prospect of divine judgment on mankind after the catastrophic destruction of the universe.[21] This lack of notice is curious; for the idea of the Return of Christ and the Last Judgment dominated primitive Christian thinking, according to the evidence of the New Testament and other early writings.[22] There is also a corresponding absence of reference to the fate of the damned and to Hell, in notable contrast to the preoccupation with these themes in mediaeval iconography. The earliest certain depiction of the Last Judgment dates to the sixth century. It appears among a series of mosaic scenes from the life of Christ in the basilica of Sant' Apollinare Nuovo, in Ravenna, to which reference has already been made.[23] The picture is obviously inspired by the prophecy recorded in the *Gospel of Matthew* xxv:1ff. It

441a

shows a youthful, beardless Christ separating the sheep from the goats. The only hint of the fateful nature of the transaction is given in the colour of the garments worn by the angel who stands to the left of the seated Christ—the sombre blue denotes damnation.[24]

Another significant omission from the subjects treated by early Christian art is the Crucifixion of Christ. As we have already noticed, the omission may be reasonably explained in two ways: that it was politically dangerous or indiscreet to represent Christ crucified; or, that Christians were primarily concerned with the Resurrection of Christ and its message of triumphant new life. The latter reason certainly

359

seems to have remained effective even after the Crucifixion began to be depicted during the fifth century.[25] For, in contrast to the emphasis laid on the Crucifixion in Western mediaeval art, the death of Christ was never portrayed at a focal point in the great churches of the Christian Roman Empire. The Cross alone did sometimes occupy such a position, as in the apsidal domes of Sant' Apollinare in Classe, near Ravenna, and S. Pudenziana in Rome; but it is then shown as a beau-

152

tiful jewelled emblem of Christianity, and not in its grim reality as the instrument of a degrading form of execution.[26]

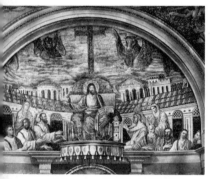

The development of Romanesque art marks a significant change in the subjects with which Christians were predominantly concerned. The most striking evidence of such change relates to the evaluation of human destiny; it finds expression in the so-called "Doom" or representation of the Last Judgment. In the place of the restrained symbolic rendering of the event in Sant' Apollinare Nuovo, a realistic imagery was now employed to emphasise the awful nature of the Great Assize before which all mankind would be arraigned. Hell and its horrors begin to be portrayed with a strange but disturbing mixture of realism

366, 368, 381,
382a, b

and symbolic fantasy; and the Devil and his ministering demons take on visible forms and inflict truly diabolical torments on the damned.[27] The resurrection of the dead is no longer left to the imagination, but is

380

graphically depicted as happening at the sound of the angels' warning trumpets.[28]

The portrait of Christ also changes in certain significant ways. Already by the fourth century, some Christians had attributed a more august countenance to their Lord. Under the probable influence of the

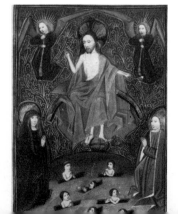

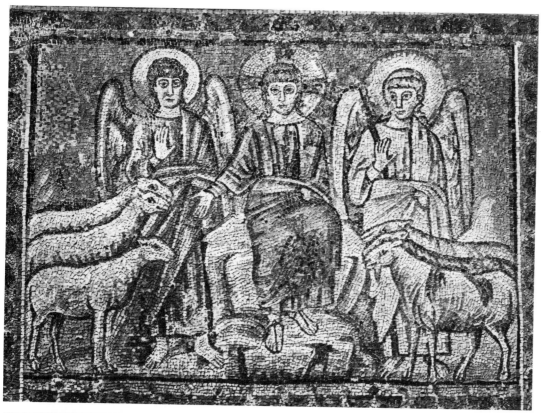

441a. Mosaic depiction of the Last Judgment in S. Appollinare Nuovo, Ravenna.

441b. Christ as feudal King-Emperor. Sculptured tympanum at Moissac, France (1110-1120).

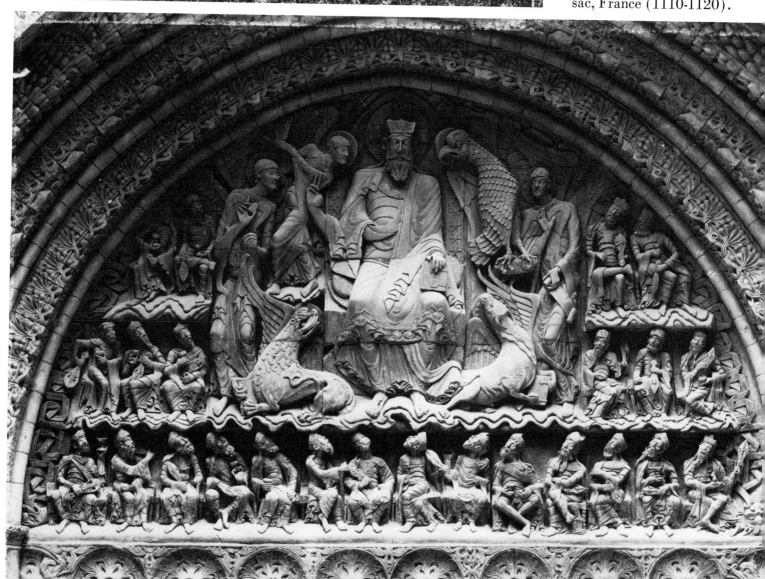

440

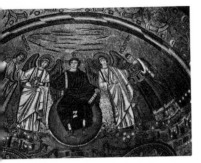

62

441b

382b

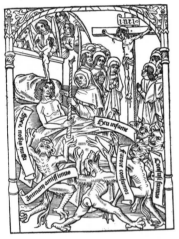

442

382b

majestic images of Jupiter and the Alexandrian god Sarapis, they depicted Christ with a mature bearded face and large impressive eyes, thus replacing the expressionless visage of the young beardless hero of early catacomb art.[29] The two types continued together for some centuries as acceptable images of Christ, as the mosaics of Sant' Apollinare Nuovo notably show.[30] But the Christ of Western mediaeval art was a more complex figure. He appears in various guises which reflect the characteristic trends of the mediaeval doctrine of God and Man. The most significant of these roles may be designated as Christ the King, Christ the Victim, and Christ the Judge.

The kingly role of Christ is an obvious development from the early conception of him as the Cosmocrator or Ruler of the Universe.[31] But the mediaeval conception of the kingship of Christ has another significance, for it relates to the feudal structure of mediaeval society.[32] It embodied the idea of Christendom, or the Kingdom of Christ, of which the pope and the Holy Roman Emperor were respectively the sacred and secular representatives on earth. Mankind, or rather that fragment of it that lived in Europe, was conceived as a hierarchical structured society over which Christ ruled through his appointed officers, who were ordered in a descending sequence of delegated authority and responsibility. The essential framework of this society was provided by the Church, presided over by the pope; and it was the duty of the emperor and other princes to protect the Church and to uphold its authority and enforce its decrees.[33]

The divine purpose in this order of things was the salvation of human souls. It was believed that Christ had made this salvation possible by his own sacrificial death, and that he had arranged for its implementation through the sacramental system entrusted to his Church. With this belief went a view of human life as a perilous journey of the soul through this world, which was infested with demons intent on achieving its eternal damnation.[34] Though freed by baptism from the Original Sin in which it was born, the frail soul needed the constant care and guidance of the Church and the grace of its sacraments, if it was to complete its journey in a state of grace. The moment of death was especially critical; for, as numerous pictures show, it was thought that the minions of Satan gathered about the death-bed in a final determined effort to seize the soul as it emerged with the last breath from the dying body.[35]

Consistent with this view that Christ had made possible the salvation of man by his own sacrificial death, which was the price incurred by human sin, was the grimly realistic portrayal of him as the Suffering Victim. This presentation took three forms: as the Man of Sorrows, crowned with thorns and lacerated body; as the Crucified, nailed in agony to the Cross; and as the dead Christ, held by his sorrowing Mother, his stiff body showing the wounds of Crucifixion and the spear thrust.[36] As we have already seen, these images were designed to emphasise the physical horror of Christ's suffering. They reflect a preoccupation with the pain and agony caused by the enormity of man's sin. The contrast between the Christ of the crucifix or the *pietà* and Christ the King is shocking, and it was meant to be so; for it was an essential factor of the mediaeval *Weltanschauung*. Mediaeval man, whatever his rank in society, was thus taught to realise that it was for his salvation that the Divine King had become a man, had suffered so terribly and died—at this cost he had been redeemed.

45, 103, 327

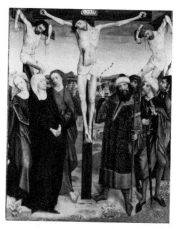

103

It was this theme that inspired the third of the images that characterised the presentation of Christ in mediaeval art, namely, that of the awful Judge of mankind. In this role, Christ appears in the "Doom," which was sculptured on the tympana of cathedrals, or painted on the chancel arches of churches, or drawn for private meditation in books of prayer.[37] He presides at this Last Judgment, at which the fates of all men will be eternally decreed, exhibiting the wounds of his Crucifixion as the attendant angels show the instruments of his suffering—the Cross, the pillar of flagellation, and the lance. Thus is he presented as the implacable Judge, who menaces sinful mankind with the awful evidence of what their sins have cost in suffering to him. For the time of repentance and amendment of life is now past, and all generations, resurrected in their physical bodies, stand before him for judgment. For the sinner, at this fatal moment, the only hope of mercy depends on the Virgin's intercession, who kneels before her stern-faced Son as she pleads for frail humanity.[38] The awful ordeal of the fateful assessment was also graphically shown. In the centre of the scene the archangel Michael weighed each soul, as he warded off the efforts of demons to secure the verdict of the scales and so make certain of their prey.[39]

443a, b
380

Mediaeval art and architecture gave expression to many other aspects of Christian faith and practice, as Christianity reached its fullest flowering at this period, both as a religion and a culture. Much of it was

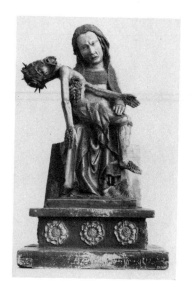

327

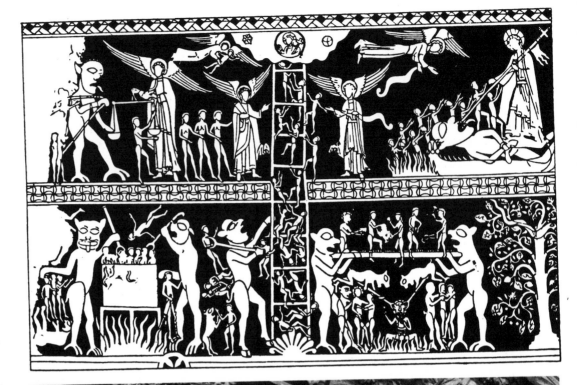

442. *The Ladder of Salvation.* Mural painting in church of SS. Peter and Paul.

443a. The "Doom" over the central portal of the Cathedral of Bourges.

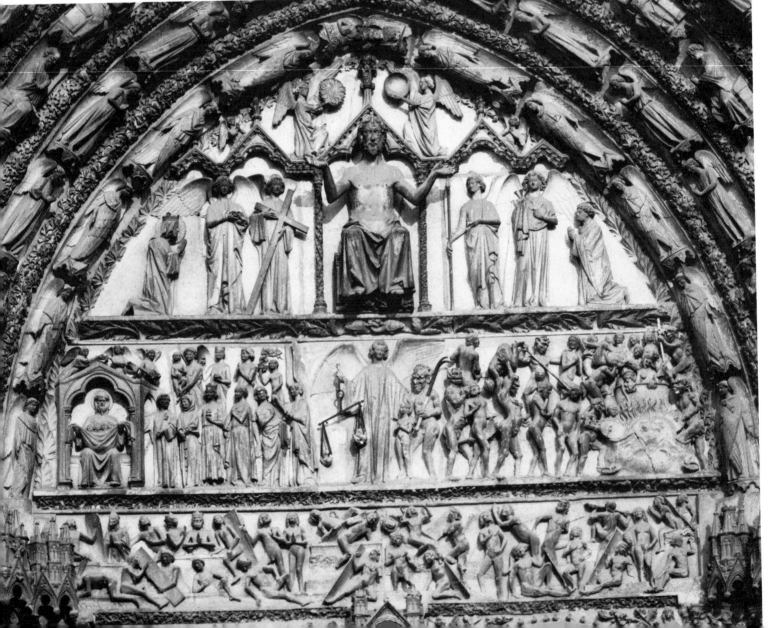

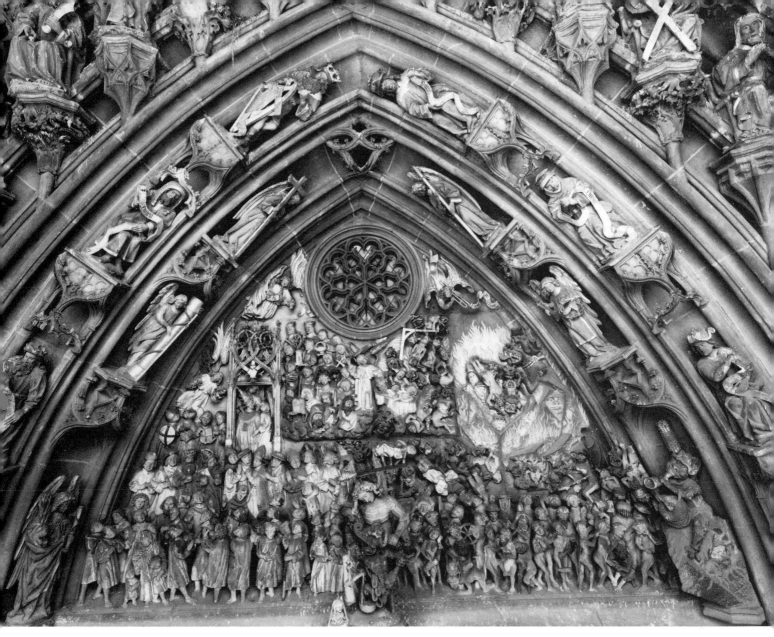

443b. The "Doom" of the Cathedral of Bern.

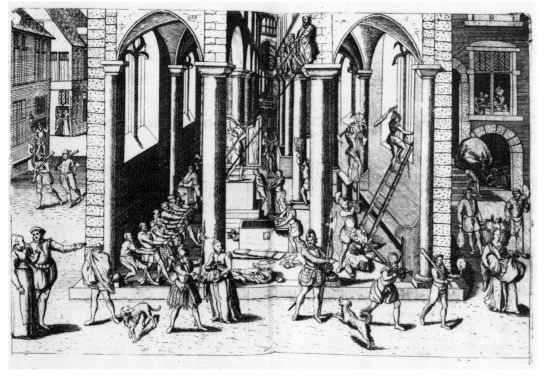

444. *Iconoclasm in the Netherlands.* Engraving from Baron Eytzinger's *De Leone Belgico* (Cologne, 1583).

noble and uplifting, and it gave the faithful a sense of participation in the mighty drama of God's purpose, that stretched from the creation of the world to its future *dénouement,* when the just would for ever enjoy the beatific vision and the wicked suffer eternally in Hell.[40]

The Reformation destroyed the rich heritage of Catholic art and ritual in many countries of Europe. But, though the images and paintings disappeared from the churches, the iconographic tradition still continued in a private context.[41] Illustrated bibles, works like Foxe's *Book of Martyrs,* and depictions in books of religious devotion and instruction imparted a visual imagery of incalculable influence.[42] Pictures of religious subjects were approved in the home, and some like Holman Hunt's *Light of the World* and Thorwaldsen's carvings have formed for countless persons their conception of Christ.[43] In Catholic Europe and the Americas the ritual and iconographic expression of the faith never diminished. Indeed, to the contrary, art became a potent weapon of the Counter Reformation in stimulating the ardour of Catholic devotion.[44] The Baroque church, in its architecture and imagery, both mirrored and inspired the intense emotion that came to characterise Catholicism in both its public and private aspects—thus, in Rome, Bernini's *Cathedra Petri* ecstatically exalts the papal claim within the Basilica of St. Peter, while his *Ecstasy of St. Theresa* in Santa Maria della Vittoria seeks to portray the experience of mystical trance.[45]

(margin references: 444; 445a, b; 446; 447)

IX. THE PARADOXES OF ANICONIC FAITHS

We may fittingly end this brief essay in interpretation by noting what might be termed the negative evidence of those strongly monotheistic faiths that have forbidden, explicitly or implicitly, the linear or plastic representation of deity. Two religions, Judaism and Islam, are so distinguished; for Christianity, though inheriting the monotheistic tradition of Judaism, boldly attempted in the Middle Ages to portray both the Trinity and God the Father, as we have seen.

That Hebrew religion was not always aniconic is clearly attested in the Old Testament writings. The Golden Calf made at Sinai and the bull images set up by Jeroboam doubtless represent an established

445a. *The Light of the World,* by Holman Hunt.

445b. Thorwaldsen's relief of Christ at the Last Supper.

446. The *Cathedra Petri*, by Bernini, in St. Peter's, Rome.

447. Opposite: Bernini's *Ecstasy of St. Theresa*, in S. Maria della Vittoria, Rome.

131

tradition of cultic practice.[1] Then, there are the precise directions given in the Mosaic Law for the making of images of cherubim, and their location in the "holy of holies," as guardians of the Ark of Yahweh.[2] There is much reason for thinking that these cherubim were originally conceived as the bearers of Yahweh. Ezekiel significantly saw Yahweh enthroned above the cherubim in his vision on the banks of the river Chebar (x:1ff). Despite the aniconism of later Judaism, it is evident that the Jews still visualised Yahweh as having human form. Thus the synagogue frescoes of Dura-Europos and other depictions of biblical scenes represent divine intervention by the hand of God emerging from the sky.[3] The Angel of Yahweh was depicted anthropomorphically in some mediaeval Jewish books,[4] and, most surprisingly, there are actually a few representations of God himself.[5] The instinct to locate the divine presence in worship found carefully prescribed expression both in the Mosaic Law concerning the Ark and the tabernacle, and later in the construction of the "holy of holies," in the temple.[6] And in synagogue worship the focus of attention is inevitably the scroll of the Law, set within its ornate ark or tabernacle.[7]

131, 348, 349

136

135

136

385-87

Although Muslims can rightly claim that their mosques are devoid of images, the *mithrab* significantly provides a focal point for worship and essential emphasis is laid upon the right *qibla*.[8] In Mecca itself, the Ka'ba is the holy object *par excellence,* and for pilgrims the touching of the sacred Black Stone set within it is the emotional climax of their arduous journey.[9] Muslim artists have not hesitated to depict scenes from the life of Muhammad, and they have given form to the angel Gabriel, through whom Allah's revelations to the Prophet were generally given.[10]

This evidence has, surely, its own peculiar significance for our study. For in each of these religions, which have consciously rejected the iconography of deity as a reprehensible heathen practice, the human instinct for visual conception has found various compromise forms of satisfaction. Although essential stress has been laid upon the transcendence of supreme deity, the desire for some visible focus of the divine presence has concentrated on certain things, respectively, a point of direction and a book, and endowed them with a cultic significance which is not wholly dissimilar to that which invests the icon. That this should be so, even in a most carefully qualified sense, is not surprising;

387

for however strong may be man's aspirations for a wholly spiritual conception of deity, he is obliged to use in his thinking a mind that is fashioned by contact with a physical environment and that is essentially based within his own physical body. As Xenophanes of Colophon perceived long ago, men must inevitably make their gods in their own image.[11] But with that conclusion, we must not overlook the significance of the fact, which Xenophanes missed, that man is the only animal that makes such images.

Notes

PART ONE

1. The translation of religious texts in the nineteenth century supplied the most powerful, if not the original, impetus to the history and comparative study of religions. Most notable were the fifty volumes of *The Sacred Books of the East* (Oxford, 1879–1904, 1910), for the publication of which Friedrich Max Müller (1823–1900), Professor of Comparative Philology in the University of Oxford, was responsible. The decipherment of the ancient languages of Egypt and Mesopotamia during this period also greatly contributed to the literary approach to the study of religion. Cf. L. H. Jordan, *Comparative Religion: Its Genesis and Growth*, pp. 114 ff. It is significant that Jordan in his companion volume, *Comparative Religion: Its Adjuncts and Allies*, in which he surveys the growth of the subject to 1915, records nothing about interest in the iconography of religion beyond the three insignificant references on pp. 444, 456, and 464. The comparatively brief attention given to the subject in the twelve volumes of the *Encyclopaedia of Religion and Ethics* (ed. J. Hastings) and in the six volumes of *Die Religion in Geschichte und Gegenwart* (ed. K. Galling) is symptomatic of the preoccupation with literature and the under-evaluation of iconography for the study of religion. The relevant articles in these works deal almost exclusively with the history of art. The *Bilderatlas zur Religionsgeschichte*, of which the first *Lieferung* appeared in 1924, provided a valuable collection of illustrations, but the meagre accompanying text fails generally to draw out their significance. This tradition of neglect is continued by the *International Bibliography of the History of Religions* (from 1952), which does not specifically list iconography or art.

2. See ill. 1 and 10. G. Clark, *World Prehistory*, p. 51, gives the radio-carbon dating of the Gravettian (Upper Perigordian) era, to which he assigns the female figurines (pp. 54–5), as 22,000–18,000 B.C. P. J. Ucko/A. Rosenfeld, *Palaeolithic Cave Art*, pp. 26–7, 31, 66–7, seem to date the period from 24,000 to 1900 B.C. Cf. Giedion, *The Eternal Present*, pp. 452–3; W. Torbrügge, *Prehistoric European Art*, pp. 13–19.

3. See ill. 2. Cf. D. Diringer, *The Alphabet*, pp. 21–5, 31–3; G. R. Driver, *Semitic Writing*, pp. 1–7, plates I, 2; M. E. L. Mallowan, *Early Mesopotamia and Iran*, pp. 14–15.

4. Cf. Diringer, pp. 34–5; A. H. Gardiner, *Egyptian Grammar*, pp. 5, 30–4, on ideograms or "sense-signs."

5. See ill. 3 (a. & b.). Cf. R. Hamann, *Aegyptische Art*, pp. 96–102; Gardiner, p. 7; K. Lange/M. Hirmer, *Egypt*, plates 4, 5, p. 397.

6. Cf. D. H. Smith, "Chinese Concepts of the Soul," in *Numen*, V, pp. 167–70; H. O. Stange, in *Anthropologie religieuse* (ed. C. F. Bleeker), p. 138.

7. Cf. S. G. F. Brandon, *Man and His Destiny in the Great Religions*, pp. 26–8.

8. Cf. S. G. F. Brandon, *Creation Legends of the Ancient Near East*, pp. 8–9.

9. See ill. 4. Cf. Brandon, *Creation Legends*, pp. 59–61, 89–90, 123–4.

10. See ill. 5. Cf. F. Lexa, *La magie dans l'Egypte antique*, I, pp. 77, 78, 88.

11. Cf. G. G. Coulton, *Medieval Faith and Symbolism*, chap. XV; A. Malraux, *The Metamorphosis of the Gods*, pp. 199 ff. See below, pp. 294, 390.

12. Cf. E. Mâle, *L'art religieux du xiie. siècle en France*, pp. 161–85; O. von Simson, *The Gothic Cathedral*, pp. 8 ff.; F. Heer, *The Medieval World*, pp. 316–18, 333–5; L. Bréhier, *La Civilisation byzantine*, pp. 234–44; E. Panofsky, *Meaning in the Visual Arts*, pp. 153 ff. (*Abbot Suger of St.-Denis*).

13. Cf. H. Breuil, *Quatre cents siècles d'art pariétal*, pp. 44–5; E. T., pp. 23–4; Ucko/Rosenfeld, pp. 110–15, 124, 143–4.

14. Elaborate precautions were taken to block the entrance to the tomb proper, in order to prevent robbery and desecration that might imperil the eternal well-being of the dead. The modern visitor to the tombs of the Theban necropolis is generally impressed by the freshness and careful execution of the mural paintings destined to remain for ever in profound darkness. Cf. H. Bonnet, *Reallexikon*, p. 259.

15. Cf. E. D. Adrian, *The Physical Background of Perception*, pp. 54 ff.

16. See ill. 6, and pp. 385 f.

17. Cf. *H.D.B.*, p. 413, A. Lods, in *E.R.E.*, VII, pp. 138–42; E. Bevan, *Holy Images*, pp. 17–19, 39–45. On Jewish religious art at Dura-Europos, see J. Neusner, *H.R.*, IV, pp. 81 ff., and below, pp. 277 ff.

18. Cf. E. Sell, in *E.R.E.*, VII, pp. 150–1.

19. Cf. E. J. Martin, *A History of the Iconoclastic Controversy*, *passim*; D. Talbot Rice, *Byzantine Art*, pp. 20–4; G. E. von Grunebaum, "Byzantine Iconoclasm and the Influence of the Islamic Environment," in *H.E.*, II, pp. 1–10.

20. Cf. Coulton, *The Fate of Medieval Art in the Renaissance and Reformation*, chaps. xix–xxii.

21. Cf. S. G. F. Brandon, in *Holy Book and Holy Tradition* (ed. F. F. Bruce and E. R. Rupp), pp. 1–19. See pp. 390 f.

22. Cf. S. G. F. Brandon, "Ritual: Its Nature and Function in Religion," in *The Dictionary of the History of Ideas* (ed. P. P. Wiener), with bibliography.

23. Ill. 8. Cf. L. G. Wickham Legg, in *Liturgy and Worship* (ed. W. K. L. Clarke and C. Harris), pp. 691–2, 694–5, 700–1.

24. Cf. G. E. Mylonas, *Eleusis and the Eleusinian Mysteries*, pp. 261–72, 282; J. E. Harrison, *Ancient Art and Ritual*, pp. 35–8.

25. Cf. *D.C.C.*, p. 484b.

26. Palaeolithic ritual burials have left no iconographic evidence.

27. Cf. G. Clark, *The Stone Age Hunters*, pp. 43–5; J. Hawkes, *History of Mankind*, I, pp. 52–3, 82–6.

28. Cf. Clark, *op. cit.*, pp. 41–2; J. Maringer, *The Gods of Prehistoric Man*, pp. 14–20.

29. How far this funerary equipment represented the personal belongings of the deceased is, of course, unknown. But it would appear that the various implements and ornaments put in the graves were still useful, and not merely symbolic. With regard to the food offerings, it would seem unlikely that burials would always have coincided with an occasion when food was plentiful.

30. For a list of contemporary fauna, see Ucko/Rosenfeld, pp. 28–9; A. Laming, *Lascaux*, pp. 126–52.
31. See pp. 25 ff.

PART TWO

1. Cf. *E.R.E.*, VII, pp. 314–19.
2. *Pyr.* 1981 a–b. Cf. Brandon, in *The Saviour God* (ed. S. G. F. Brandon), p. 20; R. O. Faulkner, *Ancient Egyptian Pyramid Texts*, I, p. 286.
3. Cf. Brandon, *op. cit.*, pp. 19–28.
4. Cf. A. Moret, *Mystères égyptiens*, p. 21: "Le personnel se compose de prêtres qui jouent les rôles de la famille osirienne." Moret is dealing here with the Osirian mysteries performed in the Ptolemaic temples at Edfu, Denderah and Philae; but, as *Pyr.* 1255 shows, ministrants, impersonating Isis and Nephthys, moved towards the royal corpse, which was assimilated to the dead Osiris, from prescribed directions. Cf. Faulkner, I, p. 286, n. 17; Bonnet, *Reallexikon*, pp. 376–8; "Klageweib," "Texte, die Abschnitte aus der Geschichte des Osiris behandeln, sind anscheinend altern Mysterienspielen entnommen," p. 621b; J. Gwyn Griffiths, *The Origins of Osiris*, pp. 28–9.
5. Cf. Bonnet, *Reallexikon*, pp. 620–3; I. E. S. Edwards, *The Pyramids of Egypt*, pp. 150–4; J. Spiegel, "Das Auferstehungsritual der Unaspyramide," in *A.S.A.E.*, Lll (1956); A. Piankoff, *The Pyramids of Unas*, pp. 9–10; S. Schott, *Mythe und Mythenbildung im alten Aegypten*, pp. 46–52, 123–7; P. Barguet, in *R.H.R.*, CLXXVII (1970), pp. 65–9.
6. Cf. Bonnet, *Reallexikon*, p. 257b; E. A. W. Budge, *The Mummy*, p. 404.
7. Cf. Bonnet, *Reallexikon*, pp. 570–1a; Schott, pp. 51–2; H. Kees, "Das Eindringen des Osiris in de Pyramidentexte," in S. A. B. Mercer, *The Pyramid Texts*, IV, pp. 123–39; J. Gwyn Griffiths, pp. 21–4.
8. The Osirian mortuary ritual, which was well established when the *Pyramid Texts* were compiled, was still being practised in the fourth century A.D., when pagan cults were forcibly suppressed in favour of Christianity.
9. *Pyr.* 167a–c: cf. Brandon, *op. cit.*, p. 20; Faulkner, I, p. 46; Piankoff, p. 64.
10. The earliest possible evidence of the cult of Osiris is a *djed* pillar amulet found in a First or Second Dynasty grave: cf. W. B. Emery, *Archaic Egypt*, pp. 122–3.
11. W. B. Emery records Second Dynasty (*c.* 3000 B.C.) evidence of "first tentative steps towards true mummification" (*op. cit.*, pp. 162 ff., plate 25a).
12. Cf. *D.C.C.*, p. 444; *E.R.E.*, V., pp. 559b–560a; *R.G.G.*, IV, 421, 891; J A. Jungmann, *The Mass of the Roman Rite*, II, pp. 206–17; Fortescue, *Ceremonies of the Roman Rite Described*, pp. 59–60, 191.
13. The custom of elevating the sacred elements seems to have originated in France in the twelfth century. Rubrics also directed the celebrant to stand with arms extended, after the Elevation, thus dramatically representing the crucified Christ. Cf. O. B. Hardison, *Christian Rite and Christian Drama in the Middle Ages*, pp. 64–5, 79; *E.R.E.*, V, pp. 560–3; Jungmann, I, pp. 119–21.
14. E.g., Egyptian depictions of sacrifice invariably show the officiant making a gesture of holding up the offering concerned to a deity. Cf. *Bilderatlas*, 2–4 Lief., Abb. 82, 85, 86, 89. Similar gestures of "offering up" are prescribed for in the Jewish sacrificial cultus; e.g., *Leviticus*, vii:34, xiii:24, xvi:14 ff.

I, Ritual, p. 17

15. See the significant parallelism drawn between the Jewish ritual of atonement and the atoning death of the Divine Christ in the *Epistle to the Hebrews*, iv:14–v:10. Cf. *R.A.C.*, VI (1966), pp. 98–106; Brandon, in *The Sacral Kingship* (1959), pp. 471–7, *Jesus and the Zealots*, pp. 281–2.

16. An interesting case in point has been provided by the excavation of Masada, where archaeology has revealed the hitherto unknown ritual practices of the Zealots: cf. Y. Yadin, *Masada*, pp. 164–7; *Tefillin from Qumran, passim.*

17. Cf. G. E. Mylonas, *Eleusis and the Eleusinian Mysteries*, pp. 261–72; J. Harrison, *Prolegomena*, pp. 567–70; R. C. Zaehner, *Hinduism*, pp. 25–6, 50 ff; G. C. Vaillant, *The Aztecs of Mexico*, pp. 192–3, 199–200.

18. Cf. J. Dölger, in *Jb.f.A.C.*, 5 (1962), 10. "Das Kreuzzeichen im Taufritual," pp. 10–22; L. Duchesne, *Christian Worship*, pp. 331, 184 ff. ("fraction of bread"); J. H. Srawley, in *Liturgy and Worship*, pp. 343–4. Hardison, pp. 64ff., *D.C.C.*, pp. 851a–b, 1255b; E. O. James, *Christian Myth and Ritual*, pp. 143–4.

19. Cf. *D.C.C.*, p. 484b; see also p. 126a; *E.R.E.*, V, p. 562a.

20. E.g., in the Roman rite: "ut omnis homo hoc sacramentum regenerationis ingressus in vera innocentia nova infantia renascatur" (cf. Duchesne, p. 312). See also the statement of the officiating priest, in the Anglican *Book of Common Prayer* (1662), after the act of baptising; "Seeing now, dearly beloved brethren, that this Child is regenerate, and grafted into the body of Christ's Church ..." See below, p. 384.

II, Art and Architecture, p. 25

1. Cf. P. J. Ucko/A. Rosenfeld, *Palaeolithic Cave Art*, pp. 116–239 (an extremely critical account of various interpretations, but finally admitting the legitimacy of that of "sympathetic magic," p. 239). See also T. G. E. Powell, *Prehistoric Art*, pp. 31–72; S. Giedion, *The Eternal Present*, pp. 60–1, 285 ff; A. Lommel, *Prehistoric and Primitive Man*, pp. 15–17; G. Clark, *The Stone Age Hunters*, pp. 74–86; J. Maringer, *The Gods of Prehistoric Man*, pp. 97–100.

2. Cf Ucko/Rosenfeld, pp. 50, 104–5, 170.

3. Cf. Ucko/Rosenfeld, pp. 40–1, 161–4, 172–4, 179–81; Giedion, pp. 50 ff., 65.

4. Cf. Giedion, pp. 437–54. Th. Mainage, *Les religions de la Préhistoire*, p. 287, cites one example found in a grave at Brunn, Moravia. Whereas these figurines are generally regarded as having a fertility significance (see pp. 48, 347.), a mortuary connection has been suggested by G. R. Levy, *The Gate of Horn*, p. 57, and J. Hawkes, *Prehistory*, p. 213.

5. Cf. H. Breuil, *Quatre cents siècles d'art pariétal*, pp. 279–81, E.T., pp. 278–81; Giedion, pp. 469–77; Leroi-Gourham, *Art of Prehistoric Man*, pp. 303–4.

6. Cf. J. Mellaart, *Earliest Civilizations of the Near East*, pp. 89–101.

7. It is significant, in this connection, that the "Venus of Laussel" holds a bison's horn (ill. 46).

8. See ill. 415 and p. 359.

9. Cf. H. Frankfort, *The Birth of Civilization in the Near East*, pp. 15 ff., *Art and Architecture of the Ancient Orient*, pp. 2 ff.; R. Hamann, *Aegyptische Kunst*, pp. 34 ff.; E. Otto, in K. Lange/M. Hirmer, *Egypt*, pp. 375 ff.; C. Aldred, *Egypt to End of Old Kingdom*, pp. 15 ff.

III, Cult Image, p. 26

1. See n. 1 in Section I. See also P. Wernert in *H.G.F.*, I, p. 93; H. Breuil/R. Lantier, *Les hommes de la Pierre Ancienne*, p. 318; J. Hawkes, pp. 203–6.

2. Cf. E. N. Fallaize, "Puppets," in *E.R.E.*, X, pp. 446–7; E. R. Dodds, *The Greeks and the Irrational*, pp. 194, 205, n. 96.

3. On the possible "black magic" significance of a picture showing the death of a bird-headed man at Lascaux (see ill. 21 and caption), cf. Brandon, *Man and His Destiny in the Great Religions*, pp. 20–1, 29–30. On the problems of this picture, cf. G. Charrière, "La scene du puits de Lascaux," *R.H.R.*, vol. 174 (1968), pp. 1–25. See Part III, p. 353.

4. "Jede Statue ist in sich ein Ersatzleib und verbürgt des Toten Bestand," Bonnet, *Reallexikon*, p. 118b, see also pp. 119–20, 699 ("Serdab"); Hamann, pp. 22–6; J. Vandier, *La religion égyptienne*, pp. 124, 133; Aldred, pp. 104–25; S. Morenz, *Aegyptische Religion*, pp. 212–13; Ranke/Hirmer, *Egypt*, plates 86, 120, 121, p. 425.

5. See ill. 24. Cf. Maringer, p. 64; Giedion, p. 291; Wernert, in *H.G.R.*, I, p. 62; Mainage, pp. 293–4, 348.

6. See ill. 25. The abbé Breuil reproduced both a drawing and a photograph of the figure in his *Quatre cents siècles d'art pariétal*, p. 166, see also pp. 176–7. The accuracy of Breuil's drawing has been questioned: e.g., by O. G. S. Crawford in *Antiquity*, XXVII (1953), p. 48, and defended convincingly by D. A. E. Garrod, *ibid.*, pp. 108–9. Cf. Ucko/Rosenfeld, pp. 136–7, 204, 206; Clark, pp. 88–9; Leroi-Gourhan, plate 57, pp. 132, 366–8.

7. E.g., J. Hawkes, pp. 163, 204–5; E. O. James, *Prehistoric Religion*, pp. 173, 175, 232; H. Kühn, *Die Felsbilder Europas*, pp. 13, 15–16; Levy, pp. 23–5.

8. Cf. Brandon, *History, Time and Deity*, pp. 15–18, 20, and below, pp. 350 ff.

9. See ill. 28, also ill. 50. On the significance of the locus of Canova's statue of Pius VI, see J. Toynbee/J. W. Perkins, *The Shrine of St. Peter*, pp. 21, 28, 225–6. Reference might also be made to the mediaeval Christian custom of depicting the donors of some religious paintings in an attitude of devotion adjacent to the heavenly company portrayed: e.g., the *"Pietà"* of Villeneuve-lès-Avignon (c. 1457), now in the Louvre, and Jan Van Eyck's *Madonna and Child with the Chancellor Rolin* (c. 1433–35) also in the Louvre (ill. 28). See also pp. 243 ff.

10. There seems to be overemphasis on the pelvic region, the breasts are invariably large and pendulous, and many figures are steatopygous: cf. Giedion, pp. 438–44; Levy, pp. 57–8; Torbrügge, *Prehistoric European Art*, pp. 16–19.

11. See ill. 1, 30, 46. Carefully delineated heads, carved from ivory, have been found at Dolní Vêstonice and Brassempouy, which attest a Palaeolithic ability to portray facial features: cf. Powell, *Prehistoric Art*, p. 9, figs. 8 and 9; Torbrügge, pp. 13–14.

12. Cf. Levy, pp. 57–8; Torbrügge, p. 17. See below, pp. 344 f.

13. Cf. A. Laming, *Lascaux*, pp. 65–6; Leroi-Gourhan, plate 72; Breuil, *Four Hundred Centuries of Cave Art*, pp. 118, 122, fig. 86, 126–7, 128, fig. 89; Ucko/Rosenfeld, pp. 95–7, p. 192, fig. 85, who rightly remarks on this and some other imaginary creatures of cave art, "there was clearly no purpose in either killing off these animals or increasing their numbers." G. Charrière (*R.H.R.*, CLXXVII, 1970, pp. 133–45) sees an element "caricaturale" rather than "mythique" in the "Unicorn," but thinks that it has a religio-social context.

14. Ill. 27; see also ill. 25.

15. Cf. Giedion, pp. 463–8, 489–512. M. Wernet (*H.G.R.*, I, p. 63, fig. on p. 65) has suggested that some headless figures painted on a rock at Minatedon in eastern Spain may represent spirits. Kühn, pp. 100–1, describes such a figure found at El Ratón as a "dämonische Gestalt."

16. But the objects of his physical environment, which he depicted, were limited

to the animal. It is to be noted that Palaeolithic art has so far furnished no representation of celestial objects or of vegetation or rocks. The earliest depictions of the sun and stars seem to date from the Mesolithic period: cf. Maringer, p. 169, fig. 49; Kühn, Taf. 70.

17. Cf. Kühn, pp. 12–23; Wernert in *H.G.R.*, I, pp. 89–97; Lommel, *Prehistoric and Primitive Man*, p. 17a. On the significance of Palaeolithic art as evidence of man's dawning concept of creativity, see Brandon, *Creation Legends of the Ancient Near East*, pp. 7–9.

18. Of particular interest in this connection are the depictions of demonic beings, which doubtless expressed deeply rooted common fears. See ill. 32, 33. Cf. Kühn, pp. 96–103.

19. Cf. Lange/Hirmer, plate 15, p. 401; Aldred, pp. 74–5.

20. Cf. W. Westendorf, *Painting, Sculpture and Architecture of Ancient Egypt*, pp. 209, 216; M. Murray, *Egyptian Sculpture*, pp. 180, 181, plate LIII.

21. Cf. W. Crooke, *E.R.E.*, VII, p. 144b; B. Rowland, *Art and Architecture of India*, p. 15; A. K. Coomaraswamy, *History of Indian and Indonesian Art*, pp. 45, 50; the theophany passage in *Bhagavadgītā* clearly shows that supreme deity in the form of Vishnu was already conceived as having innumerable arms, mouths and eyes (XI.15 ff.). The date of the *Bhagavadgītā*, as a whole or in its various parts, is much disputed by scholars, suggestions ranging from pre-Buddhist period, i.e., before the sixth century B.C., down to fourth century A.D. Cf. F. Edgerton, *The Bhagavad Gītā*, Part 2, pp. 30–3; A. A. Macdonald, *History of Sanskrit Literature*, pp. 283 ff.; J. Gonda, *Die Religionen Indiens*, I, p. 267; *D.C.R.*, pp. 136–7. Coins of Kanishka and Huvishka (second to third century A.D.) show Śiva with four arms (three heads on Huviska coins). J. Allan (*Catalogue of Coins of Ancient Indian in British Museum*, p. cxliii) dates a multi-headed deity on coins of Ujjain to the second to third century B.C. On the three-headed Śiva at Elephanta, cf. H. Zimmer, *Myths and Symbols in Indian Art and Civilization*, pp. 148–51.

22. See *Hindu Mythology* (J. Hackin, *et al.*), p. 131 (figs. 23, 24), p. 132, fig. 26, p. 141, fig. 32; Rowland, plates 105(b), 120(b), 127(a, b).

23. Ill. 38, 39. Cf. G. Henderson, *Gothic*, p. 156. For a representation of the Father and Son as two torsos stemming from one trunk, with the Spirit as a bird, see M. Rickert, *Painting in Britain: The Middle Ages*, plate 92 (from Lothian Bible, *c.* 1200). See the interesting "Trinity" of J. Bellegambe (plates 511–20) in the Musée at Douai: cf. E. Carli, J. Gudiol, G. Souchal, *Gothic Paintings*, ill. 64. An interesting variation occurs in the Retablo of the high altar of the church of the Cartuja de Miraflores, near Burgos (1469–99): the Holy Spirit is depicted as a woman.

24. Ill. 40–5. It is instructive to note that representations of Christ in the iconographic traditions of Eastern and Western Christendom, although they exhibit great variations, enshrine a unity of ethos that is never achieved in the representations, in native idiom, of Christ by Indian or Chinese Christians. Cf. *R.G.G.*, IV, Taf. 68, 702–4 ("Christliche Kunst in den jungen Kirchen"). Another interesting comparative example is provided by the presentation of ancient Egyptian religious themes in the art of Ptolemaic and Roman Egypt. Cf. *Bilderatlas*, 9–11. Lief. ("Die Religionen in der Umwelt des Urchristentums"), Abb. 6, 7, 14, 17, 24, 26–31, 38–42, 48, 57, 65–72; G. Posener, *Dictionary of Egyptian Civilization*, ill. on pp. 246, 247.

25. *Wisdom of Solomon*, xiv:1 ff.; see also *Epistle of Jeremy apud Book of Baruch*, vi:4–73. Cf. R. H. Pfeiffer, *History of New Testament Times*, pp. 317, 426–32.

26. xiv:15 (R.V.).

27. xiv:20 (R.V.). It has been suggested that the author of *Wisdom* derived this theory of the origin of idolatry from the Stoic philosopher Posidonius, in view of the comparatively mild condemnation of idolatry contained in it (the *Epistle of Jeremy* [see n. 25] is more typical of the Jewish attitude here). Cf. E. Bevan, *Holy Images*, pp. 68–70; see also pp. 63 ff.

28. What was so obvious to the author of the *Epistle of Jeremy* could not have escaped the attention of those who venerated images; e.g., "But they [images] are as one of the beams of the temple; and men say their hearts are eaten out, when things creeping out of the earth devour both them and their raiment: they feel it not when their faces are blacked through the smoke that cometh out of the temple: upon their bodies and heads alight bats, swallows, and birds; and in like manner the cats also" (*apud Baruch*, vi:20–2; R.V.).

29. See above, Section II, n. 5.

30. E. G. Giedion, pp. 449–54; Levy, pp. 64, 66; J. Hawkes, pp. 213–14, 215(9); R. Pittioni, *Die urgeschichtlichen Grundlagen der europäischen Kultur*, pp. 64, 66; J. Przyluski, *La Grande Déese*, pp. 46 ff., E. O. James, *Cult of the Mother Goddess*, pp. 20–5; Maringer, pp. 108–14. P. J. Ucko, in his recent (1968) *Anthropomorphic Figurines of Predynastic Egypt and Neolithic Crete, with Comparative Material from the Prehistoric Near East and Mainland Greece*, has given detailed reason for doubting whether many of the figures studied can be legitimately interpreted as "mother goddesses." Unfortunately, he excludes the Palaeolithic evidence from his survey. There can be little doubt, in view of evidence from Çatal Hüyük, that the Palaeolithic "Venuses" do adumbrate a Neolithic cult of the Great Goddess. See below, pp. 356–60.

31. An attempt is made to answer this question in Part III, pp. 344–8.

32. See ill. 47. Cf. Bonnet, *Reallexikon*, pp. 487, 488–90; E. A. Budge, *The Book of Opening the Mouth*, II, pp. 135–209.

33. Cf. Budge, *The Mummy*, pp. 350–1, 461, and plate XXVII; Bonnet, p. 487–8; Brandon, *Saviour God*, p. 22; Vandier, *La religion égyptienne*, pp. 113–14.

34. Cf. E. Ebeling, *Tod und Leben nach den Vorstellungen der Babylonier*, pp. 100–22. See the significant rubric: "Dieser Neumondgott . . . das Menschenwerk . . . reicht ohne Mundöffnung den Weihrauchduft nicht, isst nicht Kraut, (trinkt) nicht Wasser" (p. 100). The effective rite was that of washing the mouth of the statue with holy water ("Mundwaschung"). Note also the supposed effect of the ritual as stated in two accompanying adjurations: "Das Bild, das an einem heiligen Ort geboren ist!"; "Bild, am Himmel geboren" (p. 106). Cf. B. Meissner, *Babylonien und Assyrien*, II, pp. 237–8.

35. Cf. *E.R.E.*, VI, p. 144b; L. S. S. O'Malley, *Popular Hinduism*, pp. 25–6; H. D. Smith, *Vaisnava Iconography*, pp. 2–3.

36. Cf. *E.R.E.*, VI, pp. 144b, 160b; see also p. 113a.

37. The Christian apologist Minucius Felix says in derision of pagan image worship: "ecce ornatur, consecratur, oratur: tunc postremo deus est, cum homo illum voluit et dedicavit" (*Octavius*, xxii:5). Cf. *R.A.C.*, II, pp. 306–7; Bevan, pp. 32–4; E. R. Dodds, *The Greeks and the Irrational*, pp. 293–4.

38. Cf. *R.A.C.*, II, pp. 325–33, 334–41; *R.G.G.*³, III, pp. 164–7 ("Heiligenbilder"); A. Grabar, *Byzantium*, pp. 185–91, *Christian Iconography*, pp. 83–6; L. Bréhier,

La civilisation byzantine, pp. 266–77; E. Mâle, *L'art religieux du siècle en France*, pp. 200–4; H. H. Hofstätter, *Art of the Late Middle Ages*, pp. 9–12. Bevan, *op. cit.*, p. 95, suggests that the early Christian identification of the pagan gods with devils in polemic against idolatry opened way in turn for Christian image worship. The Second Council of Nicaea prescribed the use of incense and lights in honouring holy images: see below, p. 334.

39. Probably the earliest explanation of image worship is given in the so-called Memphite Theology (*c.* 2700 B.C.). Ptah, the god of Memphis, is there credited with creating the other Egyptian gods, their sanctuaries and cult images, "made of all kinds of wood, all kinds of mineral, all kinds of clay": cf. Brandon, *Creation Legends*, p. 42. Dio Chrysostom, Maximus of Tyre, Plotinus and Porphyry set out reasoned defences of image worship: Bevan, pp. 70–7; *R.A.C.*, II, pp. 316–18; Grabar, *Beginnings of Christian Art*, pp. 287–91.

40. According to *Deut.* (x:1 ff.), the Ark was a chest of acacia wood, containing the stone tablets of the covenant of Yahweh with Israel; but there is much reason for thinking that it constituted the throne—seat of Yahweh. It was so charged with numinous power that the unfortunate Uzzah, who touched it with the best of intentions, was struck dead by Yahweh—II *Sam.* vi:6–7. Cf. *H.D.B.*², p. 53; H. H. Rowley, *Worship in Ancient Israel*, pp. 53 ff.; *E.J.R.*, p. 41; A. Lods, *Israël*, pp. 493–8. See below, Part III, p. 398.

41. See ill. 49. Cf. Ranke/Hirmer, plate 266 and p. 527; Bonnet, *Reallexikon*, pp. 505 ("Naos"), 780–1, see also pp. 410–11 ("Kultbild").

42. See ill. 50. Cf. Ranke/Hirmer, plates 134, 153, 222–7, XLVIII, L, LI, 229 (cf. pp. 485–8), LIII, 231, 262, 265, 266.

43. See ill. 51. Cf. G. Roeder, *Ae.R.T.B.*, III, pp. 72–141; A. Moret, *Le rituel du culte divin journalier en Egypte, passim, Le Nil et la civilisation égyptienne*, pp. 452–4; A. Erman, *Die Religion der Aegypter*, pp. 173–6; Vandier, pp. 175–9, 198–9; Bonnet, *Reallexikon*, pp. 640–1; Morenz, pp. 91–3; note particularly his comment: "Uberdies wird uns dabei die Bedeutung unseres Lehnwortes 'Kultus' in ihrem schlichten Wortsinn klar: Man 'pflegt' (*colere*) das Bild des Gottes" (p. 92).

44. See ill. 52; also an Assyrian example (ill. 53). Cf. Vandier, pp. 189–94; Roeder, *Ae.R.T.B.*, III, pp. 202, 238–41, Taf. 17. Compare also the Christian example, ill. 54.

45. Cf. H. W. Fairman, *Myth, Ritual and Kingship* (ed. S. H. Hooke), pp. 86–7. On the Mammisi, cf. Bonnet, *Reallexikon*, pp. 209–10 ("Geburtshaus").

46. Cf. Erman, *Religion der Aegypter*, pp. 179–80.

47. Cf. Bevan, *Holy Images*, pp. 28–9; *E.R.E.*, VII, p. 146a.

48. Cf. See Bede, *Eccles. Hist.*, II, xiii; *Daniel* xi:8.
Cf. Meissner, II, p. 129; *E.R.E.*, VII, p. 118a.

49. Minucius Felix, *Octavius*, xxvii:1; see also St. Paul, I *Cor.* x:19–20. Cf. Bevan, pp. 90 ff. On the survival of an iconographic tradition of the pagan gods, cf. J. Seznec, *La survivance des dieux antiques*, pp. 29–34.

50. Cf. A. Harnack, *History of Dogma*, V, pp. 326–7, 327, n.1; Bevan pp. 153–4.

51. Icons of supernatural origin (*acheiropiēta*—"not made by (human) hands") were known from the sixth century. There was an apocryphal legend that Jesus had sent a handkerchief miraculously imprinted with his visage to King Abgarus of Edessa; the icon called the *mandylion* was eventually brought to Constantinople. In the monastery of the Panagia Hodigitria an icon was vener-

ated as a portrait of the Virgin Mary painted by St. Luke: cf. Bréhier, pp. 268–70; J. B. Segal, *Edessa*, pp. 72, n.6, 76 ff., 215, n.1, 250; A. Grabar, *Christian Iconography*, p. 84, see also p. 68; *R.G.G.*³, I, 1798–9, II, 1645–6. A portrait of Christ, alleged to be that received by St. Veronica on her veil, has been in Rome since the eighth century (ill. 56); cf. *D.C.C.*, p. 1414; *R.G.G.*, VI, 1365–6. The Holy Shroud at Turin, known from *c.* 1350, is supposed to bear the imprint of the body of the crucified Christ (ill. 57): cf. J. Walsh, *The Shroud*, *passim; The Times* (London), May 16, 1970, p. 11. Cf. Harnack, V, pp. 317–30; Bevan, pp. 113 ff. The celebrated "Volto Santo" crucifix in Lucca Cathedral (ill. 58) was reputed to have been made by Nicodemus: on its curious influence, cf. Mâle, *L'art religieux du xiie. siècle*, pp. 253–7.

52. St. Bonaventura's *Life of St. Francis*, chap. II. See ill. 60.

53. *Summa*, Pars iii, *Quaest* XXV, Art. 3. See ill. 59.

54. See ill. 61, 62, 63. Cf. Schug-Wille, pp. 196–7.

55. Ill. 64–6. Cf. D. Seckel, *The Art of Buddhism*, Part II, chap. iii ("The Buddha Image"); *D.C.R.*, pp. 453b–4a; M. Percheron, *Buddha and Buddhism*, pp. 176–80; Rowland, p. 94; J. Finegan, *Archeology of World Religions*, pp. 284–5; *E.R.E.*, VII, p. 120b. On the Buddhist iconography of Japan, cf. B. Frank in *R.H.R.*, CLXXVII (1970), pp. 114–17.

56. Cf. Rowland, pp. 262 ff:, plates 178–84; Finegan, pp. 304–5, fig. 124–6; C. Sivaramamurti, in *2500 Years of Buddhism* (ed. P. V. Bapat), pp. 304–5.

57. Ill. 67. Cf. Rowland, pp. 265–6; Coomaraswamy, pp. 203–5.

58. Ill. 68. Cf. Rowland, pp. 265–7; Seckel, pp. 128–32. There were originally 505 Buddha statues at Barabudur.

59. Ill. 69b. Cf. H. Maspero, "Les ivories chinois et l'iconographie populaire," in *Les religions chinoises*, I, pp. 229–39; in *Asiatic Mythology*, fig. 28, 30–3, 35, 37–8, 44, 65, 68, 69, 76, 77; H. Munsterberg, *Art of Far East*, pp. 66, 88, 101, 128, 131; D. H. Smith, *Chinese Religions*, p. 171; A. Christie, *Chinese Mythology*, pp. 26–7, 58–9, 64, 67, 92, 109, 113, 129.

60. Ill. 70, 71, 72. Cf. Harrison, *Prolegomena*, pp. 187–97; A. Ross, *Pagan Celtic Britain*, pp. 68, 99 ff., plates 36, 37.

61. Ill. 73, 74. Cf. G. Zarnecki, *Later English Romanesque Sculpture*, pp. 6–8, fig. 10, 13, 19–24, 26, 43–6, 54–5, 104; E. R. Ellis Davidson, *Scandinavian Mythology*, pp. 118, 119 (figs.), 127. See also H. Schade, *Dämonen und Monstren*, pp. 32–8.

1. Ill. 75. Cf. F. Sierksma, *The Gods As We Shape Them*, plate 54 and p. 170. Similarly problematic are the "eye-idols" of Brak: see ill. 308. Cf. M. E. L. Mallowan, *Early Mesopotamia and Iran*, pp. 44–50.

IV, Symbolism, p. 63

2. Ill. 76. See also the Rondanini *"Pietà,"* in the Castello Sforzesco, Milan, which is even more enigmatical. Cf. R. Schoot, *Michelangelo*, pp. 238–47; R. E. Wolf and R. Millen, *Renaissance and Mannerist Art*, p. 83.

3. Ill. 77. Cf. Lübke-Pernice, *Die Kunst der Griechen*, p. 199, Abb. 239: "ist Athene hier als ganz junges Mädchen in schlichter Peplostracht ohne Ägis, nur mit dem korinthischen Helm als einziges Attribut ihrer Würde, dargestellt"; G. Hafner, *Art of Crete, Mycenae and Greece*, pp. 140–1.

4. Ill. 78, 79. Cf. Lübke-Pernice, pp. 289–300; Hafner, pp. 186–7; A. de Ridder and W. Deonna, *L'art en Grèce*, pp. 111–13: "Praxitèle dénude le premier entièrement la déesse (Aphrodite de Cnide, milieu du IVe siècle) . . . Elle (Aphro-

dite dévoilée) dut en effet surprendre autant que la hardiesse de Michel-Ange, osant le premier dévêtir entièrement le Christ et la Vierge" (pp. 112–13). Cf. K. Clark, *The Nude*, pp. 64–85; V. Karageonghis, *Treasures of the Cyprus Museum*.

5. Cf. G. Van der Leeuw, *La religion*, p. 439 "*Le Symbole est une participation du sacré à sa configuration actuelle. Entre le sacré et sa figure existe une communion d'essence*"; M. Eliade, *Traité d'histoire des religions*, chap. xiii, *Images and Symbols*, pp. 12 ff.

6. Ill. 80. Cf. E. A. W. Budge, *Osiris and the Egyptian Resurrection*, I, pp. 28–61; Gwyn Griffiths, *Origins of Osiris*, pp. 53–4; E. Otto, *Egyptian Art and the Cults of Osiris and Amon*, colourplates III, IV, VII, VIII; plates 16–20; these depictions of a recumbent Osiris have a special significance in symbolising the immortality of the deity's generative powers. See ill. 185.

7. Ill. 81. Cf. Lübke-Pernice, pp. 229–31; Hafner, pp. 142–3 (who assumes, without giving reasons, that the statue represents Poseidon); J. Boardman, *Greek Art*, pp. 122, 125–6.

8. Cf. H. J. Rose, *Handbook of Greek Mythology*, pp. 48, 63.

9. Ill. 82a, b. Cf. Sierksma, plates 74, 75, and p. 177; C. A. Burland, *The Gods of Mexico*, pp. 74, 90, 137; W. Krickeberg, H. Triborn, W. Müller, O. Zerries, *Pre-Columbian Religions*, pp. 17, 48; E. G. Vaillant, *The Aztecs of Mexico*, pp. 24, 89, 176, plates 28, 61.

10. Ill. 85. Cf. C. Aldred, *Akhenaten*, plates 5, 6, 10, 46, 47, 52–4, p. 66; Brandon, *Religion in Ancient History*, pp. 133–48. On the *ankh* as symbol of life, cf. Bonnet, *Reallexikon*, pp. 418–20 ("Lebensschleife"); M. Cramer, *Das altaegyptische Lebenzeichen, passim*.

11. Ill. 86. Cf. Ranke/Hirmer, plates 104, 105, pp. 422–3.

12. Cf. Bonnet, *Reallexikon*, pp. 308b–9a, 708a–9a.

13. For the symbolism of the *djed* column, see ill. 97. Cf. Bonnet, *Reallexikon*, pp. 149–53.

14. In early Buddhist art, the Buddha was represented by symbols only, e.g., his footprints. See ill. 84.

15. Ill. 36, 37a. Cf. Zimmer, *Myths and Symbols in Indian Art and Civilization*, pp. 126, 128, 138, 148, 187, figs. 25, 29, 30, 64; Gonda, *Religionen Indiens*, I, pp. 8, 256 ff.; J. Dawson, *Classical Dictionary of Hindu Mythology*, pp. 177–9; *D.C.R.*, pp. 409–10; Rowland, pp. 29, 184, 229; *E.R.E.*, VI, pp. 700b–1a.

16. Ill. 88. Cf. Sierksma, plate 69 and p. 175; Zimmer, pp. 128–9.

17. Ill. 89. Cf. *Kleine Pauly*, IV, 1065–6; *E.R.E.*, IX, p. 819b; *Bilderatlas*, 13/14. Lief. (*Die Religion der Griechen*, by A. Rumpf), Abb. 14, 29, 30, 32, 67, 70, 196.

18. See *John* i:29, 36; I *Cor.* v:8.

19. Ill. 90. The idea of worshipping Christ under the figure of the Lamb is first attested in *Rev.* v:6–14 (see de Bourguet, *Early Christian Painting*, ill. 91). The Lamb as a symbol of Christ appears on an Italic sarcophagus of the fourth century. Grabar, *Christian Iconography*, pp. 135–6, ill. 328, see also 329. In the Catacomb of Commodilla (c. 350), Christ is shown as a "Lamb blessing loaves": cf. P. de Bourguet, *Early Christian Painting*, ill. 24. It is significant that in the Catacomb of Praetextatus a representation of Susanna as a lamb between the two Elders (wolves) is identified by the inscription of her name, *ibid.*, ill. 55. Cf. *E.R.E.*, XII, p. 136b.

20. Ill. 91. Cf. Hofstätter, p. 169.

21. Cf. F. Grossi, Gondi, *I monumenti cristiani*, pp. 51 ff. R. Eisler, *Orpheus, the*

Fisher, passim.; R.G.G., II, p. 986; Bonnet, *Reallexikon,* pp. 191–4. See also the great survey by F. J. Dölger, ΙΧΘΥΣ, 5 vols.

22. Ill. 92. Cf. Grabar, *Christian Iconography,* pp. 8, 19, 142–3, ill. 5, 255, 257–8, *Beginnings of Christian Art,* ill. 82, p. 287; Eisler, pp. 71 ff., plates XXXVII, XLVI, XLVII; *The Crucible of Christianity* (ed. A. Toynbee), pp. 271(23), 296, 339.

23. In mediaeval art, fish appear as the zodiacal sign Pisces: e.g., in sculptured symbols of the months on the façade of Amiens Cathedral and in the *Très Riches Heures du Duc de Berry* (see edition of J. Lougnon and R. Cazelles, 14, "Anatomical Man"). Cf. Seznec, pp. 61, 64, 71; E. Mâle, *The Gothic Image,* pp. 67–9. Fishes appear, with various kinds of birds, as decorative motives on the sixth-century *ambo* in SS. Giovanni e Paolo, Ravenna; cf. van der Meer/Mohrmann, *Atlas of Early Christian World,* p. 137, fig. 439.

24. Ill. 94. Cf. Mâle, *Gothic Image,* pp. 173–5; G. Henderson, *Chartres,* p. 118, ill. 53–6; A. Katzenellenbogen, *Sculptural Programs of Chartres Cathedral,* pp. 63–5.

V. Ritual Drama, p. 76

1. Cf. K. Sethe, *Dramatische Texte zu altaegyptischen Mysterienspielen,* pp. 1–5; H. Junker, *Die Götterlehre von Memphis,* pp. 3–4, 6–16; Brandon, *Creation Legends,* pp. 30 ff., plate I.

2. Cf. S. A. B. Mercer, *Religion of Ancient Egypt,* chap. V; J. Gwyn Griffiths, *The Conflict of Horus and Set, passim.*

3. See the declaration (fifteenth-century): "It came to pass that the reed and the papyrus were set at the outer portal of the House of Ptah: they signify Horus and Set, who are reconciled and united": cf. J. A. Wilson, in *A.N.E.T.,* p. 5a.

4. Cf. Brandon, *History, Time and Deity,* chap. II.

5. The Palette of Narmer (see ill. 3) probably predates the Memphite mystery play by some five centuries. A ritual mask of Anubis preserved at Hildesheim (ill. 95) would seem to indicate that the mask was modelled on depictions of Anubis. Cf. Westendorf, pp. 214–15.

6. See n.3 above. Cf. H. Frankfort, *Kingship and the Gods,* p. 27.

7. Ill. 96. Cf. Ranke/Hirmer, plates 88, 89, p. 421. There is iconographic evidence that at the coronation of a pharaoh, priests impersonating Horus and Set ritually bound together papyrus and reed (lotus) plants, being respectively symbols of Lower and Upper Egypt. Cf. Bonnet, *Reallexikon,* p. 397b, Abb. 107.

8. Cf. Brandon, *Creation Legends,* p. 42.

9. Ill. 97. The Stele of Ii-kher-nofret records the part played by this Twelfth Dynasty official in a mystery play concerning the passion of Osiris, which was periodically performed at Abydos: cf. J. A. Wilson, in *A.N.E.T.,* pp. 329–30. Cf. Bonnet, *Reallexikon,* pp. 494–6; Moret, *Mystères égyptiennes, passim;* Mercer, *op. cit.,* pp. 372–7; Budge, *Osiris and the Egyptian Resurrection,* II, pp. 1–43.

10. See Ill. 373 and pp. 363 f. below.

11. Ill. 98a, b. Cf. Otto, *Egyptian Art and the Cults of Osiris and Amon,* plate 8, p. 68; Baedeker's *Egypt* (1902), pp. 293–4; J. Capart, *Thebes,* p. 275, fig. 190; B. Porter/R. L. B. Moss, *Topographic Bibliography of Ancient Egyptian Hieroglyphic Texts, Reliefs and Paintings,* II, p. 139(36).

12. Cf. J. Yoyotte in *S.O.,* IV, p. 66; Brandon, *Judgment of the Dead,* p. 31, 304(96). If the *post-mortem* judgment was ritually enacted here, the question arises of its depiction in the walls of the chamber. Was it so recorded in order to perpetuate

the efficacy of the transaction after its completion? This question must always attend depictions of ritual actions.

13. Pp. 19–21.

14. Certain interesting questions arise, if the *post-mortem* judgment was anticipated ritually: was it enacted during the ritual of embalmment or would it have been part of the actual funerary rites? Why was it not frequently depicted on the walls of tombs as was the "Opening of the Mouth"? Were scales used in such a ritual drama; and, if they were, why have none been found in tombs or elsewhere? Against the seemingly negative implication of these questions, it should be noted that there is a *Coffin Text* (*C.T.*, IV, Spell 335) in which the fateful scales are hypostatised as an awful demonic being—they seem to be so vividly conceived as to suggest that they had been actually seen: cf. Brandon, *Judgment of the Dead*, p. 23. See *Guide to Egyptian Collections in British Museum* (1909) ill. on p. 141.

15. See below, on the Sacred Dance (pp. 326–32).

16. Ill. 36. Cf. Zimmer, pp. 151–5; A. L. Basham, *The Wonder That Was India*, pp. 308, 375–6, plate LXVI; Rowland, pp. 197–8, plate 128; Coomaraswamy, pp. 126–7.

17. Cf. A. Gaur, in *S.O.*, VI, pp. 318–19.

18. Ill. 99, 100. Cf. Rowland, plates 2, 3, 4(a), 14, 17, 22, 23, 48. Coomaraswamy, pp. 64–5.

19. Cf. Basham, p. 385; Gaur, "Les danses sacrées en Inde," in *S.O.*, VI, pp. 315–42. See below, p. 327.

20. Ill. 101. Cf. M. Wheeler, *Civilization of Indus Valley and Beyond*, ill. 43, 47–51; E. Mackay, *Early Indus Civilizations*, plates XVI, XVII(8,9).

21. Cf. Rowland, plates 18, 31, 34, 37, 77(a), 78(b), 88(a); Coomaraswamy, figs. 16, 24, 27, 79, 80.

22. See pp. 26–76, 326–32.

23. Cf. Harnack, IV, pp. 272, 276–303; V, pp. 308–23; VI, pp. 46–54, 232–43; VI, pp. 47–50; F. Heer, *Aufgang Europas*, pp. 122–5; C. Dawson, *Religion and the Rise of Western Culture*, pp. 41–3; G. G. Coulton, *Five Centuries of Religion*, I, chaps. VII and VIII; *R.G.G.*, IV, 404–7, 412–15; N. Zernov, *Eastern Christendom*, pp. 239–47; *E.R.E.*, V, pp. 540–63 (J. H. Srawley); E. I. Watkin, *Catholic Art and Culture*, pp. 59–61; B. J. Kidd, *The Later Medieval Doctrine of the Eucharistic Sacrifice, passim*; E. O. James, *Christian Myth and Ritual*, chap. V.

24. Narsi, *Homily* XVII(A), trans. R. H. Connelly, *Liturgical Homilies of Narsi*, vol. VIII (*T.S.B.P.L.*), pp. 3–4. Cf. O. B. Hardison, *Christian Rite and Drama in the Middle Ages*, pp. 36, 39–40, 64.

25. See ill. 102. Cf. Hardison, pp. 35–6, 39, 79; P. Lacroix, *Military and Religious Life in the Middle Ages*, p. 210, fig. 176 (miniature from fifteenth-century missal).

26. Ill. 103. Crucifixes representing a suffering Christ appeared in Western mediaeval churches from about the ninth to the tenth century. The setting of the crucifix above the altar dates from the fifteenth century: cf. *D.C.C.*, p. 358; *R.G.G.*, IV, pp. 47–9. For examples of realistic crucifixes, see F. Souchal, *Art of Early Middle Ages*, pp. 224, 244; Hofstätter, *Art of Late Middle Ages*, pp. 106, 107; see also the *Vesperbild* on p. 105; cf. G. Henderson, *Gothic*, pp. 159 ff.; *R.G.G.*, I, pp. 363–5 ("Andachtsbild"). Painted representations of the Crucifixion as altarpieces and *pietàs* abounded in mediaeval churches. Cf. M. D. Anderson, *The Imagery of British Churches*, pp. 44–6, 126; G. H. Cook, *English Medieval*

Parish Church, pp. 150–61, 172, plates 68, 70. Interesting depictions of the furnishings of altars in the *Très Riches Heures*, 80 and 120. A significant depiction that relates the soteriological efficacy of the Crucifixion to the event itself is to be seen in the altarpiece of Amelsbüren (now in the Landersmuseum Münster, Westphalia), by Johann Koerbecke (*fl.* 1446–91). The Harrowing of Hell is set in a meaningful juxtaposition to the Crucifixion: cf. Hofstätter, pp. 186–7. See ill. 61.

27. Cf. Duchesne, *Christian Worship*, pp. 503–14.

28. Ill. 104. Cf. Hardison, pp. 112 ff.

29. Ill. 105. Cf. Hardison, pp. 122–6; J. Evans, *English Art, 1307–1461*, pp. 169 ff.

30. Cf. Hardison, pp. 127–8; Anderson, pp. 48–9.

31. Ill. 106. Cf. Fortescue, pp. 322–5 (for modern practice). The ceremony seems to have originated in Jerusalem and is described in the *Peregrinatio Etheriae* (*Silviae*) : see text in Duchesne, p. 510; cf. C. Kopp, *Holy Places of the Gospels*, p. 385. Cf. Hardison, pp. 130–4. See generally *The Liturgy of Maundy Thursday, Good Friday and the Easter Vigil*, ed. T. W. Burke.

32. Cf. Hardison, pp. 178 ff., 220 ff.; L. Réau and G. Cohen, *L'art du moyen âge*, pp. 417–18.

33. Cf. Hardison, pp. 192–4; M. D. Anderson, *Drama and Imagery in English Medieval Churches*, pp. 26–9.

34. Cf. Anderson, *Drama and Imagery*, pp. 115–77; Mâle, *Religious Art*, pp. 106–12.

35. See *The Harrowing of Hell* in the Chester drama cycle: A. C. Cawley (ed.), *Everyman and Medieval Miracle Plays*, pp. 157–69.

36. See ill. 107. Cf. Anderson, *Drama and Imagery*, pp. 128, 129; Mâle, *L'art religieux du xIIe. siècle en France*, chap. IV.

37. Cf. Anderson, *Drama and Imagery*, pp. 125 (fig. 7.), 139 (fig. 10). An interesting depiction of the martyrdom of St. Apollonia as a scene from a mystery play occurs in *Les Heures d'Etienne Chevalier* by J. Fouquet (*c.* 1452–60), see ill. 108; cf. Höfstatter, p. 152.

38. The libretto accompanying ancient Egyptian ritual action is invariably of an incantational or declaratory kind. Thus, most utterances in the *Pyramid Texts* begin with *dd*, that is, "recite."

1. Cf. Breuil, *Four Hundred Centuries of Cave Art*, pp. 167, fig. 116, 279 ff.; Giedion, pp. 525 ff. **VI, The Sanctuary, p. 89**

2. Cf. *D.C.R.*, p. 179a. In ancient Rome and Etruria a ritual pit, known as a *mundus*, was regarded as an entrance to the nether world: cf. Grenier, *Les religions étrusque et romaine*, pp. 31–2.

3. Ill. 109a, b. Cf. Ranke/Hirmer, pp. 503–7, plates 248–50.

4. Ill. 37a. Cf. Rowland, p. 188, plate 120(a) ; Coomaraswamy, p. 100, fig. 194, 195.

5. Ill. 110a. Cf. A. Stein, *On Ancient Central-Asian Tracks*, chap. XII; Finegan, *Archeology of World Religions*, pp. 308 ff.; R. Grousset, *In the Footsteps of the Buddha*, pp. 239–41, 335–7; Seckel, pp. 69–73. According to Seckel, p. 136, the *caitya* cave sanctuary is "an expression in monumental form of the primitive hermit's cave."

6. Cf. Brandon, *Creation Legends*, p. 110: in most creation texts, it is the service of the temples with which mankind is especially concerned; the origin of certain great temples is sometimes ascribed to the gods themselves. However, the Sumerian king Gudea (*c.* 2100 B.C.) and the Neo-Babylonian Nabu-na'id have both left accounts of how they received divine commands in dreams to build temples for specific gods: cf. Saggs, *Greatness That Was Babylon*, p. 364.

7. Ill. 413. Cf. Mellaart, *Earliest Civilizations of the Near East*, pp. 41–2, fig. 19, 20, 89 ff., fig. 62, 80, 84, 86.

8. Ill. 17a, b, 18. Cf. Mellaart, pp. 93–7.

9. The Egyptian temple was called *ḥ.t nṯr* or "house of the god" (Erman/Grapow, *Wörterbuch*, III, p. 4). Cf. Bonnet, *Reallexikon*, pp. 778 ff. The Sumerian word *É* and the Akkadian *Bîtu*, both meaning "House," signified the temple: *bît-ili* (Akkadian) = "house of the god." Cf. Dhorme, *Religions de Babylonie et d'Assyrie*, pp. 174–5; Meissner, II, pp. 5–7, 72 ff.; M. Jastrow, *Aspects of Religious Beliefs and Practice in Babylonia and Assyria*, pp. 265–73; Mallowan, pp. 36 ff.

10. Pp. 45–63.

11. Cf. Brandon, *Creation Legends*, pp. 18 ff.; E. A. E. Reymond, *The Mythical Origin of the Egyptian Temple*, pp. 43–52, 273 ff.

12. Ill. 110b. Cf. Brandon, *Creation Legends*, pp. 72–3.

13. Cf. Tab. VI. 22, 59–62: in *A.N.E.T.*, pp. 68b–9a. Cf. Brandon, *Creation Legends*, pp. 91 ff.

14. Ill. 111. Cf. Bonnet, *Reallexikon*, p. 100 ("Benben"), pp. 543–5 ("On"); pp. 735–8 ("Sonnenheiligtum"); Aldred, *Egypt to End of Old Kingdom*, pp. 97–9, *Akhenaten*, pp. 237–8, ill. 104–5, 111–13; Ranke/Hirmer, pp. 450–3; Vandier, pp. 165–7, 197.

15. Ill. 112; see also ill. 49. Cf. Bonnet, *Reallexikon*, pp. 782–8; Ranke/Hirmer, pp. 432–4, 446–7, 484–96, 502–7, 525–34, and related plates; Vandier, pp. 167–9.

16. Ill. 113. Cf. Bonnet, *Reallexikon*, p. 787a: "So weitet sich der Temple zu einem Abbild der Welt"; Reymond, p. 285; Ranke/Hirmer, plates 138, 223, 238.

17. Cf. Bonnet, *Reallexikon*, p. 787.

18. Ill. 114. Cf. Erman, *Die Religion*, p. 169, Abb. 68; Bonnet, *Reallexikon*, p. 747.

19. H. W. Fairman describes the effect of the dedication of a temple, when it was "handed over to its lord," according to the rites used at Edfu: "The result of this final act (the 'opening of the mouths' of all images and depictions of the gods) was that not only the statues, but the entire temple, its reliefs and its furnishing became alive and active." ("Worship and Festivals in an Egyptian Temple," in *B.J.R.L.*, 37, 1954, p. 173). The dedication ceremony was repeated annually, "so that year by year the temple was re-consecrated and its life renewed." Cf. Reymond, chap. 15 ("The Bringing to Life of the Temple"). See also J. A. Wilson, *The Intellectual Adventure of Ancient Man* (ed. H. and H. A. Frankfort), pp. 21–2; Morenz, *Aegyptische Religion*, pp. 92–3, 110; Frankfort, *Kingship and the Gods*, pp. 267–74 (for a comparison of Egyptian and Mesopotamian ideas in this connection).

20. Ill. 115. Cf. H. D. Smith, pp. 228 ff.; Rowland, pp. 166 ff., 174, plates 52a, 102–4, 106, 123–4; Coomaraswamy, p. 83 (who gives a more practical interpretation); Basham, plates XIX–XX; J. Auboyer, *The Oriental World*, pp. 51, 54, 58, 62, 66–7.

21. Cf. Rowland, p. 167; S. Kramrisch, *The Hindu Temple*, I, pp. 14–17, 29–39.

22. Ill. 116. Cf. Rowland, p. 174, see also pp. 96, 172; Basham, pp. 362, 369, plate LV; Auboyer, p. 67. Coomaraswamy, pp. 64–5, stresses the fertility motif. On the position of images generally, cf. Kramrisch, II, pp. 299–305.

23. Ill. 117. Cf. Rowland, p. 171, plate 104b; Basham, p. 361, plate XXIa; Coomaraswamy, p. 116, fig. 217; Munsterberg, *Art of India and Southeast Asia*, p. 108.

24. Cf. Rowland, pp. 164, 165. See also Coomaraswamy, pp. 125-6.
25. Ill. 118. Cf. *D.C.R.*, pp. 591-2 ("Stupa"); Rowland, pp. 51 ff.; S. Dutt, *Buddhist Monks and Monasteries in India*, pp. 182-8; T. N. Ramachandran, in *2500 Years of Buddhism*, pp. 277-82.
26. Ill. 119. Cf. Rowland, pp. 52-8, 62 ff., plates 20-1, 25-7; Dutt, pp. 221-3; Auboyer, pp. 16-19; Seckel, pp. 103-32.
27. Cf. *E.R.E.*, I, p. 735b; Th. von Scheffer, *Die Kultur der Griechen*, pp. 122, 126-7; Lübke-Pernice, p. 63; de Ridder/Deonna, p. 329.
28. Ill. 120. "Les peintures et les reliefs racontent les aventures divines et hévoïques, perpétuent les actes de culte, les scènes d'offrande," de Ridder/Deonna, p. 65.
29. Ill. 121a, b. Cf. Lübke-Pernice, pp. 232-44; K. Woermann, *Geschichte der Kunst*, I, pp. 313-17, Taf. 46; Hafner, pp. 153, 155; Bevan, p. 73.
30. Ill. 122. Cf. G. E. Mylonas, *Eleusis and the Eleusinian Mysteries*, pp. 104, 106, n.2 139 ff.
31. Cf. Mylonas, p. 148. *Hymn to Demeter*, lines 99, 270-2.
32. Ill. 123. "The importance of the cult depended upon the fact that the initiates found themselves in the same spot visited by the Goddess and could see the sacred landmarks sanctified by her sojourn," Mylonas, p. 106, n.2; see also p. 200.
33. Ill. 124. Cf. Mylonas, pp. 113 ff.
34. *Hymn to Demeter*, 480-2. Cf. N. Turchi, *Fontes Historiae Mysteriorum Aevi Hellenistici*, pp. 97-9.
35. Cf. Mylonas, chap. IX; Harrison, *Prolegomena*, pp. 567-71; V. Magnien, *Les mystères d'Eleusis*, pp. 176 ff.; *Kleine Pauly*, II, pp. 243-5; *R.A.C.*, IV, pp. 1100-5.
36. Cf. Mylonas, pp. 82-85.
37. Ill. 124. Cf. *Kleine Pauly*, I, pp. 1450-5; W. K. C. Guthrie, *The Greeks and Their Gods*, pp. 183 ff.; G. Tarsouli, *Delphi, passim*; Rossiter, pp. 374, 376-7, 381.
38. Ill. 125. Cf. *R.A.C.*, V, pp. 531-9; Rossiter, pp. 241-5.
39. Ill. 126. Cf. A. Maiuri, *The Phlegraean Fields*, pp. 110-19.
40. Ill. 127. Cf. *O.C.D.*, pp. 943-4; W. Warde Fowler, *Religious Experience of Roman People*, pp. 136-7; H. J. Rose, *Ancient Roman Religion*, pp. 53-5.
41. Ill. 128. Cf. M. Wheeler, *Roman Art and Architecture*, pp. 104-5; L. Curtis and A. Nawrath, *Das Antike Rom*, pp. 56-7, Abb. 146-50.
42. Ill. 129. Cf. L. A. Campbell, *Mithraic Iconography and Ideology*, pp. 6-10, 49-50; M. J. Vermaseren, *Mithras*, pp. 37 ff.
43. Cited by Porphyoius, *de antro nymph.* 5-6, in Turchi, p. 289.
44. Ill. 130, Cf. Campbell, pp. 35, 211(h), 348-54, 385-6 (see related plates); Brandon, *Man and His Destiny*, pp. 290 ff., *History Time and Deity* (see under index and pl. IV); Vermaseren, *Corpus Inscript et Monument. Relig. Mithriacae*, figs. 29a, b, 35, 36, 89, 90, 109, 125, 144, 152, 153, 156-7, 188, 197, 210-11, 227, 230.
45. Ill. 129. Cf. Campbell, pp. 2 ff., 7, 247 ff. Vermaseren, *Mithras*, pp. 67-70, 81; F. Cumont, *Mysteries of Mithra*, pp. 21 ff.
46. Ill. 131. II *Sam.* vii:2 ff. I *Kings*, v:2 ff., vi:19 ff., viii:1-11; I *Chron.* xvii:1 ff., xxii:1 ff., xxviii; II *Chron.* ii:1 ff. See Josephus, *Ant.*, viii:71-5.
47. *Exodus* xxv:8 ff. *Cf. H.D.R.*, pp. 53, 948-51; *E.J.R.*, p. 41; H. H. Rowley, *Worship in Ancient Israel*, pp. 53 ff.
48. II *Sam.* vi:1 ff.

49. I *Kings* viii:10, 13, 15 ff.; I. *Chron.* xxi:28–xxii:2. Cf. Rowley, pp. 76–7.

50. Cf. *H.D.B.*, pp. 961 ff.; *E.J.R.*, pp. 378–9; A. Parrot, *The Temple of Jerusalem, passim.* See Josephus, *Jew. War*, V: lines 184–247, for an account of the Herodian temple.

51. Ill. 132b. Cf. F. J. Hollis in *Myth and Ritual* (ed. S. H. Hooke), pp. 91 ff.

52. I *Kings* vi:19–29. On the origin and nature of the cherubim, cf. *H.D.B.*, p. 133; *R.A.C.*, I, pp. 62–3, 78–9, 92(c), 172 ff. Josephus cautiously comments: "As for the cherubim themselves, no one can say or imagine what they looked like" (*Ant.* VIII:73). The presence of such images in Solomon's temple constituted a serious problem in view of the Torah prohibition of images. Cf. Parrot, pp. 33–9.

53. *Exodus* xxviii:29, 35. Josephus (*Jew. War*, V: 219) describes the "holy of holies" as "unapproachable" (*abaton*), "inviolable" (*achranton*), and "invisible to all" (*atheaton pasin*). Cf. Pedersen, III–IV, pp. 243–50. On the cosmic significance of the tabernacle in rabbinic thought, cf. R. Patai, *Man and Temple*, p. 108.

54. Ill. 133. Cf. *H.D.B.*, pp. 950, 963, 964, 966. Cf. Rowley, *op. cit.*, pp. 84–6. On the Menorah, cf. *E.J.R.*, p. 258; J. Leveen, *The Hebrew Bible in Art*, pp. 14 ff.

55. According to *Numbers* xxi:4–9, Moses had been commanded by God to make a bronze serpent as a cure for snake-bite. II *Kings* xviii:4 records the destruction of this serpent image, called Nehushtan, by Hezekiah. Cf. *H.D.B.*, p. 898; Pedersen, III–IV, p. 251. Rowley (p. 87) thinks that it was a Jebusite sacred symbol, which was transferred to the temple from an earlier Jebusite sanctuary.

56. I *Kings* vii:21–2; see Josephus *Ant.* VIII:77–8. Cf. Pedersen, III–IV, pp. 243, 688; Rowley, pp. 81–2.

57. I *Kings* vii:23–6; II *Chron.* iv:2–5. Cf. *H.D.B.*, p. 963; Lods, *Israël*, p. 481; Patai, *Man and Temple*, pp. 110–11; Rowley, pp. 82–3; Parrot, pp. 45–7.

58. This important object, so essential for the sacrificial cultus, is not mentioned in the account of the furnishing of Solomon's temple in I *Kings* vii. However, reference is made to it in I *Kings* viii:64; cf. II *Chron.* iv:1. Cf. Rowley, p. 86; *H.D.B.*, p. 963.

59. I *Kings* viii:13. Cf. Th. A. Busink, *Der Temple von Jerusalem von Salombo bis Herodes*, I, pp. 637–42; Parrot, pp. 52–6.

60. Solomon is represented as acknowledging thus in his Prayer of Dedication: I *Kings* viii:27.

61. *Jew. War*, VI: 299. Tacitus, *Hist.*, V: 13, also records this prodigy.

62. It is significant that Jesus of Nazareth is represented as saying: "He who swears by the temple, swears by it and by him who dwells in it" (*Matt.* xxiii:21).

63. Cf. E. Schürer, *Geschichte des jüdischen Volkes im Zeitalter Jesu Christi*, II, pp. 232 ff., 279–305; J. Jeremias, *Jerusalem zur Zeit Jesu*, II, Teil, pp. 3–40; Rowley, *op. cit.*, chap. 3.

64. On these vestments, see below pp. 314–18.

65. Cf. M. Granet, *La pensée chinoise*, pp. 118, n.5, 387; M. Danielli in *Folk-Lore*, LXIII (1952), pp. 204–26, J. Needham, *Science and Civilization in China*, II, pp. 359–63; *D.C.R.*, pp. 282–3.

66. Cf. *D.C.R.*, pp. 346–7; W. Willetts, *Chinese Art*, I, pp. 313 ff.; W. Watson, *China Before the Han Dynasty*, p. 184; *E.R.E.*, VII, pp. 130–1, see also I, pp. 694–6.

67. Ill. 134.

68. Cf. D. H. Smith, *Chinese Religions*, pp. 142–4, see also in *Numen*, IV, pp. 200–3; Willetts, II, p. 677; R. Goepper, with J. Auboyer, *The Oriental World*, pp. 108–9.

69. Cf. *E.I.*, III, pp. 315–89; M. S. Briggs in *The Legacy of Islam*, pp. 158–67; Finegan, pp. 508–11; *D.C.R.*, p. 452.

70. Ill. 135. Cf. *D.C.R.*, pp. 521–2; E. J. Grube, *The World of Islam*, p. 39 (plan of mosque of Ibn Tulun, Cairo); A. H. Christie in *Legacy of Islam*, p. 109: "Islamic art had its beginnings in the mosque."

71. Ill. 136. Cf. *E.I.*, II, pp. 584–92; Gaudefroy-Demonbynes, *Mahomet*, pp. 478–83; *D.C.R.*, p. 388.

72. Cf. M. Hamidullah, "Le pèlerenage à la Mecque," *S.O.*, III, pp. 103, 106, 108–10, 112, 115, 120; *E.I.*, III, pp. 31–8; *D.C.R.*, pp. 502–3.

73. Ill. 137. Cf. Briggs in *Legacy of Islam*, pp. 162–3. The number of minarets signified the prestige of the mosque concerned: the Great Mosque at Mecca acquired seven.

74. See ill. 138, 139. Cf. Finegan, *Archeology of World Religions*, pp. 511–13; M. Join-Lambert, *Jerusalem*, pp. 116, 170–2, ill. 85–6, 89; C. Kessler, *J.R.A.S.*, 1970, pp. 2–14, who suggests (p. 11, n. 20) that 'Abd al-Malik probably thought the Rock was the site of Solomon's temple, and that the interior inscription has a propaganda significance.

75. Ill. 140, 141. Cf. S. Marinatos, *Crete and Mycenae*, pp. 40, 151–2, plates XXVII–XXX; C. Picard, *Les religions prehélléniques*, pp. 191–2.

76. Since the Lydian word for the double axe was *labrys*, some scholars would connect the double axe with the traditional weapon of Zeus of Labraunda and with the Labyrinth of Knossos. Zeus of Labraunda was a Hellenised form of the Hittite weather-god Teshub, who is represented as wielding a double axe, probably as a symbol of thunder. In Crete, however, the double axe was associated with the Great Goddess. Cf. C. Picard, *Les religions prehélléniques*, pp. 199–201; R. W. Hutchinson, *Prehistoric Crete*, pp. 224–5; *Kleine Pauly*, III, pp. 431–2; J. Hawkes, *Dawn of the Gods*, pp. 50, ill.(h), 131–2, plate 15; *D.C.R.*, pp. 122–3.

77. Cf. Marinatos, pp. 36, 152, plates 128–9; Hawkes, pp. 138–40; Picard, pp. 112–13; Hutchinson, pp. 210–11.

78. Cf. Marinatos, plates 42, 47, 127, 128–9, 136–7; Hawkes, ill. on pp. 46, 89, 126, 140.

79. "Archaeological evidence suggests that the Cretans felt themselves close to their deities under the open skies, in a sacred wood, on a mountain top, and especially in caves," Marinatos, p. 34; Picard, pp. 103–4; Hutchinson, pp. 218 ff.

80. Ill. 142. For Cretan and Mycenaean examples, see Marinatos, plates 111, 206–7, pp. 148–9, 172–3; Hutchinson, pp. 206–7; Hafner, p. 43.

81. Ill. 143. Marinatos produces a number of photographs of female statues which he designates idols (pl. 11, 128, 131, 135–7). The evidence of location, which he cites on p. 37, certainly suggests that these figures, even the "Orans" type, represented the Minoan Mother Goddess. He notes that the divine identity of the celebrated faïence snake-goddess of Knossos has been questioned, but he seems prepared to accept it as such: p. 38, plate XXXIV, 70. Hutchinson (p. 208, plate 9) gives the same identification, as does Jacquetta Hawkes, for this figurine and all the other images concerned. A cult image has recently been found *in situ* at Mycenae: cf. Lord William Taylor: "New Light on Mycenaean Religion," in *Antiquity*, XLIV (1970), pp. 270–80 and plates.

82. Cf. Macalister, "La religion de l'époque mégalithique," in *H.G.R.*, I, pp. 99–105; J. Hawkes, *Prehistory*, I, pp. 248 ff.; G. Sieveking, "The Migration of the Megaliths," in *Vanished Civilisations* (ed. E. Bacon); J. D. Evans, *Malta*, pp. 84 ff.

83. *Genesis* xxviii:17–19.

84. Cf. Lods, *Israël*, pp. 142, 176–7; G. von Rad, *Genesis*, pp. 280–1.

85. Ill. 145. Cf. J. Gray, *The Canaanites*, ill. 25, 26, p. 230; K. M. Kenyon, *Amorites and Canaanites*, p. 50.

86. Ill. 146. Cf. R. J. C. Atkinson, *Stonehenge*, pp. 58 ff.

87. Cf. Atkinson, pp. 34–41, 98 ff.

88. Cf. Atkinson, pp. 166 ff. Atkinson thinks that the carvings of axes and daggers on some of the stones might be "conventional representations of a cult-figure, possibly a mother goddess," pp. 32, 177–8.

89. Cf. Atkinson, pp. 163–5, "Silbury Hill," *Antiquity*, XLI (1967); J. Hawkes, "God in the Machine," *Antiquity*, XLI (discussion of recent astronomical theory concerning purpose of Stonehenge).

90. Cf. Atkinson, *Stonehenge*, pp. 77–8, 92, 179. See ill. 144.

91. Ill. 147. Cf. G. C. Vaillant, *The Aztecs of Mexico*, pp. 157 ff., plates 37, 50–1, 60, 61, 227; G. H. S. Bushnell, *The First Americans*, ill. 26, 30, 37–9, 41, 43, 53–5, 66, 72, 73.

92. Cf. Bushnell, ill. 70.

93. Cf. J. Soustelle, *Daily Life of the Aztecs*, p. 28.

94. Ill. 148. Cf. *R.A.C.*, IV, 358–70; M. Gouch, *The Early Christians*, pp. 59–61; A. Grabar, *Beginnings of Christian Art*, pp. 59–62, *Christian Iconography*, pp. 21–4.

95. Cf. *R.A.C.*, I, 1249–59. "In christl. Zeit ist das Wort (Basilika) nicht mehr auf einem bestimmten Gebäudetypus beschränkt" (1249). On pre-Christian "Kultbasiliken," see *ibid.*, 1247–9. See also Grabar, *Beginnings of Christian Art*, pp. 63–5, 160–84.

96. Ill. 149a, b. Cf. *R.A.C.*, 336–43; Gough, pp. 65–71, 138, 140–3.

97. Cf. *R.A.C.*, I, 343–7; van der Meer, *Early Christian Art*, pp. 70–5; J. Lassus, *Early Christian and Byzantine World*, pp. 41–2; J. Toynbee and J. W. Perkins, *The Shrine of St. Peter*, pp. 213–16. Of particular value for showing the growth of fourth-century basilica, see the excavations at Bône in Algeria, on the site of ancient Hippo Regius, the see-city of the famous Augustine: E. Marec, *Monuments chrétiens d'Hippone*, pp. 23 ff. The vision of the souls of the martyrs beneath the heavenly altar in 1 *Rev.* vi:9 must have been very influential. Cf. Charles, *Revelation of St. John*, I, pp. 172–4.

98. Ill. 150. Cf. *R.A.C.*, I, 348–9; F. van der Meer/C. Mohrmann, pp. 128–31; Grabar, *Byzantium*, fig. 8, 19, 24, 26–8. See Part III, p. 383.

99. On the significance of baptism, see below, pp. 383 f.

100. The personification of the Church as the Bride of Christ already occurs in the New Testament (*Ep. to Ephesians* v:23ff.); the Church is vividly personified in feminine form in the second-century *Shepherd of Hermas* (e.g., Vision 2, iv). The idea of Mother Church soon found iconographic expression: cf. Van der Meer/ Mohrmann, p. 139 (see particularly ill. 453 of a tomb mosaic [c. 400] depicting a basilica inscribed *Ecclesia Mater*).

101. Ill. 152. Cf. Grabar, *Byzantium*, fig. 145, p. 135; see also the apse mosaic of SS. Cosma e Damiano, Rome, *ibid.*, p. 136, fig. 146; Van der Meer/Mohrmann, p. 151, fig. 496; Lassus, p. 39, ill. 22.

102. Ill. 62, 153. Cf. Grabar, *Byzantium*, fig. 147, 150; Van der Meer/Mohrmann, p. 149, ill. 491; Gough, pp. 190-1. Grabar, *Christian Iconography*, p. 43, comments: "The scene is obviously inspired by court ceremonial, and the costume attributed to the martyr saints confirms this."

103. Ill. 154a, b. Cf. Grabar, *Byzantium*, p. 157, fig. 170-73; and Gough, pp. 192-3, who suggests that the scene may commemorate the participation of Justinian and Theodora in the actual consecration ceremony of S. Vitale in 547.

104. Ill. 155. Cf. Bovini, *Sant' Apollinare Nuovo*, pp. 24, 26, plates 7, 59-63; Van der Meer/Mohrmann, p. 153, ill. 508; Lassus, ill. 32.

105. Ill. 156. Cf. Bovini, pp. 28-9, plates 3-6, 49-55; Van der Meer/Mohrmann, p. 153, ill. 501; Lassus, ill. 31.

106. Ill. 157. Cf. Bovini, pp. 14-22, plates 4-7, 9-43; Lassus, ill. 31-6; E. Hutton, *Ravenna*, pp. 211-15.

107. Cf. Grabar, *Christian Iconography*, p. 100, who seems to suggest that these Gospel scenes "served prophylactic ends"; see also *ibid.*, pp. 18, 21.

108. See ill. 128, and p. 103. Cf. Grabar, *Byzantium*, pp. 11 ff.

109. Ill. 158a, b. Cf. Grabar, *Byzantium*, pp. 86-98, fig. 1, 91-103; M. Maclagen, *The City of Constantinople*, pp. 52-62, 97-100.

110. Cf. Grabar, ill. 102. For the view of an Orthodox Christian on the significance of the domed space, see N. Zernov, *Eastern Christendom*, p. 279: "This liturgy is conceived as a corporate action, and the building itself is an image of the cosmos. The cupola represents the heavenly vault."

111. Ill. 159. Cf. Grabar, fig. 123, *Christian Iconography*, ill. 175, Lassus, ill. 41; D. Talbot Rice, *Byzantine Art*, ill. 134.

112. Ill. 160. L. Bréhier, *La civilisation byzantine*, pp. 235-7; Talbot Rice, pp. 116-7.

113. See above, pp. 106-11.

114. Cf. *R.G.G.*, I, 1276-7, "Bilderwand"; *D.C.C.*, p. 676; Zernov, ill. 59.

115. Ill. 161; see also J. Harvey, *The Gothic World*, ill. 13, 43-53, 62-4, 138-9, 167-70, 174-8. This layout continued the basilica tradition. Even where the *coro* and chancel screens were used, as in Spanish and English cathedrals and parish churches, the purpose was not to cut off the altar from the laity as did the *iconostasis*, but to emphasize the chancel by separating it from the nave. The gradual proliferation of side altars did not change the focal position or status of the high altar, but reflected the multiplication of Masses. Cf. *R.G.G.*, I, pp. 259-61 (on the increased emphasis on the altar in modern Catholicism, see *ibid.*, pp. 262-3); H. Focillon, *The Art of the West*, I (Romanesque Art), 7; F. Souchal, *Art of Early Middle Ages*, p. 9-10 (who also stresses the aspect of the Romanesque church as a fortress of God against encompassing demonic powers); A. Rodriguez/L.-M. de Lojendio, *Castille Romane*, I, (*passim*); F. Heer, *The Medieval World*, p. 316-18, who deals, too, with the Romanesque church as a divine fortress, as does A. Hauser, *Social History of Art*, I, pp. 166-8, 171: O. von Simson, *The Gothic Cathedral*, pp. 8 ff. ("The church is, mystically and liturgically, an image of heaven"); P. Meyer/M. Hürlemann, *English Cathedrals*, pp. 10-11; A. H. Thompson, *Cathedral Churches of England*, pp. 98-101, 107-9, 202 ff.; G. H. Cook, *The English Medieval Parish Church*, pp. 163-5, also pp. 151 ff.; E. I. Watt, *Catholic Art and Culture*, pp. 70-3.

116. Cf. von Simson, pp. 54-5 on the "metaphysics of light." See ill. 16, 102. Cf. M. Aubert, *High Gothic Art*, pp. 25-6.

117. Ill. 162a, b. Cf. von Simson, pp. 8-11, 37-9. "In its imagery, the High Gothic cathedral sought to embody the whole of Christian knowledge, theological, natural,

and historical, with everything in its place and that which no longer found its place, suppressed." E. Panofsky, *Gothic Architecture and Scholasticism*, pp. 44–5; Hofstätter, pp. 8–9. See also Otto (*Idea of the Holy*, p. 70), on the "numinous" aspect of the Gothic cathedral.

118. See *The Flowering of the Middle Ages* (ed. J. Evans), p. 82 and accompanying illustration from a thirteenth-century French illuminated Bible; see ill. 163.

119. See ill. 164. The mediaeval cathedral did, indeed, tower over its city, as the Cathedral still does over Chartres.

120. Cf. Harnack, VI, p. 241, see also VII, pp. 47–8.

121. Ill. 165. Cf. Lacroix, pp. 230, ill. 192, 193, 195; Coulton, *Five Centuries of Religion*, I, chap. VII, pp. 481–7, 491–9; MacCulloch, *Medieval Faith and Fable*, chap. X; J. Trachtenberg, *The Devil and the Jews*, pp. 109–23 ("Host and Image Desecration").

122. Cf. Duchesne, *Christian Worship*, pp. 405–12; R. W. Muncey, *History of Consecration of Churches and Churchyards*, chaps. I–IV. See also W. K. Lowther Clarke, in *Liturgy and Worship*, pp. 706–13, *R.A.C.*, III, 278–83.

123. Cf. Duchesne, pp. 409, 417–8; Muncey, pp. 48–52.

124. *Rev.* xxii:13, cf. i:8. Cf. *D.C.R.*, p. 17.

125. Ill. 166. Cf. Muncey, chap. VII.

126. Cf. Duchesne, pp. 405–6, 413–16; Muncey, pp. 19–20, 40–3, 46.

127. Cf. Muncey, pp. 94–100.

128. Ill. 91. *Rev.* v:6 ff., xxi:22 ff. From the sixteenth century the Blessed Sacrament was reserved in a tabernacle, i.e., canopied structure set in the middle of the altar; previously it was kept in a hanging pyx or "sacrament house": cf. *D.C.C.*, pp. 199, 1318; Lacroix, p. 243, fig. 200, showing arrangement in the mediaeval Cathedral of Arras. On the service known as "Benediction of the most holy Sacrament," see *Liturgy and Worship*, pp. 742–5.

129. This belief finds graphic expression in many hymns, mediaeval and modern. The following verse from an Anglican hymn by W. Bright (1824–1901) is a particularly eloquent example:

> And now, O Father, mindful of the love
> That bought us, once for all, on Calvary's Tree,
> And having with us him that pleads above,
> We here present, we here spread forth to thee,
> That only Offering perfect in thine eyes,
> The one true, pure, immortal Sacrifice.

VII, The Tomb,
p. 134

1. See ill. 9 and pp. 341 ff.

2. Cf. *E.R.E.*, XII, pp. 516–19; G. Van der Leeuw, *La religion*, pp. 312–13; Brandon, *Man and his Destiny*, pp. 78 ff., 121 ff.

3. Cf. Emery, *Archaic Egypt*, pp. 128–64; Bonnet, *Reallexikon*, pp. 257–60; Budge, *The Mummy*, pp. 395–420; Kees, *Totenglauben*, p. 33: "So gut der Gott im Tempel wohnt, so haust der Tote bei seiner Kulstätte im Grabe."

4. See ill. 167. Cf. Bonnet, pp. 90–5; Budge, pp. 348–51; C. Desroches-Noblecourt, *Tutankhamen*, pp. 63–101.

5. Cf. J. E. Quibell, *Excavations at Saqqara* (1912–14), plate XXXII, p. 13; Bonnet, p. 257b.

6. See ill. 214, 406a, b. Cf. Bonnet, p. 258b, 259a; H. Junker, *Pyramidenzeit*, pp. 112–16; Kees, *Totenglauben*, p. 126; Lange/Hirmer, plates 66–72, VIII, IX, 83–4, pp. 412–15, 419–20.

7. Ill. 23. Cf. Bonnet, pp. 118b–20; Budge, pp. 458–60, plate XXXVI; Kees, pp. 56–7: "Ihr gebührte ein Eigenleben, da sie Ersatzkörper des Toten diente, daher die ausgeklügelten Schutzmassnahmen für die Grabstatuen gegen Verlust oder Beschädigung." Cf. Lange/Hirmer, plates 52–62, 64–5, 81, 86.

8. Ill. 168. Cf. Bonnet, pp. 677–9; Lange/Hirmer, plate 73; Westendorf, pp. 65–6; Aldred, ill. 117.

9. See pp. 362 ff.

10. Cf. Emery, pp. 128–9; Bonnet, pp. 148–9 ("Dat"); Kees, *Totenglauben*, pp. 59–61.

11. Cf. Excusus II, IV, XXVII, in S. A. B. Mercer, *The Pyramid Texts*, IV; Bonnet, p. 6220; Vandier, pp. 74–6; Breasted, *Development*, pp. 139–41; Kees, pp. 67–97.

12. Ill. 169. Cf. Budge, *The Mummy*, pp. 209–15; G. E. Smith/W. R. Dawson, *Egyptian Mummies, passim*; Bonnet, pp. 482–7. Emery, *op. cit.*, pp. 162, 163, found evidence of the beginning of mummification in the Second Dynasty.

13. Ill. 170. Cf. Woolley, *Excavations at Ur*, pp. 52–90; A. Parrot, *Archéologie mésopotamienne*, I, pp. 397–404.

14. There has been much speculation about the significance of these burials, which seem to indicate a temporary divergence from the general view of the *post-mortem* existence held in ancient Mesopotamia. A. Moorgat (*Tammuz: der Unsterblichkeitsglaube in der altorientalischen Bildkunst*, pp. 54–79) interprets them in terms of a Tammuz ritual; Frankfort (*Kingship and the Gods*, p. 400, n.12) suggests that they are burials of "substitute" kings and their retinues. Cf. Woolley, pp. 77–84; Brandon, *Man and His Destiny*, pp. 72 ff.

15. Ill. 171. Cf. W. Watson, *Early Civilization in China*, pp. 76–83, *China Before the Han Dynasty*, pp. 69–75, 126–39, plates 8–12, 52; Finegan, *Archeology of World Religions*, pp. 362–3.

16. Ill. 172, 173. Cf. C. F. A. Schaeffer, *Cuneiform Texts of Ras Shamra-Ugarit*, pp. 49–56, plate VII, fig. 3, plate XXVIII, fig. 1, plate XXIX, figs. 2, 3; G. Contenau, *La civilisation phénicienne*, pp. 115–16, 186–90; Picard, *Les religions préhelléniques*, pp. 205–6; A. Parrot, *Le "Refrigerium" dans l'au-delà, passim*.

17. The ancient Egyptians actually wrote letters to the dead, inscribing them on vessels used for mortuary offerings so that they would not escape the attention of the deceased (see ill. 174). Cf. A. H. Gardiner/K. Sethe, *Egyptian Letters to the Dead*; A. H. Gardiner, *The Attitude of the Egyptians to Death and the Dead*, pp. 20–4; Vandier, p. 231. There is Talmudic evidence of a Jewish custom of placing a dead person's pen and ink in the grave: cf. *E.R.E.*, I, p. 458b.

18. Cf. Brandon, *Man and His Destiny*, pp. 74 ff., 93–4, 110 ff., 260–2. See *Epic of Gilgamesh*, Tablet XII, in A. Heidel, *Epic of Gilgamesh*, pp. 99–101.

19. Ill. 175. Cf. *E.R.E.*, pp. 501b–2a; D. Sourdel, in *S.O.*, IV, pp. 192, 197–8; R. Eklund, *Life Between Death and Resurrection in Islam*, pp. 5–6; A. J. Wensinck, *The Muslim Creed*, pp. 129, 164–5; *D.C.R.*, pp. 271–2, "Examination in the Grave"; Brandon, *Judgment of the Dead*, pp. 147–8. See also E. W. Lane's *Manners and Customs of the Modern Egyptians* (first published in 1836), pp. 483–5.

20. Ill. 176. Cf. I. E. S. Edwards, *The Pyramids of Egypt*, pp. 238 ff.; Emery, *Archaic Egypt*, pp. 139 ff.; Budge, pp. 396–405.

21. Ill. 177. Cf. Lange/Hirmer, p. 400, 406; Edwards, pp. 45 ff.; Budge, pp. 404–15; Aldred, ill. 76, pp. 82–3.

22. Ill. 13, 178. Cf. Bonnet, pp. 619–23; Kees, *Totenglauben*, pp. 66–70; Vandier, pp. 74–6; Brandon, *Creation Legends*, pp. 15–29.

23. Cf. Edwards, pp. 234–5.

24. The dead pharaoh exclaims: "A stairway to the sky is set up for me, that I may ascend on it to the sky" (*Pyr.* 365: cf. *Pyr.* 1749). Cf. Edwards, pp. 236–7; Kees, pp. 69–70.

25. Ill. 179, see also ill. 219. Cf. Aldred, ill. 81, 83, pp. 87, 90–1, see also ill. 92; Lange/Hirmer, p. 405; Bonnet, pp. 738–41 ("Sonnenschiff"); *Dictionary of Egyptian Civilization* (ed. G. Posener), p. 265; Kees, pp. 73–4.

26. From the so-called *Song of the Harper:* cf. *A.N.E.T.*, p. 467a; Erman, *Literature of the Ancient Egyptians*, pp. 132–4; Brandon, *History, Time and Deity*, pp. 79–80.

27. Ill. 180a, b. Cf. Lange/Hirmer, plates 8–17, pp. 398–401; Edwards, pp. 45–66.

28. On the Middle Kingdom royal pyramids, cf. Edwards, pp. 170–96, who thinks that Ahmose I, the first king of the Eighteenth Dynasty, was the last to build a pyramid, and this was a "dummy" at Abydos. Cf. Kees, pp. 259–63.

29. Ill. 181. Cf. Budge, pp. 416–20; Bonnet, pp. 182–4 ("Felsengrab"); Lange/Hirmer, plate 216, pp. 472–5.

30. Ill. 182a, b. Cf. Bonnet, pp. 833–4 ("Totentempel"); Lange/Hirmer plates XV, XVI, 127–31, 241–6, 253, pp. 430–4, 498–502, 508–15.

31. "Man glaubte den Totenkult besser gesichert, wenn man ihn mit dem eines Gottes verschmolz, an dessen Tisch der König als Kultgenosse Anteil hatte," Bonnet, p. 834a.

32. Cf. Kees, *Totenglauben*, pp. 230–6; Bonnet, pp. 2–4.

33. The Cretan Zeus was probably a vegetation god of the dying-rising type: cf. Hutchinson, *Prehistoric Crete*, pp. 204–5; Guthrie, *The Greeks and Their Gods*, pp. 50–1; Picard, *Les religions préhelléniques*, pp. 117–18. A "Tomb of Bel" (i.e., Marduk, the patron god of Babylon) was also known: cf. Frankfort, *Kingship and the Gods*, pp. 322–3.

34. Cf. Bonnet, pp. 144–5; Roeder, *Ae.R.T.B.*, I, pp. 232–3; Gwyn Griffiths, *Osiris*, pp. 92–5.

35. Ill. 183. Cf. Roeder, pp. 233, Ab. 40; Bonnet, p. 3b; Otto, *Egypt. Art and the Cults of Osiris and Amon*, plate 13, p. 69; *Bilderatlas*, 2–4. Lief., Abb. 147; Budge, *Osiris and the Egyptian Resurrection*, I, p. 56, II, p. 76. On the dismemberment of Osiris' body and the claims of many places in Egypt to have some part of the body, see Plutarch, *De Iside et Osiride*, lines 357–9; cf. Diodorus of Sicily, *Bibliotheca Historica*, I, 21, 1–9.

36. Cf. *A.N.E.T.*, pp. 329–30. Cf. Otto, *op. cit.*, pp. 42, 43.

37. Cf. *A.N.E.T.*, p. 330b. Cf. Kees, *Totenglauben*, pp. 236–52; Otto, pp. 42–3; Moret, *Mystères égyptiens*, pp. 8–11; Frankfort, pp. 201–7; Gwyn Griffiths, p. 51. Ritual portrayals of the burial and resurrection of Osiris were also performed in the temples at Philae and Denderah: cf. Moret, pp. 20–31; Bonnet, pp. 494–6 ("Mysterien").

38. Cf. Kees, pp. 243–9; J. Yoyette, in *S.O.*, III, pp. 30–40.

39. Ill. 184. Cf. Lange/Hirmer, pp. 484–7, plates 222–9, XLVIII–LI; Otto, plates 13, 14, 16–17. Gardiner, *Egypt of the Pharaohs*, p. 250; Baedeker, *Egypt*, pp. 219–23. On "Nun," cf. Brandon, *Creation Legends*, pp. 16–18.

40. Cf. Bonnet, pp. 567–8 ("Osireion"), pp. 576–7 ("Osirisgrab"); Kees, pp. 239–40; C. Gaudet, "The Tomb of Osiris at Abydos," *W.P.*, III, pp. 986–91.

41. Ill. 185. Cf. Otto, pp. 47, 60 (18, 19); Yoyette in *S.O.*, p. 67, n.45; Emery, *Archaic Egypt*, pp. 61–2; W. M. Flinders Petrie, *History of Egypt*, I, pp. 15–16.

42. Ill. 186. Cf. J. B. Hurry, *Imhotep*, pp. 5–28; Bonnet, pp. 322–4; Erman, *Die Religion der Aegypter*, pp. 326–7.

43. Cf. Hurry, pp. 29–73; Erman, pp. 394, 415; H. Idris Bell, *Cults and Creeds in Graeco-Roman Egypt.* pp. 11, 68–9.

44. There were temples at Philae and Thebes, as well as Memphis. There was also a sanatorium in the temple complex at Deir el Bahari: cf. Hurry, pp. 43–57.

45. Cf. Hurry, pp. 49–53.

46. Cf. W. B. Emery and H. S. Smith, in *Antiquity*, XLIV (1970), pp. 195–8. See also Hurry, pp. 27–8, 42.

47. Cf. Bonnet, pp. 47b–8a, 651–2, 654; E. Bevan, *The Ptolemaic Dynasty*, pp. 41–6; Bell, pp. 3–4, 19–20.

48. Cf. Baedeker, *Egypt*, pp. 135–7.

49. Ill. 187. Cf. Hurry, p. 44; Bonnet, p. 652b.

50. Ill. 188. Cf. M. D. Coe, *The Maya*, pp. 104–6, plate 50, see also plate 47; G. H. S. Bushnell, *The First Americans*, pp. 52–3, ill. 37–9.

51. Cf. Coe, p. 106.

52. Cf. L. R. Farnell, *Greek Hero Cults and Ideas of Immortality*, p. 281; V. von Wilamowitz-Möllendorf, *Der Glaube der Hellenen*, II, pp. 17–18; L. Gernet/A. Boulanger, *Le génie grec dans la religion*, p. 255–6; M. P. Nilsson, *Greek Folk Religion*, pp. 18–20; Brandon, *Man and His Destiny*, pp. 182–3.

53. Pindar, *Pyth.* V, 107. Cf. Rohde, *Psyche*, I, p. 210, n.1; Guthrie, *The Greeks and Their Gods*, pp. 220–1.

54. Farnell, *op. cit.* p. 239.

55. Cf. *E.R.E.*, VI, p. 652b; see also Picard, *Les religions préhelléniques*, pp. 291–2.

56. Cf. Rohde, I, pp. 34–6; *E.R.E.*, XI, p. 739; *R.A.C.*, I, 318(2); *O.C.D.*, pp. 419–20; Guthrie, pp. 220–2.

57. Ill. 189. Cf. Harrison, *Prolegomena*, pp. 325–31; Nilsson, *op. cit.*, p. 71; Rohde, I, p. 142, n.3. Serpents have been regarded as embodiments of the dead in many other religions: cf. *E.R.E.*, XI, p. 405–6a.

58. Cf. Harrison, pp. 330–1; *E.R.E.*, VI, p. 653a.

59. Cf. Gernet/Boulanger, pp. 260–1; *E.R.E.*, VI, pp. 654b–5, X, pp. 651b–2.

60. Cf. Nilsson, pp. 18, 19, fig. 10, in *L.R.G.*, II, p. 214; Rohde, I, pp. 159–60; *Kleine Pauly*, II, 1104.

61. Ill. 190. Cf. Harrison, pp. 340–8; Rohde, I, pp. 184–5.

62. Pausanias, IX, 39: 5–14. Cf. Guthrie, pp. 225–8; Rohde, I, p. 120, n.2; Harrison, pp. 578–80.

63. A somewhat parallel case to that of Trophonios is provided by Zalmoxis, a chthonic daimonic being, whose oracle was consulted by the Getae of Thrace. Cf. Rohde, I, p. 121, n.1, II, pp. 7, n.3, 28 ff.; A. D. Nock, *Classical Review*, XL (1926), pp. 184 ff.; Dodds, *The Greeks and the Irrational*, pp. 144, 165–6.

64. The raising of the dead prophet Samuel by the so-called Witch of Endor is a most notable example of this belief: II *Sam.* xxviii:3–25. Cf. W. O. Oesterley, *Immortality and the Unseen World*, pp. 101–3, 127–35; Pedersen, *Israel*, IV, pp. 480–3; Brandon, *Man and His Destiny*, pp. 112–15.

65. Ill. 191. Cf. J. Jeremias, *Heilgengräber in Jesu Umwelt*, p. 127: "Er (the Evangelist) denkt es sich ganz konkret so, dass die Stammutter Rahel in ihren Grabe anwesend ist und von Grabe aus mit mütterlichen Herzen das grausame Geschick ihrer Kinder miterlebt und mit untröstlichen Weinen begleitet." On the traditional Tomb of Rachel, cf. Finegan, *Archeology of the New Testament*, pp. 24–5; C. Kopp, *The Holy Places of the Gospels*, pp. 31, 36, 46.

66. Cf. E. Lohmeyer/W. Schmauch, *Das Evangelium des Matthäus*, p. 397(2).

67. Cf. Jeremias, *op. cit.*, p. 131.

68. Cf. Jeremias, p. 138; Lods, *Israël*, pp. 402–4.

69. Cf. Jeremias, pp. 18–23, 118–25; E. Klostermann, *Das Matthäusevangelium*, p. 188.
70. Cf. *E.R.E.*, I, pp. 458b–9.
71. See the list given by Jeremias, pp. 29–106.
72. *Jewish War*, IV:531–2.
73. See ill. 192. Cf. Finegan, *Archeology of New Testament*, pp. 191–6, see also pp. 184–6.
74. See ill. 193a, b.
75. Cf. Finegan, p. 193; Jeremias, pp. 122–3. On the wide range of meaning of *nephesh*, cf. M. Avigad, *Ancient Monuments in the Kidron Valley*, pp. 66–73; A. R. Johnson, *The Vitality of the Individual in the Thought of Ancient Israel*, pp. 9–26.
76. Cf. Finegan, pp. 192–4, cf. p. 185. The tomb apparently contained the body of Solomon also.
77. See Josephus, *Jewish Antiquities*, V:393–4, VIII:179–83. Cf. *Acts* ii:29. Cf. Jeremias, pp. 56–7; Finegan, pp. 149–50.
78. *Jewish Antiquities*, VIII:181–2. The text has the qualifying words *tou deous*—"of the terror" (variant: *theou*—"of God") before *hilastérion mnéma*.
79. *Ibid.*, 183.
80. The separation of the actual burial place from the cenotaph (*nephesh*) enabled cultic service to be offered without contracting ritual uncleanness. Cf. Jeremias, pp. 121–3.
81. b. *Ta'an.* 16a. Cf. Jeremias, pp. 138–9. See also *E.R.E.*, I, pp. 458a–9. It is interesting to note that tomb-towers, called *naphsha*, were erected in Syria: cf. J. B. Segal, *Edessa*, pp. 23, n.4, 29.
82. Quoted by Harīrī, *Maqāma*, xxxii, in *E.R.E.*, VIII, p. 521a.
83. See ill. 194. Cf. *E.R.E.*, VIII, p. 521a; Finegan, *Archeology of World Religions*, pp. 506–7; G. M. Sugana, *Life and Times of Mohammad*, illus. on p. 41.
84. Cf. M. Hamidullah, in *S.O.*, III, p. 121.
85. The term for the tomb is derived from the word *walī*, meaning "friend": cf. *D.C.R.*, pp. 548–9.
86. Ill. 195. Cf. *E.R.E.*, XI, pp. 66b–7a; *D.C.R.*, p. 548b; E. Deremenghem, *Muhammad and the Islamic Tradition*, illus. on pp. 84, 85, 174; M. Rémond, *La Kabylie*, p. 144.
87. Cf. *E.R.E.*, XI, p. 67.
88. Cf. *D.C.R.*, p. 663 ("Ziyāra"); *E.R.E.*, XI, pp. 67b–8a.
89. Ill. 196, see also 119. Cf. D. Seckel, *Art of Buddhism*, pp. 103–32; *D.C.R.*, pp. 591b–2a; S. Dutt, *Buddhist Monks and Monasteries of India*, pp. 182–8.
90. Cf. Thomas, *Life of the Buddha as Legend and History*, pp. 152, 154, 155–6, 158 ff.; Dutt, p. 184.
91. Cf. Thomas, p. 160; *E.R.E.*, XI, pp. 901b–2a.
92. Ill. 118. Cf. Dutt, pp. 184–5.
93. Cf. Dutt, pp. 184–6; *E.R.E.*, XI, pp. 903b–4a.
94. Ill. 197. Cf. C. Eliot, *Hinduism and Buddhism*, III, p. 77; *D.C.R.*, p. 535a; *E.R.E.*, X, p. 660b; R. Curle, "Shwe Dagon: Buddha's Greatest Shrine," in *W.P.*, I, pp. 134–41.
95. Cf. Eliot, III, pp. 25–8; Finegan, *Archeology of World Religions*, p. 299.
96. Cf. M. Granet, *La religion des Chinois*, p. 67; *Chinese Civilization*, p. 335.
97. Cf. Granet, *La religion*, pp. 67–8; *Chinese Civilization*, pp. 335–6; *E.R.E.*, III, p. 729b; Smith, *Chinese Religions*, pp. 88–9.

98. Cf. L. Wieger, *History of Religious Beliefs and Philosophical Opinions in China,* pp. 122–3; Granet, *Le pensée chinoise,* p. 42.

99. See ill. 198. Cf. Finegan, *op. cit.,* p. 348; E. G. Parrinder, *Worship in the World's Religions,* pp. 142–3. See also Smith, pp. 146–7.

100. See pp. 143–9.

101. Ill. 199. Cf. H. T. F. Duckworth, *The Church of the Holy Sepulchre, passim;* A. Parrot, *Golgotha and the Church of the Holy Sepulchre, passim;* Kopp, pp. 374–94; K. Kenyon, *Jerusalem,* pp. 146–7, 151, 154, 190–1; Finegan, *Archeology of the New Testament,* pp. 163–73.

102. Melito, bishop of Sardis (*fl.* 150), is the first recorded pilgrim to the Holy Places of the Gospels (cf. Eusebius, *Eccles. Hist.,* IV, xxvi:14). Cf. Finegan, *op. cit.,* pp. xiii–iv.

103. Eusebius, *Life of Constantine,* III, cap. 25–6.

104. *Ibid.,* III, cap. 29–30, also cap. 25. Cf. H. Kraft, *Kaiser Konstantins religiöse Entwicklung,* pp. 119–21.

105. Eusebius, *op. cit,* III, cap. 33–9. Cf. Grabar, *Beginnings of Christian Art,* pp. 163–9; Finegan, pp. 164 ff.; J. W. Crowfoot, *Early Churches in Palestine,* pp. 9–21.

106. Ill. 200. The site of Golgotha is first mentioned in 333 by an anonymous pilgrim from Bordeaux (*Itinerarium a Burdigala Hierusalem usque,* ed. P. G. Geyer). Cf. Kopp, pp. 374–7; Finegan, p. 164; Duckworth, pp. 93–135.

107. Cf. Kopp, pp. 382–8; Finegan, p. 167; Join-Lambert, *Jerusalem,* p. 110; Duckworth, pp. 124–7; Parrot, *Golgotha and the Church of the Holy Sepulchre,* pp. 66–83.

108. *Peregrinatio Etheriae (Silviae)* I, in Duchesne, *Christian Worship,* pp. 492–3, see also pp. 490–1, 541–2. Mediaeval pilgrims spent two separate nights of vigil in the Church of the Holy Sepulchre: see the account of the fifteenth century. Friar Felix Fabri in H. F. M. Prescott, *Jerusalem Journey,* pp. 133–41.

109. "Candelae autem vitreae ingentis ubique plurimae pendent et cereopala plurima sunt, tam ante Anastasim quam etiam ante Crucem, sed post Crucem," *Peregrinatio Etheriae,* 3, in Duchesne, pp. 493–4.

110. Cf. Join-Lambert, pp. 174–211; S. Runciman, *History of the Crusades,* I, pp. 20–79; P. Alphandéry, *La Chrétienté et l'idée de croisade,* pp. 10–42.

111. Cf. Alphandéry, pp. 157–9; Cook, *The English Medieval Parish Church,* p. 89; R. Barber, *The Knight and Chivalry,* pp. 225 ff.

112. Ill. 201a, b. *Eothen* (first published in 1844; ed. London, 1948), p. 137. Kinglake records an occasion in which nearly two hundred people were killed in the fracas. Cf. Frazer, *Balder the Beautiful (G.B.* X), I, pp. 128–30: for other Easter Fire rituals, see pp. 121 ff.

113. Pp. 127–33.

114. Cf. Prescott, pp. 141–2, 212–16. See the unique model of the Holy Sepulchre built by Konrad von Altdorf (*d.* 957), bishop of Constance, in the Cathedral of Constance in memory of his pilgrimage to Jerusalem. Cf. Aubert, *High Gothic Art,* pp. 144–5. The Templar church of La Vera Cruz (*c.* 1204), near Segovia, contains a replica of the Dome of the Rock.

115. See ill. 202.

116. See n.102.

117. *Epistle to the Smyrnaeans,* XVIII (in the *Apostolic Fathers,* ed. J. B. Lightfoot, p. 196). Cf. *E.R.E.,* X, pp. 653–4.

118. See p. 120.

119. The cult has been equally well established and flourishing in the Eastern Church: cf. Bréhier, *La civilisation byzantine*, pp. 258–9, 261–6.

120. See ill. 203. Cf. J. Toynbee/J. W. Perkins, *The Shrine of St. Peter*, p. 154; L. Hertling/E. Kirschbaum, *The Roman Catacombs and Their Martyrs*, pp. 92–8; M. Gough, *The Early Christians*, pp. 72–9.

121. Cf. Toynbee/Perkins, pp. 165–6.

122. Ill. 204. Cf. Toynbee/Perkins, pp. 195–206; Hertling/Kirschbaum, plate 20.

123. *Contra Vigilantium*, 8, in Toynbee/Perkins, pp. 214, 234(50). Cf. Hertling/ Kirschbaum, plate 21 (p. 94).

124. *De gloria martyrum*, xxviii, in Toynbee/Perkins, pp. 212–13, 234(45).

125. Cf. O. Cullman, *Petrus: Junger-Apostel-Märtytrer*, pp. 127–82; E.T., *Peter: Disciple-Apostle-Martyr*, pp. 113–57.

126. Ill. 205. Cf. *Horizon Book of Great Cathedrals* (ed. J. Jacobs), pp. 250–8; R.G.G., I, 1857; Lacroix, pp. 382–3; *Santiago de Compostela España* (Editora Nacional, Madrid), *passim*.

127. Cf. A. Kendall, *Medieval Pilgrims*, pp. 103–7; J. Evans, *Life in Medieval France*, pp. 78–80. The succour given by St. James of Compostela was celebrated by a votive fresco as far away as Überlingen in Germany: cf. *Horizon Book of Great Cathedrals*, pp. 262–3. See also G. Lorenzo Mellini, *El Maestro Mateo en Santiago de Compostela*, on the *Portico de la Gloria*.

128. Ill. 206. Cf. Mâle, *L'art religieux du xiie. siècle en France*, pp. 288–92; J. M. Pita Andrade, *Le chemin de Saint-Jacques, passim*.

129. Cf. A. L. Poole, *From Domesday Book to Magna Carta, 1087–1216*, pp. 214–16, 336–7; *D.C.C.*, pp. 146–7.

130. Cf. A. P. Stanley, *Historical Memorials of Canterbury*, pp. 102, 195–200. Outside England, there were relics of Becket at Rome, Verona, Florence, Lisbon, Mons, Bourbourg, Douay, St. Omer and Sens.

131. Cf. Stanley, pp. 248–61; J. Gardiner, *The English Church in the Sixteenth Century*, p. 201.

132. See ill. 207a, b. Cf. Stanley, pp. 230–3; Murray's *Handbook to the Cathedrals of England*, Part II (1861), pp. 364–72; Kendal, pp. 112–17.

133. Cf. Stanley, pp. 282–6. See also M. Hürlimann/P. Meyer, *English Cathedrals*, frontispiece 7, plate 9.

134. Chaucer, *The Canterbury Tales*, Prologue.

135. Ill. 208.

136. Cf. Brandon, *History, Time and Deity*, pp. 10–11. Cf. below, pp. 341 ff.

137. See pp. 29, 136.

138. It is a curious fact that the Egyptian artist was always most careful to represent the nipples on both male and female statues and paintings.

139. See Ill. 23. Cf. Ranke, *Art of Ancient Egypt*, ill. 51–74, 92–9, 140, 152, 161; Hamann, Abb. 6–9, 13–16, 20, 114–16, 132–41, 144–5, 165–7; Westendorf, pp. 30–3, 34–5, 38–41, 52–3, 62–71, 206.

140. Ill. 22. Cf. Westendorf, p. 96.

141. Ill. 209. Cf. Bonnet, *Reallexikon*, pp. 74–7; Brandon, *Man and His Destiny*, pp. 42–4; L. V. Zabkar, *A Study of the Ba concept in Ancient Egyptian Texts* (Oriental Institute, Chicago, 1968).

142. Ill. 210. Cf. Lange/Hirmer, plate 86, p. 421.

143. Ill. 211. Cf. Bonnet, *Reallexikon*, pp. 28–9; Budge, *The Mummy*, pp. 306 ff.; Westendorf, pp. 30–8, 82–3; Lange/Hirmer, plates 86, 98–9, p. 422; see also colour plate XIII.

144. Cf. Westendorf, pp. 84, 85; Bonnet, *Reallexikon*, pp. 158-60 ("Dreissigjahr-fest").

145. Ill. 212. Cf. Westendorf, p. 80; Lange/Hirmer, plates 256, 260, pp. 521-2, who attribute the block form to Egyptian preference for massive shapes; Hamann, Abb. 308, p. 286; Bonnet, *Reallexikon*, p. 326.

146. Ill. 168. See p. 136.

147. Ill. 211, 213. Cf. Westendorf, p. 67. *Uzat*-eyes were later painted on coffins. On the *uzat*-eye, cf. Bonnet, *Reallexikon*, pp. 854-6; Budge, *The Mummy*, pp. 316-18, 343, 427; Posener, *Dictionary of Egyptian Civilization*, pp. 250-1; W. Helck/ E. Otto, *Kleines Wörterbuch der Aegyptologie*, pp. 52-3.

148. Cf. J. Sainte Fare Garnot, in *H.G.R.*, I, pp. 326-37; Budge, *The Mummy*, pp. 439-50.

149. E.g., on the tomb of Herkhuf (*c.* 2500 B.C.): "As for any man who shall enter into (this) tomb as his mortuary possession, I will seize him like a wild fowl, he shall be judged for it by the Great God." Cf. K. Sethe, *Urkunden des Alten Reiches*, I, 122, ill. 15-16. See also Breasted, *Dawn of Conscience*, pp. 125-6; Brandon, *Judgment of the Dead*, pp. 15-16.

150. See the sense of disillusionment in the so-called *Song of the Harper*: "The gods who lived formerly rest in their pyramids/The beautified dead also, buried in their pyramids/. . . What are their places (now)? Their walls are broken apart, and their places are not—As though they had never been!"—*A.N.E.T.* p. 467a; cf. Erman, *Literature of the Ancient Egyptians*, pp. 132-4; Brandon, *History, Time and Deity*, pp. 80-2. On the significance of the "Appel aux vivants" formula, see *H.G.R.*, I, pp. 333-7.

151. Cf. *H.G.R.*, I, p. 331; Bonnet, *Reallexikon*, p. 157: "In ihrer Form und in der Anlage des Bildschmuckes unterscheiden sich diese Denksteine nicht von den Grabsteinenen." The environs of the shrine of Osiris at Abydos was a favourite location for such funerary stelae.

152. Ill. 214. Cf. Lange/Hirmer, plates 66, 68-9, 71-2, colour plates VIII-IX, pp. 76-7, 83, 84, colour plates XIX, XXI-VII, plates 168-71, 173-7; Westendorf, pp. 55, 71, 114-23; Ranke, *Art of Ancient Egypt*, plates 244-59, 261-5.

153. Cf. Spiegel, *Totengericht*, pp. 11-12, 14; Brandon, *Judgment of the Dead*, p. 13.

154. Ill. 215. Cf. Lange/Hirmer, colour plates XIX, XXI-II, XXV-VII, p. 442; Westendorf, pp. 114-19.

155. Ill. 216. Cf. Lange/Hirmer, plates 66-7, 74, 172-7, pp. 448-50; Hamann, Abb. 122-3, 146, 151, 152, 243-4; Westendorf, pp. 123, 128-9, 186. Possibly the picture of the deceased Menena at Thebes (*c.* 1410 B.C.) follows the earlier tradition: see Westendorf, ill. on p. 120.

156. Ill. 217. Cf. Westendorf, pp. 124-5, 150-1, 153, 187, 189; Lange/Hirmer, colour plates XXIV, XXVIII; see also XXIX and plate 172. On the "Opening of the Mouth," see above, p. 48.

157. See above, pp. 26 ff.

158. Ill. 218. Cf. Westendorf, pp. 143, 160-1, 163, 178-9, 183, 188; Lange/Hirmer, colour plate XVII, plate 145, colour plates XLVI, XLVIII-LI, plates 228-9; Bonnet, *Reallexikon*, p. 261.

159. Ill. 219. Cf. Lange/Hirmer, plates 150, 220, p. 440; Westendorf, pp. 174-6; Bonnet, *Reallexikon*, pp. 17-20 ("Amduat"); Piankoff, *Shrine of Tut-Ankh-Amon, passim*.

160. Ill. 220a, b. Cf. Budge, *The Mummy*, pp. 223-4, 463-8; Westendorf, pp. 54, 72-7; Bonnet, *Reallexikon*, pp. 157-8 ("Dienerfiguren").

161. Ill. 220c. Cf. Bonnet, *Reallexikon,* pp. 849–53 ("Uschebti"); Budge, *The Mummy,* pp. 251–8.

162. From the Eighteenth Dynasty, the number of *ushabtis* deposited in individual tombs steadily increased. In some tombs 365 have been found, doubtless one for service on each day of the year; often such an *ushabti* army was provided with an overseer figure: cf. Bonnet, *Reallexikon,* p. 852.

163. Ill. 221b. Cf. Bonnet, *Reallexikon,* pp. 655–69; Budge, *The Mummy,* pp. 426–32; R. T. Rundle Clark, *Myth and Symbol in Ancient Egypt,* plates 17–18, pp. 253–6.

164. Ill. 222. Cf. W. M. Flinders Petrie, *Roman Portraits and Memphis* (IV), pp. 1–14, with numerous plates. See also Westendorf, pp. 234–7.

165. Ill. 223. Cf. Bonnet, *Reallexikon,* pp. 365–8; Budge, *The Mummy,* pp. 240–6.

166. The funerary iconography of Egypt represents a tradition that emerged about 2700 B.C. and continued until the suppression of paganism in favour of Christianity in the fourth century A.D. Cf. Budge, pp. 212–14, on evidence of mummification in the fourth century A.D.

167. Ill. 224. Cf. V. Karageorghis, *Treasures in the Cyprus Museum,* plate IX and pp. 11–12.

168. Cf. Picard, *Les religions préhelléniques,* pp. 94, 113–14; J. Hawkes, *Dawn of the Gods,* pp. 89–90, 122.

169. Ill. 225. Cf. Hawkes, *op. cit.,* p. 126, see also p. 151.

170. Ill. 226. Cf. James, *Cult of the Mother Goddess,* pp. 22–46; *Bilderatlas,* 7. Lief. (G. Karo), Abb. 1–16; Hawkes, pp. 45–50; A. Parrot, *Archéologie mesopotamienne,* I, pp. 296–7; *C.A.H.,* vol. of plates I, pp. 112–14; Mellaart, *Early Civilizations of Near East,* pp. 52, figs. 28, 64, figs. 75, 94, 103 (sepulchral locations not specified); S. Alexiou, Parrot in *I.L.N.,* vol. 237, p. 226, fig. 8.

171. Cf. Parrot, *op cit.,* I, p. 297, fig. 72.

172. James, *Cult of the Mother Goddess,* pp. 22–46; Hawkes, pp. 26–7, 30–4.

173. Cf. G. R. Levy, *The Gate of Horn,* pp. 95, 131; James, pp. 131–2; J. Charbonneaux in *H.G.R.,* II, pp. 20–1; J. Przyluski, *La Grande Déesse,* p. 125; Hawkes, pp. 142–6; Harrison, *Prolegomena,* pp. 266–7.

174. Cf. P. J. Ucko, *Anthropomorphic Figurines of Predynastic Egypt and Neolithic Crete, with Comparative Material from the Prehistoric Near East and Mainland Greece* (1968), which, however, does not consider the Palaeolithic data.

175. Ill. 227a. See also ill. 185. Cf. Bonnet, *Reallexikon,* pp. 93–5; *Bilderatlas,* 2–4 Lief. (H. Bonnet), Abb. 113.

176. See above, p. 138 and ill. 171.

177. Cf. W. Willetts, *Chinese Art,* I, p. 293; H. G. Creel, *Confucius and the Chinese Way,* pp. 118–19, 310(6).

178. Ill. 227b. Cf. Watson, *Early Civilization in China,* ill. 108, 109; Christie, *Chinese Mythology,* pp. 20, 70–1.

179. Ill. 228. Cf. R. Goepper (with J. Auboyer), *The Oriental World,* p. 95, fig. 63; Munsterberg, *Art of Far East,* p. 38. The custom of providing funerary equipment eventually developed into the provision of paper substitutes: cf. E. R. and K. Hughes, *Religion in China,* pp. 22–3.

180. Ill. 229. Cf. Goepper, p. 101; Finegan, *Archeology of World Religions,* p. 370, fig. 163 (period of Six Dynasties, A.D. 220–581), fig. 167; A. Silcock, *Introduction to Chinese Art,* pp. 177–8; Munsterberg, *Art of Far East,* pp. 10, 76–7.

181. Ill. 230. Cf. Goepper, p. 121, figs. 79, 80; Christie, p. 133; Munsterberg, pp. 72–3.

182. Cf. J. E. Kidder, *Japan Before Buddhism,* p. 193.

183. Cf. Kidder, pp. 192–6; Finegan, *op. cit.*, p. 424; Munsterberg, pp. 48–9.

184. Ill. 231. Cf. Kidder, plates 96–101, pp. 196–201; Finegan, fig. 187; Goepper, ill. 88.

185. Ill. 232. Cf. A. Rowe, *Cyrenaican Expeditions of University of Manchester, 1955–7*, pp. 3–4, plates 2, 13(c), 27(a), 28(a,b,c), 29, 30(a,b), 31. The last three plates show the same type of image with facial features. See also examples in F. Chamoux, *Cyrène sous la monarchie des Battides*, plates X–XIII, pp. 293–5. On the mounting of these images on the covers of sarcophagi, cf. Chamoux, pp. 296–7.

186. Cf. *Der Kleine Pauly*, III, 54.

187. See ill. 122. Cf. Harrison, *Prolegomena*, pp. 277–83. On the ritual *anodos* of Persephone at Eleusis, cf. Mylonas, *Eleusis and the Eleusinian Mysteries*, pp. 148–9.

188. See p. 354 below. Cf. J. Harrison, *Ancient Art and Ritual*, pp. 34–41; Van der Leeuw, *La religion*, pp. 459–61.

189. Pindar, *Pyth.* IX, 101 sq., refers to the cult of *Gē Bathykolpos* ("deep-bosomed Earth") at Cyrene, which would seem to have been a native cult. On Libyan sacred stones, cf. O. Bates, *The Eastern Libyans*, pp. 173–6. It is significant that the Egyptian goddess Neit, who cared for the dead, was associated with Libya (cf. Bonnet, *Reallexikon*, pp. 516–17; see also Bates, pp. 205–7). Chamoux, *op. cit.*, p. 299, thinks that the faceless image developed out of an aniconic stone pillar which supplied a locus for the soul of the deceased and a focus for funerary offerings. He identifies the funerary divinity with Persephone or Gē, the Earth Mother, and concludes: "Les tombeaux de Cyrène se hérissaient ainsi, semble-t-il, d'images de la Maîtresse des Ombres, surgissant à demi de la terre, son domaine, pour dévoiler le mystère de son visage doux et grave à chaque nouveau trépassée" (p. 300). Nilsson, *Geschichte d. griech Religion*, I, p. 177, n. 7., Taf. 52.5, does not attempt to interpret the significance of the images beyond saying that they represent divinities, not human beings.

190. Ill. 233. Cf. T. Heyerdahl, in *Vanished Civilizations* (ed. E. Bacon), pp. 338–40. See also Heyerdahl's *Aku-Aku, passim*, and Heyerdahl and E. N. Ferdon, *Archaeology of Easter Island*, vol. 1 (1961). For an earlier account, see S. Routledge, *The Mystery of Easter Island* (1919) and in *Wonders of the Past* (ed. J. A. Hammerton, 1925), vol. III, pp. 902–26.

191. Ill. 233. Cf. Heyerdahl, *Aku-Aku*, p. 340.

192. Cf. Heyerdahl, *ibid.* See p. 48.

193. Cf. *ibid.*, pp. 343–4.

194. Ill. 235. Etruscan ash-urns sometimes had the form of a house: cf. R. Bloch, *The Etruscans*, plate 11 and p. 246. This custom was anticipated in the earlier Villanovan culture: cf. G. Bendinelli, *Compendio di storia dell' arte etrusca e romana*, pp. 33–5 and fig. 22 ("Al concetto dell' urna intesa come la casa del morte, sottentra qui l'idea che le ceneri conferiscano a quell' invulcro materiale qualche cosa di attinente all stessa personalità fisica e spirituale del definto," p. 35), see also fig. 120. Cf. M. Pallottino, *The Etruscans*, p. 170.

195. Ill. 236. Cf. D. Strong, in *Vanished Civilizations*, ill. 18; Bendinelli, pp. 156, 158, figs. 117, 118; J. Heurogen, *Daily Life of the Etruscans*, pp. 163–4.

196. Ill. 237. The depiction of these monsters probably had an apotropaic purpose.

197. Ill. 238. Cf. A. Stenico, *Roman and Etruscan Painting*, figs. 5–7, 10–20, 22, 25–31, 34–45, 58; W. Dräyer, *Tarquinia*, Abb. 1–4, 11–16; Strong, *op. cit.*, ill. 19, 25, 27.

198. Ill. 239a. Cf. Strong, p. 181(27): *D.C.R.*, p. 256.

199. It is likely that the deceased is indicated by the holding of the egg. Cf. Stenico, figs. 10, 26, 58. The funeral banquet took place after the burial and was periodically repeated at the tomb. It was believed that the *manes* of the deceased was present on these occasions: cf. Cumont, *After Life in Roman Paganism*, pp. 53–6.

200. Cf. ill. 239b. A. Grenier, *Les religions étrusque et romaine*, pp. 78–9 ("les jeux sont une méthode et une technique magiques pour rejeunir les morts, les dieux, les vivants et le monde entier").

201. It is possible that the Etruscan funerary games were related to human sacrifices for the dead; probably the shedding of blood, the "life-substance," was deemed to profit the dead. Scenes of slaughter and sacrifice are found in tombs of the late period, notably at Vulci and now in the Museo Torlonia, Rome: cf. Bendinelli, pp. 188–96, figs. 146, 147. Cf. Grenier, pp. 66, 74–5.

202. Ill. 240. Cf. Bendinelli, p. 126, fig. 96.

203. Ill. 241. Cf. Strong, p. 177(17), Bendinelli, pp. 101–2.

204. The bull, on the other side of the frieze, is depicted as an ordinary animal, lying down. The group of human figures adjacent is equally difficult to interpret. These figures greatly intrigued D. H. Lawrence, as his delightful *Etruscan Places* shows (cf. pp. 99–100, Penguin ed.).

205. It is interesting to compare the Etruscan scene with some curious figures in the margin of the Bayeux Tapestry: cf. F. Stenton, *The Bayeux Tapestry*, plate 6 and detail, plates 15, 18, 19, 73.

206. Ill. 243. Cf. Bendinelli, pp. 184, 186, figs. 142, 146; S. Cles-Reden, *Das Versunkene Volk*, p. 70, Abb. 69; G. Dennis, *Cities and Cemeteries of Etruria*, II, frontispiece, p. 160; Grenier, pp. 59–63, 65–6; *Kleine Pauly*, I, 1138–9 ("Charon"); Bloch, ill. 75 and p. 254.

207. Cf. Bendinelli, pp. 197–8, fig. 150; Strong, p. 181(26); Pallottino, plate 24a, p. 171; A. Hus, *The Etruscans*, pp. 108–9; Grenier, pp. 60, 62, 66.

208. Ill. 243. Cf. pp. 199–200, fig. 151; Bloch, plate 25; Grenier, pp. 43, 59, 64.

209. E.g., the sacrifice of Polyxena: cf. Hus, p. 109; Bendinelli, fig. 131; *C.A.H.*, vol. of plates IV, pp. 62–5.

210. Bloch, pp. 159–60; Bendinelli, pp. 214–15; Hus, pp. 110–11. See J. M. C. Toynbee, *Death and Burial in the Roman World*, pp. 12–14.

211. Ill. 244a. At the important Etruscan centre of Chiusi, so-called "Canopic" urns continued the earlier Villanovan custom. These canopic urns are surmounted with a representation of the head of the deceased or sometimes a statuette: see ill. 244b. Cf. Strong, p. 173(6,7); Dennis, II, pp. 91–2; E. Pais, *Storia dell' Italia antica*, I, p. 177. For varied examples of the more elaborate sarcophagi, cf. Strong, p. 171, 188(48), 189(50); Pallottino, plates 2(a), 4(a,b), 6(a), 10; Cles-Reden, Taf. 33–6; Bendinelli, pp. 86–8, figs. 63, 99, 100, 133, 134, 135, 138–140, 143–4; Panofsky, *Tomb Sculpture*, plates 70, 78, 80, 82–6, pp. 28–30.

212. Ill. 245. Cf. Bendinelli, pp. 186, 188, fig. 144, see also fig. 119; Dennis, II, pp. 411–21; Toynbee, pp. 23–4.

213. On the *lasa* (*lasas*), cf. Grenier, pp. 37–8, 48, 54. For an interesting parallel to the "false door" of the early Egyptian tomb and its accompanying figures, see the Tomba degli Auguri, at Tarquinia: cf. Bendinelli, p. 103, fig. 78. See ill. 168.

214. Ill. 246. Cf. A. Dupont-Sommer, *Les Araméens*, pp. 115–16, fig. 12; Du Ry,

Art of Ancient Near and Middle East, p. 207. For comparison, see also the curious Stele of Tarhunpiyas (eighth century B.C.), from Marash, and now in the Louvre: cf. G. Garbini, *The Ancient World,* p. 104, fig. 74.

215. Dupont-Sommer, p. 116.

216. Cf. Dupont-Sommer, fig. 13 and p. 116; *A.N.E.T.,* p. 504–5. It probably dates from the seventh century B.C. Cf. A. Parrot, *Le "Refrigerium"* pp. 66–8.

217. *Elegy Written in a Country Churchyard,* by Thomas Gray (1716–1771).

218. Ill. 247. Cf. M. A. R. Colledge, *The Parthians,* pp. 154–5, plate 37, see also pp. 40–6; Du Ry, *Art of the Ancient Near and Middle East,* pp. 210–11. See also the colossal statues of protecting deities erected before the tomb mound of King Antiochus of Commagene (69–34 B.C.), plates 29, 31, in Colledge, *op. cit.*

219. Ill. 248. Cf. J. B. Segal, *Edessa, "The Blessed City,"* plates 1–3, see also plate 25(a,b).

220. Cf. Segal, pp. 56–7.

221. Ill. 249. Cf. G. Ryckmans, in *H.G.R.,* IV, illus. on pp. 307, 323–5; Finegan, *Archeology of World Religions,* ill. 212–16; D. Kirkbride, in *I.L.N.,* vol. 237 (Aug. 13, 1960), pp. 202–3.

222. Cf. Ryckmans, *op. cit.,* IV, p. 323b.

223. Ill. 250. Cf. Ryckmans, *op. cit.,* p. 324; Finegan, plate 215 and p. 479.

224. Ill. 251. Cf. Marinatos, *Crete and Mycenae,* plates XXXIV, 162–7 (electrum), pp. 81–2, 90–1, 99, 166; Hafner, *Art of Crete, Mycenae and Greece,* pp. 38, 44.

225. Compare the series of masks illustrated by Marinatos, plates 162–7. Hafner, p. 44, thinks that the masks represent "a given type" rather than individuals.

226. Cf. Marinatos, plates 146, 147, pp. 158–9.

227. Even in the classical period some grave goods were deposited with the dead: cf. *E.R.E.,* IV, p. 474b.

228. Cf. Brandon, *Man and His Destiny,* pp. 160–82. "Il faut, aussi, quand les vieilles idées animistes se sont obscurcies, commémorer le défunt, rappelar son souvenir par une effigie, dresser sur sa tombe un *sēma,*" de Ridder/*Deonna,* p. 68.

229. Ill. 252, 253. Cf. Panofsky, *Tomb Sculpture,* figs. 25–7; Lübke-Pernice, p. 163; J. M. Cook, *The Greeks in Ionia and the East,* pp. 61–3; F. Altheim, *Weltgeschichte Asiens im griechischen Zeitalter,* I, p. 119.

230. Ill. 254. "Der Name der am sog. Harpyienmonument aus Xanthos dargestellten Vogelwesen kann nicht als gesichert gelten, eher sind diese den Sirenen zu vergleichen, denen sie wesensverwandt sind," *Kleine Pauly,* II, 945. Cf. Harrison, *Prolegomena,* pp. 177–8; Panofsky, p. 20.

231. See below, pp. 388–94.

232. Cf. Hafner, pp. 98–9. On the mortuary significance of the snake, see above, p. 150 and n. 57, also ill. 189, 190.

233. Ill. 255a, b. Cf. Panofsky, figs. 28–43; T. von Scheffer, *Die Kultur der Griechen,* Abb. 180–4; Lübke-Pernice, Abb. 239, 295–7, pp. 258–9; Hafner, pp. 202, 221, 224–6; *C.A.H.,* vol. of plates II, pp. 102–5.

234. Ill. 256.

235. Ill. 257.

236. Ill. 258. Cf. C. M. Bowra, *The Greek Experience,* pp. 39–40, plates 38–41, 62–4; *Bilderatlas,* 13/14. Lief (A. Rumpf), Abb. 186–8.

237. Cf. Rohde, *Psyche,* II, pp. 379–80; Guthrie, *The Greeks and Their Gods,* pp. 260–4; Nilsson, *Gesch. d. griech. Relig.,* II, p. 221.

238. Cf. J. W. Mackail, *Select Epigrams from the Greek Anthology*, p. 53 (XXXVIII).

239. Reference might be made in this connection to the relief of the "Mourning Athena" (see ill. 77 and p. 67). It is difficult to identify the nature of the stone pillar or stela which the goddess contemplates in sorrow. If it were a funerary stela, it would seem that an attempt was made to represent the abiding sorrow of Athena's tutelary goddess at the death of her devotees, or perhaps of warriors who had fallen in the defence of her city.

240. Cf. Brandon, *Man and His Destiny*, pp. 184–93 and documentation.

241. Ill. 259. Cf. Lübke-Pernice, pp. 124–6, 288, Abb. 138, 331–2; Hafner, pp. 199–200; F. Norman Pryce, in *Wonders of the Past*, I, pp. 13–17; Cook, *The Greeks in Ionia and the East*, pp. 148–52; Panofsky, pp. 23–4, ill. 50–3; von Scheffer, pp. 299–300, 334; Woermann, *Gesch. d. Kunst*, I, pp. 341, 359–60, Abb. 380, 381; *Kleine Pauly*, III, 1100.

242. See Plato's *Phaedrus*, 248: "Such is the life of the gods; but of the other souls, that which follows a god most closely and resembles him most nearly, succeeds in raising the head of its charioteer into the outer region, and is carried around with the immortals in their revolution, though sore encumbered by its horses . . ."

243. Ill. 260. Cf. *Kleine Pauly*, II, 183: "Kentauromachien sind als myth. Parallelen zum Kampf der Griechen gegen die Barbaren gedacht." See also de Ridder/ Deonna, pp. 100–1.

244. Ill. 261a. Cf. G.-G. Lapeyre/A. Pellegrin, *Carthage punique*, plate V, p. 225. It was found in the nécropole de Sainte-Monique, Carthage, with other anthropoid sarcophagi of Carthaginian *rabs*, and dates from the third century B.C. According-ing to S. Gsell, *Histoire ancienne de l'Afrique du Nord*, IV, p. 209, in the sar-cophagus the skeleton of an old woman was found—"sous la statue de la belle et jeune prêtesse, on a trouvé le squelette d'une vieille femme édentée, aux mâchoires saillantes, au nez gros et large." G. Charles-Picard, *Les religions de l'Afrique antique*, pp. 66–8, thinks that the figure is an image of the goddess Tanit, rejecting the view of M. J. Carpocino (*Mem. Pont. Ac. Arch.*, I, 1921, pp. 109–17) that the statue represents "la morte, mais divinisée et assimilé à la déesse." He admits, however, that such sarcophagi derive from the earlier Phoenician anthropoid sarcophagi (see ill. 261a). The iconographic evidence found in the Punic tombs at Carthage has a great importance for the history of religions: cf. A. L. Delattre, *Carthage: nécropole unique voisine de Sainte-Monique* (deuxième trimestre des fouilles, 1898); *Nécropole des Rabs, Prêtres et Prêtresses de Carthage*, n.d.

245. Cf. Panofsky, figs. 54–9, 89, 90, 98–121, 123–35, pp. 27–38; J. M. C. Toynbee, *Art of the Romans*, plates 55–62, pp. 95–107, 254–6; *C.A.H.*, vol. of plates V, pp. 98–101, 116, 177a, 178–9, 198a, 200–2.

246. Ill. 262. The present cover, with its recumbent image, is a substitute for the lost original, taken from another ancient sarcophagus of similar design. Cf. Panofsky, p. 30. See below, ill. 278 and n. 275.

247. Cf. A.-J. Festugière, "La Mosaique de Philippopolis et les sarcophages au 'Pro-methée,' " *Revue des Arts*, VII (1957), pp. 157 ff. On Prometheus as creator of man, c.f. Brandon, *Creation Legends of the Ancient Near East*, p. 189. For another "Prometheus" sarcophagus, now in the Louvre, cf. Panofsky, fig. 168.

248. Cf. Panofsky, figs. 105–8; I. A. Richmond, *Archaeology, and the After-Life in Pagan and Christian Imagery*, plates III, V. See below, 271.

249. Ill. 263.

250. Cf. Richmond, pp. 34–7; Panofsky, p. 34; Cumont, *After Life in Roman Paganism*, pp. 201–3.

251. This inference is reasonable, but unfortunately it is not certain whether the present cover was the original one.

252. Ill. 264. Cf. Panofsky, figs. 91–4, p. 31; Toynbee, pp. 89–91, *Death and Burial in Roman World*, pp. 245–81.

253. Ill. 265. Cf. L. Curtius/A. Nawrath, *Das Antike Rom*, Taf. 183, p. 64; Panofsky, figs. 95–7; *C.A.H.*, vol of plates IV, pp. 72–3, V, pp. 188–9. The custom of aristocratic Roman families to display masks of their ancestors at a funeral should be noted here: cf. *Kleine Pauly*, II, 1372–3.

254. Ill. 266. There has been, and still continues, much conflict of opinion among the specialists concerned as to which of the many ossuaries, found at various sites, are to be distinguished as Jewish-Christian as opposed to Jewish. P. E. Testa concludes his massive study (*Il simbolismo du guideo-cristiani*): "I guideo-cristiani della Chiesa Madre espressero la loro fede, più che con formule filosofico—teologiche, con simboli e con segni, quasi proiezioni figurative e concrete, e quasi riti sacramentari. Questo simbolismo si espresse con cinque elementi essenziali, cioè con *lettere e-numeri sacri*, con *sigilli della Croce e del Nome* e con *segni nasconti*" (p. 570). See Cap. VIII and Tav. 36–42. Cf. Finegan, *Archeology of the New Testament*, pp. 228–49, see also pp. 216 ff.; D. Fishwick, "The Talpioth Ossuaries Again," in *N.T.S.*, X, pp. 49–61; E. Dinkler, "Kreuzzeichen und Kreuz," in *Jb.f.A.C.*, 5(1962), pp. 93–107, Taf. 4–7.

255. Ill. 267. Cf. Testa, pp. 95–114, Tav. 1–3, 10–15, 18–21, 34–5.

256. Cf. Testa, pp. 570–1; J. Daniélou, *The Crucible of Christianity* (ed. A. Toynbee), pp. 268–9, 276b.

257. On the Resurrection significance of the symbolism, cf. Testa, pp. 334–5, 537.

258. See pp. 164–71.

259. Ill. 268. Cf. L. Hertling/E. Kirschbaum, *The Roman Catacombs and Their Martyrs*, passim; F. Grossi Gondi, *I monumenti cristiani*, pp. 315–96; Van der Meer/Mohrmann, *Atlas of Early Christian World*, pp. 28, ill. 80–97, 557–73; 99–100 (catacombs at Naples).

260. Ill. 269. An interesting reflection of contemporary practice is preserved in the apocryphal *Acts of John* (c. A.D. 150): "On the next day John came, accompanied by Andronicus and the brethren, to the sepulchre at dawn, it being now the third day from Drusiana's death, that we might break bread there" (72), in H. R. James, *The Apocryphal New Testament*, p. 245. The extant evidence suggests that celebration of anniversaries was established by the start of the third century. Cf. Van der Meer/Mohrmann, *Atlas*, ill. 54–61, p. 42; Hirtling/Kirschbaum, pp. 72 ff., 77 ff., 166–7 (which give a well-balanced discussion of the question of the celebration of Mass in the catacombs); Duchesne, *Christian Worship*, p. 284; Parrot, *Le "Refrigerium,"* pp. 155, 158–9; *D.C.C.*, p. 23; *D.C.R.*, p. 294; *E.R.E.*, III, p. 718–19.

261. Cf. *E.R.E.*, IV, p. 456a; R. W. Muncey, *History of the Consecration of Churches and Churchyards*, pp. 109–10.

262. Ill. 268. On the possible Egyptian derivation of the iconography of this scene, cf. A. Hermann, in *Jb.f.A.C.*, 5(1962), pp. 60–9.

263. Ill. 270, 271. Cf. P. du Bourguet, *Early Christian Painting*, plates 8, 26, 38, 40, 42, 44, 45, 62–4, 77, 79, 84, 96, 99, 117, 127, 129; Grossi Gondi, pp. 8–25; Van der Meer/Mohrmann, ill. 86, 89, 90, 557, 558, 560; Th. Klauser, "Studien

zur Entstehungsgeschichte der christlichen Kunst IV," in *Jb.f.A.C.*, 4(1961), pp. 128–45, Taf. 6–10; Grabar, *Beginnings of Christian Art*, ill. 78, 100, 102, 239, 256, 257.

264. Ill. 92, 269. Cf. Van der Meer/Mohrmann, plates 48, 49, 54–61, 396; Grossi Gondi, pp. 26–30; Hertling/Kirschbaum, pp. 236–42.

265. Ill. 272, 273. See the masterly study of the origin and evolution of the "Good Shepherd" and the "Orans" by T. Klauser, in *Jb.f.A.C.*, 1(1958), pp. 22–51; 2(1959), pp. 115–45; 3(1960), pp. 112–33; 7(1964), pp. 67–76; 8/9(1965–6), pp. 126–70; 10(1967), pp. 82–120. He concluded that both figures derived from pagan prototypes (p. 117).

266. Ill. 273. Cf. Grabar, *Christian Iconography*, pp. 75–6, ill. 189, 190, *Beginnings of Christian Art*, pp. 209–10. "Sowohl den Schafträgertypus wie auch den der Orans nahm man wohl von Anfang an auch gerne zuhilfe, wenn es galt, Privatpersonen darzustellen," Klauser, *Tb.f.A.C.*, 10(1967), p. 117. Cf. Grossi Gondi, p. 71.

267. Cf. Grabar, *Christian Iconography*, pp. 75–6. Coptic art provides an exception: the "Orans" posture was frequently used to depict individual persons. See ill. 274a. Cf. K. Wessel, *Coptic Art*, plates 74, 75, 78–80.

268. Cf. Grabar, *Beginnings of Christian Art*, pp. 82–98, du Bourguet, pp. 35–7, ill. 48–52, 57–61, 78.

269. Two notable exceptions, of great significance for interpreting the purpose of catacomb art, which date from the end of the fourth century, are the portrayal of Veneranda's being led by St. Petronilla into Heaven (ill. 274a) and the introduction of Vibia into Paradise (ill. 274d). Cf. Grabar, *Beginnings of Christian Art*, plate 231, p. 211; *Christian Iconography*, p. 15, ill. 32, 33. The latter representation constitutes a curious problem. Although the picture appears in the Christian Catacomb of Praetextatus, Rome, and Grabar refers to it as a Christian painting (*Christ. Icon.*, p. 15), the evidence of other pictures, to which it is related in the hypogea, clearly shows that Vibia was the deceased wife of a man named Vincentius, who was a priest of the cult of Sabazios—a mystery religion of Phrygian origin and Jewish associations. The fresco of the *Inductio* of Vibia into Paradise was the last of a sequence portraying the Rape of Vibia by Pluto (clearly patterned on the Rape of Persephone), and her judgment and vindication before the tribunal of Pluto (see ill. 274b, c). Various explanations have been offered for this pagan burial in a Christian tomb, but no certain conclusion can be drawn. The representation of the *Inductio* of Vibia affords a significant parallel to the introduction of the Christian Veneranda into Heaven. Cf. Gressmann, *Die orientalischen Religionen im hellenistisch-römischen Zeitalter*, pp. 120–3; Cumont, *Les religions orientales dans le paganisme romain*, p. 61–2; W. O. E., Oesterley, in *The Labyrinth* (ed. S. H. Hooke), pp. 151–7; *Bilderatlas*, 9–11. Lief. (J. Leipoldt), Abb. 164–7. See pp. 385 f.

270. Ill. 275. Cf. Van der Meer/Mohrmann, ill. 91–3, 561–8, 574–6; Grossi Gondi, Tav. 1 and 2. "This 'peace' is much more than a mere rest, an absence of strife and pain. It is most properly the union with God, the enjoyment of God's company. The souls of the departed live a real life in this 'peace'," Hertling/Kirschbaum, p. 193, see pp. 192–5. There is undoubtedly a proleptic factor in such statements or pronouncements; for it assumes that the deceased had been justified at a *post-mortem* judgment. On the absence of reference to judgment in this catacomb art, see Part III.

271. Cf. Grabar, *Christian Iconography*, pp. 10–11, 18, 21; Grossi Gondi, p. 252. It

is significant in this connection that, with one possible exception (see ill. 276), scenes of the Passion and Crucifixion of Christ were never depicted in the catacombs. In the exception mentioned, there is a suggestion of victory (see n. 279). It is important to notice a possible "magical" use by early Christians of depictions of "salvation events" in the form of engraved seal-stones set in signet rings. The existence of such seal-stones is attested by Clement of Alexandria (early third century), in his *Pedagogue*, I, iii. 11. See ill. 276. Cf. Klauser, *Jb.f.A.C.*, 4(1961), pp. 139–42, 145. See also Grabar, *Christian Iconography*, pp. 97–8.

272. Cf. Grabar, *Christian Iconography*, pp. 32 ff.; *Beginnings of Christian Art*, pp. 123–9; Panofsky, *Tomb Sculpture*, pp. 39 ff.; Grossi Gondi, pp. 91–101.

273. Ill. 277. Cf. Grabar, *Beginnings of Christian Art*, ill. 130, 132–3, 135, 140, 147–8, 268; Van der Meer/Mohrmann, plates 101, 104, 107, 108, 167.

274. Cf. Grabar, *Beginnings of Christian Art*, pp. 242–64 and illus.; Gough, *The Early Christians*, pp. 172–8; Panofsky, figs. 147–9, 153, 155–7, 159–60, 162–3.

275. Ill. 278a, b. Cf. Grossi Gondi, pp. 102–3; Van der Meer/Mohrmann, ill. 169, see also ill. 34, 171–2, for comparison with pagan Prometheus sarcophagus (ill. 262). Cf. Grabar, *Christian Iconography*, p. 122, ill. 268.

276. Ill. 279a. Cf. Schug-Wille, *Art of Byzantine World*, pp. 44–5; Van der Meer/Mohrmann, ill. 466, 467, p. 143; Grabar, *Beginnings of Christian Art*, ill. 295, 296, pp. 265–9, *Christian Iconography*, pp. 124–5, ill. 297, 298. See below, p. 258. The sarcophagus of Junius Bassus (see ill. 279b), which shows scenes of Christ's trial before Pilate, also presents Christ enthroned in Heaven. See Grabar, *Christian Iconography*, ill. 29.

277. See ill. 278a, b. Cf. Van der Meer/Mohrmann, ill. 163–6.

278. According to Grossi Gondi, pp. 100–1, a variety of causes probably accounts for the lack of inscriptions recording the names of the deceased. As the sarcophagus of Junius Bassus shows, such inscriptions were sometimes carved on the cover or rim of the receptacle.

279. Cf. Panofsky, p. 48. It is interesting to note that the "Doom" of Reims Cathedral represents the dead rising out of antique sarcophagi: cf. J. Fournée, *Le Jugement Dernier*, planche V.

280. Ill. 280a. Cf. J. Beckwith, *Coptic Sculpture*, plate 114, see also plates 78, 115, 118, 123, 127; Wessel, *Coptic Art*, plates 74, 75, 76, 79, 80, 86, pp. 94 ff.

281. On the transformation of the *ankh* into the Christian cross, cf. M. Cramer, *Das altägyptische Lebenszeichen*, pp. 5 ff.

282. Ill. 280b. For a similar memorial of a lady Cresconia, see Panofsky, fig. 175. Cf. du Bourguet, pp. 158, 159: du Bourguet amends the name "Crescentia" to the masculine form of "Crescentius," but the original provides no justification for this.

283. Cf. Panofsky, pp. 51 ff.; Bréhier, *La civilisation byzantine*, pp. 20–4.

284. Ill. 281. Cf. Muncey, *History of Consecration of Churches and Churchyards*, pp. 118 ff. On the overcrowding of cemeteries, cf. Lacroix, *Military and Religious Life in the Middle Ages*, pp. 477 ff.: it is estimated that more than two million persons were buried in the Cemetery of the Innocents, Paris, in the course of six centuries.

285. Ill. 282. Cf. H. Focillon, *Art of the West*, II, p. 55; A. von Borsig, *Die Toscana*, p. 50; Baedeker's *Italy* (ed. 1962), p. 410. The Campo Santo is in significant proximity to the Cathedral and Baptistery at Pisa.

286. Ill. 283, 284, 285. Cf. Panofsky, pp. 50 ff., figs. 192–4, 197–205, 211–18, 277–8,

324, 331, 339, 346, 354–7, 367, 371, 377–85, 387–9, 396, 402–4, 410, 429–38, 440, 442; L. Stone, *Sculpture in Britain: The Middle Ages*, plates 126a, 136, 139(b), 156; H. Trivick, *Monumental Brasses, passim.*

287. Ill. 286. Cf. Panofsky, figs. 213, 214, p. 55; Heer, *Medieval World*, plate 84; Bäuml, *Medieval Civilization in Germany*, p. 250, ill. 50.

288. Ill. 287. Cf. Panofsky, figs. 289, 290, pp. 70–1; Heer, *Medieval World*, plate 50, p. 175.

289. Ill. 288. Cf. Panofsky, pp. 86–7, fig. 403.

290. Cf. Brandon, *Judgment of the Dead*, pp. 14–17. Some catacomb inscriptions do eulogise the dead in stereotyped formulas such as *bene merenti* ("to the well-deserving"); cf. Hertling/Kirschbaum. pp. 191–2.

291. Ill. 289. Cf. Stone, pp. 182, 183, 262(13), plate 137, pp. 62, 81; J. Evans, *English Art, 1307–1461*, p. 179. Above the altar of the chantry chapel, Despenser and his wife were depicted kneeling in adoration before representations of the Trinity and Coronation of the Virgin. Cf. F. H. Crossley, *English Church Craftsmanship*, pp. 106 ff. and illus.

292. Ill. 291. Cf. Panofsky, fig. 251; Wolf/Millen, pp. 202–3. Reference might also be made to the tomb of Philip II of Spain, near the high altar in the Escorial: cf. Lacroix, fig. 362, see also fig. 361 (of the now destroyed tomb of St. Remigiús). Cf. Panofsky, fig. 355a–b.

293. Cf. Panofsky, fig. 191, pp. 50–1.

294. Ill. 292, 293. Cf. Panofsky, figs. 195, 196, 208, 219–22, 225–6, 227, 246–7, 273, 303–11, 327, 332–7, 340–5, 360a–b, 397–9, 403, pp. 55 ff.; Stone, plates 105, 109, 112, 115, 117, 121, 142, 143, 155–7, 170–3; P. Brieger, *English Art (1216–1307)*, plates 76–7; Evans, *op. cit.*, pp. 68, 70–7.

295. Ill. 294a, b. Cf. Panofsky, figs. 256–71, 347–9, 356–8, 364–5, pp. 63–6, 80–1; Stone, plates 168, 178(b), pp. 213–16, fig. 9.

296. Ill. 295a, b. Cf. G. H. Cook, *Mediaeval Chantries and Chantry Chapels*, pp. 121–2; R. D. Reid, *Wells Cathedral*, pp. 61–2; Evans, pp. 158–9, plate 72b; Panofsky, figs. 261, 262, 265, 266a, 269, 331, 348–9, 354. Significant in this connection is the direction given by Isabel, countess of Warwick, in her will, in 1439, for her tomb at Tewkesbury: "And I will that my statue be all naked, with my hair cast backwards, according to the design and model which Thomas Porchalion has for that purpose" (Evans, p. 158). Compare the image of the emaciated Buddha (ill. 296).

297. Trivick, *Monumental Brasses*, pp. 83–4, figs. 212, 213, 216, 225.

298. Cf. J. Huizinga, *The Waning of the Middle Ages*, chap. XI; J. Nohl, *The Black Death*, pp. 134 ff.; T. S. R. Boase, chap. VI ("King Death"), in *The Flowering of the Middle Ages* (ed. J. Evans); P. Ziegler, *The Black Death*, pp. 283–8.

299. Ill. 297. Cf. B. Berenson, *Italian Painters of the Renaissance*, pp. 101–2.

300. Ill. 298, 299. Cf. Mâle, *Religious Art*, pp. 142–50; Huizinga, pp. 144–51; T. A. Cook, *Rouen*, pp. 305–10; T. Tindall Wildbridge, *The Dance of Death, passim*; Réau, *Iconographie de l'art chrétien*, II (ii), pp. 637–55; Lacroix, figs. 369–92; Hofstätter, *Art of Late Middle Ages*, pp. 148–9, 202–3, 209, see also on p. 147 a French ivory carving (c. 1450) representing *Vanitas*; Anderson, *Imagery of British Churches*, pp. 169–73. It is interesting to compare the Christian "Danse Macabre" with the Tibetan Buddhist picture in ill. 299.

301. In the Akkadian myth of the *Descent of Ishtar into the Underworld*, the goddess threatens to bring up the dead from the "Land of No Return," so that they may devour the living, for the dead outnumber the living, cf. *A.N.E.T.*, p. 107(20).

302. Ill. 300, 301. Cf. *Les Très Riches Heures du Duc de Berry* (ed. J. Lougnon and R. Cazelles), p. 82; M. Kay, *Bruegel*, plates 32, 33, p. 37.

303. Ill. 302. Cf. Panofsky, p. 60, fig. 21. On the mediaeval funeral service, cf. A. S. Duncan-Jones in *Liturgy and Worship*, pp. 620–1.

304. See ill. 217.

305. Ill. 303a, b. Cf. Rorimer, *The Cloisters*, pp. 99–100, fig. 44; J. Evans, *English Art, 1307–1461*, pp. 173–84; Cook, *Medieval Chantries*, pp. 6 ff.

306. Ill. 304. A mosaic pavement of a third-century A.D. tomb found at Lambiridi, Algeria, provides a remarkable pagan anticipation of the salvation theme in Christian sepulchral iconography. In the tomb, a Roman lady, Cornelia Urbanilla, had been buried, and her shrouded corpse is depicted in the top section of the mosaic. The central scene shows a nude delibitated male figure seated before an impressive bearded man, who holds the other's hand after the manner of a physician. Below these figures, a Greek inscription reads *ouk ēmēn, egenomēn, ouk eimi, ou melei moi* ("I was not; I came into being; I am no more; it concerns me not"). The cynicism of this inscription, which can be paralleled by other Greek and Latin epitaphs, is probably to be understood in terms of the symbolism of the scene depicted above. This scene is admittedly enigmatic; but there is good reason for thinking that the bearded figure represents the healing-god Asklepios, who was regarded as a divine saviour, able to raise men to a new life. Hence, this funerary mosaic would seem to express faith in a *post-mortem* salvation for Cornelia Urbanilla, through Asklepios. Cf. J. Carcopino, *Aspects mystiques de la Rome païenne*, pp. 207–54.

307. Ill. 305. Cf. Panofsky, figs. 230–4, 236–43, pp. 58–9; Souchal, *Art of Early Middle Ages*, p. 240; Zarnecki, *Later English Romanesque Sculpture*, fig. 41, p. 56.

308. Cf. Brandon, *History, Time and Deity*, pp. 206–10.

1. See ill. 306 for a particularly eloquent example of a votive statue: it shows King Hammurabi of Babylon (*c.* 1792 B.C.) kneeling in adoration before the god Amurru, to whom it is dedicated for the king's life. Cf. Parrot, *Archéologie mésopotamienne*, I, p. 361, plate XI; Frankfort, p. 61, plate 63; *H.G.R.*, I, plate facing p. 400 (here identified as "fidèle agenouillé." See also ill. 27.

2. Cf. Frankfort, *Art and Architecture of the Ancient Orient*, p. 23. "The dedicatory inscriptions of these statues show that they were, in fact, a monumental form of prayer: facing the deity, they explicitly reminded him of the good works done and asked for a prolongation of life," Groenewegen-Frankfort, *The Ancient World*, p. 85.

3. Ill. 307. Cf. Frankfort, *op. cit.*, plates 13–17, pp. 24, 30; Mallowan, *Early Mesopotamia and Iran*, pp. 43–4; Groenewegen-Frankfort, pp. 78 ff.; Garbini, *The Ancient World*, ill. 17, 18, p. 35. The statues appear to have been carefully buried when the earlier temple was rebuilt—evidently they were regarded as the property of the god and so had to be preserved. Cf. Parrot, *Archéologie mésopotamienne*, p. 376. See also Groenewegen-Frankfort, Arrest Movement, pp. 160–1.

4. Cf. Frankfort, *op. cit.*, plates 13–17, pp. 24 ff.

5. Ill. 308. Cf. Mallowan, pp. 46–50, and illus.; R. Pettazzoni, *The All-Knowing God*, pp. 82–4; O. G. S. Crawford, *The Eye Goddess*, *passim*.

6. Cf. Mallowan, p. 48.

7. Ill. 309. Cf. Karageorghis, *Treasures in the Cyprus Museum*, plates XXVIII,

VIII, Votive Iconography, p. 243

XXIX, p. 19; S. Casson, *Ancient Cyprus*, pp. 181–3: according to Casson (p. 184), such votive statues "represent neither the deity worshipped nor the dedicator, but rather an ideal, idealized or actual personality which, to the deity, would be the most welcome representative of the dedicator at the sanctuary."

8. Ill. 310. See the extensive range of examples illustrated in G. M. A. Richter, *Kouroi: Archaic Greek Youths*. On the mounting of these statues, see *ibid.*, pp. 13–14.

9. Ill. 311. According to Dr. Richter (*ibid.*, p. 2), it is clear "that the kouros type was not confined to Apollo but was a favourite expression of the early Greek sculptor, with a variety of meanings. It may represent a god or, more frequently, a mortal—a victorious athlete or a youth who died before his time. . . . That the same type was used for Apollo and mortals is natural when we remember that to the Greeks Apollo was in appearance simply a glorified young man." She accepts that the *kouros* type derived inspiration from Egypt. Cf. de Ridder/Deonna, *L' art en Grèce*, pp. 103–4; Hafner, pp. 89, 90, 92, 97, 110; Boardman, *Greek Art* pp,. 73–6; B. Ashmole, *The Ancient World*, pp. 164–7.

10. Ill. 312a, b. See the selection of examples given by G. M. A. Richter, *Korai: Archaic Greek Maidens*, who concludes, after discussing the meaning of these statues: "That the korai did not represent well-known individuals is indicated by the fact that practically all of them are nameless. On the extant bases only the dedicant, or the artist, or the deity to whom the offering is made is cited. In the few cases where a kore is given a name, as in the Geneleos group . . . she is a young member of a family" (p. 4). Dr. Richter cites an instance of a fisherman dedicating a *kore* to Poseidon after a successful catch. The significance of the hand gestures of the *korai* statues is also uncertain (*op. cit.*, pp. 3–4). Cf. Boardman, *Greek Art*, pp. 76–81; Hafner, pp. 77, 78, 91, 109, 114–16; Ashmole, pp. 167–70: "They are agalmata, objects of delight calculated to please the heart of the goddess as they do those of her human worshippers" (p. 169).

11. Ill. 313. Cf. Richter, *Kouroi*, pp. 26, 27, figs. 9–11; Hafner, p. 87.

12. Many of the statues of Aphrodite were probably of this votive kind (see ill. 79); Cf. W. H. D. Rouse in *E.R.E.*, XII, pp. 641–3.

13. Ill. 314, Cf. *Bilderatlas*, 13/14. Lief. (A. Rumpf), Abb. 137, 139–42; W. H. D. Rouse, *Greek Votive Offerings* (Cambridge, 1902), pp. 217 ff.; *E.R.E.*, VI, pp. 549–50.

14. Ill. 314. Cf. Erman, *Die Religion der Aegypter*, pp. 142–3, Taf. 5.

15. Ill. 316.

16. As, for example, in the Chapelle du Saint-Sang, of *E.R.E.*, VII, p. 112a.

17. Cf. Evans, *English Art, 1307–1461*, pp. 213–16.

18. Ill. 317. Cf. Hofstätter, pp. 246–7. See also the inscription on the fine retable from Teruel, now in the Cloisters, New York: cf. Rorimer, *The Cloisters*, pp. 198–9.

19. Ill. 318. Cf. *The Eighteenth Century* (ed. A. Cobban), ill. 6, p. 283, pp. 294–5 (fig. 2).

20. Ill. 319. Cf. Hofstätter, pp. 206–7.

IX, Sculptured Crosses, p. 250

1. Cf. Stone, p. 10: "The high cross itself is certainly a native form of monument, the adaptation by the Saxons and then by Christianity of the ancient menhir cult

of the Celts." Cf. J. Godfrey, *The Church in Anglo-Saxon England*, pp. 175 ff.; R. H. Hodgkin, *History of the Anglo-Saxons*, I, 362; M. and L. de Paor, *Early Christian Ireland*, pp. 124–6.

2. Cf. D. M. Wilson, *The Anglo-Saxons*, pp. 60–1; Stone, p. 10.

3. Ill. 320. Cf. Stone, pp. 10–14; Hodgkin, I, pp. 362–4, fig. 54, plate 51; Godfrey, pp. 179–80.

4. Ill. 321b.

5. "Heroic, fair/This young knight who was God made bare/
His breast . . ./He climbed the gallows and gave/No second thought, being brave and sure" (Gavin Bone, *Anglo-Saxon Poetry* [1943], p. 58). See below.

6. Ill. 322. Cf. Stone, pp. 10, 13–14; C. Dawson, *Religion and the Rise of Western Culture*, pp. xi–xii.

7. Cf. Hodgkin, I, p. 363.

8. Cf. Brandon, *Jesus and the Zealots*, p. 69, n.5 (with documentation). See also the hymn of Venantius Fortunatus (530–609): "Vexilla Regis prodeunt."

9. Cf. M. Alexander, *The Earliest English Poems*, p. 106. Cf. Godfrey, pp. 176–7, 191–4.

10. Ill. 323. Cf. H. R. Ellis Davidson, *Scandinavian Mythology*, pp. 104, 128, illus. on pp. 115, 120, 121; Stone, pp. 32, 239(7), plate 19a.

11. Cf. F. Henry, *Irish Art* (A.D. 800–1020), pp. 133 ff.; Stone, pp. 26–7. See also *Illus. Regional Guides to Ancient Monuments*, vol. V (North Wales), pp. 18–19.

12. Ill. 325. Cf. Henry, p. 138, plates 76–85, 106; de Paor, pp. 147–9.

13. Cf. Henry, pp. 157 ff.

14. See examples given by Henry, *op. cit.*, plates 7, 65, 66, 70, 76, 87, 93, 101, 102, 103–4, see also the plaques illustrated on plates 8, 45(book), 53, 54, see pp. 162 ff. The depictions of the Last Judgment have a similar hieroglyphic character (see ill. 324).

15. Ill. 326. Cf. *H.G.R.*, III, illus. on pp. 175–82, 185, 187, 188, 191, 193–204, 206, 208–10.

X, Religion and Narrative Art, p. 256

1. Ill. 327. In this sense, the crucifix epitomises the eternal significance of the sacrifice of Christ, which the Eucharist sacrifice represented liturgically. The crucifix, in this context, may be compared with the icon of Osiris, which represented the god as eternally the "dying-rising" god. Cf. Brandon, *Man and His Destiny*, p. 63. See also *R.G.G.*, IV, 654; Hofstätter, pp. 105, 164–5.

2. According to Giedion, *op. cit.*, p. 65, "there are indications that time as we understand it—the chronological sequence of past, present and future, and the erasing of one by the other—had no meaning for prehistoric man. This partly explains the superimposition of animal outlines, one over the other, without obliterating those which lie below. They all exist simultaneously." This inference can well be challenged. At Lascaux, for example, animals seem to be moving from right to left (see ill. 10). Moreover, the illustrations which Giedion gives (pp. 66–7), from primitive art, of pregnant animals and women with the unborn offspring shown inside the bodies surely have a biological rather than a time significance. Byzantine artists also represented the Virgin Mary bearing Christ in her womb; see ill. 328. Cf. Grabar, *Christian Iconography*, pp. 128, plates 304–5.

3. See ill. 279, and Section VII, n. 276 (for documentation). The sarcophagus dates from *c.* 350. It possibly reflects the changing Christian attitude towards Pilate: cf. Brandon, *Trial of Jesus*, pp. 155–6, *Religion in Ancient History*, pp. 266–7.

4. On the *Labarum* and *Chi Rho* monogram, cf. *R.G.G.*, IV, 1105; F. J. Dolger, *Jb.f.A.C.*, 8/9 (1965–6), pp. 47 ff.; *D.C.R.*, p. 404a.

5. It is significant that what is probably the earliest representation of the Crucifixion is a pagan parody of it: see ill. 329. The suspicion with which Christianity was first viewed, as a politically subversive movement, made the Crucifixion of Christ a source of danger and embarrassment to Christians: cf. Brandon, *Trial of Jesus of Nazareth*, pp. 156–8. Cf. H. Leclercq, *La vie chrétienne primitive*, p. 85 (pl. XLIX), Gough, pp. 83–4; P. de Labroille, *La réaction païenne*, pp. 197–9.

6. Cf. Grabar, *Christian Iconography*, pp. 18, 21. See above, p. 217.

7. Ill. 3a, b.

8. Ill. 330a, b. Cf. Frankfort, *Art and Architecture of Ancient Orient*, pp. 33–4; S. Moscati, *Historical Art in Ancient Near East*, pp. 88, 90.

9. On Ningirsu, cf. Dhorme, *Les religions de Babylonie et Assyrie*, pp. 102–3, 129–30; C.-F. Jean, *La religion sumérienne*, pp. 71–81.

10. Ill. 331. Cf. Y. Yadin, *Art of Welfare in Biblical Lands*, pp. 228–41; Lange/Hirmer, p. 493; Moscati, p. 86.

11. Ill. 332. Cf. R. N. Frye, *The Heritage of Persia*, pp. 88–90; Zaehner, *Dawn and Twilight of Zoroastrianism*, pp. 75, 156; R. Campbell Thompson, "The Rock of Behistun," in *W.P.*, II, pp. 554–61.

12. Ill. 333. Cf. R. Ghirschman, *Iran*, pp. 294–5, plate 43(b), fig. 86. See also E. Porada, *Ancient Iran*, pp. 202–7; Du Ry, *Art of Ancient Near and Middle East* pp. 162, 164.

13. Ill. 334. Cf. Bendinelli, *Compendio di storia dell' arte etrusca e romana*, p. 333, figs. 256–8; Toynbee, *Art of the Romans*, pp. 69–71, plate 44; Curtius/Nawrath, *Das Antike Rom*, pp. 55–6, Abb. 143. The column was erected by the Roman Senate, in honour of Marcus Aurelius, between A.D. 176 and 193. "Giove Pluvio, o altra figura soprannaturale alata, gocciolante di poggia, interviene a salvare dalla minacciosa siccità i Romani e a sommergere nell' alluvione l' esercito nemico," Bendinelli, *ibid.*

14. Cf. I. C. Lockhead, *The Siege of Malta, 1565*, pp. 6–7, 58–62.

15. Ill. 335. Cf. Lockhead, pp. 34–5. The first fresco of the series depicts the arrival of the Turkish armada at Malta, which is shown in map form: *ibid.*, pp. 32–3.

16. A striking instance of pictorial assertion by a successful warrior, that the deity had invested with regal power, is to be seen in a rock relief at Naqsh-i Rustem. Ardashir I (A.D. 224–241), founder of the Sassanian dynasty, is depicted receiving the diadem from the supreme Iranian deity, Ahura Mazdah: see ill. 336. Cf. Porada, pp. 202–3.

17. Ill. 337a, b, c, see also ill. 4. Cf. Bonnet, *Reallexikon*, pp. 380–7; Frankfort, *Kingship and the Gods*, pp. 73–4, 105; A. M. Blackman, *Luxor and Its Temples*, pp. 67–70, 163–70; Lange/Hirmer, plates, 30–2.

18. On the Hatshepsut reliefs, cf. Blackman, pp. 163–70.

19. Although Amun is represented, it was in the person of the king that the god visited the queen, as the accompanying text clearly states: "This august god Amūn, lord of the Thrones of the Two Lands, came, when he had made his

mode of being the majesty of this her husband, the king of Upper and Lower Egypt"; cf. Blackman, p. 68.

20. Ill. 4: cf. Brandon, *Creation Legends*, pp. 60–1. On the *ka*, see below, Part III, Section IV, n.5.

21. The pharaohs are often represented as being suckled at the breast of a goddess: see ill. 33. Cf. Posener, *Dictionary of Egyptian Civilization*, p. 170; Blackman, p. 169; *Bilderatlas*, 2–4 Lief., Abb. 62.

22. It is difficult to distinguish any consistent differentiation of location in the series of scenes: e.g., the birth scene seems to imply that the transaction is taking place in this world, except for the representation of the (infant) *ka*, while the two lower registers are filled with deities, presumably existent on another level of being.

23. There are, of course, obvious exceptions as when, for example, Muhammad is represented visiting the next world, to see the fate of the damned (see ill. 386), and also the Buddha: cf. Sugana, *Life and Times of Buddha*, p. 33 (Burmese miniature).

24. Ill. 339. Cf. Rowland, *op. cit.*, pp. 62–5, plates 20–1, 25–7; Coomaraswamy, p. 66, n.1, ill. 53, 104, 140–1; Seckel, pp. 261–6.

25. Ill. 340. Cf. T. Athol Joyce, "Boro Budur: The Soul of Java," in *W.P.*, I, pp. 183–94; Rowland, pp. 260–5: "On entering Barabudur, the pilgrim penetrates the world of the Buddha to read in its reliefs the story of man's journey down the long night of birth and death to ultimate enlightenment with the culmination of the career of its Bodhisattva in the realms of the mystic Buddhas" (p. 262); see also plates 180–2, 184(B); Seckel, pp. 263, 269; Coomaraswamy, pp. 204–5, fig. 353.

26. Ill. 341. Cf. Rowland, p. 236, ill. 119: see also ill. 186.

27. Ill. 342. What is surely one of the most remarkable creations of Hindu religious art is the "Descent of the Ganges" (*Gangāvatārana*) at Mamallapuram, near Madras, dating from the seventh century A.D. It is sometimes known as "Arjuna's Penance." The designer of this mighty essay in "continuous narrative" art utilised a cleft in a great rock wall to portray the mythical origin of the Ganges, according to the *Rāmāyana*, I, 38–44. Water was originally chanelled in to flow down the cleft, through the midst of the medley of figures, divine, human and animal, concerned with the miraculous bringing of the divine river down to earth from heaven. The purpose of this vast essay in iconography was to show how all orders of being are affected by the power (*tapas*) generated by the austerities of an ascetic—in this instance, Bhagīratha, who is represented at two successive phases of his stupendous ascetical exercise that brought the Ganges down to earth. Cf. Zimmer, *Myths and Symbols in Indian Art and Civilization*, pp. 112–21; Rowland, pp. 181–2, plate 114; Coomaraswamy, p. 103; V. Ions, *Indian Mythology*, pp. 106–7, 119 (interpreted as "Arjuna's Penance"); Munsterberg, *Art of India and Southeast Asia*, p. 93.

28. Ill. 343a. Cf. Rowland, pp. 233, 236–7, plates 149–50, 160; Coomaraswamy, pp. 192–3; E. Candler, "Angkor: A Marvel Hidden in the Jungle," in *W.P.*, I, pp. 38–50.

29. Ill. 343b. Cf. Rowland, pp. 233–6, Seckel, p. 56; Coomaraswamy, pp. 192–4.

30. Ill. 344, 345a, b, c; cf. V. Macchioro, *The Villa of the Mysteries in Pompeii* (which contains a foldout giving the complete sequence of scenes); Bendinelli, *op. cit.*, pp. 366–8; Stenico, *Roman and Etruscan Painting*, p. 35, plates 70–5; A.

Maiuri, *La Villa dei Misteri* (ed. 1947), *passim*; G. Zuntz, "On the Dionysiac Fresco in the Villa dei Misteri at Pompeii," *P.B.A.*, XLIX, plates I–VII.

31. For a recent appreciation, see the documentation given by Zuntz in his monograph noted above. To this might be added V. Macchioro, "La liturgia orfica di Pompei," in his *Zagreus: studi intorno all' Orfismo*, pp. 19–168.

32. Cf. *Kleine Pauly*, 2(967), 77–85.

33. Zuntz thinks (p. 190) that the Pompeiian frescoes probably derived from an original series in the royal temple of Dionysos at Pergamon.

34. See ill. 345a, b, c: "this daemon is an intruder; a Roman interpolation in the Greek original," Zuntz (p. 183), who suggests that "the punishing Fury" was a Roman importation as a warning to a Roman bride against "extra-marital sexual relations (p. 197). According to Macchioro, *Zagreus*, p. 125, "La flagellazione era dunque la repetizione della morte di Zagreo." By this ritual (and painful) identification with Zagreus in his passion, the initiate shared in his rebirth—"Chi veniva flagellato nei misteri di Zagreo moriva come lui e rinasceva come lui" (p. 126). M. Brion, *Pompeii and Herculaneum*, pp. 158, thinks that the winged daemon was an acolyte who "wears a theatrical costume, including that pair of wings so often seen on Greek harpies and the Etruscan female spirits associated with funeral cults."

35. There is uncertainty about the position of the original entrance and exit of the chamber. According to R. Herbig, *Neue Beobachtungen am Fries der Mysterienvilla in Pompeji*, p. 14, n.1, and Macchioro, *Zagreus*, pp. 20-2, *The Villa of the Mysteries in Pompeii*, p. 14 and plan 2, the entrance was through the doorway in the longer wall, opposite the window. Zuntz, however, maintains that entrance was intended through the wider doorway, so that the visitor was faced by the representation of Dionysos (*op. cit.*, p. 178). Whatever the true location of the entrance, the visitor instinctively turns to his left, so that the cloaked female figure initiates the ritual movement implicit in the series of frescoes.

36. She has rightly been designated "*La Entrante*." The woman who attires herself is identified by Zuntz as the "Bride," and the richly adorned lady who looks meditatively at her as the "*Domina*" or "lady of the house," whose daughter is the "Bride" (p. 193). Macchioro, *Zagreus*, pp. 56–61, interprets the figure of her toilette as the *sposa mistica* and the pensive lady as a priestess (*sacerdotessa*).

37. Macchioro, p. 64, describes the meal as "L'agape, cioè il pasto lustrale, che precedeva l'iniziazione."

38. There is evidence that Dionysos was worshipped under the form of a kid (*eriphos*), which was one of his titles. Cf. Harrison, *Prologemena*, pp. 594–7; Guthrie, *Orpheus*, pp. 178–9; Macchioro, pp. 69–74.

39. Cf. Zuntz, pp. 182–8. Macchioro, pp. 82–120, believes that the initiate sees in the bowl a revelation that she must be identified with Zagreus in suffering and death, in order to become reborn in him, and thus "diventar baccante."

40. The upper part of the figure of Ariadne has, unfortunately, been destroyed, but the main features of this group can be restored from similar depictions of Dionysos and Ariadne. In terms of the Dionysiac mythology, Ariadne was the prototype of the mortal woman transformed into a goddess through ecstatic union with Dionysos (see ill. 263 above). Cf. Zuntz, pp. 178–9; Macchioro, pp. 463 ff.; *Kleine Pauly*, I, 543–5; I. A. Richmond, *Archaeology and the After-Life in Pagan and Christian Imagery*, pp. 34–6; J. Carcopino, *La basilique*

pythagoricienne de la Porte Majeure, pp. 128–31; N. Brion, *Pompeii and Herculaneum*, p. 158.

41. It would seem that the giant *phallos*, and its revelation in this scene, had been anticipated in the scene of the ritual meal where the priestess appears to be consecrating with her left hand a similarly shaped, but smaller, veiled object. That a sexual factor was involved in the ritual portrayed in the Villa of the Mysteries, and that it was probably a form of sacred marriage (*hieros gamos*), consummated *sub specie Dionysi*, seems to be generally agreed by scholars. The consecration of the veiled *phallos*, as a symbol of communion with Dionysos, at the preparatory ritual meal could constitute an intelligible prelude, in the ritual drama, to what seems to be the agonised unveiling of the giant *phallos*; which, in turn, was to be followed by the flagellation of the neophyte. As noted in the text, the alarm shown by the neophyte at what she sees in the bowl of the Silenus possibly signifies that union with the god involved suffering. Cf. Zuntz, pp. 182, 190, 194, 197; Macchioro, pp. 121–3: "Lo scoprimento del *phallos* era il simbolo della unione sessuale della persona col dio, della iniziazione perfetta concepita come *ierós gámos*. . . ."

42. See n. 34.

43. "La palingenesi, cioè la rinascita della neofita in baccante," Macchioro, p. 130, see also p. 131. Cf. Zuntz. p, 183.

44. Zuntz, pp. 192–3, 199–200; Brion, pp. 158–9.

45. See ill. 217.

46. Brion, pp. 158–9, is of the opinion that the ritual acts were mimed: "The phallus unveiled and the loves of Dionysos and Ariadne mimed before her, the postulant understood the spiritual meaning of the mysteries in which she was participating. . . . She had to go through suffering, perhaps further to identify herself with Ariadne. . . . The flagellator lashed in earnest, hard and unsparingly."

47. Cf. J. Leveen, *The Hebrew Bible in Art*, pp. 10 ff.; E. L. Sukenik, *Ancient Synagogues in Palestine and Greece*, pp. 61–7, fig. 8, plate IX.

48. "In the days of Rabbi Jochanan men began to paint upon the wall, and he did not hinder them." *'Abhōdhāh Zārāh*, Fol. 42c, quoted by Leveen, *op. cit.*, p. 56, see also pp. 12–13.

49. Cf. Leveen, pp. 56–68; J. Neusner, "Judaism at Dura-Europas," in *H.R.*, 4 (1964), pp. 100–1.

50. Cf. Neusner, pp. 91 ff.; M. Rostovtzeff, *Città carovaniere*, pp. 143–5, plates XXX–IV.

51. Ill. 346a, b. Cf. Leveen, pp. 28 ff.

52. Ill. 131. Cf. Leveen, pp. 36–40, who identifies the classical temple as a representation of the restored Temple of Yahweh (pp. 36–7); Grabar, *Beginnings of Christian Art*, ill. 67, 68, 69 (colour reproductions).

53. Ill. 347. Cf. Leveen, pp. 40–4.

54. Ill. 348. Cf. Leveen, pp. 45–8.

55. Ill. 349. For a comparison of the treatment of the subject in Christian catacomb art, see Neusner, *op. cit.*, fig. 5; see also pp. 89–90. Cf. Leveen, pp. 35–6. According to E. R. Goodenough, *By Light, Light*, p. 108, "Moses is presented here somewhat in the character of one of the great founders of new religions of the ancient world, as a canonised and almost deified hero, founder of the Jewish religion; a counterpart in some degree of Buddha and Christ."

56. Divine intervention is similarly shown in the fresco of Elijah and the Valley of Dry Bones. The same device is used in early Christian art: see ill. 268.

57. Ill. 347. Cf. Neusner, pp. 87–9, who presents an interesting contrast between the interpretation of the scene made by Goodenough, based upon comparative material, and that of C. H. Kraeling, who draws chiefly upon rabbinic material. Neusner commends Goodenough's method (p. 102).

58. Notably by Goodenough in vols. IX–XI of his *Jewish Symbols in the Graeco-Roman Period*. Thus in vol. X, p. 205, he writes of the iconographic scheme of the Dura synagogue: "The Jews here, while utterly devoted to their traditions and Torah, had to express what this meant to them in a building designed to copy the inner shrine of a pagan temple, filled with images of human beings and Greek and Iranian deities, and carefully designed to interpret the Torah in a way profoundly mystical."

59. Thus, the true significance of the saving of the infant Moses was that, by divine providence, Pharaoh's daughter unwittingly saved the future deliverer of Israel from the Egyptian bondage. In other words, the real theme of these Dura paintings is the destiny of Israel.

60. See ill. 270, 277.

61. Ill. 350. Cf. Grabar, *Beginnings of Christian Art*, pp. 272–4, ill. 304–8, *Christian Iconography*, pp. 137–8, ill. 333–7; Gough, *The Early Christians*, pp. 179–80, ill. 53–4.

62. Ill. 351. Cf. Brandon, *Trial of Jesus of Nazareth*, p. 158, ill. 20.

63. Ill. 352. The scene to the left of the Sapphira episode is difficult to identify. It possibly relates to the incident recorded in *John* i:35–6, the water indicating the Jordan and the hand in the sky referring to the divine designation of Jesus as the Lamb of God.

64. The carvings on one of the ends of the Brescia *lipsanotheca* (ill. 353) provide a particularly interesting example of an assemblage of scenes and symbols that require a measure of expert interpretation to make their meaning clear. Indeed, there is one symbol, the pair of balances on the right leg of the casket, which is very problematical. It could be interpreted as signifying the Judgment of the Dead. If this were so, it would constitute our earliest iconographic evidence of the weighing of the soul in Christian art. The earliest example known so far is a carved representation of the archangel Michael (*c.* A.D. 450) in the monastery church at Alahan in Isauria (reproduced in Gough, *op. cit.*, ill. 28). As we have seen, there is much evidence of single scenes (e.g., cultic acts and examples of divine salvation) having a magical function, even in Christianity.

65. Ill. 354. Cf. Mâle, *The Gothic Image*, pp. 355–66; Rickert, *Painting in Britain: The Middle Ages*, plates 111–13; Anderson, *Imagery of British Churches*, pp. 129–34, plate 17. Illustrated manuscripts of the Apocalypse contained the text, which helped with the interpretation of the pictures: e.g., see A. G. and W. O. Hassall, *The Douce Apocalypse*, pp. 5 ff.

66. Ill. 355. The legend of St. Theophilus is presented, in vigorous Romanesque sculpture, in the abbey church of Sainte-Marie, Souillac, without an explanatory inscription. Cf. Mâle, *L'art religieux du xiie. siècle en France*, pp. 371, 433–4, fig. 250; Focillon, I, plates 100, 111. The subjects of many paintings and sculptures in mediaeval churches defy identification. See, for example, ill. 356, 357. Another enigma is the foliate head or so-called "Green Man" (see ill. 358). Representations abound in mediaeval churches and were obviously meaningful.

They are often interpreted as symbols of the pagan "Vegetation Spirit"; but there is reason for doubting whether this could explain all examples.

67. Ill. 359–62. Cf. Gough, pp. 180, 260–1; J. Beckwith, *The Andrews Diptych,* pp. 31, 35.

68. Ill. 362. It is significant that on the door of the Holy Sepulchre a relief of Christ raising Lazarus maintains a tradition that starts in catacomb art, as we have already seen. The rotunda, on the top of the Sepulchre, could relate to the Constantinian Church of the Holy Sepulchre. A rotunda also appears in other contemporary depictions of Christ's tomb: see Beckwith, *op. cit.,* ill. 3, 39, 40.

69. Ill. 363. Cf. Kidson, *The Medieval World,* pp. 24–5.

70. Ill. 364. Cf. J.-F. Ruffy, *Les fresques de Giotto à l'Arena de Padoue,* pp. 3–10; Martindale, *Gothic Art,* pp. 187–90; A. Malraux, *The Metamorphosis of the Gods,* pp. 337–8.

71. Ill. 265. Cf. Ruffy, p. 12.

72. In the sense, that is, that a woman had to be found, who was pure enough and willing to become the Virgin Mother of the Saviour of the world. Thus, it could be argued, upon Mary the divine plan for man's salvation once depended. However, in his treatment of the *Protevangelium* legend, Giotto's paintings do not deify the Virgin as much mediaeval art and literature tended to do. Cf. Ruffy, p. 9; Coulton, *Five Centuries of Religion,* I, pp. 138–73; Mâle, *The Gothic Image,* pp. 231–66; MacCullock, *Medieval Faith and Fable,* pp. 102–19; P. Evdokimov, *La femme et le salut du monde,* pp. 207–21.

73. Ill. 366. Cf. Ruffy, pp. 46–8.

74. Ill. 367. Cf. Martindale, pp. 194–7; Berenson, *Italian Painters of the Renaissance,* pp. 88–93—a sensitive appreciation of Duccio's achievement in the *Maestà.*"

75. See ill. 61.

76. The depiction of the subject in this context seems to be unique: Brenk Beat, *Tradition und Neuerung in der christlichen Kunst der ersten Jahrtausends: Studien zur Geschichte des Weltgerichtsbildes,* surprisingly does not notice the fact. Cf. Brandon, *Judgment of the Dead,* p. 119, plate 3; *D.C.R.,* p. 232 ("Descent into Hades").

77. It is significant that Docetism, i.e., the belief that Christ only "seemed" to be crucified, was vigorously rejected as a heresy when it arose in the second century. Cf. Brandon, *History, Time and Deity,* pp. 189–90.

78. Ill. 369. See also ill. 162a, b, 366, 368. Cf. *The Flowering of the Middle Ages* (ed. J. Evans), pp. 237, 288–9; Mâle, *L'art religieux du xiie. siècle,* pp. 406–19, 435–7, *The Gothic Image,* pp. 247–58, 365–89; J. Fournée, *Le Jugement Dernier,* pp. 61–150, plates I–LVI (the study is planned as an exposition of the significance of the presentation of the Last Judgment in the glass of the Cathedral of Coutances); Brenk Beat *op. cit., passim* (particularly valuable for the Byzantine depiction of the Last Judgment); D. Milošević, *The Last Judgment, passim;* Brandon, *The Judgment of the Dead,* chap. V. It should be noted that the traditions of Byzantine art were not conducive to narrative art, the presentation of the Last Judgment being the notable exception. There were, however, local schools that produced vigorous episodic depictions of the life of Christ, of which "The Raising of Lazarus," painted (*c.* 1320) on a wall of the monastery church at Gracanica (Serbia) is an outstanding instance: see Talbot Rice, *Byzantine Art,* ill. 255, also pp. 266–307; Bréhier, *La civilisation byzantine,* pp. 514–15,

523 ff., 532–3 (on the mosaic cycles in the church of Chora [Kahrié-Djami], Constantinople, 534–5, plates XII (Le Recensement devant Quirinus), XIV–XV. See also A.-M. Cocognac, *Le Jugement Dernier dans l'art, passim*.

XI, Illuminated Manuscripts, p. 294

1. Ill. 370. Cf. P. Barguet, *Le Livre des Morts des Anciens Egyptiens*, p. 8. The original Egyptian title for the composition was the "Book of Coming Forth to the Day."

2. Cf. Bonnet, *Reallexikon*, pp. 620–3 ("Pyramidentexte"), 669–70 ("Sargtexte"), 824–8 ("Totenbuch"); Barguet, pp. 8–24; A. Moret, "Le Livre des Morts," in *Au temps des Pharaons*, pp. 199–243.

3. Cf. Budge, *The Book of the Dead*, pp. xli–xlv. Certain coffins, dating from the end of the Eleventh Dynasty, are inscribed with a variant mortuary text known as *The Book of the Two Ways*, which is explained by the illustrated map or plan, painted on them (ill. 371). This map depicts the dangers that face the dead as they journey to Ro-setau, the land of the dead. Two routes are shown, one by land and one by water, but each beset by grisly horrors: cf. Vandier, *La religion égyptienne*, pp. 91–3; Kees, *Totenglauben*, pp. 285–9 ("So schlägt uns das Zweiwegebuch mit seinen Anhängseln die Brücke von Pyramiden und Sargtexten zu Amduat und Pfortenbuch, wie wir sie den Königsgräbern des Neuen Reiches finden," p. 289), 292–3.

4. Ill. 372a, b. Cf. Budge, *The Book of the Dead: Facsimile of the Papyrus of Ani*, Sheet 10.

5. Ill. 373. Cf. Brandon, *Judgment of the Dead*, pp. 28–31; J. Yoyotte, in *S.O.*, IV, pp. 46–50.

6. See pp. 29 f. Cf. Brandon, *History, Time and Deity*, pp. 14–18.

7. Ill. 374. Cf. Barguet, p. 129; Budge, *Book of the Dead*, pp. 288–9; *Papyrus of Ani*, p. 109 (text ed. 1967).

8. The rubric to Chapter 93 reads: "Formula to prevent N. [i.e., the deceased] from being transported by boat eastwards, in the underworld." For Charon, see ill. 258.

9. Cf. Brandon, *Judgment of the Dead*, pp. 28, 29, 37–9.

10. Cf. Brandon, pp. 31–2; Baguet, p. 158; C. Maystre, *Les Déclarations d'Innocence*, pp. 10–12.

11. Cf. Brandon, pp. 32–4; Baguet, pp. 158–64; Maystre, pp. 14–51; J. A. Wilson, in *A.N.E.T.*, p. 34.

12. Cf. Brandon, pp. 37–41.

13. Ill. 375. Cf. Brandon, pp. 30–1; "The Weighing of the Soul," in *Myths and Symbols* (Eliade *Festschrift*), pp. 91–9.

14. See Brandon, p. 47, fig. 4; Budge, *Book of the Dead*, p. 149–50. There are some variations in what is weighed: in the Papyrus of Nebsini the deceased is weighed against his heart; sometimes the figure of the goddess Maat takes the place of her father symbol: Cf. Brandon, p. 204.

15. See ill. 305.

16. See ill. 98.

17. Cf. Brandon, *Judgment of the Dead*, pp. 9–10. See also the author's essay, "The Proleptic Aspect of the Iconography of the Egyptian Judgment of the Dead," in *Festschrift* for Geo Widengren.

18. See W. Y. Evans-Wentz, *The Tibetan Book of the Dead*. Cf. E. Conze, *Buddhist Scriptures*, pp. 221 ff.

19. Cf. Brandon, "The Ritual Technique of Salvation," in *The Saviour God* (E. O. James *Festschrift*), pp. 19–28.

20. Evans-Wentz subtitled his edition "The After-Death Experiences on the *Bardo* Plane, according to Lāma Kazi Dawa-Samdup's English Rendering." *Bardo Thödol* means literally "Liberation by Hearing on the After-Death Plane" (Evans-Wentz, p. 2). According to the ancient Egyptian view of human nature, the physical body was essential for *post-mortem* existence, and this life was definitive: cf. Brandon, *Man and His Destiny*, pp. 37–69.

21. See the list of illustrations in the manuscript used in Evans-Wenzt's edition: *op. cit.*, pp. 68–71; the frontispiece gives an example of the nature of the drawings (see also p. xxvii). The picture printed in Evans-Wenzt's edition of the Tibetan conception of the Judgment of the Dead (see ill. 376) was made in 1919 for Evans-Wentz in Gangtok, Sikkim, "in strict accord with monastic tradition" (see pp. xxx–iii, and 37–9). Cf. D. L. Snellgrove, in *D.C.R.*, pp. 613–16.

22. Ill. 377b. Cf. Brandon, *op. cit.*, chap. 9 and 10.

23. The earliest known Christian book illustrations date from the fifth century and come from a codex of the *Book of Kings*, called the *Quedlinburg Itala*. The oldest illustrated codex of the Gospels is the Rossano Codex (see ill. 378a): cf. Van der Meer, *Early Christian Art*, pp. 111–12.

24. Cf. S. Mitchell, *Medieval Manuscript Painting, passim*, J. Beckwith, *Early Medieval Art*, pp. 30 ff.; R. Hicks, *Carolingian Art*, pp. 95–122.

25. Ill. 378b. Cf. *Guide to the Exhibited Manuscripts, Part III*, in the Greenville Library, British Museum, p. 28, item 82.

26. Ill. 379. Cf. *Guide to Exhibited Manuscripts*, Part III, p. 31, item 102.

27. Ill. 380. Cf. Mitchell, ill. 22, 81, 121, 122.

28. On the significance of this feature, see Part III.

29. Ill. 381. Cf. *Les Très Riches Heures du Duc de Berry* (ed. J. Longnon *et al.*, illus. 91 (Hell), see also the illustration of Purgatory (illus. 100), a subject comparatively rarely illustrated.

30. For another macabre depiction in this *Book of Hours*, see above, ill. 301; see also in *op. cit.*, ill. 77, 80, 86, 90, 138. Cf. Porcher, *The Rohan Book of Hours*, plate 8; Mitchell, ill. 81, 141.

31. Ill. 382a, b. Cf. T. S. R. Boase, in *The Flowering of the Middle Ages* (ed. J. Evans), p. 244; Hofstätter, p. 194; *R.G.G.*, I, 609–10; Huizinga, pp. 147 ff.; Reau, *Iconographie de l'art chrétien*, I, pp. 655–7.

32. This is necessarily a subjective impression, based upon a variety of considerations, not all of them being of a specifically iconographic kind. In process of time, in both Catholic and Protestant art, depictions of God the Father, the Judgment of the Dead and Heaven and Hell inevitably passed out of fashion. Indeed, the abandonment of these subjects in Christian art has proceeded *pari passu* with a reluctance to deal with such themes in Christian theology and homiletics. There has, correspondingly, been a greater concentration on the life of Jesus (see ill. 383). However, many Christian hymns still evoke vivid visual images about these doctrines. An important aspect of the present *malaise* that affects Christianity is that its doctrines involve a srongly anthropomorphic imagery, which found expression in a rich iconography that now causes embarrassment. Sometimes modern artists will boldly resort to the traditional imagery: for example, in the new Coventry Cathedral (see ill. 384). Cf. *R.G.G.*, IV, Taf. 62–8; J. P. Martin, *The Last Judgment in Protestant Theology*.

33. Cf. Grube, *The World of Islam*, pp. 11–12. The representation of human figures did occasionally occur: see, for example, those carved on a *mihrab* of an eleventh century mosque in Mosul in Talbot Rice, *Islamic Art*, p. 98, ill. 95. There is no specific condemnation of the portrayal of living forms in the *Qur'ān*, but certain sayings attributed to Muhammad in the *Hadīth* have been so interpreted. Cf. *D.C.R.*, pp. 100–1.

34. Cf. E. Dermenghem, *Muhammad and the Islamic Tradition*, illus. on pp. 14, 15, 19, 32–4, 37, 43, 45, 48, 53, 55, 72, 97–100, 105, 108, 115, 116, 119, 121, 125–6, 128, 149, 168–9, 171—these illustrations afford a valuable insight into Islamic iconography: they mainly depict episodes from the life of Muhammad, including five from the Edinburgh MS of the *Jami'al-Tawarikh*; *H.G.R.*, IV, illus. on pp. 337–41, 343, 349, 350, 353 (an interesting Turkish depiction of Paradise), 369; M. Soulah, *L' Islam et l'évolution de la culture arabe*, illus. on pp. 27, 33, 59— modern Algerian depictions; Grube, ill. 31, 35, 53, 58, 59, 69, 70, 78; Sugana, *Life and Times of Muhammad*, numerous illustrations from various MSS; Talbot Rice, *Islamic Art*, pp. 117, 218, ill. 113, 114, 117, 221.

35. Ill. 385, 386.

36. Ill. 387.

37. Cf. Coomarswamy, *Rājput Painting, passim, History of Indian and Indonesian Art*, pp. 127–40; Rowland, pp. 202–6.

38. Ill. 388. See also the interesting Kāngrā picture of Krishna subduing Kāliliya: cf. Rowland, plate 133; Coomarswamy, *History of Indian and Indonesian Art*, plate 268. See ill. 389a, b.

39. Cf. Seckel, *The Life and Times of Buddha*, pp. 272 ff.

40. Cf. Sugana, *ibid.*, p. 67.

41. Ill. 390.

XII, Ritual Vestments, p. 312

1. Ill. 391. Cf. Dhorme, pp. 199–200, 215: the king also made his offerings to the deity naked; Jean, *La religion sumérienne*, pp. 146, 205, 212, n.6, plates 90, 91, 92; Mallowan, p. 58.

2. See I *Sam.* xix:24; *Isaiah* xx:2 ff.

3. Ill. 140, 143; cf. J. Hawkes, *Dawn of the Gods*, pp. 90, 110; Picard, *Les religions préhelléniques*, pp. 75, 159–60, 194.

4. Cf. *D.C.R.*, p. 475.

5. It is instructive to review the practice of Protestant churches in the matter of liturgical dress. Many Protestants, who rejected the Catholic vestments at the Reformation, adopted a black gown, with various adjuncts, for their ministers at divine service.

6. Ill. 11, 217. Cf. Bonnet, *Reallexikon*, pp. 606–7 (who notes the distinctive breast-ornament worn by the high priest of Memphis), 697–8 ("Sempriester"), 581–2 ("Panther"—Bonnet thinks that the panther skin had some deeper meaning than that of its being a survival of a primitive form of dress; but he refrains from defining that meaning after surveying much relevant data); S. Sauneron in *Dictionary of Egyptian Civilization* (ed. G. Posener), pp. 223–5. See n.49 below.

7. Ill. 7. Cf. Bonnet, pp. 607–8, 719–20.

8. Ill. 392. Cf. Warde Fowler, *Religious Experience of the Roman People*, pp. 180, 195(35); Harrison, *Prolegomena*, p. 522.

9. Ill. 392. Greek priests often wore wreaths when officiating, and in some cults donned garments and masks to impersonate deities. The Roman priesthoods

wore various insignia: e.g., the flamines put a short red cloak over the *toga*, and, when sacrificing, the *galerus* made of the skin of a sacrificial victim; the Flamen Dialis wore a cap surmounted by a olive twig. Cf. *O.C.D.*, pp. 729–30; Warde Fowler, *Religious Experience of the Roman People*, pp. 176–8, 180, 194 (22, 24), 195(35); *E.R.E.*, X, pp. 306, 328–9.

10. Cf. A. C. Bouquet, *Hinduism*, pp. 39–41, Dubois/Beauchamp, *Hindu Manners, Customs and Ceremonies*, pp. 117–18. See the important study of Indian textile symbolism by S. Kramrisch in *Myths and Symbols* (Eliade *Festschrift*), pp. 41–5.

11. See ill. 25, also 26.

12. Cf. *E.R.E.*, I, pp. 495–6, 520–1.

13. See ill. 95, 82a, b, 393a. Cf. Frankfort, *Art and Architecture of Ancient Orient*, p. 94b. R. Eilser, *Man into Wolf*, pp. 33, 130–6; Vaillant, *The Aztecs of Mexico*, plates 57–8, 60–1. On the Mithraic masks (*simulacra*), cf. L. A. Campbell, *Mithraic Iconography and Ideology*, pp. 304–14, fig. 21. See ill. 393a for *archigallus* of cult of Cybele in female attire: cf. Carcipino, *Aspects mystiques de la Rome païenne*, pp. 76–7.

14. Cf. Rowley, *Worship in Ancient Israel*, pp. 50–1; Lods, *Israël*, pp. 312–13.

15. *Exodus* xxxix:1.

16. *Exodus* xxxix:6–7. Considerable mystery surrounds the origin and nature of the ephod in Hebrew literature. It seems to have been a means of divination or connected with some form of oracle, possibly with the equally mysterious Urim and Thummim: cf. Lods, *op. cit.*, pp. 499–500 (perhaps the best summary): Pederson, *Israel*, III–IC, p. 224; Rowley, *op. cit.*, pp. 66–8; *E.J.R.*, pp. 129–30.

17. *Exodus* xxxix:8–21. Cf. *H.D.B.*, p. 113. According to *Exodus* xxviii:30, Moses is instructed: "And in the breastpiece of judgment you shall put the Urim and Thummim . . . thus Aaron shall bear the judgment of the people of Israel upon his heart before the Lord continually."

18. *Exodus* xxxix:22–6.

19. E.g., see the fate of the unfortunate Uzzah, who accidentally touched the Ark of Yahweh: II *Sam.* vi:6–9. Cf. Pederson, III–IV, pp. 267–71; T. H. Gaster, *Myth, Legend and Custom in the Old Testament*, pp. 263 ff.

20. xxxix:27–31; cf. xxviii:36–8. Cf. *H.D.B.*², p. 666.

21. Something of what was imagined to be the consequences of permitted contact with Yahweh is given in *Exodus* xxxiv:29–35, where Moses' face radiated a blinding light after his descent from Mount Sinai.

22. Cf. W. Wirgin and S. Handel, *History of Coins and Symbols in Ancient Israel*, pp. 200–1.

23. Josephus, *Jewish Antiquities*, ill. 184–7, *Jewish War*, V: 229–36. On the significance of Josephus and his writings, cf. Brandon, *Religion in Ancient History*, chap. 20.

24. *Ant.* III: 184–7. He explains the golden bells and pomegranates as signifying thunder and lightning (*War*, V: 231).

25. *Ant.* III: 214–18. On the problematical Urim and Thummin, which appears to have been some means of divination, cf. *H.D.B.*², pp. 1019–20.

26. Cf. Brandon, *Fall of Jerusalem and the Christian Church*, pp. 164–6.

27. Cf. Brandon, *Jesus and the Zealots*, pp. 80–1, 101–2, 103.

28. Josephus also gives an account of the vestments of the ordinary priests (*Ant.* III: 151–8).

29. See ill. 383: Holman Hunt has depicted the Jewish rabbis in the Temple wearing the *tallit*. Cf. *E.J.R.*, p. 372.

30. Cf. *D.C.C.*, p. 1415; *R.G.G.*, I, 343–5; Duchesne, *Christian Worship*, pp. 379–80.

31. Ill. 384. Cf. Van der Meer/Mohrmann, ill. 455, p. 141; Grabar, *Byzantium*, plate 171, where Maximianus and the deacons are shown in the retinue of Justinian. See also the interesting mosaic depiction of Pope John IV, and St. Venantius (c. 640), in the Baptistery of St. John Lateran, Rome: cf. Chatzidakis/Grabar, *Byzantine and Early Medieval Painting*, ill. 106. Cf. Van der Meer, *Early Christian Art*, ill. 14, 40–2, pp. 133, 141–3.

32. Cf. Duchesne, pp. 379–81, 384–90.

33. Cf. Duchesne, p. 381; *D.C.C.*, pp. 29, 268–9.

34. Ill. 395a, b. Cf. F. H. Bäuml, *Medieval Civilization in Germany, 800–1273*, plate 7 a, b; *The Dark Ages* (ed. D. Talbot Rice), ill. 17, p. 306.

35. See ill. 16. Cf. Lacroix, p. 225, fig. 186; *D.C.C.*, pp. 44, 561, 849, 1294; Duchesne, pp. 390–4; Fortescue/O'Connell, *Ceremonies of the Roman Rite Described*, pp. 11–12.

36. See ill. 102. Cf. *D.C.C.*, pp. 370, 1380; Duchesne, pp. 382–3; Fortescue/O'Connel, pp. 12, 14.

37. See ill. 281. Cf. *D.C.C.*, p. 341.

38. See ill. 286. Cf. *D.C.C.*, pp. 174b, 357, 909, 1167; Fortescue/O'Connell, p. 15; Duchesne, pp. 397–8.

39. Cf. Duchesne, p. 398 (on the *traditio* of vestments at ordination); *D.C.C.*, p. 1415b.

40. Ill. 396. Cf. *Opus Anglicanum* (Catalogue of Exhibition in the Victoria and Albert Museum, 1963), plates 1–24; on the Syon Cope, pp. 23–6; Rickert, *Painting in Britain: The Middle Ages*, pp. 151–2, ill. 135–9, *D.C.C.*, pp. 313–14 ("Colours, liturgical").

41. Cf. *D.C.C.*, p. 1415b.

42. Ill. 397; see also ill. 34, 50, 210. Cf. Bonnet, *Reallexikon*, pp. 394–5, 844–7 ("Uräus"); Frankfort, *Kingship and the Gods*, pp. 20, 107–9; Gardiner, *Egyptian Grammar*, pp. 491–2.

43. Ill. 397. Cf. Bonnet, pp. 211–12 ("Geissel"), 400–1 ("Krummstab").

44. Ill. 40, 80, 375. Cf. Moret, *Le Nil et la civilisation égyptienne*, pp. 90–2, 98–9; Gwyn Griffiths, *Origins of Osiris*, pp. 86–9.

45. Cf. Gardiner, *Egyptian Grammar*, p. 495 (38).

46. Cf. Mercer, *Religion of Ancient Egypt*, pp. 137–40, fig. 27.

47. Ill. 40, 80, 375. Cf. Gwyn Griffiths, pp. 53–4.

48. Ill. 86. Cf. Westendorf, pp. 84–5; Frankfort, *op. cit.*, pp. 83–8, figs. 24–6.

49. See ill. 217. Cf. Bonnet, pp. 581–2 (the panther was associated with the goddess Mafdet and Seschet—but the true ritual significance of the panther skin remains obscure), 697–8.

50. Cf. K. Goldammer, "Die Welt des Heiligen im Bilde des Gottherrschen," in *La Regalità Sacra*, pp. 514–19.

51. Cf. J. B. Aufhauser, "Die sakrale Kaiseridee in Byzanz," in *La Regalità Sacra*, p. 536; L. Bréhier, *Les institutions de l'empire byzantin*, pp. 8–12.

52. Ill. 398, see also ill. 154. Cf. Bréhier, pp. 12–16, 54–6, 85–8; Aufhauser, 537–41; F. Heiler, "Antikes Gottkönigtum im Christentum," in *La Regalità Sacra*, pp. 563–7; Talbot Rice, *Byzantine Art*, ill. 396, 413 (showing the crowning of the emperor Romanos and his empress Eudoxia by Christ).

53. Cf. Heiler, *op. cit.*, 567–80, see also M. Maccarrone, "Il sovrano 'Vicarius Dei' nell alto medio evo," in *La Regalità Sacra*, pp. 581–94.

54. See ill. 8. Cf. L. G. W. Legg, *Liturgy and Worship* (ed. W. K. L. Clarke and C. Harris), pp. 691–2, 694–5, 700–2; L. Rogier, "Le caractère sacré de la royauté en France," in *La Regalità Sacra*, pp. 610, 616–19.

55. Ill. 399. Cf. Legg, *op. cit.*, pp. 694–6. See also photographs of coronation of Elizabeth II in L. E. Tanner, *The History and Treasures of Westminster Abbey*, pp. 1, 105–24. For a mediaeval representation of the English monarch crowned and enthroned, see the portrait of Richard II (fourteenth-century) in Westminster Abbey: cf. Rickert, ill. 162.

56. Cf. M. Granet, *La pensée chinoise*, pp. 341, 361–89; J. Needham, *Science and Civilisation in China*, II, pp. 21–6.

57. Cf. W. E. Soothill, *The Hall of Light*, pp. 26, 114–15; D. H. Smith, "Divine Kingship in Ancient China," in *Numen*, IV(1957), pp. 172–6, 185–8, 200–3.

58. Ill. 400. Quoted from the *Book of Yü* in Legge's translation; cited by Soothill, pp. 196–7.

59. Ill. 401 (on Taoism, cf. M. Maspero, *Les religions chinoises*, pp. 49–63; Fung Yu-Lan, *Short History of Chinese Philosophy*, chaps. 6, 9, 18; D. H. Smtih, *Chinese Religions*, chap. 9. On the Chinese dragon, cf. Smith in *Numen*, IV, pp. 194–5, in *D.C.R.*, pp. 245–6.

1. See ill. 25, 46.

2. Sachs, *Histoire de la danse*, p. 8.

3. Sachs, pp. 38 ff., 47 ff.

4. Sachs, pp. 38–76. The indices under Dance-Dances-Dancing in the volume of *Bibliography and General Index* to Frazer's *Golden Bough* are instructive of the range and variety of the subject. Cf. G. van der Leeuw, *Sacred and Profane Beauty*, pp. 11–72, *La religion*, pp. 366–8.

5. Ill. 402. Cf. Emery, *Archaic Egypt*, pp. 74, 75, 108–9, 123, fig. 37; Bonnet, pp. 158–60; Frankfort, *Kingship and the Gods*, pp. 79–88, ill. 26; E. Uphill, "The Egyptian Sed-Festival Rites," in *J.N.E.S.*, XXLV(1965), pp. 365–83.

6. See ill. 345a, b, c.

7. Ill. 403. Cf. J. Harrison, *Prolegomena*, pp. 388–400; *Kleine Pauly*, III, 899–901; P. Devambez, *Greek Painting*, ill. 95, 126; van der Leeuw, *Sacred and Profane Beauty*, pp. 61–6.

8. Ill. 404. Cf. *E.R.E.*, IV, pp. 641–3; Dermenghem, *Muhammad*, pp. 168–71; *Man, Myth and Magic*, vol. 2, pp. 622–4 (illus.); Sachs, pp. 23–4.

9. Cf. A. Métreau, "Sorcellerie, magie blanche et médicin dans la religion du vodou," *R.H.R.*, 144 (1953); M. Deren, *Divine Horsemen: The Living Gods of Haiti*, passim; *Man, Myth and Magic*, vol. 2, illus. on pp. 773, 774.

10. Cf. *Man, Myth and Magic*, vol. 2, pp. 522–3 ("Corybantes"), 591 (illus.); vol. 3, 1345 (illus.), 1352.

11. See pp. 29–36, 350–2.

12. *Ancient Art and Ritual*, pp. 101–17, *Prolegomena*, pp. 436–44.

13. Cf. MacCulloch, *Medieval Faith and Fable*, pp. 256–9; *Man, Myth and Magic*, vol. 2, pp. 599–600.

14. See ill. 36. Cf. Zimmer, *Myths and Symbols in Indian Art and Civilization*, pp. 151–7; A. Gaur in *S.O.*, VI, pp. 317–18.

15. Ill. 405, see also ill. 100. Cf. pp. 82 f. above. Cf. Gaur, *op. cit.*, pp. 319 ff.; Munsterberg, *Art of India and Southeast Asia*, pp. 10–11, 14, 20–1, 130–1.

XIII, Ritual Dance. p. 326

16. See the theophany passage in the *Bhagavadgītā*, XI, 25 ff. Cf. Zimmer, pp. 36–7; Brandon, *History, Time and Deity*, pp. 31–7. Akhenaten in his *Hymn to the Aten* almost identifies the life of Nature with that of the Sun (*Aten*): cf. *A.N.E.T.*, pp. 367–9.

17. Cf. Sachs, pp. 74–6; Frazer, *The Magic Art*, II, pp. 48, 65 ff., 106; VII, pp. 95 ff., 307, VIII, pp. 326 ff.; Du Ry, p. 78.

18. Cf. H. Wild, in *S.O.*, VI, p. 50. On the Egyptian word for dance *ꞽbꜣw* and its alternative uses, cf. Erman/Grapow, *Wörterbuch*, I, p. 62. For the determinative sign of *ẖbꞽ* (dance), cf. Gardiner, *Egyptian Grammar*, p. 438.

19. See n.5.

20. See ill. 97. Cf. Bonnet, *Reallexikon*, pp. 149–53 ("Dedpfeiler").

21. Cf. Wild, *S.O.*, VI, pp. 45–8; Uphill, *op. cit.*, p. 380. Through its Osirian association the *djed* column also symbolised the resurrection of Osiris from death and his victory over the evil Set.

22. Cf. Wild, p. 105, n.37.

23. "Ces hommes, apparement, miment un épisode de la légende osirienne, à savoir la lutte des partisans d'Osiris et de Seth, comme cela se passait à Abydos au cours de la représentation des mystères," Wild, p. 47.

24. Cf. Bonnet, pp. 766–7; Wild, p. 42.

25. Cf. Wild, p. 58, 65 ff.; Bonnet, p. 766.

26. Cf. Wild, pp. 61–2; II *Sam.* vi:12–23.

27. Cf. A. Caquot, in *S.O.*, VI, pp. 126–7: "La danse est effectuée en un état rituel de quasi-nudité. . . . Une telle tenue souligne le caractère érotique de la danse et le sens général du culte dont elle fait partie. Le châtiment de Mikal, sa stérilité, indique également qu'il s'agit d'un culte de fécondité" (p. 127).

28. *Exodus* xxxii:19. The passage is probably a veiled polemic against the Yahweh cult, centered on bull images, established by Jeroboam I at Bethel. Cf. Caquot, *op. cit.*, pp. 123–4. In this passage, dancing as such is not condemned, and there is an abundance of evidence that dancing was regarded as a right and proper way of serving Yahweh—e.g., *Psalm* 149:3: "Let them praise his name with dancing, making melody to him with timbrel and lyre!" Oesterley explained the absence of reference to dancing in the ritual prescriptions of the Torah as due to its pagan origins (*Sacred Dance*, p. 33); but, as Caquot points out (*op. cit.*, p. 121), the silence is more probably due to the fact that dancing was not a specialist activity, but an accepted spontaneous expression of popular worship.

29. Chiefly in the form of distinctive hair styles: cf. A. Erman/H. Ranke, *Aegypten und aegyptisches Leben im Altertum*, pp. 279–83, Abb. 119–22. These authors illustrate a ball-dance performed by girls depicted in a tomb at Beni Hasan: *op. cit.*, Abb. 119. See also Lang/Hirmer, *Egypt*, plates 168–9, 170.

30. Ill. 406a, b. Cf. Erman/Ranke, p. 282, Abb. 122.

31. Cf. Lang/Hirmer, *Egypt*, p. 415; Wild, pp. 69–72. "A la puissance de la mort, la culture extravertie oppose le charme vital. En présence même de la Grande Dompteuse, elle s'assure par ses danses la procréation et la vie nouvelle" (p. 62).

32. Ill. 406b. One group is appropriately called "Under the Feet." The other group is named "The Wind"—it possibly represents the crops bending under the wind, to rise again. Cf. Erman/Ranke, p. 282.

33. See pp. 175 ff. It is significant that figures of women performing what seems to be a funerary dance are carved on the sarcophagus of King Ahriman of Byblos (tenth century B.C.): cf. Du Ry, p. 197. For other scenes of dancing in Etruscan tombs, see ill. 238, and Stenico, *Roman and Etruscan Painting*, ill. 12, 36, 40, 43, 62.

34. Cf. J. A. Wilson, in *A.N.E.T.*, pp. 18 ff.; Erman, *Literature of the Ancient Egyptians*, pp. 14 ff.
35. Cf. Brandon, *Man and His Destiny*, pp. 45–6.
36. *A.N.E.T.*, p. 21a.
37. Ill. 408. Cf. Kees, *Totenglauben*, p. 114; Wild, pp. 91–8.
38. "Il faut donc s'imaginer les danseurs *Mouou* comme des mimes, tenant le rôle d'émissaires de la divinité de l'au-delà" (Wild, p. 93). Cf. Bonnet, pp. 767–8.
39. Cf. *Man, Myth and Magic*, vol. 3, pp. 1267–8 ("Helston Furry Dance"); vol. 2, pp. 587–97 ("Dance," illus.).
40. Cf. van der Leeuw, *Sacred and Profane Beauty*, pp. 32–8, 50–3, 66–74.

<p style="text-align:right">**XIV, Incense,**
p. 332</p>

1. Cf. E. O. James, *Origins of Sacrifice*, pp. 256 ff.; *D.C.R.*, pp. 545–7.
2. The ritual use of incense is attested in the *Pyramid Texts*: e.g., Utterances 25, 200. Cf. Faulkner, *Ancient Egyptian Pyramid Texts*, I, p. 5; Piankoff, *The Pyramid of Unas*, p. 58.
3. Plutarch, *de Iside et Osiride*, 357.
4. Cf. Bonnet, *Reallexikon*, pp. 624–6 ("Räucherung"), 871 ("Wohlgeruch").
5. See ill. 52. Cf. Vandier, pp. 176–8; Erman, *Die Religion der Aegypter*, p. 177: "Zunächst das Räuchern, ohne das sich der Aegypter einen Kultus überhaupt nicht denken konnte, den der Duft des Weihrauches reinigte und heiligte den Raum; nennt man doch den Weihrauch einfach *den Göttlichmacher*."
6. Cf. Budge, *The Book of Opening of the Mouth*, II, pp. 5–10; Erman/Ranke, *Aegypten*, Abb. 163. On the use of frankincense (*libanōtos*) in mummification, see Herodotus, II, xi.10. An interesting reference to the mortuary use of incense occurs at the end of the Akkadian myth of Ishtar's Descent into the Underworld: "May the dead arise and smell the incense"; *A.N.E.T.*, p. 109a.
7. Cf. *E.R.E.*, VII, pp. 201–5; *R.G.G.*, VI, 1571 ("Weihrauch"); Furlami, *Riti babilonesi e assiri*, p. 13: "Perciò in quasi tutti sacrifici mesopotamici era indispensabile l'incensiere e senza la fiamma e il fuoco dell' incensiere non era quasi conceptibile sacificio"—see p. 108; Meissner, II, pp. 76–7, 84–6.
8. Cf. *E.R.E.*, VII, p. 203–4.
9. *Exodus* xxx:34: Cf. Rowley, *Worship in Ancient Israel*, pp. 84–6.
10. *Lev.* x:1–3.
11. Cf. W. H. C. Frend, *The Donatist Church*, pp. 4, 8; J. Lebreton/J. Zeiller, *History of the Primitive Church*, IV, p. 648.
12. Cf. C. Clemen, *Religionsgeschl. Erklärung d.N.T.*, p. 195; E. Klostermann, *Das Matthäusevangelium*, pp. 16–17.
13. Cf. Charles, *Revelation of St. John*, I, pp. 226–31. See ill. 408(X).
14. Cf. Fortescue/O'Connell, *Ceremonies of Roman Rite*, pp. 449–51.
15. Cf. Fortesque/O'Connell, pp. 95–9.
16. Cf. Duchesne, *Christian Worship*, p. 412.
17. Cf. Fortesque/O'Connell, pp. 339–44. The most spectacular use of incense is doubtless to be found in the use of the *Botafumiero* in the Cathedral of Santiago de Compostela. This hugh censer is suspended from the roof and is swung in an arc that traverses the two transepts of the cathedral.
18. On the various materials used for incense, cf. *E.R.E.*, VII, p. 201.
19. In Zoroastrian eschatology, after death the just smell a fragrant breeze and the unjust a foul wind: cf. Brandon, *Man and His Destiny*, p. 284.

PART THREE

I, Themes, p. 339

1. Pp. 26 ff.

II, Palaeolithic Art and Ritual, p. 341

1. A reasoned case for complete personal annihilation seems first to have appeared in the West in the teaching of Epicurus (342–271 B.C.), and was anticipated by some two centuries by the Buddha in India: cf. Brandon, *Man and His Destiny*, pp. 179–80, 340 ff.

2. Ill. 9; pp. 134 f.

3. Cf. Mainage, *Les religion de la Préhistoire*, p. 188; James, *Prehistoric Religion*, p. 28; Breuil/Lantier, *Les hommes de la Pierre Ancienne*, p. 307; V. G. Childe, *Progress and Archaeology*, p. 80.

4. Another possibility might be that red pigment was applied to the corpses of those who had lost much blood in death.

5. Cf. James, pp. 28–9; A. de Waal Malefijt, *Religion and Culture*, pp. 116–17; G. R. Levy, *The Gate of Horn*, p. 67.

6. Ill. 408. Cf. Mainage, pp. 171–2, 188–9.

7. Cf. Breuil/Lantier, pp. 304, 306; James, p. 30; Maringer, *Gods of Prehistoric Man*, p. 53.

8. Cf. J. Hawkes, *History of Mankind*, vol. I (Prehistory), pp. 208–9; Maringer, pp. 14–20; D. A. Garrod, *C.A.H.*, I, Part 1, pp. 80–1.

9. Cf. Brandon, *History, Time and Deity*, pp. 7–12, 206 ff.

10. *Cf. Man and His Destiny*, pp. 26–8; Hawkes, *op. cit.*, pp. 104–5, 108–13; W. F. Albright/T. O. Lambdin, *C.A.H.*, I, Part 1, pp. 130–1.

11. A. N. Whitehead wrote with great insight: "Men found themselves practising various rituals, and found the rituals generating emotions. The myth explains the purpose of the ritual and the emotion" (*Religion in the Making*, p. 13). In origin it would seem that ritual action was often accompanied by a kind of emotive libretto, which tended to be both declaratory and commentarial. Cf. Harrison, *Ancient Art and Ritual*, pp. 33 ff.; de Waal Malefijt, pp. 187–9.

12. Cf. Giedion, *The Eternal Present*, pp. 54–5; A. Lommel, *Prehistoric and Primitive Man*, p. 17; Laming, *Lascaux*, pp. 187–8, 192; Powell, *Prehistoric Art*, p. 26; Maringer, pp. 97 ff.; Ucko/Rosenfeld, *Palaeolithic Cave Art*, pp. 123–48.

13. Ill. 1, 30, 46. See pp. 25, 48.

14. Cf. Powell, pp. 12–20; Giedion, pp. 437–54. Mainage, p. 287, cites only one example found in a grave (at Brunn, Moravia).

15. Ill. 46 and 411. See pp. 48.

16. Cf. Breuil, *Quatre cents siècles d'art pariétal*, pp. 279–81, and figs. 318–20; E. T. pp. 279–81, and figs. 318–20. See also Levy, p. 60, plate 7 (c, d); Giedion, pp. 469–77; Leroi-Gourhan, *Art of Prehistoric Man*, pp. 303–4 discusses the chronological problem and concludes that some reliefs are Middle Aurignacian.

17. See ill. 18, 140, 141, and pp. 26, 357.

18. "This Laussel figure illuminates a widening of purpose, she is not engrossed in her own maternal role, fundamental as it remains, but projects her potency to external things implied by the horn," Powell, p. 22. Menghin, *Weltgeschichte der Steinzeit*, p. 148, saw the horn as evidence of "eine lunare Mythologie." Leroi-Gourhan, p. 303, suggests that "Venus" may be drinking from the horn; he also talks of "bison sanctuaries" (p. 179).

19. Cf. Brandon, *Creation Legends of Ancient Near East*, pp. 5 ff.
20. Ill. 412. Cf. Laming, *Lascaux*, p. 69; Breuil, *Four Hundred Centuries of Cave Art*, p. 106, fig. 71.
21. Cf. Leroi-Gourhan, pp. 90-6.
22. Pp. 29 ff.
23. Cf. C. H. Ratschow, *Magie und Religion*, pp. 80-1; de Waal Malefijt, pp. 85-9, 97-8; Geo Widengren, *Religionsphänomenologie*, pp. 4-10.
24. Cf. Leroi-Gourhan, pp. 366-8.
25. See ill. 25 and n.34 (Part II).
26. See Part II, n.35. Cf. K. J. Narr, "Approaches to the Religion of Early Paleolithic Man," *H.R.*, 4(1964), p. 18.
27. Cf. Breuil, *Quatre cents siècles d'art pariétal*, p. 176; Breuil/Lantier, pp. 325-8; Wernert in *H.G.R.*, I, p. 95; James, *Prehistoric Religion*, p. 173; Laming, *Lascaux*, pp. 191-2.
28. "L'esprit régissant la multiplication du gibier et les expéditions de chasse," Breuil, p. 176. Cf. Maringer, p. 195.
29. E.g., the many so-called "dying-rising" gods: cf. *D.C.R.*, p. 251.
30. See ill. 10 and p. 33.
31. Engravings of "snow owls" are found at Les Trois Frères: cf. Breuil, fig. 123; Leroi-Gourhan, pp. 366, 455, ill. 626.
32. See the other "disguised shaman" at Les Trois Frères, shown in ill. 27.
33. See Part II, Section III, n.6.
34. Cf. Leroi-Gourhan, p. 132. The legs are certainly human in form.
35. See pp. 29-33.
36. Cf. Brandon, *History, Time and Deity*, p. 18.
37. Cf. *op. cit.*, pp. 206 ff.
38. Palaeolithic archeology gives no indication of how early man regarded death—whether as a natural happening or due to the assault of some daemonic force. The latter view has been more general among mankind: cf. Brandon, "The Personification of Death in Some Ancient Religions," in *Religion in Ancient History*, chap. 3.
39. Ill. 21, and Part II, Section III, n.3. Cf. Breuil, *Quatre cents siècles d'art pariétal*, pp. 131, 134-5, 148, 150-1 (fig.); F. Windels, *The Lascaux Cave Paintings*, pp. 27, 63; Leroi-Gourhan, plate 74; Lomel, p. 27, ill. 4.
40. Cf. Ucko/Rosenfeld, pp. 43-4; Powell, pp. 62-3; Lommel, p. 27, ill. 4 (caption); Maringer, pp. 58-62; Laming, pp. 93-6, 100, 189; Leroi-Gourhan, pp. 315-16, who cites an engraving on a reindeer horn, found at Laugerie Basse (*op. cit.*, fig. 439) as a parallel—the parallel is not convincing on comparison; Charrière, in *R.H.R.*, t. 174, pp. 1-25, who ascribes the condition of the bird-headed man to "demi asphyxié par les émanations de CO_2(voire partiellement anesthésié ou excité par elles . . ." (p. 22).
41. See Breuil, fig. 113.
42. Cf. Brandon, *Man and His Destiny*, p. 21, n.2.
43. Cf. G. Condominas, *S.O.* VII (*Le Monde du sorcier*), pp. 13-23; *D.C.R.*, "Shamanism," pp. 571-2.
44. Breuil was of the opinion that the Palaeolithic artists formed "colleges" of specialists, closely connected to, if not identical with, the "sorcerers" (*Four Hundred Centuries of Cave Art*, pp. 22-3. Cf. Ucko/Rosenfeld, p. 137.
45. Cf. Brandon, *Creation Legends*, p. 5.

III, Great Goddess, p. 356

1. Cf. P. Evdokimov, *La femme et le salut du monde*, pp. 207-21.
2. P. 26.
3. See ill. 413. Cf. *I.L.N.*, Feb. 2, 1963, pp. 162-3, figs. 12, 16; Feb. 8, 1963, p. 195, fig. 7; Mellaart, *Earliest Civilizations of Near East*, pp. 96-7.
4. Ill. 414. Cf. Mellaart, pp. 86, 88, figs. 60, 61, 63, 82, 86. Compare ill. 417: cf. A. Arribas, *The Iberians*, p. 255(21).
5. See ill. 18. Cf. *I.L.N.*, Feb. 2, 1963, pp. 163-4, figs. 11-23, 25; Feb. 8, 1964, p. 195, figs. 4, 6; Mellaart, pp. 93-7, ill. 84, 85, 86.
6. Ill. 415. Mellaart (ill. 65, p. 98) describes them as "enormous vultures pecking at headless human corpses"; see also *C.A.H.*, I, Part 1, p. 312. Their huge size suggests that these birds were conceived as being supernatural.
7. See ill. 330a, b.
8. See ill. 31, 33.
9. At Çatal Hüyük, the goddess appears, iconographically, as "a young woman, a mother giving birth or as an old woman, in one case accompanied by a bird of prey, probably a vulture" (Mellaart, p. 92).
10. Cf. Mellaart, ill. 87, pp. 98-100; *C.A.H.*, I, Part I, pp. 309, 314.
11. Ill. 416, 417.
12. Cf. J. D. Evans, *Malta*, chaps. III, IV, and related illus.; G. Sieveking, "The Migration of the Megaliths," in *Vanished Civilizations* (ed. E. Bacon).
13. See ill. 32, 33, for very early examples of daemonic beings. Ill. 31 may show Palaeolithic prototypes. Cf. P. Wernert, "Les hommes de l'age de la pierre représentaient-ils les esprits des défunts et des ancêtres?", in *H.G.R.*, I; see also the Neolithic rock drawings of daemonic beings given by Kühn, *Die Fels-bilder Europas*, figs. 78-96, Taf. 66-74, 103. According to Van der Leeuw, "Dans la croyance aux demons, ce qui se projette à l'extérieur, ce n'est pas la peur de quelque chose d'effrayant que l'insaisissable" (*La religion*, p. 130). There is doubtless much truth in this statement; but, as we saw earlier, man's imagination has also been a potent factor (see above, p. 33).

IV, Egyptian Salvation, p. 360

1. Pp. 17 ff. Ill. 12, 14, 95.
2. So firmly established was the royal Osirian mortuary cult that the priests of Heliopolis were constrained to incorporate it in the corpus of the *Pyramid Texts*, although it ran counter to their conception of a solar afterlife for the king. Cf. H. Kees, "Das Eindringen des Osiris in die Pyramidentexte," in Mercer, *Pyramid Texts*, IV, pp. 123-39. Divine origin was claimed for Chapter 30 of the *Book of the Dead*: cf. Brandon, *Judgment of the Dead*, p. 39.
3. Ill. 418. Cf. Emery, *Archaic Egypt*, pp. 128-64.
4. See pp. 136 ff. The importance which the Egyptians attached to embalmment and a proper ritual burial is significantly presented in the Middle Kingdom *Story of Sinuhe:* cf. Brandon, *Man and His Destiny*, pp. 45-7.
5. See ill. 4, 22, 23, 337a, b, c. On the nature of the *ba, ka* and *akh*, according to literary sources, cf. Brandon, *op. cit.*, pp. 40-7, with documentation.
6. See ill. 168.
7. See ill. 178, 179, 219. Cf. Erman, *Die Religion der Aegypter*, p. 103; Kees, *Totenglauben*, pp. 67-97, 132-59; Breasted, *Dawn of Conscience*, pp. 109-13, 147-8, 236-7, 260-1.
8. Ill. 419. Cf. Bonnet, *Reallexikon*, pp. 161-2; ("Earu-Gefilde") R. Weil, *Le Champ des Roseaux et le Champ des Offrandes*, pp. 102-10; Zandee, *Death as an Enemy*, pp. 25-31.

9. Cf. Brandon, *History, Time and Deity*, pp. 18–25.
10. Ill. 420. Cf. Brandon, *ibid.*, p. 56.
11. Cf. Brandon, *Judgment of the Dead*, pp. 11 ff.
12. Cf. Brandon, *ibid.*, pp. 6 ff.
13. See ill. 373, 375, pp. 00. Cf. Brandon, *ibid.*, pp. 28–31.
14. Ill. 421a. On the conception of *maat*, cf. Bonnet, *Reallexikon*, pp. 431–4; Morenz, *Aegyptische Religion*, pp. 12–3; Brandon, *Judgment of the Dead*, pp. 11, 13, 16–19. The determinative sign in hieroglyphs for the word *maat* was an object resembling a chisel, perhaps symbolising straightness: cf. Gardiner, *Egyptian Grammar*, p. 535 (II).
15. Cf. Brandon, *Judgment of the Dead*, pp. 36–7.
16. Pp. 19–21.
17. Ill. 422. Cf. Bonnet, *Reallexikon*, pp. 702–15; Mercer, *Religion of Ancient Egypt*, pp. 48–61; Zandee, pp. 214–15; Brandon, *Religion in Ancient History*, pp. 33–5.
18. Ill. 423, 424. Cf. E. Hornung, *Altägyptische Höllenvorstellungen, passim*; Zandee, pp. 18–24, 147 ff.; Brandon, *Judgment of the Dead*, pp. 29, 43–6, fig. 3.
19. Ill. 425. Cf. Brandon, *Creation Legends*, pp. 26–8; Bonnet, *Reallexikon*, pp. 536–9.
20. See ill. 221b, and p. 179.
21. Ill. 185. Cf. Mercer, pp. 90–6.
22. Ill. 426. Cf. C. J. Bleeker, "Isis as Saviour Goddess," in *The Saviour God*, pp. 1–16. This vision of Isis which Apuleius describes (*Metamorphoses* XI, 3–4) is undoubtedly derived from the iconography of the goddess.
23. Ill. 86, 402, pp. 71, 320.
24. See ill. 219, 373–5.

1. Ill. 427. Cf. Brandon, *Man and His Destiny*, pp. 72–4, 110–15; *E.R.E.*, IV, pp. 473–5.
2. See Part II, Section VI, The Sanctuary.
3. Ill. 428. Cf. Dhorme, *Les religions de Babylonie et d'Assyrie*, pp. 72–8, 115–19; Dussaud, *Les religion des Hittites, et des Hourrites, des Phéniciens et des Syriens*, pp. 365–6, 373–6, J. Gray, *The Canaanites*, pp. 123–5, 133–8; James, *Cult of the Mother Goddess*, chaps. II–VI, VIII.
4. Ill. 429a, b. The apparently unrelated verses at the end of the so-called *Descent of Ishtar to the Nether World* clearly belongs to a ritual concerning the resurrection of Tammuz: cf. *A.N.E.T.*, p. 109a. *Ezekiel* viii:14 attests to the holding ritual lamentations for Tammuz, the Mesopotamian vegetation-god in Jerusalem. Cf. Frankfort, *Kingship and the Gods*, pp. 281–94.
5. Ill. 430. Cf. Vermaseren, *Legend of Attis in Greek and Roman Art, passim*; Gressmann. *Die orientalischen Religionen im hellenistischrömischen Zeitalter*, pp. 56–76, 81–110; Contenau, *La civilisation phénicienne*, pp. 93–6, 112–14; *Kleine Pauly*, I, 70–1; Frazer, *Adonis, Attis, Osiris* (*G.B.*), I, chaps. I–III.
6. Ill. 122–4. See Part III, Section VII.

1. Cf. Brandon, *Man and His Destiny*, pp. 378–9.
2. See ill. 219. Cf. Brandon, *History, Time and Deity*, pp. 19–20; Frankfort, *Ancient Egyptian Religion*, pp. 106–8.
3. Cf. *Man and His Destiny*, pp. 315 ff., with documentation.
4. See ill. 101, 296. Cf. ill. 318–19; *E.R.E.*, II, pp. 87–96; *D.C.R.*, pp. 105–6.

V, Ancient Near East, p. 369

VI, Hinduism and Buddhism, p. 372

5. Ill. 431a, cf. Basham, *Wonder That Was India*, p. 347, see also pp. 243–7; *E.R.E.*, II, pp. 63–4; *Bilderatlas*, 12 Lief., Abb. 45, 65.

6. Cf. *Man and His Destiny*, pp. 336 ff.; *D.C.R.*, pp. 214–15 ("Craving").

7. Ill. 296. Cf. Finegan, pp. 252–3, 285, fig. 104; Thomas, *History of Buddhist Thought*, p. vii, plate II.

8. Ill. 431b. Cf. Brandon, *History, Time and Deity*, pp. 99–105; *D.C.R.*, pp. 617–19; H. Nakamura, "Time in Indian and Japanese Thought," in *The Voices of Time* (ed. J. T. Fraser), pp. 77–91.

9. Cf. *D.C.R.*, pp. 122, 433–4 ("Māyā"); E. Conze, *Buddhist Thought in India*, pp. 39–40, 169–70, 224–6; S. Dasgupta, *History of Indian Philosophy*, I, pp. 58–61.

10. Cf. C. Jacques, "Les pèlerinages en Inde," in *S.O.*, III, pp. 166–70; *D.C.R.*, pp. 501–2.

11. Cf. *D.C.R.*, pp. 542–3 ("Rupa"); Seckel, *Art of Buddhism*, pp. 152–6.

12. See ill. 84, 118, 119, 196, 339. Cf. Seckel, pp. 152 ff.; T. N. Ramachandran, in *2500 Years of Buddhism* (ed. P. V. Bapat), pp. 276–88.

13. Ill. 432, 433. Cf. Seckel, pp. 261–77.

14. Cf. Conze, *Buddhism*, pp. 78–85.

15. See ill. 431b.

16. Cf. Brandon, *Judgment of the Dead*, pp. 174–88.

17. Cf. Brandon, *ibid.*, 175–7, 187.

VII, Mystery Cults, p. 379

1. For concise comparative surveys of the concept and praxis of salvation, see the author's article "Salvation," in the *Encyclopaedia Brittannica* and "Sin and Salvation," in the *Dictionary of the History of Ideas*.

2. An interesting example of a *hieros logos* is the *Homeric Hymn to Demeter* (seventh-century): see particularly 22, 473–80: Turchi, *Fontes*, pp. 63–80. Cf. Mylonas, *Eleusis and the Eleusinian Mysteries*, pp. 14–15, 38 ff. Cf. *D.C.R.*, p. 462; *Kleine Pauly*, III, 1533–42.

3. See ill. 122–4, and relating text.

4. Ill. 344, 345a, b, c, and text.

5. Ill. 274a, b, c, d.

6. Ill. 274c. Cf. Campbell, *Mithraic Iconography and Ideology*, p. 296, plate X; Vermaseren, *Mithras: The Secret God*, p. 129.

7. See ill. 435. Cf. Gressmann, pp. 37–50; Cumont, *Religions orientales*, pp. 80–94; *Bilderatlas*, 9–11, Lief. Abb. 44–61; Reitzenstein, *Die hellenistischen Mysterienreligionen*, pp. 220–34.

8. Ill. 436, 437. Cf. Carcopino, *La basilique pythagoricienne de la Porte Majeure*, *passim*; *De Pythagore aux Apôtres*, pp. 9–23; A. Strong, "Rome's Strange Temple Underground," in *W.P.*, III, pp. 1197–1204.

9. The Homeric distinction between the *psyche and thymos* ended by the 6th century B.C., and the *psyche* came to mean both the life-soul and the consciousness with Orphics and Pythagoreans. Cf. Jaeger, *Theology of Early Greek Philosophers*, p. 83; Brandon, *Man and His Destiny*, pp. 160–2, 185 ff.; Festugière, *La revélation d'Hermès Trismegiste*, III, chaps. I–II.

10. Cf. S. Angus, *Religious Quests of the Graeco-Roman World*, pp. 11–46; Nock, *Conversion*, pp. 99–121; Dodds, *Pagan and Christian in an Age of Anxiety*, *passim*.

1. Cf. Brandon, *Jesus and the Zealots* (1967) and *The Fall of Jerusalem and the Christian Church* (1957).

2. *See* ill. 148. Cf. Gough, *The Early Christians*, pp. 59–62; Gabar, *Beginnings of Christian Art*, 59–61, ill. 59, 61, 62, 63.

3. Cf. van der Meer, *Early Christian Art*, pp. 46–7, 76–80, 127–8; Marec, *Monuments chrétiens d'Hippone*, p. 103.

4. See ill. 151. Cf. van der Meer, plate 23; van der Meer/Mohrmann, *Atlas of Early Christian World*, pp. 128–131 and illus.

5. Ill. 438. Cf. L. Leschi, *Djemila: antique Cuicul*, pp. 38–42. Cf. Brandon in the *Saviour God*, pp. 31–33. On baptismal nudity see J. Z. Smith, "The Garments of Shame," in *H.R.*, 5 (1965), pp. 217–238.

6. "We were buried therefore with him by baptism into death, so that as Christ was raised from the dead by the glory of the Father, we too might walk in newness of life" (vi:4). Cf. H. Ralmer in *The Mysteries* (ed. J. Campbell), pp. 387–400; E. Dinkler in *R.G.G.*, VI, 631; Duchesne, *Christian Worship*, pp. 291 ff.; E. Stommel in *Jb.f.A.C.*, 2 (1959), pp. 5–14.

7. Cf. Duchesne, pp. 315, 330, 355–6; Rahner, p. 399.

8. Ill. 151. Cf. van der Meer/Mohrmann, ill. 412, 414; Grabar, *Byzantium*, ill. 131, 132; Crowfoot, *Early Churches in Palestine*, plate IV(b).

9. Ill. 271, 274a. Cf. Grabar, *Beginnings of Christian Art*, ill. 102, 239; du Bourguet, *Early Christian Paintings*, ill. 38, 79, 99.

10. Ill. 269, 439. Cf. Grabar, *op. cit.*, 103, 105, 110, 111; du Bourguet, ill. 2, 9, 75, 89, 103.

11. Ill. 268. Cf. du Bourguet, ill. 45, 77, 84, 117, 129.

12. Ill. 272, 273. Cf. Grabar, *op. cit.*, ill. 76, 96, 248; du Bourguet, ill. 12, 15, 32, 52, 71, 80.

13. See ill. 275. Possible exceptions, though not contradicting the point made in the text, might be "Samson's routing of the Philistines" and the "Passage of the Red Sea," both in the New Catacomb of the Via Latina. Cf. du Bourguet, ill. 115, 127. Cf. van der Meer, *Early Christian Art*, pp. 84–90.

14. Ill. 439. Cf. Grabar, ill. 103. Van der Meer/Mohrmann, fig. 396, would interpret the scene as symbolising baptism, the nude neophyte representing the *infans*, "newly born child." It is difficult to accept this interpretation in view of the graphic references to the descent of the dove in the Gospel accounts of Christ's baptism. Cf. Grabar, *Christian Iconography*, p. 115.

15. Ill. 440. Cf. Grabar, *Christian Iconography*, pp. 34–5, 116–7, ill. 81, 82; du Bourguet, ill. 22. See also the mosaic representation of Christ as the Sun God, found in the cemetery under St. Peter's, Rome: Grabar, *Beginnings of Christian Art*, ill. 74.

16. Christ is usually depicted wearing the customary dress of a teacher. Cf. van der Meer, *Early Christian Art*, pp. 86–7. Winged angels begin to appear in Christian art from the mid 5th century: e.g. in a mosaic depiction of the Holy Family in Egypt, in Santa Maria Maggiore, Rome. See Grabar, *op. cit.*, ill. 161, 162. Winged angels are featured in the 6th-century Ravenna mosaics: e.g. see ill. 62. Cf. T. Klauser, "Engel X (in der Kunst)," in *R.A.C.*, 5 (1962) 258–91; he lists angelic beings, without wings, both bearded and beardless, and with pallium, from A.D. 250 in Christian art; he also cites two winged beings, bearing the Christus-monogram on a child's sacrophagus, now at Istanbul (cf. Grabar, ill. 255), which he dates from 350–400, and a similar pair on a wooden door in S. Ambrogio, Milan.

17. Cf. Van der Meer/Mohrmann, p. 136, ill. 431–35.

18. Cf. Harnack, *History of Dogma*, IV, pp. 276–82. See also G. Millet, *Recherches sur l'iconographie de l'Evangile*, pp. 170–215.

19. See ill. 203, 204. Cf. Van der Meer, *Early Christian Art*, pp. 70–5, 134–21, plates 18, 21.

20. Cf. K. E. Kirk, *The Vision of God*, pp. 137–9; *E.R.E.* VII, pp. 253a–254; *R.G.G.*, III, 171–4, also I, 64–7.

21. Brenk Beat cites a sculptured scene of Christ dividing the sheep and goats on a sarcophagus lid, now in the Metropolitan Museum, New York, as the earliest (3rd century) representation of the Last Judgment in Christian art (*Tradition und Neuerung in der christlichen Kunst des ersten Jahrtausends*, pp. 37–40, 218, Abb. I. It should be noted that the sheep are all rams. T. Klauser doubts the validity of the identification: Jb.f.A.C. 10 (1967), pp. 242–7.

22. Cf. Brandon, *Judgment of the Dead*, pp. 98–118; A. Dieterich, *Nekvia*, pp. 1–18, 225–32.

23. Pp. 121–7.

24. Ill. 441a. Cf. Brandon, p. 118; Beat Brenk, pp. 220–1; Grabar, *Byzantium*, ill. 165; Bovini, *Sant' Apollinare Nuovo*, pp. 16–17, ill. 20. See Part I, n.528 (also ill. 275a), n.602 (ill. 329).

25. See ill. 359. Another very early (*c.* 430) example of the Crucifixion is carved on the wooden doors of S. Sabrina, Rome: van der Meer/Mohrmann, ill. 476; Gough, ill. 66, pp. 261–2; Grabar, *Christian Iconography*, pp. 131–2, ill. 317–18.

26. See ill. 152. Cf. Grabar, *Byzantium*, ill. 136, 135; van der Meer, *Early Christian Art*, p. 14; van der Meer/Mahrmann, ill. 468–71.

27. See ill. 366, 368, 381, 382a, b. Cf. Cocagnac, *Le Jugement Dernier dans l'art*, *passim*; R. Hughes, *Heaven and Hell in Western Art*, chaps. 1, 4–5; D. Milsoevic, *The Last Judgment*, pp. 26, 37, 39, 49–51, 58, 68.

28. Cf. Fournée, *Le Jugement Dernier*, pp. 126–30, plates IV, V, VII–XV; Brandon, *Judgment of the Dead*, pp. 117–8, 127–8, 235 (153), ill. 3–6, 8.

29. See ill. 440. Cf. van der Meer/Mohrmann, ill. 514–540.

30. Compare ill. 62, 441a.

31. See ill. 62. Cf. van der Meer, *Early Christian Art*, p. 131 (11).

32. Ill. 441a. Cf. Mâle, *L'art religieux du XII^e siècle*, fig. 1, pp. 7–9, 378; F. Heer, *Aufgang Europas*, pp. 116–164; R. L. Poole, *Medieval Thought and Learning*, pp. 198–223.

33. Cf. C. Brook, "The Structure of Medieval Society," in *The Flowering of the Middle Ages*, ed. J. Evans. See the interesting juxtaposition of depictions of "Christ in Majesty" and "Enthroned Emperor" in M. Backes/R. Dölling, *Art of the Dark Ages*, pp. 114–5.

34. Ill. 442. The theme of the "Ladder of Salvation" is treated in a 7th-century mural in St. Catherine's Monastery, Sinai. Cf. Hughes, p. 162.

35. See ill. 382a, b. Cf. J. Porcher, *The Rohan Book of Hours*, plate 8.

36. The theme is graphically presented in mediaeval miracle plays. Cf. the speech of Jesus at the *Judgment* in the York cycle: A. C. Cawley, *Everyman and Medieval Miracle Plays*, pp. 198–200. See also the Poems of the Passion printed in *Medieval English Verse*, trans. B. Stowe, pp. 33–41.

37. Ill. 442. Cf. Brandon, *Judgment of the Dead*, pp. 118–20, ill. 4–6; *Religion in Anc. Hist.*, p. 117 (ill.); Fournée, plates XVIII–XXI, XXV; Reau, I, pp. 727–57.

38. On the so-called *Deésis* cf. Brandon, *Judgment*, pp. 128–9, ill. 6; Fournée, pp. 103–111, see also pp. 71–4, plates XXXIII–XXXIX; Milošević, pp. 27, 40, 57, 68; Brenk Beat, pp. 84, 85, 95–8, 141, 250.

39. Ill. 63, 368, 442, 443b. The earliest known depiction of St. Michael with the scales is a carving on the portal of the monastery church at Alahan in Isauria, and dates *c.* 450: cf. Gough, ill. 28, pp. 256–7. Numerous illustrations of the *psychostasia* are given in L. Kretzenbacher, *Die Seelenwaage*. Cf. Brandon, *Judgment*, pp. 119–26, "The Weighing of the Soul," in *Myths and Symbols* (Eliade *Festschrift*).

40. Cf. Brandon, *History, Time and Deity*, pp. 195–7; C. Dawson, *Religion and the Rise of Western Culture*, pp. 267–74.

41. Ill. 444. Cf. Coulton, *Art of the Reformation*, Part II, chaps. XVI, XVIII–XX; Réau, I, pp. 444–5.

42. Cf. A. C. Dickens, *Reformation and Society in the Sixteenth Century*, ill. 1, 40, 44, 48, 49, 68, 69, 81, 91, 94, 98, 99, 100, 111, 118, 120, 132, 136, 137—a significant selection of Protestant "iconography."

43. Ill. 445a, 446. Cf. *R.G.G.*, IV, Tafel, 62–68; *D.C.C.*, pp. 666–7; Réau, I, pp. 471–6.

44. Cf. Dickens, *The Counter Reformation*, pp. 165–70; E. I. Watkin, *Catholic Art and Ritual*, pp. 96–156; G. Bazin, *Baroque and Rococo*, pp. 11–62; Réau, I; pp. 457–65.

45. Ill. 446, 447. Cf. Bazin, pp. 15, 26; M. Kitson, *The Age of Baroque*, pp. 16–17, 35.

1. Cf. *H.D.B.*, p. 413 ("Images"). Exodus xxxii:1 ff.; I Kings xii:28–33.

2. See pp. 106–11.

3. See ill. 131, 348, 349. Cf. Sukenik, *Ancient Synagogues in Palestine and Greece*, pp. 22, 34 ff., 61 ff., 83 ff.

4. Cf. J. Leveen, *The Hebrew Bible in Art*, plates XVI.2, XXV.2, XXXI.2.

5. Cf. Leveen, pp. 11, n.1, 100, n.1, plate XXX.1.

6. See p. 107.

7. Cf. *E.J.R.*, pp. 41 ("Ark of the Law"), 348–9 ("Sepher Torah"), plates between pp. 48–9.

8. See ill. 135.

9. Ill. 136, 385. Cf. M. Hamidullah, "Le pèlerinage à la Mecque," in *S.O.*, III, pp. 108, 112–15.

10. Ill. 386, 387.

11. "If oxen or horses or lions had hands and could draw with them and make works of art as men do, horses would draw the shapes of gods like horses, oxen like oxen; each kind would represent their bodies just like their own forms." Cf. Kirk/Raven, *Presocratic Philosophers*, p. 169 (172).

IX, Aniconic Faiths, p. 394

Bibliography

Acts of John in *The Apocryphal New Testament*. Trans. and ed. by M. R. James, Oxford, 1926.

ADRIAN, E. D. *The Physical Background of Perception*, Oxford, 1947.

ALDRED, C. *Egypt to the End of the Old Kingdom*, London, 1965. *Akhenaten: Pharaoh of Egypt*. London, 1968.

ALEXANDER, M. *The Earliest English Poems*, Harmondsworth, Middlesex, 1966.

ALLAN, J. *Catalogue of the Coins of Ancient India*, British Museum, London, 1936.

ALPHANDÉRY, P. *La Chrétienté et l'idée de croisade*, Paris, 1954.

ALTHEIM, F. *Weltgeschichte Asiens im griechischen Zeitalter*, 2 vols., Halle, 1947–8.

ANDERSON, M. D. *Imagery of British Churches*, London, 1955. *Drama and Imagery in English Medieval Churches*, Cambridge University Press, 1963.

ANGUS, S. *The Religious Quests of the Graeco-Roman World*, London, 1929.

Anthropologie religieuse. Ed. C. J. Bleeker, Leiden, 1955.

ANTI, C. *Il Regio Museo archeologico nel Palazzo Reale di Venezia*, Rome, 1930.

Apostolic Fathers, The. Ed. J. B. Lightfoot and J. R. Hamer, London, 1891.

ARRIBAS, A. *The Iberians*, London, 1963.

ASHMOLE, B. (with Groenewegen-Frankfort, H. A.). *The Ancient World*, New York, 1967.

Asiatic Mythology. Ed. J. Hackin, *et al.*, E.T., London, 1932.

ATKINSON, R. J. C. *Stonehenge*, London, 1956. "Silbury Hill," in *Antiquity*, vol. XLI (1967).

AUBERT, M. *High Gothic Art*, E. T., London, 1964

AUBOYER, J./GOEPPER, R. *The Oriental World* (Landmarks in the World's Art), London, 1967.

AUFHAUSER, J. B. "Die sakrale Kaiseridee in Byzanz," in *R.S.* (1959).

AVIGAD, N. *Ancient Monuments in the Kidron Valley*, Bialik Institute, Jerusalem, 1954.

BACKES, M./DÖLLING, R. *Art of the Dark Ages*, E. T., New York, 1970.

BAEDEKER, K. *Egypt: A Handbook for Travellers*. Leipzig/London, 1898.

BAPAT, P. V. (ed.) *2500 Years of Buddhism*, Publication Division, Government of India, 1956.

BARBER, R. W. *The Knight and Chivalry*, London, 1970.

BARGUET, P. *Le Livre des Morts des anciens Egyptiens*, Paris, 1967. Review of A. Piankoff, *The Pyramid of Unas*, in *R.H.R.*, CLXXVII (1970), pp. 65–9.

BASHAM, A. L. *The Wonder That Was India*, London, 1954.

BATES, O. *The Eastern Libyans*, London, 1914.

BÄUER, H. "Ikonologie," in *R.G.G.*, Tübingen, 674–6.

BAUML, F. H. *Medieval Civilization in Germany*, London, 1969.

BAZIN, G. *Baroque and Rococo*, E. T., London, 1964.

BEAT, B. *Tradition und Neuerung in der christlichen Kunst der ersten Jahrtausends: Studien zur Geschichte des Weltgerichtsbildes*, Wiener Byzantinische Studien, vol. III, Vienna, 1966.

BECK, H. G. "Bilder und Bilderverehung III. Christliche Bilderverehung und Bilderstreitigkeiten," in *R.G.G.*, I, 1273–75.

BECKWITH, J. *The Andrews Diptych*, Victoria and Albert Museum, London, 1958.
Coptic Sculpture, London, 1963.
Early Medieval Art, London, 1964.

BELL, I. H. *Cults and Creeds in Graeco-Roman Egypt*, Liverpool University Press, 1953.

BENDINELLI, G. *Compendio di storia dell' arte etrusca e romana*, Milan, 1931.

BERENSON, B. *Italian Painters of the Renaissance*, London, 1960.

BEVAN, E. R. *A History of Egypt under the Ptolemaic Dynasty*, London, 1927.

Holy Images: An Inquiry into Idolatry and Image-Worship in Ancient Paganism and in Christianity, London, 1940.

BLACKMAN, A. M. *Luxor and Its Temples*, London, 1923.

BLEEKER, C. J. "Isis as Saviour Goddess," in *The Saviour God* (1963).

BLOCH, R. *The Etruscans*, E.T., London, 1969.

BOARDMAN, J. *Greek Art*, London, 1964.

BOASE, T. S. R. "King Death," in *The Flowering of the Middle Ages* (ed. J. Evans).

BONAVENTURA, SAINT. *Life of St. Francis*, in *Little Flowers of St. Francis*, Everyman Library ed., 1925.

BONNET, H. *Reallexikon der ägyptischen Religionsgeschichte*, Berlin, 1952.

"Ägyptische Religion," in *Bilderatlas*, 2. 4. Lief., 1924.

VON BORSIG, A. *Die Toscana*, Vienna, 1939.

BOUQUET, A. C. *Hinduism*, London, 1948.

DU BOURGUET, P. *Early Christian Painting*, E.T., London, 1965.

BOVINI, G. *Sant' Apollinare Nuovo*, E.T., Milan, 1961.

BOWRA, C. M. *The Greek Experience*, London, 1958.

BRANDON, S. G. F. *The Fall of Jerusalem and the Christian Church*, London, 1957.

Man and His Destiny in the Great Religions, Manchester University Press, 1962.

Creation Legends of the Ancient Near East, London, 1963.

"The Ritual Technique of Salvation in the Ancient Near East," in *The Saviour God* (Comparative Studies in the Concept of Salvation presented to E. O. James), ed. S. G. F. Brandon, Manchester University Press, 1963.

History, Time and Deity, Manchester University Press, 1965.

Jesus and the Zealots, Manchester/New York, 1967.

The Judgment of the Dead, New York/London, 1967.

"The Holy Book, the Holy Tradition, and the Holy Ikon" in *Holy Book and Holy Tradition*, ed. F. F. Bruce and E. G. Rupp, Manchester University Press, 1968.

The Trial of Jesus of Nazareth, London/New York, 1968.

"The Weighing of the Soul," in *Myths and Symbols* (Studies in

Honor of Mircea Eliade), ed. J. M. Kitagawa and C. H. Long, Chicago University Press, 1969.

Religion in Ancient History, New York, 1969.

"Ritual: Its Nature and Function in Religion," in *The Dictionary of the History of Ideas* (ed. P. Wiener), New York.

BREASTED, J. H. *Development of Religion and Thought in Ancient Egypt*, New York, 1912.

The Dawn of Conscience, New York/London, 1935.

BRÉHIER, L. *Les institutions de l'empire byzantin*, Paris, 1949.

La civilization byzantine, Paris, 1950.

BREUIL, H. *Quatre cents siècles d'art pariétal (les cavernes ornées de l'age du renne)*, Montignac, 1952. E.T., *Four Hundred Centuries of Cave Art*, Montignac, 1952.

BREUIL, H./LANTIER, R. *Les hommes de la Pierre Ancienne*, Paris, 1951.

BRIEGER, P. *English Art (1216–1307)*, Oxford, 1957.

BRIGGS, M. S. "Architecture," in *The Legacy of Islam*, ed. T. Arnold and A. Guillaume, Oxford, 1931.

BRION, M. *Pompeii and Herculaneum*, E.T., London, 1960.

BROOK, C. "The Structure of Medieval Society," in *The Flowering of the Middle Ages*, ed. J. Evans, London, 1966.

BUDGE, E. A. W. *The Book of the Dead: Facsimile of Papyrus of Ani*, British Museum, 2nd ed., 1894.

The Book of the Opening of the Mouth, 2 vols., London, 1909.

Osiris and the Egyptian Resurrection, 2 vols., London, 1911.

The Book of the Dead: The Papyrus of Ani, 2 vols., London/New York, 1913.

The Book of the Dead (The Chapters of the Coming Forth by Day), 3 vols., London, 1898; trans. only in one vol., 2nd ed., London 1953.

The Egyptian Book of the Dead (text and trans.), Dover ed., New York, 1967.

The Mummy, 2nd ed., Cambridge, 1925.

BURLAND, C. A. *The Gods of Mexico*, London, 1967.

BUSHNELL, G. H. S. *The First Americans*, London, 1968.

BUSINK, TH. A. *Der Tempel von Jerusalem, von Salomo bis Herodes*, vol. I, Leiden, 1970.

CAMPBELL, L. A. *Mithraic Iconography and Ideology,* Leiden, 1968.

CANDLER, E. "Angkor: A Marvel Hidden in the Jungle," in *W.P.,* vol. I, pp. 38–50.

CAPART, J. *Thebes: The Glory of a Great Past,* E.T., London, 1926.

CAQUOT, A. "Les danses sacrées en Israel et à l'entour," in *S.O.* VI (*les danses sacrées*), 1963.

CARCOPINO, J. *Aspects mystiques de la Rome païenne,* Paris, 1942. *La basilique pythagoricienne de la Porte Majeure,* Rome, 1943. *De Pythagore aux Apôtres,* Paris, 1956.

CASSON, S. *Ancient Cyprus,* London, 1937.

CAWLEY, A. C. (ed.). *Everyman and Medieval Miracle Plays,* London, 1956.

CHAMOUX, F. *Cyrène sous la monarchie des Battiades,* Paris, 1953.

CHARLES, R. H. *The Revelation of St. John,* 2 vols., Edinburgh, 1920.

CHARLES-PICARD, G. *Les religions de l'Afrique antique,* Paris, 1954.

CHARRIÈRE, G. "La scene du puits de Lascaux," in *R.H.R.,* vol. 174 (1968), pp. 1–25. "La mythique licorne de Lascaux: L'élément Ω de sa bande," *R.H.R.,* vol. 177 (1970), pp. 133–45.

CHATZIDAKIS, M./GRABAR, A. *Byzantine and Early Medieval Painting,* E.T., London, 1966.

CHAUCER, G. *The Canterbury Tales,* trans. N. Coghill, Harmondsworth, Middlesex, 1958.

CHILDE, V. G. *Progress and Archaeology,* London, 1944.

CHRISTIE, A. *Chinese Mythology,* London, 1968.

CHRISTIE, A. H. "Islamic Minor Arts and Their Influence in European Work," in *The Legacy of Islam* (1931).

CLARK, J. G. *World Prehistory: An Outline,* Cambridge University Press, 1961. *The Stone Age Hunters,* London, 1967.

CLARK, K. *The Nude: A study of Ideal Art,* London, 1956.

CLEMEN, C. *Religionsgeschichtliche Erklärung des Neuen Testaments,* Giessen, 1924.

CLES-REDEN, S. *Das Versunkene Volk: Welt und Land der Etrusker,* Innsbruck, 1948.

COBBAN, A., ed. *The Eighteenth Century,* London, 1969.

Cocognac, A. M. *Le Jugement dernier dans l'art*, Paris, 1955.

Coe, M. D. *The Maya*, London, 1966.

Colledge, M. A. R. *The Parthians*, London, 1967.

Condominas, G. "Notes de lecture," in *S.O.*, VII (*Le monde du sorcier*), 1966.

Contenau, G. *La civilisation phénicienne*, Paris, 1949.

Conze, E. *Buddhism: Its Essence and Development*, 3rd ed., Oxford (Cassirer), 1960.

Buddhist Scriptures, Harmondsworth, Middlesex, 1959.

Buddhist Thought in India, London, 1962.

Cook, G. H. *Medieval Chantries and Chantry Chapels*, London, 1947.

The English Medieval Parish Church, London, 1954.

Cook, J. M. *The Greeks in Ionia and the East*, London, 1962.

Cook, T. A. *The Story of Rouen* (Medieval Towns), London, 1899.

Coomaraswamy, A. K. *History of Indian and Indonesian Art*, New York, 1965 (1927).

Coulton, G. G. *Five Centuries of Religion*, 4 vols., Cambridge University Press, 1923–50.

Art and the Reformation, 2nd ed., Cambridge University Press, 1953. *Medieval Faith and Symbolism; The Fate of Medieval Art in the Renaissance and Reformation* (constituting Parts I and II of *Art and the Reformation*).

Cramer, M. *Das altaegyptische Lebenszeichen im christlichen-koptischen-Aegypten*, Vienna, 1943.

Crawford, O. G. S. *The Eye Goddess*, London, 1957.

Creel, H. G. *Confucius and the Chinese Way*, New York, 1960.

Crossley, F. H. *English Church Craftsmanship*, London, 1941.

Crowfoot, J. W. *Early Churches in Palestine*, Schweich Lectures, 1937, London, 1941.

Crucible of Christianity, The. Ed. A. Toynbee, London, 1969.

Cullmann, O. *Petrus: Jünger-Apostle-Märtyrer*, 2nd ed., Zürich/ Stuttgart, 1960.

E.T., *Peter: Disciple-Apostle-Martyr*, London, 1953.

Cumont, Fr. *Les religions orientales dans le paganisme romain*, Paris, 1929.

After Life in Roman Paganism, New York, 1959 (1922).

CURLE, R. "Shwe Dagon: Buddha's Greatest Shrine," in *W.P.*, vol. I, pp. 134–41.

CURTIUS, L./NAWRATH, A. *Das Antike Rom*, Vienna, 1944.

DANIELLI, M. "The Geomancer in China," in *Folk-Lore*, vol. LXIII, 204–226 (1952), London.

DANIÉLOU, J. "That the Scripture Might Be Fulfilled: Christianity as a Jewish Sect," chap. XI, in *The Crucible of Christianity*.

Dark Ages, The. Ed. D. Talbot Rice, London, 1965.

DASGUPTA, S. N. *A History of Indian Philosophy*, vol. I, Cambridge University Press, 1922.

DAVIDSON, E. R. Ellis. *Scandinavian Mythology*, London, 1969.

DAWSON, C. *Religion and the Rise of Western Culture*, London, 1950.

DEGEN, K. "Kunsthandwerk II. Christliches Kunsthandwerk," in *R.G.G.*, 172–182.

DELATTRE, A. L. *Carthage: necropole punique voisine de Sainte-Monique, deuxième semestre des fouilles, juillet-decembre 1898.* Paris, [1898] *La necropole des rabs, prêtres et prêtresses de Carthage.* Paris [1904]

DENNIS, G. *Cities and Cemeteries of Etruria*, 2 vols., 3d ed., London, 1907.

DEREN, M. *Divine Horsemen: The Living Gods of Haiti*, London, 1953.

DERMENGHEM, E. *Muhammad and the Islamic Tradition*, E.T., New York/London, 1958.

DESROCHES-NOBLECOURT, C. *Tutankhamen*, E.T., London, 1963.

DHORME, E. *Les religions de Babylonie et Assyrie*, Paris, 1945.

DICKENS, A. G. *Reformation and Society in Sixteenth Century Europe*, London, 1966.

DIETERICH, A. *Nekyia: Beiträge zur Erklärung der Neuentdeckten Petrusapokalypse*, Stuttgart, 1969.

DINKLER, E. "Kreuzzeichen und Kreuz," in *Jb.f.A.C.*, 5 (1962), pp. 93–107.

"Malerei und Plastik, Part I: Spätantike," in *R.G.G.*, IV, 630–9.

DIODORUS OF SICILY, *Bibliotheca Historica*, vol. I, Loeb Classical Library, London/Cambridge, Mass., 1946.

DIRINGER, D. *The Alphabet*, London, 1948.

DODDS, E. R. *The Greeks and the Irrational*, Berkeley, Calif., 1951.

Pagan and Christian in an Age of Anxiety, Cambridge University Press 1965.

DOLGER, F. J. ΙΧθΥΣ, vol. I, Rome, 1910, vols. II–V, Münster, 1922–43.

"Das Kreuzzeichen im Taufritual," in *Jb.f.A.C.,* 5(1962), pp. 10–22.

DOWSON, J. *A Classical Dictionary of Hindu Mythology,* 7th ed., London, 1950.

DRÄYER, W. *Tarquinia: Wandmalereien aus etruskischen Gräbern,* Munich, 1957.

DRIVER, G. R. *Semitic Writings* (Schweich Lectures, 1944), London, 1948.

DUBOIS, J. A. *Hindu Manners, Customs and Ceremonies,* E.T., 3rd ed., Oxford, 1906.

DUCHESNE, L. *Christian Worship: Its Origin and Evolution,* E.T., 5th ed., London, 1927.

DUCKWORTH, H. T. F. *The Church of the Holy Sepulchre,* London, 1922.

DUPONT-SOMMER, A. *Les Araméens,* Paris, 1949.

DU RY, J. *Art of the Ancient Near and Middle East,* E.T., New York, 1970.

DUSSAUD, R. *Les religions des Hittites, et des Hourites, des Phéniciens et des Syriens,* Paris, 1945.

DUTT, S. *Buddhist Monks and Monasteries in India,* London, 1962.

Early Christian and Byzantine Art in the Victoria and Albert Museum, London, 1955.

EBELING, E. *Tod und Leben nach den Vorstellungen der Babylonier,* Band I (Texte), Berlin/Leipzig, 1931.

EDWARDS, I. E. S. *The Pyramids of Egypt,* Harmondsworth, Middlesex, 1947.

Eighteenth Century, The. Ed. A. Cobban, London, 1969.

EISLER, R. *Orpheus—The Fisher: Comparative Studies in Orphic and Early Christian Cult Symbolism,* London, 1921.

Man into Wolf, London, 1951.

EKLUND, R. *Life Between Death and Resurrection According to Islam,* Uppsala, 1941.

ELIADE, M. *Traité d'histoire des religions*, Paris, 1949.

Images and Symbols, E.T., London, 1961.

ELIOT, C.N.E. *Hinduism and Buddhism*, 3 vols., London, 1954 (1921).

EMERY, W. B. *Archaic Egypt*, Harmondsworth, Middlesex, 1961.

English Alabasters (from the Hildburgh Collection) Victoria and Albert Museum, London, 1956.

Epistle of Jeremy. Trans. in English Revised Version of *The Apocrypha*.

VON ERFFA, H. M. "Malerei und Plastik, II. Frühes und hohes Mittelalter," in *R.G.G.*, IV, 639–51.

ERMAN, A. *The Literature of the Ancient Egyptians*, E.T., London, 1927.

Die Religion der Aegypter, Berlin/Leipzig, 1934.

ERMAN, A./RANKE, H. *Aegypten und aegyptischen Leben im Altertum*, Tübingen, 1923.

Wörterbuch der aegyptischen Sprache, 5 vols., Leipzig, 1926.

EVANS, J. *English Art, 1307–1461*, Oxford, 1949.

Life in Medieval France, London, 1957.

EVANS, J. D. *Malta*, London, 1959.

EVDOKIMOV, P. *La femme et le salut du monde: Étude d'anthropologie chrétienne sur les charismes de la femme*, Tournai/Paris, 1958.

FAIRMAN, H. W. "The Kingship Rituals of Egypt," in *Myth, Ritual and Kingship* (1958).

"Worship and Festivals in an Egyptian Temple," in *B.J.R.L.*, vol. 37 (1954), 165–203.

FALLAIZE, E. N. "Puppets," in *E.R.E.*, vol. X, 446–447.

FARNELL, L. R. *Greek Hero Cults and Ideas of Immortality*, Oxford, 1921.

FAULKNER, R. O. *Ancient Egyptian Pyramid Texts*, 2 vols., Oxford, 1969.

FENG YU-LAN. *A Short History of Chinese Philosophy*, New York, 1960.

FERGUSON, G. W. *Signs and Symbols in Christian Art*, New York, 1961.

FESTUGIÈRE, A. M. J. *La révélation d'Hermès Trismégiste,* vol. III (*Les doctrines de l'âme*), Paris, 1953.

FINEGAN, J. *Archeology of World Religions,* Princeton University Press, 1952.
The Archeology of the New Testament, Princeton University Press, 1969.

FISHWICK, D. "The Talpioth Ossuaries Again," in *N.T.S.,* X (1963–4), pp. 49–61.

Flowering of the Middle Ages, The. Ed. J. Evans, London, 1966.

FOCILLON, H. *The Art of the West in the Middle Ages,* vol. I (Romanesque Art), vol. II (Gothic Art), E.T., London, 1963.

FORTESCUE, A. *The Ceremonies of the Roman Rite Described,* 6th ed. by J. O'Connell, London, 1937.

FOURNÉE, J. *Le Jugement Dernier,* Paris, 1964.

FOWLER, W. WARDE *The Religious Experience of the Roman People,* London, 1911.

FRANK, B. "Les personnages vénérés du bouddhisme japonais. Cultes et images," in *R.H.R.,* vol. CLXXVII (1970), pp. 114–17.

FRANKFORT, H. *Ancient Egyptian Religion,* New York, 1948.
Kingship and the Gods, Chicago University Press, 1948.
The Birth of Civilization in the Near East, London, 1951.
The Art and Architecture of the Ancient Orient (New Pelican History of Art), Harmondsworth/Baltimore, 1955.

FRANKFORT, H./FRANKFORT, H. A. *The Intellectual Adventure of Ancient Man,* University of Chicago Press, 1946.

FRANKFORT (GROENEWEGEN), H. A. *Arrest and Movement,* Chicago, 1951. *The Ancient World,* New York, 1967, with B. Ashmole.

FRAZER, J. G. *The Magic Art* (G.B.), 2 vols., London, 1936.
Adonis, Attis, Osiris (G.B.), 2 vols., London, 1936.
Balder the Beautiful (G.B.), 2 vols., London, 1936.

FREND, W. H. C. *The Donatist Church,* Oxford, 1952.

FRODL, W. *Die romanische Wandmalerei in Kärnten,* 2nd ed., Klagenfurt, 1944.

FRYE, R. N. *The Heritage of Persia,* London, 1962.

FURLANI, G. *Riti babilonesi e assiri,* Udine, 1940.

GAIRDNER, J. *The English Church in the Sixteenth Century,* London, 1902.

GARBINI, G. *The Ancient World* (Landmarks in the World's Art), London, 1966.

GARCÍA Y BELLIDO, A. *Les religions orientales dans l'Espagne romaine* (*E.P.R.O.*, vol. 5), Leiden, 1967.

GARDINER, A. H. *The Attitude of the Egyptians to Death and the Dead*, Cambridge, 1935.
Egyptian Grammar, Oxford, 1927.
Egypt of the Pharaohs, Oxford, 1961.

GARDINER, A. H./SETHE, K. *Egyptian Letters to the Dead*, London, 1928.

GASTER, T. H. *Myth, Legend and Custom in the Old Testament*, New York, 1969.

GAUDEFROY-DEMOMBYNES, M. *Mahomet*, Paris, 1957.

GAUDET, C. "The Tomb of Osiris at Abydos," in *W.P.*, III, pp. 986–91.

GAUR, A. "Les danses sacrées en Inde," in *S.O.*, VI (*Les danses sacrées*), 1963.

GERNET, L./BOULANGER, A. *Le génie grec dans la religion*, Paris, 1932.

GEYER, H.-G. "Kunst III. Kunst und christlicher Glaube," in *R.G.G.*, IV, 161–5.

GHIRSHMANN, R. *Iran*, Harmondsworth, Middlesex, 1954.

GIEDION, S. *The Eternal Present: The Beginnings of Art*, Oxford, 1962.

GLUECK, N. *Deities and Dolphins (The Story of the Nabataeans)*, London, 1966.

GODFREY, J. *The Church in Anglo-Saxon England*, Cambridge University Press, 1962.

GOLDAMMER, K. "Die Welt des Heiligen im Bilde des Gottherrschers," in *R.S.*, (1959) 513–530.

GONDA, J. *Die Religionen Indiens*, I, *Veda und älterer Hinduismus*, Stuttgart, 1960.

GOODENOUGH, E. R. *By Light, Light: The Mystic Gospel of Hellenistic Judaism*, New Haven, 1935.
Jewish Symbols in the Graeco-Roman Period, 13 vols., New York, 1953–68.

GOUGH, M. *The Early Christians*, London, 1961.

GRABAR, A. *The Beginnings of Christian Art*, E.T., London, 1967.
Byzantium, E. T., London, 1966.
Christian Iconography: A Study of Its Origins, Princeton University Press, 1968.

GRANET, M. *Chinese Civilization*, E.T., London, 1930.
La pensée chinoise, Paris, 1934.

GRAY, J. *The Canaanites*, London, 1964.

GRENIER, A. *Les religions étrusque et romaine*, Paris, 1948.

GRESSMAN, H. *Die orientalischen Religionen im hellenistisch-römischen Zeitalter*, Berlin/Leipzig, 1930.

GRIFFITHS, J. G. *The Conflict of Horus and Set, from Egyptian and Classical Sources*, Liverpool, 1960.
The Origins of Osiris (Müncher aegyptologische Studien, 9), Berlin, 1966.

GRIVOT, D./ZARNECKI, G. *Gilbertus: sculpteur d'Autun*, 2nd ed., Paris, 1965.

GROHMANN, W. "Malerei und Plastik VI. Im 20.Jh.," in *R.G.G.*, IV, 692–702.

GROSSI GONDI, F. *I monumenti cristiani iconografici ed architettonici dei sei primi secoli*, Rome, 1923.

GROUSSET, R. *In the Footsteps of the Buddha*, E.T., London, 1932.

GRUBE, E. J. *The World of Islam* (Landmarks of the World's Art), London, 1966.

VON GRUNEBAUM, G. E. "Byzantine Iconoclasm and the Influence of the Islamic Environment," in *H.E.*, vol. 2 (1962).

GSELL, S. *Histoire ancienne de l'Afrique du Nord*, vol. IV (La civilisation carthagenoise), Paris, 1928.

GUDIOL, J. *See* Souchal, G., *et al.*

Guide to the Exhibited Manuscripts, Part III, in the Greenville Library, British Museum, 1923.

GUTHRIE, W. K. C. *The Greeks and Their Gods*, London, 1950.
Orpheus and Greek Religion, 2nd ed., London, 1952.

HAFNER, G. *Art of Crete, Mycenae and Greece*, E.T., New York, 1968.

HAMANN, R. *Aegyptische Kunst*, Berlin, 1944.

HAMIDULLAH, M. "Le pèlerinage a la Mecque," in *S.O.*, III (Les pèlerinages), 1960.

HARDISON, O. B. *Christian Rite and Christian Drama in the Middle Ages*, Baltimore, 1965.

HARNACK, A. *A History of Dogma*, E.T., 7 vols., New York, 1961.

HARRISON, J. *Ancient Art and Ritual*, London, 1955 (reprint of 1911 edition).
Prolegomena to the Study of Greek Religion, 3rd ed., New York, 1955 (reprint of 1922 edition).

HARVEY, J. *The Gothic World, 1100–1600*, London, 1950.

HASSALL, A. G./HASSALL, W. O. *The Douce Apocalypse*, London, 1961.

HAUSER, A. *The Social History of Art*, 4 vols., E.T. London, 1962.

HAWKES, J. *Prehistory* (vol. I, Part I, of *History of Mankind: Cultural and Scientific Development*, U.N.E.S.C.O.), London, 1963.
"God in the Machine," in *Antiquity*, vol. XLI (1967).
The Dawn of the Gods, London, 1968.

HEER, F. *Aufgang Europas*, Vienna, 1949.
The Medieval World, E.T., London, 1962.

HEIDEL, A. *The Epic of Gilgamesh and Old Testament Parallels*, 2nd ed., Chicago University Press, 1949.

HEILER, F. "Antikes Gottkönigtum im Christentum," in *R.S.* (1959).

HELCK, W./OTTO, E. *Kleines Wörterbuch der Aegyptologie*, Wiesbaden, 1956.

HENDERSON, G. D. S. *Gothic*, Harmondsworth, Middlesex, 1967.
Chartres, Harmondsworth Middlesex 1968.

HENRY, F. *Irish Art* (A.D. *800–1020*), E.T., London, 1967.

HERMANN, A. "Aegyptologische Marginalien zur spätantiken Ikonographie," in *Jb.f.A.C.*, 5 (1962), pp. 60–92.

HERODOTUS, *Historiae*, ed. G. Long from the text of J. Schweighaeuserus, London, 1830.

HERTLING, L./KIRSCHBAUM, E. *The Roman Catacombs and Their Martyrs*, E.T., London, 1960.

HEURGON, J. *The Daily Life of the Etruscans*, E.T., London, 1964.

HEYERDAHL, T. *Aku-Aku*, E.T., London, 1958.
"Navel of the World," in *Vanished Civilisations* (1963).

HEYERDAHL, T./FERDON, E. N. *Archaeology of Easter Island*, vol. I. Reports of the Norwegian Archaeological Expedition to Easter Island, Stockholm, 1962.

HICKS, R. *Carolingian Art*, University of Michigan Press, 1966.

HODGKIN, R. H. *History of the Anglo-Saxons*, 3rd ed., 2 vols., Oxford, 1952.

HOFSTÄTTER, H. H. *Art of the Late Middle Ages*, E.T., New York, 1968.

HOLLIS, F. J. "The Sun-cult and the Temple of Jerusalem," in *Myth and Ritual*, ed. S. H. Hooke, Oxford, 1933.

Horizon Book of Great Cathedrals, The. Ed. J. Jacobs, New York, 1968/London, 1969.

HORNUNG, E. *Altägyptische Höllenvorstellungen* (Abhandlungen der sächsischen Akademie der Wissenschaften zu Leipzig. Philologisch-historische Klasse, vol. 59. Heft 3), Berlin, 1968.

HUGHES, E. R./HUGHES, K. *Religion in China*, London, 1950.

HUGHES, R. *Heaven and Hell in Western Art*, London, 1968.

HUIZINGA, J. *The Waning of the Middle Ages*, E.T., New York, 1954 (1924).

HURRY, J. B. *Imhotep*, Oxford, 1926.

HUS, A. *The Etruscans*, E.T., New York, 1961.

HUTCHINSON, R. W. *Prehistoric Crete*, Harmondsworth, Middlesex, 1962.

HUTTON, E. *Ravenna* (Mediaeval Towns), London, 1926.

Illustrated Religion Guides to Ancient Monuments, vol. V (North Wales), London, 1954.

IONS, V. *Indian Mythology*, London, 1967.

JACQUES, C. "Les pèlerinages en Inde," in *S.O.*, II (*Les pèlerinages*), 1960.

JAEGER, W. *The Theology of the Early Greek Philosophers*, Oxford, 1947.

JAMES, E. O. *Christian Myth and Ritual*, London, 1933.
The Origins of Sacrifice, London, 1933.
Prehistoric Religion, London, 1957.
The Cult of the Mother Goddess, London, 1959.
Seasonal Feasts and Festivals, London, 1961.
The Tree of Life, Leiden, 1966.

JASTROW, M. *Aspects of Religious Beliefs and Practice in Babylonia and Assyria*, New York, 1911.

JEAN, C.-F. *La religion sumérienne (d'après les documents antérieurs à la dynastie d'Isin)*, Paris, 1931.

JEREMIAS, J. *Heiligengräber in Jesu Umwelt*, Göttingen, 1958.

Jerusalem zur Zeit Jesu, Göttingen, 1958.

JOHNSON, A. R. *The Vitality of the Individual in the Thought of Ancient Israel*, University of Wales Press, Cardiff, 1949.

JOIN-LAMBERT, M. *Jerusalem*, E.T., London, 1966.

JORDAN, J. H. *Comparative Religion: Its Genesis and Growth*, London, 1905.

Comparative Religion: Its Adjuncts and Allies, London, 1915.

JOSEPHUS. *The Jewish War*, Book V, in Loeb Classical Library ed. of Josephus, vol. III, New York, 1928.

Jewish Antiquities, Books V and VIII, in Loeb ed., vol. V, Cambridge, Mass., 1934.

JOYCE, A. T. "Boro Budur: The Soul of Java," in *W.P.*, vol. I, pp. 183–94.

JUNGMANN, J. A. *The Mass of the Roman Site: Its origin and development*, 2 vols., E.T., New York, 1951–55.

JUNKER, H. *Die Götterlehre von Memphis (Schabaka-Inschrift)*, (Abhandlungen der preussichen Akademie der Wissenschaften, 1939, Nr. 23), Berlin, 1940.

Pyramidenzeit (Das Wesen der altägyptischen Religion), Zürich, 1949.

Die Kultkammen des Prinzen Kanjnjswt, 3rd ed., Vienna, n.d.

KARAGEORGHIS, V. *Treasures in the Cyprus Museum*, Department of Antiquities, Cyprus, 1962.

KARO, G. "Religion des ägäischen Kreises," in *Bilderatlas*, 7 Lief., 1925.

KATZENELLENBOGEN, A. *The Sculptural Programs of Chartres Cathedral*, New York, 1964 (1959).

KAY, M. *Bruegel*, London, 1969.

KEES, H. *Totenglauben und Jenseitsvorstellungen der alten Aegypter*, 2nd ed., Berlin, 1956.

"Das Eindringen des Osiris in die Pyramidentexte," in S. A. B. Mercer, *The Pyramid Texts*, IV, pp. 123–39.

KENDALL, A. *Medieval Pilgrims*, London, 1970.

KENYON, K. M. *Amorites and Canaanites* (Schweich Lectures, 1963), London, 1966.

KESSLER, C. "Abd al-Malik's Inscription in the Dome of the Rock: A Reconsideration," in *J.R.A.S.* (1970), pp. 2–14.

KIDDER, J. E. *Japan Before Buddhism*, London, 1959.

KIDSON, P. *The Medieval World* (Landmarks in the World's Art), London, 1967.

KINGLAKE, A. W. *Eothen*, London, 1948, first published in 1844.

KIRK, G. S./RAVEN, J. E. *The Presocratic Philosophers*, Cambridge University Press, 1960.

KIRK, K. E. *The Vision of God*, London, 1950.

KITSON, M. *The Age of Baroque*, London, 1966.

KLAUSER, T. "Studien zur Entstehungsgeschichte der christlichen Kunst IV," in *Jb.f.A.C.*, 1(1958), 2(1959), 3(1960), 4(1961), 7(1964), 8/9(1965), 10(1967).

"Engel X (in der Kunst)," in *R.A.C.*, 5(1962), col. 258–322.

KLOSTERMANN, E. *Das Matthäusevangelium*, 2nd ed., Tübingen, 1926.

KOLLWITZ, J. "Christusbild," in *R.A.C.*, vol. III (1957), Stuttgart, col. 1–24.

KOPP, C. *The Holy Places of the Gospels*, E.T., London, 1963.

KÖTTING, B. "Weihrauch," in *R.G.G.*, VI (1962).

KRAFT, H. *Kaiser Konstantins religiöse Entwicklung*, Tübingen, 1955.

KRAMRISCH, S. *The Hindu Temple*, 2 vols., University of Calcutta, 1946.

"Indian Varieties of Art Ritual," in *Myths and Symbols: Studies in Honor of Mircea Eliade*, ed. J. M. Kitagawa and C. H. Long, University of Chicago Press, 1969.

KRETZENBACHER, L. *Die Seelenwaage (Zur religiösen Idee vom Jenseitsgericht auf der Schicksalwaage im Hochreligion, Bildkunst und Volkglaube)*, Klangenfurt, 1958.

KRICKEBERG, W./TRIBORN, H./MÜLLER, W./and ZERRIES, O. *Pre-Columbian Religion*, E.T., London, 1968.

KÜHN, H. *Die Felsbilder Europas*, Zürich/Vienna, 1952.

DE LABRIOLLE, P. *La réaction païenne*, Paris, 1934.

Labyrinth, The. Ed. S. H. Hooke, London, 1935.

LACROIX, P. *Military and Religious Life in the Middle Ages and the Renaissance,* E.T., New York, 1964 rp. (1874).

LAMING, A. *Lascaux,* E.T., Harmondsworth, Middlesex, 1959.

LANE, E. W. *The Manners and Customs of the Modern Egyptian* (first published in 1836), 2 vols., London, 1890.

LANGE, C./HIRMER, M. *Egypt: Architecture, Sculpture, Painting in Three Thousand Years,* E.T., 4th ed. rev., New York/London, 1968.

LANGLOTZ, E./DEICHMANN, FR. W. "Basilika," in *R.A.C.,* vol. I Stuttgart, 1950, col. 1225–59.

LANKHEIT, K. "Malerei und Plastik V.Im 19.Jh.," in *R.G.G.,* IV, 685–92.

LAPEYRE, G.-G./PELLEGRIN, A. *Carthage punique,* Paris, 1942.

LASSUS, J. *The Early Christian and Byzantine World* (Landmarks of the World's Art), London, 1967.

LEBRETON, J./ZEILLER, J. *The History of the Primitive Church,* vol. IV, E.T., London, 1949.

Legacy of Islam, The. Ed. T. Arnold and A. Guillaume, Oxford, 1931.

LEGG, L. G. W. "The Coronation Service," in *Liturgy and Worship,* ed. W. K. Lowther Clarke, London, 1932, pp. 690–702.

LEHMANN, A. "Malerei und Plastik VII. Christlichen Kunst in den jungen Kirchen," in *R.G.G.,* IV, 702–4.

LEIPOLDT, J. "Die Religionen in der Umwelt des Urchristentums," in *Bilderatlas,* 9–11 Lief. (1926).

LECLERCQ, H. *La vie chrétienne primitive,* Paris, 1928.

LEROI-GOURHAN, A. *The Art of Prehistoric Man in Western Europe,* E.T., London, 1968.

LESCHI, L. *Djemila: Antique Cuicul,* Algiers, 1950.

Les Très Riches Heures du Duc de Berry. Intro. by J. Lougnon, Preface by M. Meiss, New York/London, 1969.

LEVEEN, J. *The Hebrew Bible in Art* (Schweich Lectures, 1939), London, 1944.

LEVY, G. R. *The Gate of Horn,* London, 1952.

LEXA, F. *La magie dans l'Egypte antique, de l'ancien empire jusqu'à l'époque copte,* 3 vols., Paris, 1925.

Liturgy of Maundy Thursday, Good Friday and the Easter Vigil. Ed. T. W. Burke, London, 1963.

Liturgy and Worship. Ed. W. K. Wowther Clark and C. Harris, London, 1932.

LOCKHEAD, I. C. *The Siege of Malta*, 1565, London, 1970.

LODS, A. *Isräel: des origines au milieu du viiie. siècle*, Paris, 1932.
　Les prophètes d'Isräel et les débuts du Judaisme, Paris, 1935.

LOHMEYER, E./SCHMAUCH, W. *Das Evangelium des Matthäus*, 2nd ed., Göttingen, 1958.

LOMMEL, A. *Prehistoric Art and Primitive Man*, London, 1966.

LÜBKE, W. and E. PERNICE. *Die Kunst der Griechen*, 17th ed., Vienna, 1948.

MACALISTER, R. A. S. "La religion de l'époque megalithique," in *H.G.R.*, I, pp. 99–105.

MACCARRONE, M. "Il sovrano 'Vicarius Dei' nell' alto medio evo," in *R.S.* (1959).

MACCHIORO, V. *The Villa of the Mysteries in Pompeii*, Naples, n.d.
　"La liturgia orfica di Pompei," in *Zagreus: studi intorno all' Orfismo*, Florence, 1930, pp. 19–168.

MACCULLOCH, J. A. *Medieval Faith and Fable*, London, 1932.
　"Incense," in *E.R.E.*, VII (1915), pp. 201–5.

MACDONELL, A. A. *A History of Sanscrit Literature*, London, 1928.

MACKAIL, J. W. *Select Epigrams from the Greek Anthropology*, London, 1925.

MACKAY, E. *Early Indus Civilizations*, London, 1948 (1935).

MACLAGAN, M. *The City of Constantinople*, London, 1968.

MAGNIEN, V. *Les mystères d'Eleusis*, Paris, 1950 (1938).

MAINAGE, TH. *Les religions de la Préhistoire: l'age paléolithique*, Paris, 1921.

MAIURI, A. *La Villa dei Misteri*, 2 vol., Rome, 1931.
　The Phlegraean Fields, E.T., Rome, 1937.

MÂLE, E. *L'art religieux du xiie. siècle en France, Paris*, 1953.
　The Gothic Image, E.T., London, 1961.
　Religious Art from the Twelfth to the Eighteenth Century, E.T., New York, 1958.

MALEFIJT, A. DE WAAL *Religion and Culture*, New York, 1968.

MALLOWAN, M. E. L. *Early Mesopotamia and Iran*, London, 1965.

MALRAUX, A. *The Metamorphoses of the Gods,* E.T., London, 1960.

MARTINDALE, A. *Gothic Art,* London, 1967.

Man, Myth and Magic. Ed. R. Cavendish, 7 vols., London, 1970–72.

MAREC, E. *Monuments chrétiens d'Hippone,* Paris, 1958.

MARINATOS, S./HIRMER, M. *Crete and Mycenae,* London, 1960.

MARINGER, J. *The Gods of Prehistoric Man,* London, 1960.

MARTIN, E. J. *A History of the Iconoclastic Controversy,* London, 1930.

MARTIN, J. P. *The Last Judgment in Protestant Theology from Orthodoxy to Ritschl,* Edinburgh, 1963.

MASPERO, H. *Les religions chinoises,* Paris, 1950.

MAYSTRE, C. *Les Déclarations d'Innocence* (Livre des Morts, Chapitre 125), Institut français d'archéologie orientale, Recherches d'archéologie, de philologie et d'histoire, vol. 8, Cairo, 1937.

Medieval English Verse. Trans. and ed. by B. Stowe, Harmondsworth, Middlesex, 1966.

MEISSNER, B. *Babylonien und Assyrien,* II, Heidelberg, 1925.

MELLAART, J. "Earliest of Neolithic Cities: The Third Season of Excavations at Anatolian Chatal Huyuk, Parts I & II," in *I.L.N.,* Feb. 8, 1964. *Earliest Civilizations of the Near East,* London, 1965.

MELLINI, G. L. *El Maestro Mateo en Santiago de Compostela,* Granada, 1968.

MENGHIN, O. *Weltgeschichte der Steinzeit,* Vienna, 1931.

MERCER, S. A. B. *The Religion of Ancient Egypt,* London, 1949. *The Pyramid Texts,* 4 vols., New York, 1952.

MÉTRAUX, A. "Voudou et Protestantisme," in *R.H.R.,* vol. 144 (1953), pp. 198–217.

MEYER, P./HÜRLEMANN, M. *English Cathedrals,* London/New York, 1956.

MILLET, G. *Recherches sur l'iconographie de l'Evangile aux XIVe, XVe, et XVIe siècles, d'après les monuments de Mistra, de la Macédoine et du Mont-Athos,* Paris, 1960.

MILOŠEVIĆ, D. *The Last Judgment* (Pictorial Library of Eastern Church Art, 3), E.T., Recklinghausen, 1967.

MINUCIUS, FELIX MARCUS. *The Octavius,* Loeb Classical Library ed., Cambridge, Mass., 1960.

MITCHELL, S. *Medieval Manuscript Painting*, London, 1965.

MOORTGAT, A. *Tammuz: der Unsterblichkeitsglaube in der altorientalischen Bildkunst*, Berlin, 1949.

MORENZ, S. *Aegyptische Religion*, Stuttgart, 1960.

"Das Werden zu Osiris (die Darstellungen auf einem Leinentuch der römischen Kaiserzeit (Berlin 11651) und verwandten Stücken)," in *Staatliche Museen zu Berlin: Forschungen und Berichte*, I (1957), pp. 52–70.

MORET, A. *Le rituel du culte divin journalier en Egypte*, Paris, 1902.

"Le Livre des Morts," in *Au temps der Pharaon*, Paris, 1912.

Mystères égyptiennes, Paris, 1923.

Le Nil et la civilisation égyptienne, Paris, 1926.

MOSCATI, S. *Historical Art in the Ancient Near East*, Centro di studi semitici, Universita di Roma, 1963.

MUNCEY, R. W. *A History of the Consecration of Churches and Graveyards*, Cambridge (Heffer), 1930.

MUNSTERBERG, H. *Art of the Far East*, New York, 1968.

Art of India and Southeast Asia, New York, 1970.

MURRAY, J. *Handbook to the Cathedrals of England*, Part II, London, 1861.

MURRAY, M. A. *Egyptian Sculpture*, London, 1930.

MYLONAS, G. E. *Eleusis and the Eleusinian Mysteries*, Princeton University Press, 1961.

Myth and Ritual. Ed. S. H. Hooke, Oxford, 1933.

Myth, Ritual and Kingship. Ed. S. H. Hooke, Oxford, 1958.

NAKAMURA, H. "Time in Indian and Japanese Thought," in *The Voices of Time*, ed. J. T. Fraser, New York, 1966.

NARR, K. J. "Approaches to the Religion of Early Paleolithic Man," in *H.R.*, 4 (1964).

NARSAI. *Liturgical Homilies of Narsai*, trans. by R. H. Connelly, vol. VIII of *Texts and Studies*, No. 1, Cambridge, 1909.

NEEDHAM, J. (with Wang Ling). *Science and Civilization in China*, vol. II, Cambridge, 1956.

NEUSNER, J. "Judaism at Dura-Europas," in *H.R.*, 4 (1964).

NILSSON, M. P. *Greek Popular Religion*, New York, 1940.

Geschichte der griechischen Religion, Munich, vol. I (1941), vol. II (1950).

The Minoan-Mycenaean Religion and Its Survival in Greek Religion, Lund, 1950.

NOCK, A. D. *Conversion: The Old and New in Religion from Alexander the Great to Augustine of Hippo*, Oxford, 1933.

NOHL, J. *The Black Death*, London, 1961 (1926).

OERTEL, R. "Malerei und Plastik III. Spätgotik und Renaissance," in *R.G.G.*, IV, 651–65.

OESTERLY, W. O. E. *Immortality and the Unseen World*, London, 1930.

"The Cult of Sabazios," in *The Labyrinth* (ed. S. H. Hooke).

O'MALLEY, L. S. S. *Popular Hinduism*, Cambridge, 1935.

Opus Anglicanum (Catalogue of Exhibition in the Victoria and Albert Museum, 1963), The Arts Council, 1963.

OTTO, E. *Egyptian Art and the Cults of Osiris and Amon*, E.T., London, 1968.

OTTO, R. *The Idea of the Holy*, E. T., London, 1928.

PAIS, E. *Storia dell' Italia antica*, I, Turin, 1933.

PALLOTTINO, M. *The Etruscans*, E.T., Harmondsworth, Middlesex, 1955.

PANOFSKY, E. *Gothic Architecture and Scholasticism*, Cleveland/New York, 1957.

Tomb Sculpture, London, 1964.

Meaning in the Visual Arts, I, "Abbot Suger of St. Denis," Harmondsworth, Middlesex, 1970.

DE PAOR, M. and L. *Early Christian Ireland*, London, 1958.

PARRINDER, E. G. *Worship in the World's Religions*, London, 1961.

PARROT, A. *Le "Refrigerium" dans l'au-delà*, Paris, 1937.

Archéologie mésopotamienne, 2 vols., Paris, 1946–53.

Le Temple de Jérusalem, Neuchâtel, 1954, E.T., London, 1957.

Golgotha and the Church of the Holy Sepulchre, E.T., London, 1957.

PATAI, R. *Man and Temple*, London, 1947.

PEDERSEN, J. *Israel: Its Life and Culture*, I–IV, in 2 vols., Copenhagen/London, 1926–40.

PERCHERON, M. *Buddha and Buddhism*, E.T., New York/London, 1957.

PETRIE, W. M. FLINDERS, *Roman Portraits and Memphis (IV)*, British School of Archaeology in Egypt, London, 1911.
History of Egypt, I, London, 1923.

PETTAZZONI, R. *The All-Knowing God*, E.T., London, 1956.

PFEIFFER, R. H. *History of New Testament Times (with an Introduction to the Apocrypha)*, New York, 1949.

PIANKOFF, A. *The Pyramid of Unas*, Bollingen Series XL.5, Princeton University Press, 1968.
The Shrines of Tut-Ankh-Amon, New York, 1955.

PICARD, C. *Les religions préhelléniques*, Paris, 1948.

PITA ANDRADE, J. M. *Le chemin de Saint-Jacques*, Editora Nacional, Madrid, n.d.

PITTIONI, R. *Die urgeschichtlichen Grundlagen der europäischen Kultur*, Vienna, 1949.

PLUTARCH. *De Iside et Osiride* in Plutarch's *Moralia*, Loeb Classical Library, vol. V., Cambridge, Mass., 1936.
De Iside et Osiride, ed., with trans. and commentary by J. Gwyn Griffiths. University of Wales Press, 1970.

POOLE, A. L. *From Domesday Book to Magna Carta*, Oxford, 1951.

POOLE, R. L. *Illustrations of the History of Medieval Thought and Learning*, London, 1932.

PORADA, E. *Ancient Iran: The Art of Pre-Islamic Times*, London, 1965.

PORCHER, J. *The Rohan Book of Hours*, London, 1959.

PORTER, B./MOSS, R. L. B. *Topographical Bibliography of Ancient Egyptian Hieroglyphic Texts, Reliefs and Paintings*, II, Oxford, 1929.

POSENER, G. *A Dictionary of Egyptian Civilization*, E.T., London, 1962.

POWELL, T. G. E. *Prehistoric Art*, London, 1966.

PRESCOTT, H. F. M. *Friar Felix at Large: Pilgrimage to the Holy Land in the Fifteenth Century*, London, 1954.

PRYCE, F. N. "The Mausoleum at Halicarnassus," in *W.P.*, vol. I, pp. 13–17.

PRZYLUSKI, J. *La Grande Déese*, Paris, 1950.

VON RAD, G. *Genesis*, E.T., London, 1961.

RAHNER, H. "The Christian Mystery and the Pagan," in *The Mysteries: Papers from the Eranos Yearbooks*, ed. J. Campbell, London, 1955.

RANKE, H. *The Art of Ancient Egypt*, Vienna, 1936.

RATSCHOW, C. H. *Magie und Religion*, Gütersloh, 1955.
"Bilder und Bilderverehrung, I. Religionsgeschichtlich," in *R.G.G*, I, 1268–71.
Kunst I. Kunst und Religion, religionsgeschichtlich-phänomenologisch," in *R.G.G.*, IV, 126–31.

RÉAU, L. *Iconographie de l'art chrétien*, 6 vols., Paris, 1955–59.

RÉAU, L./COHEN, G. *L'art du moyen âge*, Paris, 1951.

REID, R. D. *Wells Cathedral*, The Friends of Wells Cathedral, 1965.

REITZENSTEIN, H. *Die hellenistischen Mysterienreligionen*, 3rd ed., Leipzig/Berlin, 1927.

RÉMOND, M. *La Kabylie*, Algiers, 1937.

REYMOND, E. A. E. *Mythical Origin of the Egyptian Temple*, Manchester University Press, 1969.

RICE, D. TALBOT. *The Beginnings of Christian Art*, London, 1957.
Art of the Byzantine Era, London, 1963.
Islamic Art, London, 1965.
Byzantine Painting, Harmondsworth, London, 1968.

RICHMOND, I. A. *Archaeology, and the After-Life in Pagan and Christian Imagery*, Cambridge University Press, 1950.

RICHTER, G. M. A. *Kouroi: Archaic Greek Youths*, London, 1942, 1960.
Korai: Archaic Greek Maidens, London, 1968.

RICKERT, M. *Painting in Britain: The Middle Ages* (New Pelican History of Art), London/Baltimore, 1954.

DE RIDDER, A./DEONNA, W. *L'art en Grèce*, Paris, 1924.

RODRIGUEZ, A./DE LOJENDIO, L.-M. *Castille Romane*, vol. I, L'Abbaye Sainte-Marie de la Pierre-Qui-Vire (Yonne), 1966.

ROGIER, L. "Le caractère sacré de la royauté en France," in *R.S.* (1959).

ROHDE, E. *Psyche: Seelencult und Unsterblichkeitsglaube der Griechen*, 2 vols., Freiburg, 1898.

Romanesque Art in the Victoria and Albert Museum, London, 1957.

Rorimer, J. J. *The Cloisters* (Metropolitan Museum of Art), 3rd ed., New York, 1963.

Rose, H. J. *Handbook of Greek Mythology*, London, 1928.

Ancient Roman Religion, London, 1948.

Ross, A. *Pagan Celtic Britain*, London/New York, 1967.

Rossiter, S. *Greece* (Blue Guides), London, 1967.

Rostovtzeff, M. *Città carovaniere*, Bari, 1934.

Rouse, W. H. D. "Votive Offerings (Greek)," in *E.R.E.*, vol. XII (1921), 641–43.

Greek Votive Offerings, Cambridge University Press, 1902.

Routledge, S. "The Mystery of Easter Island," in *W.P.*, vol. III, pp. 902–26.

Rowe, A. *Cyrenaican Expeditions of the University of Manchester*, Manchester University Press, 1959.

Rowland, B. *The Art and Architecture of India: Buddhist-Hindu, Jain* (The Pelican History of Art), London/Baltimore, 1953.

Rowley, H. H. *Worship in Ancient Israel*, London, 1967.

Ruffy, J.-F. *Les fresques de Giotto à l'Arena de Padoue*, Lausanne, 1968.

Rumpf, A. "Die Religion der Griechen," in *Bilderatlas* 13/14 Lief., 1928.

Runciman, S. *A History of the Crusades*, 3 vols., Cambridge University Press, 1954.

Rundle Clark, R. T. *Myth and Symbol in Ancient Egypt*, London, 1959.

Ruppel, A. "Heilsspiegel," in *R.G.G.*, III, 192–3.

Ryckmans, G. "Les religions arabes préislamique," in *H.G.R.*, IV (1947), 307–332.

Sachs, K. *Histoire de la danse*, Paris, 1938.

Saggs, H. W. F. *The Greatness That Was Babylon*, London, 1962.

Sainte Fare Garnot, J. "Les formules funéraires des stèles égyptiennes," in *H.G.R.*, I, pp. 329–37.

Santiago de Compostela, España. Editora Nacional, Madrid, n.d.

Saviour God, The. (Comparative Studies in the Concept of Salvation, presented to E. O. James), ed. S. G. F. Brandon, Manchester University Press, 1963.

SCHADE, H. *Dämonen und Monstren,* Regensburg, 1962.

SCHAEFFER, C. F. A. *Cuneiform Texts of Ras Shamra-Ugarit* (Schweich Lectures, 1936), London, 1939.

VON SCHEFFER, TH. *Die Kultur der Griechen,* Königsburg, 1938.

SCHOTT, R. *Michelangelo,* E.T., London, 1963.

SCHOTT, S. *Mythe und Mythenbildung im alten Aegypten,* Leipzig, 1945.

SCHUG-WILLE, C. *Art of the Byzantine World,* E.T., New York, 1969.

SCHÜRER, E. *Geschichte des jüdischen Volkes im Zeitalter Jesu Christi,* 3 vols., Leipzig, 1898–1901.

SECKEL, D. *The Art of Buddhism,* E.T., London, 1964.

SEGAL, J. B. *Edessa: "The Blessed City,"* Oxford, 1970.

SETHE, K. *Urkunden des Alten Reiches,* vol. I, Leipzig, 1903.
Dramatische Texte zu altaegyptischen Mysterienspielen, I, "Das 'Denkmal memphitischer Theologie' der Schabakostein des Britischen Museums," in *Untersuchungen zur Geschichte und Altertumskunde Aegyptens,* vol. X, Leipzig, 1928.

SEZNEC, J. *La survivance des dieux antiques,* The Warburg Institute, London, 1940.

SIERKSMA, F. *The Gods As We Shape Them,* E.T., London, 1960.

SIEVEKING, G. "The Migration of the Megaliths," in *Vanished Civilisations,* ed. E. Bacon (1963).

SILCOCK, A. *An Introduction to Chinese Art and History,* Oxford, 1935.

VON SIMSON, O. *The Gothic Cathedral,* London, 1956.

SMITH, D. H. "Divine Kingship in Ancient China," in *Numen,* vol. IV (1957), Leiden, 171–203.
"Chinese Concepts of the Soul," in *Numen,* vol. V (1958), Leiden, 166–79.
Chinese Religions, London, 1968.

SMITH, G. E./DAWSON, W. R. *Egyptian Mummies,* London, 1924.

SMITH, H. D. *A Sourcebook of Vaisnava Iconography,* Madras, India, 1969.

SMITH, J. Z. "The Garments of Shame," in *H.R.,* 5 (1965), 217–38.

SOOTHILL, W. E. *The Hall of Light: A Study of Early Chinese Kingship,* London, 1951.

SOUCHAL, F. *Art of the Early Middle Ages*, E.T., New York, 1968.

SOUCHAL, G./CARLI, E./GUDIOL, J. *Gothic Painting*, E. T., London, 1965.

SOULAH, M. *L'Islam et l'évolution de la culture arabe*, Algiers, 1935.

SOURDEL, D. "Le jugement des morts dans l'Islam," in *S.O.*, IV (*Le jugement des morts*), 1961.

SOUSTELLE, J. *The Daily Life of the Aztecs on the Eve of the Spanish Conquest*, E.T., Harmondsworth, Middlesex, 1964.

SPIEGEL, J. *Die Idee vom Totengericht in der aegyptischen Religion*, Glückstadt, 1935.
"Das Auferstehungsritual der Unaspyramide," in *A.S.A.E.*, LII (1956).

SRAWLEY, J. H. "The Holy Communion Service," in *Liturgy and Worship* ed. W. K. Lowther Clarke, pp. 302–73.

STANLEY, A. P. *The Historical Memorials of Canterbury*, London, 1875.

STEIN, M. A. *On Ancient Central-Asian Tracks*, London, 1933.

STENICO, A. *Roman and Etruscan Painting*, E.T., London, 1963.

STENTON, F. *The Bayeux Tapestry*, London, 1957.

STOMMEL, E. "Christliche Taufriten und antike Badesitten," in *Jb.f.A.C.*, 2(1959), pp. 5–14.

STONE, L. *Sculpture in Britain: The Middle Ages* (New Pelican History of Art), Harmondsworth/Baltimore, 1955.

STRANGE, H. O. "Die Religion des alten China (in anthropologische Hinsicht)," in *Anthropologie religieuse*, pp. 133–39.

STRONG, D. "The Etruscan Problem," in *Vanished Civilizations* (1963).

SUGANA, G. M. *Life and Times of Buddha*, E.T., London, 1968.
Life and Times of Mohammed, E.T., London, 1968.

SUKENIK, E. L. *Ancient Synagogues in Palestine and Greece* (Schweich Lectures, 1930), London, 1934.

TANNER, L. E. *The History and Treasures of Westminster Abbey*, London, 1953.

TARSOULE, G. *Delphi*, Athens, 1958 (in Greek).

TAYLOR, LORD WILLIAM. "New Light on Mycenaean Religion," in *Antiquity*, vol. XLIV (1970), ed. G. Daniel, Cambridge, England.

TESTA, E. *Il simbolismo dei giudeo-cristiani,* Tipografia dei P.P. Francescani, Jerusalem, 1962.

THOMAS, E. J. *The Life of the Buddha as Legend and History,* 3rd ed., London, 1949.

The History of Buddhist Thought, 2nd ed., London, 1951.

THOMPSON, A. H. *Cathedral Churches of England,* London, 1925.

THOMPSON, R. C. "The Rock of Behistun," in *W.P.,* vol. II, pp. 554–61.

TINTELNOT, H. "Malerei und Plastik IV. Barock und Rokoko," in *R.G.G.,* IV, 665–85.

TORBRÜGGE, W. *Prehistoric European Art,* E.T., New York/London, 1968.

TOYNBEE, J.,/PERKINS, J. W. *The Shrine of St. Peter and the Vatican Excavations,* London, 1956.

TOYNBEE, J. M. C. *The Art of the Romans,* London, 1965.

Death and Burial in the Roman World, London, 1971.

TRACHTENBERG, J. *The Devil and the Jews: The Medieval Conception of the Jew and Its Relation to Modern Antisemitism,* Yale University Press, 1943.

TRIVICK, H. *The Craft and Design of Monumental Brasses,* New York/London, 1969.

UCKO, P. J. *Anthropomorphic Figurines of Predynastic Egypt and Neolithic Crete, with Comparative Material from the Prehistoric Near East and Mainland Greece* (Royal Anthropological Institute of Great Britain and Ireland; Occasional papers, No. 24), 1968.

UCKO, P. J./ROSENFELD, A. *Palaeolithic Cave Art,* London, 1967.

UPHILL, E. "The Egyptian Sed-Festival Rites," in *J.N.E.S.,* vol. XXIV (1965).

VAILLANT, G. C. *The Aztecs of Mexico,* Harmondsworth, Middlesex, 1950.

VAN DER LEEUW, G. *La religion dans son essence et ses manifestations,* Paris, 1948.

Sacred and Profane Beauty: The Holy in Art, E.T., London, 1963.

VAN DER MEER, F. *Early Christian Art,* E.T., London, 1967.

VAN DER MEER, F./MOHRMANN, C. *Atlas of the Early Christian World*, E.T., London, 1958.

VANDIER, J. *La religion égyptienne*, Paris, 1949.

Vanished Civilisations. Ed. E. Bacon, London, 1963.

VERMASEREN, M. J. *Corpus Inscriptionum et Monumentorum Religionis Mithriacae*, 2 vol. The Hague, 1956–60.

Mithras: The Secret God, London, 1963.

Legend of Attis in Greek and Roman Art (*E.P.R.O.*, IX), Leiden, 1966.

VOLPE, C. *Early Christian to Medieval Painting*, E.T., London, 1963.

WALSH, J. *The Shroud*, London, 1964.

WATKIN, E. I. *Catholic Art and Culture*, rev. ed., London, 1947.

WATSON, W. *China Before the Han Dynasty*, London, 1961.

Early Civilization in China, London, 1966.

WEIL, R. *Le Champ des Roseaux et le champ des Offrandes, dans la religion funéraire et la religion général*, Paris, 1936.

WENSINCK, A. J. *The Muslim Creed*, Cambridge University Press, 1932.

WENTZ, W.Y.E., ed. *The Tibetan Book of the Dead*, 3rd ed., Oxford, 1957.

WERNERT, P. "Le culte des crânes a l'époque paléolithique," H.G.R., I, 53–72.

"Les hommes de l'Age de la Pierre," H.G.R., I, 73–88.

"La signification des cavernes d'art paléolithique," H.G.R., I, 89–98.

WESSEL, K. *Coptic Art*, E.T., London, 1965.

WESTENDORF, W. *Painting, Sculpture and Architecture of Ancient Egypt*, E.T., New York, 1968.

WHEELER, R. E. M. *Civilisations of the Indus Valley and Beyond*, London, 1965.

Roman Art and Architecture, London, 1964.

WIDENGREN, G. *Religionsphänomenologie*, Berlin, 1969.

WIEGER, L. A. *History of Religious Beliefs and Philosophical Opinions in China*, E.T., Hsien-hsien Press, 1927.

VON WILAMOWITZ-MÖLLENDORF, U. *Der Glaube der Hellenen*, 2 vols., Berlin, 1931.

WILD, H. "Les danses sacrées de l'Égypte ancienne," in *S.O.*, VI (*Les danses sacrées*), 1963.

WILDRIDGE, T. T. *The Dance of Death in Painting and in Print*, London, 1887.

WILLETTS, W. *Chinese Art*, 2 vols., Penguin Books, London, 1958.

WINDELS, F. *The Lascaux Cave Paintings*, London, 1949.

WIRGIN, W./MANDEL, S. *History of Coins and Symbols in Ancient Israel*, New York, 1958.

WITT, R. E. *Isis in the Graeco-Roman World*, London, 1971.

WOERMANN, K. *Geschichte der Kunst*, 1 vol., 2nd ed., Leipzig/Vienna, 1915.

WOLF, R. E./MILLEN, R. *Renaissance and Mannerist Art*, New York, 1968.

WOOLLEY, L. *Excavations at Ur*, London, 1955.

YADIN, Y. *The Art of Warfare in Biblical Lands*, E.T., London, 1963.
Masada, E.T., London, 1966.
Tefillin from Qumran, Israel Exploration Society, Jerusalem, 1969.

YOYOTTE, J. "Le jugement des morts dans l'Egypte ancienne," in *S.O.*, IV (Les jugement des morts, 1961).

ZABKAR, L. V. *A Study of the Ba concept in Ancient Egyptian Texts*, Oriental Institute, Chicago, 1968.

ZAEHNER, R. C. *The Dawn and Twilight of Zoroastrianism*, London, 1961.
Hinduism, Oxford, 1962.

ZANDEE, J. *Death as an Enemy According to Ancient Egyptian Conceptions*, E.T., Leiden, 1960.

ZARNECKI, G. *Later English Romanesque Sculpture, 1140–1210*, London, 1953.

ZERNOV, N. *Eastern Christendom*, London, 1961.

ZIEGLER, P. *The Black Death*, Harmondsworth, Middlesex, 1970.

ZIMMER, H. R. *Myths and Symbols in Indian Art and Civilization*, New York, 1962 (Bollingen Foundation, 1946).

ZUNTZ, G. "On the Dionysiac Fresco in the Villa dei Misteri at Pompei," in *P.B.A.*, vol. XLIX (1963).

Picture Credits

ARB—Art Reference Bureau

1a. Drawings from *Creation Legends of the Ancient Near East*.
b. Courtesy, the author.
c. Courtesy, the author.
2. Department of Antiquities, Ashmolean Museum.
3a,b. Egyptian Museum, Cairo. Photos: Hirmer Fotoarchiv.
4. Drawing from *Creation Legends*.
5. Courtesy, the author.
6. Lateran Museum, Rome. Photo: Alinari-ARB.
7. Photo: General Direction of the Vatican Museums.
8. Photo: United Press International.
9. Photo: Editions Charentaises d'Art. A. Gilbert, Jarnac.
10. Photo: Archives Photographiques.
11. Courtesy, the author.
12. From *Osiris and the Egyptian Resurrection* by E. A. W. Budge. London, 1911. (Oriental Division, The New York Public Library.)
13. From *Egyptian Religious Texts and Representations* prepared by Alexandre Piankoff. *The Pyramid of Unas*, copyright © 1968 by Bollingen Foundation. Reprinted by permission of Princeton University Press.
14. Photo: Staatliche Museen zu Berlin. (*Forsuchungen und Berichte*, Akademie-Verlag, I Band, S. Morenz, *Das Werden zu Osiris*, Abt. I.)
15. From *Archaic Egypt*, by W. B. Emery, Penguin Books Ltd. Copyright © Walter B. Emery, 1961.
16. National Gallery, London.
17a,b. Photos: M. Mellaart.
18. Drawn by Grace Huxtable, copyright © M. Mellaart.
19. From *Four Hundred Years of Cave Art*, by A. Breuil, Dordogne, 1952.
20. Photo: Michael Busselle, London.
21. Photo: Archives Photographiques.
22. Cairo Museum. Photo: Hirmer Fotoarchiv.

23. Cairo Museum. Photo: Hirmer Fotoarchiv.
24. Drawing by Miss E. A. Lowcock.
25. Drawing by Miss E. A. Lowcock.
26. Courtesy, the author.
27. Drawing by Miss E. A. Lowcock.
28. Photo: Alinari-ARB.
29. Louvre. Photo: Photographie Giraudon.
30. Naturhistorisches Museum, Vienna.
31. Drawing by Miss E. A. Lowcock.
32. British Museum. Photo: Hirmer Fotoarchiv.
33. Drawing by Miss E. A. Lowcock.
34. Photo: Hirmer Fotoarchiv.
35. Louvre. Photo: Archives Photographiques.
36. Victoria and Albert Museum.
37a. Photo: Archaeological Survey of India.
37b. The Oriental Institute, University of Chicago.
38. Library of St. John's College, Cambridge.
39. Courtesy, Museum of Fine Arts, Boston. Purchased from the Decorative Arts Special Fund.
40. Manchester Museum.
41. British Museum.
42. Olympia Museum, Greece. Photo: Alinari-ARB.
43. City of Liverpool Museums, William Brown St., Liverpool 3.
44. Musée Guimet.
45. Photo: Foto Sienz.
46. Photo: Copyright by Achille B. Weider Fotografiker, Zurich.
47. Courtesy, the author.
48. Photo: Archives Photographiques.
49. Photo: Foto Lala Aufsberg, Allgau.
50. Photo: Hirmer Fotoarchiv.
51. Courtesy, the author.
52. From *Thebes of the Pharaohs*, Charles F. Nims (Elek Books). Photo: Wim Swaan.
53. From Meissner II, p. 127, Abb. 29.
54. From Lacroix, p. 239, fig. 196.
55. From Meissner II, p. 129, Abb. 30.

56. Alte Pinakothek, Munich. Photo: Marburg-ARB.
57. Photo: Copyright © Redemptorist Fathers, Holy Shroud Guild, Esopus, New York.
58. Photo: Alinari-ARB.
59. Tretiakov Gallery, Moscow. Photo: Marburg-ARB.
60. Photo: Alinari-ARB.
61. Photo: Landesmuseum für Kunst und Kulturgeschichte Münster, Westphalia.
62. Photo: Alinari-ARB.
63. Musée d'Hôtel-Dieu, Beaune. Photo: Georges Stevignon.
64. Indian Museum, Calcutta. Photo: Archaeological Survey of India.
65. From the collections in the University Museum, Philadelphia. Photo: R. Goldberg, Philadelphia.
66. Kamakura, Japan. Photo: Japan National Tourist Organization.
67. Holle Bildarchiv, Baden-Baden.
68. Photo: Republic of Indonesia.
69a. Courtesy, Museum of Fine Arts, Boston. Bequest of Charles B. Hoyt.
69b. The Wellcome Museum, by courtesy of the Trustees.
70. Griffith Institute, Ashmolean Museum.
71. Syracuse National Museum. Photo: Hirmer Fotoarchiv.
72. National Museum of Wales, Cardiff. Photo: By permission of The National Museum of Wales.
73. Photo: E. J. Powell.
74. Photo: Norwegian National Travel Office.
75. Museum of Ethnology, Leiden, Holland.
76. Photo: Alinari-ARB.
77. Photo: Hirmer Fotoarchiv.
78. Olympia Museum, Greece. Photo: Hirmer Fotoarchiv.
79. Published by permission of the Director of Antiquities and the Cyprus Museum.
80. Courtesy, the author.
81. National Museum, Athens. Photo: Alison Frantz.
82a,b. Photos: Courtesy of Museum of the American Indian, Heye Foundation, Solomon Hale Collection.
83. M. E. L. Mallowan, *Early Mesopotamia and Iran,* Thames & Hudson, London, 1965.
84. Photo: Archaeological Survey of India.
85. Photo: Marburg-ARB.
86. Cairo Museum. Photo: Hirmer Fotoarchiv.
87. Musée Guimet.
88. Musée Guimet.
89. Courtesy, the author.

90. Photo: Alinari-ARB.
91. Cathedral of St. Bavon, Ghent. Photo: A. C. L.-ARB.
92. Photo: Pontifical Commission of Sacred Architecture, Rome.
93. Photo: Archives Photographiques.
94. Photo: Lauros-Giraudon.
95. Römer-Pelizaeus Museum, Hildesheim.
96. Cairo Museum. Photo: Hirmer Fotoarchiv.
97. Courtesy, the author.
98a,b. Photos: Hirmer Fotoarchiv.
99. Central Asian Antiquities Museum, New Delhi. Photo: Archaeological Survey of India.
100. Indian Museum, Calcutta. Photo: Archaeological Survey of India.
101. Central Asian Antiquities Museum, New Delhi. Photo: Archaeological Survey of India.
102. Metropolitan Museum of Art, Anonymous Gift, 1917.
103. Wallraf-Ruchartz Museum, Cologne. Photo: Rheinisches Bildarchiv.
104. Victoria and Albert Museum.
105. By permission of the Vicar and Churchwarden of Hawton. Photo: Peter R. Morrell.
106. Photo: Spanish National Tourist Office.
107. Courtesy, the author.
108. Photographie Giraudon.
109a. © Photo: Peter Clayton.
109b. © Photo: Peter Clayton.
110a. Photo: Charles Phelps Cushing.
110b. After L. Woolley, *Ur Excavations,* II, pl. 1. Joint Expedition of the University Museum and the British Museum.
111. Courtesy, the author.
112. Courtesy, the author.
113. Photo: Hirmer Fotoarchiv.
114. Photo: Hirmer Fotoarchiv.
115. Photo: Archaeological Survey of India.
116. Photo: Government of India Tourist Office.
117. Photo: Archaeological Survey of India.
118. Calcutta Museum. Photo: Archaeological Survey of India.
119. Photo: Information Services, Consulate General of India.
120. Trustees of the British Museum.
121a. Photo: Marburg-ARB.
121b. Photo: Marburg-ARB.
121c. From *The Birth of Western Civilization,* edited by M. Grant. Thames & Hudson. London, 1964.

122. Metropolitan Museum of Art, Fletcher Fund, 1928.

123. Museum of Eleusis. Photo: Alinari-ARB.

124. Deutsches Archäologisches Institut, Athens.

125. Photo: Alison Frantz, Athens.

126. Photo: Fototeca Unione, Rome.

127. Uffizi, Florence. Photo: Alinari-ARB.

128. Photo: Courtesy, National Gallery of Art, Washington, Samuel H. Kress Collection.

129. Photo: Anderson-ARB.

130. Vatican Museum. Photo: Alinari-ARB.

131. National Museum, Damascus. Photo: Courtesy, Dura-Europos Collection, Yale University.

132a. Photo: Mrs. I. A. Brandon.

132b. Courtesy, the author.

133. Photo: Alinari-ARB.

134. Photo: Eastfoto.

135. Photo: Turkish Tourism and Information Office.

136. Photo: Ewing Galloway.

137. Photo: Turkish Tourism and Information Office.

138. Photo: Mrs. I. A. Brandon.

139. Photo: Israel Government Press Office.

140. Archaeological Museum, Heraklion, Crete. Photo: Hirmer Fotoarchiv.

141. Archaeological Museum, Heraklion, Crete. Photo: Hirmer Fotoarchiv.

142. National Museum, Athens. Photo: Hirmer Fotoarchiv.

143. Archaeological Museum, Heraklion, Crete. Photo: Marburg-ARB.

144. Photo: Victor Camilleri, Naxxar, Malta.

145. Photo: Courtesy, Maurice Dunand, Directeur de la Mission Archéologique de Byblos.

146. Photo: Aerofilms Ltd., London.

147. Photo: Mexican National Tourist Council.

148. Photo: Joseph Szaszfai, Yale University Art Gallery.

149a. From *A History of Architecture*, by Sir Banister Fletcher, Charles Scribner's Sons. New York, 1961.

149b. From *Monuments chrétienne d'Hippone*, by E. Marec (Éditions A. M. G.).

150. Photo: Anderson-ARB.

151. Photo: Hirmer Fotoarchiv.

152. Photo: Anderson-ARB.

153. Photo: Alinari-ARB.

154a. Photo: Alinari-ARB.

154b. Photo: Alinari-ARB.

155. Photo: Anderson-ARB.

156. Photo: Anderson-ARB.

157. Photo: Anderson-ARB.

158a. Photo: Monkmeyer/B. Silberstein.

158b. Photo: Turkish Tourism and Information Office.

159. Photo: Alinari-ARB.

160. Photo: Courtesy, Greek Orthodox Archdiocese of North and South America.

161. Photo: Marburg-ARB.

162a. Photo: Marburg-ARB.

162b. Courtesy, the author.

163. Royal Gallery, Dresden. Photo: Alinari-ARB.

164. Photo: British Tourist Authority.

165. Courtesy, the author.

166. Courtesy, the author.

167. Griffith Institute, Ashmolean Museum.

168. Tomb of Ateti, Cairo Museum. Photo: Hirmer Fotoarchiv.

169. From *Book of the Dead: The Papyrus of Ani*, edited by E. A. W. Budge. London/New York, 1913.

170. From *Ur of the Chaldees*, by L. Woolley, pl. II, Charles Scribner's Sons. New York, 1930.

171. Photo: Britain-China Friendship Association.

172. From *Cuneiform Texts of Ras Shamra-Ugarit*, by C. F. A. Schaeffer, pl. XXVIII (1). London, 1939.

173. Cyprus Museum, Nicosia, Republic of Cyprus.

174. Courtesy, the author.

175. From *Manners and Customs of the Modern Egyptians*, by E. W. Lane. London, 1830, 1890.

176. Photo: Hirmer Fotoarchiv.

177. Courtesy, the author.

178. The Master and Fellows of University College, Oxford and Christ's College, Cambridge.

179. © Photo: Peter Clayton.

180. Courtesy, the author.

181. Photo: Hirmer Fotoarchiv.

182a. Courtesy of The Oriental Institute, University of Chicago.

182b. Courtesy, the author.

183. Photo: Hirmer Fotoarchiv.

184. Courtesy, the author.

185. Cairo Museum. Photo: Hirmer Fotoarchiv.

186. Metropolitan Museum of Art, Rogers Fund, 1910.

187. Courtesy, the author.

188. Photo: Mexican National Tourist Council.

189. Courtesy, the author.

251. National Museum, Athens. Photo: Marburg-ARB.
252. Trustees of the British Museum.
253. Trustees of the British Museum.
254. Staatliche Museen zu Berlin.
255a. National Museum, Athens. Photo: Marburg-ARB.
255b. Metropolitan Museum of Art, Fletcher Fund, 1927.
256. National Museum, Athens. Photo: Alinari-ARB.
257. National Museum, Athens. Photo: Alinari-ARB.
258. Metropolitan Museum of Art, Rogers Fund, 1909.
259. Trustees of the British Museum.
260. Trustees of the British Museum.
261a. Musée de Lavigerie, Carthage, Tunis. Photo: Fototeca Unione, Rome.
261b. National Museum, Beirut.
262. Capitoline Museum, Rome. Photo: Alinari-ARB.
263. Walters Art Gallery, Baltimore.
264. Vatican Museum, Rome. Photo: Alinari-ARB.
265. Porta Maggiore, Rome. Photo: Alinari-ARB.
266. Institute of Archaeology, Hebrew University of Jerusalem.
267. From *Il simbolismo dei guideocristiani*, by P. E. Testa, Tav. 10, pub. Tipografia dei PP. Francescani, Jerusalem, 1962.
268. Photo: Pontifical Commission of Sacred Architecture, Rome.
269. Photo: Pontifical Commission of Sacred Architecture, Rome.
270. Photo: Pontifical Commission of Sacred Architecture, Rome.
271. Photo: Pontifical Commission of Sacred Architecture, Rome.
272. Photo: Pontifical Commission of Sacred Architecture, Rome.
273. Photo: Alinari-ARB.
274a. Photo: Pontifical Commission of Sacred Architecture, Rome.
274b. Photo: Pontifical Commission of Sacred Architecture, Rome.
274c. Photo: Pontifical Commission of Sacred Architecture, Rome.
274d. Photo: Pontifical Commission of Sacred Architecture, Rome.
275. Photo: Pontifical Commission of Sacred Architecture, Rome.
276a. Photo: Pontifical Commission of Sacred Architecture, Rome.
276b. Courtesy, the author.
277. Lateran Museum, Rome. Photo: Alinari-ARB.

278. Lateran Museum, Rome. Photo: Anderson-ARB.
279a. Lateran Museum, Rome. Photo: Alinari-ARB.
279b. Photo: Alinari-ARB.
280a. Staatliche Museen zu Berlin.
280b. Bardo Museum, Tunisia.
281. British Museum. French c. 1460. MS Add. 27697, fol. 194r.
282. Photo: Alinari-ARB.
283. Photo: Marburg-ARB.
284. Photo: Foto Mas, Barcelona.
285. Photo: Alinari-ARB.
286. Photo: Marburg-ARB.
287. Church of St. Francesco, Bologna, Italy. Photo: Marka, Milan.
288. Photo: Anderson-ARB.
289. Photo: Keith Durn & Sons, Tewkesbury, Gloucestershire.
290. Photo: R. S. Bowman, Dalton, Crewe Road, Sandbach, Cheshire.
291a. Osterreichische National bibliothek. Photo: Courtesy Austrian Information Service.
291b. Oesterreichische Fremdenverkehrswerbung.
292. Photo: © The Times.
293. Courtesy, the author.
294a. Louvre, Paris. Photo: Photographie Giraudon.
294b. Photo: F. H. Crossley.
295a. Photo: National Monuments Record, London.
295b. Photo: Courtesy of Raymond Richards, MA, FSA, FR. Hist. S, Gawsworth Hall, Macclesfield, Cheshire, England.
296. Courtesy, the Lahore Museum, Lahore.
297. Photo: Alinari-ARB.
298. Reproduced from *The Dance of Death*, by T. Tindall Wildridge. London, 1887.
299. National Museum of Ethnology, Leiden, Holland.
300. Prado, Madrid. Photo: Foto Mas, Barcelona.
301. Musée Condé, Chantilly. Photo: Photographie Giraudon.
302. Photo: Marburg-ARB.
303a. Metropolitan Museum of Art, The Cloisters Collection, Purchase, 1928.
303b. Photo: Hirmer Fotoarchiv.
304. National Museum, Algiers.
305. Copyright A. C. L., Brussels.
306. Louvre. Photo: Archives Photographiques, Paris.
307. Courtesy of the Oriental Institute, University of Chicago.

Index

Numbers in boldface refer to pages on which illustrations appear; parentheses indicate cross-references to illustrations.